JOURNALS APPROACH

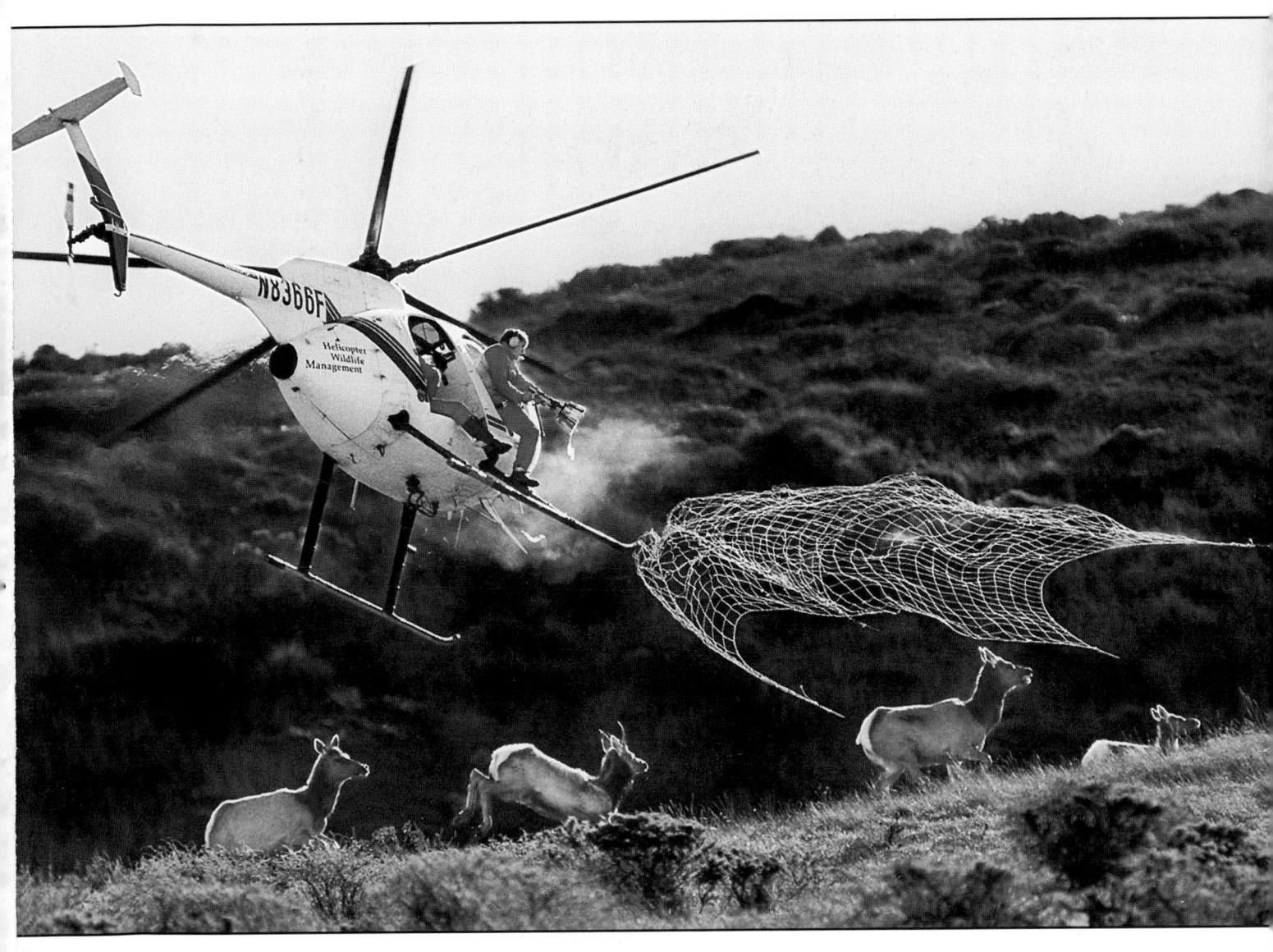

A net fired from a helicopter envelops a female tule elk. Scientists take specimens and measurements from the elk and attach a radio collar to track the movement and habits of the 270 animals in the area.

(Photo by John Burgess, Santa Rosa Press Democrat.)

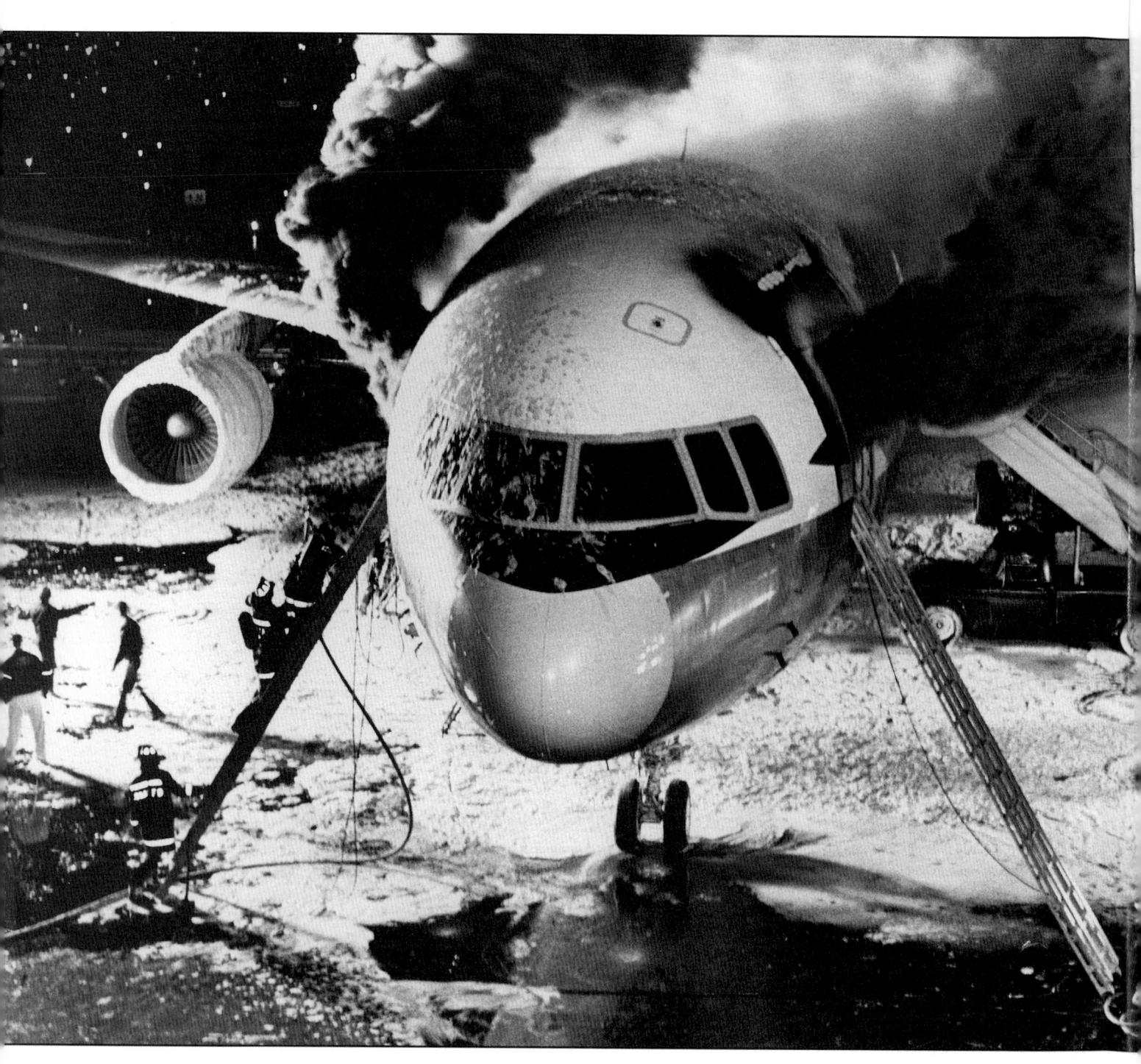

Firefighters snuff an electrical fire aboard an airplane parked on a Boston runway. (Photo by George Rizer, the *Boston Globe*.)

J O U R N A L I S M T H E P R O F E S S I O N A L S' A P P R O A C H fourth edition twentieth anniversary

Kenneth Kobré

Editing & Design by Betsy Brill

FOCAL PRESS

Boston Oxford Auckland Johannesburg Melbourne New Delhi

Focal Press is an imprint of Butterworth-Heinemann.

Copyright © 2000 by Butterworth-Heinemann

A member of the Reed Elsevier group.

All rights reserved.

No part of this work may be reproduced, stored in a retrieval system, or transmitted, in any form or by any means, electronic, mechanical, photocopying, recording, or otherwise, without the prior written permission of the publisher.

Recognizing the importance of preserving what has been written, it is the policy of Butterworth-Heinemann to have the books it publishes printed on acid-free paper, and we exert our best efforts to that end.

Cover design and interior design:

Betsy Brill, San Francisco

Cover photographs: Annie Wells, The Santa Rosa Press [California] Democrat

(Annie Wells, who won the Pulitzer Prize for the photograph of this dramatic successful rescue, is a former student of the author. The exhausted rescuer was making his third and final attempt to save the girl, while her anquished mother watched his heroic efforts. Wells now works for the Los Angeles Times.)

Illustrations: Ben Barbante, San Francisco.

Library of Congress Cataloging-in-Publication Data

Kobré, Kenneth 1946-

Photojournalism: the professionals' approach / Kenneth Kobré;

editing and design by Betsy Brill - 4th ed.

Includes bibliographical references (p.

ISBN 0-240-80415-5 (pbk. : alk. paper)

II. Title.

TR820 .K75 2000

070.4'9-dc21

99-059412

CIP

British Cataloguing-in-Publication Data A catalogue record for this book is available from the British Library

The publisher offers discounts on bulk orders of this book. For information, please write:

Manager of Special Sales Butterworth-Heinemann 225 Wildwood Avenue Woburn, MA 01801-2041 781-904-2500

10 9 8 7 6 5 4 3 2 1

Printed in Canada.

IV ■ Photojournalism: The Professionals' Approach

Dedication

This book is dedicated to my parents, Reva and Sidney Kobre.

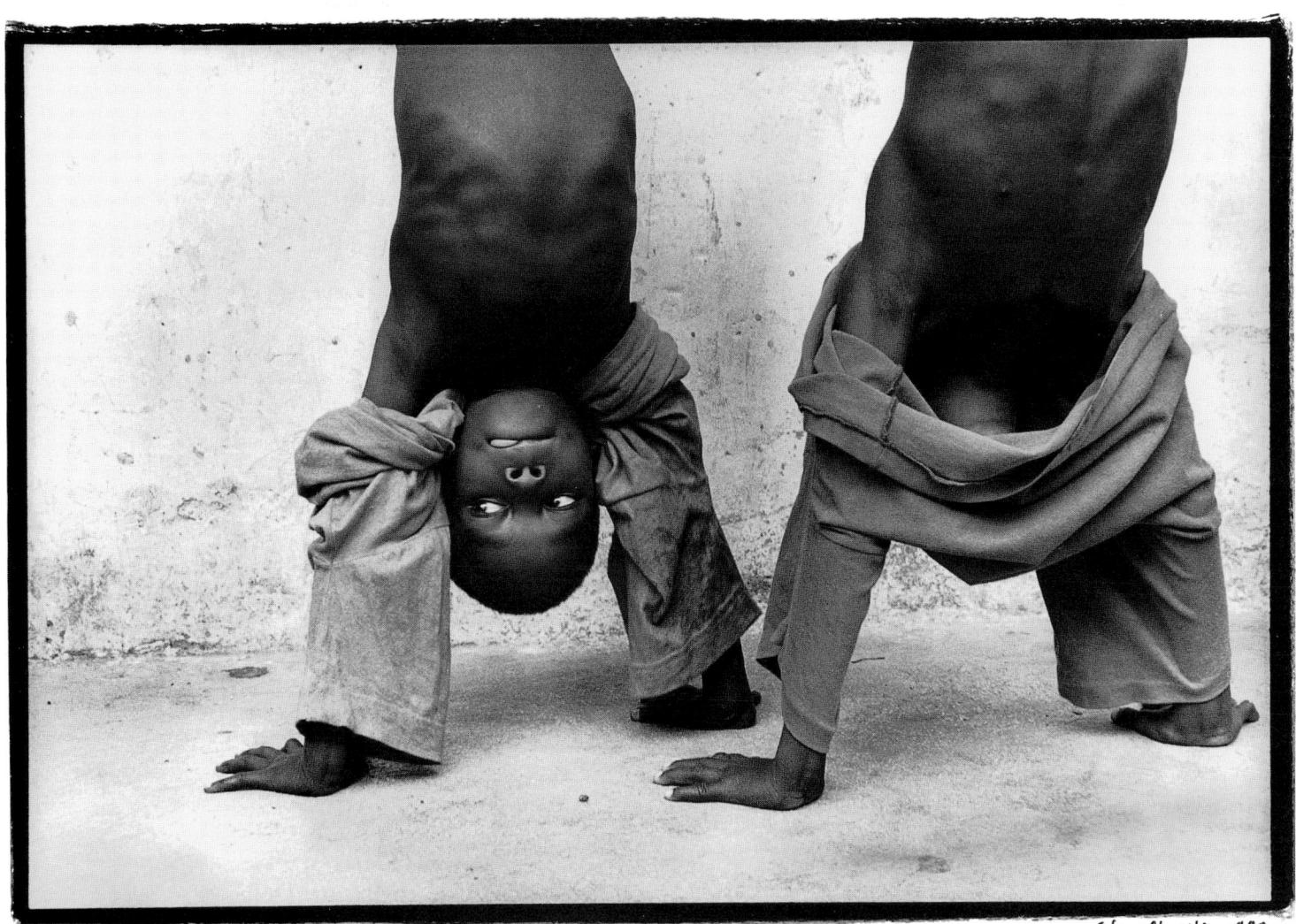

HANDGTANDS

Jennifer Cheek 1997

Children perform handstands at the Lafanmi Selavi, a home for 350 street kids in Haiti.

(Photo by Jennifer Cheek Pantaléon, Pacifica, California.)

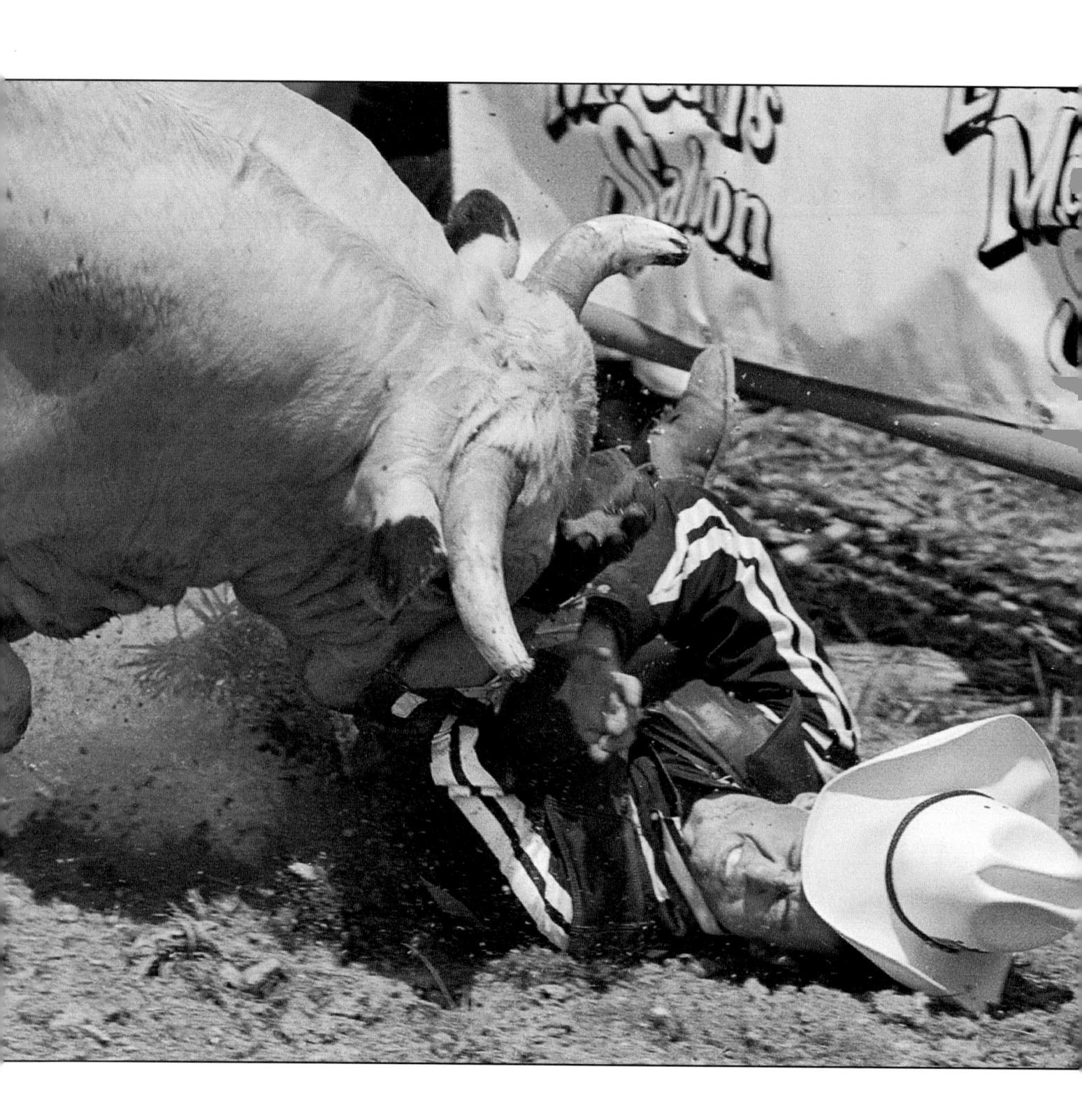

Contents

viii

Dedication

Preface

	Acknowledgments	ix			
CHAPTER ONE	Assignment	2	TEN ■ Photo Editing	188	20
TW0	Spot News	24	ELEVEN • Cameras & Film	218	
THREE	General News	44	TWELVE Digital Images	244	
FOUR	Covering the Issues	58	THIRTEEN Strobe	260	
FIVE	Features	84	FOURTEEN ■ The Law	282	
SIX	Portraits	98	FIFTEEN • Ethics	300	
SEVEN	Sports	114	SIXTEEN • History	329	
EIGHT	■ The Photo Story	136			A first time bull rider takes a spill at the annual rodeo at the Howard County
NINE	Photo Illustrations	170	Selected Bibliography Index	360 369	Fairgrounds. (Photo by Rich Riggins, Patuxent [Maryland] Publishing Co.)

Preface

Can anyone predict the future of photojournalism? The death of the field has been announced many times. When television began in the early 1950s, Robert Capa, the famous war photographer and founding member of Magnum (pages 17 and 351–352), stated that photojournalism was finished. He was wrong.

Others predicted the demise of photojournalism with the end of the weekly *Life* magazine (pages 349–350). They were wrong.

Doomsayers predicted the field's final chapter when a number of large afternoon newspapers closed. So far, they have been mistaken.

Other futurists anticipate that photographers will simultaneously shoot both stills and digital moving pictures (pages 254–255). Some even say that with the expansion of the World Wide Web, streaming video will supplant

the need for still photojournalism.

So far, the prophecies have not materialized. At the turn of the 20th century, fifty years after Capa predicted the death of photojournalism, the field is alive and well.

In fact, the World Wide Web has resulted in an explosion of easily available information. Most sites use words and still pictures to present that information. Just as on the printed page, words need still pictures to attract and hold the readers. Traditional news outlets like *The Washington Post, Newsweek, New York Times*, NBC, and CNN all have Web sites providing up-to-date news and pictures. The marriage of still images and words remains the most efficient way to report the news.

Perhaps the most hopeful is the rapid growth of personal Web pages. Today's photojournalists no longer

need a printing press to circulate their work. They can use the Web to distribute every picture and story they produce. Photographers are no longer limited to one or two pictures per story (as in print) but can offer ten or even a hundred pictures of floods in India or football in Indiana.

Thanks to growing access to the World Wide Web, millions of people around the world will be stimulated by powerful images transmitted to their computer screens—images not always preselected or filtered by conventional news agencies. The potential for quality photojournalism to affect change is greater than ever.

When the Marines landed in San Diego, the sunbather was unfazed because he was a demolitions expert who helped plan the landing. (Photo by Robert Lachman, Los Angeles Times.)

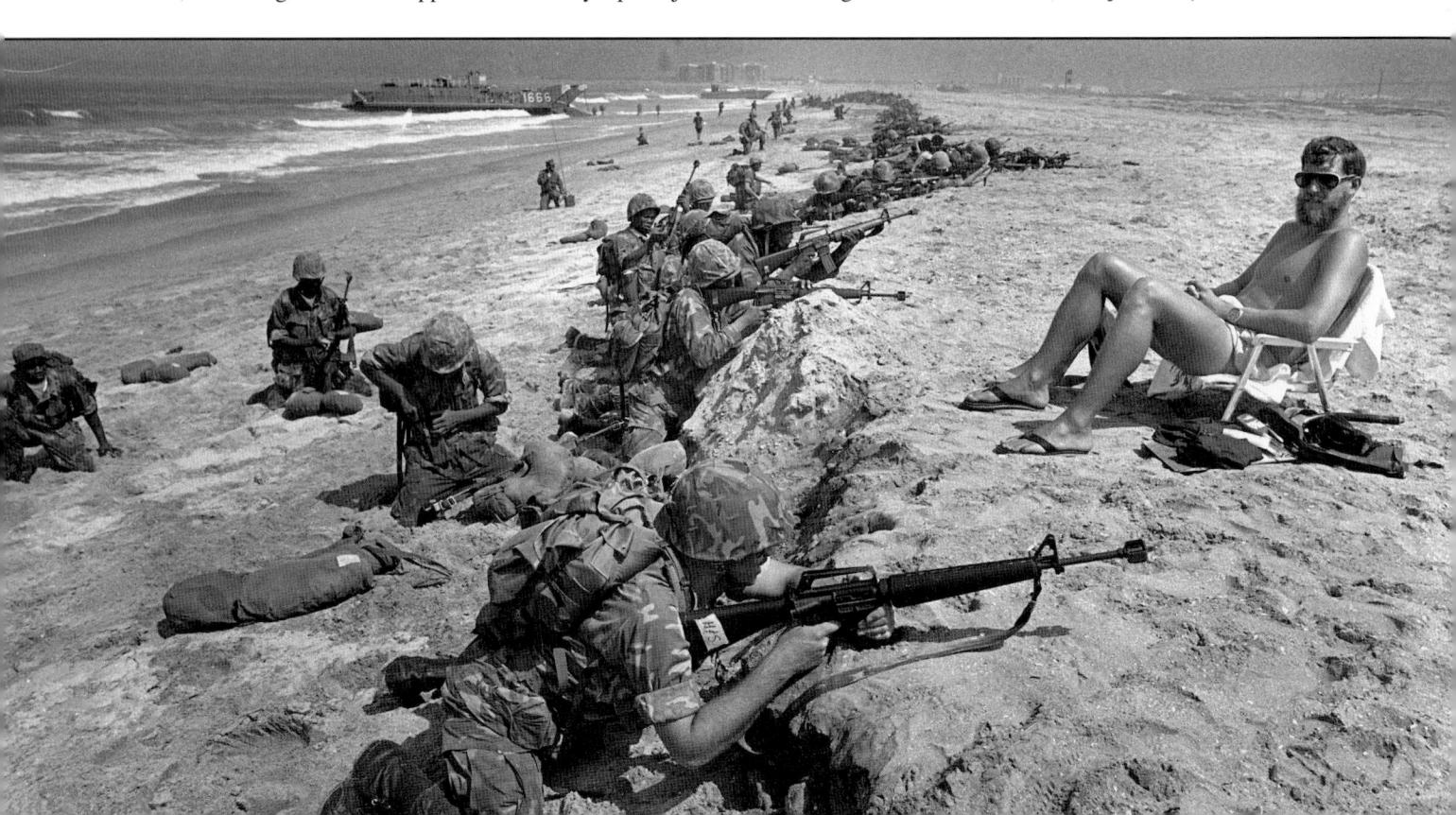

Acknowledgments

I would like to thank my parents, Dr. and Mrs. Sidney Kobré. Without their advice and guidance, I would never have written the first edition of this book twenty years ago. My father, who was a reporter, editor, and professor of journalism for many years, helped to give the book a clear journalistic focus. His specialty was the history of journalism. My mother, also a writer, suggested many ways to improve the prose style of the original manuscript.

This edition of the book would have never obtained its look nor even been completed without the devotion and love of Betsy Brill, my wife. For nearly a year, through many alterations and changes, she helped guide the project from initial idea to the final design of the printed page. Her experience as a professional photojournalist, editor, and designer helped bring my abstract ideas into reality.

For some books, the author goes to the mountaintop and writes. That is not how I developed this book or its earlier editions. From the beginning, I have based the text on interviews—both formal and informal—with working pros on newspapers, magazines, wire services, and Web sites. I have mentioned their names in the text whenever possible. Without their expertise and time, this book would not be complete.

In addition, numerous photographers, photo editors, academics, teachers who use the book, students, and lawyers have read parts of the third edition and made suggestions for this revision. I greatly appreciate their time and effort. Also for this edition, many new photographers and editors generously spent time with me to share the stories behind their work. A second wave of people helped research pictures for this revision. Without their help, the book would not have its wide diversity of images. The names of all these generous individuals are in the column on the right side of the page.

Almost all the photos in this book have been lent to me by photographers, some of whom I know and others I've not had the honor to meet; some former students and some present

ones. Their credits appear next to each of their pictures. I would like to thank them all for their generous contribution to this project. A book of this scope and quality would be impossible without their collaboration.

In fact, many photographers who shared images for this edition have told me they used the book when they were students or were just getting started. One photographer even wrote to say that not only had he used the original book when he was a student, but that after a number of years in the profession, he began teaching part-time and now assigns the text to his students. His photo, in this edition, will help a third generation.

This edition, even more so than earlier ones, is a unique collaboration. More than two-thirds of the new photographs came in digital form from photographers who prepared their own images—some scanned from negatives, some from prints, some shot with digital cameras.

I also have tried to draw on the latest research in the field. Lucinda Covert-Vail. Director of Public Service, New York University Libraries, compiled the extensive, computer-assisted searches for the final bibliography. Mary Thorsby, Denise Harvey, and Rosemarie Lion saved the day with crucial last-minute proofreading. Denise and Cammie Touli helped track down periodicals and manuscripts. Rosemarie helped prepare the more than 500 images for publication. I am grateful for Ben Barbante's good humor and his skills in explaining technical situations with clear drawings. My editor at Butterworth/Focal Press, Marie Lee, encouraged me to undertake this revision and chaperoned it to completion.

Finally, like a chemist's research lab, my classes at San Francisco State University have allowed me the opportunity to experiment on new approaches to photojournalism, particularly the picture story and the portrait. I would like to thank my students for going through the trials and tribulations of trying new ways to tell stories photographically. These experiments have resulted in several extensive photo and writing projects, parts of which appear in this book.

FOURTH EDITION REVIEWERS

Alex Burrows, Virginian-Pilot, Jimmy Colton, Sports Illustrated, Bill Duke, freelance photo illustrator; Mary Lou Foy, The Washington Post, David Guralnick. Detroit News: John Kaplan, University of Florida; Tom Kennedy, The Washington Post Online; Kim Komenich, University of Missouri; Tom Kunhardt, Kodak; Ken Light, University of California, Berkeley; Jim McNay, San Jose State University; Mike Philips, Nikon; Steve Raymer, Indiana University; Michael Scherer, University of Nebraska: C. Zoe Smith, University of Missouri; Hal Wells, Los Angeles

FOURTH EDITION PICTURE RESEARCH

Colin Crawford, Los Angeles Times; Larry Daily, MSNBC; Joe Elbert and Mary Lou Foy, The Washington Post, Jessica Murray, Magnum; Bob Swoffard, Santa Rosa Press Democrat, Hal Wells, Los Angeles

FOURTH EDITION INTERVIEWS

Nancy Andrews, The Washington Post, Nicole Bengevino, New York Times; P.F. Bentley, Time; Alan Berner, Seattle Times: John Burgess. Santa Rosa Press Democrat, Larry Daily, MSNBC; Sam Costanza, New York Post, Joe Elbert, The Washington Post, John Gaps III, Associated Press; Michael Grecco, freelance, Los Angeles; David Guralnick, Detroit News; Carol Guzy, The Washington Post, Sibylla Herbrich, freelance, San Francisco; Sheree Josephson, Weber State University; Doug Kapustin, Baltimore Sun; Richard Koci-Hernandez, San Jose Mercury News; David Hume Kennerly, Newsweek, David Leeson, Dallas Morning News; Ray Lustig, The Washington Post, Jim MacMillan, Philadelphia Daily News: Sung Park, Austin American-Statesman; Smiley Pool, Houston Chronicle, Kent Porter, Santa Rosa Press Democrat, Steve Raymer. University of Indiana: Charlie Riedel Hays Daily News; Marcel Saba, Saba Press Photos; Michelle Stephenson, Time; Diana Walker, Time; Annie Wells, Los Angeles Times, Hal Wells, Los Angeles Times; Dave Yoder, Orange County Register.

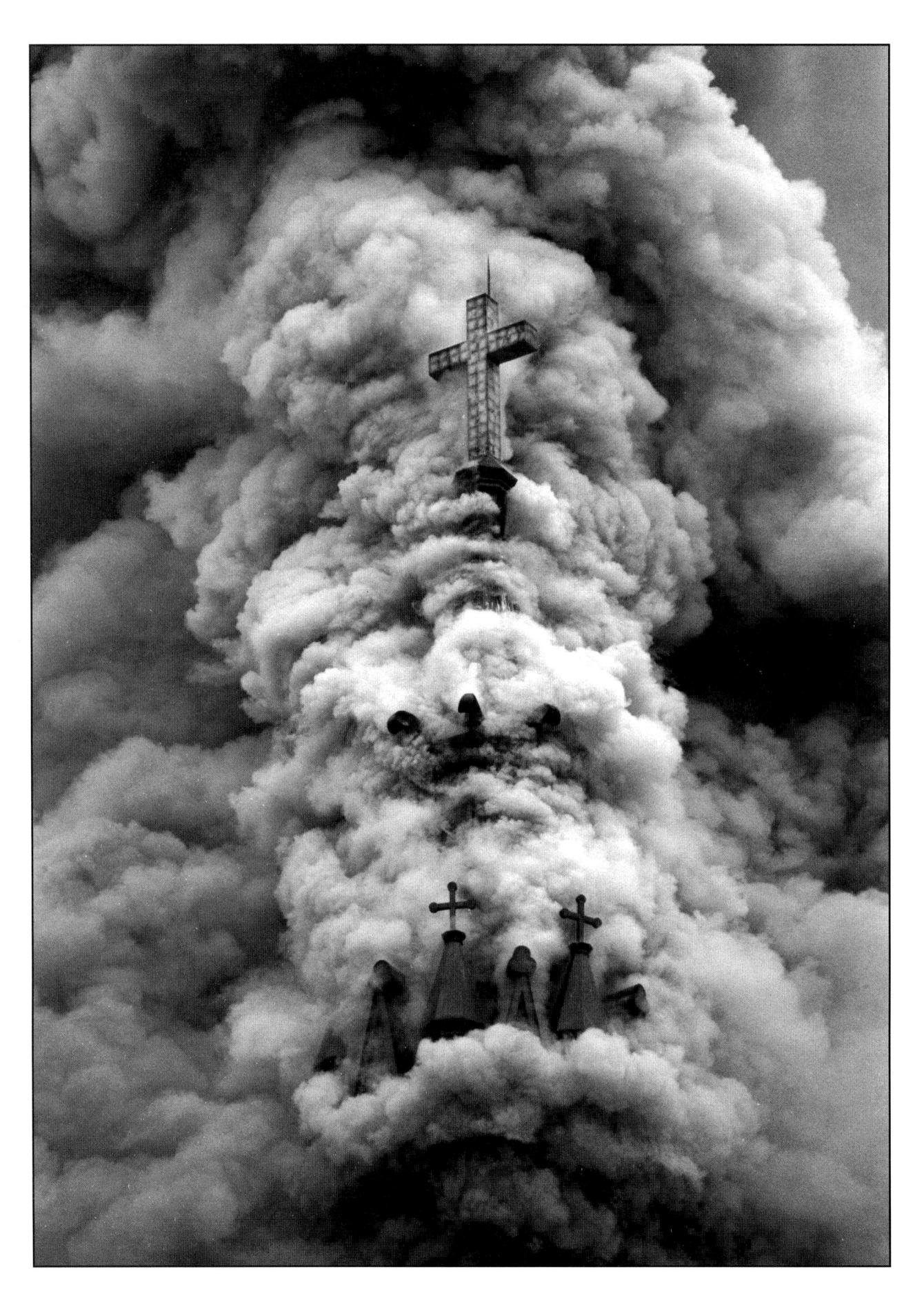

• Photojournalism: The Professionals' Approach

Assignment

WHERE TO FIND NEWS: LOOKING FOR SCOOPS

CHAPTER 1

S

teve Linsenmayer, of the Fort Wayne (Indiana) News-

Sentinel, heard the darkroom's emergency band scan-

ner cackle, "Structure fire." Looking out the window,

he saw black rain clouds covering a sky broken by distant lightning.

Linsenmayer hesitated to race out into the storm until his boss,

Keith Hitchens, came running down the hall yelling, "church fire."

Hitchens had heard the second call on the radio asking for addition-

The photographer heard about this fire at a church by monitoring the emergency scanner radio.

(Photo by Steve Linsenmayer, the *News-Sentinel* [Fort Wayne], Indiana.) al fire companies and identifying the burning

structure as St. Mary's Church. "Oh shit,"

Linsenmayer gasped as he raced by the darkroom

to grab his camera bag on the way to his car.

When he got to St. Mary's, the lightning storm that had started the blaze was still in full glory. Within minutes of starting to shoot, Linsenmayer's umbrella blew out, so he radioed back to the office to send more film, more photographers—and dry towels.

About an hour into the fire, heavy smoke started to billow out of the rear steeple. Linsenmayer kept shooting as he captured the shot of the church's crosses enveloped by smoke. The photo filled nearly the entire front page of the next day's edition. (See page 2.)

SCANNER RADIO SIGNALS FIRES AND ACCIDENTS

Most dramatic news photographs result not from city desk assignments but from vigilant photographers who monitor scanner radios to learn about breaking news situations. Police, fire, and other emergency agencies communicate with cops and firefighters in the field via low frequency, very high frequency (VHF), and ultra high frequency (UHF) radio wave bands. Each agency—the police, the highway patrol, the coast guard—broadcasts on a different frequency. A scanner radio automatically switches from one frequency to another, stopping whenever a transmission is occur-

ring. The scanner continually rotates through the frequencies it is programmed to listen for. By monitoring a scanner radio, a photographer can listen to transmissions from all the emergency agencies in an area. If a warehouse fire takes place, the dispatcher will call for fire engines and give a location. By noting the number of the alarms (indicating the size of the fire), the number of engines called, and the location, a photographer can determine the magnitude of a blaze, its news value, and whether it will be burning by the time the photojournalist arrives on the scene.

Jim MacMillan, who covers spot news for the *Philadelphia Daily News*, says that he gets 90 percent of his tips from listening to the scanner radio—make that four scanners, all of which he monitors simultaneously. One scanner is tuned to the citywide police, one to local police, one to the fire department, and one to pick up transmissions from the local TV news desk as well as the coast guard and airport.

Sam Costanza, on contract with the *New York Post*, spends six nights a week parked near the intersection of three main highways that lead to New York's boroughs—all the while monitoring the transmissions of the New York Police Department's special operations section. "I'm a listener," he says.

Political groups like
this one demonstrating
in front of an abortion
clinic in Wichita,
Kansas, often tip of
the media about the
time and place of their
protests.

(Photo by Kim Johnson for the Wichita [Kansas] Eagle.)

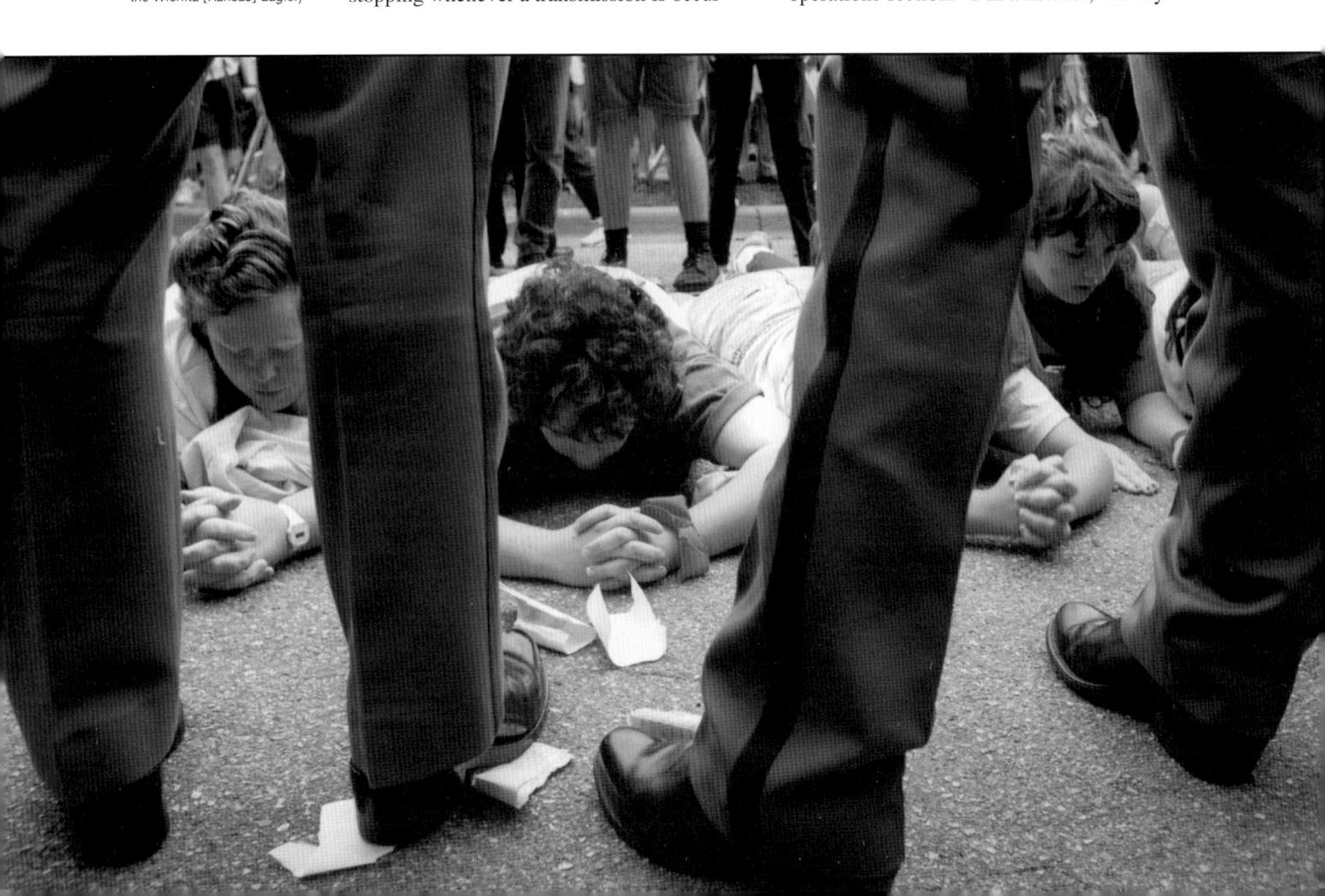

"There aren't many listeners. Other photographers respond to assignments. By the time they arrive, I'm already leaving the scene."

Kent Porter of the Santa Rosa Press Democrat, who covers spot news in a more rural area in Northern California, tracks the action with five antennae on his Nissan truck as well as a scanner inside his house. Not only does he monitor scanner transmissions, but he also carries a cellular phone and stays tuned to the local all-news radio station. He says his truck looks like a centipede

Different agencies use their own special codes when talking on the air. Porter knows he is heading out for a strong-arm robbery or assault with a weapon when he hears "211." He also knows to "be on the lookout" when he hears "B-O-L," and that "code 20" means an officer needs immediate assistance. In New York, Costanza knows that a "1045, code one," means a fire-related death.

Although there are no uniform codes from one city to another, stores that sell scanner radios usually have printed copies of local codes available.

The codes tell photographers what is taking place, but they don't always indicate the importance of the action. Every photographer interviewed for this chapter said that the tension in a dispatcher's voice reveals an emergency's significance. "I listen for the voices on the scanner," says Santa Rosa's Porter. "I know the tones of voices. . . . The stress in their voices will tell you so much." The Post's Costanza puts it this way. "The dispatchers have distinctive voices—you can tell when they are alarmed. Listen hard and quick. You might only get one shot at it."

OTHER SOURCES FOR NEWS

What else do photographers use to keep in touch with the news pulse of the city or the country or the world, especially when they can't monitor a scanner radio all day?

STAY TUNED TO ALL-NEWS RADIO. TELEVISION, AND WEB SITES

Alternatives include all-news radio stations, television stations that provide frequently updated news reports, and Web sites that post the latest information as soon as it comes across the wires.

An all-news radio station or a cable network like Cable News Network (CNN) interrupts in-progress programming immediately if an emergency arises. These stations monitor several scanner channels, including the fire and police departments, and will announce when a major fire alarm or multicar accident occurs. The all-news channel's weather forecaster will predict natural disasters such as hurricanes or tornadoes. The information provided by all-news stations isn't as immediate as what you'll learn on the scanner, but their reports often will suffice.

For magazine and freelance photographers working overseas, CNN as well as the BBC and MSNBC provide around-the-clock news updates. Even photographers covering huge, breaking, international stories turn to one of the twenty-four-hour outlets to get news in English and see how the rest of the world is receiving the story.

Today, many photojournalists on foreign assignments carry laptop computers with modems that they can connect into local telephone outlets. Once connected, they can track developing stories on the Web and, of course, send pictures and communicate with editors.

USE CONTACTS

Michael Meinhardt of the Chicago Tribune has developed his own system of finding out about local spot news as it happens. Using a system of pagers, two-way radios, cellular phones, and a network of sources and contacts, he stays abreast of news as it breaks in the Chicago and greater-Chicago area.

Firefighters, police officers, dispatchers, and even air traffic controllers at surrounding airports notify Meinhardt of news events via a voice-message pager that he carries twentyfour hours a day. He has befriended these contacts at other news events, where he introduced himself, left a business card, and followed up by giving them photographs of themselves at work.

"You'd be surprised how many of them remember me when the news breaks," he says.

"Additionally," he explains, "I belong to a network of contacts led by a local radio news reporter who is considered the dean of spot news. . . . We all have two-way radios on our own frequency that we monitor around the clock. . . . Once the closest person arrives on the scene, I can usually ascertain whether it's worth traveling to shoot pictures. They can also let me know how urgently I need to get there before the scene clears up."

Not surprisingly, Meinhardt is considered a great source of information by his colleagues in the newsroom and by the newspaper's city desk.

TIPS HELP

News organizations often get leads on top news stories when people call or write with tips. In fact, some newspapers and a few magazines offer monetary rewards for tips. The desk editor sizes up the event; then, if

the decision is to respond, the editor or an assistant may send out a reporter and photographer or call a local freelancer.

Special interest groups also notify news outlets if group members think publicity will do them some good. If minorities, mothers on welfare, gays, or antinuclear groups, for example, are going to stage a protest for which they want coverage, they might contact local and national outlets with the time and place of their planned demonstration.

BEAT REPORTER KNOWS THE TERRITORY

Most news outlets assign reporters to cover a certain beat: city hall, hospitals, or police headquarters for a city newspaper, or the White House, education, or medicine for a national magazine. These specialists keep up with the news and events in their area; consequently, they know when to expect a major story to break. The city hall reporter may call in to the city desk and say, "The mayor is greeting some astronauts today. It will be worth a good picture." The editor will probably assign a photographer. The magazine reporter may need pictures of a school for the gifted for a story on education in America. The magazine's photo editor, often in New York or Washington, will assign a photographer who is under contract with the publication or call a local freelancer.

PR OFFICE IS THERE TO AID YOU The Senator will arrive at her office at 9:00 A.M. She leaves for the airport at 10:15 A.M. to dedicate a new runway. She will be at the Golden Age Senior Citizens home from 11:30 A.M. to 12:30 P.M. Then, during a 1:00 P.M. lunch at Parker House, the Senator will meet with the Committee for State Beautification.

If you want to know the whereabouts of the Senator practically every minute of the day, just consult the politician's schedule. The Senator's personal or press secretary arranges the itinerary weeks in advance. Mayors, congressional representatives, senators, and the president of the United States have carefully planned schedules, usually available through their press officers.

Companies, schools, hospitals, prisons, and governmental departments also have press or public relations offices. These offices, sometimes called public affairs or public information departments, generate a steady stream of news releases announcing the opening of a new college campus, the invention of a long-lasting light bulb, or the start of a new special education program. Many of these PR releases suggest good picture possibilities.

SCHEDULES IN PRINT OR ONLINE

Another source for upcoming news events comes daily to your doorstep rolled and held with a rubber band. The daily newspaper carries birth, wedding, and death announcements. It prints schedules of local theaters, sports events, parades, and festivals. When the circus arrives in your town, the newspaper is where you'll find the time and place of the big top show.

Web sites also offer complete listings of upcoming events. Many organizations and sports facilities list activities on their own sites. Surf the Web for updated schedules.

TRADE MAGAZINES AND SPECIALIZED WEB SITES SUPPLY UNUSUAL LEADS For more unusual activities, check special interest newspapers, magazines, and special interest groups on the Web. Dog and cat lovers, cyclists, plumbers, skateboarders, mental health professionals, and environmental groups all publish magazines or newsletters, and most have Web sites that announce special events.

To track upcoming happenings with visual possibilities, newspapers, wire services, and magazines maintain log books listing the time, place, and date of future activities that might turn into a story. The notation in the book includes a telephone number for the sponsoring organization in case the photographer needs more information. Freelancers can adapt this idea to track events for themselves.

WORKING WITH REPORTERS: CLICKERS MEET SCRIBBLERS

PHOTO REQUEST STARTS THE PROCESS

Whether it's *Time* magazine or the *New York Times*, most news organizations have many more staff reporters than photographers. From their sources, these newshounds generate potential stories. When an editor approves a story proposal, the reporter makes out a photo request.

For the photographer, the key to great photo coverage depends on the information and arrangements on the photo request. Typical assignment requests include the name of the person or event to be photographed, as well as the time, date, and place. The editor usually assigns a slug—a one- or two-word designation for the story that serves as the story's name until the copy desk writes a final headline. The assignment sheet often includes a brief description of the proposed article as well as a telephone number with which to contact the key subject if anything needs to be changed.

Photograph people in action. Whenever possible, avoid the office portrait. (Photo by Milbert Brown, Chicago Tribune.)

MAKING THE MOST OF AN ASSIGNMENT

PHILADELPHIA'S HOMELESS: HOW THEY SURVIVE

Tom Gralish of the *Philadelphia Inquirer* recalls that when he received an assignment to photograph the homeless, editors suggested he "might do portraits of the street people, each standing in front of their grates or cardboard boxes or whatever else they called home. At that point, I wasn't sure what I would do, but I decided then and there that whatever it was, it would be the most honest photography I'd ever done. I was determined to do something as true as possible to the traditional ideals of documentary photojournalism."

Consequently, Gralish did not set up portraits.

Instead, he followed street people with names like Hammerman, Spoon, and Redbeard through the ups and downs of their barren, subsistence lives. He photographed them staying warm atop steam grates on a frozen street, drinking wine, and panhandling. He showed them sleeping in boxes. Rather than a series of formulated, posed portraits, Gralish photographed the nitty gritty of these men's lives. For his efforts, he won both the Pulitzer Prize and the Robert F. Kennedy Memorial Prize.

(Photos by Tom Gralish, the Philadelphia Inquirer.)

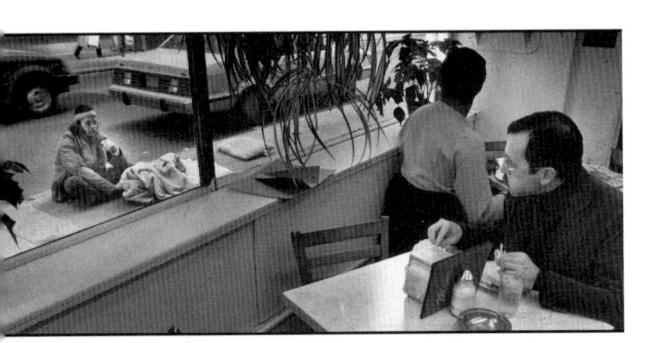

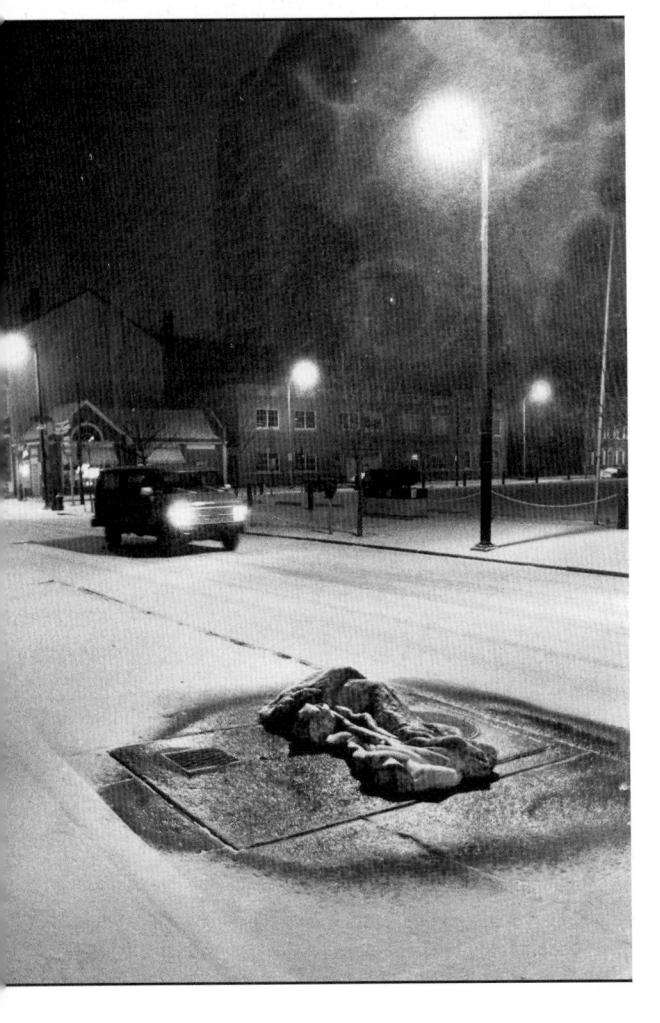

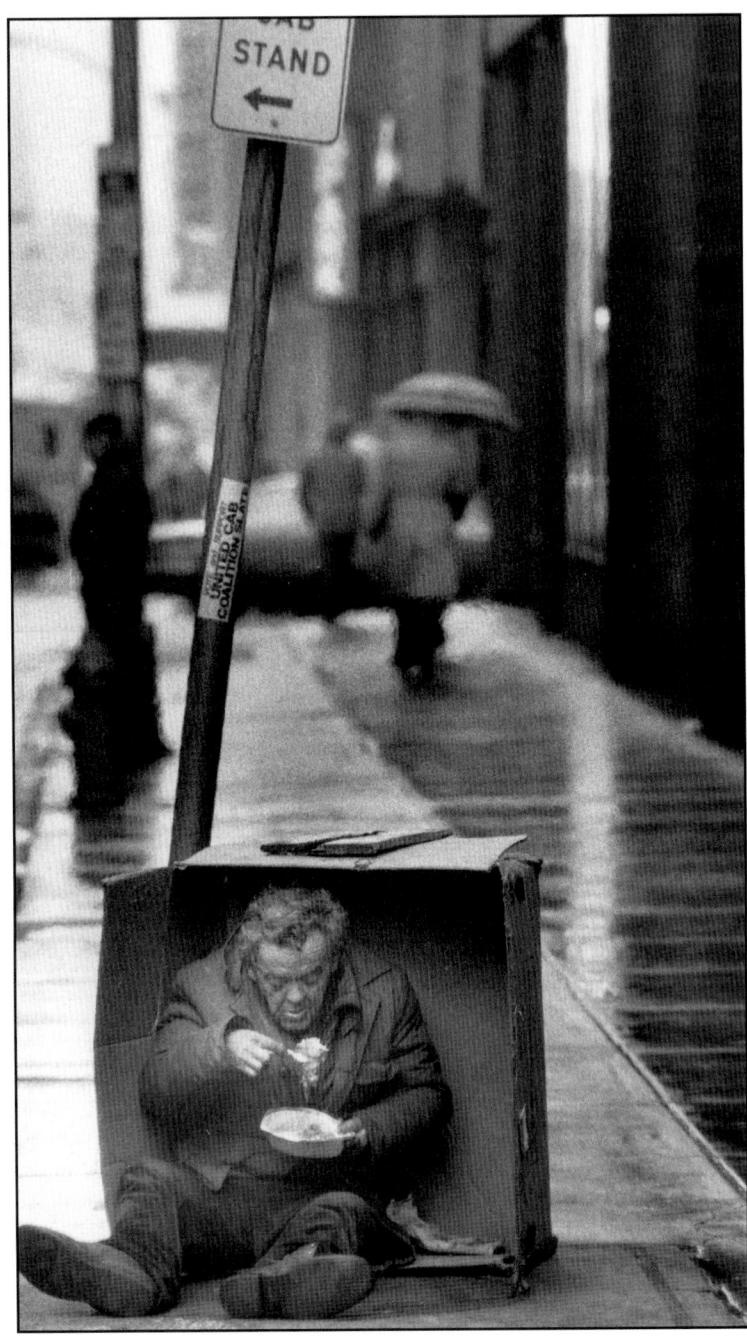

8 ■ Photojournalism: The Professionals' Approach

PHOTOGRAPHER AND REPORTER MEET AHEAD OF TIME

Under the best of circumstances, the reporter, photographer, and assigning editors meet or talk on the telephone or by E-mail at this point in the story's development to discuss the team's approach or define the story's thrust. Here, the photojournalist can suggest visual ways to tell the story that correspond to the reporter's written approach. The photographer can recommend a candid approach, a portrait, or a photo illustration—and also can estimate the amount of time needed for the shoot, or identify props and necessary clearances.

At some outlets, unfortunately, the photographer never meets with the reporter and assigning editor. Rather, the shooter receives the information from an intermediary editor, or is briefed by notes on the assignment sheet. In these circumstances the photographer plays a reduced role in determining the story's final outcome. Located at the end of the assigning chain, the photographer has little say in determining the best approach to the story.

BEST TIME FOR AN ASSIGNMENT

At many news organizations, the reporter calls the subject and makes shooting arrangements for the photographer. Sometimes this saves the photographer time. In most cases, though, the reporter will probably overlook great picture opportunities. The reporter, for example, may decide to do a story about the controversial principal at Lincoln High. The writer asks when the principal is free for an interview and pictures. The principal responds: "Well, I'm busy all day. I greet the kids as they get off the bus. Then I meet with parents and teachers. Next I observe classes and eat lunch with the kids. Then I usually work with student discipline problems in the afternoon. All the teachers and students are gone by four. How about meeting me in my office after four?"

From the reporter's point of view, four o'clock is fine. The principal is free to answer questions and chat in a quiet environment in her office. From the photojournalist's perspective, four o'clock is okay if formal portraits or head shots are all that are sought. But four o'clock is a disaster if the photojournalist wants to shoot revealing candids.

The shooter should be at school at 7:30 A.M. as the principal greets the kids, again at noon when she eats with her teachers and students. Ideally, the photographer will later observe the principal's work with disciplinary problems. These pictures would show whether the principal is stern or kind,

friendly or tough, or a little of each. Were the photographer to shoot when the writer originally planned, the resulting pictures would probably be of the subject standing in front of the building, in a hallway, or inside a classroom. The environmental portrait would show what the principal looked like but would hardly reveal her character.

PHOTOGRAPHERS MAKE THEIR OWN ARRANGEMENTS

Although reporters can hold a telephone interview or call back later for more facts, photographers need to be present when the subject is engaged in work. Photographers and photo editors need to educate those who report, or assign reporting, about this need if pictures are ever to go beyond the routine.

Photographers usually find that they can make better arrangements than a reporter or editor because they know the kinds of pictures they are looking for. Photographers are mindful of both the subject's activities and the quality of light at different times of the day. High noon outside rarely provides attractive light for an outdoors portrait, for example. Ideally, photographers would get names and phone numbers of subjects and then make the appointment, or decide what other pictures might go with the story. The reporter might tape the interview at four o'clock, and the photographer might arrange to shoot the subject from dawn until dusk on a different day.

When scheduling a shoot with a subject it's always good to ask, "What is your typical day like?" As the subject describes a normal day's activities, you can note which hours the person is sitting behind a desk talking and which hours he or she is doing something active and therefore photogenic. You also should find out if anything unusual is coming up that would lend itself to revealing photos.

ON THE SCENE: WORKING IN TANDEM For some types of news, the photographer and reporter must cover the event together. Sometimes it's the reporter who knows the important players. Sometimes the photographer needs a second set of eyes to help provide protection, such as at a violent street protest. "You be my extra ears," says Ellie Brecher, a photographer-friendly reporter for the Miami Herald, "and I'll be your extra eyes." (See Chapter 3, "General News," page 49, for special situations where photographers must not share information.)

Even at dangerous breaking news events like street riots, when the situation calls for all available eyes and ears, the photographer and reporter should not become wedded at

FROM A WRITER'S **POINT OF VIEW**

Reporter Ellie Brecher of the Miami Herald shared the following suggestions to photographers in 4Sight, a newsletter published by Region 4 of the National Press **Photographers** Association:

- Understand the assignment by talking to the reporter
- ahead of time Don't barge into an interview
- Share information with the reporter
- Bring ideas to the reporter
- Have your technical act together

the hip. Each has different needs. One is following the action as it flows down a street, while the other is checking a quote and making sure the name is spelled correctly. However, while the photographer and reporter each need independence, the two also need to reconnect every once in a while to confirm they are developing the story in parallel ways.

Although the photographer and writer don't shoot and interview at the same moment, they should coordinate the message of their words and pictures. Photographers should pass on their observations about the subject or event to the writers. Writers can explain to photographers the gist of their leads.

In the end, the reader will be looking at both the picture and the accompanying story. If the writer describes the subject as drab, yet the picture shows a smiling person wearing a peacock-colored shirt, the reader is left trying to resolve the conflict. Writers and photographers should resolve any conflict between words and pictures before the story goes to press.

PICTURE POLITICS

With good planning, editors avoid poor use of photo resources. However, many news outlets continue to operate in a traditional structure long unfriendly to the effective use of photography.

Traditionally, news organizations have been organized to handle assignments proposed by either reporters or editors. Photographers rarely originated story ideas. And even if they did, the photo-reporters received little in the way of picture play for their efforts.

The old-style process (still widely used today) works this way: once the reporter gets the green light, research begins. The reporter might interview subjects, check the publication's library for related articles, do a Web search, call authorities, and, finally, write the copy over a period of days or even weeks. Only when the story is nearly completed and ready for publication does the reporter fill out a photo request. Finally, the photo department becomes aware of the issue.

With the story written and the publication date set, the photographer has little room to maneuver. While the reporter took days and weeks to develop the story, the photographer may have only hours to produce photos. While juggling three or four other assignments for the day, the photojournalist is unlikely to be able to shoot in the best light, have time to wait for a candid moment, or to reshoot.

THE BUDGET MEETING

At most news organizations, the decision about how much space to allocate to a story as well as where it will play takes place at a daily, weekly, or monthly conference often known as a budget meeting. Representing each section of a publication, different editors pitch their best stories to the managing editor, who ultimately decides which stories get cover display and which are buried inside. While the photo editor speaks up for pictures at this meeting, the word editors always outnumber the lonely representative from the photography department. (See Chapter 10, "Photo Editing.")

Here, each editor represents a part of the paper or magazine. Individual editors defend their turf. On a large newspaper, the sports editor, fashion editor, city editor, and foreign desk editor might each have an entire section. On a news magazine, the national editor, political editor, and music editor each might have a minimum number of pages to cover the most important topics in a specific area. Too often, the photo editor has no designated turf: there is no space assigned solely to photo stories. Though seated at the table with other decision makers, the picture editor has no formally reserved space.

Furthermore, the picture editor is up against colleagues who think that their sections cover the most important news, contain the best writers, and ought to have the most space. And, because more and bigger photos mean fewer words, few editors see the advantages of storytelling pictures that eclipse longer stories. Furthermore, managing editors, most of whom move up from the writing rather than the visual side of the publication, make the final decisions about the use of space. The upshot at most publications: even a very outspoken photo editor can rarely counterbalance these inherent structural biases toward words.

The World Wide Web, on the other hand, because it can present an unlimited number of pictures without incurring additional cost, has inherent capacity advantages over print publications. On Web sites, you might think, having space for pictures should not be an issue.

Think again.

The "splash page" or "home" page provides the reader with an essential guide to a Web site. The demand for space by section editors on the home page means that pictures are often run the size of postage stamps. In addition, because of download speed considerations, Web meisters often reduce the number of pictures on the opening page as well as their size so the pages will load quickly. Just

when photographers thought they had found a photo-friendly medium on the Web, they discovered their work squeezed again. Technological advances will probably change this, but for now, it's the same old battle for space.

TAKE A REPORTER TO LUNCH

To avoid the trap of being the last one to know about important stories—and having your pictures played poorly—try this. If you are a new staffer, ask the managing editor which reporter stands out in the newsroom. If you have been on staff for a while, you probably already know the names of the best writers.

Start by introducing yourself to one reporter and asking what he or she is working on. If the story sounds interesting, talk about picture possibilities. If you know that an event is coming up that would help explain the story, suggest to your photo editor or managing editor an assignment that will help illustrate the story. On your own, start reading about the issue. If you notice a picture that might support the story, shoot it. Look for as many ways as you can to photograph the writer's story even before the wordsmith has finished the masterpiece.

When the story results in a formal photo request, your editor will likely assign the job to you because you already have started on the photos. By now you have a clear idea of the possible pictures that would help the story. Also, because the story was written by a top writer, it will probably get prominent play.

If you continue to look for good writers, anticipate photo requests, and build alliances with the word side, you will probably find writers agreeable to listening to your story ideas. A writing/photography partnership is likely to claim more space than your proposal alone.

GENERATE YOUR OWN ASSIGNMENT Sometimes a photographer pulls over next to an overturned car, jumps out, and shoots. No written assignment needed here. Most often, a photographer receives a verbal or written assignment from an editor. But many photographers report that their best assignments are those they proposed themselves. Self-generated assignments allow the photographer to pick exciting topics that lend themselves to visuals. When a photographer has researched a good story, the next step is to request a reporter to provide the needed text. The more stories photographers propose, the more control they will have over their work. Fred Larson spent weeks photographing the tough

To avoid being attacked during his forays into San Francisco's Tenderloin neighborhood. San Francisco Chronicle staffer Fred Larson dressed unobtrusively and hid his camera inside a portable stereo. (Photo by Scott Sommerdorf, San Francisco Chronicle.)

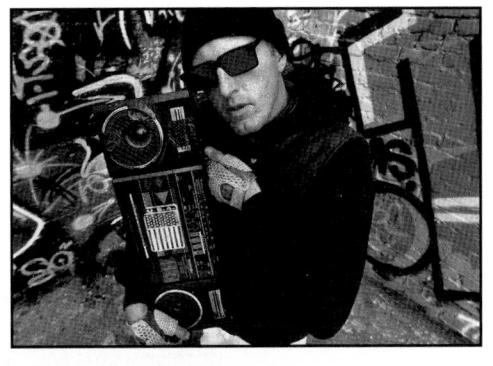

San Francisco neighborhood known as the Tenderloin. Chapter 4, "Covering the Issues," features other successful self-generated assignments.

INTERNATIONAL ASSIGNMENTS

Many of today's newspapers have expanded their beats to include the world. From covering earthquakes in India to uprisings in Rwanda, newspaper photographers are literally on the move. Photographers who covered high school football on Friday night may find themselves boarding a plane for

Street fighters continued their battle while an unobtrusive Larson moved in close with his camera-in-a-boombox. (Photo by Frederic Larson. San Francisco Chronicle.)

The overall shot of the Thunderguard Bike Club establishes for the viewer the size of the motorcycle gang. (Photo by Fred Comegys, Wilmington [Delaware] News Journal.)

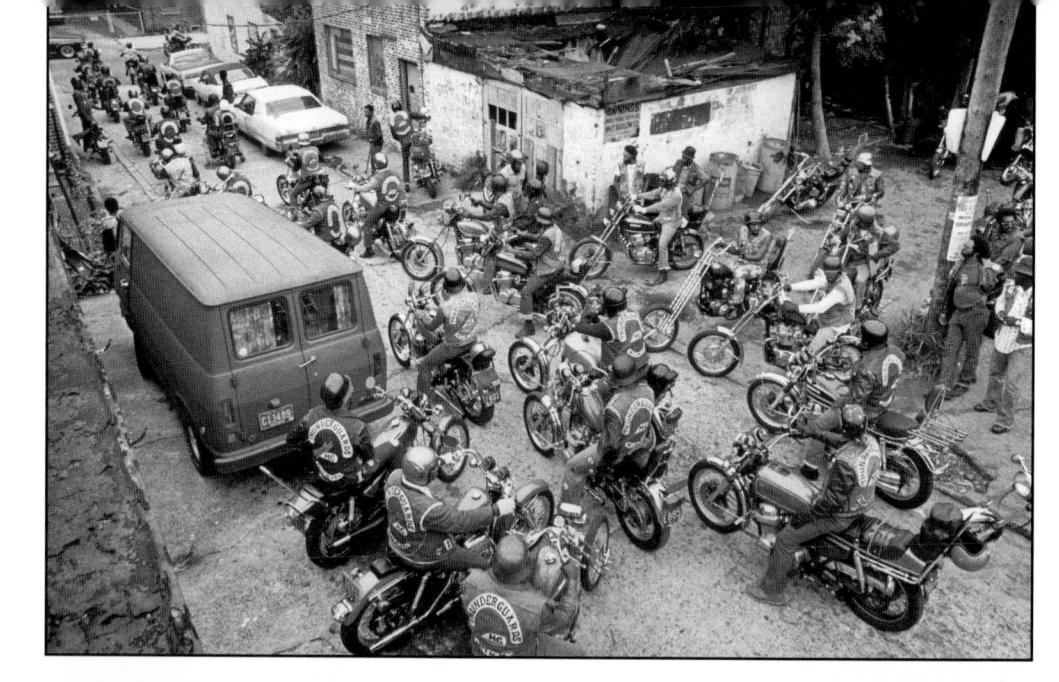

When published alone, a medium shot must tell a complete story. As SWAT team officers move in, a woman and child run from a check-cashing outlet where more than one hundred customers had been held hostage after an attempted armored car robbery went bad in
Philadelphia.
(Photo by Jim MacMillan,
Philadelphia Daily News.)

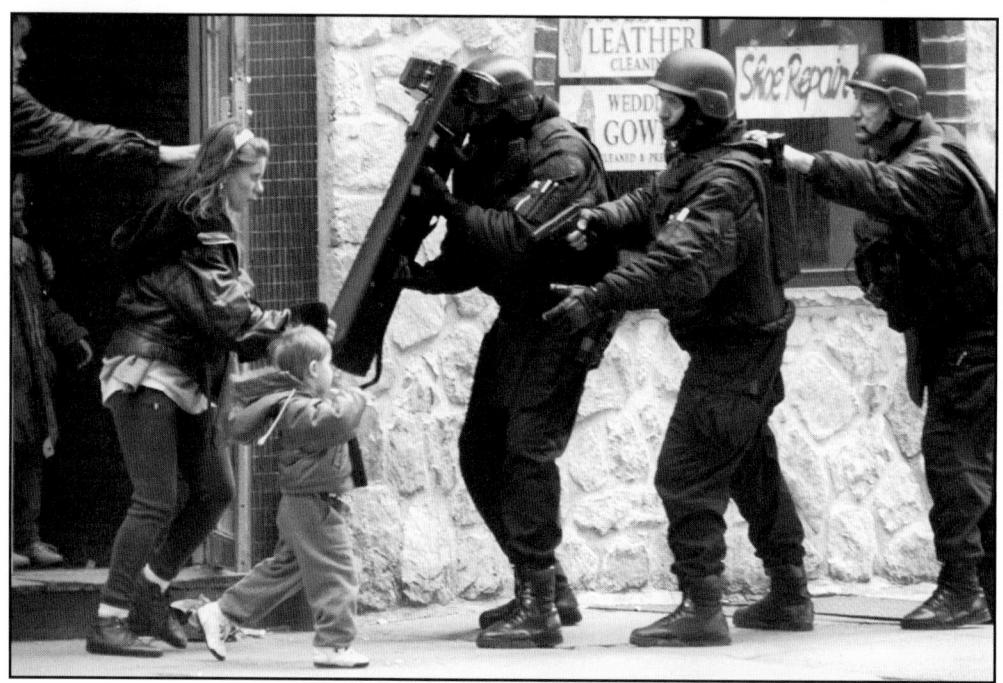

Nothing beats a close-up for drama. The tight crop leaving just the two eyes of the doll and the one of the child jolts

the reader's attention.
(Photo by Richard
Koci-Hernandez, San Jose
Mercury News.)

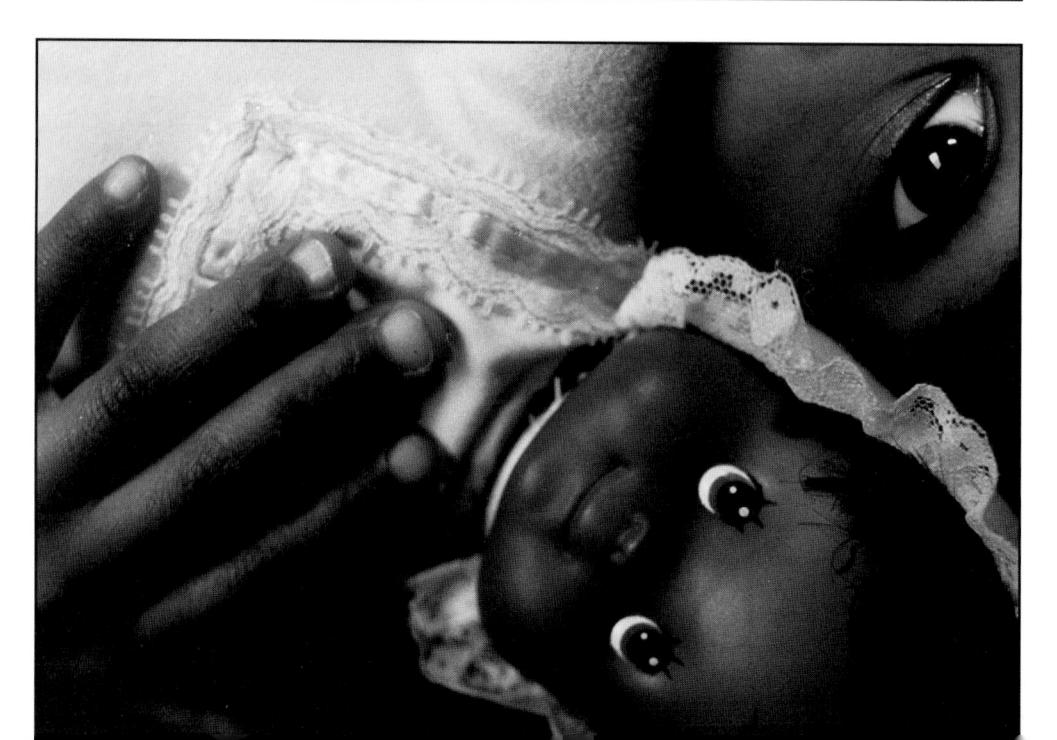

Kosovo on Sunday morning. Never has the mastery of foreign languages or knowledge of international affairs been more important to photojournalists.

Michael Kodas, who has covered international news for the *Hartford Courant*, reads voraciously: the *Wall Street Journal*, the *Christian Science Monitor*, and the *New York Times*, among others.

National Public Radio is also a good source of international news for car-bound photographers. And if an intensive language course is out of your budget, try substituting language tapes for your favorite rock 'n roll groups when you're stuck in traffic.

And don't forget the most basic preparations, as recommended by freelancer Keith Philpott: pack an up-to-date passport in your camera bag at all times, and make sure your inoculations are current for travel in developing countries.

Carol Guzy, who covered the Ethiopian famine for the *Miami Herald* and the tumbling of the Berlin Wall for *The Washington Post*, says to pack light for international assignments. She carries as little photo gear as she feels she can get away with, she says, but does bring an extra camera body—and film, lots of film.

ASSURING VISUAL VARIETY

OVERALL SHOT SETS THE SCENE If readers themselves were at a news event, they would stand in the crowd and move their eyes from side to side to survey the entire panorama. The overall photo gives viewers at home this same kind of perspective. The overall allows viewers to orient themselves to the scene.

For some stories, an overall might include just a long shot of a room. For others, the overall might cover a city block, a neighborhood, or even a whole town. The scope of the shot depends on the size of the event. The overall shows where the event took place: inside, outside, country, city, land, sea, day, night, and so on. The shot defines the relative position of the participants. In a confrontation, for example, the overall angle would show whether the demonstrators and police were a block apart, or across the street from one another. The overall shot also allows the reader, by judging crowd size, to evaluate the magnitude of the event.

Margaret Bourke-White, a member of the original *Life* magazine staff, always shot overalls on each assignment, even if she didn't think they would be published. She explained that she wanted her New York editor to see the shooting location so that he could interpret the rest of the pictures she

had taken.

Generally the overall requires a high angle. Rick Ferro knew this when he was flown in by the *St. Petersburg* (Florida) *Times* to cover the earthquake in the San Francisco Bay Area. After renting a car, his first stop was at a large hardware store, where he purchased a thirty-foot ladder in anticipation of photographing an overall of the collapsed I-880 freeway in Oakland. The ladder came in handy, as Ferro was able to climb to the top of the wreckage and shoot photos of the ongoing rescue.

When you arrive at a news event, quickly survey the scene to determine what is happening. Then search for a way to elevate yourself above the crowd. In a room, a chair will suffice. But outside, a telephone pole, a leafless tree, or a nearby building will give you the high vantage point you need for an effective overall. When caught in a flat area, even the roof of your car will add some height to your view.

The wider-angle lens you have, obviously, the less distance from the scene you will need. However, on a major news story that encompasses a vast area, such as a flood, hurricane, or conflagration, you may need to work with your editors to rent a helicopter or small airplane to get high enough to capture the dimensions of the destruction.

MEDIUM SHOT TELLS THE STORY
The medium shot should "tell the story" in one photograph. Shoot the picture close enough to see the participants' action, yet far enough away to show their relationship to one another and to the environment. The medium shot contains all of the storytelling elements of the scene. Like a news story lead, the photo must tell the whole story quickly by compressing the important elements into one image. The medium shot is the story's summary.

An accident photo might show the victims in the foreground, the wrecked car in the background (see page 39). Without the car, the photo would omit an essential detail—the cause of the victims' injuries. With only the crumpled car, the reader would wonder if anyone had been hurt. The combination of elements—car plus victims—briefly tells the basic story.

A medium shot gains dramatic impact when the photograph captures action. Although the camera can catch fast action on film, you may still have difficulty: action often happens so quickly that you have no time to prepare. Shooting news action is like shooting sports action (see Chapter 7, "Sports"). For both, you must anticipate

when and where the action will take place. If a man starts a heated argument with a police officer, you might predict that fists will fly and an arrest will follow. You must aim your camera when the argument starts and not wait until a punch is thrown. If you hesitate, the quarrel might end while you're still fiddling with your equipment.

For the medium shot, a wide-angle lens such as a 24mm or 28mm works well, although a normal 50mm will do.

CLOSE-UP ADDS DRAMA

Nothing beats a close-up for drama. The close-up slams the reader into eyeball-to-eyeball contact with the subject. At this intimate distance, a subject's face, contorted in pain or beaming happily, elicits empathy in readers. (See page 12.)

How close is close? A close-up should isolate one element and emphasize it. Not all close-ups include a person's face. Sometimes objects can tell the story even when the story involves tragedy. A close-up of a child's doll covered with mud might tell the story of a flood better than an aerial view of the disaster.

Longer lenses enable photographers to be less conspicuous when shooting close-ups. With a 200mm lens, you can stand ten feet away and still get a tight facial close-up.

The telephoto lens decreases the depth-of-field and thus blurs the foreground and background. This effect isolates the subject from unwanted distractions.

Rather than using a telephoto for close-up work, some photographers employ a macro lens or a standard lens with an extension tube. With either of these lenses, the camera can take a picture of a small object such as a contact lens and enlarge it until it is easily seen.

HIGH/LOW ANGLES BRING NEW PERSPECTIVE

Since most people see the world from a sitting or standing vantage point, a photo-journalist can add instant interest to a set of pictures simply by shooting from a unique elevation. Shoot down from a thirty-story building or up from a manhole cover. Either way, the viewer will get a new, sometimes jarring, but almost always refreshing look at a subject. Even when covering a meeting in a standard-sized room, just shooting from the height of a chair or taking pictures while sitting on the floor can add interest to your pictures.

Avoid the "5' 7" syndrome." On every assignment, avoid taking all your pictures at eye level. When you start shooting, look

High angles such as this shot from above the net in a volleyball game help to give the reader a new perspective on the story.

(Photo by Charlie Riedel, the *Hays* [Kansas] *Daily News.*)

around for ways to take the high ground. Whether going out on a catwalk or shooting from the balcony, find some way to look down on the scene you are shooting. For a low perspective, some 35mm cameras allow you to remove their pentaprism housings so you can shoot (literally) from ground zero.

GOING WIDE Walter Green, who worked for the Associated Press for many years, noted that he took most medium shots with a 24mm lens. With this lens, Green got extremely close to the subject and filled the entire negative area. The resulting pictures, he said, tended to project a more intimate feeling between the subject and the viewer.

Because Green worked close to his subjects, few distracting elements intervened in front of his camera. Also, at this close distance, Green could emphasize the subject. Finally, Green's wide-angle took in a large area of the background, thus establishing the relationship of the subject to his or her surroundings.

The photographer's low-angle perspective turned what could have been a routine picture of a window washer into a whole new view of the activity.

(Photo by Doug Kapustin, the *Baltimore Sun.*)

Eugene Richards, a photographer who has won numerous awards, is master of the wideangle lens. His lens is like a mother spreading her arms to include all her children in an embrace. Richards' wide-angle lens encompasses his subjects, often bringing together two elements into one picture to tell a more comprehensive story in a single image. His subjects, which also have appeared in books. have ranged from drug addicts (Cocaine True, Cocaine Blue) to emergency room personnel (The Knife and Gun Club). One of his award-winning pictures includes, to the right of the frame, a tiny coffin in the front seat of a hearse; in the middle, open car doors; and, at the extreme left, a young child. Richards brought together the widely separated elements of the child-sized coffin and the youngster in one visual whole.

WIDE-ANGLE DISTORTION

Buying a wide-angle lens is not a photographer's cure-all. The wider the angle of the lens, the greater the chance for apparent distortion.

This is because you can focus very close to a subject with a wide-angle lens. But the closer any part of a subject is to the lens, the bigger it will appear in the picture.

If you stand relatively close to and above a person, and tilt the camera with its wide-angle lens down to include the subject's full length, head to feet, the subject's head will appear to be the size of a basketball, while the feet will seem small enough to fit into baby shoes. (See this effect used deliberately on page 184.)

If you stand at the base of a building and point your wide-angle lens up to include the structure's whole height, the resulting pictures will look as if the building is falling over backwards. This happens with any lens, but particularly so with a wide-angle lens used close to a building.

To avoid distortion with the wide-angle lens, you must keep the back of the camera parallel to the subject. When shooting a building, you must either get far enough away or high enough that the back of your camera is perpendicular to the ground and therefore parallel to the structure.

Not only does the extreme wide-angle lens produce visual distortion, but using this lens in some situations can also disrupt the scene the photographer is shooting.

A camera held two feet away from the action might disrupt the situation. On the other hand, as with Eugene Richards' picture of addicts shooting up, sometimes subjects just ignore the close-in camera because their immediate needs are so compelling.

SHOOTING STYLES DIFFER

Photographers stay on location until they get the best picture possible within their time limits. Amateurs take a few snaps and hope for the best. Professionals search for the decisive moment and know when they get it. A pro might take a hundred or even a thousand frames to get the perfect moment.

As George Tames, a former *New York Times* photographer, once said, "If you see a picture, you should take it—period. It is difficult, if not impossible, to recreate a picture, so do not wait for it to improve. Sometimes the action gets better, and you will take that picture also, but if you hesitate and don't click the shutter, you've lost the moment, and you can't go back."

A contact sheet from a novice shows thirty-six frames of thirty-six different scenes. Professionals visually explore each scene, taking a number of pictures of essentially the same thing but at different moments or from different angles. (See a contact sheet on page 192.) Usually this means that they will take a few shots, then move to a different position and shoot the same thing from a fresh vantage point. They might shoot six frames from one location and then walk around the subject and shoot six more. By watching the subject as well as the background, photographers are trying to find the perfect balance of a picture's elements while capturing a revealing expression or telling body position.

Each photographer's shooting style differs, though. Russell Miller, in his book *Magnum*, *Fifty Years at the Front Line of History*, described a wide range of shooting styles practiced by the diverse members of the Magnum picture agency, which was founded after World War II.

ERNST HAAS

Ernst Haas, a Magnum photographer known for his exquisite color work, always began shooting before the action occurred, according to Eve Arnold, another Magnum photographer. Haas, she said, followed through to the peak of the action, then tapered off.

HENRI CARTIER-BRESSON

On the other hand, Magnum's Henri Cartier-Bresson is famous for capturing one decisive moment in an image. In fact, his 1952 book was published in the United States under the title *The Decisive Moment*.

The decisive moment suggests a sense of perfect shutter timing to freeze action at its peak. But Cartier-Bresson also looked for balanced composition. He wrote: "To me, photography is the simultaneous recognition, in a fraction of a second, of the significance

of an event as well as of a precise organization of forms which give that event its proper expression. . . . Inside movement, there is one moment at which the elements in motion are in balance. Photography must seize upon this moment and hold immobile the equilibrium of it."

For Cartier-Bresson, a photograph must not only freeze an instant of time, but it must also capture that instant within a well-designed composition. See pages 351–353.

(Cartier-Bresson, however, did shoot some 15,000 rolls of film during his active career—not all of which were decisive moments—according to Claude Cookman's dissertation, "The Photographic Reportage of Henri Cartier-Bresson, 1933–1973.")

ROBERT CAPA

Robert Capa, whose real name was André Friedmann, was perhaps the world's greatest war photographer and the founder of Magnum. He had yet a different approach to shooting. See pages 351–352.

According to Magnum colleague Eve Arnold, Capa's contact sheets did not show persistence in pursuing a sequence as did those of Ernst Haas. Nor were Capa's individual pictures well-designed, like CartierBresson's. Yet Capa took some of the most memorable pictures ever recorded on film. During the Spanish Civil War, he photographed a soldier, arms outflung, falling backward at the moment of being killed. Capa also took the classic World War II D-day landing pictures (page 352). Capa was killed while covering the war in Indochina (Southeast Asia).

When Eve Arnold told *New Yorker* writer Janet Flanner that Capa's pictures were not well-designed, the reporter shot back, "History doesn't design well, either." After that, Arnold said, "I began to understand that the strength of Capa's work was that just by being there, where the action was, he was opening new areas of vision.

"He was aware that it is the essence of a picture, not necessarily its form, which is important."

CATCHING CANDIDS

What sets photojournalistic pictures apart from other types of photography? The photojournalistic style depends on catching candid moments. Good photojournalists have developed the instinct to be at the right place, at the right time, with the right lens and camera. Often, they can steal images like a

For this decisive kiss after a 4H rodeo, the photographer captured the revealing moment within a strong composition. Henri Cartier-Bresson, the French photojournalist who coined the term "decisive moment," tested the composition of his pictures by viewing them upside down to determine if they were successfully designed.

(Photo by Aristide Economopoulos, *The* [Jasper, Indiana] *Herald*.)

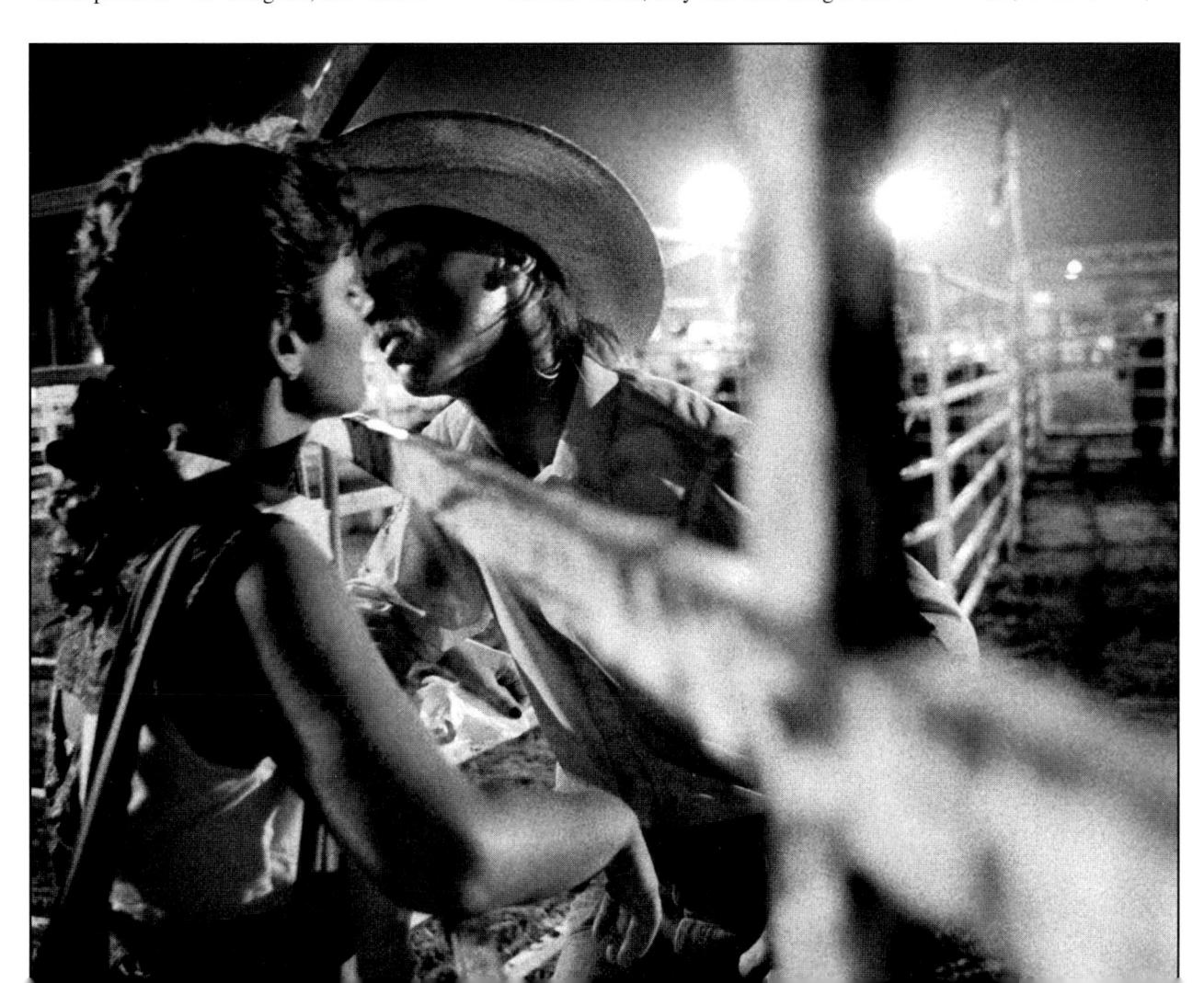

Using a 300mm f/2.8 telephoto lens, the photographer was able to remain in the distance. With a long lens, a photographer can often shoot pictures without being observed.

(© Photo by George Martell, the Boston Herald.)

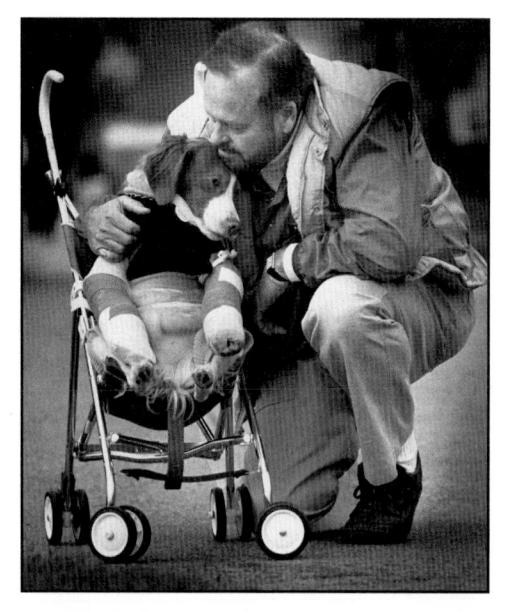

The photographer snapped this candid by moving in quickly with a wide-angle lens.

(Photo by Norm Shafer, the Fredericksburg [Virginia] Free-Lance Star.)

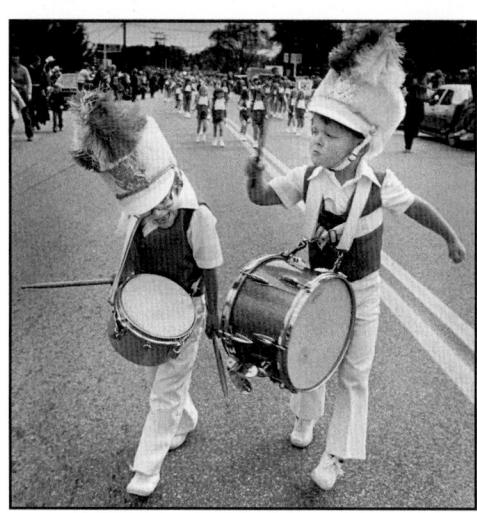

Although both women vere aware of the photographer, he was still able to capture this candid interaction

pickpocket, without anyone ever knowing that photographic sleight-of-hand has taken place.

Photojournalists must catch their subjects as unaware as possible to record real emotions. Rather than stage-managing pictures, photographers observe but do not direct. The results depend on their ability to capture intimate moments without interrupting.

With good candid pictures, subjects are never caught gazing at the camera. Eye contact tips off the reader that the picture is not candid and suggests that the subject was at least aware of the photographer and might even be performing for the lens.

THREE APPROACHES TO CANDIDS Big game hunter

Like a hunter stalking prey, the photojournalist studies his or her subject. Sighting through a rifle-like telephoto lens, 100mm to 300mm long, the photographer stands across the room or across the street. The photographer watches, waits, and tries to anticipate what might happen next.

Patience. Patience. Patience.

On a tip from a local pet hospital, the *Boston Herald*'s George Martell waited for the right moment to photograph a man and his injured five-year-old Brittany Spaniel, Yowser. Using a baby stroller to transport the dog, the man brought Yowser to Angel Memorial every day for treatment. The dog had been hit by a tractor-trailer, and his owner, who suffered a heart condition, was unable to carry the dog himself.

With a 300mm telephoto lens, Martell was able to shoot without distracting the man

Although both women were aware of the photographer, he was still able to capture this candid interaction between a 72-year-old high school student and her classmate. The women were more fascinated by one another than they were by the photographer's presence.

(Photo by Ronald Cortes, The Philadelphia Inquirer.)

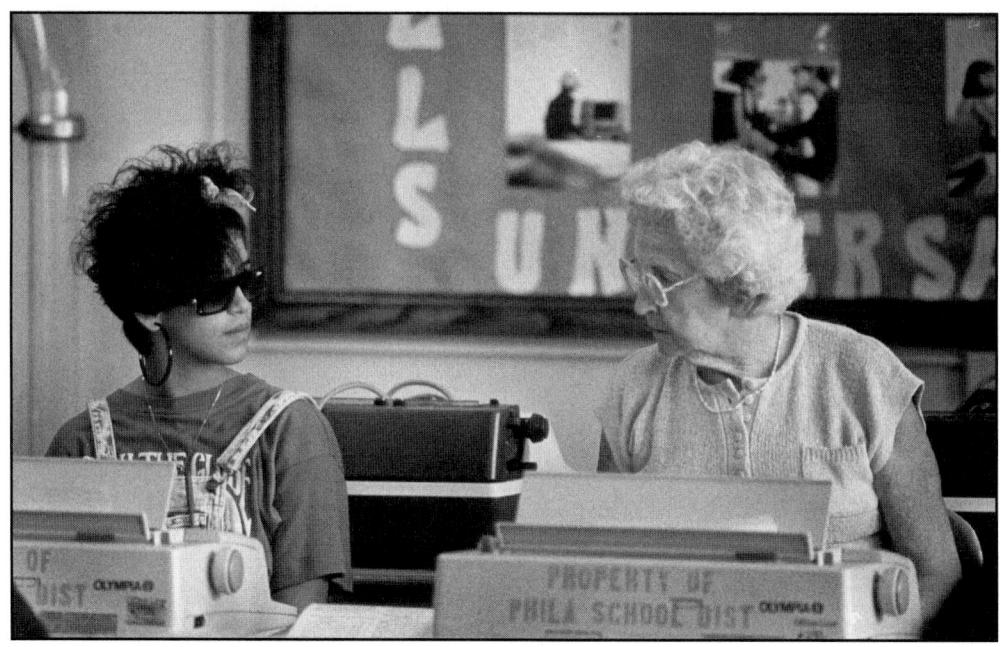

upon his arrival. The photographer caught a tender moment as the owner hugged the injured dog before taking him out of the stroller. The long lens and wide aperture provided an additional advantage for the picture. At f/4 with a 300mm lens, distracting background elements went out of focus and left just the owner and his on-the-mend friend isolated in the frame. When feature hunting, Martell carries a 300mm, an 80-200mm, and a 20-35mm zoom lens.

Hit and run

Rather than trying to operate unobserved, some photographers use the hit-and-run approach. They catch candids by walking past the subject, shooting quickly with a wide-angle lens, and then moving on. Observers have described Henri Cartier-Bresson's technique in this way. The French candid-catcher would pause in front of his subject and, with one fluid motion, raise his Leica, focus, and click several frames. By the time the subject turned toward the photographer, Cartier-Bresson had already gone his way. This type of hit-and-run photography leaves subjects unaware they have been photographed.

Norm Shafer of the Fredericksburg (Virginia) Free-Lance Star was shooting the King George Fall Festival parade when he noticed two young drummers getting bored with the marching. Realizing that he might have a potential feature, Shafer got in step with the young marchers.

One drummer started to tease the other with his stick. Shafer moved in, shooting with his 24mm wide-angle lens focused at about ten feet. Just as one drummer selected the other fellow's head for a practice timpani, Shafer began to shoot.

Engrossed in their own rhythms, the two drummer boys never noticed Shafer and his camera. As the embarrassed mother of one of the misbehaving boys pulled her son out of the parade, Shafer continued to record the incident because, as he explained later, "you never know till you see the film if you have the exact moment." Shafer had caught the moment.

Out-in-the-open

Sometimes photojournalists don't have to use subterfuge to catch a candid. The out-in-theopen approach works when the subject, engaged in an activity that is so engrossing, forgets for a moment the photographer's presence. For example, Ron Cortes was doing a picture story for the Philadelphia Inquirer about a 72-year-old woman returning to high school to finish her degree. The

senior scholar took everything from math to typing. In the typing class, Cortes snapped a picture of a more typical student giving the older woman the once-over. Although the subjects knew Cortes was there to take pictures, they became so involved in their own activities after a while that they paid no attention to him-and he was able to catch candid moments. (See Chapter 4, pages 92–93 for more on candids.)

PRESET YOUR CAMERA

Whether you are shooting with a manual or automatic camera, set its aperture and shutter speed before you point the camera. If you're fiddling with the camera's dials, you might catch the subject's attention instead of a candid moment.

Select the appropriate lens before you bring the camera to your eye. With a manual focus camera, swing the lens once by the subject and stop just long enough to focus. As an alternative, you might focus on an object exactly the same distance away as your subject. With a telephoto lens, which requires critical focusing, you must focus on the subject, not on a nearby equivalent.

Some photographers prefer the wide-angle lens for candids, even though they must come closer to the subject. Prefocused at ten feet with a small aperture like f/16, you can use a 28mm lens to snap away happily without ever touching the focusing ring.

Finally, take your light meter reading without alerting your subject by pointing your camera toward an area that is receiving the same amount of light as the subject, and then adjusting your f-stop/shutter speed combination accordingly.

Now, watch your subject. You've preset your camera and now you must concentrate on your subject's expression and, when it's right, swing the lens, frame, and snap away.

Alternatively, use your camera's autofocus option: with autofocus selected, you are free to concentrate on action, not on hardware. With autofocus cameras, you can work at wide apertures like f/2.8 or f/3.5 but still get sharp pictures, even close to the subject.

If you see a funny incident taking place, you can swing the camera up and frame, pressing the release at the same time. The lens will rotate automatically to catch a natural moment. (See pages 125-126 and 220-221 for more about autofocus.)

ANTICIPATION AND TIMING

Catching candids requires photographers to have the skills of the weather forecaster. They must guess what is going to happen based on how they see a situation

developing. If two kids have their fists up, they are likely to fight. A couple holding hands might kiss. Sometimes the photographer, like the meteorologist, judges the evidence correctly and is prepared with the right lens, film, shutter speed, and f-stop. At other times, like the weatherperson, the photographer misinterprets the data.

A photographer's timing to release the shutter at the optimum moment is as important as anticipation. Even with motor drives and autofocus, photographers must "get into the flow of the action." Most action builds to a peak and then settles down again. Almost every event has a crucial moment.

CANDIDS WHEN THEY KNOW YOU'RE THERE

Photographers often face the problem of taking a subject's picture, even though the subject is aware of the photographer's presence.

To snare candids when the subject is aware, Carol Guzy, of *The Washington Post*, tries to stick around long enough until her subjects forget she is there and return to their natural activities. Diana Walker, who shoots behind-the-scene photos at the White House for *Time* magazine, must catch candids in a private area almost every day. She tries to avoid conversation with her subjects so they will forget she is there. (For more details on her technique, see Chapter 3, pages 47–49.)

SAVE THE LAST FRAME

Most photographers stop shooting before the end of the roll. They have been caught with only one frame left just as something spectacular takes place—such as a person leaping out of a building. They raised their cameras and ran out of film. By changing film before reaching the last frame, photographers build in some insurance. Having blank film at the end of the roll is like having money in the bank. You might not ever need it, but it might save you in an emergency—and reduce your own anxiety.

WHEN AND WHERE TO SELL NEWS PHOTOS

STAFF PHOTOGRAPHER VS. FREELANCER

What should you do when you've nailed a good spot news picture?

The answer depends on whether you are a staffer or a freelancer. If you are a staff photographer and you've stumbled on a major train disaster, you should shoot your pictures, then contact your editor. Provide a brief description of the accident and your photos. Your editor will weigh the importance of the train wreck story against other news of the

day, and will decide whether you should remain at the scene or return to the office to process your photos before deadline if you can't transmit digital images. If you are a freelance photographer and you have a good spot news photo, you have, under the same circumstances, many more options for your pictures.

MARKETING SPOT NEWS: A CASE STUDY

After the earthquake that rocked San Francisco in 1989, journalism student Kaia Means was one of thousands who initially thought the quake was "just another" shaker. Visiting friends atop Russian Hill, however, the San Francisco State University student noted, moments after the quake, a huge cloud of dust rising above the Marina District. She said her good-byes and left for a 5:30 P.M. meeting, thinking she'd drive by the Marina first to see what the dust was all about.

"I knew I had to turn in a spot news assignment sometime during the semester," recalls Means, who was a news-editorial major taking her second semester of photography. "So I thought I'd drive by to see if there was anything to take a picture of."

Means found more than fallen bricks and broken glass. The first photographer on the scene, the 22-year-old student from Norway photographed a distraught father awaiting the rescue of his wife and baby. Beside the father in the crowd, Means photographed firefighters carrying the baby from the building, its father grieving in the foreground. Later, in tears from the realization that the baby was dead, Means photographed the mother's rescue and reunion with her husband.

Although Means was "shaking all over" by the time she finished shooting the tragedy, the young photojournalist's real-life midterm exam was just beginning.

Determining possible outlets

The photo student's pictures certainly had wide local and national interest. And Means was in a good bargaining position because she had exclusive images. However, the earthquake had shaken local news outlets as well as buildings and bridges.

Means took the film to the San Francisco Examiner, which had lost all electricity and phone capabilities and was conducting its photo operation out of a van in the paper's parking lot. Having told the photo chief about the pictures, she helped out for a while and then left the film, marked "DEAD BABY" on the canister.

In less chaotic circumstances, Means could have bargained for the sale of the pictures.

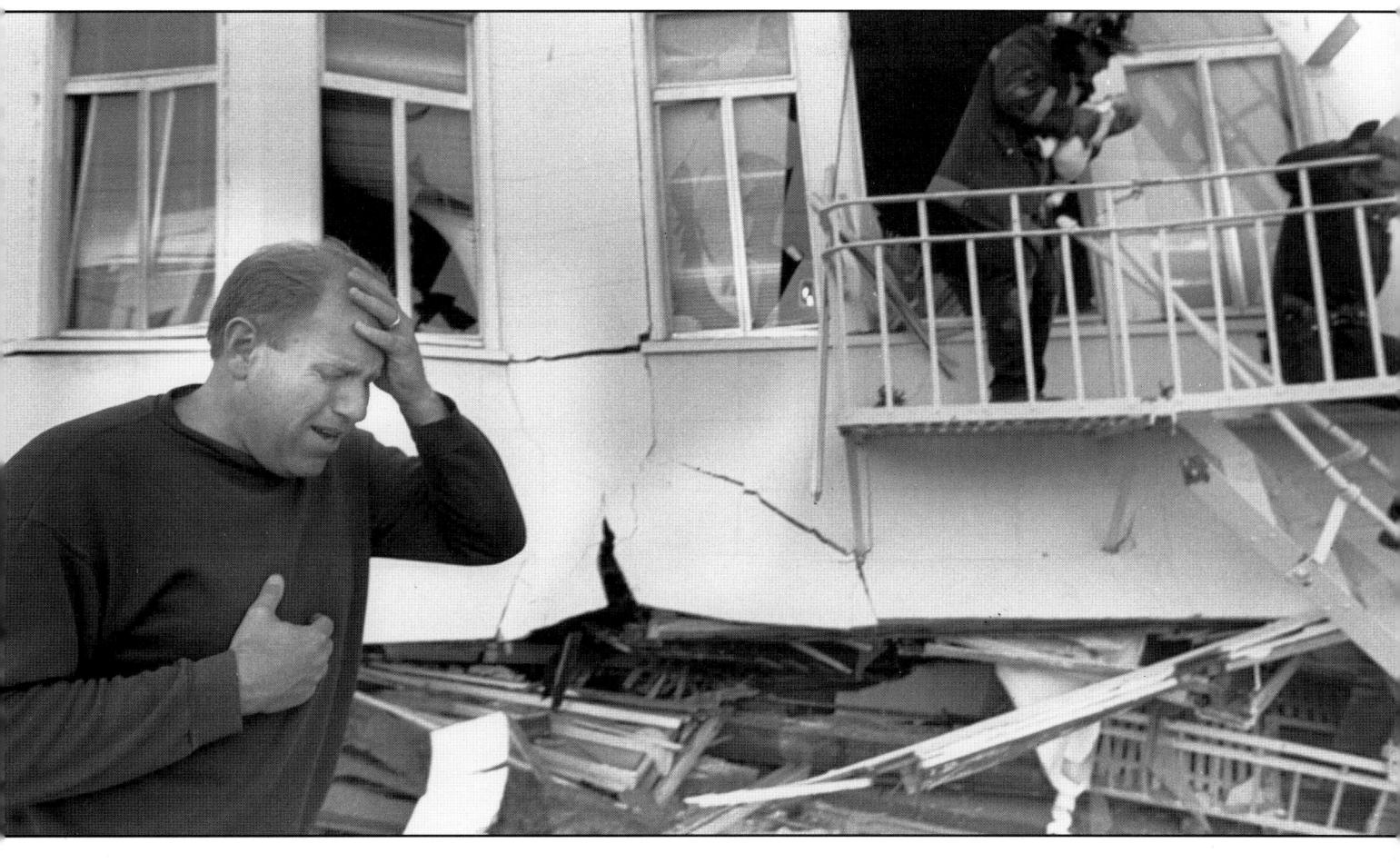

Having gotten a bid from the Examiner, she could have contacted local TV stations to see how much they would offer for rights to the photos.

With the story's national impact, she could have offered the film to the wire services. either the Associated Press (AP), Agence France-Presse (AFP), or Reuters—all of which depend a great deal on stringers and freelancers. None of the services maintains a large enough photo staff to cover the country—or the world—thoroughly. Many photos appearing in print and carrying the AP, AFP, or Reuters credit line are taken by independent photographers.

Alternatively, in the case of a big disaster like this earthquake or perhaps a tornado, Means could have called other large dailies around the country. Today, newspapers want their own photos of a major story to augment those supplied by the wires, and many send staff photographers. However, none would have had this series of pictures.

But with phone lines down and chaos around her, Means left the film with the Examiner. Naturally, she was surprised when she opened the paper the following day and did not see the dramatic pictures. She called to see what had happened and learned

that, in the confusion, the film had never been processed.

Following more confusion at the Examiner, the young photojournalist finally got her film back-still unprocessed two days after the event. Under normal circumstances, this series of faux pas would have spelled photographic disaster for the fledgling photojournalist. The pictures' timeliness would have dissipated long before.

However, once the film was processed, it was easy to see that these were no ordinary pictures. It was time to seek a national market. The news magazines were already closing by the time the film had been processed, and they rarely buy anything but color. Her photo teacher, this author, gave her the number of Peter Howe, who, at the time, was picture editor at Life magazine. Means took over from there. Howe was out of town, but editors at Life wanted to see the prints.

After viewing the pictures, Life editors purchased first North American rights for six months and sent a reporter to San Francisco to interview Means and the parents she had photographed. When an order for a follow-up story came in, the second-semester photo student received the five-day Life assignment. In the year-end issue of the magazine, Means'

A few minutes after the 1989 San Francisco earthquake, a father reacts as his dead baby is removed from a collapsed apartment building. The photographer sold the picture to Life magazine.

(Photo by Kaia Means.)

photo of the distraught father ran as a double-truck in addition to two of the follow-up pictures she shot on assignment.

Time element is crucial

Don't underestimate the value of your pictures, and don't wait too long to find a buyer for them.

As a student, Means could have assumed that professional photographers would have had more dramatic pictures than hers. However, although the *Examiner* missed its chance, Means' photos turned out to be some of the most moving images to come out of the disaster.

In any news event, even if other photographers are present at the scene of an accident or fire, their equipment might fail, or you might have a shot from a better angle. For the price of a telephone call, you can find out if an editor is interested and would like to see your film.

Because of the time element, the best market for spot news is a newspaper or wire service. Means' instincts in taking the film to one of the city's major dailies was right on. However, it was the national interest in the quake that gave the photos an unusual second chance with *Life*. Editors have called the earthquake of 1989 the top news story of the 1980s. Certainly, *Life* magazine recognized its importance by including Means' coverage in its wrap-up issue that year.

If you have a timely fire, accident, or crime picture, the curious editor will usually ask you to bring the raw film to the newspaper or have it picked up by cab. A lab technician will develop the film, and an editor will quickly scan the negatives to determine if the photo has news value. If the story has significant national appeal, a news magazine like Time, Newsweek, or U.S. News & World Report might buy the photo, if it's in color. These magazines maintain very small fulltime photo staffs, so they also buy outside photos. Good editors don't mind a quick telephone call on a spot news story because they can't afford to ignore you and possibly miss the chance of publishing a Pulitzer Prizewinning picture.

What newspapers, magazines, or wire services pay for a picture depends on the value of the photo at the time of publication. *Life* magazine originally paid Abraham Zapruder between \$25,000 and \$40,000 (according to the *New York Times*) for his 8mm movie film of President John F. Kennedy's assassination. In contrast, the Associated Press (AP), Reuters, and Agence France-Presse (AFP) pay a standard rate of less than \$100 for most pictures they buy from freelancers. Still, each

photo is unique, and its value must be dealt with on a case-by-case basis. If the story has national significance, you might call a picture agency like Mercury Pictures or Black Star. If you turn your pictures over to a photo agency, its representatives will handle the negotiations with domestic and foreign magazines but will usually split the profit with you.

FREELANCE CONSIDERATIONS

WORKING WITH A PICTURE AGENCY Many photographers work with picture agencies to get assignments and to sell their stock photos. Picture agencies like Black Star, Saba Press Photos, Matrix, and Gamma Liaison call on magazine editors daily to pitch story ideas and to sell individual pictures. Sometimes proposals come from photographers. Sometimes agency employees come up with ideas. Ideally, the agency persuades a magazine to give its photographer an advance that goes toward shooting the assignment. At a minimum, the agency tries to get an editor's commitment to look at the story once it's finished. The agency negotiates the fee and then keeps a 40 to 50 percent commission, depending on its arrangement with the photographer.

Agents also try to sell pictures in international markets. Once the story is shot, they copy it and send out sets of pictures to representatives in different countries. In these cases, both the representative in the other country and the agency take a cut of the proceeds. Larger agencies also have representatives who take photographers' portfolios to magazine editors, advertising agencies, and design firms. Picture agencies need photographers with different shooting styles to appeal to a wide range of potential clients.

SELLING STOCK PHOTOGRAPHY

Picture agencies also help photographers handle financial billings, edit images after an extensive shoot, and organize and sell their stock photos.

Once a story has appeared, for example, book publishers and others sometimes call the agency to buy images that appeared in the story. The agency keeps pictures on file for these occasions. After a photographer's story about rickshaws in Bangladesh has appeared in a magazine, the photographer still has the outtakes and unused images. Over the next weeks, months, and even years, the stock agency might hear from a magazine looking for different modes of transportation or a query from a book publisher who needs pictures of human labor. To illustrate out-of-the-way travel destinations, an advertising agency might call

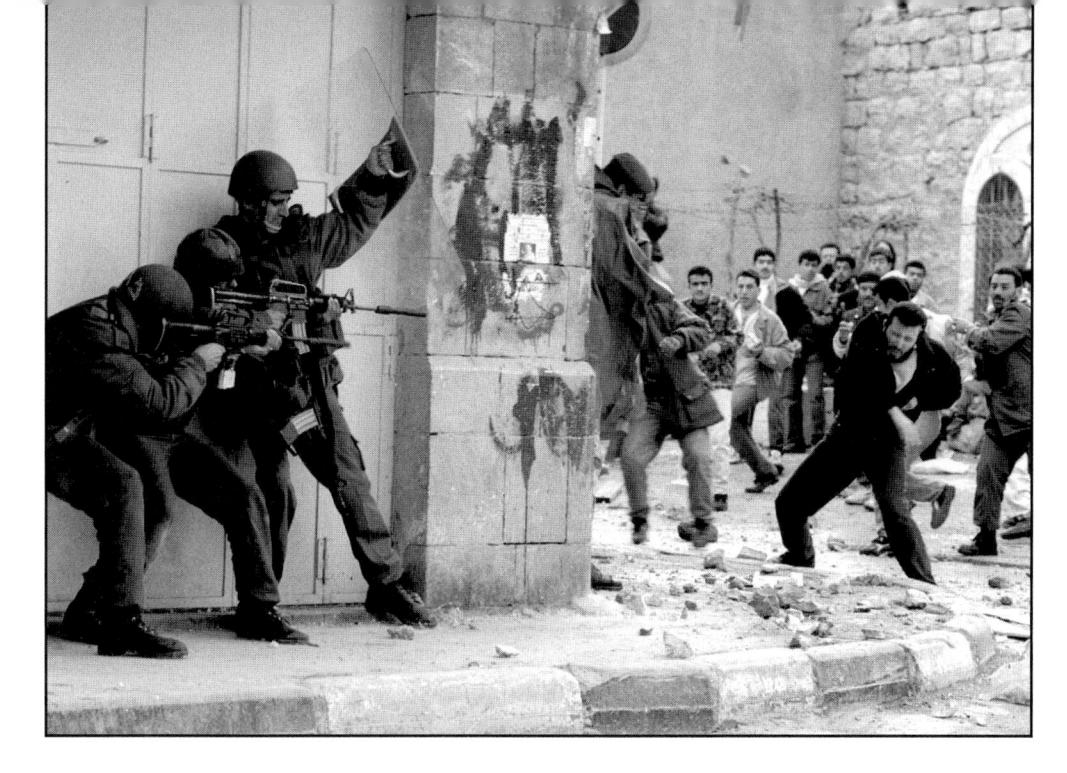

A Palestinian rioter is shot while throwing stones at Israeli soldiers during confrontations on the street marking the divide between Israeli and Palestinian controlled Hebron. Freelance photographers often use picture agencies to help market their images. An Italian agency called Contrasto handled the sale of this photo for the photographer. Photo by Wendy Sue Lamm, Contrasto.)

seeking pictures of exotic Bangladesh. The agency can resell the same pictures repeatedly. Stock photos that keep generating income are like money in the bank for some photographers, says Marcel Saba, owner of Saba Press Photos. Repeat sales of outstanding images allow photographers to undertake new projects or, in the case of photographers with exclusive images, even to retire from the business.

Do-it-vourself sales

Some photographers prefer to sell their stories and their stock themselves. The obvious advantage of self-representation is that you keep all the profits. The disadvantage is that editors and picture researchers might not realize you have the image they're seeking, or might call on deadline when you are away from the office. Photographers with international reputations can market their work without an agency's help. Less widely known photojournalists often need the resources of an established agent to open doors.

The Internet, on the other hand, has helped many individual photographers market their photos independently. Picture editors and researchers can more easily find the photographer who has a specialized collection of images, say, of rickshaws in Bangladesh, or women working in Asian countries. When a researcher turns to the Net to find sites on a topic like rickshaws or women working, the photographer's Web page appears. Then the researcher can contact the photographer directly for a high-quality image.

At this point, the buyer and seller would determine a price and rights for using the image. Check out the Web site of "Editorial Photographers [EP]," a group of professionals who help one another on contract and

pricing issues (http://www.netspace.org/ edphoto/indexpage2.html).

For more on copyright, see Chapter 14, "The Law."

The magazine market

Most magazines have few staffers, so they rely on pools of freelancers. Sometimes they hire freelancers through agencies. In these cases, the agency keeps a commission from the assignment fee. At other times, magazines work directly with photographers. Many magazine picture editors spend time looking at portfolios of aspiring photographers. Magazines like Business Week and Time need photographers in all parts of the world to call on for quick turnaround on assignments. Some magazines have budgets that allow them to send a particular photographer with special skills, talents, or style wherever he or she is needed.

Often magazines need specific kinds of photographs. The "lit portrait" (see Chapters 6 and 13), which usually involves shooting with power packs, multiple strobes, soft boxes, or umbrellas, accounts for half of Saba Press Photos' assignments from magazines, says the agency's owner, Marcel Saba. The veteran agent bemoans the fact that magazines today are seeking less photojournalism and more celebrity portraiture.

Sometimes Saba will identify a story he thinks is great, but he won't be able to get a magazine advance. "We'll tell a photographer go do it," he says. "We believe in it so much we'll pay the \$3,000 advance. When the money comes back after a sale, we split it. We've had a good record, but we have done stories—including a powerful one about the worst jail in Venezuela—where we have not made a dime back."

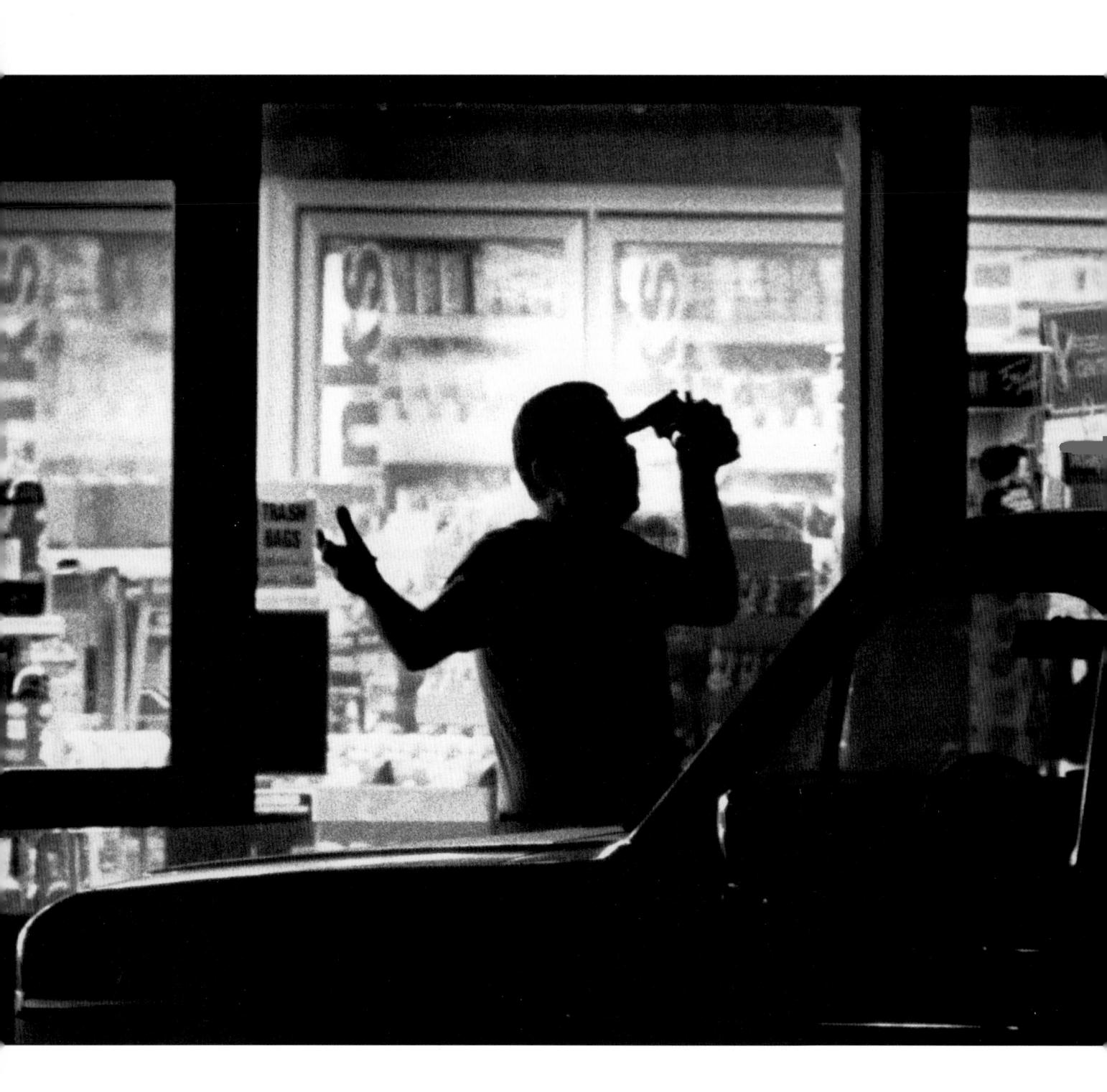

Spot News

HOSTAGE SITUATION: A CASE STUDY

CHAPTER 2

t home early one morning, Fort Worth Star
Telegram staffer Joyce Marshall received a call

from her paper's city desk. Her editor said that a

man was holding his wife hostage at a 7–Eleven convenience store

in nearby Arlington, Texas. Joyce threw on her clothes and, without

brushing her teeth or combing her hair, jumped into her car, think-

From daylight until dark, Joyce Marshall waited seven hours while the tense hostage situation played itself out. The stand-off finally ended (LEFT) when the man took his own life. His wife, whom he had been holding hostage, escaped (RIGHT). (Photos by Joyce Marshall,

(Photos by Joyce Marshall, Fort Worth Star-Telegram.)

ing, "This is probably a false alarm. Most of them are." With her cameras already in the trunk, she sped the five miles to the store in her two-door

Subaru. As soon as she pulled to a stop, she got

out of her car, grabbed her gear, and checked with the police officer in charge for an update on the situation. After determining that this standoff was the real thing, she called her office for backup equipment, including a 600mm lens and a two-way portable radio.

She knew that the man had already shot and possibly killed someone inside the store. Later, she learned that the gunman's name was Thomas Stephens. His wife had left him because of his continued physical abuse during their seventeen-year marriage. When the divorce papers had come through the day before, he had snapped. He left the drug treatment center he was in and tracked down his wife, who was working at the store. In the process of taking her hostage, he killed several of her coworkers.

Knowing there had already been gunfire at the store, Marshall used a car in a nearby driveway as protection. She had a clear view of the store window. Her telephoto lens and radio arrived via another staffer who took up a position behind the store.

"I was inside the police barrier," Marshall recalls. "The area was cordoned off. The time dragged on interminably. I had not eaten, I could not get a drink of water. I had not brushed my teeth or my hair, and there was no bathroom available."

Marshall knew, however, that if she left she would not be able to get across the police barrier again. "I had to stay," she recalls.

As the sun was setting directly into Marshall's camera, police went in to remove the victims. Marshall constructed a homemade sunshade on her lens barrel with some cardboard she found nearby and tape she kept wrapped around one leg of her tripod.

When police took the victims out of the store, the officers left the front door open. With her eye glued to her viewfinder, Marshall noticed Stephens coming to the front of the store while holding a gun to his wife's head. Marshall snapped off several frames.

By this time, a crowd had gathered behind the police lines. The neighborhood audience drank pop and beer and watched the situation in the 7-Eleven unfold in front of them like a movie playing in a theater. When the SWAT team arrived, the crowd started to yell, "Shoot them, shoot them. Hurry up and get this thing over with."

As the sun dropped in the late afternoon sky, Marshall began switching to more sensitive film. She went from color print film rated at ISO 200 to 400 then to 800. When Marshall could see no color at all in the scene, she threaded in a roll of ISO 400 black-and-white, which she rated at 1600.

Soon after the photographer loaded her camera with black-and-white film, the sun dropped behind the horizon, leaving only the lights in the store for illumination. Just then, Marshall could make out some movement at the front of the store—a shadowy figure so low to the ground she could not photograph it. The figure turned out to be Stephens' wife. Marshall learned later that when the gunman allowed his wife to go to the bathroom, she slipped out of the store.

Within a few minutes, Stephens, holding a gun to his head, walked out of the store. He told police he would shoot himself at the count of thirty.

Marshall thought to herself, "Surely they will do something about it."

In the silhouette against the store's window she could see that the gun's hammer was pulled back, ready to fire. When he got to thirty, Stephens paused a few seconds. Marshall quickly took a few frames.

Then the gunman fired a bullet into his own head. He slumped to the ground. The crowd rushed in to see what had happened.

"I'm not sure I shot a photo of the body," Marshall says now. "My mind was on getting the film back to the paper."

After racing back to the paper's darkroom and processing the film, Marshall quickly printed the frame of Stephens pointing the gun to his own head.

She found the negative of Stephens holding his wife hostage, which was a difficult one to print because of the sun's flare. Also, because the subjects occupied only a small part of the negative, she had to enlarge the image extensively.

The paper's editors felt the suicide picture was too graphic for the front page of the *Fort Worth Star-Telegram* and ran it inside, but they played the hostage photo as the lead picture on page one for the following day.

CRIMES MAKE HEADLINES

Crime, whether it's a hostage situation in Arlington or a riot in Boston, is costly to society. It can be a deep human tragedy for criminals and their families as well as for victims and theirs.

Almost any kind of crime makes a printable story in newsrooms across the country. The cub reporter soon learns that whether it's an atrocious murder or a \$100 hold-up of a gas station, the event is considered news in city rooms from coast to coast. Depending upon the crime's violence, the amount of money involved, the prominence of the people involved, or the crime's humorous or unusual aspects, the news is featured with varying amounts of emphasis.

HOSTAGE HERO

ARMING FOR ACTION

Most spot news photographers have worked out the exact combination of cameras, lenses, and strobes that they need to work in the particular area they cover. Those who mainly shoot mayhem at night carry different hardware than those on the day shift. Photographers covering murder in the big city pack differently than those covering wildfires in the countryside.

Daytime arsenals

The Philadelphia Daily News' Jim MacMillan, who usually works daylight hours, never leaves home without three cameras, including one mounted to a 500mm f/4 lens and connected to a monopod. As if that weren't enough glass power, he carries a 1.4X and a 2X tele-extender. "In Philly, the police keep us far away from the crime scene," MacMillan says. "I've gotten some of my best pictures from a block away." To carry all three cameras and lenses at one time, MacMillan hangs his 20-35mm zoom around his neck, slings the 80-200mm zoom on his shoulder, and hauls his 500mm lens, pointing backwards, over his left shoulder. "I can put two hands on any one of them at any time," he points out.

On the fire watch for most of the dry season in Northern California, Kent Porter of the *Santa Rosa Press Democrat*, uses the full complement of lenses. "I use a 300mm quite a bit," he says. "At a working fire I try to get pictures of the weary firemen. I use a 20mm so I can get close to my subjects and incorporate the area the people are working in."

Night on the streets Sam Costanza, shooting mostly at night for

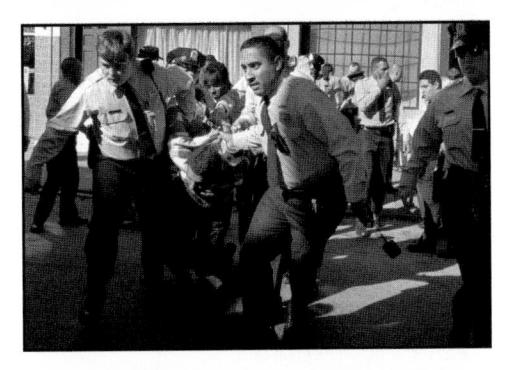

the *New York Post*, rarely gets to use a long lens. He does most of his work with the Vivitar 283 or 285 flash, which he prefers over the more expensive dedicated flashes made by Nikon and Canon. "When you're running around on the scene, you're banging your cameras around. There's a good chance

- → After a high-speed chase into the center of Philadelphia, a triplemurder suspect bailed out of his car and led police on a brief footchase. As officers closed in, guns drawn, the suspect takes a hostage (the man in the middle), and places the barrel of his gun into his own mouth. Jim MacMillan shot this part of the sequence with a 500mm lens plus a 1.4 tele-extender, giving him an effective 700mm telephoto. The long lens allowed him to stay back and avoid the possibility of taking a bullet him-
- → The hostage wrestles away his attacker's gun.

- After the hostage tries to pulls the gun away, police open fire, hitting their suspect twice. Police carry the wounded suspect to the paddy wagon. Using a second camera body, MacMillan rushed in and shot this photo with a wide-angle lens.
- The relieved hostage sits alone for a moment, giving a prayer of thanks while police arrest the gunman.

The hostage was unharmed, and hailed as a hero by police for his cool demeanor under pressure. MacMillan, using his 80-200mm zoom on his third camera body, took this candid portrait. The whole incident lasted only thirty seconds.

(Photos by Jim MacMillan, *Philadelphia Daily News.*)

that the foot of the strobe will break off. Why take a chance of breaking a \$400 Nikon flash?" The Vivitar usually costs less than a fourth of that price.

Costanza cranks his lens to infinity, sets his camera's shutter speed to 1/60 sec., and leaves the Vivitar's auto setting on "yellow."

"With those settings, I know everything will be in focus," he explains.

Costanza sets up his camera and strobe like a point-and-shoot so that he can concentrate on the scene and not worry about technical details.

At night, usually working around a hostile crowd, anxious police, or upset relatives, the New York newshound often gets off just one shot with his strobe. No need for a motor drive, either, he says. It's got to be right. No second chances here.

Porter in California, though, warns against using the strobe in some night news situations. The strobe light can be dangerous in a hostage situation, he cautions, especially when a confrontation involves guns. "The light of a flash is like a report of a gun," he says. "You can also blind the police with the strobe." During a tense hostage situation, Porter sticks to shooting available light with his long lenses—even at night.

Sergeant Carl Yates of Louisville, Kentucky, agrees. "Never underestimate the potential impact of a sudden flash of bright light at a night scene. It can anger officers; in some cases, escalate the incident; or worse,

A LISTENER'S STORY

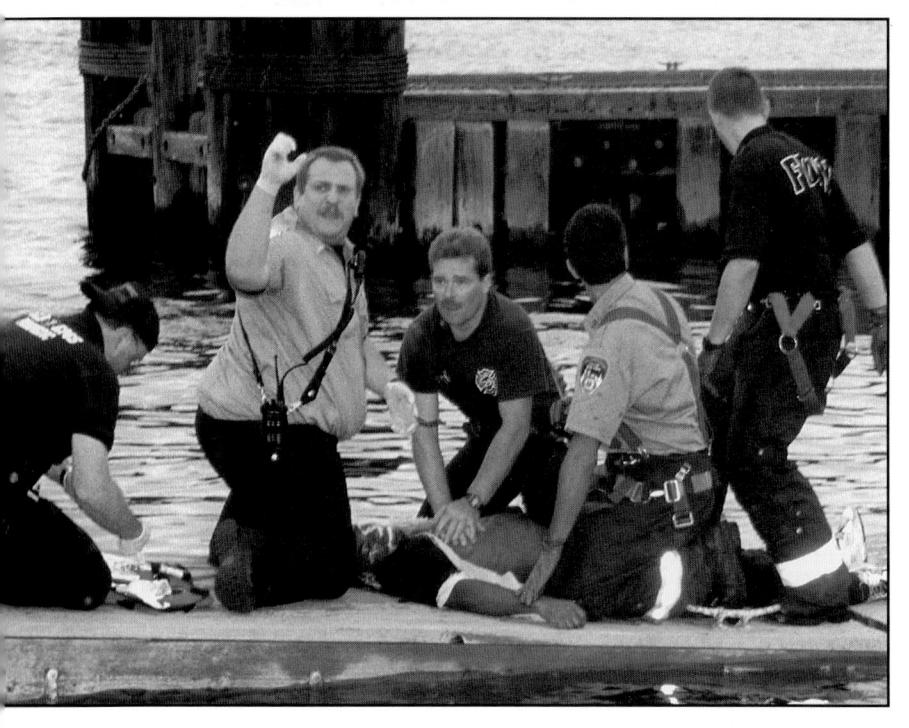

Medics frantically try to revive one of two drowning victims. To arrive in time to cover this kind of spot news, Sam Costanza carefully monitors two scanners in his car and an additional portable scanner that he carries with him.

(Photo by Sam Costanza, New York Post.) The hour was sneaking up on midnight in Manhattan. Sam Costanza was sitting behind the wheel of his 1976 Ford Maverick, casually listening to the crackling sound of his scanner radio. So far, the evening was business as usual for the veteran contract photographer for the *New York Post*. Then he caught the New York City Police Department's special operations dispatcher saying, "10-10 shots fired on Wheeler Avenue in the Bronx."

Costanza didn't budge, but he kept listening.

A shooting on Wheeler Avenue was not news. Just another of many weekly shootings in that rough section of the Bronx. Definitely not page one news for the next day's *Post*. There was no payoff for Costanza, a contract photographer, to cover "another routine shooting" in New York City.

But, the next transmission from the special operations dispatcher alerted Costanza that a "newsworthy condition" was shaping up.

The disembodied voice over the radio said, "Three men to Jacobi Hospital for trauma."

From his years of listening to the police department, Costanza knew that the second transmission meant that three officers were involved in a situation involving the death of a civilian but that no officers had been injured. According to police procedure, a New York officer always goes to a city hospital following situations involving the death of a civilian—"trauma." Putting the first and second transmissions together, Costanza figured that police had been involved with the "10-10 shots fired."

"Now my wheels are turning," Costanza recalls. "I begin to head for the Bronx from my current position on the upper Westside of Manhattan."

Pushing his powder blue Maverick at eighty miles per hour down the Sheridan Expressway, the photographer heard the crucial third transmission by the Special Operations Division, but by now the dispatcher's voice is tense. "Perp down. DOA, 1157 Wheeler Avenue, Bronx."

Costanza's experienced ears easily translated the facts: at least three police officers had been involved in shooting another person—and that person was now dead at 1157 Wheeler Avenue, Bronx.

The photographer arrived at Wheeler Avenue, parked, jumped out of his car and slung his two Nikons, mounted with Vivitar 283s, over his shoulder—ready to go. Starting toward the crime scene, which was halfway down the block, he was accosted by no fewer than four officers who, seeing the cameras, told him he could proceed no further because an active crime scene had been set up.

Faced with tough, big city cops attempting to block his access to crime scenes nearly every night of his working life, Costanza wasn't discouraged. Not wanting to waste any more time, he returned to his car and
light up officers and others, making them potential targets."

GETTING ALONG WITH THE COPS When Sam Costanza approaches a crime scene at night, the first thing he does is shout "New York Post photographer." But he doesn't wait to begin taking pictures. "By the time the 'New York' comes out, I've fired the first picture," he says. On the nighttime crime beat, Costanza must be within fifteen to thirty feet of his subject to get a wellexposed picture. Otherwise, the light from

When faced with police at a crime scene, Costanza advances confidently but will walk away instead of confronting police if they are

his strobe just won't be bright enough.

hostile. Jim MacMillan, who covers at least thirty murders a year for the Philadelphia Daily News, says that he goes in with confidence. "If I am going to get in a dispute with them over my rights, I have already lost," he says. Like Costanza, MacMillan will try to find the path of least resistance, but he has still faced everything from special treatment to harassment. The cops are especially protective of the scene if children are involved or if a cop has been hurt, he says. Under those circumstances. "I know I am going to run into problems," he notes.

When the police say no pictures The police cite a number of reasons for pushing the media away from crime, accident, or

drove to the other end of the block. This time, he knew he'd need a ruse to get near the scene. Wearing a black military fatigue jacket, he left the blue Maverick and headed out with just one Nikon and flash unit tucked under his arm and out of view of the officers down the block. He placed his hand radio, cranked up to full volume, in his upper jacket pocket. Perhaps, he hoped, the uniformed cops on this end of Wheeler would mistake him for a detective. He started up the dark street.

The ruse worked. The uniformed cops, he recalls, "neglected to accost me." Costanza got to within twenty-five feet of the crime scene, where he began to notice styrofoam cups, at least thirty by his first count, placed upside down on the sidewalk. From past experience, he knew that the police use the cups to mark the location of spent bullet rounds or bullet casings. From the number of cups, he also realized that an incredible orgy of gunfire had taken place. He had never seen so many cups at a crime scene.

"As soon as I spotted the cups, I knew that this was the picture," Costanza says. "The cups would immediately show that multiple rounds had been fired in this area no larger than forty square feet.

Costanza also knew that once he pulled out his camera and shot off a picture, the cops would shut him down. He knew he could get off one and only one shot before he was kicked out.

"I knew that once I took the picture, I was going to be in trouble with the other cops," he explains.

From under his arm, Costanza picked up the camera and flash. He had pre-focused the camera on infinity, set the f-stop at 5.6 on his 35mm lens, the shutter speed at 1/60 sec., and the strobe on "auto-yellow" to mirror the aperture setting on his lens. Just as a pair of plainclothes investigators walked by the overturned marking cups, he managed to fire off three frames.

"All hell broke loose," he says. The police quickly surrounded him and "escorted" him off the block.

The first thing Costanza did when he got back to his waiting Mayerick was call the city desk of the New York Post. "At least thirty shots appear to have been fired by N.Y.P.D., and there's a dead perp in the vestibule at 1157 Washington Avenue," he reported.

The editor responded, "I'm only interested if it's a cop that gets shot, not a perp."

Despite the editor's bad call, Costanza had left the scene with some incredibly important pictures, he later learned. Four members of N.Y.P.D.'s elite Street Crimes Unit had fired forty-one-not just thirtybullets at Amadou Diallo, an unarmed immigrant from Guinea. West Africa.

Nineteen bullets riddled the man's body. Diallo's death set off an intense racial conflict in New York and a review of policies used by New York's finest.

As this book goes to press, the four officers were found not guilty of second degree murder, and a new round of protests have erupted not just in New York but around the country.

While the Post never ran Costanza's picture, his agency, Sipa Press, sold the image to publications around the world. For Costanza, it was just another routine night in the life of a spot news photographer.

To get this exclusive picture of the cups marking dozens of **bullet casings after New** York police officers shot an unarmed man. Costanza had to sneak up to the crime scene. He was able to fire only three quick frames before the police hustled him away. (Photo by Sam Costanza,

New York Post.)

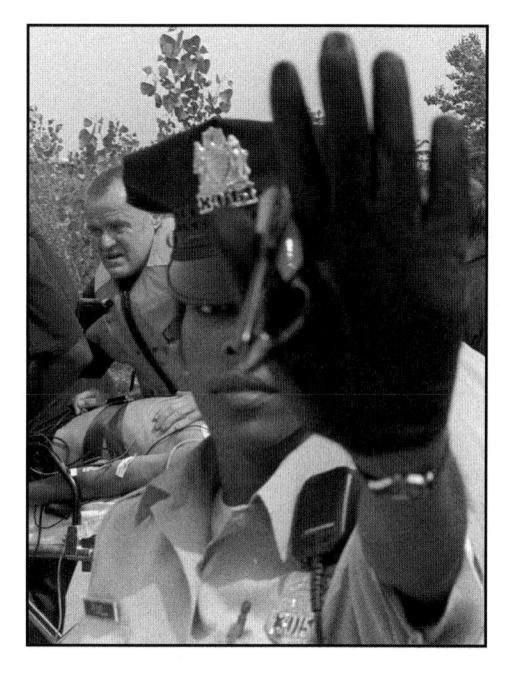

A police officer attempts to block the photographer's camera with her hand as rescuers hurry a drowning victim to an ambulance. Unfortunately, photographers have no more rights than the general public when it comes to access to crime, accident, or disaster scenes. Police may tell you to leave, they may limit your access to an outer perimeter, but they may not take away your film.

(Photo by Jim MacMillan, the *Philadelphia Daily News.*)

disaster scenes. They sometimes feel (mistakenly) that they have a duty to protect the privacy of citizens from the press, says Donald Middlebrooks, who has written about police and photojournalistic access. He says that sometimes the police claim to be pushing the media away to prevent interference with rescue efforts or to avoid some pretrial problem that will prevent them from successfully prosecuting their case.

Too often, these reasons are an easy dodge for getting reporters and photographers out of law enforcement's hair at a time when the police are excited and sometimes overwhelmed by a disaster or a crime scene in which they are working. But that doesn't mean you can ignore the police when they don't want you around.

Know your bounds

Many police agencies today are using the two-perimeter system in dealing with the media, says Sergeant Yates of the Louisville, Kentucky Police Department. They first establish an outer perimeter as a barrier for the general public. Once the scene has been secured, they create an inner perimeter for the news media.

One way to avoid some problems is to be aware of the crime scene perimeter. If you get there before the police put up the yellow tape, you do not want to contaminate the scene—by stepping on a bullet, for example. Kent Porter recounts the time he arrived before police when a man had been bludgeoned with a tire iron twenty-seven times. "My shoeprints got all over the crime scene," he recalls. "I had blood on my shoes. 'We have to make sure you are not the murderer,' the cops said. And then they took my shoes. The only thing I had to wear were my spiked baseball shoes."

The outer perimeter is designed to keep away curiosity-seekers. Photographers with media credentials should be able to cross the outer perimeter but not the inner perimeter. The inside yellow tape, known as the "hot zone," is where the crime scene is located.

Sergeant Yates suggests that photographers look for an officer (preferably a commanding officer), identify themselves, and then ask, "Could you direct me to where you want the news media?" If this fails, ask if there is anyone on the scene in charge of public information.

The Sergeant cautions photographers not to violate the inner perimeter. You actually have no more legal right of access than the general public. What you do have, and what you hope the police will recognize, is a more significant reason to be there than the general public does. (See Chapter 14, "The Law.")

Yates recommends that, unless an immediate photo is necessary, you should take time to talk to officers before shooting. Try to get a feel for the mood of the scene.

Police are particularly on edge when a fellow officer has been injured or killed and may overreact to your presence. "These are times to ask first and shoot later," Yates points out. "Express regrets and ease into the situation."

In the rare instances when you arrive at the scene of a crime in progress, the police do not have the right to evict you even for your own safety. Of course, don't get in their way. They definitely have enough problems without trying to protect you.

Finally, Yates observes, don't argue with a police officer. "You can argue until you're blue in the face," he says, "and all you will usually be left with is a blue face."

On the scene

Once the police have set up their perimeter, you often have to shoot with a long lens and even add the tele-extender. Jim MacMillan's 500mm lens and extenders come in handy at times like this.

Sometimes the problem is not the length of lens but of time. You just have to wait.

Sam Costanza has done a lot of waiting in his time. He puts it this way: "Wait for the chief medical examiner to get there. Wait for the crime scene detectives to arrive. Wait for the medical examiner to check the wounds. Wait for the police photographer to photograph the body. And, finally, wait for the crime scene detectives to look to see if there are any weapons on the ground." While shooting spots news can produce an adrenaline rush, it can also result in fallen arches and tired legs.

Kent Porter in Santa Rosa says he tries to be as thorough as the detectives themselves. "I check to see if I have all the evidence on the film," he says. "Do I have all the names I need? If it is a shooting, do I have a picture of the gun? Do I have the picture of the main investigator? Do I have all the players the

reporter has talked to? Do I have a photo of the surrounding scene? Did I get low and shoot the tape?" To ensure complete coverage, Porter says that he always shoots the crime like it was a picture story with a beginning, middle, and end.

PHOTOGRAPHING A CRIME IN PROGRESS

Unlike reporters who can reconstruct the details of a mugging from police reports and eyewitness accounts, the photographer must be at the crime scene to get action pictures. Robbers, kidnappers, rapists, and murderers tend to shy away from the harsh glare of public exposure.

PREDICTING VIOLENCE

A photographer with a good news sense, however, can learn to predict some situations that might erupt into violence. For instance, a group called ROAR (Restore Our Alienated Rights) began organizing opposition to court-ordered busing the summer before South Boston's all-white high school was scheduled for desegregation. The media, tracking the growing size of the protest, evaluated the intensity of local residents' feelings and predicted chaos, perhaps even violence, on the first day of classes. Photographers and

reporters representing both local and national media gathered early in the morning in front of the school. Hundreds of police, assigned to escort the African-American youths from bus to building, stood across the street from taunting white teenagers and their parents. When buses carrying the African-American students arrived, the crowd broke through the police lines.

A full-scale riot started. Mounted police wielding clubs scattered the rock-throwing demonstrators.

During the ensuing violence, the crowd hurled rocks and bottles at newspaper, magazine, and TV photographers. The police provided no security for the working press; officers even tripped and pushed photographers. Caught between the police and the demonstrators, the media were hated by both. White residents of South Boston thought the media were too liberal in support of integration; the police believed the media had unfairly criticized them. Fortunately, no photographers were seriously injured.

STAYING ALIVE: A CASE STUDY Whether anticipating violence or racing into it on assignment, photographers must stay mentally alert to protect themselves while You can predict some crime news. Violence was likely on the first day of busing to achieve integration at South Boston High School. As school opened, mounted police used billy clubs to disperse rock-throwing, antibusing demonstrators.

(Photo by Ken Kobré, for the *Boston Phoenix*.)

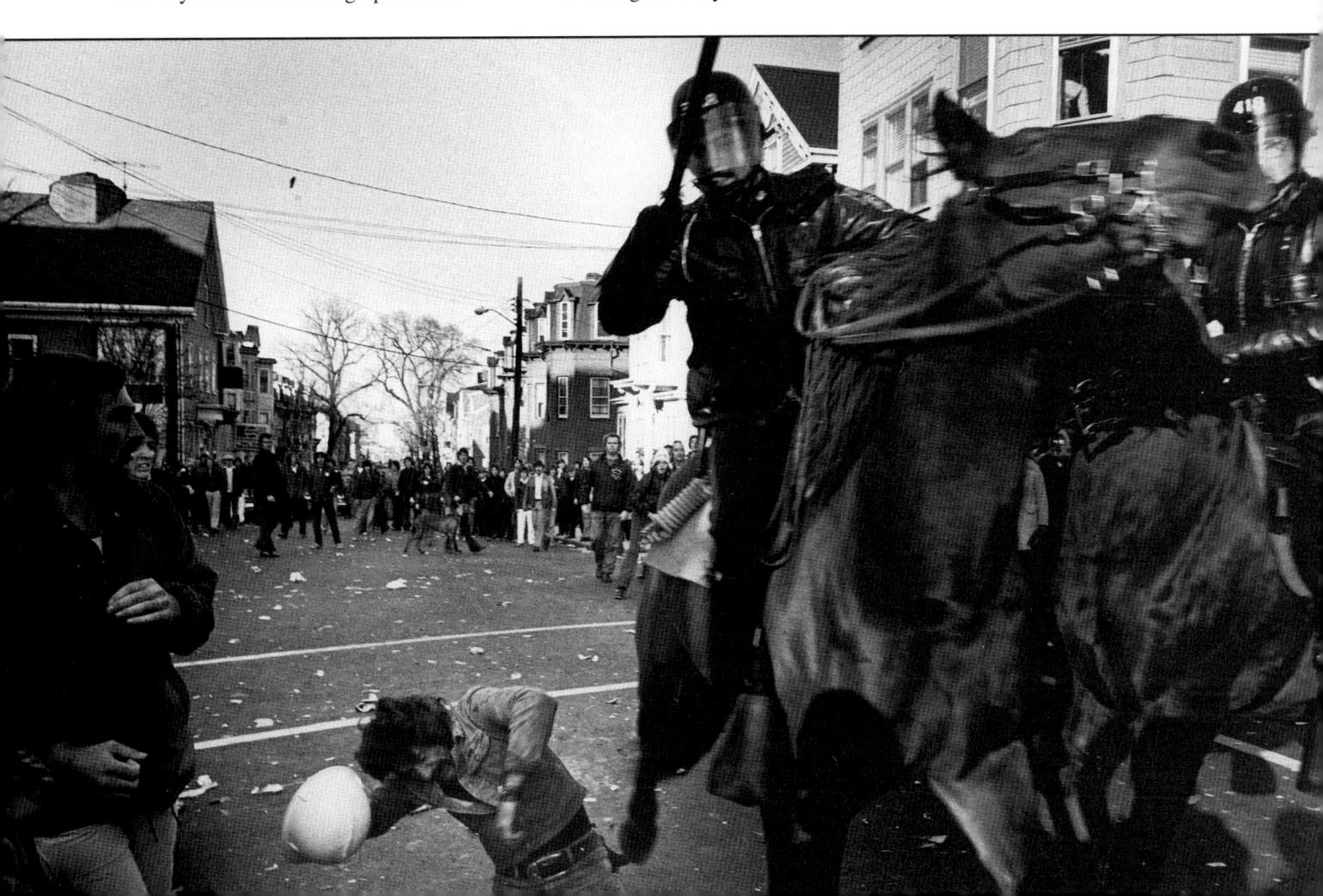

covering the story.

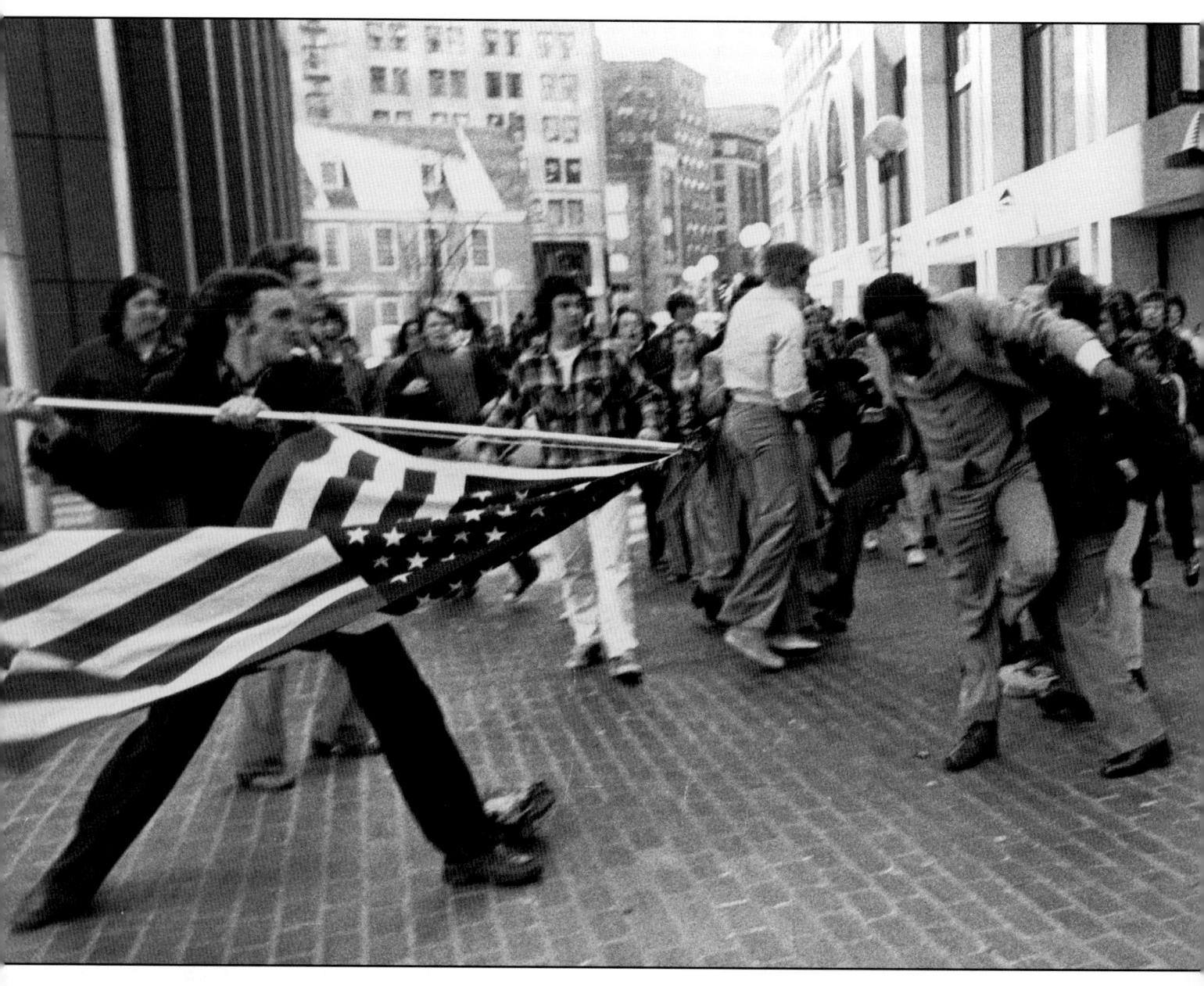

The attacker was part of an antibusing group that had just recited the pledge of allegiance during a demonstration at city hall. The unfortunate African-American man just happened to be walking by.

(Photo by Stanley Forman, the Boston Herald.)

With the acquittal of white police officers who had been videotaped beating Rodney King, an African-American man, Los Angeles erupted into riots. By the second day of the riots, the Associated Press called in John Gaps, III. Gaps is one of the photographers the AP flies in when the agency needs an extra shooter who can hit the ground running. They call this breed of photojournalist a photographic "fireman." Gaps handles photographic emergencies.

"They told me to get to L.A.," Gaps recalls of receiving the assignment as the riots started to unfold. He landed at LAX, rented a car, and, after picking up another AP staffer (one who had never been in a riot), headed for 18th and Broadway—the heart of the violence.

The photographers drove up to a blazing electronics warehouse, where looters were still hauling out the expensive goods.

"It didn't seem like a violent crowd," Gaps recalls. "I told the other photographer that I was going to park the car. If I could get on the ground, we wouldn't look like a driveby." Gaps knew that by shooting from the car, he could be mistaken for an undercover policeman. Gaps' less experienced partner, however, started shooting pictures through the windshield of people running by.

Almost immediately, a young Latino came to the driver's side of the car and aimed a gun at Gaps. Gaps picks up the story:

"I put my hands up, opened the car door and said 'Here.' I showed him the camera, an Nikon 8008 with a 35mm-70mm zoom and strobe on it, and held it out the car door.

"Here, take the camera," Gaps told the man. "He lowered the gun, reached across and took the camera from me. He had the camera in his hand, and I was starting to pull out.

"He raised the gun and aimed at me through the [closed] window," Gaps recalls. "Then he pulled the trigger right by my head. The car window just exploded. Fortunately, the glass deflected the bullet. He was standing right beside me when he pulled the trigger. He tried to blow my head off.

"Then I looked up, and traffic had cleared in front of the car. I hit the accelerator and drove like a bat out of hell down the street with my head down.

"I got about two blocks away before I stopped to see if anyone was hit. The bullet was lodged in the back seat.

"I guess we looked like cops taking pictures from the car. That set people off. We're just lucky we got out alive."

Of course, no flak jacket or bulletproof vest would have saved Gaps had the shooter's aim been slightly more accurate. If there is a moral to the story, it is to be careful in a riot. Even an automobile provides no real protection.

WHY SHOOT FIRES?

Reporting fires is an important part of the photojournalist's job. More than 500,000 homes catch fire each year. Fires also destroy apartment houses, stores, office buildings, and factories. Fires sweep through schools where children are having classes. Autos and trucks burn up, and fires devastate forests in all parts of the country.

Altogether, 2 million fires are reported annually, costing more than \$12 billion in property damage, according to the National Board of Fire Underwriters. Still more serious than monetary loss, thousands of people die in fires each year.

A photo can show not only the emotion of the participants but also the size of the fire better than words can. If a fire breaks out on the twenty-third story of a building from which an occupant might jump, a photo can indicate just how high twenty-three stories really is. The reader can quickly grasp the danger of jumping. If a wooden warehouse

During a protest in front of the California State University offices, a cop sprayed a demonstrator with mace. The photographer used a flash to help freeze the action and catch the trail of mace.

(Photo by Pete Erickson, San Francisco State University *Golden Gater.*)

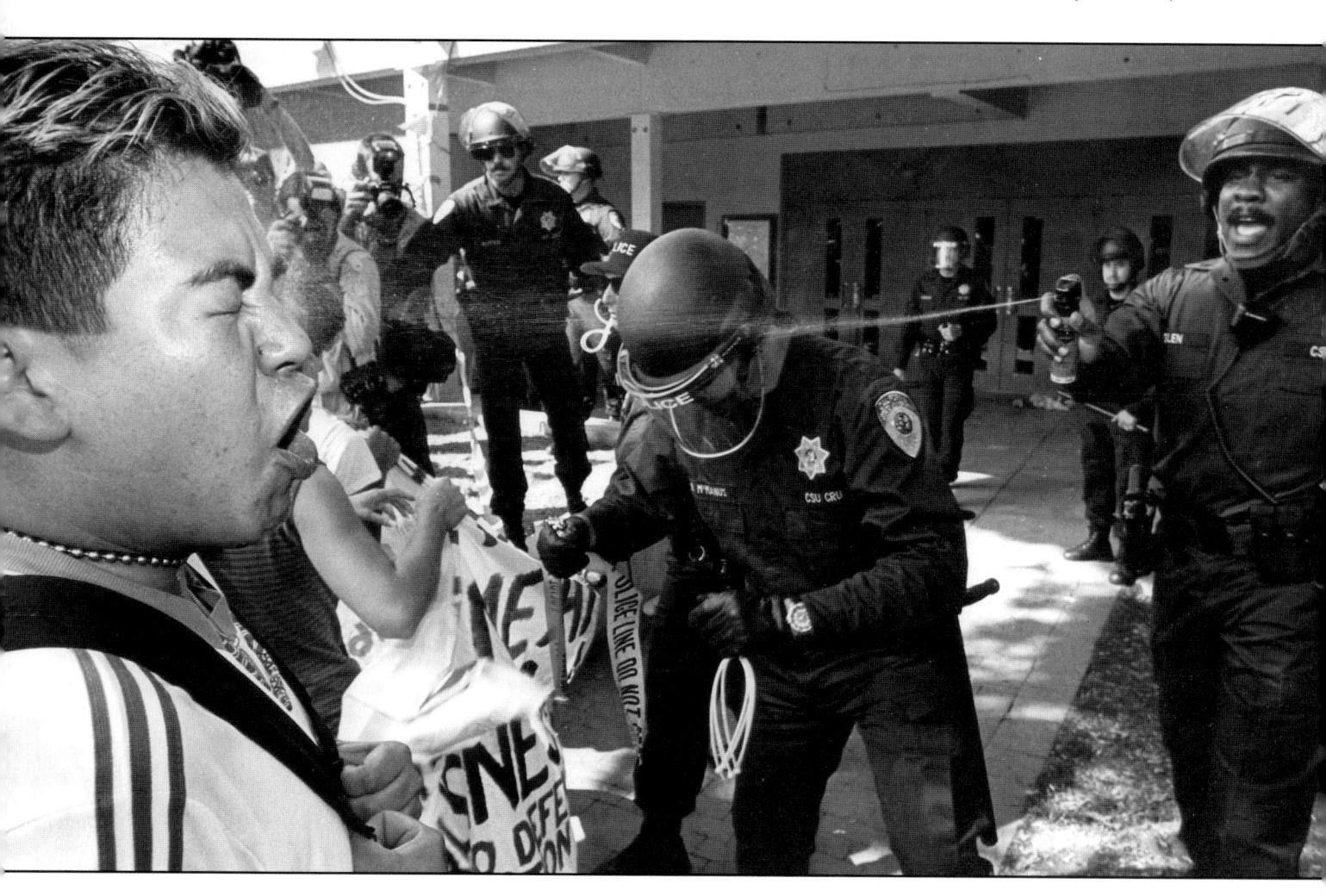

catches fire, requiring four companies to halt the spread of the flames, a photo can give the reader an idea of the vastness of the blaze.

After the fire has been extinguished, a photo of the charred aftermath carries impact beyond a mere statistical description of the loss. A photo of a house burning or an office worker trapped in a building ignites an empathetic reaction in the viewer, who thinks, "that could be my house . . . that could be me in that building."

FINDING AND FLEEING FIRES

Scanner radios, of course, provide one key way to learn about fires, but you can even develop a sense for when fires might occur. Kent Porter of Santa Rosa, California, has become an amateur meteorologist. By watching for low humidity and high winds, he is aware of the kinds of days when Northern California will be susceptible to wild fires. These fires might start in a field of dry grass, a grove of trees, or in someone's backyard. When conditions are right, such fires escalate quickly—which is exactly what happened in Oakland, California.

Kent Porter described it this way. "It was windy and really warm. The humidity was down. I told my girlfriend, 'There's going to be a fire today.' I called my boss while I was driving down the road. I knew I was supposed to cover the football game, but I knew there was going to be a big fire. I turned on my car radio and heard the first reports coming from Oakland: 'Oakland Hills on fire.' The Oakland Hills fire turned out to be the biggest urban fire in history . . . more than 3,000 buildings were lost."

PLAN FOR TRAFFIC

While good news photographers know their hometowns extremely well, they also use their town's Thomas Brothers maps, a series of maps available nationwide that provide the most accurate and complete road guides for different areas. A Thomas Brothers map for your area will pay off when you don't have time to ask at the local filling station for directions to 25th and Capp.

Jim MacMillan in Philadelphia notes that as he nears the location of a fire, he can find the flames by following the trail of leaking water that fire trucks leave. At night, he says, smoke will be evident in the glow of streetlights if a fire is in the area. To avoid the possibility of colliding with fire trucks, shut off your radio, open your windows, and listen for fire engine sirens. When you arrive, find a parking spot that doesn't block fire hydrants—and plan for your escape.

"Get your film back to the office before the

firefighters are prepared to leave," explains the *Boston Globe*'s George Rizer. "If they're parked in back of you, you'll be stuck until the fire is over and they've all packed up their equipment. You'll miss your deadline."

OVERALL SHOT SETS THE SCENE Once you have arrived at a fire and parked, you will want to start taking pictures. "The first thing I do," says Kent Porter, "whether it is a house fire or brush fire, is take a picture through the window. I always shoot an overall of the whole scene, at the moment I drive up to the scene."

When you first see a fire, you should take a record shot since you don't know if the fire will flare up or die down. Later, to establish the size of the blaze, the location of the trucks, and the type of building that is burning, you might look for a high vantage point from which you can shoot an overall photo.

WATCH FOR THE HUMAN SIDE

Once you have your overall shot, look for the human side of the tragedy. Are people trapped in the building? Will the firefighters bring up ladders to rescue the occupants, or have they already escaped? Do the firefighters have to administer mouth-to-mouth resuscitation or other kinds of first aid?

"Look for people's reactions," advises Jim MacMillan of the *Philadelphia Daily News*, "Play their ordinary lives against the crisis they are going through."

Meanwhile, don't overlook the efforts of the firefighters to put out the blaze. Without interfering, shoot the ladder and pump companies as they spray water on the flames. Keep an eye out for people overcome by smoke or exhaustion.

Kent Porter recommends using a 300mm lens to get tight on the firefighters' faces.

Fires inevitably attract people. Whether in a big city or a rural town, a fire brings out an audience—whether neighbors or just passersby. The crowd stares with wide eyes and open mouths, seemingly transfixed. Try to capture on film this psychological attraction.

LOOK FOR THE ECONOMIC ANGLE Show the dimensions of the incident so that the reader learns whether the fire was a minor one or a major conflagration. Take a picture that indicates the kind of structure burned—single-family home, apartment house, business, or factory. Show how near the burned building was to other threatened structures in the neighborhood.

As the fire subsides, seek out a location where you can shoot a summary photo

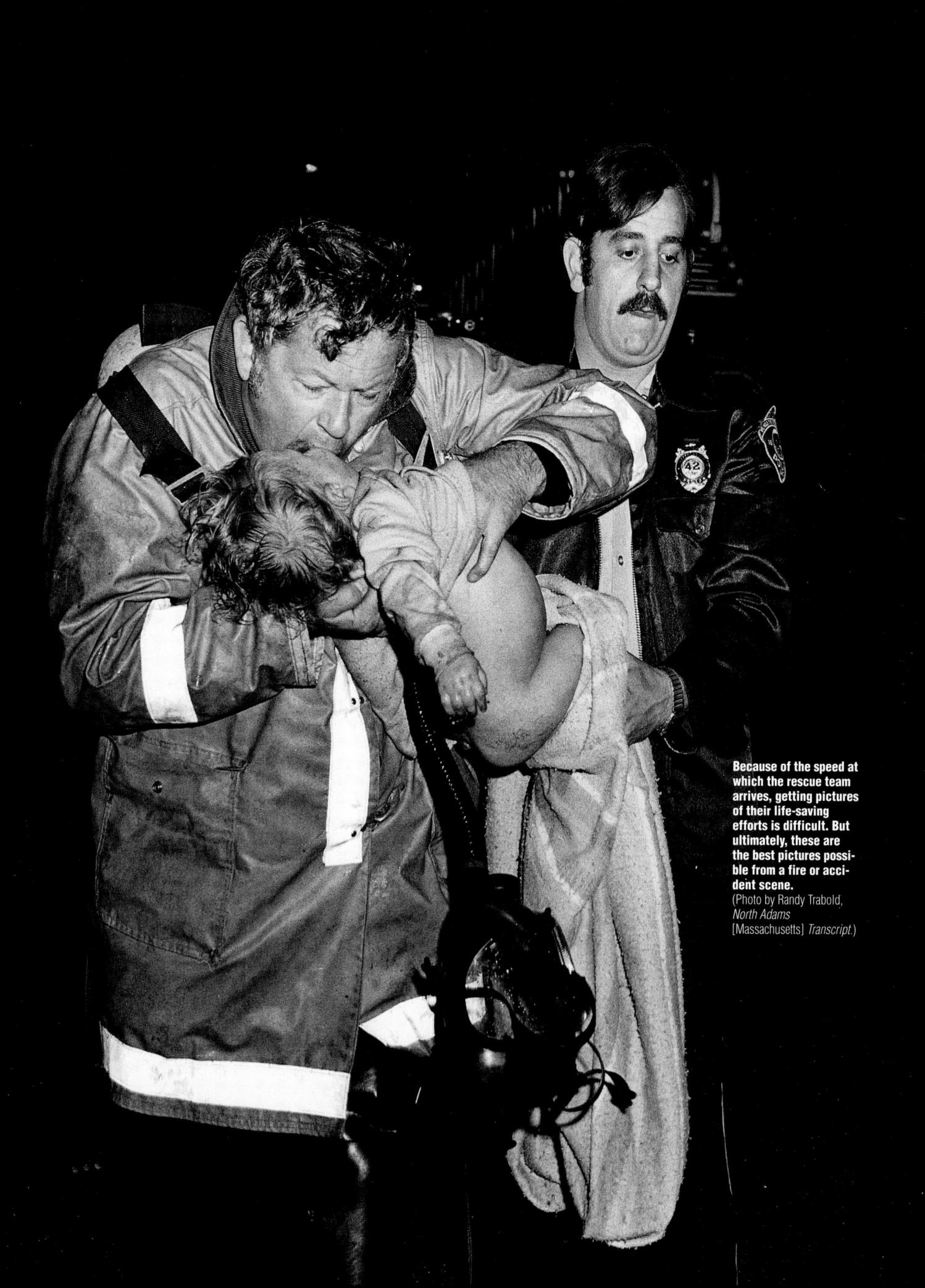

LEAP FOR LIFE: A FIRE IN BOSTON

Stanley Forman, three-time Pulitzer Prize-winning photographer, knows Boston like the back of his hand. In this instance, he was cruising when he actually smelled smoke and pulled up to the burning house along with police. Trapped on the roof, the man in the pictures first handed down the child. When the woman froze, the man pushed her off before he jumped. The woman suffered minor injuries, but everyone else was okay. Forman approached the fire as if shooting a picture story. He takes the reader through the danger to the trapped residents on the roof, follows up with pictures of the rescue, and comes in tight to end with a close-up of the officer holding the child. (Photos by Stanley Forman.)

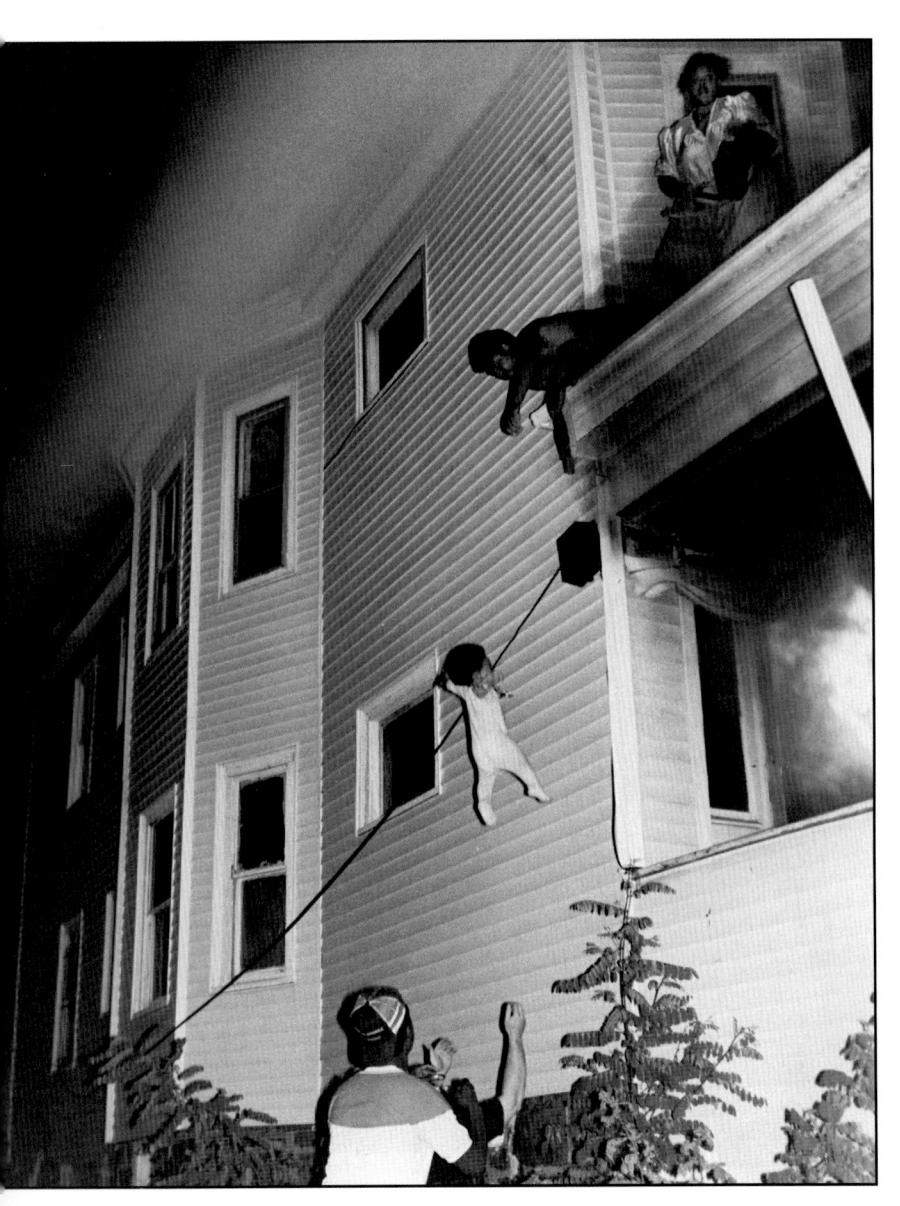

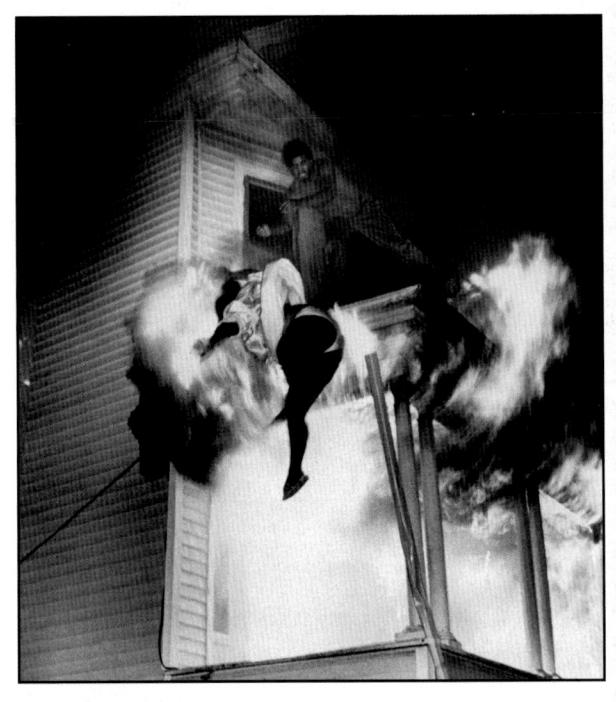

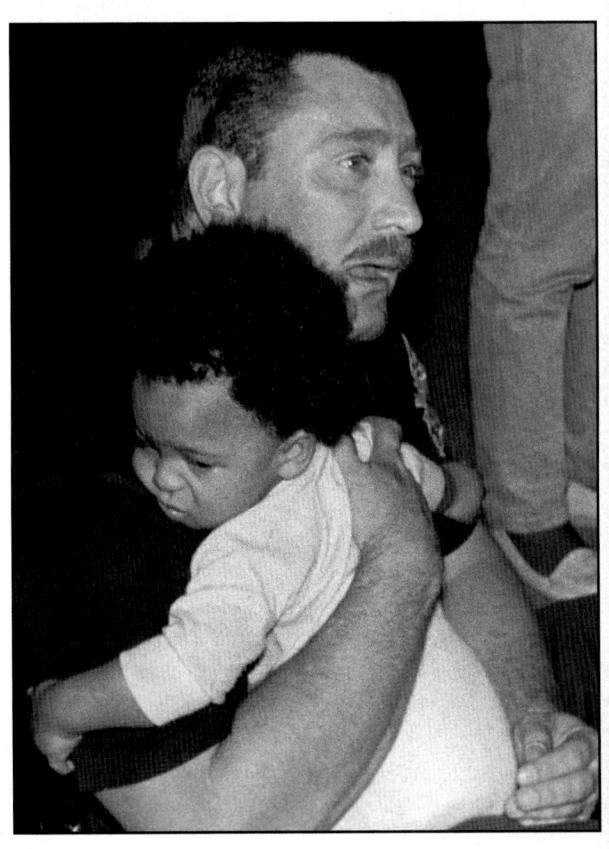

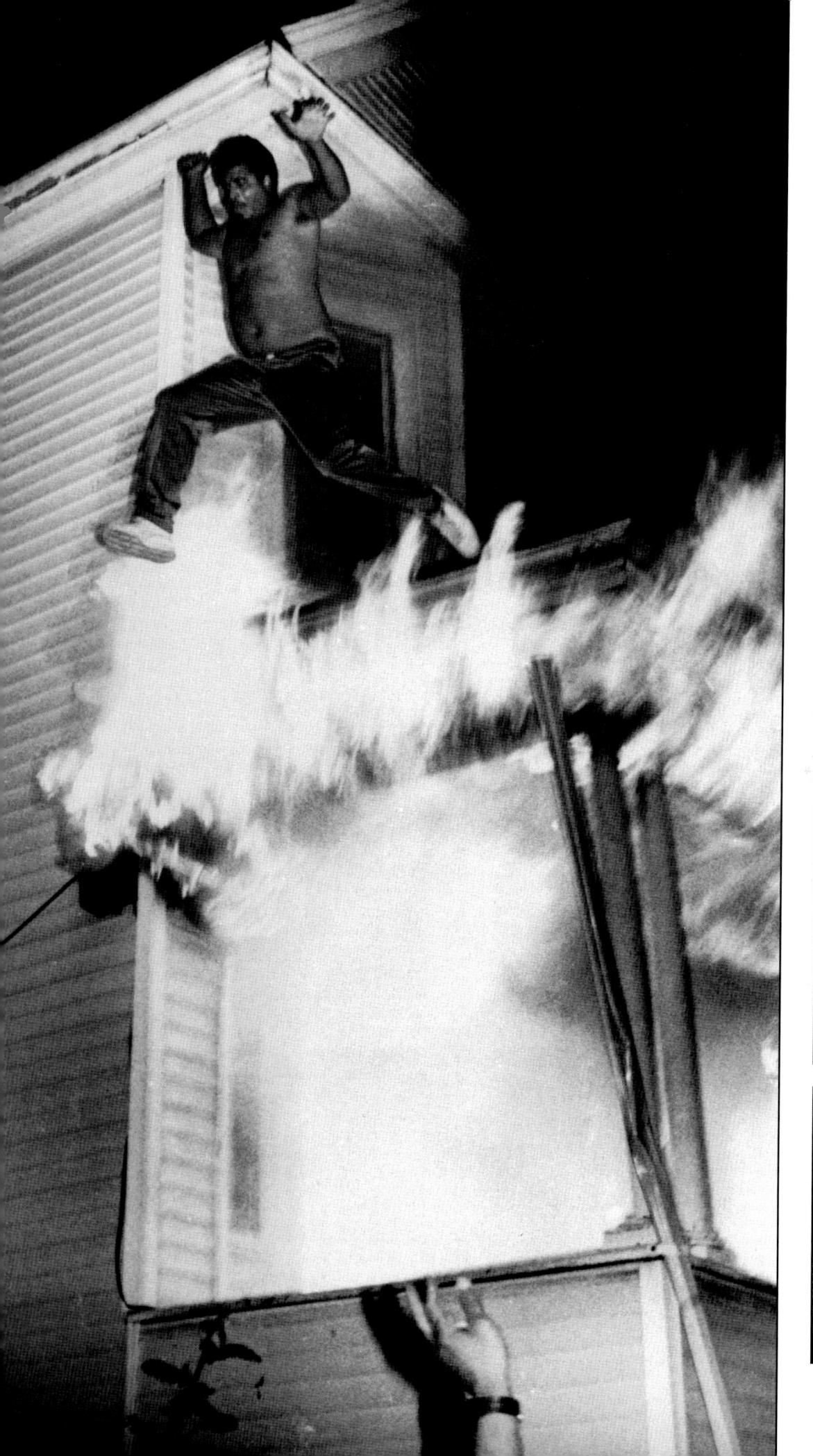

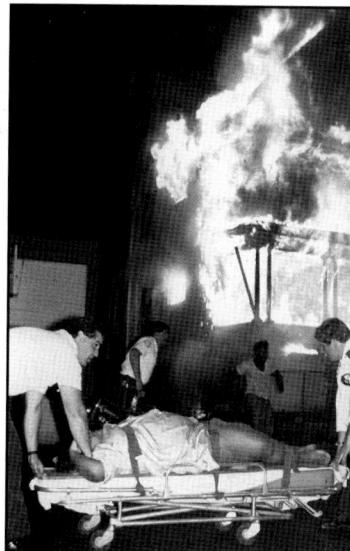

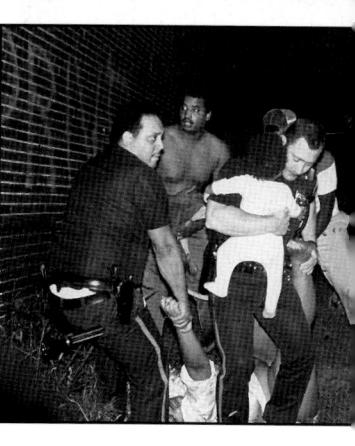

Don't let your light meter be thrown off by the bright flames at a night fire. While the flames engulfing the house will come out in the final picture, a longer exposure is needed to bring out the building and surrounding areas.

(Photo by Dan Lassiter, Fort Morgan [Colorado] Times.)

showing the extent of the damage. If you can accompany the fire inspector into a building, you might be able to photograph the actual cause of the blaze. When the fire marshal suspects arson, detectives will be called in to investigate. Investigators at work supply additional photo opportunities.

You might return to the scene of the fire the following day to photograph the remains of the charred building. Often, residents return to salvage their property. The next day's photo of the woman carrying out her watersoaked photo album might communicate more pathos than the pictures of flames and smoke of the night before.

You also can follow up a fire story by checking to see whether there has been a series of fires in the same area over the past year. If you find that certain blocks of houses or stores tend to have an unusually large number of fires, suggest that the editor run a group of fire pictures on one page, demonstrating the persistence of the fire hazard in that neighborhood.

FEATURES HIGHLIGHT THE SIDELIGHTS

Besides spot news, photographers can find good material for feature photos at fires. A picture story about the Red Cross worker who attends every fire might provide a sensitive sidebar story. A small town may have an all-volunteer company, including a dentist who drills teeth and a mechanic who repairs cars when not battling flames.

Capturing this split life in pictures offers your readers a unique photo feature story.

GET THE FACTS

Always try to get factual data such as the firefighters' names and companies. Interview both the fire and police chiefs for cutline information: the exact location of the fire, the number of alarms sounded, the companies that responded, an estimate about the extent of the damage, and the names of the injured and what hospitals they were taken to.

NIGHT FIRES ARE DIFFICULT

Night fires tend to sneak up between midnight and 6 A.M.—a time when people are sleeping and smoke goes unnoticed. Arsonists choose nighttime for this reason. Because nighttime fires are not reported quickly, they tend to be larger and more frequent.

Photographically, night fires pose difficulties. The *Boston Globe*'s George Rizer, for example, does not take a reflected lightmeter reading at nighttime fires.

"Why bother?" he asks. "A meter reading will be misled by the light from the flames and will not give an accurate indication of the amount of light reflected off the sides of the building."

For night fires, Rizer puts his camera on manual, uses a slow shutter speed, and adds flash. At a faster shutter speed, the flames would still appear in the image, but the building would go black. Rizer is balancing the light from the strobe with the available light from the fire, the streetlights, and the portable lights put up by the fire department. (See Chapter 13, "Strobe.")

Within fifty feet, the flash also helps to light up the building.

With Fuji's 800-speed color negative film, Kent Porter in California uses the same basic technique as Rizer in Boston. Porter puts his flash on 1/8 power. Using his 20mm or 24mm lens, he shoots at f/5.6, at usually a 1/30 sec. He warns against using this technique with a long lens, though, lest you give your subjects "red eye." (See Chapter 13, "Strobe.")

Besides lighting up the foreground, the strobe has an additional benefit. If the fire-fighters have brought in portable lights to work by, the spots will give off an orange color. The light from your strobe will help to counterbalance this orange cast from the tungsten lights. (See Chapter 13, "Strobe.")

But with the slow shutter speed, you must avoid even slight camera movement during the exposure.

Rizer recommends resting the camera on a car, a fire hydrant, or holding the camera

tightly and leaning against a lamppost to cut down camera movement.

Philadelphia's Jim MacMillan finds that he can even use his longer lenses at night if he braces himself carefully. He will shoot at 1/15 or 1/8 sec. with his 200mm lens when he is leaning securely against a car or utility pole.

He tries to wedge the camera lens against a stationary object and then "hammer off a number of frames to try to get one sharp."

But he puts away the strobe when flames start shooting out of every window in the building.

"If it looks like a Christmas tree," he says, "you can shoot in available light, and you'll get great, action-packed fire pictures."

COVERING ACCIDENTS AND DISASTERS: GRIM BUT NECESSARY

(Dateline Baltimore) One Dead, 21 Hurt in Bethlehem Steel Blast (Dateline Houston) Fatal Accident on Southwest Freeway Kills Six So read the daily headlines, as accidents take their toll of more than 100,000 lives and 10 million injuries each year (according to the National Safety Council). Almost half the accidents in the United States involve motor vehicles.

But people also die from falls, burns, drowning, gunshot wounds, poisonings, and work-related accidents.

Accidents make news. If one million Los Angeles residents drive home on the freeway safely on Friday night, that's not news. But if two people die in an auto crash at the Hollywood Boulevard on-ramp, then newspaper readers want to read a story and see a picture of the accident.

PHOTO POSSIBILITIES: * FROM TRAGIC TO BIZARRE

If one hundred accidents take place daily in a typical city, no two will be identical. However, all accidents have certain points in common for the photographer.

Check human tragedy first Concentrate on the human element of any tragedy. Readers relate to people pictures. Five people were injured in this accident. All lived. As the rescue team removed the passengers, the mother asked for her baby. Using a low angle, the photographer created a powerful composition. (Photo by Dan Poush, the [Salem, Oregon] Statesman-Journal.)

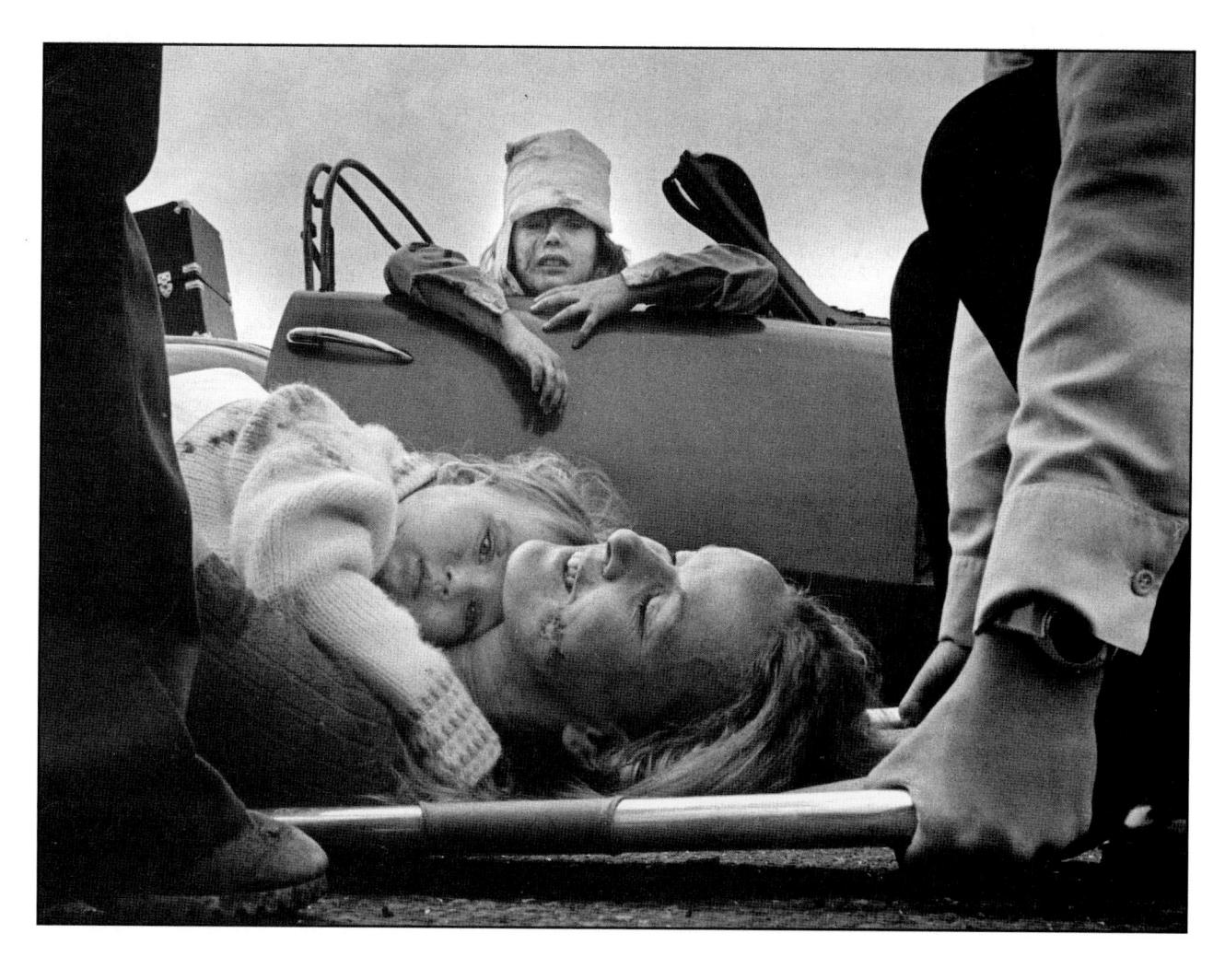

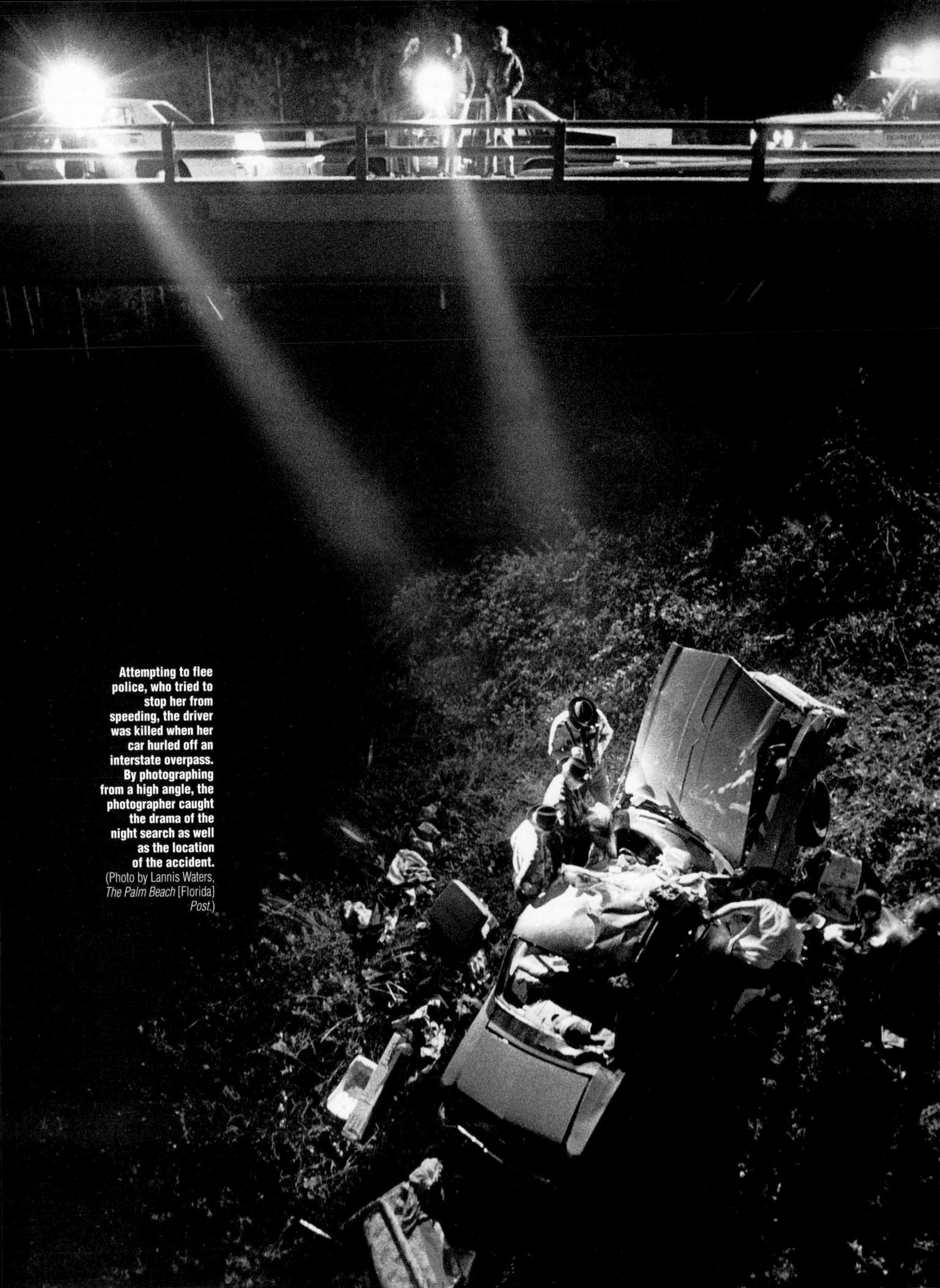

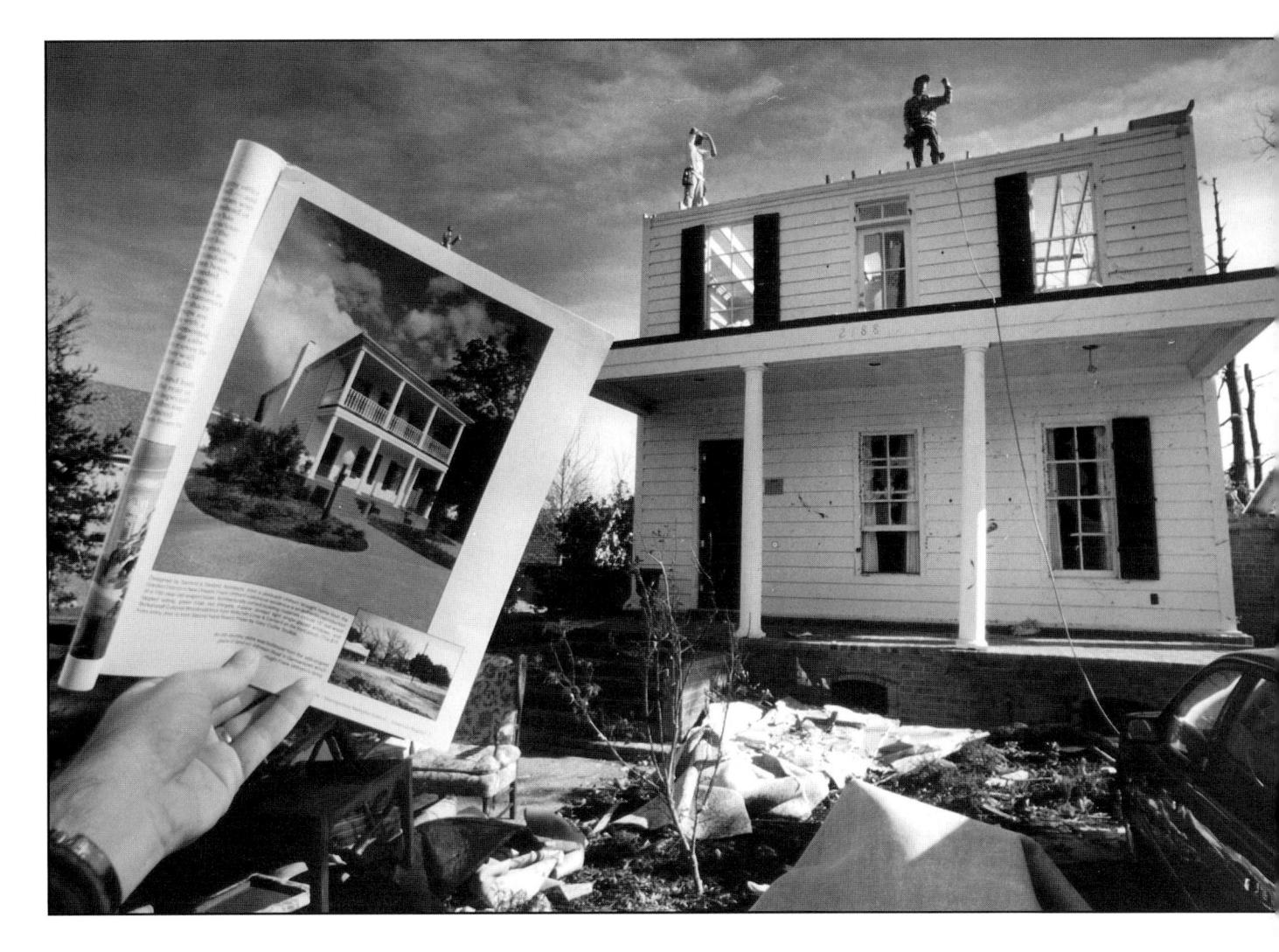

Make a record

Make a straightforward record of what happened. The viewer, who doesn't know how the two cars hit or where they landed on the street, wants to see the cars' relationship to one another and to the highway.

Symbolic pictures imply rather than tell

In some situations, the accident story is better told with a symbolic rather than a literal picture. A bent wagon lying in the street carries its own silent message. There is no need to show the body of the dead child.

Photograph the cause

In many news events such as riots or murders, there is no way of photographing the cause of the disturbance. At an accident, however, you can sometimes show clearly what caused the collision. For instance, if a car failed to stop on a slippery street, you might show the wet pavement in the foreground and the damaged vehicle in the background.

On a dry day, you might photograph skid marks left by the car as it screeched to a halt. Perhaps the accident was caused by the poor visibility of street signs. In that situation, a picture that showed the confusing array of flashing lights and day-glo billboards that distracted the driver would be effective.

Show the impact

Accidents affect more than the drivers of the involved vehicles. Look in both directions for long lines of blocked traffic and drivers slowing down to gaze as they pass the site.

Follow up

If accidents keep occurring at one particular intersection, you might follow up to see if the highway department does anything to correct the hazard. A time exposure showing the traffic congestion might help to spur the highway department into action.

Feature one aspect

Notice how people adapt to their misfortune. Record the kinds of items people save from Just one month before a tornado ripped the roof from this home, it had been featured in an architectural magazine. Using the magazine spread in the photograph helps tell the before as well as the after of this disaster. (Photo by Robert Cohen, the

(Photo by Robert Cohen, the Memphis [Tennessee] Commercial Appeal.) their wrecked vehicles. Note whether they act angry, sad, or frustrated. Catch the sorrow on the face of an owner of a new Corvette as she views for the first time her crumpled fender. See if an owner of a thirteen-year-old Toyota reacts the same way when he sees the damage inflicted on his clunker.

Don't become hardened, however. No matter what the size of the mishap, the accident usually is still a tragedy, or at least a traumatic experience, to the people involved.

THE BIGGEST PROBLEM MAY BE GETTING THERE

Taking pictures at the scene of a spot-news event requires a photographer with a cool head, someone who can work under pressure and adverse conditions. You need no unusual equipment or techniques—just nerves of steel and an unruffled disposition. However, before you arrive at the accident scene, you must be prepared. Load your camera and charge up your electronic flash so you will be ready to start clicking the minute you get out of the car.

In fact, getting to the accident in time is often the biggest challenge for the spot-news photographer. If you're stuck on the North Loop and two cars crash on the South Loop, you might find only a few glass shards from a broken windshield by the time you get to the scene.

The ambulance has come and gone. Removed by the wrecker, even the smashed vehicles are already on their way to the garage.

Consequently, a spot-news photographer's two most important pieces of equipment—after camera gear, of course—are a scanner radio and a city map. The radio provides the first report of the accident and the detailed map shows the quickest way to get to the scene of the collision. Stanley Forman, three-time Pulitzer Prize winner, attributes his success to the fact that he knows his city like the back of his hand. (See Forman's dramatic fire coverage on pages 36 and 37 and on page 324.)

A spot-news photographer finds that the hardest to cover is the story in which all forms of transportation are down. During a flood, hurricane, tornado, or blizzard, you often can't drive a car or ride public transportation.

Faced with a major natural disaster, you can sometimes get assistance from one of the public agencies such as the police department, fire department, Red Cross, civil defense headquarters, or the National Guard. In case of disasters at sea, you can telephone the Coast Guard.

Each of these agencies has a public information officer who handles problems and requests from the media. When a major disaster occurs, many of these agencies provide not only facts and figures but transportation, as well, for the photojournalist.

When the oil tanker Argo Merchant ran

Few fender benders
merit photographic coverage—except when
the driver is a trainee at
the "Easy Method
Driving School."
While serious to the
student driver, this
minor accident takes on
the properties of a
funny feature photo.
(Photo by J.M. Eddins, Jr.,

Photo by J.M. Eddins, Jr., Patuxent [Maryland] Publishing Co.)

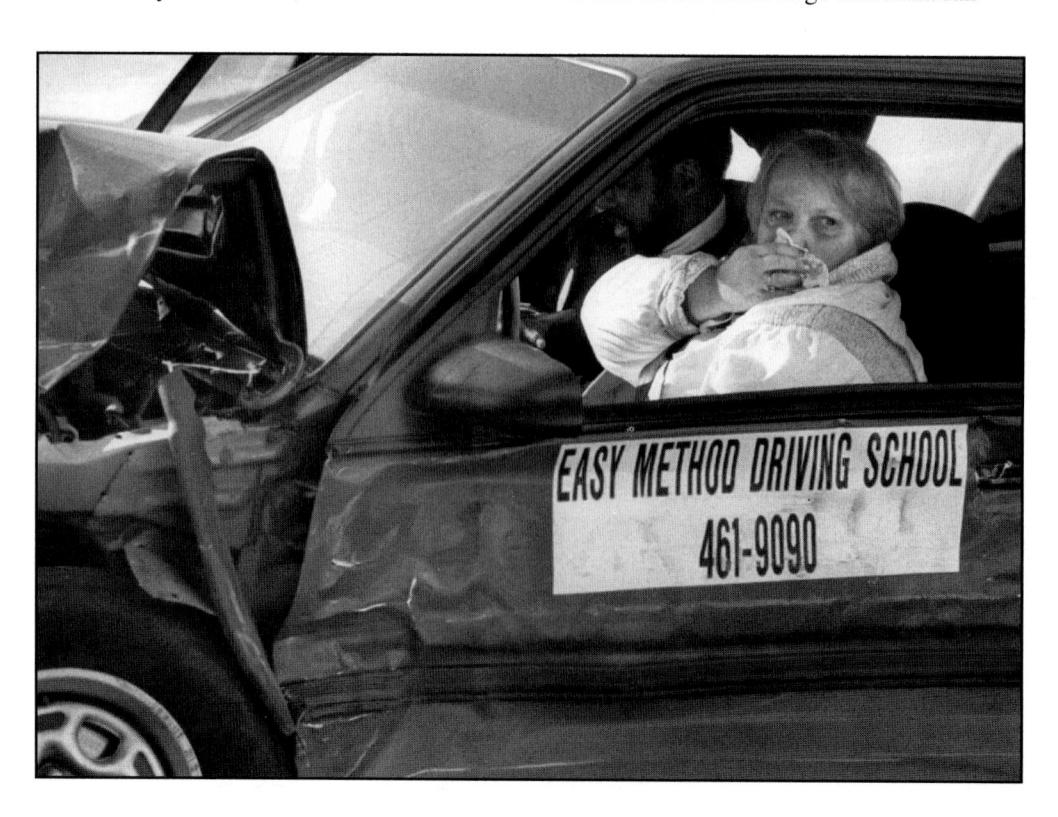

42 Photojournalism: The Professionals' Approach

aground, cracked in half, sank off Nantucket Island, and leaked thousands of barrels of oil into the sea, the author contacted the U.S. Coast Guard on Cape Cod in Massachusetts. The Coast Guard arranged for the author to fly in one of its planes to take pictures over the site.

In another instance, when all of New England was buried under four-foot snow drifts during a major blizzard, the author contacted the National Guard, which provided a four-wheeled-drive vehicle and a driver so the photographer could shoot outlying areas hit by the storm.

As UPI's former New England photo bureau chief, Dave Wurzel, once said, "When a big storm breaks and everyone else heads for home, that's when the spot-news photographer goes to work."

DON'T SHOOT THE LAST FRAME

News photographers use multiple camera bodies so that they don't have to change film when the action is coming down. Some carry two or three bodies. Sam Costanza even carries a point-and-shoot automatic camera just in case he needs a backup.

One piece of advice worth repeating: remember when shooting news not to shoot to the end of the roll. "I change film like crazy," says Jim MacMillan. The Los Angeles Times' Annie Wells attributes her Pulitzer Prize (see cover) to conserving film while photographing the heroic rescue of a young woman in a flooded river. (Wells shot the picture while at the Santa Rosa Press Democrat.) The last thing you want is to have to change film at the most dramatic moment of the day.

The oil tanker Argo
Merchant went aground
and broke up off the
coast of Nantucket.
Thousands of gallons of
heavy fuel oil soiled the
water. The Coast Guard
provided journalists
transportation by
helicopter to the
wreck site.

(Photo by Ken Kobré, for the *Boston Phoenix*.)

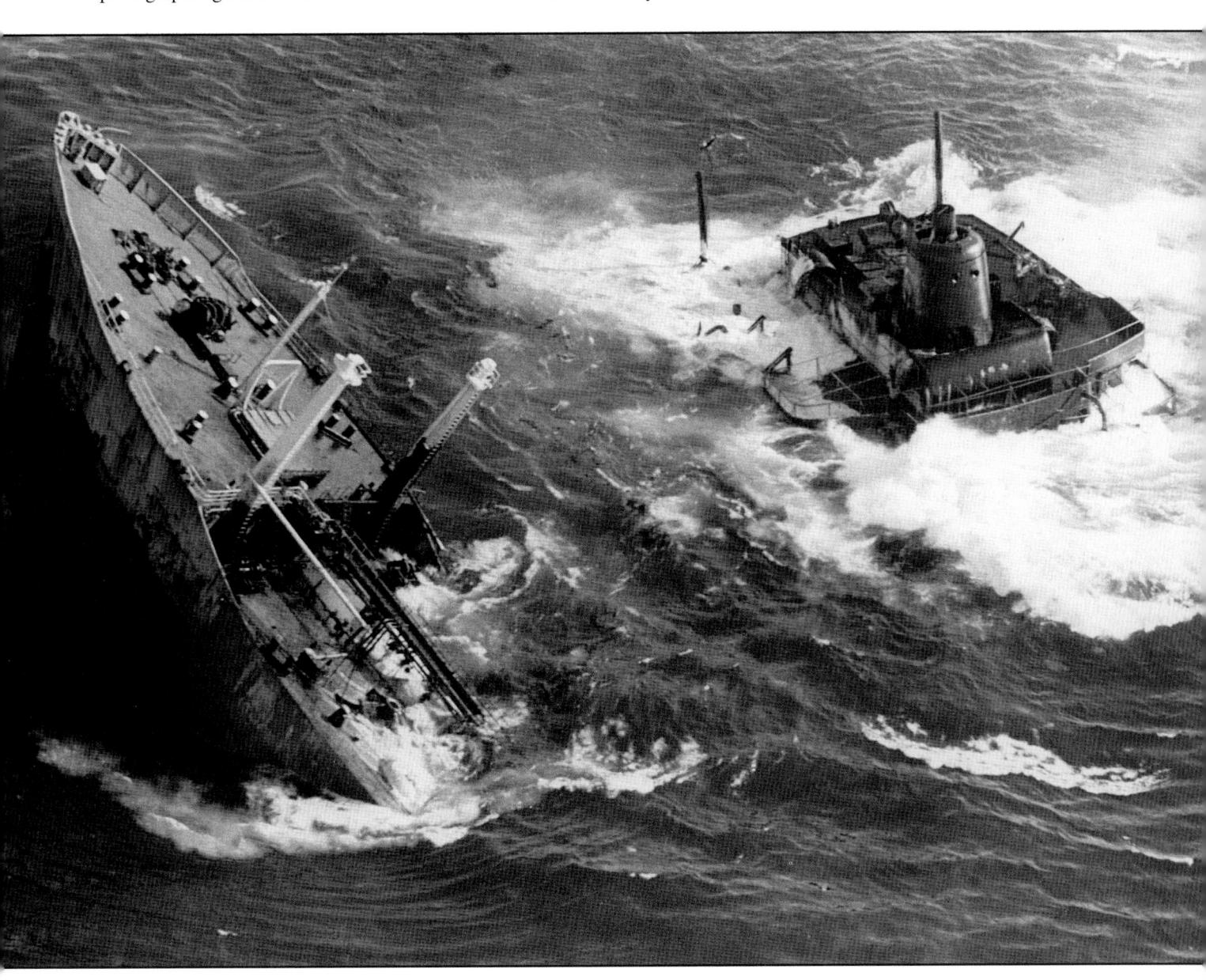

General News

oliticians seek interviews and photographs. Press aides

POLITICS, POLITICIANS, & MEDIA EVENTS

CHAPTER 3

dream up news events and organize news conferences to attract coverage. Astute politicians know that reelection depends on good media coverage. The monetary worth of a page-one photo is inestimable—most newspapers will not even sell front-page space for advertising.

A politician plans media events that attract the camera, even if

Helped by the photographer's low angle, the outstretched hands and campaign poster summarize the story of **Bob Dole's presidential** campaign.

(Photo by P.F. Bentley, for Time magazine.)

the events themselves have little news value.

Called "photo opportunities," these nonevents have

been designed for the camera journalist.

Diana Walker, who covers the White House for Time magazine, had behind-the-scenes access to the first couple during a trip to Africa. Walker was able to catch this rare, unguarded moment of President Clinton and his wife, Hillary, joking around together.

(Photo by Diana Walker,

Time magazine.)

If the president puts on a stupid hat for a photo, an editor can't resist using the picture. Politicians manipulate photographers and photographers manipulate politicians, both to their mutual benefit. Politicians look for free publicity and photographers want visual events. Editors think readers want to see politicians in costume. The picture of the senator wearing a cowboy hat is not wrong. It's just not good journalism.

Politicians come alive at election time. The old "pol" leaves the desk in his plush office and starts pressing the flesh at ward meetings, cultural parades, and organizations for the elderly. The young challenger, by contrast, walks the streets of the ghetto with her suit jacket thrown over her shoulder. Both candidates plaster stickers on cars, erect bill-boards, appear in "I Promise" TV ads, and attend massive rallies. A photographer can take two sets of campaign pictures: one set shows the candidate's public life—shaking hands, giving speeches, and greeting party workers; the other shows the candidate's private life—grabbing a few minutes alone with

the family, planning strategy behind closed doors, raising money, pepping up the staff, and collapsing at the end of a fourteenhour day.

All too often, newspapers and Web sites present their readers with a one-sided visual portrait of the candidate—the public side, planned and orchestrated by the candidate's campaign directors. News outlets tend to print only upbeat, never downbeat, pictures; only happy, never sad, moments. Photographers continue to churn out photos of the candidate shaking hands and smiling—photos that reveal little about the person who wants to run the city, state, or federal government.

GOING BEHIND THE SCENES

The major U.S. news magazines have done a much better job of behind-the-scenes coverage than most of the country's newspapers and news Web sites. To capture insightful pictures of politicians, some magazine photographers and their news organizations have developed special access to high-level officials. While these photojournalists have

uncommon access, their techniques are still useful for photographing people whose lives seem to be one long "photo op."

Diana Walker, contract photographer for Time magazine, has been covering the White House since the last year of the Carter administration. Presidents come and go at the White House. Walker remains. Walker says she is afforded access behind the scenes at the White House to show readers what the president is about when he is offstage. "I can show you relationships and atmosphere," she says, "how these people look when they are not in front of the lights and microphones."

Walker tries to be a "fly on the wall" when photographing private moments in a president's life. "My whole approach is for the president not to know I am there. I try not to engage with him-ever. I don't talk unless he talks to me," she says.

By becoming as familiar—and as unobtrusive—as the wallpaper in the Oval Office, Walker quietly records intimate moments inside the White House. The night before President Clinton's impeachment trial began, she recalls, "The President turned to his wife, suddenly put his arms around her neck and held on to her just for a quick second." That photograph, she says, captures a personal moment and an emotion that the President would not necessarily reveal in public.

While the President knows that Walker is in the room, neither he nor his staff can control how the people in the Oval Office will behave, she points out. "The scene is set, but the characters are themselves."

Walker, by the way, shoots only black-andwhite film when photographing inside the White House. Time now signals its behindthe-scenes access by publishing these kinds of stories in black and white.

P.F. Bentley, a *Time* contract photographer who also shoots all his assignments in black and white, has covered every presidential election since 1980.

Shooting solely in black and white all these years, Bentley has followed the campaigns of George W. Bush, Bill Clinton, Robert Dole, and Newt Gingrich for up to a year at a time. As Bentley says, the campaign stops are just

Using only available light and shooting on black-and-white film, the photographer caught this backstage moment during **President Clinton's** 1996 campaign. **Avoiding conversation** with the subject whenever possible in these behind-the-scenes situations. Walker tries to stay inconspicuous. (Photo by Diana Walker, Time magazine.)

the tip of the iceberg. "In the hotel room is your picture."

At the 1992 Democratic convention, Bentley's picture of Bill Clinton warming up his vocal cords in the steam room before going onstage was more revealing than any picture of the candidate at the podium.

STRATEGIES FROM THE PROS

While not every photographer has the chance to shadow presidential candidates for months at a time or to document the President of the United States on a daily basis, the experiences of shooters like Bentley, Walker, and other magazine professionals provide insights into how to cover any official—from governor to mayor to local supervisor.

WATCH BUT DON'T TALK

Diana Walker, who takes intimate pictures of presidents "off-stage" by keeping her thoughts to herself, has developed several techniques for avoiding conversation with her subjects. If someone looks at her, she immediately breaks eye contact by looking at her watch, she says. If they try to start a

conversation, she adjusts her camera or changes film.

"Of course, if the President begins to talk to me," she admits, "I have no choice but to answer back." She describes her working manner as "trying to be as discrete, quiet, out-of-the-way, and unobtrusive" as she can. "Of course, he knows I am in the room," she continues, "but it is the closest I can get to the way people really are."

Covering politicians on the campaign trail has taught P.F. Bentley flexibility. The observer should remain unobserved, he says.

"You have to become a chameleon," he explains. "You have to adjust to who they (the politicians) are and to their routine. After awhile, you kind of know their moods. You know when to go in tight, when to back off, and, finally, when to lay low." If things aren't going on, for example, he will usually walk out of a room and check in later. "I don't hover all the time," he notes.

Newsweek photographer David Hume Kennerly is a well-known raconteur when he is not working, but he, too, finds it advantageous not to talk when he is trying to catch

The Time
photographer caught
this moment between
the President and
his daughter Chelsea
during his second
inauguration.
(Photo by Diana Walker,
Time magazine.)

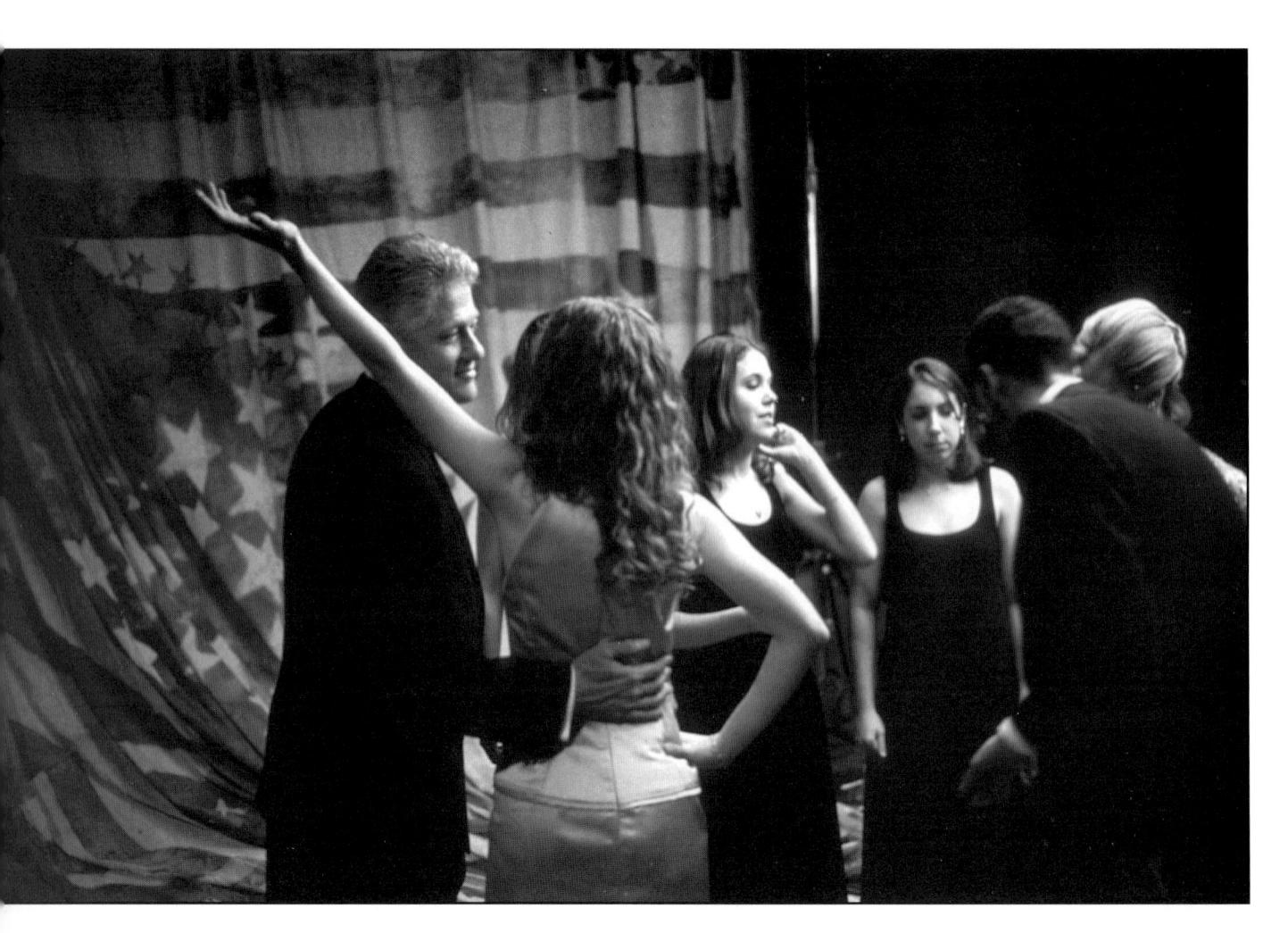

candids among politicos. "Usually I am in a place where there is no reason for me to talk," he observes.

ZIP YOUR LIPS

All the photographers interviewed for this book who work behind the scenes have made tacit agreements with their subjects not to reveal what they overhear. "I don't talk about what I hear, and my writers never ask me," says *Time*'s Walker. Her colleague, campaign specialist P.F. Bentley, agrees: "Of course, there is a trust that I won't ever talk about anything I hear."

Newsweek's Kennerly points out that still photographers have a real advantage over their television counterparts. Politicians can be themselves and say what is on their minds with still photographers in the room. They know their comments will remain off the record.

With video cameras rolling, he maintains, politicians are unlikely to be their usual loquacious selves. "If you introduce sound into the situation, politicians will not talk naturally," he says.

NO GEAR YOU CAN HEAR

To accomplish this unobtrusive kind of photography, both *Time* and *Newsweek* photographers rely on fast lenses and sensitive film to avoid using flash. Bentley's mantra is "No gear that you can hear." He shoots with Leicas and a Canon EOS A-2, using 24mm f/1.4, 35 f/1.4, and 100mm f/2 lenses.

Walker, too, shoots with Leicas and a Canon, using 24mm, 35mm, and 50mm lenses and a longer lens—"just in case." In each frame, she explains, she tries to include the President and other players who are in the Oval Office. "I am not doing tight head shots," she points out. Walker is looking for relationships, not portraits. But if a portrait is appropriate, she has that longer lens in her bag.

SELL YOURSELF

You can have the right approach, the right film, and the best cameras, but without access to politicians, you can't make revealing pictures. P.F. Bentley talks to politicians ahead of time about recording their entire campaigns from the inside. "I tell

The photographer caught this revealing moment of Bob Dole crying after he resigned from the Senate to concentrate on his presidential bid.

(Photo by P.F. Bentley, for *Time* magazine.)

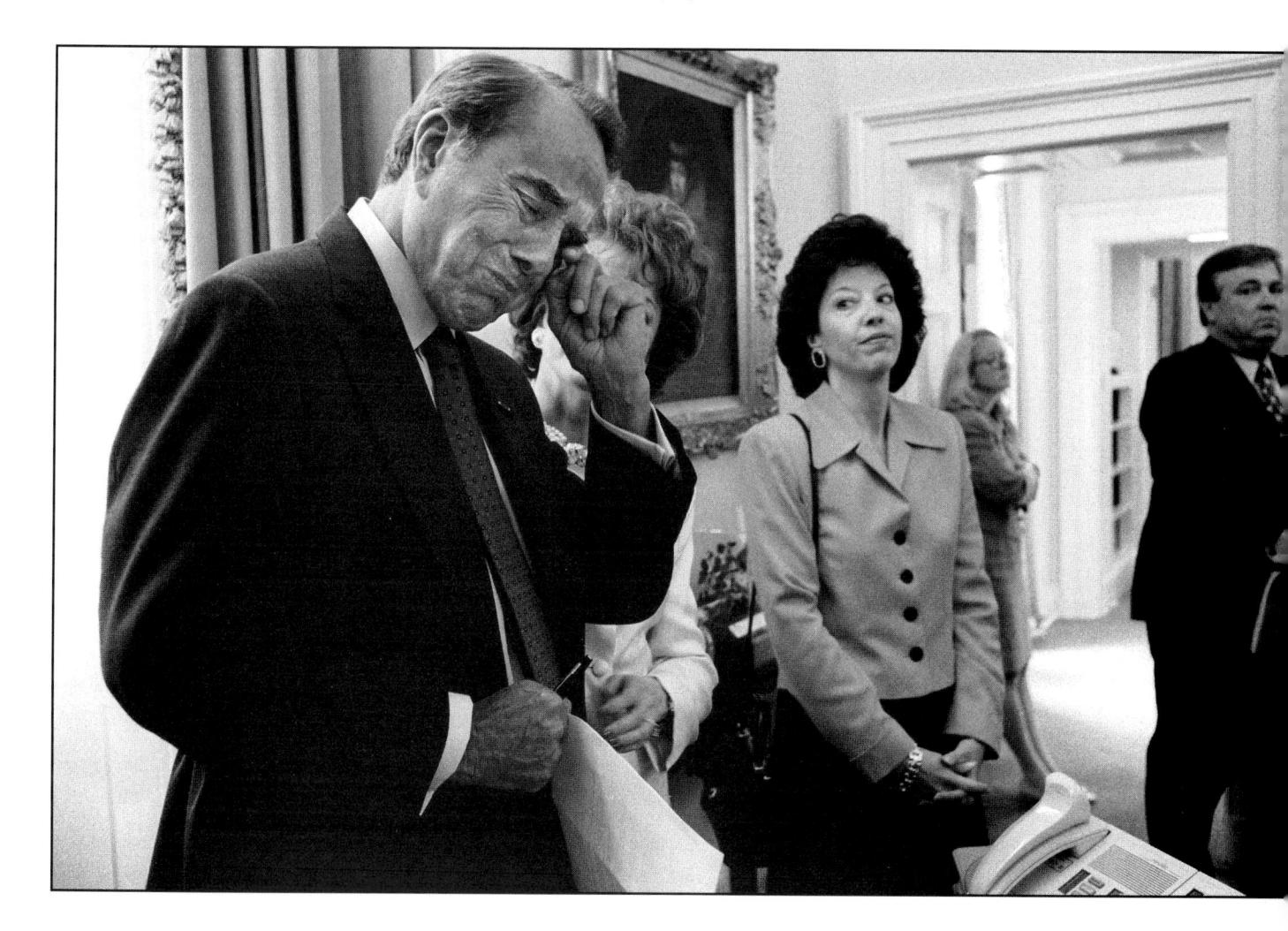

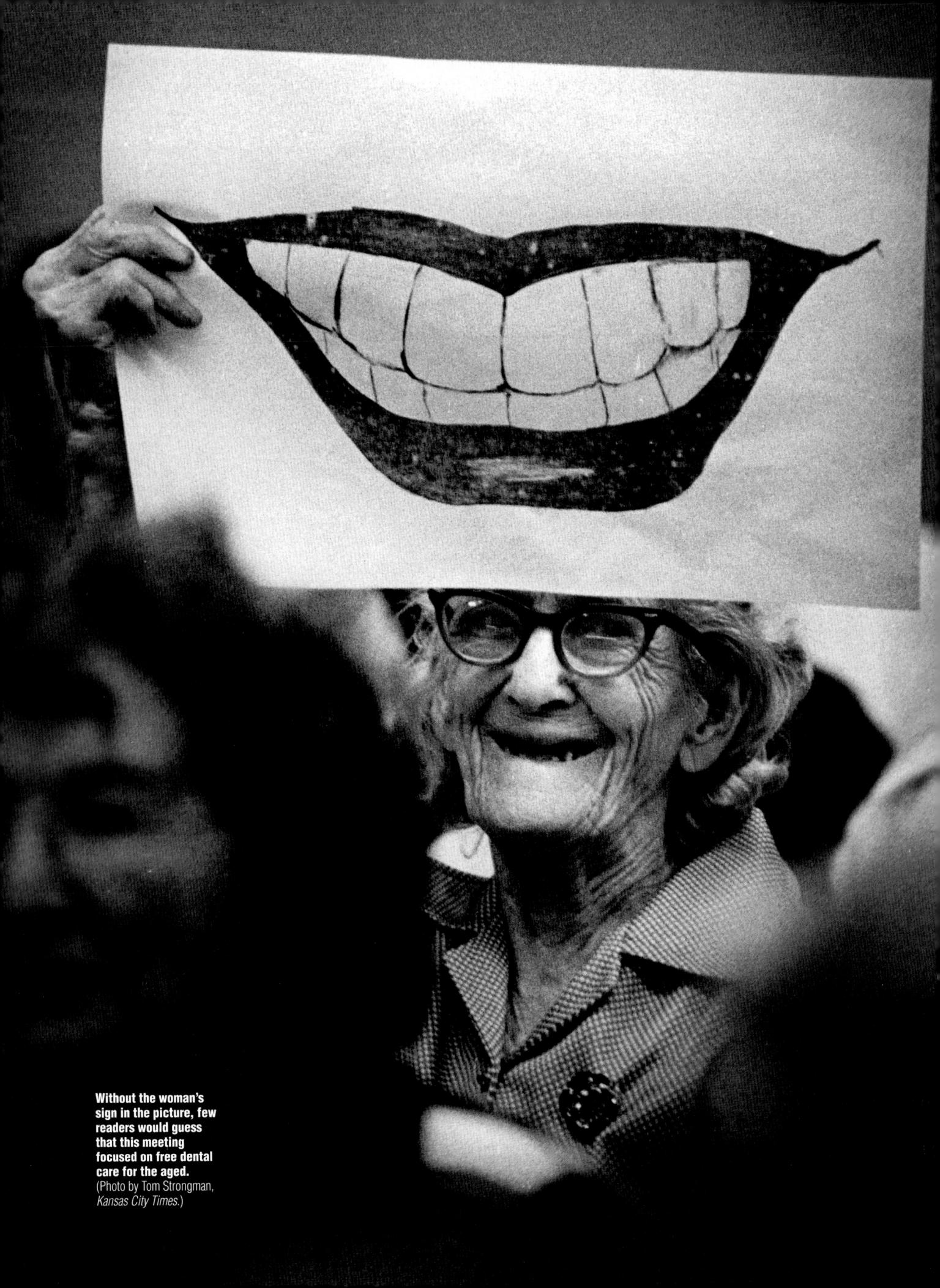

them about the type of pictures I will take and the type I won't take. They know they are part of history." Bentley assures the politicians that he is not out to ridicule them by taking "cheap-shot" pictures. No photos of scratching or adjusting, no images of people eating, he assures potential subjects. "I have been in the hotel room where the candidate is in his underwear," he says. "That is not the kind of picture I care to take. It is not a picture that has any meaning."

Kennerly, who has been on the inside as the White House photographer for President Ford and on the outside as the *Newsweek* photographer covering Clinton, has learned about getting access under difficult conditions. "The picture is only a small part of what I do. I am a salesman first and foremost. I have to sell people to come into their lives."

Congressional representatives and senators are, for the most part, easy to deal with, he says. They have to be reelected and they have to get along. "Photographers are not considered to be the enemy," he says. "Reporters fall into that category."

Having worked in Washington on and off since the Ford administration, Kennerly has excellent connections. "I actually know a lot of senators," he says. "I would count ten senators that I am well acquainted with and could call on a moment's notice.'

During President Clinton's impeachment trial, photographers were denied access to the Senate chambers during the proceedings. Kennerly likens the situation to covering a bullfight when you can't see the bull or the matador. He wanted to take exclusive photographs at a high-level meeting of the representatives who were bringing the ominous charges against the President. He called on an old friend for whom he had done a favor twenty years ago. The friend was now a representative—and one of the managers of the impeachment trial. The twenty-year-old favor paid off, and Kennerly got an exclusive for Newsweek.

MEETINGS GENERATE NEWS

In large cities and small towns, journalists cover the news of governmental meetings because the results of those meetings are important to readers. Meetings possess the same news value as do fires and accidents. Often, the results of a governmental meeting—those involving changes in the tax rate, for instance—directly bear on readers' lives even more than yesterday's fender-bender.

Meetings and press conferences carry a challenge: they test the photographer's creativity. Unfortunately, a critical meeting of the Senate Armed Services Committee looks very much like an ordinary meeting of the local zoning board.

If the pictures remained uncaptioned, readers could easily be confused. Press conferences as well as awards ceremonies all tend to look identical after a while.

Sometimes, through the creative application of framing techniques, catching the moment, and using long lenses and light, the photographer can help portray the excitement, the tension, the opposition, and the resolution of the meeting.

FACE AND HANDS REVEAL EMOTION Ray Lustig, of The Washington Post, has covered some of the most momentous as well as some of the most trivial political moments in the country's recent history. He works Capitol Hill on his beat as The Post's chief political photographer. When Lustig raises his 70-210mm f/2.8 zoom lens at a committee hearing or press conference, he looks for expressive faces. "A wrinkled brow, a grin, or a curled lip can add life to a routine meeting picture," Lustig says. "Hands, too, reveal a speaker's emotion." Readers, of course, understand the meaning of a clenched fist or a jabbing finger.

REVEALING VS. ACCIDENTAL PHOTOS A speaker's facial expressions and hand gestures can be accidental and misleading. They might have nothing to do with the personality of the individual or the thrust of the message. Suppose that during a luncheon the governor is discussing closing the border to illegal immigrants. You take 100 to 200 frames. You might catch a shot while he is eating—showing him with his mouth screwed into a knot. This picture, although an actual moment, reflects nothing about the nature of the topic or even the speaker's character. The misleading picture, in fact, tends to distort the news rather than reveal it.

As Time's P.F. Bentley points out, "I don't care who it is, eating pictures are ugly. Once people start to eat, it is not a picture I care to have."

WHO'S WHO IS IMPORTANT

Meetings, speeches, or press conferences in a town take on news value based on the personalities involved and on the importance of the subject debated.

The photographer must know or be able to recognize the players in the game without a scorecard. If you are not familiar with the participants in a meeting, ask someone for information about the speakers. What are their names? Which are elected officials? Who is best known? With this information,

The hands of Massachusetts' former Secretary of **Human Services**, Jerald Stevens. reveal the pressure, the pleasure, the tension and the relaxation of this powerful state official. (Photos by Bill Collins.)

you can zero in on the most newsworthy individuals.

Here is how Ray Lustig prepares for a day on Capitol Hill. "When I am preparing to go to the Hill, I first review the Reuters daybook. (The daybook lists all the upcoming activities, including Congressional caucuses, press conferences, speeches, etc.) If I have questions, I try to meet with the appropriate editors—national, defense, for example. When I get to the Hill in the morning, I check the Web for committee schedules. I read The Washington Post thoroughly before I arrive, and when I get to the pressroom I take a look at the New York Times and The Washington Times. I also will do a quick scan of our newspaper's Web sites. I also carry a pager that gives me information from both Houses' radio/TV gallery of events. I am doing my homework. I've got to know what is going on. That's my business."

The advantage of all this reading and preparation is that Lustig has a broad grasp of all

the day's planned news. This allows him to select the most visual and or most newsworthy events to cover.

Finally, his complete preparation allows him to be the first to arrive at a packed hearing or overcrowded press conference. He gets there early and stakes out a spot. His meticulous forethought gives Lustig the edge on his competition.

PROPS ADD MEANING

Props can add meaning to a routine meeting photo. If someone holds up a prop, the reader will have an easier time understanding the point of the photo. If the speaker who denounces the lack of gun control laws brings to the meeting a few Saturday Night Specials, the photographer can photograph the person examining or displaying the guns. A photo of an elderly woman, missing her dentures and holding aloft a poster of a toothy smile, helped summarize a meeting on free dental care for the aged (page 50).

You will find it hard to take a picture that communicates as well as this photo of a fundraising meeting for the Cincinnati Zoo—complete with cat-napping cheetah. (Photo by Patrick Reddy, the Cincinnati Enquirer.)

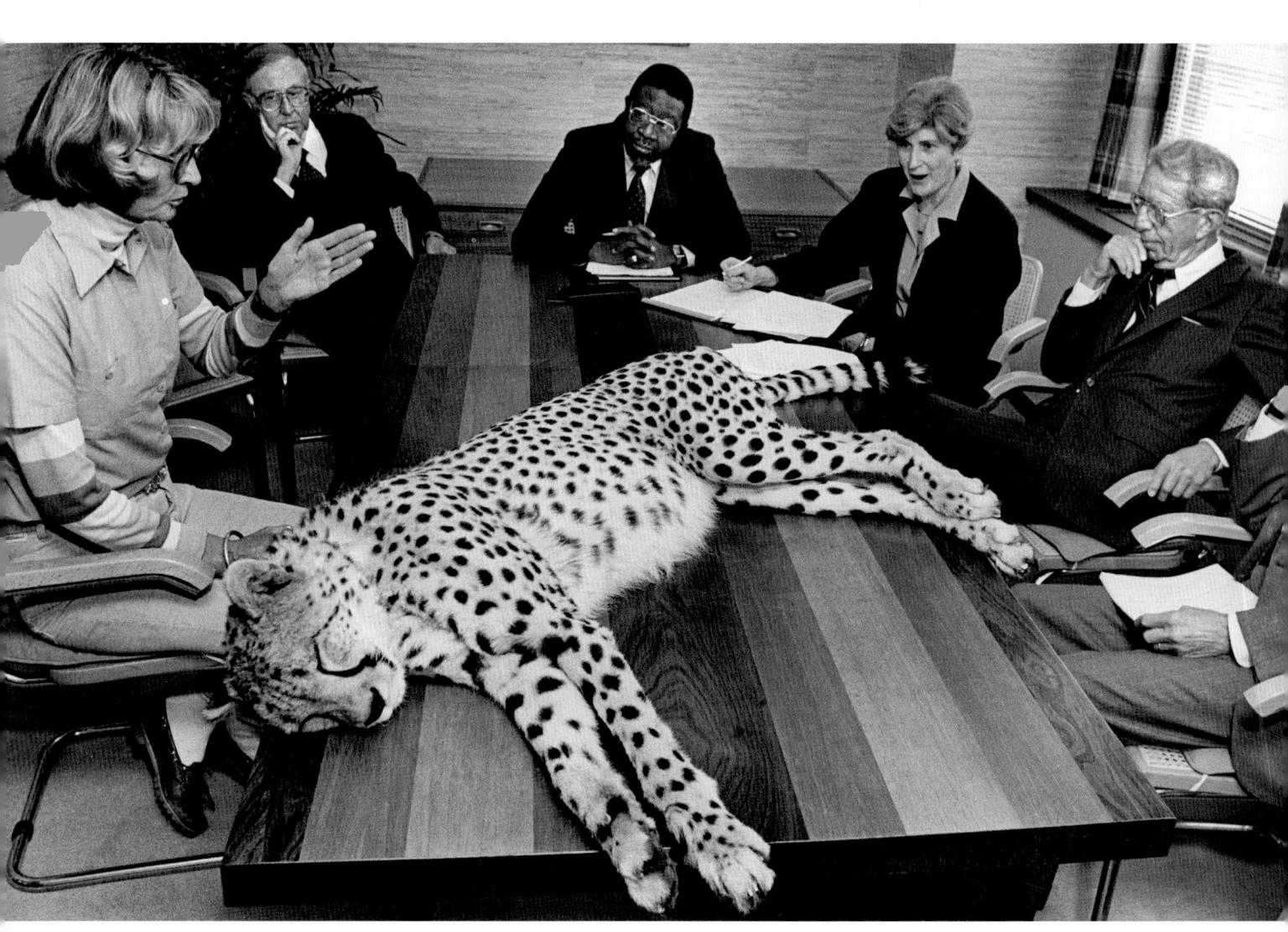

Republican Senator Dan Coates (Indiana) holds legislation that would create a comprehensive health care package. Republicans critical of the plan claimed it was too big, complicated, and bureaucratic. Both the Senator and the photographer know that props help visualize the story behind a meeting or press conference. (Photo by Ray Lustig, The

Washington Post.)

SURVIVAL **TACTICS**

When Ray Lustig covers an important committee meeting on Capitol Hill for The Washington Post, his gear bag contains two strobes and two Nikon camera bodies: one with a 28mm-70mm zoom lens and the other with a 70mm-210mm zoom lens. He uses the short

zoom for "overalls" of the conference room but saves the telephoto zoom for close-up portraits. The close-up brings the viewer and the subject nearer than they normally would meet in public.

Lustig also carries a small aluminum tripod seat, which allows him to sit rather than kneel while waiting for a picture. "You need it," he says, "because it saves wear and tear on your body." He also carries a monopod and a cable release.

Seated on his tripod stool, his camera mounted on the monopod and his cable release at the ready, Lustig can shoot at slower shutter speeds when necessary and also keep his lens aimed at his subject during those long, drawn-out meetings. Without

 Shooting these dignitaries from the side eliminated dead space between subjects. Photographing with a telephoto lens appears to bring the subjects closer together. (Photo by James K.W. Atherton, The Washington Post.)

 Avoid shooting perpendicular to the line of speakers. The perspective results in a picture with large blank spaces between each person, and each face appears quite small. (Photo by Jan Ragland.)

Enterprising photographers can avoid standard speaker pictures by moving away from the pack and looking for an interesting way to combine storytelling elements in one picture, such as the one on the right of former Senator Lloyd Bentsen. (Photos by Kathy Strauss.)

tiring his arm or having to keep his eye glued to the viewfinder, Lustig can train the lens on his target and look for gestures, mannerisms, and expressions—all the way through each politician's long-winded speech.

PHOTOGRAPH THE ISSUES

Almost all political issues can be translated into pictures. If the mayor says city education is poor and should be improved, the photographer must search for supporting evidence of the claim. Are schools overcrowded? Do students hang around in the halls with nothing to do after class? If racial tension exists between white and African-American students, can the journalist photograph the hostility? A set of realistic photos will transform rhetoric into observable issues. Photographers spend too much time shooting political mug shots and too little time digging up visuals that either confirm or deny the claims of politicians.

When covering a campaign, election, or any other contested issue, photographers have the same responsibility to "objectivity" as reporters. Like reporters, photographers can directly distort a scene.

A super-wide-angle lens can make a small room look large. Strong lighting and harsh shadows can transform, in Jekyll-and-Hyde fashion, a mild-mannered speaker into a tyrannical orator. Even more damaging, photographers, like writers, can report one side of an issue and, intentionally or not, leave the other side uncovered.

Because papers often run only one or two pictures, such biased photo reporting creeps into the paper easily. Honest photographers, however, try to select the lens, light, and camera angle as well as a representative moment or scene to present a fair view of a complicated topic.

Unfortunately, few newspaper photographers receive adequate time for investigative political photography. An editor finds it easy to send a staffer to cover a press conference. The editor knows the time and place of the gathering and can guarantee that some usable "art" will result. But readers don't want to see another "mayor talking" picture. They already know what the mayor looks like. They want to determine if the mayor is telling the truth about the school system. Pictures can supply part of the evidence for the mayor's assertions or negate his allegations.

STEER CLEAR OF THE PACK

Even if you're out conducting photographic political investigations, your editor in all likelihood will continue to assign you to rallies, speeches, and "photo opportunities." Cover these events if you must, but resist the PR-packaged photos politicians hope to see in tomorrow's paper. At the most, look where the packaging has peeled away—but don't be surprised if you can't find reality. At the least, turn your camera toward the crowd to find unusual political boosters. And, photographically, struggle to avoid the cliché of simply recording the routine picture.

Sometimes you will have to shoot next to other photographers. *The Washington Post*'s Ray Lustig, who sometimes has to vie for position among twenty other still and video shooters, warns that you should avoid using a 20mm lens in this situation. To get close enough to your subject with a 20mm lens, you will have to walk in front of all your fellow shooters—and block their shots. The best solution to herd journalism, he points

out, is to avoid the pack and find another angle for the shot.

Without doubt, all political rallies start to look alike. But, by angling for a new view, like the one of clapping hands and Lloyd Bentsen, perhaps you can at least bring back a photo you and your readers haven't seen thousands of times before.

COME EARLY—STAY LATE

Alex Burrows, director of photography at the *Norfolk Virginian Pilot*, tells this story about several of his photographers who were assigned to cover a funeral. "One of our young photographers was assigned the grave site. He thought his work was over after the service, but one of our pros stayed really late and got a shot of one of the funeral directors putting a final flower on the covered grave site. It was a great ending photo for the two-page spread. The younger photographer learned a lesson."

The advice "come early and stay late" will serve you well whether you are covering a funeral or other events like rallies, parades, or fairs. The best parade pictures often occur when the performers are waiting to begin. They are loose, natural, and relaxed. They

often are kidding one another and joking around. You are more likely to get candid moments at this point than after the parade begins and the participants go into performing mode. Likewise, at the parade's end, the tuba player might be feeling goofy enough to put his head in the horn, or the majorette might be energized enough to really party. Don't leave even after the principals have gone home. The leftover signs and banners forlornly festooning a trash barrel might tell more about the event than the staged moments earlier in the day.

When covering events like street fairs, isolating your subject within the crowd is difficult. You can't use a long lens and let a wide aperture blur the background because extraneous heads in the foreground will interfere with your picture. You can dramatize your main target if you can get near enough with a wide-angle lens, but you will still have to contend with a bothersome visual background. Of course, you can use a low angle with the sky as your background, or perhaps shoot with a telephoto from a high perch and let the ground serve as a nondistracting background. You can also try working the edges of the crowd. Here you will find most of the

When you cover a parade or other event, try to get there early and stay late. Often the best pictures occur when the participants are not performing. (Photo by Robert Cohen, Memphis [Tennessee] Commercial Appeal.)

Rather than photograph meetings and press conferences about the plight of the elderly, the entire photo staff of the *Philadelphia Daily News* documented the lives of elderly citizens for six months.

(Photo by Michael Mercanti, *Philadelphia Daily News.*) same characters you were targeting before, but you can more easily—with any length lens—visually isolate them from the distracting crowd.

IN-DEPTH PHOTOJOURNALISM

PHOTOGRAPH THE TOPIC, NOT THE TALKER

Even with the best lens technique and a keen sensitivity to light, photographers still have trouble distinguishing for readers the difference between a city council meeting called to increase taxes and a meeting convened to decrease the number of district schools.

The difference between these meetings lies in what the council members said verbally, not what they did visually. The photojournalist must translate speakers' words into pictures that portray the underlying controversy.

Arthur Perfal, a former associate editor of *Newsday*, gave his view of the problem at a conference of editors.

"Remember that people talking often supply material for good stories," Perfal said, "but they seldom supply material for good pictures. Particularly when the same officials or the same chairmen are doing the talking. Let the photographer go where the action is—shoot what they're talking about."

MEDIA EVENTS AND "PHOTO OPS"

After news conferences, meetings, and public events, the awards ceremony ranks as one of the most common of planned news events.

Some photographers argue that pictures of staged situations like awards ceremonies and news conferences simply should not run. Greg Mironchuk, a photographer in Revere, Massachusetts, spoke for many colleagues in his comments to the National Press Photographers Association online discussion list, NPPA-L.

"It doesn't matter if (a press conference) was set up by the President, the World Health Organization, your local police department, Demi Moore's press agent, or the Maharishi Mahesh Yogi," he wrote.

"It's still a set-up and still something that wouldn't exist without a press presence. . . . We (The Press) are in tacit collusion with every flack, hack, and terrorist that calls a

press conference. If we didn't come, there'd be no reason to do it."

Many news outlets, however, especially in smaller communities, continue to publish such pictures. In his column for News Photographer magazine, Bryan Grigsby, photo editor at the *Philadelphia Inquirer*, discussed his strategy for dealing with such assignments. "Whenever I get an assignment to cover something that is obviously being staged for the media, I ask the photographer to step back and record the staged quality of that event rather than go along with the intended charade of the event's sponsors."

If you polled professional photojournalists, they would vote overwhelmingly to eliminate awards pictures. Some news outlets, in fact, have policies forbidding awards photos except for special circumstances. Most editors, nevertheless, continue to assign handshaking, check-passing pictures.

THE STORY BEHIND THE AWARD As with meeting pictures and political pictures, the real secret to covering press conferences and awards lies in searching out the reason for the event and bringing out this fact in your picture. Sometimes you only have to arrange a portrait to point out the meaning of an event. If a woman wins an award for marksmanship, her gun included in the portrait cues the reader to the nature of the award.

At other times, you could try to shoot candids to clarify the point of an announcement. If a press conference announces the invention of a new kind of wheelchair, you might try to photograph the inventor taking his invention for a test ride.

In some cases, an award might even be a peg for a picture story. For example, the ceremony at which Annemarie Madison received an award for her work with people dying from AIDS was, as most of these stiff ceremonies are, a visual zero. However, her dedication and compassion became the subject of a moving photo story that was part of a photo project that won awards of its own— "Helpers in the War on AIDS." (See "Developing a Feature Beat" in Chapter 4, "Covering the Issues.") ■

Occasionally, a press conference produces a revealing picture. Vanessa Williams was forced to step down as Miss America after nude photos of her appeared in Penthouse magazine. Here, the beleaguered Miss America Pageant chairman holds the crown while waiting for the replacement, Suzette Charles. to finish the news conference at which she would be crowned. (Photo by Michael Mercanti, Philadelphia Daily News.)

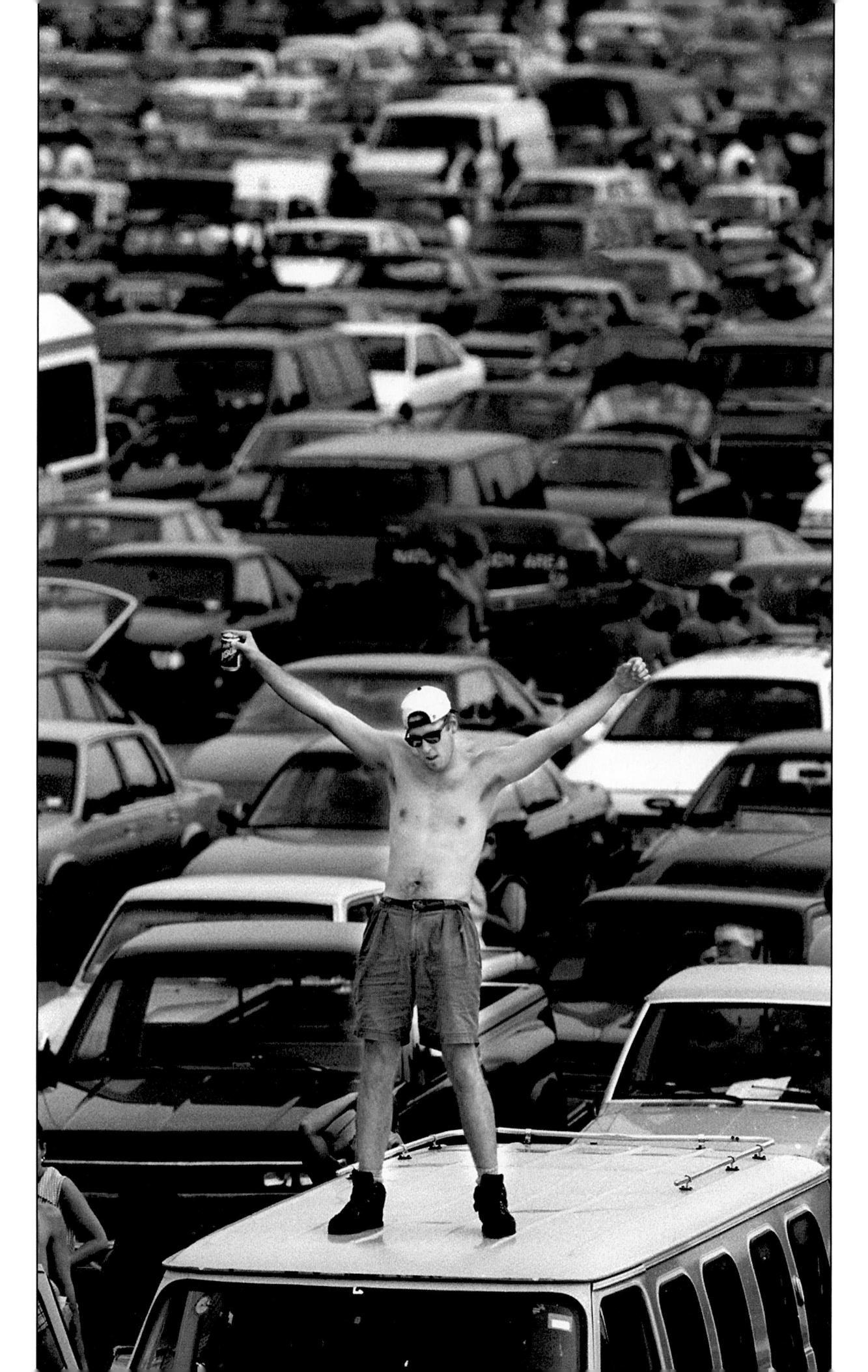

Covering the Issues

BACKGROUNDING THE NEWS

CHAPTER 4

hotojournalism can bring about change. Since the turn of the century, on every continent on the globe, concerned photographers have brought to public awareness

issues ranging from hunger and poverty to repression and torture. In the early twentieth century, Jacob Riis (page 336) exposed slum conditions suffered by new immigrants in New York City. Lewis Hine (page 337) sneaked into American factories to document industry's

The combination of Pearl Jam, booze and teenagers equals one big party. "It's what everybody does, and it brings us together," says one concertgoer. Research shows first use of alcohol begins around age 13. Drunken driving is the leading cause of death among young Americans. (Photo by Brian Plonka, The Spokesman-Review [Spokane, Washington].)

abusive use of children as laborers. During

America's Great Depression, Dorothea Lang

recorded bread lines and crop failures for the

U.S. Farm Security Administration (FSA).

More recently, David Peterson updated the farm story with pictures depicting farm crises in Iowa. Stephanie Welsh photographed controversial female genital mutilation rites in Africa. David and Peter Turnley documented the horrors of apartheid in South Africa, and Sebastiao Salgado showed the horrific working conditions endured by gold mine laborers in South America.

These are all examples of passionate photographers who believed that the world might care if the visual truth were told. They were all willing to find a way to shoot their stories and then to share their work with the public.

Not all of these projects righted the social wrongs they documented. But Vicki Goldberg, in *The Power of Photography*, does track down cases where photography played a direct role in solving a social problem or even changing a country's policies. She attributes the passage of the Civil Rights Act, in part, to photos by Charles Moore that appeared in *Life* magazine. Moore covered demonstrations and sit-ins in Birmingham, Alabama, in the early 1960s. His pictures showed African Americans being attacked by snarling police dogs and blasted by water

canons. Moore's unforgettable images helped put public opinion solidly behind the Civil Rights movement.

Malcolm Browne's picture of a Buddhist monk setting himself on fire to protest the repression of Buddhism in Vietnam (page 300), along with Eddie Adams' photo of a public execution by the Saigon police chief (page 326), and Nick Ut's photo of a napalmburned little girl screaming in pain as she ran down the road, all had a cumulative effect on American policy in Vietnam. These and other images helped build an opposition to the Vietnam War that eventually led to U.S. withdrawal.

Today, some progressive news organizations give photographers time to cover stories. Carol Guzy (pages 79–83) spent weeks in Haiti, the Sudan, Somalia, and Ethiopia for in-depth stories for *The Washington Post*. Melanie Stetson Freeman traveled around the world photographing a series on the exploitation of children (below) for the *Christian Science Monitor*. Eugene Richards shot for months while covering the cocaine epidemic for *Life*.

When unable to get assignments from news organizations, photographers often turn to

The photographer traveled around the world to produce a series titled "Children in Darkness, the Exploitation of Innocence."
These children in India are forced to beg for money.

(Photo by Melanie Stetson Freeman, *Christian Science Monitor.*)

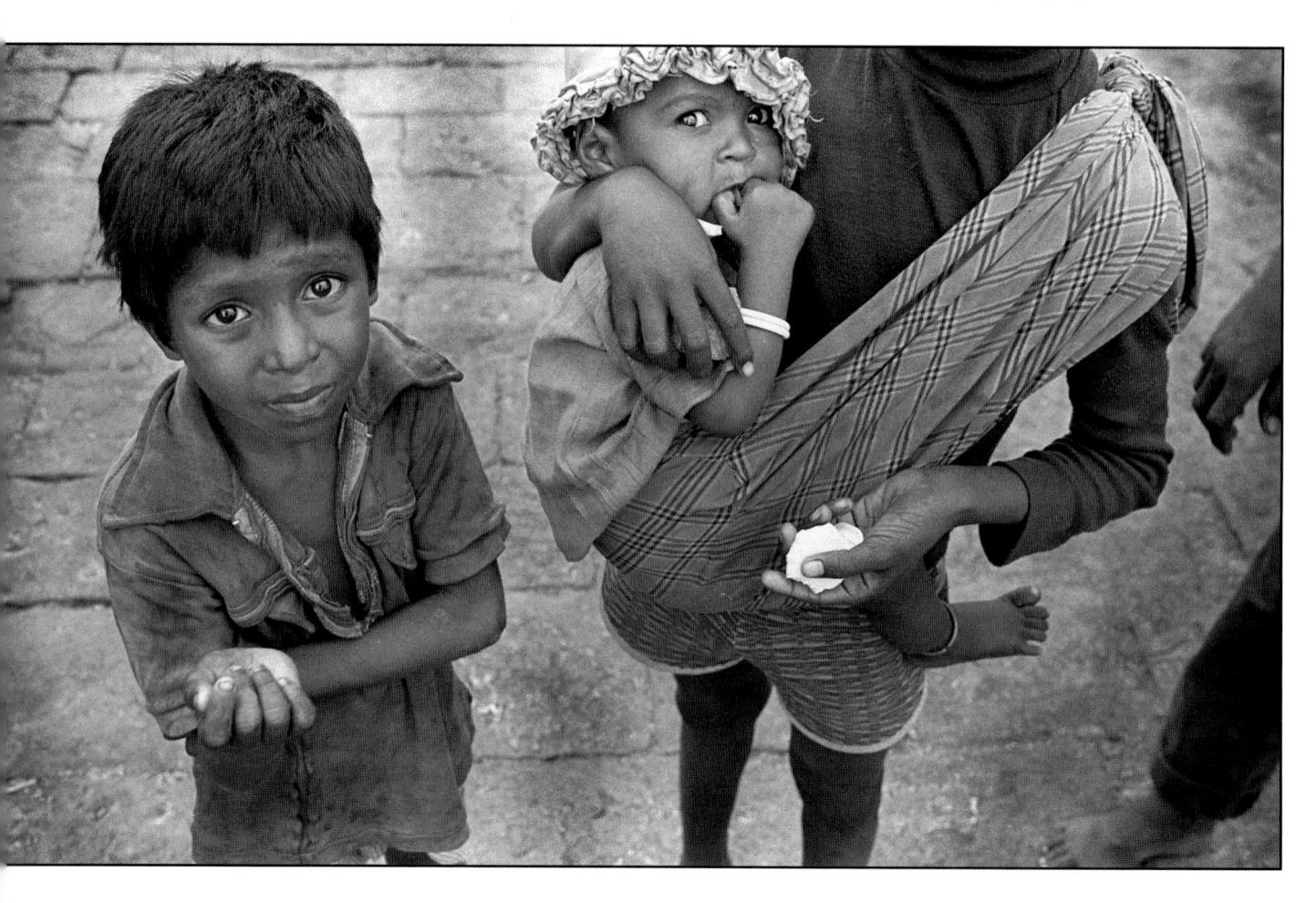

grants to help underwrite their projects. Alan Berner received a grant from the National Press Photographers Association and Nikon to explore the changing face of the West (pages 76–77). Donna DeCesare has received grants from the Alicia Patterson Foundation as well as the Mother Jones International Documentary Fund to photograph gangs in Los Angeles and El Salvador (pages 74–75). (The Mother Jones Fund awards grants to photographers in five different regions of the world.) This author received a Freedom Forum stipend to partially underwrite a project on children born to crack-addicted mothers (pages 72–73). The Guggenheim and the Alexia Foundation are among other foundations that help support photojournalists.

Other photographers have undertaken projects on their own time and dime. David Guralnick flew to Bucaramanga, Colombia in South America, at his own expense, to photograph American plastic surgeons providing free medical help to children born with harelips and other disfigurements. Without backing or assurance of publication, Ken Light photographed the Mississippi Delta region of the United States (page 138). Cristina Salvador self-supported her documentary project on the life of Gypsies in the United States (pages 152-157).

Some photographers work alone. The Boston Globe's Stan Grossfeld, a former winner of the Pulitzer Prize, shoots his own picture stories and often writes the accompanying text. Other photographers work in groups. The entire staff of the Long Beach Press-Telegram, for example, produced a story following the path of a killer bullet from its use in a murder through the accused killers' trial (pages 164–166). Also see pages 68-72, "Developing a Feature Beat," for how one group developed a beat to tackle a large project.

Some photographers like collaborating with a writer. Photographer Michael Williamson worked with writer Dale Maharidge on projects including Journey to Nowhere: The Saga of the New Underclass, which documented the effects of lost jobs.

The photographer/writer team also coauthored The Last Great American Hobo, about riding the rails in America. And the team produced a book called And Their **Children After Them**, a follow-up to the famous book from the 1930s. Let Us Now Praise Famous Men, which itself was a collaboration between writer James Agee and Walker Evans, the Farm Security Administration (FSA) photographer.

Williamson and Maharidge published their extensive projects as books. While only a

few documentary photojournalism projects wind up in bookstores, many are published as special sections or multipart series in newspapers or as a series of double-truck layouts in magazines.

Of course, although some newspapers and magazines make room for these projects, others won't give up the space for photo-driven stories. Fortunately, the World Wide Web is also an excellent outlet for long, in-depth projects. Still other photographers have found ways to share their stories with the public by exhibiting their pictures in cafés and art galleries.

Perhaps as important as how photojournalists choose to work on and share their projects is how they identify the topics to pursue. Here is where their journalistic skills come in.

ISSUE REPORTING

NURSING HOMES: A CASE STUDY Translating numbers into people In California, investigators determined that, over a three-year period, poor care in state nursing homes was a factor in 126 deaths. The San Jose Mercury News decided to investigate the findings.

Mercury News reporters discovered that "An aide shook a 74-year-old man in Long Beach so violently, an investigator said, that his brain was slammed against his skull 'like a clapper in a bell." Nurses diligently charted the progression of bedsores on an 81-yearold woman in Los Gatos until there was "black stuff oozing from her body"—but failed to save her life.

Photographing statistics

The paper's graphics editor assigned Judy Griesedieck to illustrate the series.

Problem one: The subjects of the story, the abused elderly, were dead and buried.

The solution: Photograph current treatment of the elderly in nursing homes.

Problem two: Nursing home owners and managers, aware of the stories the paper had already published, did not want a San Jose Mercury News photographer anywhere near their nursing homes.

The solution: Griesedieck started the assignment by calling twenty nursing homes. Only two said she could come in and look around. Then Griesedieck talked to the paper's lawyer, who pointed out that while nursing homes were private property, Griesedieck could enter and photograph if she was invited into the home by one of the residents. She could photograph the person who invited her without being evicted by the management of the nursing home.

(LEFT) A San Jose nursing home resident watches as the world goes by.

CALIFORNIA'S NURSING HOMES: NO PLACE TO DIE

Judy Griesedieck
bypassed nursing home
officials to develop relationships with families and
doctors who allowed her to
photograph the conditions
of neglect in the nursing
homes. She balanced her
hard-hitting pictures of
neglect with pictures
showing love and care
by staffers as well as by
family.

(Photos by Judy Griesedieck, for the *San Jose Mercury News.*)

(ABOVE) Awilda Olmoa, a nurse's aide, combs the hair of 100-year-old Gregoria Santos.

(BELOW) A nursing home resident sits alone and neglected for hours.

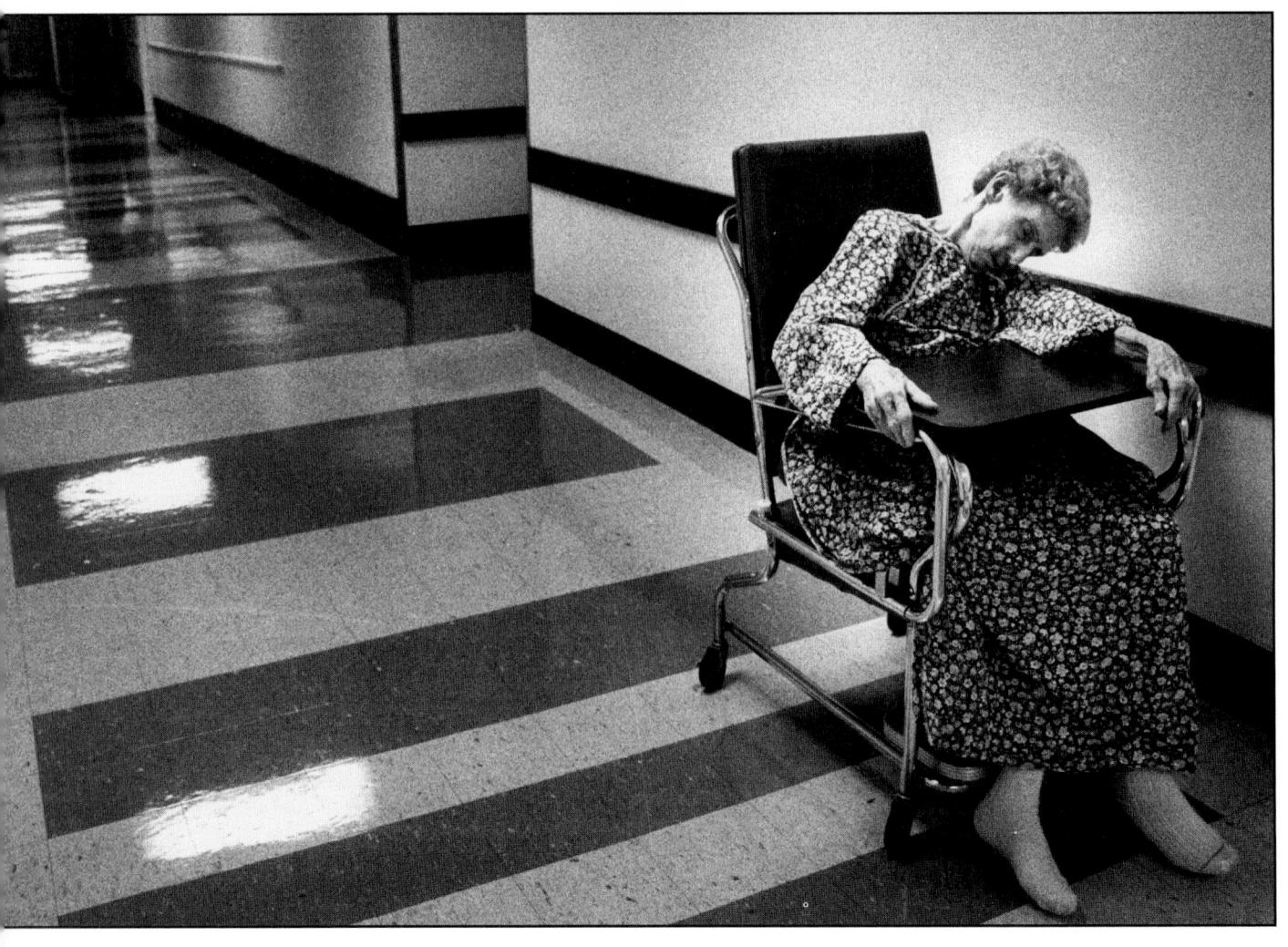

62 ■ Photojournalism: The Professionals' Approach

Gaining access

To meet people in the homes, Griesedieck attended meetings of Bay Area Advocates of Nursing Home Reform, most of whom were relatives of people in nursing homes. They were happy to introduce the Mercury News photographer to their mothers, fathers, wives, and husbands who were living with inadequate care. With invitations from the residents she met through the Advocates organization, Griesedieck began to shoot the story.

In one home, a daughter brought Griesedieck in to see her mother. The older woman had bedsores because of neglect. In another home, a patient would be in bed at 9 A.M. and would still lie there—undressed, unattended, and with no outside stimulation—when the photographer left at 5 P.M.

But Griesedieck also found evidence of love and compassion at the nursing homes. The Mercury News photographer watched a man who visited his wife daily, bringing his spouse a rose on each visit. The man spoonfed his wife lunch each day. The husband said to Griesedieck, "I don't think she knows who I am," and started crying.

Griesedieck also entered nursing homes by accompanying a doctor who treated Alzheimer's disease, which makes people forgetful. Here again, she had to get permission ahead of time from every patient or guardian before she could take pictures.

The photographer also made arrangements with the California Department of Health Services, which carries out unannounced inspections of nursing homes. The inspectors called Griesedieck the morning of surprise nursing home visits and, when possible, she followed the health service employees on their investigative raids.

Results

The four-part series in the Mercury News ran with Griesedieck's powerful pictures illustrating each day's stories. Under the headline "A requiem of neglect," reporters described the lack of care that caused each of the 126 deaths that had occurred over the previous three years. The series caused the state commission to relaunch an investigation of California's nursing homes and its system for policing them. The series was a runner-up for the Pictures of the Year Canon Photo Essayist Award.

Griesedieck, however, continued to have nightmares about what she saw. Until leaving California, she continued to visit the old people in several of the homes. "What I saw made me sad," she says. "I might be here some day. People in these homes had great careers—doctors, models—and now. . . . "

And now, at least, people do know about the situation in these homes and can take action because of solid investigative reporting and photography by Griesedieck and her fellow staff members.

INGREDIENTS FOR IN-DEPTH COVERAGE

Important issues

Griesedieck started with an important issue. Her paper had published a number of spotnews stories about deaths due to neglect in nursing homes and about official investigations. The paper had given each of the stories only inside play. In seeing the pattern generated by the numbers—noting the repetition of deaths due to neglect—the paper went beyond the individual news story.

The pictures and story attempted not only to document the phenomenon of needless death but also to show the cause of the problem-neglect.

Over the year-long project, Griesedieck tried to bring the statistics—126 deaths in state nursing homes caused by neglect—to light. She zeroed in on individual stories that provided examples of the larger trend. She showed Carrie Chelucci being checked for bedsores. She showed Lucille Dennison, who has Alzheimer's disease, asleep in her wheelchair in the hall of a locked wing in the home.

Just as important, Griesedieck balanced these hard-hitting pictures with those showing love and care by some attendants and doctors.

Like most investigative stories, Griesedieck's took time. The paper made a commitment of resources - a commitment of one photographer's time. Although she did not work fulltime shooting this story alone, the paper gave her sufficient time from her daily shift to research the issue, make contacts, telephone possible subjects, and wait for their responses. Many newspapers think nothing of assigning a reporter for weeks or even months on an investigative story. Unfortunately, most papers fail to provide sufficient time for good visual reportage.

Display

Obviously, the photographer needed to make powerful images for the article, and Griesedieck's pictures were superb. Equally important, however, the images needed a showcase. The Mercury News featured a large lead picture on page one each day the series ran. Its editors also used photos extensively inside.

GENERATIONS UNDER THE INFLUENCE

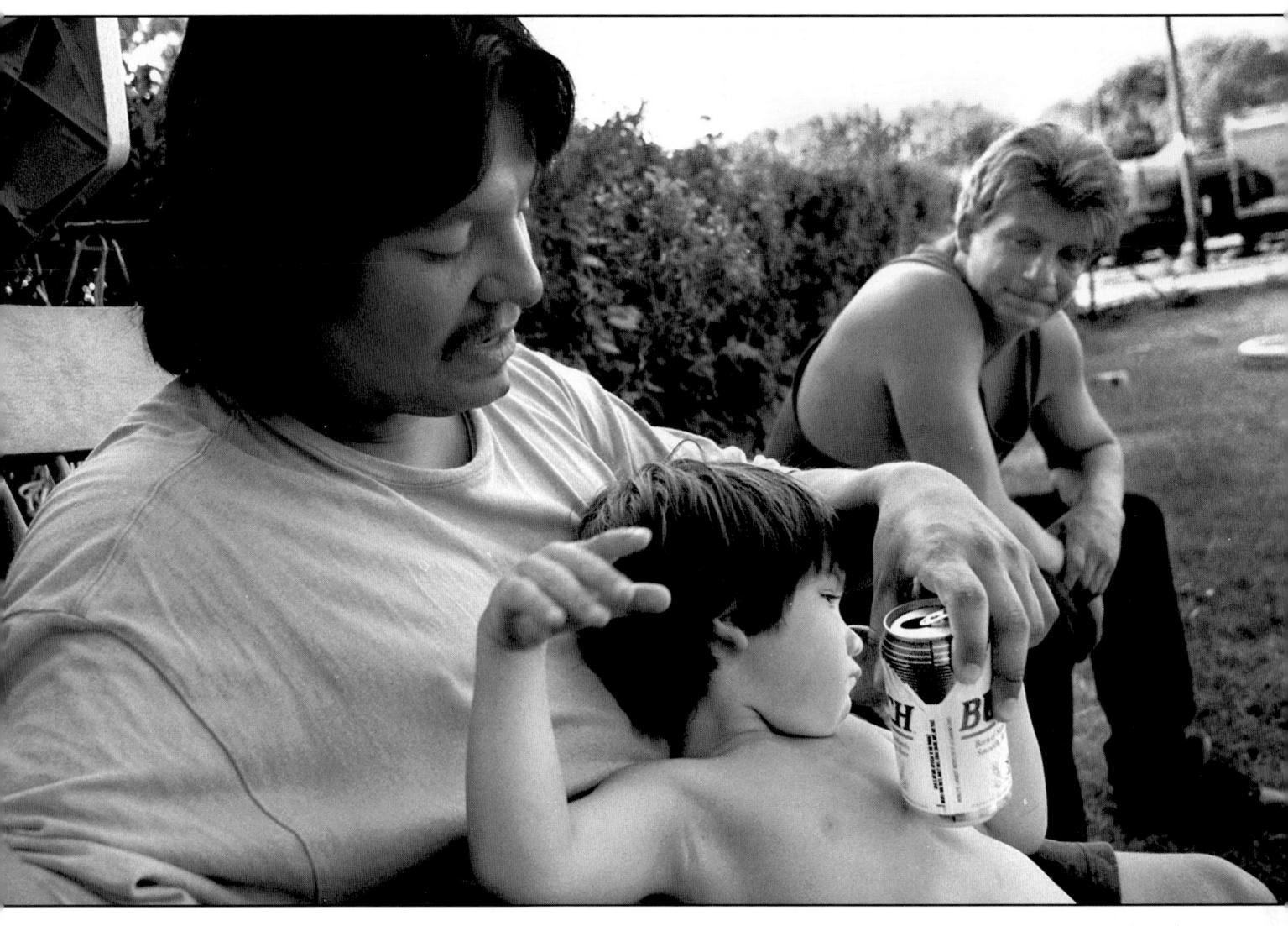

ALCOHOL: BRINGING US TOGETHER

Photos by Brian Plonka The Spokesman-Review (Spokane, Washington)

(ABOVE) For some, the introduction to alcohol comes at an early age. Three-year-old James Donato Ramirez rebuffs his father's attempt to share a beer. "It doesn't smell good," says James.

A lcohol can be a legitimate and joyous influence in our everyday lives," writes photographer Brian Plonka, of the *Spokesman-Review* in Spokane, Washington. "It is with us in the locker room when we toast championships. It joins us at the dining room table for family celebrations."

Plonka spent more than two years focusing his camera on the impact of alcohol on American society. He calls his project "an attempt to put faces on an issue that is so tightly woven into society's tapestry that we often don't realize when it is causing our own lives to unravel."

Plonka and his editors laid out the package to show alcohol "bringing us together" and "tearing us apart." The sixteen-page special edition also showed alcohol's influence on the young, on adults, on one family, and on a single person undergoing therapy. These four pages include but a few photographs from the extensive investigation.

(ABOVE) For many, like these businessmen at the Scotch Malt Whiskey Society in Chicago, tasting alcohol loosens the tongue and tightens the bonds of friendship. Some 26,000 members strong, the Scotch Malt Whiskey Society is the world's largest drinking club.
(BELOW) "Come on, man. Do it!" says a buddy prompting his friend to guzzle from a "beer bong" at a Northern Illinois University party. The friend sucks beer from a tube attached to a funnel: total consumption time for 12 ounces—less than 10 seconds.

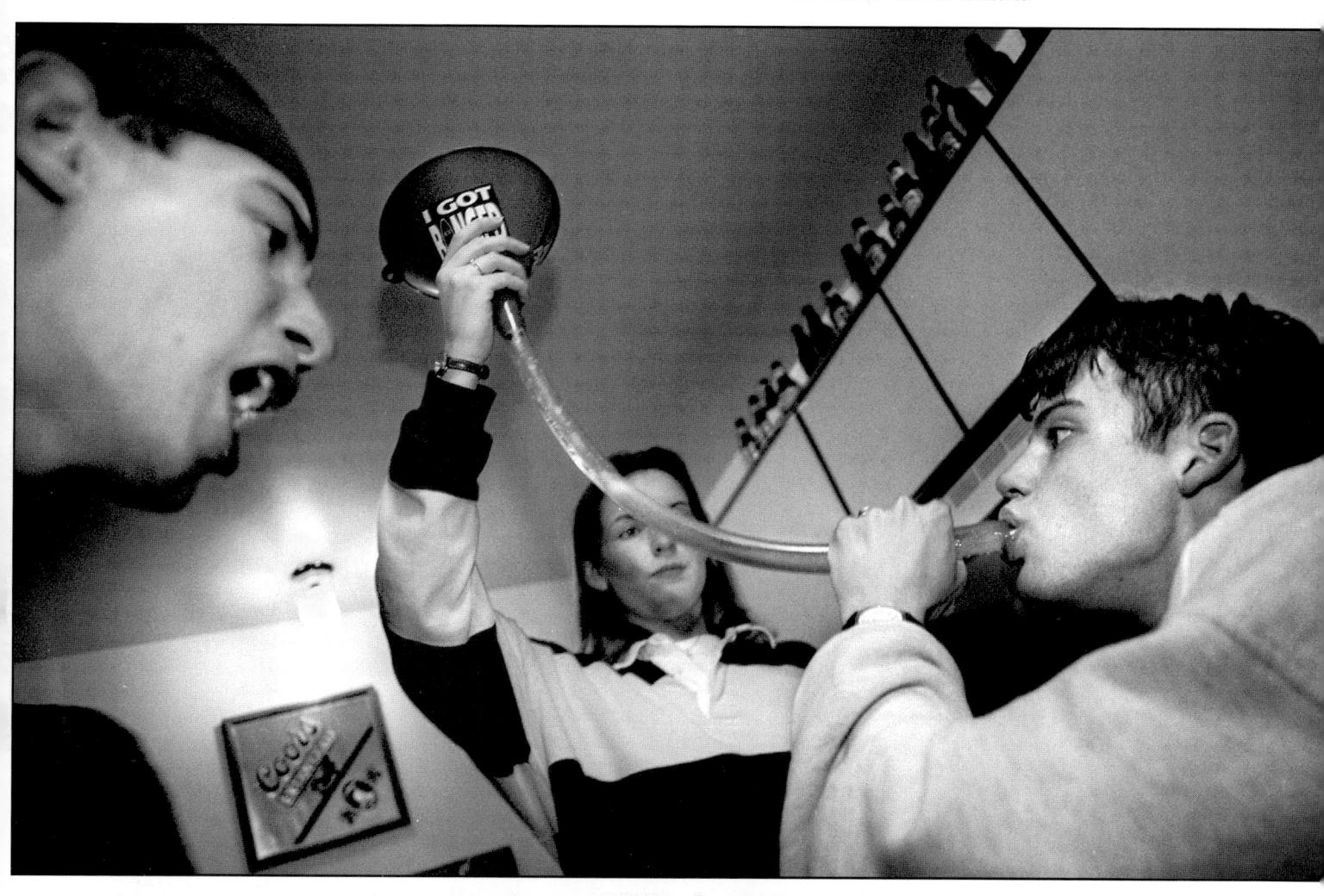

(LEFT) Students "wind down" after a week of classes with beer and liquor. Some say they like the carefree mood alcohol gives them; others say they like the way it allows them to let down their guard.

more on next page 🗕

GENERATIONS UNDER THE INFLUENCE

ALCOHOL: TEARING US APART

(ABOVE) In an effort to reach potential customers, alcohol companies spend hundreds of millions of dollars a year promoting their product.

SOBERING STATISTICS

- Alcohol abuse costs society an estimated \$116 billion a year.
- As many as 6.6 million children live with at least one alcoholic parent.
- Alcohol is associated with up to half of all traffic fatalities.

(ABOVE) Three cases of beer take a toll on men at a poker party at a cheap motel. After several hours of drinking, card playing becomes impossible.

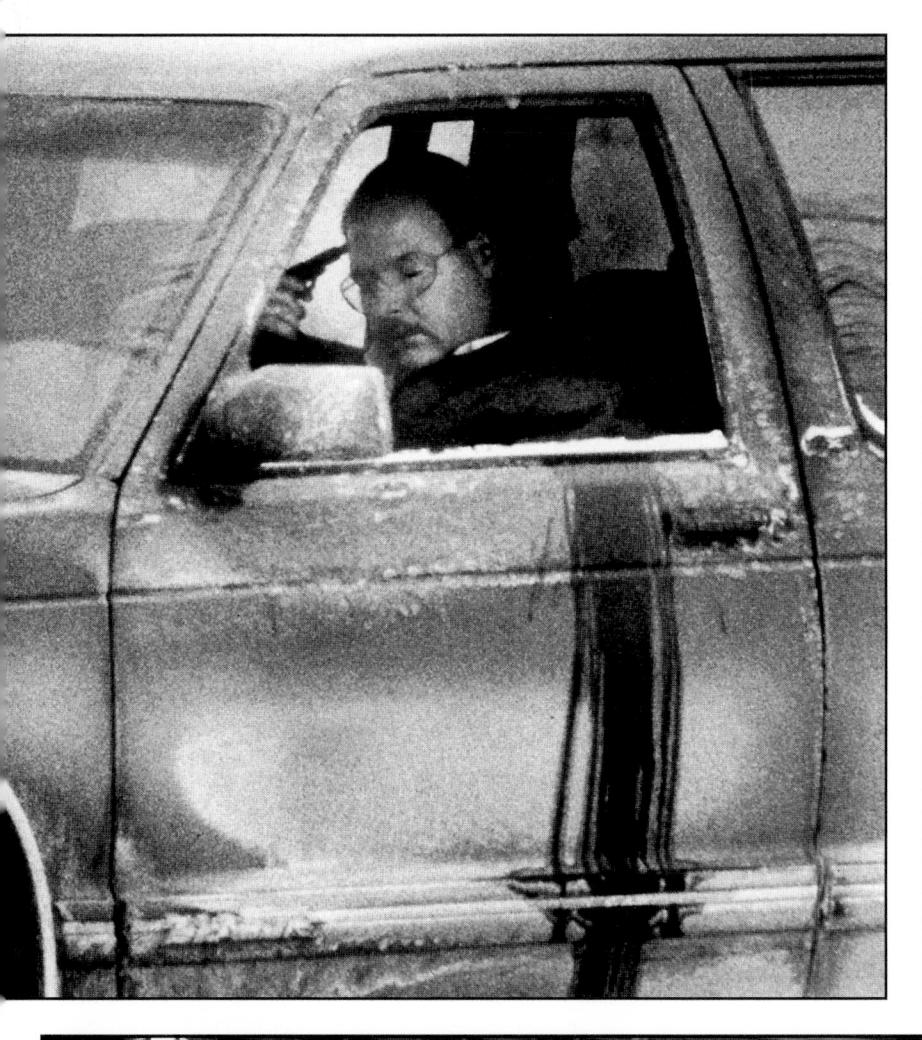

(LEFT) In 1994, Virgil Carmichael lost his job and began drinking heavily in his car. After failing to get attention by smashing a bottle of booze against his door, he placed a pistol to his head. The incident was resolved peacefully.

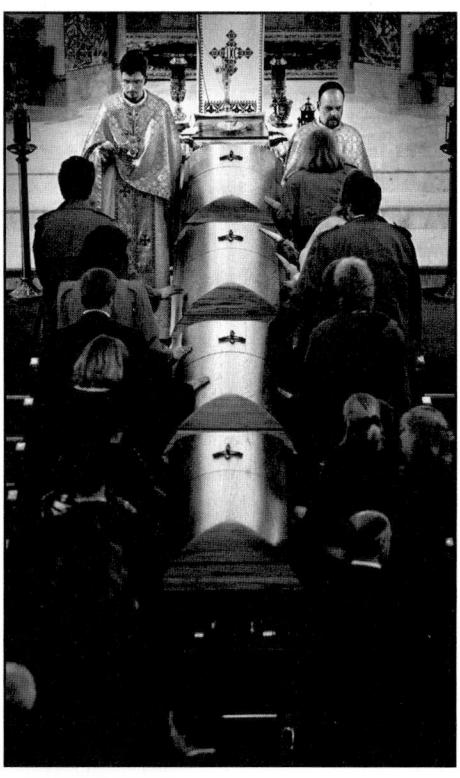

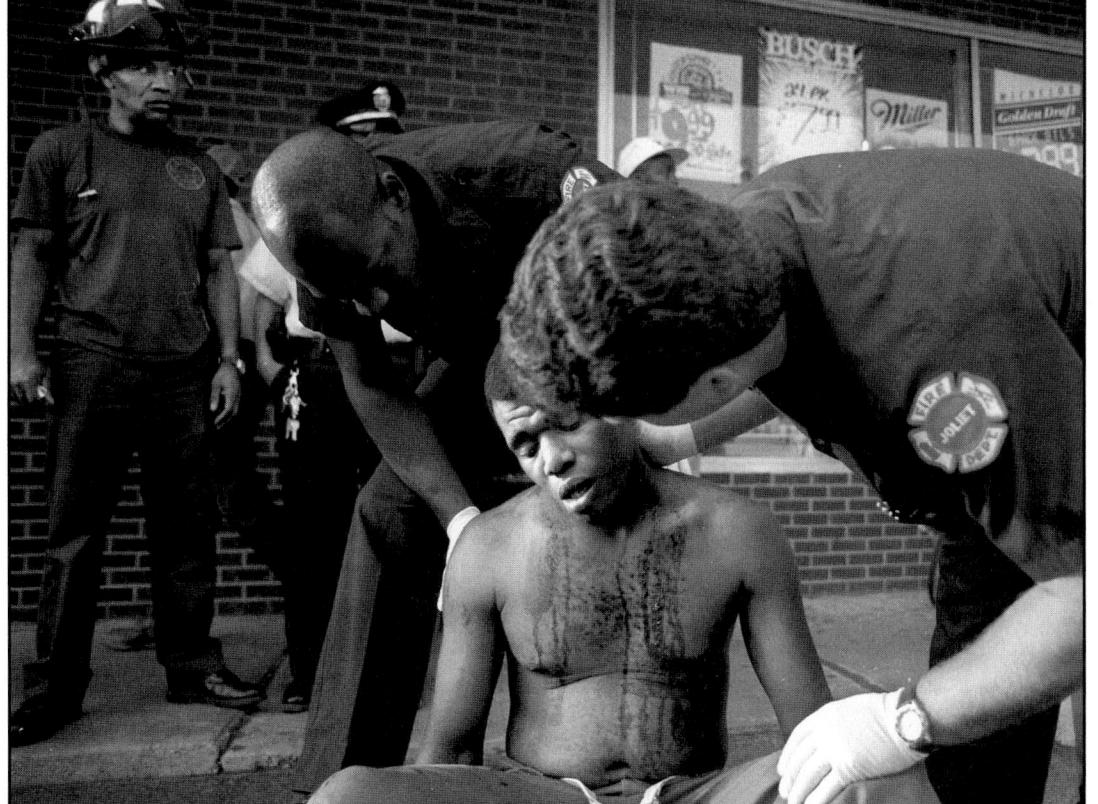

(ABOVE)
Friends and family pay their last respects to Peter
Sawczuk, his wife, Sharon, and their daughters, Elizabeth and Kathryn. The entire family was killed by an eighteen-year-old alleged drunk driver as they drove to their summer home.

(LEFT) A dispute over the rationing of a six-pack results in a companion shoving this man's head through a liquor store window.

BACKGROUNDING THE NEWS

"No Place to Die: California's Nursing Homes" is an outstanding example of "backgrounding" the news, a term Sidney Kobré, the author's father, coined in a book by that name written in 1939.

Backgrounding means explaining the cause of a news story. Backgrounding means applying psychology, sociology, and economics to a news event to put it into perspective. While photography is an excellent medium for recording the immediate—the fire, the accident—you can also use photos to explain. In the future, with television's instant reportage of breaking news, still photography will find an increasingly important role in providing in-depth coverage that identifies patterns and explains causes.

Magazine about people who helped people with AIDS. (Cover photo by Annie Wells.)

DEVELOPING A FEATURE BEAT

Another way to produce meaningful photojournalism projects is to develop your own specialty area—a beat.

For years writers have pried loose news by covering a beat. Typical beats include police, hospital, and courts. Reporters on police beats check the precinct headquarters each day to see what is going on. They look over the police blotter and talk to the sergeant to find out if anyone reported a major or unusual crime during the night. Getting the inside track on current investigations, reporters find out about possible suspects. They know when the police plan to carry out a gambling raid or drug bust. They also get to know personalities in the department—the seasoned police officer as well as the new rookie fresh from the police academy. From these contacts and observations, beat reporters don't just react to the news; they also can interpret and predict it. If the police go on strike, they can explain why. If a cop dies in the line of duty, they can write a story based on personal knowledge of the officer.

Feature photographers—whether they work on the staff of a news outlet or work independently as freelancers—can also cover a beat. Rather than choosing the police, hospital, or courts, they might select education, science, medicine, or religion.

GETTING THE IDEA

Sometimes a beat can grow out of one story. In the mid-1980s, the author happened upon volunteers assembling panels of the AIDS quilt: each piece was a memorial to a person who had died of the disease, and the whole was a testimony to the collective toll that the disease had taken. Though "The Names Project" since has been displayed in venues around the world, only its volunteers knew

about it at the time. After photographing a story about the quilt and the people working on it for *People* magazine, the author did another story about an AIDS volunteer, Rita Rockett, who threw catered brunches and performed every other Sunday for AIDS patients on Ward 5A of San Francisco General Hospital.

It turned out that there were many unsung volunteers at work in San Francisco to help the growing number of people afflicted with the deadly disease.

PAST STORIES ON THE TOPIC

By 1987, there had been several excellent photo stories on people with AIDS. Steve Ringman, who was with the *San Francisco Chronicle* at the time, Cheryl Nuss at the *San Jose Mercury News*, and Alon Reininger for Contact Press Images had all photographed moving stories. Each had concentrated on patients, showing their battles against the agonizing deaths they faced.

A new angle would focus on the outpouring of support in the San Francisco Bay Area to provide emotional, physical, and economic help to people with the incurable disease. The resulting photo project, produced by journalism students at San Francisco State University, was eventually called "Helpers in the War on AIDS."

While the original identification and later unraveling of the cause of AIDS provided the basis of important news stories, approaching the issue from the viewpoint of the helpers gave the story a new twist.

ORGANIZATION

One photographer could photograph the AIDS "beat." However, in this instance, "Helpers in the War on AIDS" became a group project at the journalism department of San Francisco State University. Each photographer researched, developed, and photographed three stories over a fourteen-week period. In addition to taking pictures, all group members either worked with writers or provided the text for the project's stories themselves.

Research

Before photography began on the project, the group brought in experts in order to learn about AIDS and to get story leads. Specialists ranged from San Francisco's Health Department expert on AIDS to journalists who had been tracking the story for several years. Group members read Randy Shilts' book, *And the Band Played On*, which analyzed the government's delayed and inadequate response to the growing

epidemic. Other leads came from the classified listings in local gay newspapers. Chris Adams, a student writer in the group, who has since died from the AIDS virus, provided a key link to the gay community.

Having a beat gives a focus to research, and research directs you beyond the facts of an issue to investigate causes of a problem, solutions, and, usually, stories that other journalists have not covered extensively.

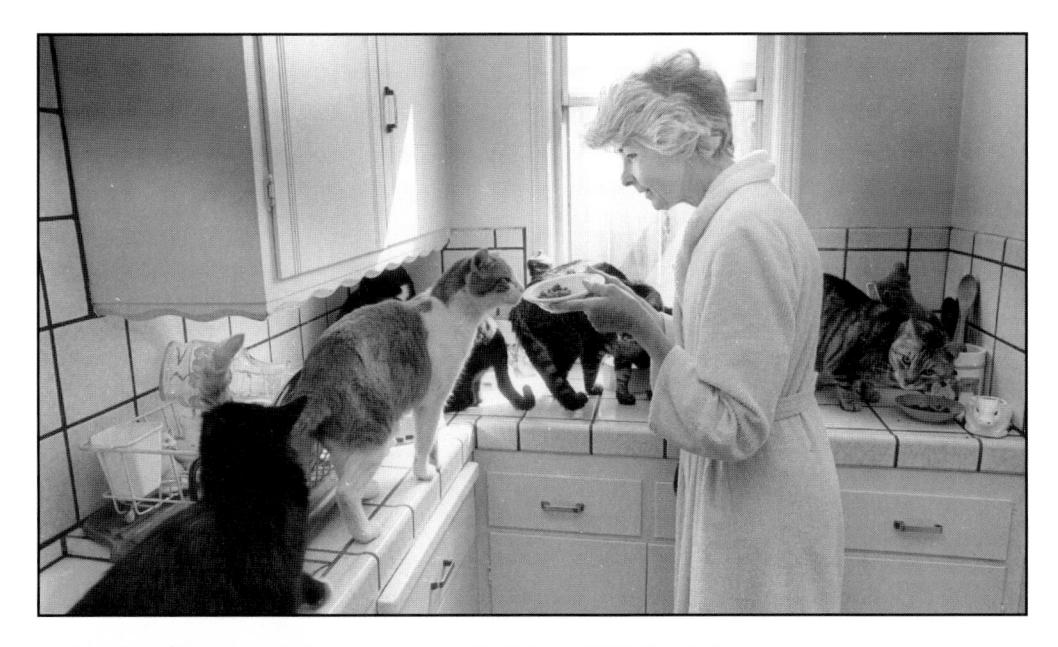

- Knowing how much people love their pets, volunteers for PAWS (Pets Are Wonderful Support) care for pets when their owners, who have AIDS, are in the hospital. The volunteers then help find new homes if necessary when the owners die. (Photo by Mary Calvert, from
- Helpers in the War on AIDS.)
- When a group of photojournalists collaborated on a beat focusing on helpers in the war on AIDS, a host of stories unfurled, including one about volunteers who bring food to people too sick to cook. (Photo by Mary Calvert, from Helpers in the War on AIDS.)

INITIAL STORIES

To get a handle on such a large subject, the SFSU project's photographers divided the topic into sections including medicine, religion, alternative healing approaches, minorities, physical support, emotional support, and so forth. Once the photographers selected subject areas, they began making telephone calls, and telephone calls, and more telephone calls. Then the photojournalists arranged for meetings with the subjects. Often these meetings involved no photography at all. For one story, photographer Anne Wells started by volunteering at the first private nursing home for people with AIDS on the West Coast.

Another of Wells' stories was called "The Godfather," about a man who raised money and then made wishes come true for hospitalbound AIDS patients. If a patient needed a TV, The Godfather would provide it. If a patient needed a bathrobe, The Godfather would bring one. Kim Gerbich worked on a story eventually called "Mamacita of the AIDS World," about a female social worker who cared for homeless AIDS patients living in a rundown transients' hotel. Mary Calvert photographed a woman who cared for the pets of people with AIDS. Calvert also followed the work of volunteers for "Project Open Hand," an organization that provides meals for people shut in with AIDS. (See previous page.)

In the AIDS Ward at San Francisco General Hospital, a nurse allowed herself to be the subject of a story. Photographer Yvonne Soy tried to depict how a nurse works with people day after day knowing they will not live much longer. The project's story list included a makeup artist who helped camouflage the ugly purple scars of Kaposi's sarcoma that sometimes afflict people with AIDS. The list also included a story about a faith healer and her work with the sick.

The story list grew as the photographers dug into the subject. Everyone knew someone who was helping out in the AIDS community. Soon the photographers started to uncover stories about people who helped prisoners with AIDS and volunteers who helped teen-age prostitutes avoid the disease.

START-UP PROBLEMS

After the photographers uncovered the initial leads for their stories, problems started to crop up. While many of the helpers were happy to have their pictures taken, sometimes their friends with AIDS did not want photos of themselves published. Some didn't want out-of-town friends to see them scarred by Kaposi's sarcoma. Others didn't want

people to know they were gay. Sometimes, the photographer would start on a topic, begin photographing the relationship between a helper and a patient, and, suddenly, the patient would die. The story would end before it began. Hospitals worried about lawsuits if the photos were published—even though the photographers obtained photo release forms from every subject. "Helpers in the War on AIDS" was a difficult story to photograph.

ONE STORY LEADS TO ANOTHER

For good beat coverage, besides reading the daily papers and the special-interest gay newspapers, the photographers returned to their primary sources week after week for new leads. Sources such as research experts, specialized doctors, hotline workers, counselors, and friends with AIDS supplied suggestions for new stories.

Sometimes when working on a beat, photographers may find that the first story doesn't pan out. But it may lead to another, even better opportunity—an opportunity a photographer might not have had without developing contacts in the field.

For example, while researching one story, photographer Sibylla Herbrich spoke at length with Ernie, who had AIDS. She asked him if he knew anyone doing extraordinary work with people who had the disease. He told the photographer that she must meet Annemarie.

Annemarie Madison, a striking woman with long silver hair and a Mother Teresa smile, took the photographer with her as she went day after day to see her "boys." Annemarie's boys were men who, a few months earlier, had been in the prime of their lives. Now they were near death. As a volunteer with the San Francisco Home and Health Care Hospice, Annemarie changed the men's beds, listened to their complaints and fears, and wiped saliva from their mouths. Whatever they needed, she provided. She was both a substitute mother and a father confessor. She was there to ease their pain and to provide dignity to their deaths. No pictures at first. In the beginning, Herbrich came to know Annemarie and her "boys" before she brought out her camera. Then the photographer obtained permission to photograph from each person with whom Annemarie was working. Soon Herbrich was photographing everything.

One Monday, the photographer accompanied Annemarie to the hospital to see Ernie, the man who had told Herbrich about Annemarie in the first place. On Wednesday, when Herbrich returned with the hospice

HELPERS IN THE WAR ON AIDS: SHE'S THERE WHEN MEN DIE

Annemarie Madison (FAR LEFT) is a volunteer hospice worker. (NEAR LEFT) Annemarie provides emotional support to the friends and relatives of Ernie, one of hundreds of her "boys" to die of AIDS. (BELOW) She comforts Ernie during his dying moments. These pictures are part of a story that was the product of a photographer's beat.

(Photos by Sibylla Herbrich, from Helpers in the War on AIDS.)

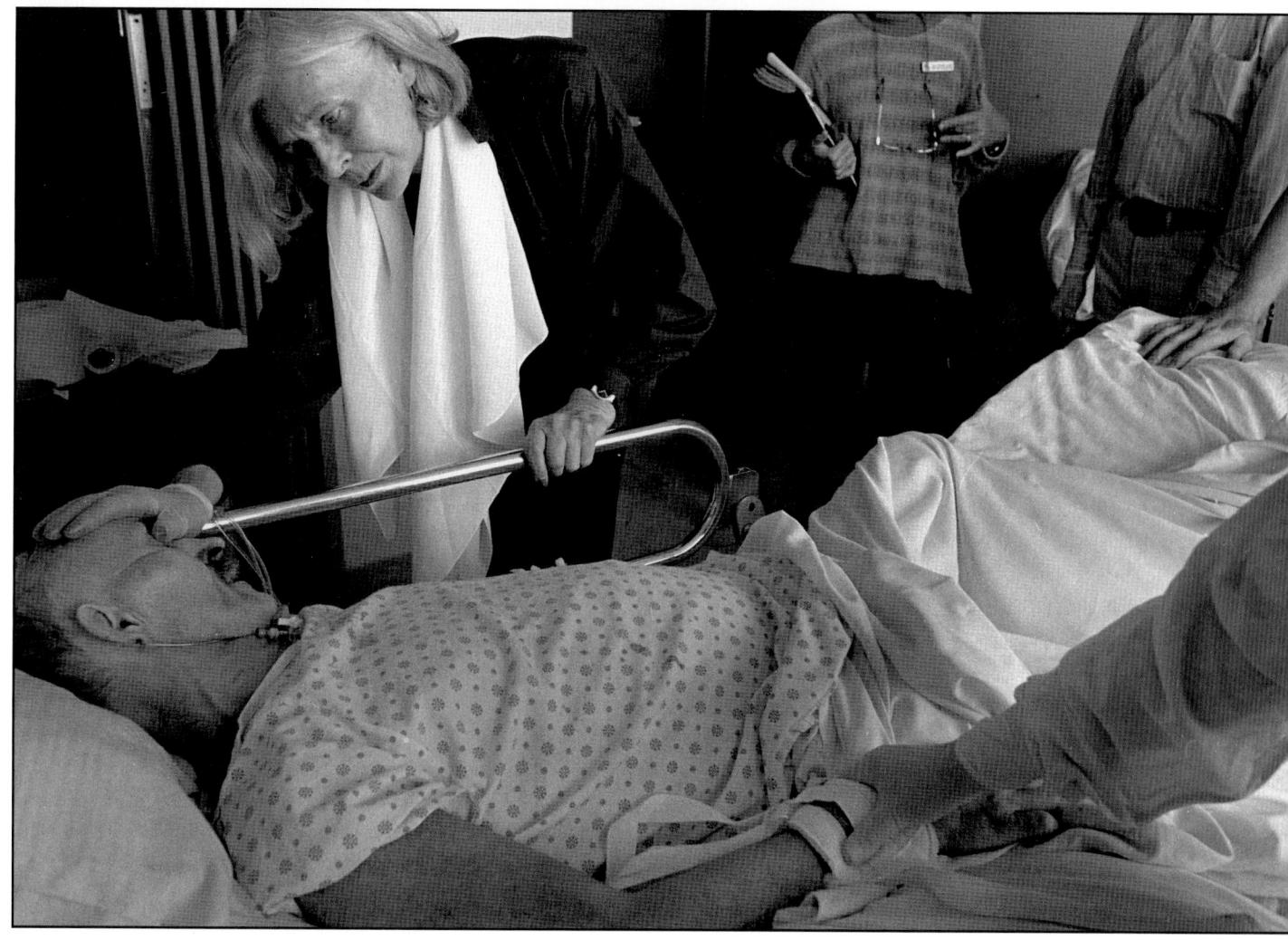

worker, Ernie looked much worse. His friends were in the hospital room. Herbrich later wrote about that day:

"On the afternoon of June 9, for the first time I saw someone die. Ernie Smith died of AIDS at the age of 56. I photographed the hours of his dying and for two days I could not process the film. I stared at the one little roll that contained him in life and also in death. He died in the moment of the 'black space' between two frames. . . . I didn't sleep for a long time."

Herbrich's story, along with others in the project, was published in a seventy-six-page magazine named *Helpers in the War on AIDS*. The project won the national Sigma Delta Chi Award for feature photography and tied for first place in the college division of the Robert F. Kennedy Awards for Coverage of the Disadvantaged.

INFORMATIVE FEATURES
REQUIRE EXTENSIVE RESEARCH
For more informative features, such as those
produced in the "Helpers" project, you will
need to perfect your skills as a reporter:

- 1) pick an area of specialization;
- 2) make contacts with experts in the field;
- 3) become familiar with the issues and new trends on the subject.

Once you hear about a story that sounds interesting, arrange to photograph it. Often you will need to return several times to secure complete coverage. After shooting the pictures, you can write the captions and submit the feature series. You might suggest to your editor that a more detailed story by a reporter would amplify your series of pictures. To assure future stories on the subject, stay in touch with your sources. These contacts will tell you when something new happens that might make striking pictures.

Few newspapers will release photographers to work full time on their beats. You will probably need to fit your special beat around routine assignments. Developing a feature area rarely produces great pictures on the first day. You need time for research. In the long run, though, a beat will generate meaningful feature pictures that will remain permanently in the viewer's memory.

CRACK: THE NEXT GENERATION

This project began as the first wave of children with

ADDRESSING THE PROBLEM

Photos by Ken Kobré.

what has come to be known as Crack Baby Syndrome were entering the nation's public schools. At first, a prenatally drug-exposed child's prognosis was grim. Born prematurely to crack-addicted mothers, these children were thought by researchers to be living time-bombs—damaged mentally and physically and perhaps even a threat to society once they were grown. At one time, this group of children was even called the "lost generation." Recent research, however, shows that, with intervention, some prenatally drug-exposed babies can grow up healthy—emotionally, physically, and mentally. Reproduced in part, this story looked at various stages of the lives of children born to crack-addicted mothers.

Conservative estimates suggest that at least 11 percent of all newborns in the United States today were exposed in the womb to one or more illicit drugs.

(LEFT ABOVE) Exposed to crack cocaine in the womb and born addicted, this newborn experiences severe withdrawal symptoms. (LEFT BELOW) Addicted newborns are extremely sensitive to light. Covering their eyes helps them rest.

(BELOW) Bathing is one of the few ways nurses have found to comfort drug-exposed newborns. Soap and warm water soothe the frantic babies. The bath also removes the sweat that envelopes them as they go through withdrawal.

(LEFT) For some at-risk children, the slightest disruption sets off a temper tantrum, like this one. These children exhibit extreme mood swings. Researchers have learned that early intervention focusing on interaction with other children, individual work on children's problem areas, and parent counseling can help at-risk children improve significantly. These children are part of the Parent Child Intervention Program preschool in East Palo Alto. California.

(ABOVE) To calm some of the at-risk children at nap time, a teacher stretches her legs across one child, holding the youngster down while massaging the back of another student. The first group of students in the early intervention programs now being "mainstreamed" into classes with average children are showing signs of success.

AMERICA'S SHAMEFUL EXPORT

SHIPPING GANG VIOLENCE TO LATIN AMERICA

Photos by Donna DeCesare.

Photographer Donna DeCesare lived in El Salvador during the 1980s and has been documenting the lives of Salvadoran gang members in Los Angeles and El Salvador since 1993.

In her pursuit of the story, she learned that the U.S. policy of deporting criminal immigrants (legal and illegal) is having no impact on gang violence in the United States but is further destabilizing the youths' lives while wreaking havoc on the Latin American countries where the youths are sent, cultures in which they are actually strangers.

"No matter how many gang members

you deport, things are not going to change as long as society is not addressing the needs of youth," says Magdalena Rose-Avila, co-founder of Homies Unidos, a group that works with gang members in El Salvador and the United States.

In their "home" countries, the Americanized youths are all but outcasts, shunned by employers, often harassed by police, and sometimes jailed—even when they've committed no crimes in those countries.

As in the United States, the outcasts create their own communities—complete with violence and drugs.

Non-profit groups are working with many of the youths. Activists say the United States must develop hemispherewide approaches to the problem—that deportation is not the answer. ■

(ABOVE, BOTTOM) Cocaine use, once the domain of El Salvador's upper class, is now common in shanty towns. Here, deported Los Angeles gang members smoke piedra, or crack cocaine, mixed with marijuana.

(LEFT) Members of Mara Salvatrucha, one of the most notorious Latino gangs in Los Angeles, take target practice in a rural area outside Los Angeles County. The gang's ranks swelled during the 1980s.

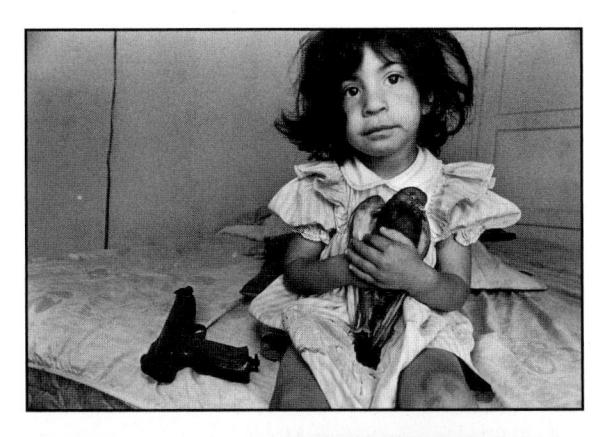

(LEFT) Three-year-old Esperanza sits beside a gun belonging to her gang-member uncle.

(BELOW) Salvadoran youths often view gang life as something to emulate. Here, Mara Salvatrucha members initiate new recruits with a ritual beating.

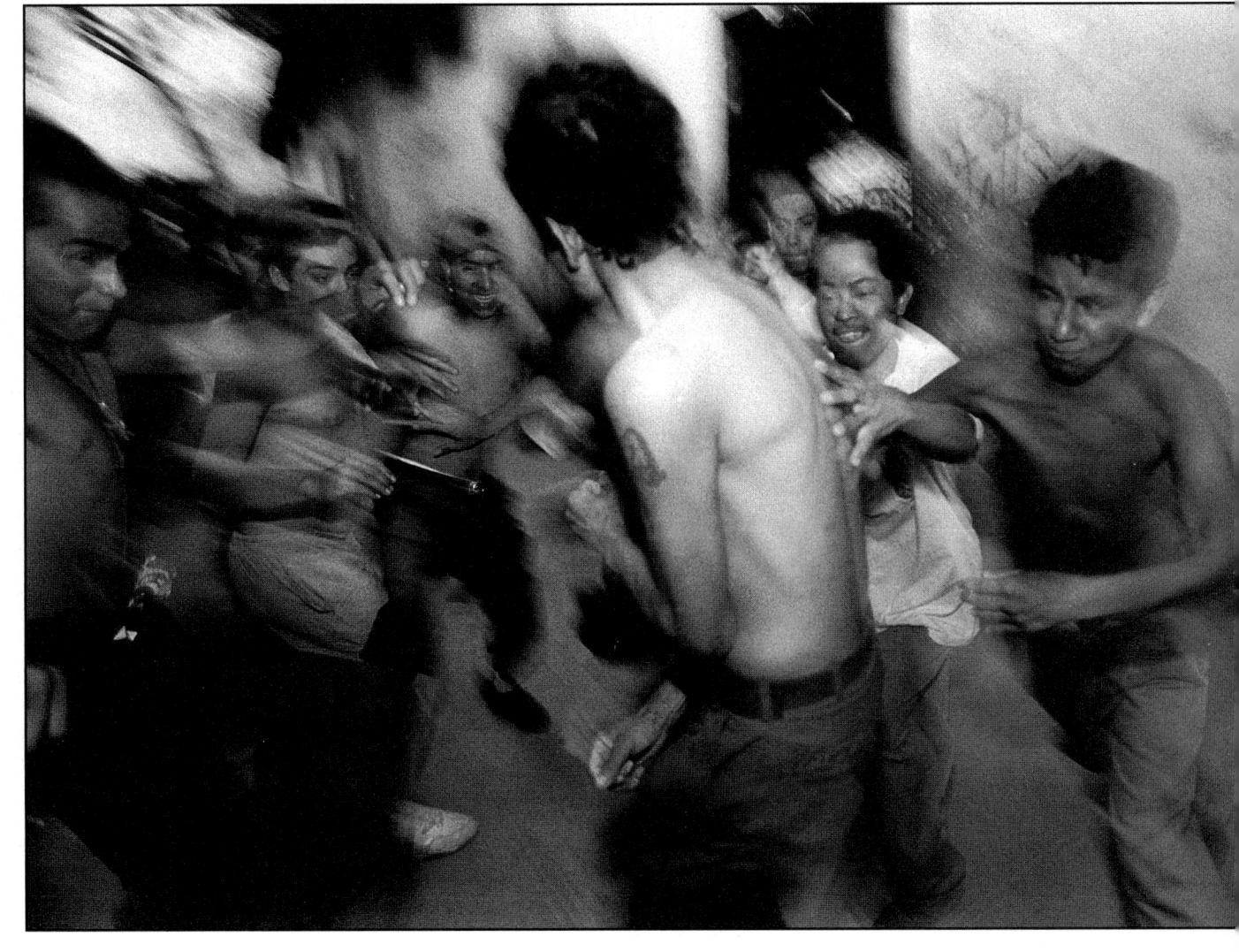

THE AMERICAN WEST IN THE '90s

PICTURES FROM A STRANGE & ORDINARY LAND

Photos by Alan Berner © Seattle Times

A lan Berner, who works for the Seattle Times, received a Nikon/NPPA Sabbatical grant to photograph "The West." His goal, he told Seattle Times writer Terry McDermott, was to photograph the West in the 1990s as Arthur Rothstein had done during the

1930s. Rothstein had photographed the region for the Farm Security Administration (FSA) during the Great Depression. Rothstein's assignment had been to document disaster. As McDermott points out, Berner's six-month photographic journey took place during the 1990s, a period of broad prosperity.

Berner's juxtapositions of the artificiality of modern life with the region's natural grandeur resulted in a variety of ironic images that capture late 20th century

Americans' relationship with the vast area known as "The West."

As Terry McDermott wrote in the story that accompanied the *Times*' publication of Berner's images, "We once thought the West was so grand, so heroic, the landscape would automatically make heroes of those who strode it. No more. We have moved from being heroes to being almost inconsequential. Don't ever forget, these photographs warn, you're just a visitor.

"You're left with the overwhelming impression that people don't belong out here. The land is too powerful." ■ (BELOW) At this dump with a view, discarded refrigerators form their own artificial ridge line near Santa Fe, New Mexico.
The Sangre de Cristo Mountains are in the background.

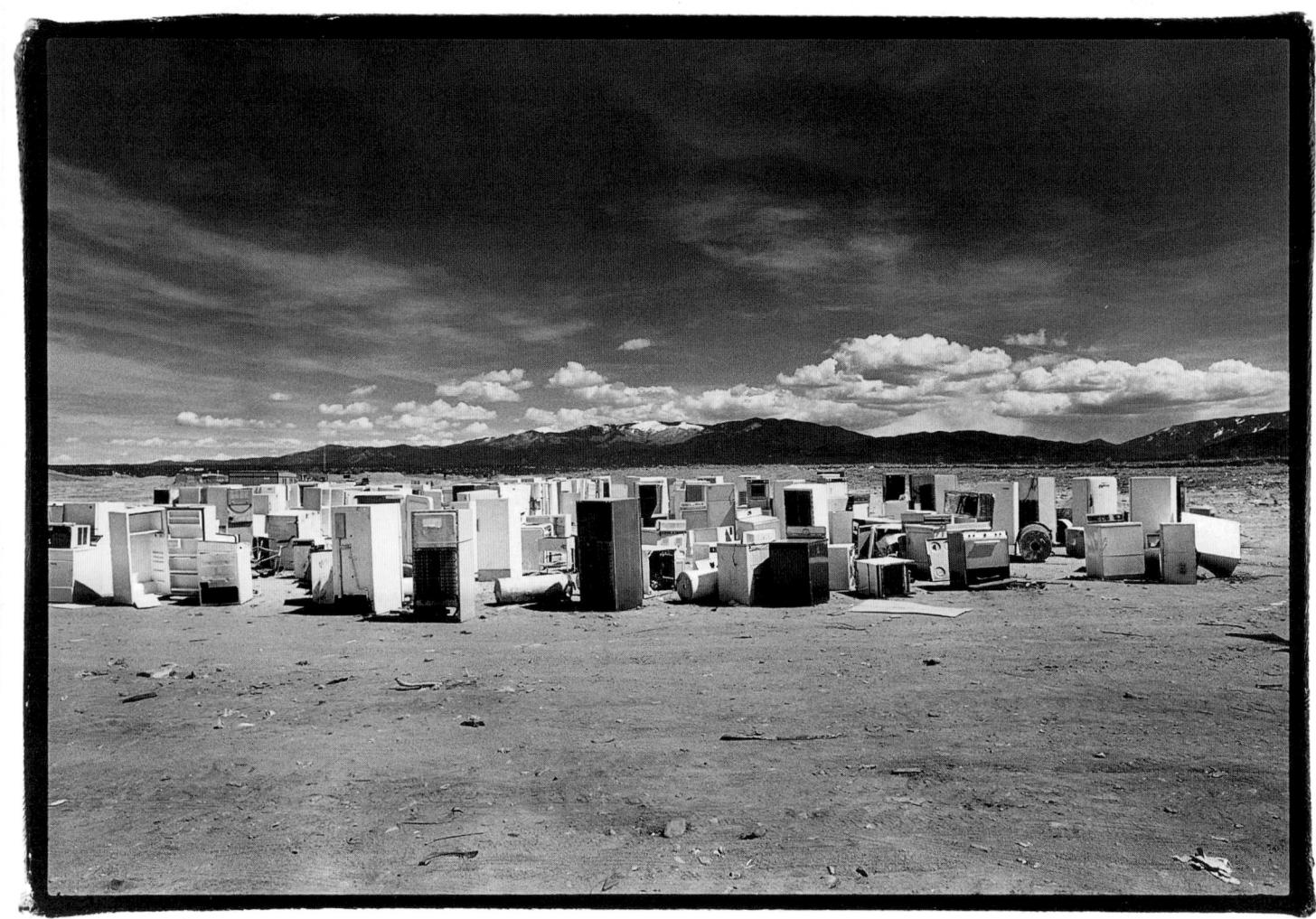

South Fe, New Morres

(BELOW) Chief Nelson Wallulatum of the Wasco Tribe and Col. Tim Wood of the U.S. Army Corps of Engineers break ground for new fishing sites being built where Bonneville Dam flooded traditional sites on the Columbia River. The sites were promised 56 years ago.

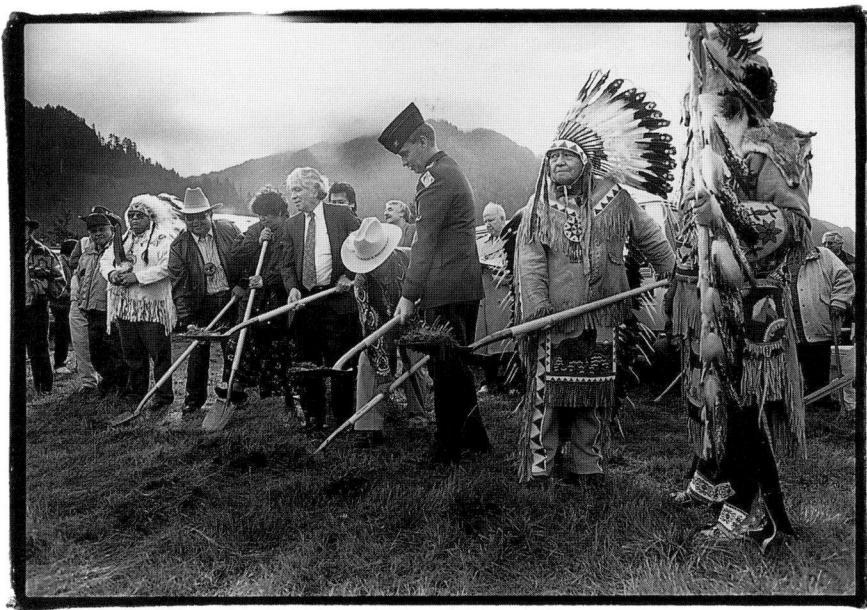

BREAKING GROWED

(BELOW) Tepees forming their own skyline at the annual Salmon Homecoming Celebration frame Seattle in the background.

SEATTLE, Washington

SuperMall Anbur, Washwator

(LEFT) Investors and dignitaries watch the "eruption" of the fake Mount Rainier front facade of the SuperMall at the mall's grand opening in Auburn, Washington, in 1995.

CAROL GUZY: A PORTFOLIO

(This material is based on the author's personal interview with Carol Guzy and an article in *News Photographer Magazine* by Pete Souza.) People who think of photojournalists in terms of the stereotypical movie version—hard-bitten, cynical, neurotically driven, competitive, and macho—miss the boat when it comes to one of the most celebrated news photographers of our time, the petite, unassuming Washington Post photographer Carol Guzy.

Guzy has covered some of the worst disasters, wars, famines, and conflicts occurring in the last decade of the twentieth century. From the mud slides of Amero, Colombia, to the exodus in Rwanda, to famine in Ethiopia, and lawlessness and anarchy in Haiti, Carol has photographed misery, murder, survival, and even moments of joy.

She has won the Pulitzer Prize twice, been selected Photographer of the Year three times by the National Press Photographers Association (NPPA), and been chosen White House Photographer of the Year seven times, along with many other awards.

This decorated photojournalist had set out to be a nurse, but an art school photography class, pursued with her boyfriend's 35mm camera, changed her life. Instead of applying for nursing positions, Guzy applied for an internship at the *Miami Herald*. Her work there led to a job in one the newspaper's suburban bureaus.

Independent of her regular assignments, she covered

Miami's Haitian community during a time in which most media attention focused on Cuban immigrants. Guzy describes herself as working "twenty-four hours a day" on that project for a year. Her commitment paid off. Based on her research and photos, the paper ran a special section on Miami's Haitian community. The pictures took top honors at the Atlanta photojournalism seminar and served as a springboard for her career.

The Herald began sending Guzy on international assignments, including the coverage of a devastating mudslide in Amero, Colombia. Her pictures of that disaster earned her first Pulitzer Prize, which she shared with Michel duCille.

After a burnout period that led to depression, she left the *Miami Herald* and went to work for *The Washington Post*, where she has covered everything from a homeless couple attending President George Bush's inauguration to the U.S. marines landing in Haiti and the crisis in Kosovo.

What's her secret?

"I really try to stay open—a childlike-wonder thing—trying to see it for the first time," she says. "I have a tremendous empathy. I imagine how someone else is feeling. This can be a blessing and curse" for a photographer, she observes. Guzy theorizes that her innate

HAITIAN STREET JUSTICE

Photos by Carol Guzy The Washington Post

(ABOVE) There is no shelter for the man whom the crowd believes was part of a band of thieves that killed their beloved community leader.

(RIGHT) The man pleads for his life at the hands of the angry crowd of mourners who had just left the funeral of their community leader.

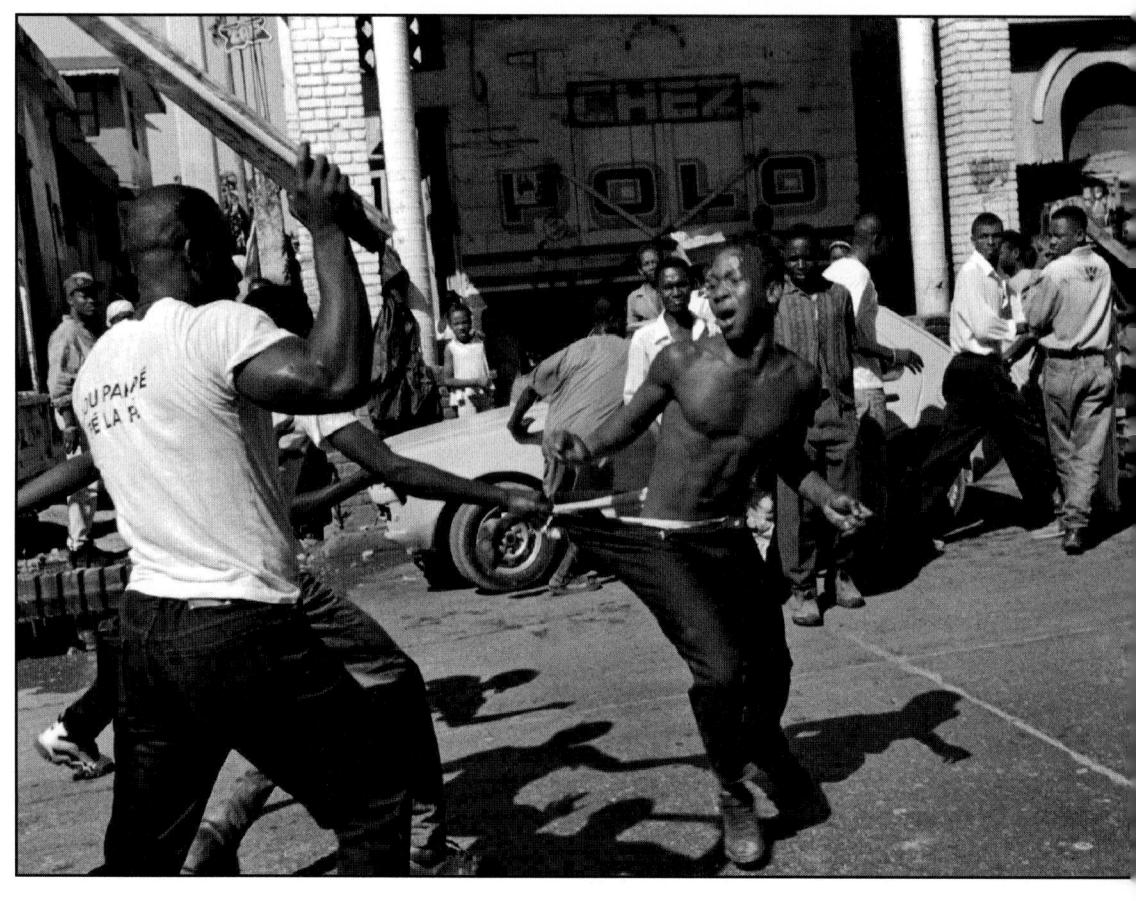

compassion might result from her own father's death when she was only six.

Guzy expresses her compassion both on assignment and in person in a thoughtful, subdued way. "I'm quiet by nature," she observes. "I'm horrible in social situations. I'm not the life of the party. But I think it helps in photo situations to be the way I am because they forget about me.

But Guzy also has incredible tenacity. "I have tremendous patience," she admits. "If you just wait a little while longer, something touching will take place.'

The crash of TWA Flight 800 off Long Island, New York, tested Guzy's staying power. Dozens of photographers flew in to cover the tragedy's aftermath. Grieving families came to the beach to express their pain and leave mementos. For Guzy, the story was not over until the last family left. She returned to the beach day after day to take pictures. On what turned out to be the last day family members came to the shore, one woman sat alone with a rose. That picture told the whole story. Other photographers shot one or two families on the first day and moved on to the next big news story, but Carol stayed until she got the photo she was looking for. "Good enough is never enough," she says. She

advises young photographers to stay a little longer and go the extra mile.

Whenever possible, Guzy tries to shoot "off" the main event. Covering the 1996 Democratic Convention, for example, she shot demonstrators outside more than the politicians inside the convention hall. "I tend to shoot the fringe as opposed to the mainstream stuff," she says.

Guzy's pictures run the gamut from intense violence to quiet, intimate moments. Her pictures in Haiti show a vigilante mob beating a man to death in the streets. Yet she maintains the ability to look for-and findintimacy, as well.

Guzy spent a week in Mali photographing the nomads there. "It was a grueling week," she recalls. "The light and heat were brutal. The land was so stretched out it took me forever to go from one family to another. One morning was magical, however."

On that morning, the photographer saw two women walking together, their backs to her and her camera. One woman draped her arm over the other's shoulders. The tiny rear end of a naked baby appeared to be almost suspended between them. Carol photographed the women as they continued on their way. At first glance, the viewer almost can't tell which woman

more on next spread -

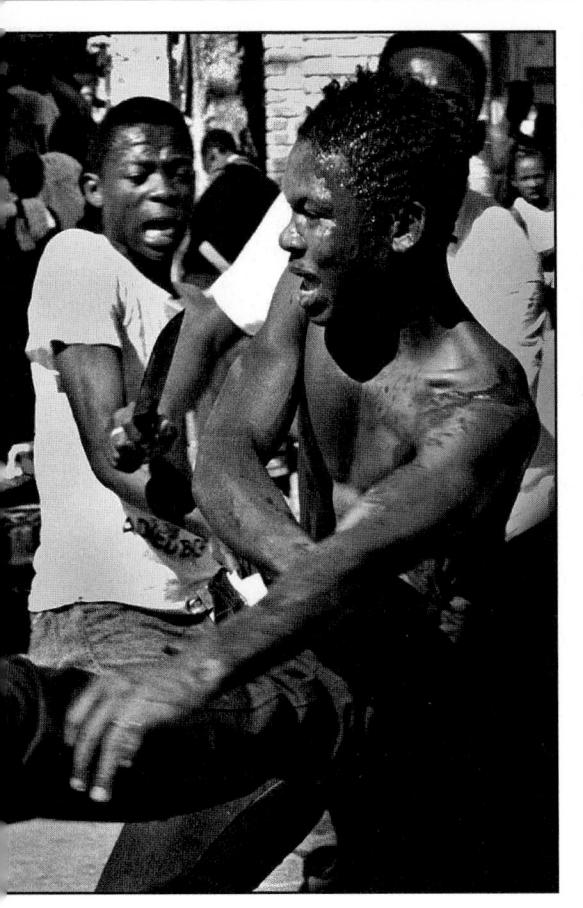

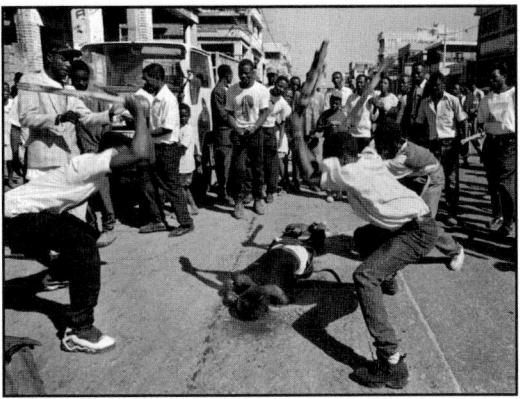

(LEFT) A knife finally ends the life of the suspected thief and murderer.

(ABOVE) The angry crowd continues to beat his lifeless body.

"I didn't look at these pictures for a long time . . .because I just couldn't deal with it. It was horrifying and there was a lot of guilt in thinking maybe I could have done something. I am sure in my heart that this man would have died no matter what I would have done. At first I was also not sure if I should show anyone these pictures, but I think they should be shown because the worst thing I could do would be to hide what is actually happening down there."

- Carol Guzy, interview with Pete Souza, News Photographer Magazine.

CAROL GUZY: A PORTFOLIO

Photos by Carol Guzy

© The Washington Post

carries the baby. Friendship, motherhood—it's all there in this one image, with nary a face to be seen.

The magic was in "the moment" she seeks in all her pictures.

"I'm looking for little pictures—moments of tenderness mean a lot," she explains. The response from editors, readers, and contest judges to the picture of the women and the baby was overwhelming. But perhaps Guzy's own mother puts it all into perspective. Examining the prize-winning picture, Guzy's typically American mother observed, "I can't understand it. It's a really cute picture, but why don't they have diapers on that baby?"

"Everyone sees something different," Guzy says.
"My mother looked at the picture like a mother, not as a photographer." ■

more photos on next spread -

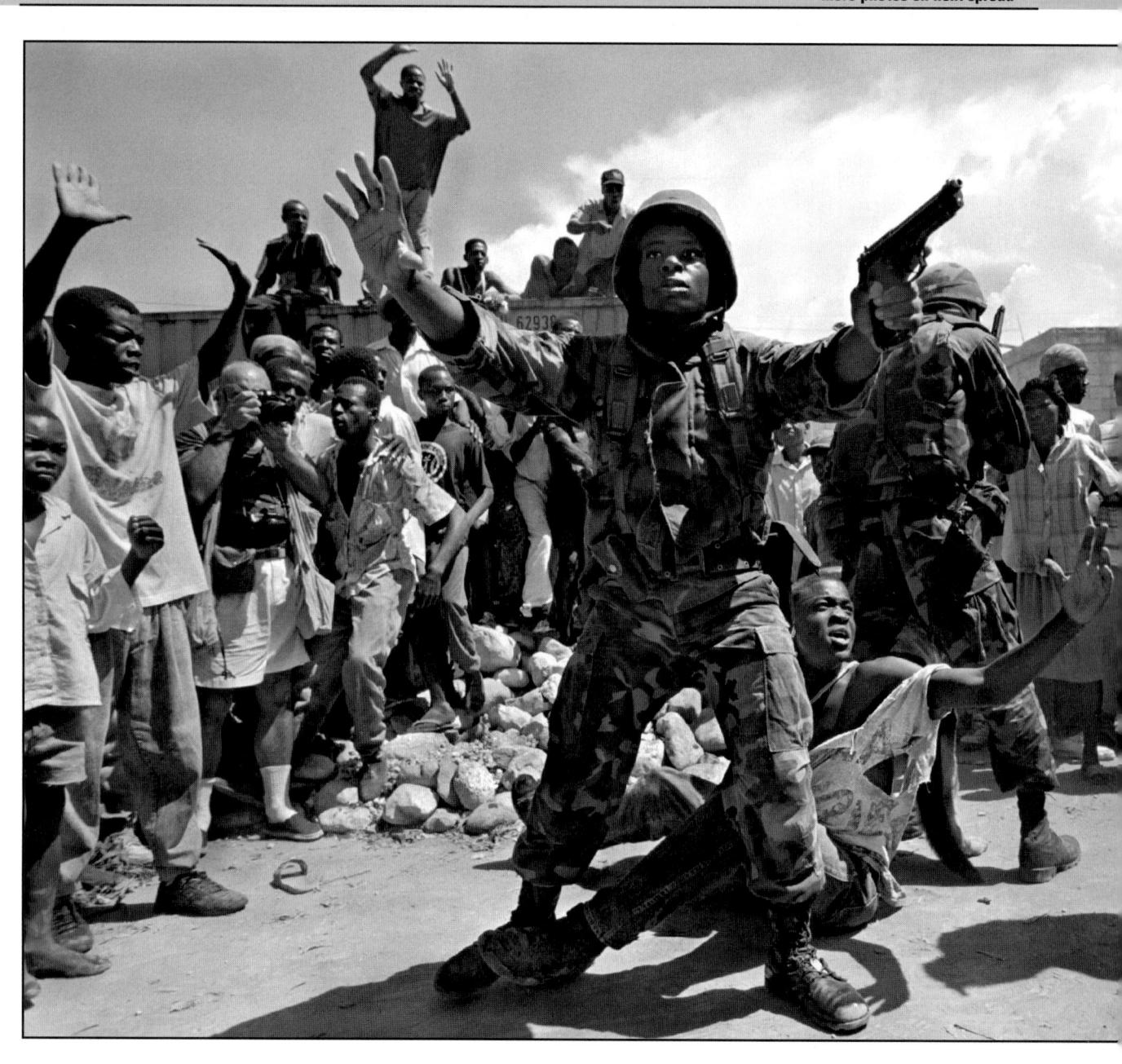

(ABOVE) A U.S. soldier orders the crowd to stand back after they tried to kill a man they thought had thrown a lethal grenade into a demonstration. U.S. troops had been sent to Haiti to restore some semblance of law and order. Guzy photographed from the front—an angle no other photographer got of this particular moment.

(RIGHT) Desert wanderers, the Nomadic Tuareg people of Mali live isolated lives. They roam the Saharan desert by camel with their meager belongings. Two friends walk from their tent with a child.

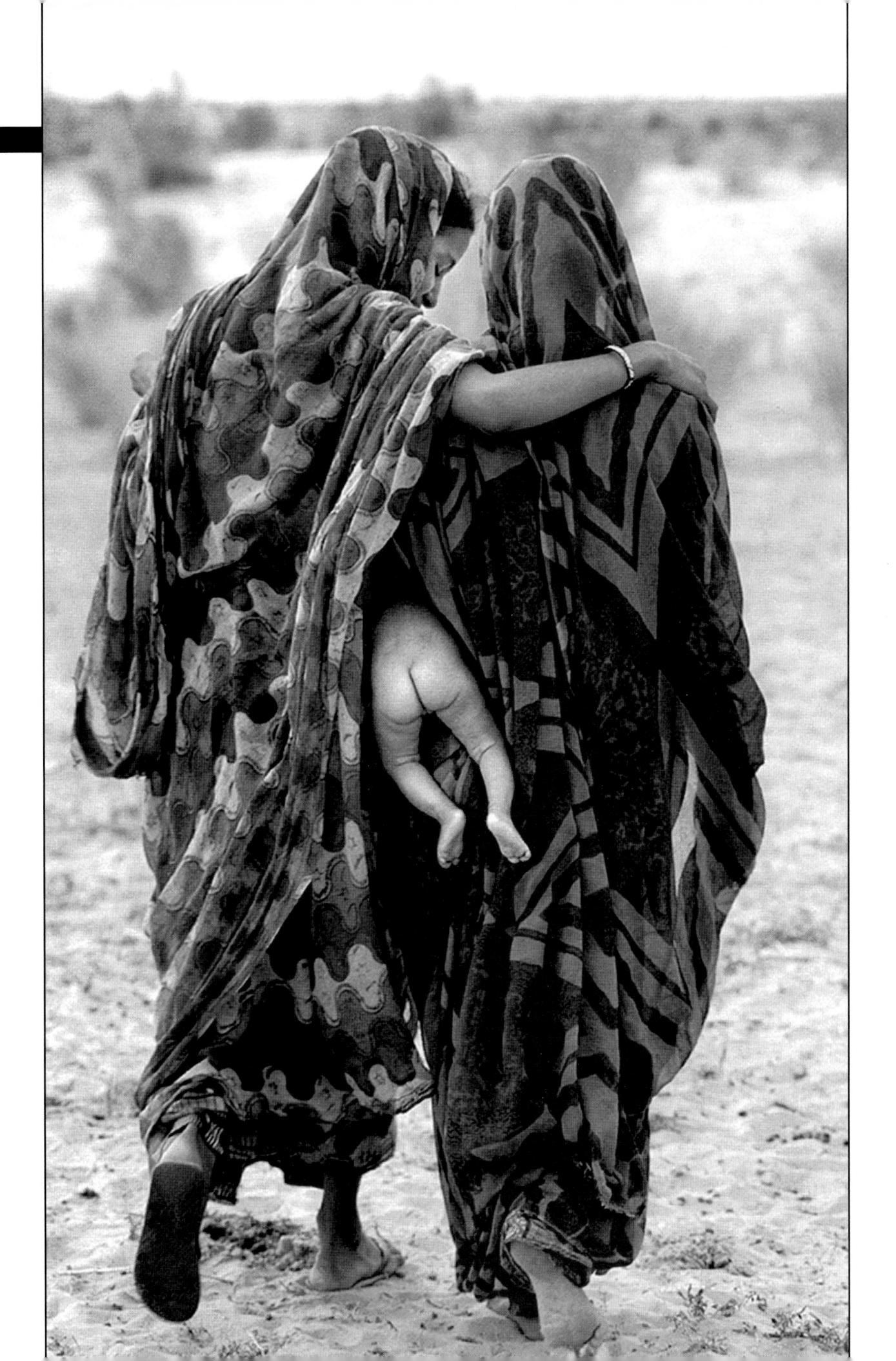

CAROL GUZY: A PORTFOLIO

RWANDAN EXODUS

Photos by Carol Guzy
© The Washington Post

Rwandan Hutu refugees began an

exodus of biblical proportions as they left their camps in Zaire to return home after more than two years. The rebel movement in Eastern Zaire had used intimidation and fear to control the refugees' movements.

Although apprehensive about returning to their country following the Tutsi genocide, the estimated one million refugees began their long trek. Along the way, the sick fell, people died, children were lost, and babies were born. Aid workers cared for people as they could and sent in trucks to move people home. Rwanda welcomed the refugees as joyful laughter of reunions with family and friends echoed in the land. — Carol Guzy

(BELOW) A young refugee walks past the body of a woman killed before she could return to her village. "I saw the dead body, and I set up and waited for people to react," Guzy explains. "I used a telephoto i isolate. I cropped it in the camera to cut off distracting elements like a person's head because I wanted the focus to be on the kid." (BELOW) Volunteer "body pickers" had poured lime on a mass grave in Mugunga camp in Zaire. Fierce fighting by rebels had released the hold on refugees by Hutu extremists. Many were killed as the exodus began.

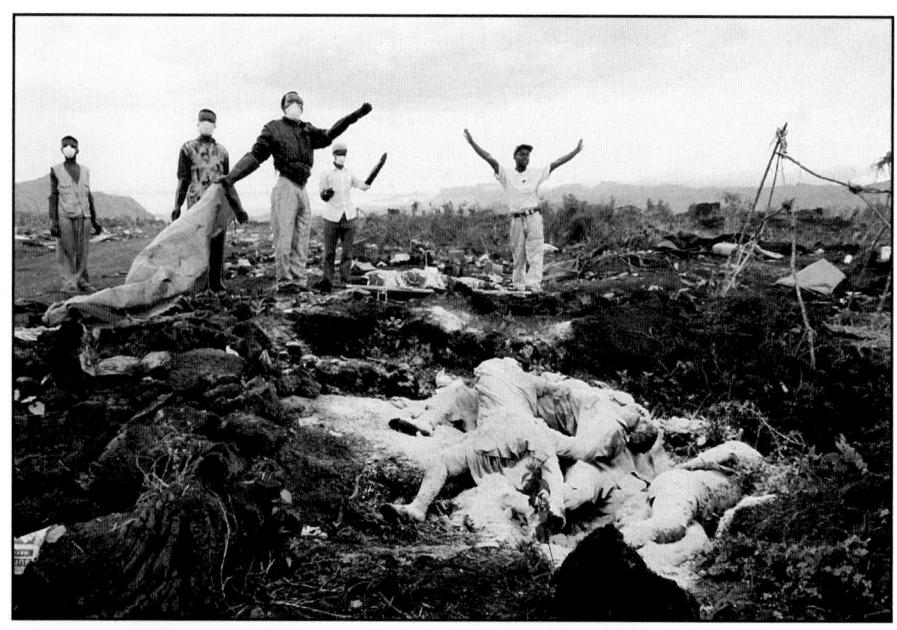

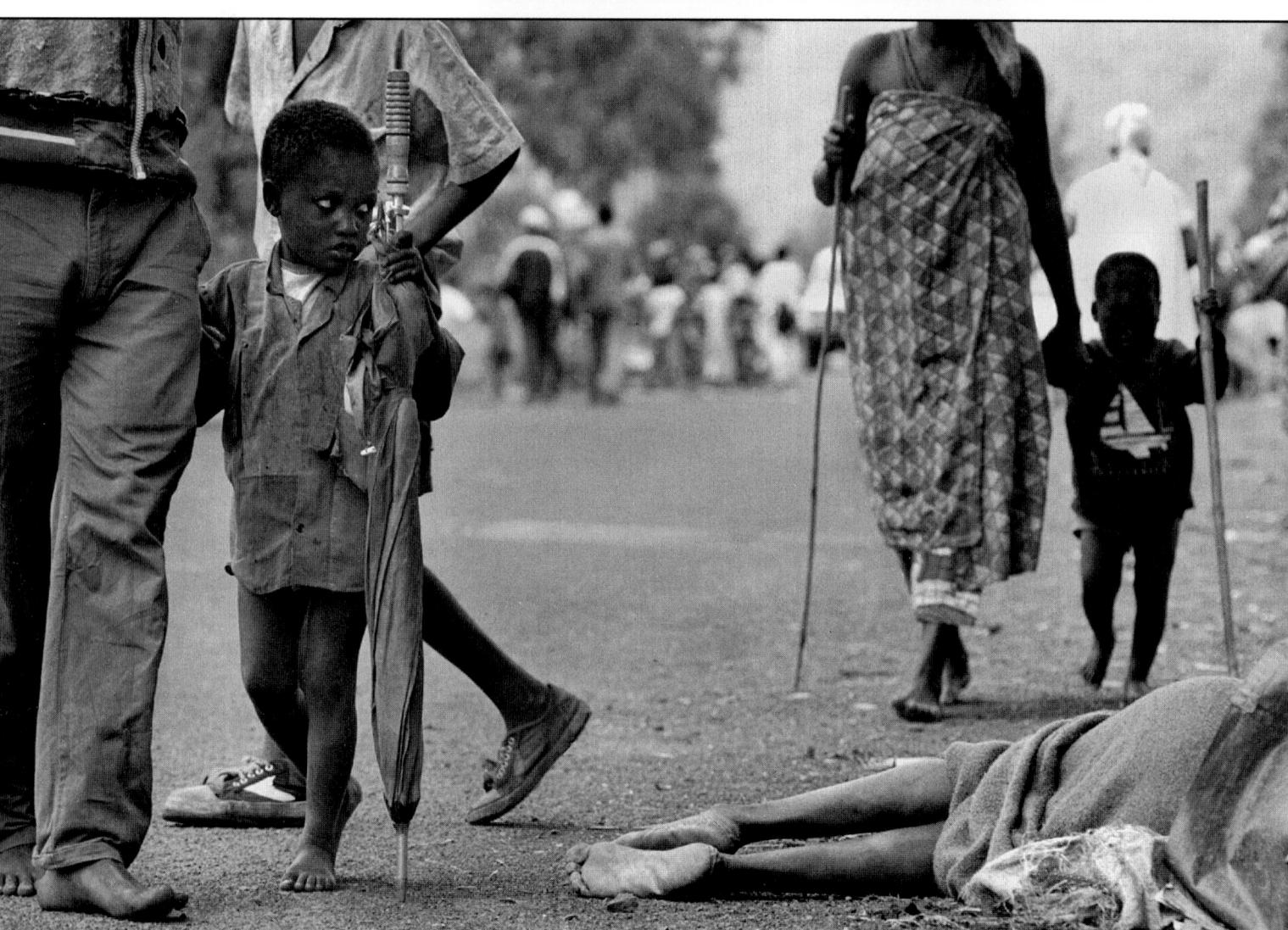

Photos by Carol Guzy,
© The Washington Post

(BELOW) A baby lies near his gravely ill mother on the road from Gisenyl to Kigali, Rwanda. "I watched for the child's eyes. They are the windows to

his soul," says Guzy. "After I took the picture, I went to the Red Cross care center and told them to come and save the mother."

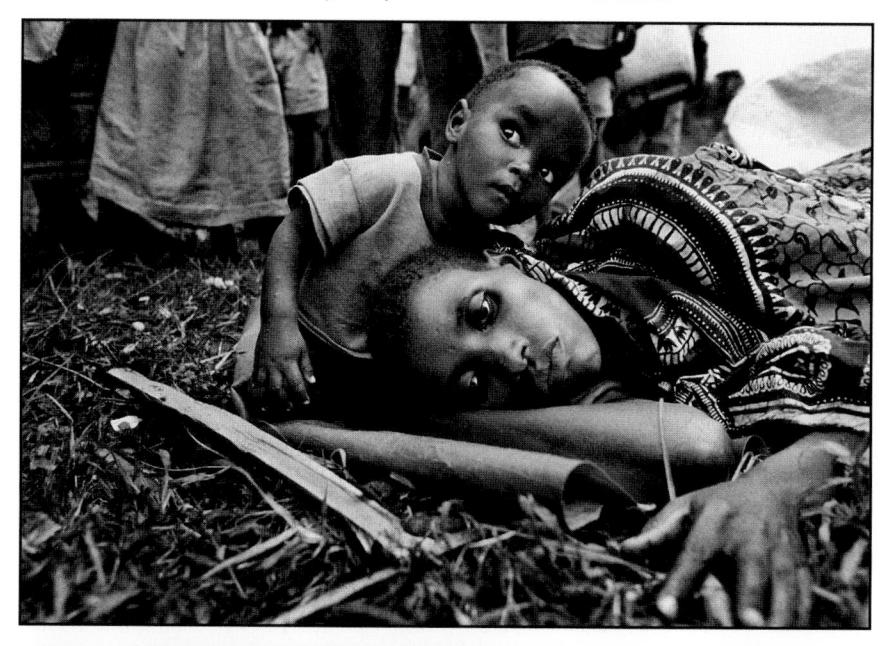

(BELOW) This exhausted Rwandan refugee breaks down into tears when she is unable to get on a truck going back to her home village.

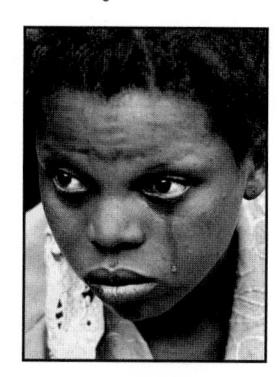

(BELOW) A refugee sees his father for the first time in more than two years as he returns to his village in Rwanda. "I used a wideangle lens in this situation," Guzy recalls. "With so many people around, someone would block my view with a telephoto."

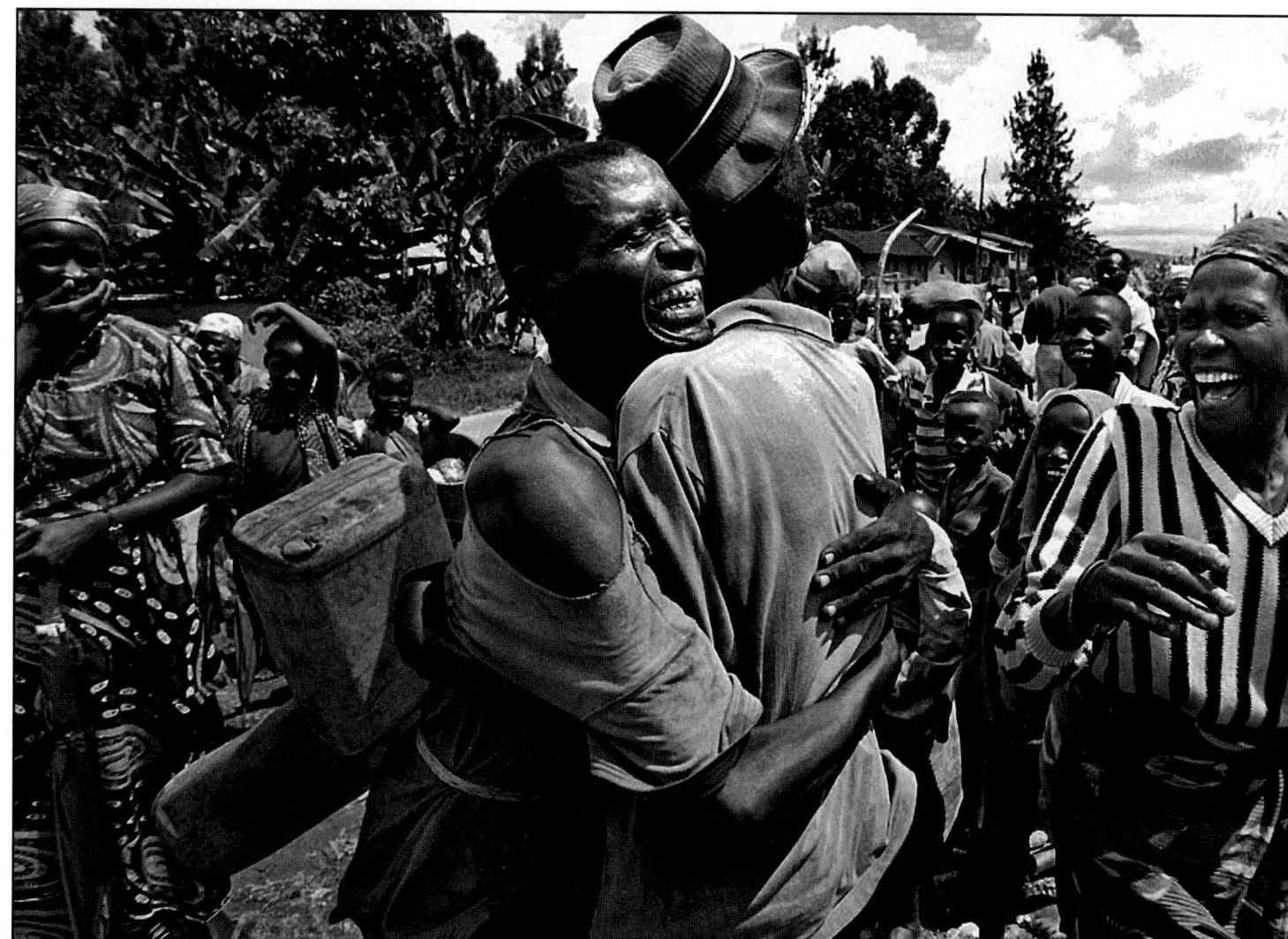

Features

WHAT ARE FEATURES?

CHAPTER 5

eature photos provide a visual dessert to subscribers

who digest a daily diet of accident, fire, political, and
economic news. Many newspaper editors argue that

because readers receive so much depressing news in the gray columns of type, subscribers deserve a break when they look at pictures.

For some papers, feature pictures not only provide a diversion from the news but have become the mainstay of the front page.

Consistently, reader surveys show that subscribers respond favorably

Feature pictures provide a visual break from routine news. (Photo by Jim Evans, Jackson, Wyoming.) to feature pictures. (See pages 196-200, Chapter 10,

"Photo Editing," for more on reader preferences.)

Features also allow newspapers to play up average citizens in circumstances other than accidents and other tragedies. While Mark Johnson, a Massachusetts freelancer, argues that most feature pictures are interesting only to the people in the pictures, Charlie Riedel of the Daily News in Hays, Kansas, says, feature pictures "freeze experiences in time so others can scrutinize them."

Gordon Converse, who worked for the Christian Science Monitor for more than twenty years, described feature photography as the "search for moments in time that are worth preserving forever."

For Mark Hertzberg, director of photography at the Journal Times, in Racine, Wisconsin, "the measure of a newspaper's success is how many of these moments are in clippings held onto readers' refrigerator doors with magnets."

HOW FEATURES AND NEWS DIFFER

TIMELESSNESS

Feature photos differ from news photos in several respects. A news picture portrays something new. Because news is timely, news pictures get stale quickly. Many feature pictures, on the other hand, are timeless. Feature pictures don't improve with time, as good wine does, but neither do they turn sour. Some newspapers, in fact, refer to features as evergreens. Like evergreen trees, feature photos never turn brown. Wire service photos showing President Clinton giving his inaugural speech carry little interest today. Yet feature pictures like those in this chapter will long retain their holding power.

SLICE OF LIFE

A news picture accrues value when (1) its subject is famous, (2) the event is of large magnitude, or (3) the outcome is tragic. A feature picture, by contrast, records the commonplace, the everyday, the slice of life. The feature photograph, sometimes called "wild art" or "stand-alone art," tells an old story in a new way, with a new slant.

Two children playing games at a day care center will not change the state of world politics, but the photo might capture a funny

A feature picture records the commonplace, an everyday happening, or a slice of life. A child's curiosity at the Harvard day care center is a natural feature subject.

(Photo by Ken Kobré, for the Boston Phoenix.)

moment and therefore provide a feature picture.

With hard news. the event controls the photographer. Photojournalists jump into action when their editor assigns them to

cover a plane crash or a train wreck. When they reach the scene, they limit their involvement to recording the tragedy.

As a feature photographer, on the other hand, you often can generate your own assignments. In fact, many newspapers call features "enterprise pictures."

You might arrange to spend the day shooting photos of a man who makes artificial arms and legs.

Or you might head to a school for dog groomers, looking for a student learning how to clip a poodle.

"FEATURIZING" THE NEWS

News does not stop with fires and accidents, and features don't begin with parks and kids. The division between these two types of pictures is not that clear-cut. The sensitive photographer, for instance, could uncover features even at a major catastrophe. This is called "featurizing the news." The main story The photographer saw this quiet, commonplace moment as a feature picture. The screen and grill give this picture its haunting look and transform the ordinary act of gazing into an image that projects feeling. (Photo by Richard Koci-Hernandez, San Jose Mercury News.)

might describe a fire's damage to an apartment house, and give a list of the injured and dead. The news photo might show the fire-fighter rescuing the victims with the building burning in the background.

For a news feature, the photographer might take a photo of a firefighter being kind to a dog. This picture, along with a caption about the canine rescue, might be printed as a sidebar alongside the main story and photos, which would concentrate on the residents' injuries and the general damage to the building. Likewise, a picture of a tree that appears to be growing out of a wrecked car straddles the line between news and features.

UNIVERSAL EMOTIONS

Great feature pictures, and there are few, evoke a reaction in the viewer. When viewers look at a powerful feature photo they might laugh, cry, stand back in amazement, or peer more closely for another inspection. The photo has succeeded.

Some features are even universal in their appeal. They will get a response no matter in which country they are shown. When individuals in Russia, China, an African nation,

or the United States respond to the same photo, then the photographer has tapped into the universally understood language of feature pictures.

The term feature picture tends to serve as a catchall category. In fact, some writers define features as "anything that's not news."

Yet many pictures fit into neither the news nor the feature category. Snapshots from a family album, for example, don't really belong in either pigeonhole.

GOOD FEATURE SUBJECTS

Years back, each time a new photographer was hired by Florida's *St. Petersburg Times and Independent*, a veteran staffer would draw the newcomer aside to explain the secret ingredients of the feature picture.

"Friend," he would say, "if you need a feature picture for today's edition, you can't go wrong by taking photos of kids, animals, or nuns wearing habits."

These were not bad words of advice because a large percentage of published feature pictures includes kids, animals, and sometimes, even nuns.

The tree appearing to grow out of the overturned car transforms this routine news situation into a humorous news feature.

(Photo by Kent Porter,

(Photo by Kent Porter, Santa Rosa [California] Press Democrat.)

Kids imitating adults

Photographers find children to be relatively easy and willing subjects because they act in natural ways, play spontaneously, and look cute. "Kids are good subjects for features because they are uninhibited," says Charlie Riedel in Kansas. "They tend to be themselves. They don't have anything to prove to anyone." To grownups, children seem particularly funny when they imitate adult behavior. The child often acts as a mirror, showing the adult how grown-up behavior appears to the younger generation.

Ulrike Welsch, a specialist in photographing children when she worked for the *Boston Globe*, always asked permission of parents before photographing youngsters. "That way the parent does not become suspicious and does not interrupt the shooting," Welsch explains. If the parent is not around, Welsch would ask the child to lead the way to the adult, giving Welsch the opportunity to secure the permission. Although asking permission interrupts the child's activity, Welsch notes that, as soon as the parent gives the goahead, the child always quickly resumes his or her natural play. Given the unhappy reality

of today's headlines of child abductions and molestations, this advice has never been more on target.

The incongruous

A photo of nuns holding guns looks odd because nuns and guns don't seem to go together. A revolutionary soldier peering through a point-and-shoot camera would appear equally mismatched. And a picture of a technician appearing to be peering into the posterior of a prehistoric predator will always evoke a chuckle. Such photos provide eye-catching features.

People like people

Clearly, the feature does not restrict photographers to picturing only kids, animals, and nuns, although whenever you can include these elements in a picture, the photo has a greater chance for publication. People of any age prove fascinating when they labor or learn, play or pray.

Animals acting like people

People commonly attribute human traits to animals. People respond to pictures in which

A technician readies a robotic dinosaur for a tail connection. Even extinct animals make for fun features.

(Photo by Robert Cohen, *Memphis* [Tennessee] *Commercial Appeal.*)

A nun with a gun seems incongruous and therefore provides the subject for a good feature. The guns were actually donated to the camp the sisters administered.

(Wide World Photos.)

Sarah Betz, nine years
old, had just offered the
camel a carrot that she
held by her teeth.
When animals act like
people, such as this
camel kissing a child,
they provide good
feature material.
(Photo by Scott Heckel, The
Canton [Ohio] Repository.)

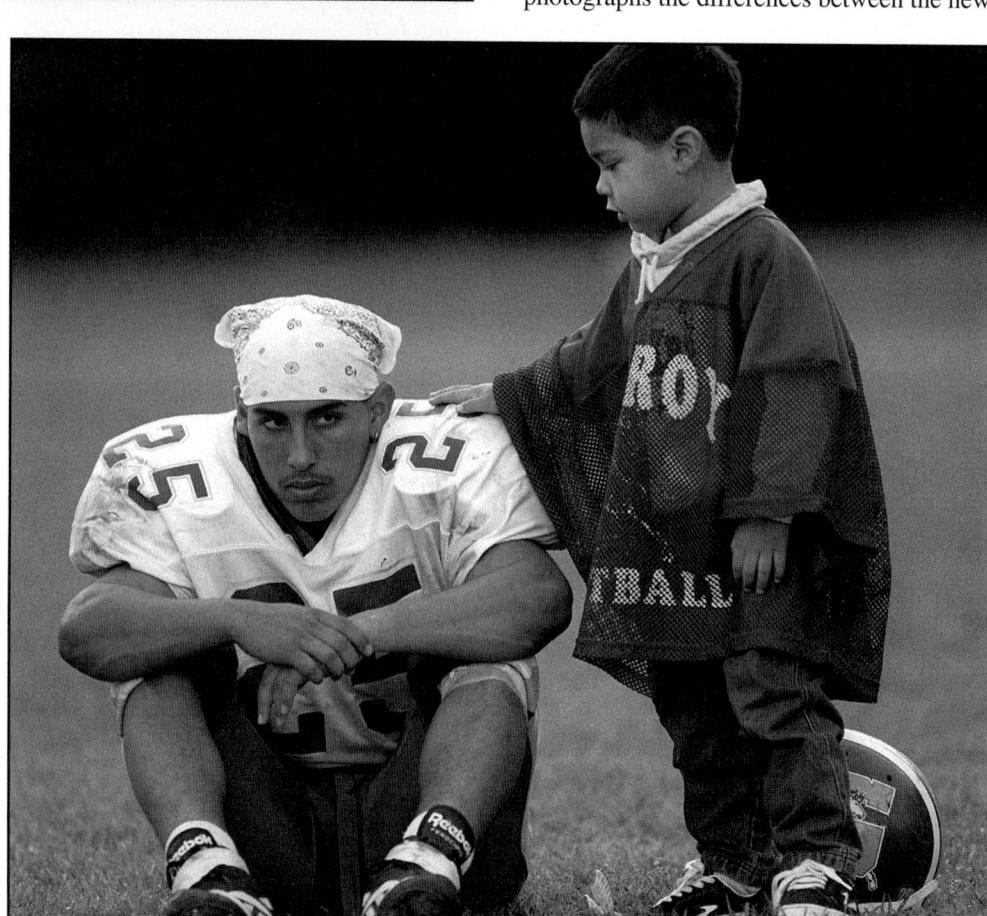

Children imitating
adults, like this
four-year-old boy
comforting his uncle
during a losing football
game, prove to be
appealing feature
subjects.

(Photo by Terry Pierson, *The Gilroy* [California] *Dispatch.*)

pigs seem to smile or chimps look bored—and camels kiss cute little girls. Pet lovers often believe their animals exhibit human emotions and treat their animals as if they were little human beings. Dog fanciers feed their pooches at the dinner table, dress them in sweaters for walks, and at night tuck them in velvet beds. Such idiosyncrasies supply the material for good features.

DISCOVERING FEATURES

KEEP A FRESH EYE

To keep a fresh eye for features, Ulrike Welsch gets in her car and drives to an area she's never seen before. The experience is similar to traveling to a new country, even though the place might be only a few miles away. Whenever you live in the same place for awhile and see the same things daily, you grow accustomed to your surroundings.

Psychologists call this phenomena "habituation." Feature photographers face the same problem. They come to accept as commonplace the unique aspects of the areas they live in and cover.

"Whenever I go to a new place, even if it's just a little way down the road, everything is novel," Welsch points out. She notices and photographs the differences between the new

environment and her familiar territory. When she first arrives, her eye is sharpest.

Those first impressions usually lead to her best photos. "I take pictures I might have overlooked if the subjects were in my backyard," she says.

When called on for a feature picture by 5:00 P.M. for the next day's metro section cover, many photographers jump in their cars and head to their favorite neighborhoods.

Like a fisherman returning to a fondly remembered fishing hole, they go back hoping for one more catch of the day.

Other photographers start cruising. Charlie Riedel, who has spent almost his entire life photographing in the small town of Hays, Kansas, says that he finds 95 percent of his features by driving around.

Alan Berner, who works for the *Seattle Times*, says that if you see a picture when you are driving, stop the car and shoot. "In general, you can't go back and get it again." Doug Kapustin of the *Baltimore Sun* agrees: "You think you should stop. If you don't, you will regret it later."

Some photographers, however, shun the car

The photographer saw these boxes stacked on the sidewalk and anticipated that the mover would try to transport all of them at once, so he waited until the man returned and got this dramatic shot. The boxes, filled with styrofoam hats, were actually quite light. (Photo by Paul Miller, San Francisco.)

altogether. Even if they are on their way to an assignment, they prefer to walk if they have the time. They point out that if you are in a car whizzing through a neighborhood, you miss seeing how the residents respond to one another. This interchange provides the basis for good features. As Greg Locke, chairman of the Photojournalism Caucus of the Canadian Association of Journalists, told *News Photographer* magazine, "Talk to people you meet. Sometimes keeping moving means you are never in one place long enough to see what's going on."

TAKE A CANDID

Constantine Manos, an outstanding freelance feature photographer for Magnum picture agency, looked for candid features during the year he spent shooting 500 rolls of black-and-white and color film for a forty-projector slide show called "Where's Boston?"

He says that he never posed or arranged any of the pictures contained in the show. Manos says he explored each area of the city on foot, introducing himself to the residents. "If you sneak up on people," he explains, "they have a right to resent you. Instead, if you say 'Hello,' and talk a bit about what you are doing, people will let you continue with your work. All my subjects are aware of me."

Henri Cartier-Bresson, a founding member of Magnum who is often referred to as the father of candid photography, used a different approach for taking street pictures. According to Russell Miller in his book *Magnum: The Story of the Legendary Photo Agency*, Cartier-Bresson liked to pop up, as if out of nowhere, take a picture, and then innocently walk on as if nothing had happened.

Many photographers are fearful of photographing strangers on the street. Going up to a someone you do not know and sticking a camera in his or her face is not a natural act for everyone.

Emily Nottingham studied the brief relationship formed between feature photographers and their target subjects in her doctoral dissertation "From Both Sides of the Lens: Street Photojournalism and Personal Space." This relationship, while it might last only a few seconds or minutes, greatly affects the outcome of the picture, as well as how the subject and the photographer feel about the encounter.

In her study, Nottingham found that 86 percent of the time people were approached by photographers on the streets of Bloomington, Indiana, they agreed to be photographed, cooperated with the photographer, and even

It's break time
for the Not-Ready-forSwine-Time Porkers, as
a member dressed as a
six-armed goddess
enters a port-a-potty
at the World
Championship Barbecue
Cooking Contest.
For feature photos, look
for the out-of-place.
(Photo by Steven G. Smith
The Memphis [Tennessee]
Commercial Appeal.)

gave their names and addresses. The high percentage of cooperative—and satisfied—subjects reported in the study should put at ease those photographers fearful of street photography.

Nottingham also found that photographers who emphasized forming a relationship with the subjects as people rather than simply as subjects received a more favorable response from the individuals they were photographing. "Those photographers tended to take more time with the subjects than the other photographers, spent a larger percentage of that time in conversation, and exchanged more personal information with the subjects," she observed.

While the photographer/subject bond does not indicate the quality of the final image, the study clearly shows that sensitive, caring photographers will find their subjects more receptive.

Keep in mind, however, the differences between what Nottingham observed in Indiana and Cartier-Bresson's approach to street photography.

The Indiana approach involves an introduction by the photographer before taking a picture. The Cartier-Bresson approach depends on a photographer taking pictures without engaging the subject.

In fact, Cartier-Bresson's method, when executed in the style of the master himself, means that the photographer will shoot so fast that subjects will not realize they have been photographed.

Of course, photographers must decide which approach will work best for them and be most comfortable for them.

UNIQUE VANTAGE POINT

Sometimes the key to the feature photo is not a candid moment found on the street but rather taking the viewer to see a common event from a unique vantage point. "I try to show people what they would not normally see," says Charlie Riedel, who climbed a radio tower to show someone changing a light bulb atop it. Such an ordinary act seen at ground level certainly wasn't interesting, but from the tower, where few people ever get to go, readers saw an everyday activity from a fresh perspective.

Riedel, who has no symptoms of vertigo, has climbed radio towers, mounted his cameras on bikes, airplanes, parachutes, and Gyrocopters. Not only does he go up, but he climbs down manholes and even under trampolines to bring the readers in his small town a unique perspective. More commonly, he just climbs a tree or takes the prism off his

Just about everyone has probably seen kids jumping on a trampoline. But how many have ever gone beneath the net to watch the fun? This unique vantage point not only shows people something new but creates a most unusual picture. (Photo by Charlie Riedel, The Hays [Kansas] Daily News.)

camera and lies flat on the ground to give his readers a new view of their world.

AVOID THE TRITE

The bread-and-butter feature in today's newspaper is still the pretty child playing in the park or the chimp clowning at the zoo.

Photographers take pictures of kids and animals so often that these topics can become trite.

Robert Garvin, writing in *Journalism Quarterly*, explained the genesis of the unsubstantial feature picture.

"I have known picture editors (including myself up until ten years ago) who, on a dull afternoon, assign a photographer to walk around town and photograph anything he sees. What does he see? On an August day, he sees a small boy in the spray of a fire hydrant, or a group of tenement dwellers sitting on a fire escape.

"These are so obvious that every passerby has seen them in the newspaper for the last forty years. If there is no thought and preparation, one cannot expect striking pictures with more lasting merit."

When Arthur Goldsmith, an editor for *Popular Photography* magazine, once judged the Pictures of the Year Contest, he concluded that pictures in the feature category tended to be hackneyed that year.

He wrote, "Feature pictures often mean space fillers for a slow news day. Here are the visual puns, the cornball, the humorous, the sentimental, the offbeat. (Greased pigs and belly dancers were especially big during this year's competition.)"

Goldsmith said editors divide the photo world into two camps. "Either an event is hard news, which usually means violence, death, horror, confrontation, etc., or the event is a 'feature,' meaning something that appeals to our warm, furry sentimentality. But between the two extremes—the agony of the spot-news disaster and the ecstasy of the feature picture—lies that great amorphous zone that is most of our life."

This photographer made a feature by photographing this line of bicycle cops in silhouette. He exposed for the sky and let the riders go black. (Photo by Charlie Riedel,

Hays [Kansas] Daily News.)

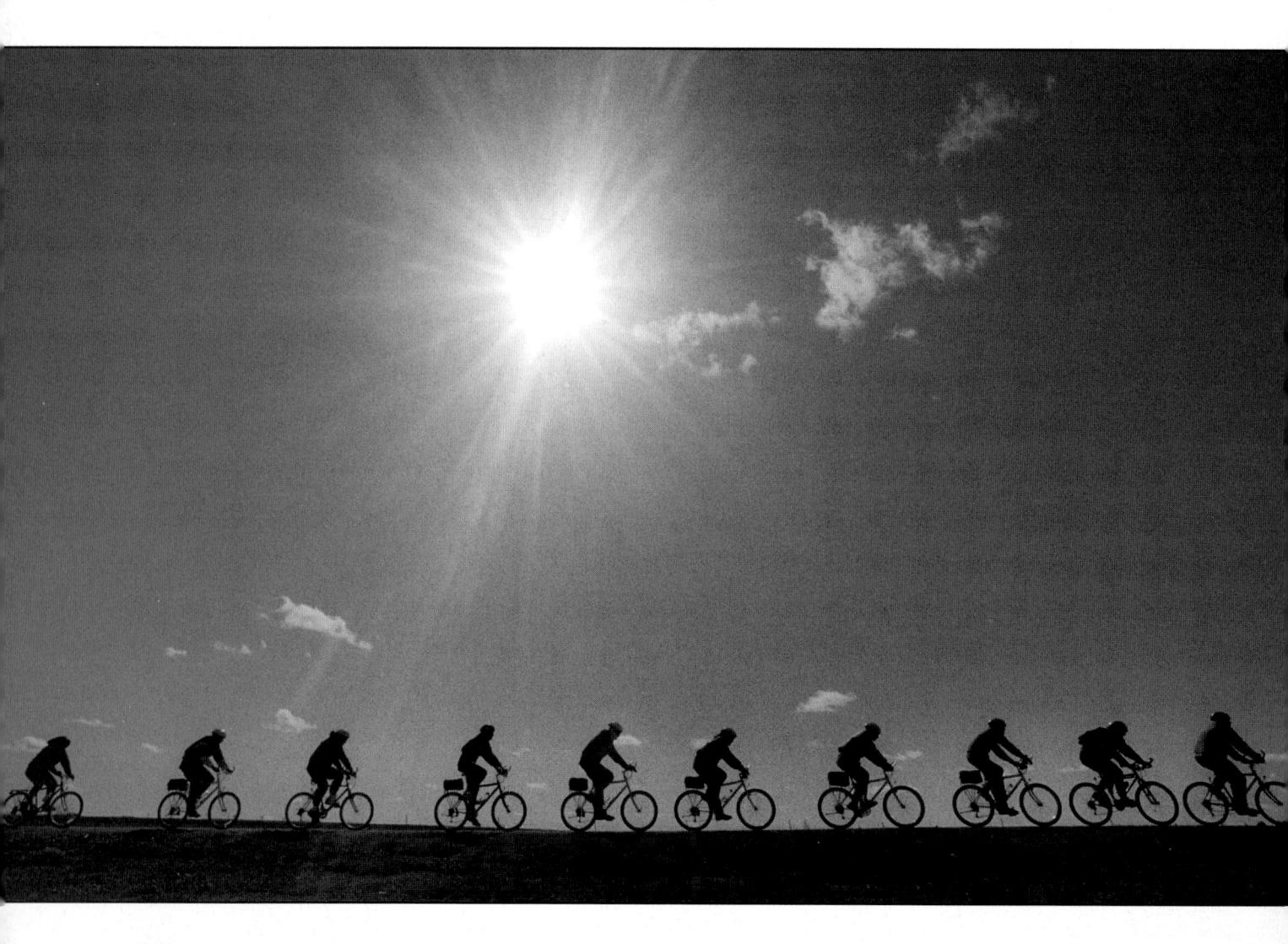

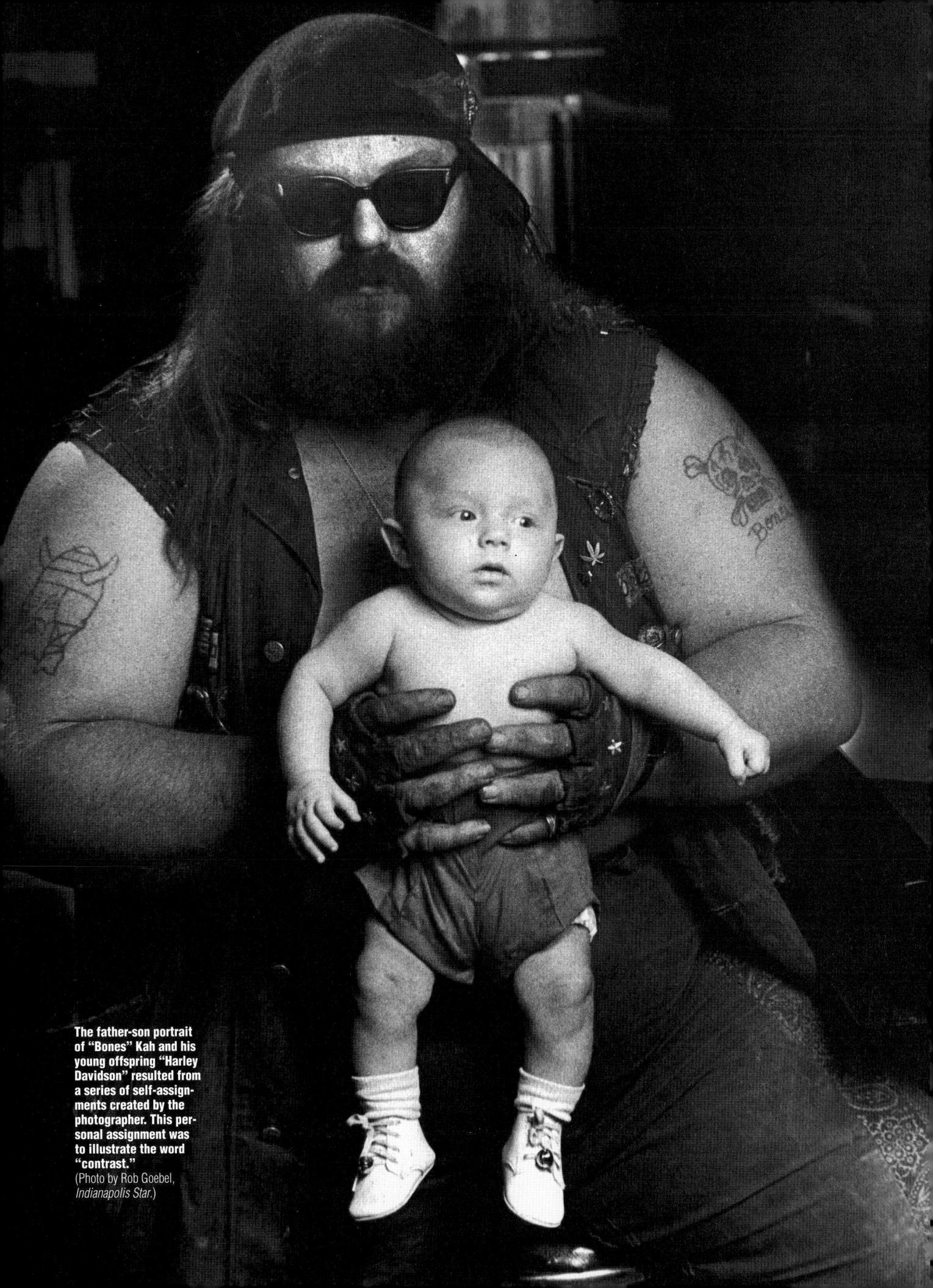

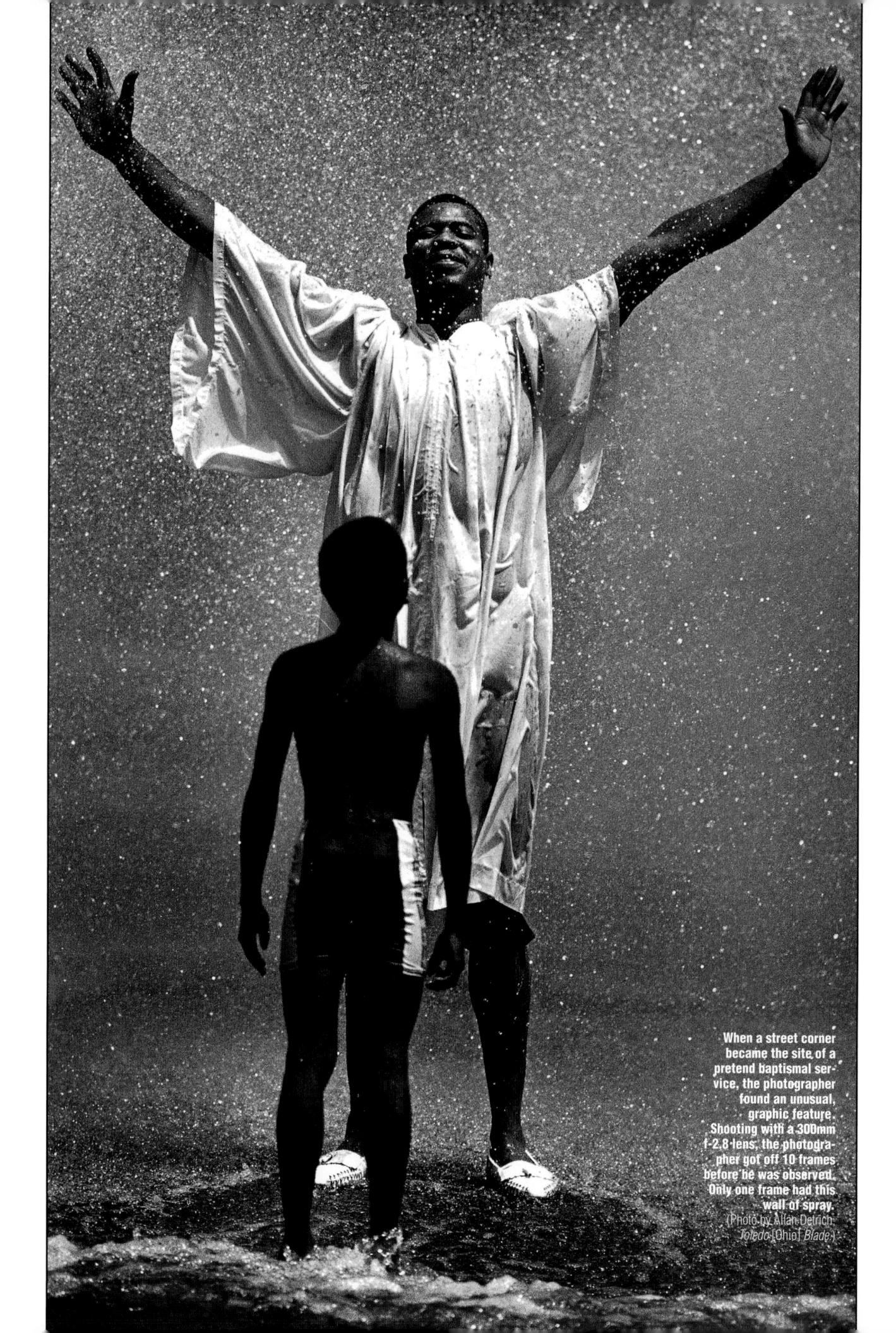

THERE MUST BE TWENTY WAYS TO FIND A FEATURE . .

You can make the most of your feature hunting time—and possibly have your image displayed on readers' refrigerators-by having an organized approach to looking for features. Here are some suggestions, in no particular order, to send you on your way.

- Head for a good cruising location such as the old part of town or a special neighborhood like Chinatown or Little Italy, where people are out and about.
- Keep an idea book containing pictures you admire as reminders to yourself of places or people that can make good subjects.
- Watch the calendar for upcoming topical days like the first day of summer, Flag Day, Secretaries Day, Dr. Martin Luther King, Jr., Day.
- Shoot from a unique vantage point such as the top of City Hall's dome, underwater at the town's pool, or beneath a trampoline.
- Collect news releases about upcoming events and activities that individuals or organizations are trying to promote.
- Give out your business cards and ask people to fax, call, or E-mail you with story suggestions or picture possibilities.
- Check the classified ads for people who are trying to sell belongings. You will find for sale everything from trained chimpanzees to antique art collections.
- Peruse events calendars for listings ranging from the opening of a science fair to the Gay Pride Parade.
- Get on the mailing lists of organizations—the more obscure the better. Ask them to send you newsletters and press releases.
- 10) Localize a national story or trend. If swing dancing is the rage in New York and San Francisco. is it happening on your campus or in your hometown, too?
- 11) Walk around a new neighborhood you have never explored before.
- 12) Select a word like "love" to capture in a picture. Then go looking for examples that reflect the word. A couple holding hands might come to mind, but see what other examples of this emotion you can find. Other words to try: contrast (see page 95), old and young, friendship.

- 13) "Firsts" can be funny. Time your arrival to catch the first day of school, the first time off the diving board at swimming lessons, or the first time to dissect a frog in biology class.
- 14) Seek out striking scenics. From Ansel Adams' "Moonrise Over Hernandez" to the National Geographic's sunsets in Saudi Arabia, scenics can be scintillating.
- 15) Dig out dangerous professions like high-wire walkers, test pilots, or lion tamers. You should also check out unusual, if not dangerous, professions: tea taster or flagpole painter come to mind.
- 16) Study the students at vocational schools. What's in the curricula at the mortuary academy, the hairdressing school, or the clown college, all listed in the yellow pages?
- 17) Simplify the world by looking for graphic photos like silhouettes, patterns, or shadows.
- 18) On your way to an assignment, take the time to stop if you see a situation that lends itself to a feature.
- 19) Experiment using unusual lenses like a fish eye, 600mm telephoto, or close-up macro lens.
- 20) Develop a feature beat. (See Chapter 4, "Covering the Issues," pages 68-72.) ■

A worker dusts off a William Rush sculpture titled "Silence." A portrait of **George Washington** oversees the ticklish situation. A funny juxtaposition of painting, statue, and feather duster transforms this common activity into a feature. (Photo by David Maialetti, Philadelphia Daily News.)

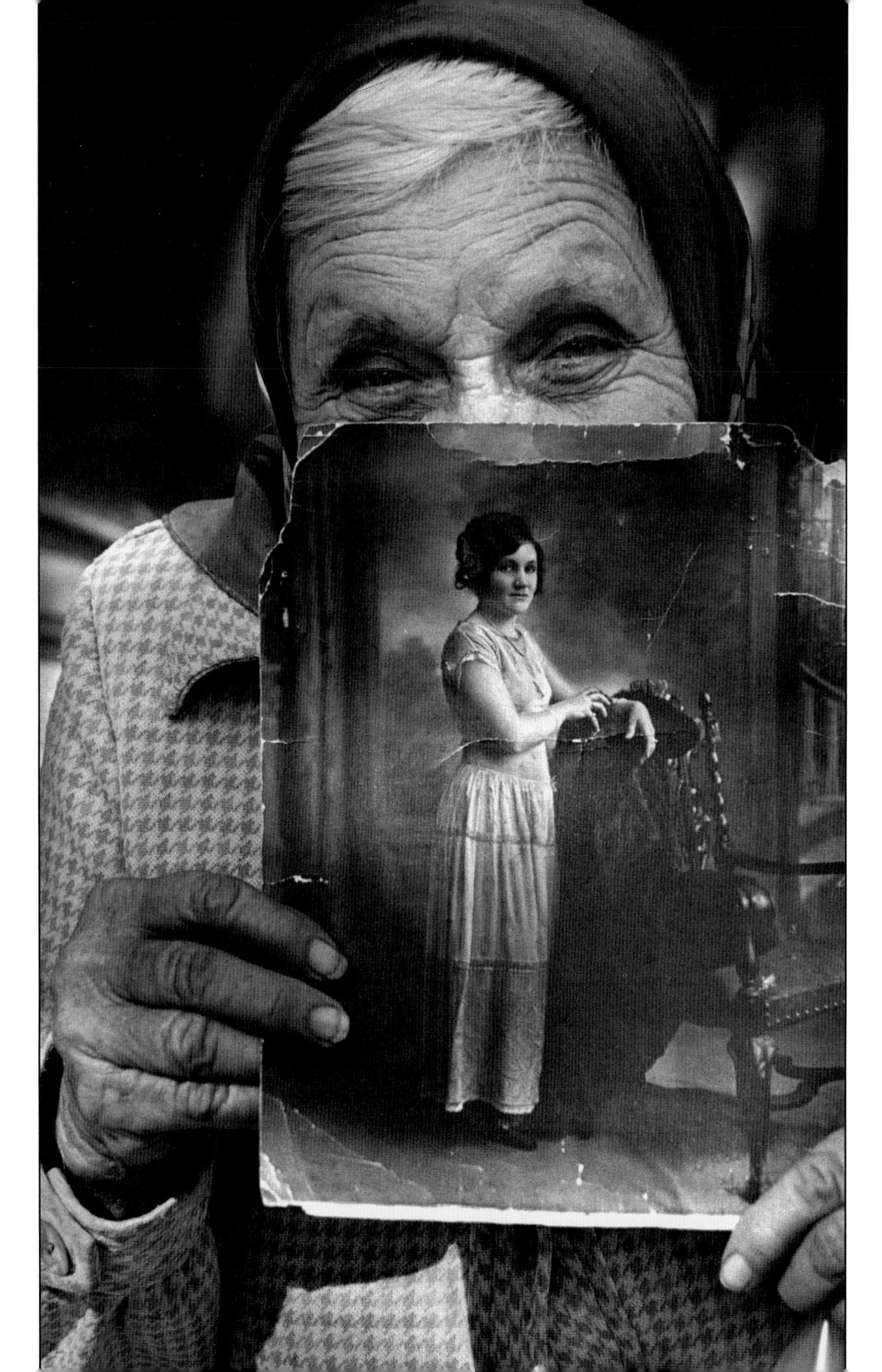

Portraits

THE JOURNALISTIC PORTRAIT

CHAPTER 6

he journalistic portrait of a scientist shouldn't look
like that of a steelworker. An aggressive personality
deserves a different portrait from the shy and retiring

type. To tell each person's story, photojournalists shoot both posed and candid portraits. Candid photography can produce honest, believable portraits without a lot of elaborate prompting, staging, or lighting, says Steve Raymer, the longtime staff photographer for the

By getting to know the woman through conversation, the photographer put her at ease. While talking, the woman pulled out a picture of herself taken many years ago. (Photo Timothy Bullard, Grant's Pass [Oregon] Daily Courier.)

National Geographic who now teaches at Indiana

University. "It's a matter of knowing the subject,

using the light, and waiting for the moment,"

he observes. (For more on candids, see Chapter 1 and Chapter 3.)

Even when they arrange elements for a portrait, photojournalists look for honest, candid moments. Nicole Bengiveno, who shoots for the *New York Times*, expresses the sentiment of many of her colleagues. "My favorite pictures are real moments when the subjects have forgotten you are there," she says. Indeed, shooting posed portraits is not a natural activity for many news photographers, whose instincts are to observe—not control.

Often, however, photographers have only fifteen minutes to take a portrait. As Richard Koci-Hernandez of the *San Jose Mercury News*, explains, "I'm in Silicon Valley. The computer geeks have become the movie stars of the 90s. Before they were famous, these guys would let me hang out for four or five days. Now they're superstars and won't give me the time."

Sometimes, only a portrait with the subject in a specific environment or with certain props will tell the journalistic story. Given

Catching a real moment gives intimacy to this portrait of a person with AIDs. (Nicole Bengiveno, for

Newsweek)

constraints like these, he says, "I hope for a candid moment within the posed situation."

PUTTING YOUR SUBJECT AT EASE

If someone doesn't feel comfortable in front of the camera, the best photojournalistic techniques in the world won't produce a revealing portrait. When a photographer disappears behind the camera, even if it is a relatively small 35mm, the shooter loses eye contact with the subject, who is left alone to respond to a piece of coated glass and a black mechanical box—not exactly a situation conducive to stimulating conversation.

Bengiveno of the *New York Times* can relate to people who freeze when faced down by a camera. "Every photographer should have a camera pointed at them," she says. "It is a scary feeling."

To understand the mindset of "the subject," Richard Koci-Hernandez photographed himself. "I took a lot of self-portraits so that I would know how uncomfortable it is to have your picture taken," he says.

Photographers develop different techniques to loosen up and relax their subjects. Keep in mind that an approach that works for one photographer might not work for you. Here are some choices to consider.

TALK IT OVER

One of the most enjoyable aspects of photojournalism is meeting different kinds of people. The most successful photojournalists research why their portrait subjects are in the headlines. During a shooting session, the talk usually turns to the person's involvement in the story. When people become engrossed in conversation, they often forget about the camera, which allows those candid "moments" in otherwise controlled situations.

"Ideally, I will talk to the subjects for fifteen to twenty minutes to find out what in their life might relate to the picture assignment," Koci-Hernandez says.

Then he asks them, "Where do you feel comfortable?" he says. "I take advice if people are willing to give it."

Smiley Pool of the *Houston Chronicle* enlists his subjects as collaborators. "How do you want to have your picture made?" he asks. "It's your picture."

The best ideas often come from his subjects, Pool says. "Other times, you have to dream something up."

The Austin American-Statesman's Sung Park also tries to get to know his subjects personally. "I start a normal conversation. I try to figure out their personality. I try to keep a conversation going while I set up my lights."
LOOK 'EM IN THE EYE

"When we put the camera to our eye it blocks our face," says David Leeson of the *Dallas Morning News*. "It's like staring down a gun barrel. I find it unnerving." Leeson solved the problem in a unique way. "I'm still using Nikon F2s and F3s [older camera models]," he explains. "I take the prism off. The camera is at waist level 75 percent of the time I am shooting portraits. This way, I can maintain eye contact."

Taking the prism off the camera allows Leeson to chat casually with the subjects while he shoots. "The subject can see my face and see my smile," he says.

Alfred Eisenstaedt, an original *Life* magazine staffer, avoided the disruption of picking up and putting down the camera by using a tripod and cable release. He put his camera on a tripod and focused, which freed him to talk directly and keep eye contact with his subject while taking pictures with the cable release. "For me," he said, "This method often gives the most relaxed pictures."

LET PEOPLE BE THEMSELVES

The secret to posing is to study your subjects, says Sibylla Herbrich. As photographer and photo editor of *The San Francisco Daily Journal*, her job for more than five years was to cajole fifteen minutes or so from the billable hours of busy attorneys to take their portraits for the legal newspaper.

"During the time you initially meet them and while you are setting up the lights or arranging the background, you can watch for the subject's natural body language," she says.

How do they hold themselves, erect or relaxed? Do they point with their fingers or make a fist? Which way do they tip their head? When they are relaxed, do they use one hand or two to hold up their head?

"Look to see how comfortable they are with their own body," Herbrich recommends. "Start by shooting the way they are naturally standing. Then, if they are frozen, hands rigidly at their sides and face pointed straight ahead, remind them of a gesture that you had

The director of the Ethnic Dance program was stiff and formal in her office. Once in the rehearsal hall, with the music playing in the background, she started to move to the beat. (Photo by Ken Kobré for the

(Photo by Ken Kobré for the San Francisco State University Annual Report.)

seen them use earlier." Although you are directing the person, the body position you suggest will be natural, not something you've imagined.

BE A BORE (BUT NOT A BOOR)

When you have time, the boredom technique works well; if you wait long enough, the subject often gets tired of posing, and you can shoot natural-looking photos that result in casual, relaxed portraits.

Arthur Grace, who has been a staffer for both *Time* and *Newsweek* and photographer for the book *The Comedians*, says, "Once you put people in a location, you just wait, and they will get lost in their own thoughts." Grace just sits there. "Maybe I'll take one frame to make them think that I've started, but I haven't." Eventually, the subjects get so bored they forget they are having their picture taken and they relax. That's when Grace goes to work.

Sibylla Herbrich of the *Daily Journal* says, "If I tell the person I am taking a break, they relax. I pretend to change film, for example. As soon as they are relaxed and think that the session is on hold, I start to shoot again."

For a variation on the boredom technique, Richard Koci-Hernandez uses a 4" x 5" camera. After situating his subject next to a strobe light, the photographer starts adjusting the swings and tilts on the camera he often uses for portraits. While waiting for him to fiddle with the controls, people begin to relax. "You get genuine body gestures," he says. "They rest their head into their hands. They turn their head away from the light just so. Then, boom, that is where I shoot the picture."

As the photo shoot seems to be coming to an end, the thoughtful photojournalist often looks for one more frame. The *New York Times*' Bengiveno says that sometimes when people think the picture session is over they let their guard down. "They might put their hand over their head," she says. "Then the real shooting session begins."

LET SOMEONE ELSE DO THE TALKING Because it's often difficult to work the camera and carry on a meaningful conversation simultaneously, some photographers find it valuable to shoot pictures while the subject is being interviewed. If an interviewer doesn't accompany you on an assignment, take a

A writer (left) and his subject were on a book tour. The photographer took the pair to the newspaper's studio and managed to get this lively reaction by kidding around with the subjects during the photo and interview session. The lighting for the portrait gives it a "high key" feel.

(Photo by Julie Stupsker

(Photo by Julie Stupsker, San Francisco Examiner.)

friend along. When no outsider is available, look for someone on location, like the subject's colleague, to whom he or she might enjoy talking. Involved in conversation, the subject thaws and becomes animated—and the resulting photograph is natural and not contrived.

USE LIGHT TO TELL THE STORY

Whether soft from the side or streaming in from above, light in all its various incarnations usually determines the picture's mood. When photographers shoot a picture that is lit brightly but has only a few shadows, the photo is called "high-key." (See opposite page.) They often employ high-key lighting for pictures of brides, for example, because they want the photo to have an upbeat mood.

When a more moody effect is desired, however, photographers often choose lighting that will leave large areas of the picture in shadow. The photo's dominant tones are dark gray and black (see below and pages 105 and 108). At night, a tough police chief might be photographed with the available light of a street lamp. The moody character of the lighting will coincide with the story's thrust.

For many photographers, the atmosphere created by light in a portrait is more important than any other element.

SEEING THE LIGHT

"I arrive fifteen minutes early to a portrait session," says Koci-Hernandez of the *Mercury News*. "I look for a beautiful shaft of light in the hallway. Then I put the subject in it and hope and pray for a candid moment to occur."

The San Jose photographer goes on to point out that "you can have everything working against you—background, uptight person. But if you have great light, everything will work out."

Like Koci-Hernandez, Nicole Bengiveno will use any light she can find. "There have been times I have used the headlight of a car, street lamps, or a table lamp," she says. The *New York Times* provides Bengiveno with fast Fuji Color 800 ISO film, so the quantity of light is not as important as its quality.

To find the right light and to catch her subjects in a more relaxed atmosphere, Bengiveno often will take people for a walk in the streets of New York. This allows her to

For this portrait of a centenarian, the photographer waited until the old man looked down at the child. The sidelighting and the right moment gave this picture its warmth.

(Photo by Sung Park, Austin [Texas] American-Statesman.)

spend some time with them and watch how they move. "When I walk with someone, I try to keep the session flowing," she says. "All of a sudden I will turn a corner and see some great light."

Bengiveno was assigned to photograph a person who claimed to have memories of being abducted by aliens. She walked the subject around the South of Houston (SoHo) section of New York looking for anything that suggested "otherworldliness."

"We found a loft building with a fire escape," Bengiveno recalls. "The sun was shining down, casting a shadow through the fire escape. The light gave the feeling of something emanating from above." While the shadows did not prove the existence of aliens, they did help shift the sense of reality, adding a haunting mood to the picture.

"I love discovering and finding things, being spontaneous," she says.

LET THERE BE LIGHT

David Leeson of the *Dallas Morning News* calls light his chief tool for shooting dynamic portraits. "My primary concern is the lighting," he says. "The background is secondary. The angle is my third concern."

"I want to use the light to draw people's eyes to and get them to pay attention to a certain part of the photograph," Lesson

says about what he calls his "multilayered" photographs.

"But in the process, I don't want them to miss the other layers. I want their eyes to flow from bottom to top."

Leeson has developed a strobe technique to guide the viewer's eye through a portrait. "I 'telephoto' my strobe so that I get a tunnel effect—a lot of fall off," he explains. "For the subject, I expose the strobe properly, but I generally underexpose my ambient light or background by one to two stops." Leeson holds the strobe off camera and aims it at the area in the foreground that he wants to light. By his choice of shutter speed, he dims the rest of the picture so it will come out a little darker than the light from the strobe. (See Chapter 13, "Strobe.")

UNDERSTAND LIGHT

To add depth to a subject's face, arrange the person so that the main light, whether it is from flood, flash, or window, falls toward the side of his or her face. Unlike direct frontal light, side light adds a roundness and three-dimensionality to the portrait.

Side light also emphasizes the textural details of the face—a technique especially suited for bringing out the character lines in a person's features.

Alternatively, Hollywood photographers

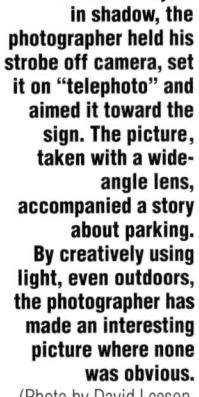

With the subject

(Photo by David Leeson, Dallas Morning News.)

light actors with a large flat light located near the camera's lens to eliminate shadows. Shadowless light, sometimes called "butterfly" lighting, tends to eliminate wrinkles, giving a youthful look to the portrait sitter. (See more on lighting in Chapter 13, "Strobe.")

COMPOSITIONAL ELEMENTS ADD IMPACT

COMPOSITION

CAN CONVEY CHARACTER

Suppose your editor assigns you to photograph a banker. You size up the situation and decide to show "The Banker as a Stable Person in the Community." You might want to position the person in the middle of the frame, lending balance and therefore dignity to the picture. You have used composition to help tell your picture story, conveying to the reader the point you wish to make about the banker.

Suppose, on another day, you must photograph the director of the Little Theater, an offbeat dramatic group. You want your picture of the director to be as exciting and tension-producing as a good Stephen King thriller. By placing the director of the theater on the edge of your viewfinder and leaving the remaining area black, you can produce an off-balanced picture that suggests added visual suspense.

The location of the picture and props in it tell the viewer something about a subject's profession, hobbies, and interests.

A portrait taken in a dark factory, with the worker holding a wrench, says something different about the sitter than a portrait taken in a pristine office with the accountant seated at a computer.

CLOSE-UP VS. SCENE-SETTER

The effect of the final picture changes, depending on whether the photographer fills the frame with the sitter's face or stands back for a full-length portrait. An extreme close-up, for instance, appears to bring the subject so near that the viewer gets the feeling of unusual intimacy with the sitter.

On the other hand, because body language and clothing help to reveal a sitter's personality characteristics, the photographer sometimes must take a step backwards to include in the composition the full length of the subject. Sometimes an overall photo can reveal more than a close-up showing only the face.

BACKGROUND AND PROPS HELP TELL THE STORY

Alfred Eisenstaedt, one of the original *Life* photographers, wrote, "By now I've learned that the most important thing to do when you photograph somebody in a room or

Often, a photographer can use dramatic light to capture a portrait. For a portrait of humor columnist Art Buchwald, the photographer used a low angle to pick up the just the rim light and reflection on the author's glasses. (Richard Koci-Hernandez, San Jose [California]

Mercury News.)

Eyes looking straight at the camera establish a strong bond between the reader and the artist in this picture. Also, this direct eye contact tells the reader that the picture is a portrait and not a candid. (Photo by Ken Kobré for the Boston Phoenix.)

outside is not to look at the subject but at the background."

Eisenstaedt would concentrate on the background behind the subject for two reasons. First, the background details help report the story. The sharecropper's rundown shack relates the farmer's problems. The plush office of a new corporate executive suggests one of the job's perks.

Second, the background affects a photograph's "readability." Readability means that the subject must not get lost in the details of the environment.

In a black-and-white photo, a dark subject can blend into a dark background, never to be seen again. If you photograph a whitehaired man standing in front of a light wall, the man's hair may seem to disappear into the wall. To avoid this, place the man in front of a dark wall and his hair will not disappear.

Because the world is colorful, the photographer shooting black-and-white film might not remember that a red-shirted Santa Claus might blend in with the green Christmas tree in the final image.

Though red and green are different hues, they can be of equal brightness, which means the film records them as nearly matching shades of gray. Santa Claus might look as if he were growing out of the tree in a blackand-white print. You can improve readability by choosing a background with a tone that contrasts with the subject. You could place Santa Claus in front of a light-toned wall, for instance.

Even in color, background is critical. A clashing, busy background can easily distract the reader from the subject of the photo. Light as well as tone, color, and background can help define and separate the subject from the background.

Direct some light to the back of the subject's dark hair and create a highlight that helps visually separate the subject from a dark wall.

PROVIDE CLUES TO THE "INNER PERSON"

Besides quality of the light and composition, other elements add to the storytelling nature of a portrait. A subject's face, hands, and body position reflect the psychological state of the sitter. Is the subject smiling or showing a grim face? Are his hands pulling at his beard or resting at his side? Is he standing confidently or shifting awkwardly?

FACE

Of all the elements in a photo, the face still carries a disproportionate amount of psychological weight. Studies show that children,

almost from birth, recognize the basic elements of a face, including the eyes, nose, and mouth.

Whether true or not, people assume that the face is the "mirror of the soul." If the face is the soul's reflection, then the soul is multidimensional. Even the most sedate face reflects a surprising number of variations. Take a thirty-six-exposure roll of film of one person's face as she talks about her favorite topic. Note the number of distinctly different expressions the person exhibits. Is one frame of those thirty-six pictures true to the nature of the person? Have the others missed the essence of the person's underlying character? The great portraitist Arnold Newman says in his book One Mind's Eye, "I'm convinced that any photographic attempt to show the complete man is nonsense. We can only show what the man reveals."

The photojournalist usually selects an image of the subject talking, laughing, or frowning, an action coinciding with the thrust of the news story. When a recently appointed city manager expresses fear about his new job, the photo might show him with his hand massaging his wrinkled brow. A year later, a story in which the city manager talks about his accomplishments might show him talking and smiling. The photojournalist's portrait doesn't reveal a person's "true inner nature" as much as it reflects the subject's immediate response to his or her present situation.

EYES

Where should the subject look? Early journalism portraits taken around the turn of the century showed the sitter staring into the camera's lens during the prolonged time exposures. During the Depression, Farm Security Administration subjects seemed always to gaze into space. Portraits taken during the 1960s and 1970s often showed the subjects looking as if they were in action, never noticing the camera's presence. Through the 1980s, portraits tended to return to the direct gaze.

Photographers felt that the viewer would be most involved with a portrait's subject when the two made eye contact. David Leeson of the Dallas Morning News continues to ask the subject to look into the camera. "I don't want any doubt in the reader's mind that this is a portrait," he says, echoing the sentiment of many photojournalists.

However, this convention—subject looking directly into the lens—is in the process of yielding to another. Confronting with so many subjects staring into the lens, some photographers in the late 1990s began returning to the Depression-era approach in

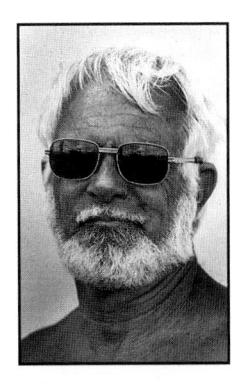

In black-and-white, the subject will appear to blend or pop out, depending on which background the photographer chooses.

For this portrait of John Singleton, writer and director of the movie "Boyz N the Hood," the photographer took the subject to South Central Los Angeles, where the story was set. The "Watch Tower" in the background is a landmark for the area. For a dramatic "low key" effect, the photographer aimed a single light at the director's face and left the rest of the picture in deep shadow. (Photo by Michael Grecco, Inc., for LA Style; the photo also appeared in Entertainment Weekly and Vibe magazines.)

which the subject looks away from the camera into the distance. "Sometimes I have the subjects looking away," says Bengiveno of the *New York Times*. "Sometimes I have them looking over their shoulder. It depends on what feeling I want."

Like other stylistic variables that contribute to this kind of picture, this new convention is likely to change as well.

BODY LANGUAGE

Hands help tell the news in a nonverbal way. A news photographer covering a speech won't even bother to click the shutter until the lecturer raises a hand to make a point. When shooting a portrait, watch the individual's hands as she toys with her hair, holds her chin, or pushes up her cheek. A person chewing his fingernails reveals a certain amount of tension about the situation in which he finds himself.

Desmond Morris' excellent book, *Manwatching: A Field Guide to Human Behavior*, is a terrific tool for improving your observational skills. Morris documented various types of gestures and signals that people use to express inner feelings. The way

an individual stands, whether as straight as a West Point cadet or as bowlegged as a cowboy, provide clues about the subject's upbringing. Studying ways people communicate nonverbally can sensitize you to good picture possibilities.

PRECONCEIVING THE PHOTO

When assigned to shoot a portrait, many photojournalists go to great lengths to imagine how a picture might look before they ever arrive on the scene.

Richard Koci-Hernandez of the *San Jose Mercury News* says he almost always has some kind of preconceived notion when he approaches a portrait. "Sometimes you have to illustrate a point," he says. "If a scientist has invented a new baseball bat, I know I am going to need the bat in the picture."

To stay fresh, Koci-Hernandez maintains an idea book. "I clip out portraits from magazine and newspapers," he explains. "I keep the pictures in a binder and flip through the book before I go into a portrait session." The book serves as an inspiration and an idea bank, he says.

Michael Grecco, assigned to photograph

This piece by Piet Mondrian, "Composition," shows the distinctive lines and rectangular blocks the painter used to compose his paintings. (The Museum of Modern Art, New York, The Sidney and Harriet Janis Collection.)

For this portrait of Piet Mondrian, the photographer used sheets of paper and a painter's easel to reflect the artist's painting style. A comparison of the artist's work (ABOVE) shows the inspiration for the photographic portrait.

Quentin Tarantino for *Playboy* magazine, was inspired by the sight of some old electrical apparatus he spotted in a prop shop. He knew instantly he would use it for his picture of the "high voltage" director (page 109).

ENVIRONMENTAL DETAILS TELL THE STORY

From a studio portrait, or even from a photograph of an individual animatedly engaged in conversation, the viewer can't tell a banker from a bandit, a president from a prisoner. The wrinkles of a brow or the set of the eyes reveal little about a subject's past, profession, or newsworthiness. An environmental portrait, however, supplies enough details with props and choice of background to let the reader know something about the lifestyle of the sitter. In an environmental portrait, the subject is photographed at home, at the office, or on location, whichever place best reflects the story's theme. As in a traditional studio portrait, the environmental photo generally has the subject look directly into the camera. But rather than sitting the subject before a plain seamless paper background, as in a studio portrait, an environmental portrait positions the person amid the everyday objects of his or her life.

ARNOLD NEWMAN: SYMBOLS REINFORCE THEME

Arnold Newman, a master of the environmental portrait who has taken the official photographs of U.S. presidents, outstanding artists, and corporate executives, often arranges his portraits so the background dominates. The subject in the foreground is relatively small. In fact, one famous portrait of Professor Walter Rosenblith of the Massachusetts Institute of Technology shows him wearing headphones with an oscilloscope in the foreground and a mazelike baffle system in the background. His face takes up a small percentage of the picture with the lines of the experimental chamber occupying the rest of the area.

Newman says that the subject's image is important, "but alone it is not enough. We must also show the subject's relationship to the world."

The power of Newman's photos lies in his choice of symbolic environmental details that not only show the sitter's profession but also the style of the sitter's work. For example, Newman photographed the modern artist Piet Mondrian at his easel. The artist is known for his exploration of pure shape and color (see opposite page). By creating a composition with the vertical bar of the easel juxtaposed against rectangular shapes on the wall,

Newman's portrait of Mondrian suggested the artist's own style.

Although Newman might not think of himself as a photojournalist, his approach to the portrait is reportorial. He goes beyond the lines in the subject's face to tell his audience something about the person's work and life.

Technically, the environmental portrait does not differ from any other portrait. The photographer can use a normal or, if necessary, a wide-angle lens. Because the photographer wants to record the environmental background sharply, maximum depth of field is needed. You can increase the depth of field by stopping down the aperture to a smaller opening. This, however, requires a longer shutter speed. Using the camera on a tripod gives the photographer freedom to use longer exposures—if the subject can hold still.

PSYCHOLOGICAL PORTRAITS

ANNIE LEIBOVITZ:

BUILDING A PORTRAIT

For portraits of actors like Tom Cruise or Meg Ryan, the reader has a frame of reference—the famous face has been on television, in the movies, and on magazine covers. By the time Annie Leibovitz, who has shot many covers for *Rolling Stone* and *Vanity Fair*, photographs a celebrity, the viewer probably has read about the person in magazines or heard interviews on talk shows.

Leibovitz tries to go past a topographic map of the face. Her pictures ask the questions: What makes this person famous? What is the psychological factor that separates this individual from others in the field?

Leibovitz is not interested in showing the viewer details of the subject's life or lifestyle. She does not depend on found items in a celebrity's house or office on which to build the picture like Arnold Newman. She is not waiting and watching for a candid moment in the style of Cartier-Bresson. Rather, she imagines what the picture ought to look like. Then she creates that look.

For instance, Leibovitz photographed Dennis Connor, captain of the winning America's Cup racing team, wearing a red, white, and blue shirt, wading in a pond, sailing a toy boat. Although the America's Cup challenge represents millions of dollars in investments and winnings, the picture caught Connor's little-boy spirit. Leibovitz did not happen upon Connor wading one afternoon in the pond. She and her stylist bought the props, dictated the clothes, and located the perfect pond.

Leibovitz builds rather than takes a picture. In conjunction with the subject, she dreams up a visually startling way to portray that

In this daring and stylistically original portrait of the Beatles' John Lennon and his wife Yoko Ono, the photographer explored the couple's intense psychological relationship. (Photo by Annie Leibovitz, Rolling Stone.)

individual. Leibovitz, for example, photographed the African-American comic Whoopi Goldberg in a white bathtub filled with milk. She persuaded John Lennon to lie, nude, curled in a fetal position around his wife, Yoko Ono. Leibovitz's pictures lie somewhere between psychological portraits and photo illustrations.

Her mannered, stylized approach has influ-

enced many other magazine and newspaper photographers.

GROUP PORTRAITS

SHOW ALL THE FACES

A prime requirement of a formal group picture is that it shows, as clearly as possible, each person's face. This takes careful planning. Arranging people shoulder-to-shoulder

might work, but if the group grows to more than a few people, the line will be excessively long and each person's face will appear quite small in the final print.

Instead, you could arrange the people in rows, one row behind the other. Typically, you want to have the short people in the front and the taller ones in back. With an extremely large group like a band or a football team, you have little choice but to arrange the members, military style, at different levels but in a fixed formation.

SOFT LIGHT IS BEST

For group portraits, soft light that creates the minimum of shadows is usually the most effective. If you can, avoid lighting that creates strong, well-defined shadows typical of a bright, sunny day. When you must take a large group portrait on a perfectly clear day, look for the open shade of a tree or large building to provide even lighting.

ADD ZEST

TO SMALL-GROUP PORTRAITS

Try different levels. When the assembly is limited to between three and eight members, creativity is possible. Try to keep each person's head on a different level. With a combination of kneeling, sitting, and standing, you usually can arrange an attractive juxtaposition of heads so that each is spatially located on a different elevation. The closeness of the bodies holds the picture together as a unit; the staggered arrangement adds visual interest.

Dress them alike. A group of clowns in costume could lighten up a graduation picture at the Ringling Brothers Clown School.

Hand 'em props. A cooking class holding spatulas and saucepans would serve up a picture of their activities.

Watch the background. Women welders in front of the foundry where they work would reinforce the viewer's understanding of this group's profession.

Pose to carry information. A group of teenagers slouching in front of a low-slung car tells a different story than the same group posed sitting in classroom chairs.

TIMING IS EVERYTHING

Henri Cartier-Bresson told this story to Russell Miller for Miller's book *Magnum: The Story of the Legendary Photo Agency.* Cartier-Bresson had been asked to photograph Simone de Beauvior, the French writer/philosopher and author of *The Second Sex.* "She wanted me to take the photo, and she said to me, 'I am rather in a hurry, how long will you be?' And I said just what came into my head: 'A bit longer than a dentist, but not as long as a psychoanalyst."

Apparently, that was the wrong length of time for a portrait because Cartier-Bresson never got the picture.

Knowing the location of the door is just as important as knowing the location of the shutter. With a few frames left at the end of the roll (just in case), you should pack your gear before you wear out your welcome. Photographers have a bad reputation for asking for just one more picture.

Leave in good standing with your subjects because you never know when they will be in the news again and you will need to make a new portrait.

In a group portrait, try to stagger the placement of heads to allow each to occupy a different level. This arrangement maximizes the size of each face.

(Photo by Vincent S. D'Addario, Springfield [Massachusetts] Newspapers.)

For a creative group portrait of San Jose State University's Spartan Daily photo staff, everyone jumped into the university's long-awaited new pool for an underwater picture. After many tries, the photographer was able to get a photo of the whole staff at the same time.

(Photo by Michael Burke, Redding [California] Record Searchlight.)

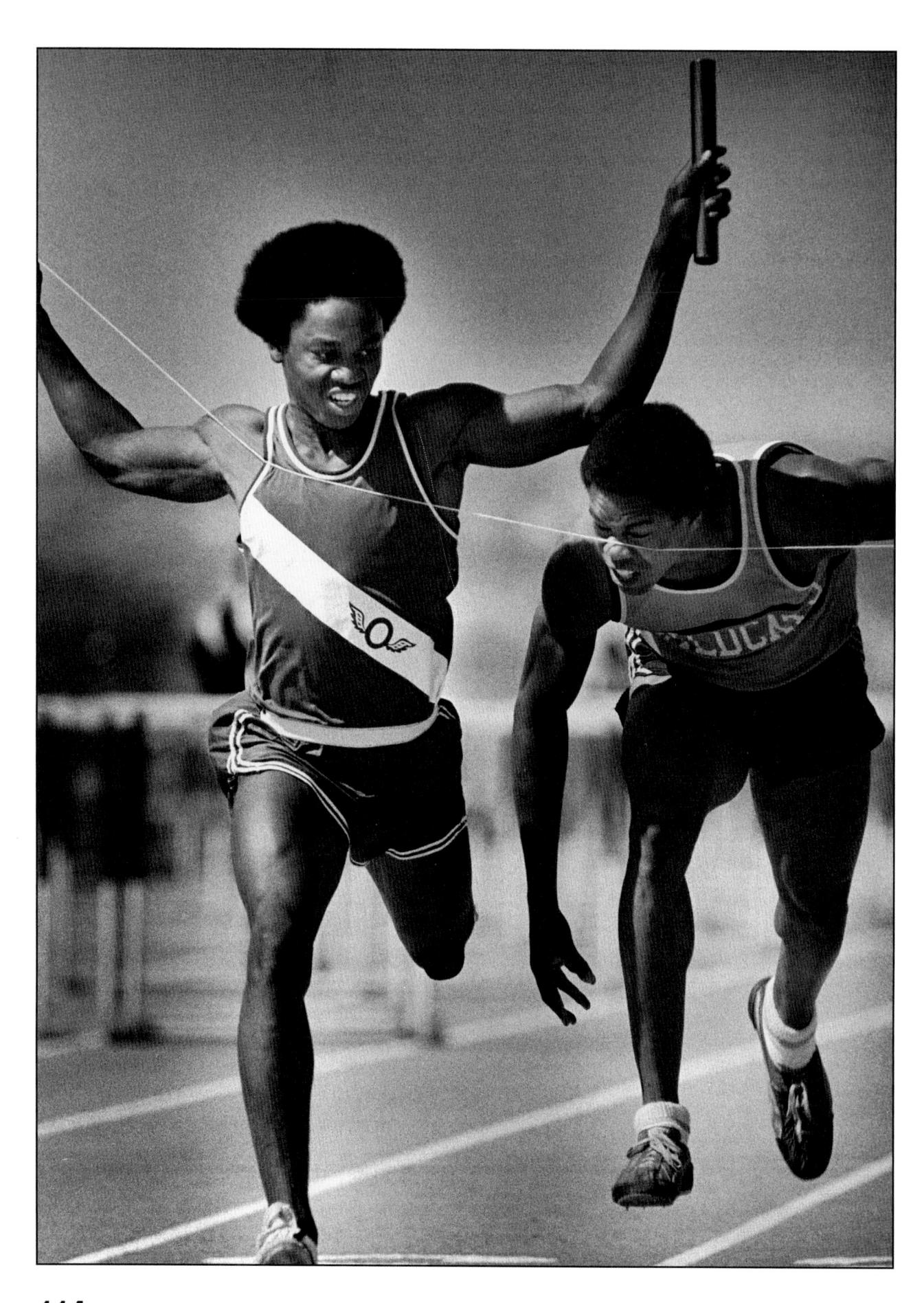

• Photojournalism: The Professionals' Approach

Sports

SPORTS AS NEWS

CHAPTER 7

ports photographers are like athletes. They must have the aim of a football quarterback, the reflexes of a basketball guard, and the concentration of a tennis player.

Sports photographers talk about getting in slumps just as baseball players who are having trouble at the plate get into ruts.

"At the beginning of the season I'm rusty," says Brad Mangin, a sports freelancer whose clients include *Sports Illustrated* and the

By zone-focusing on the finish line, you are guaranteed a sharp photo of the winning runner. A check of your depth-of-field scale will tell you how far the range of sharpness in the picture extends. (Photo by Patrick Downs, Los Angeles Times.)

National Basketball Associated Photos.

"After a few games I get into the groove."

Some newspapers rotate their staffs on sports

assignments, so it's hard for them to find a "groove."

Just as players on the field cannot afford to lose their concentration, so photographers on the sidelines must be aware of every subtle movement in the game. Mangin tries to avoid talking to other photographers on the sidelines but sometimes slips up. "I was socializing with Kim Komenich from the [San Francisco] Examiner," he confides, "and we both missed a key play at last week's home opener." Pam Schuyler, who photographed for the Associated Press and produced a book about the Celtics basketball team, says that she won't even sit next to other photographers when she is shooting basketball because the other photographers distract her too much.

TIMELY PHOTOS PARAMOUNT

Sports photographers strive to capture in a unique way the fast-paced action and drama of competition. A good sports photo and a well-written news story have similar characteristics: both are timely and both have high reader interest.

Timeliness in a sports picture is essential. Nobody cares about a week-old game score, but millions of viewers stay up to see scores on the eleven o'clock newscast. Interest is so high in sports that millions of people watch the World Series on television, and even more see the summer and winter Olympics.

Sports is big business, and the financial side of football or baseball rates as much attention as any other business story. Players are bought, sold, and traded for millions of dollars: clubs approach the bidding block, ready to spend millions for promising superstars. Readers want to see pictures of these superstars sinking a basket, knocking a home run, or winning a marathon. Editors are aware of this star-gazing. "A paper is more likely to run a picture of a top star hitting a home run than a lesser player doing the same thing, even if the pictures are equally good," George Riley, a longtime wire photographer once observed.

So sports photographers have to become sports fans; they must read about sports regularly to learn who the top stars are, and what newsy things have happened to them lately. Frank O'Brien, who shot for the *Boston Globe* for many years, would comb the paper's sports pages every day to pick up information on a player he might have to cover. He looked for stories about injured players and major trades, about fights and feuds among players and between players and coaches, about impending records, and about disputes over money. O'Brien also

would study the paper to see if a player was having a hot streak that week. This news angle adds an extra dimension to a sports photo. Also, if a player is making news on the sidelines, readers want to see how the athlete is performing on the court or the field.

When Hank Aaron hit his 715th home run to break Babe Ruth's career record, every camera in the stands clicked because the event was big news. A broken record is history in the making. As sportswriter George Sullivan once said, "One job of the newspaper is to record history." In baseball, especially, there seems to be an almost endless array of records to break. Surely, the record book has listed the left-hander who had the most hits during an out-of-town night game pitched by a southpaw.

Photographers can't memorize the record book, so they should check with the team statistician before every game to see if any new records are likely to be broken. A recordbreaking homerun or free-throw might be the most newsworthy moment of the game, and an editor will want to see a picture of it.

SUMMARIZING THE GAME IN ONE PHOTO

A sports story's lead usually contains the names of both teams or players and the outcome of the game. It also describes the game's highlights—the turning point or winning goal, the star of the game, and injuries to important players. Knowledgeable sports photographers follow the game closely enough that their pictures complement the story's lead.

"I always try to develop the lead picture that will parallel the thrust of our wire story," explains George Riley. "The wire service will often play up the top scorer in the game, so I will need a picture of him in action." If a particular play changes the course of the game, the photographer should have a shot of this play on film.

A good sports photographer watches the action but doesn't stop when the final whistle blows. Sometimes the expressions on the athletes' faces after

a tense meet tell the story better than an "action" shot.

Sports shooter Mangin says that at the end of a game, he looks for the crowd's elation or anything else that will characterize the game's emotional flavor. "If you are Thinking he had won, the biker on the left raised his hands just before the finish line. The biker on the right passed him at that moment. This sports news photo leaves no doubt in the viewer's mind which cyclist won the race.

(Photo by Scott R. Linnett, San Diego Union-Tribune.)

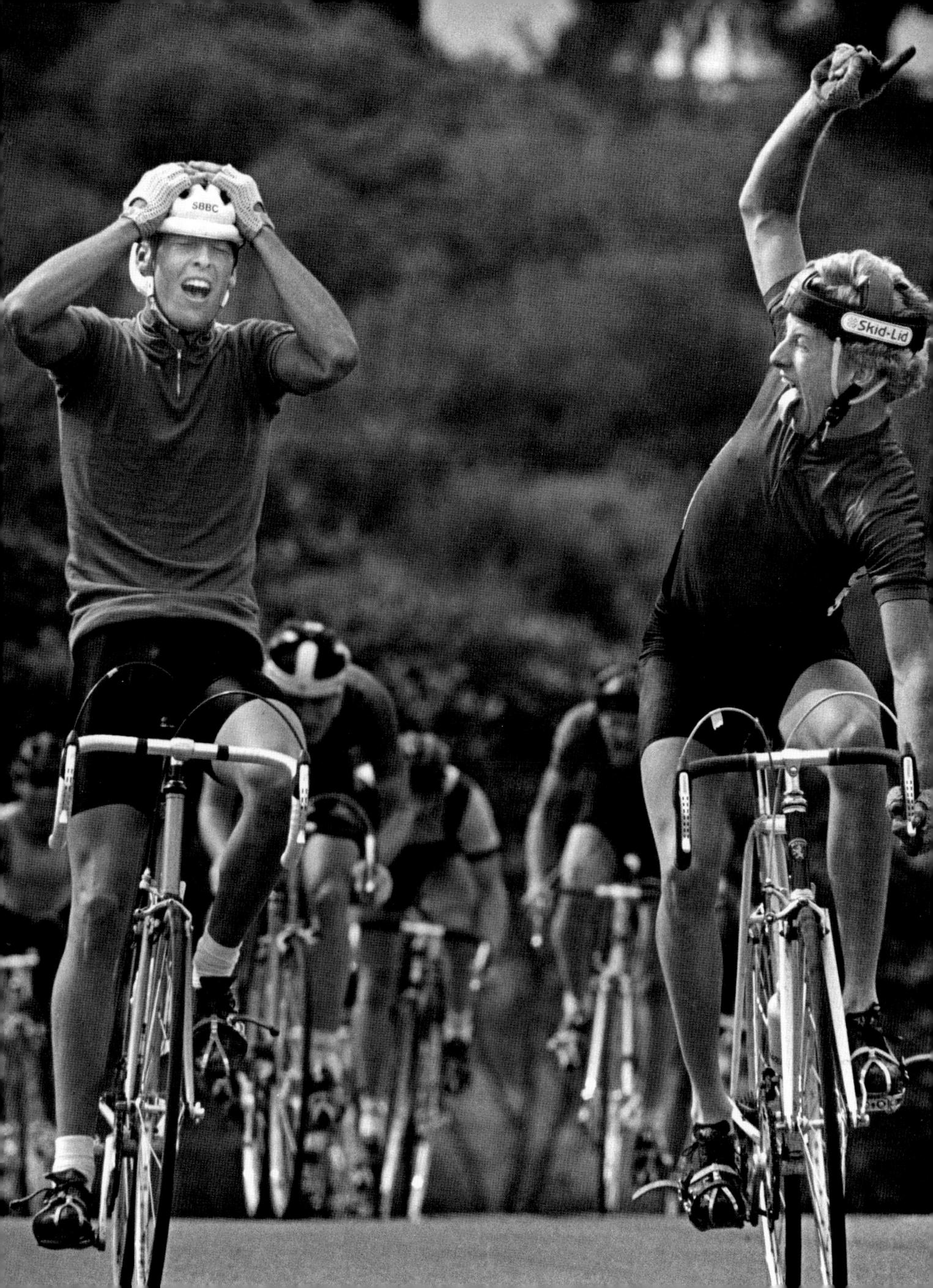

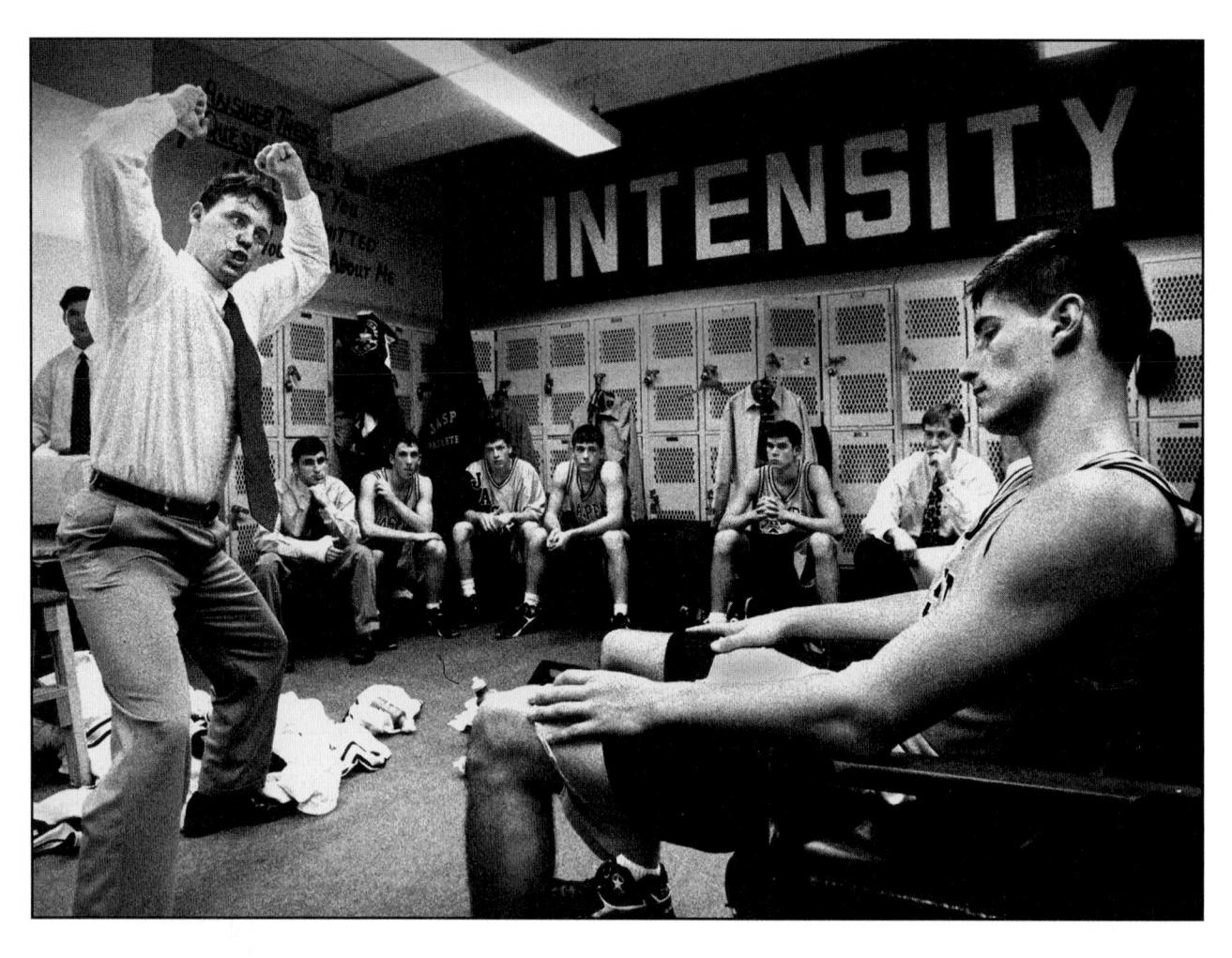

Sometimes a photographer will find the contest's revealing photo in the locker room rather than on the court. This first year coach tries to inspire his starting center during a half-time pep talk. Despite the seeming lack of "intensity," the pep talk worked, and the team broke its five-game losing streak.

(Photo by Aristide Economopoulos, *The Jasper* [Indiana] *Herald*.)

working for the hometown paper, you need to photograph the jubilation or dejection at the end of the game," Mangin says.

These pictures will often tell more about the outcome of the game than the peak action. With the action picture, you don't know who won unless you have the key play, Mangin points out.

CATCHING REACTIONS ON AND OFF THE FIELD

Sports photographers look for the interesting, the unusual, the emotional, and the unexpected, both on and off the field. What's happening on the bench can be as interesting as what's happening on the field. Watch the field and the sidelines simultaneously. You might lose some action plays sometimes, but you will get great emotional, storytelling pictures this way.

Coaches are under tremendous pressure because their jobs are on the line every time the team takes the field.

A picture of a coach pacing the sidelines, yelling at the referees, or jamming his finger at other coaches can reveal his underlying tension. Players feel that same pressure.

The clenched jaw of a player sitting on the sidelines or the wince of an athlete wearing a cast could also tell the evening's story.

CAPTIONS NEEDED

Whether the picture shows critical action on the field or reactions off, photographers must have complete caption information. The caption, as it is called in a magazine, or cutline, as it is known in a newspaper, is the explanatory line of type usually found below the printed photograph.

If it is not obvious from the picture, a caption should answer the five Ws plus the H: Who? What? When? Where? Why? and How? Readers will know whether the photo depicts a basketball game. But they might not know when in the game the picture was taken, the identity of the players, or the significance of the play.

A photographer's nightmare is to bring back 200 shots of a game, develop the negatives, select one frame with excellent action, and then not know the players' names, what happened, or when the action took place. Fortunately, players wear large numbers on their uniforms. If the numbers are visible in

the print, the player can be identified by matching the number against the roster list in the program. To determine when the play occurred, take a picture of the scoreboard after each major play or at the end of each quarter. By working backwards on the roll from the scoreboard frame, you can tell when each shot was taken and which play led to which scores.

Play-by-play statistics sheets, available from officials after the game, also help photographers write accurate captions. Besides shooting frames of the scoreboard, sophisticated sports photographers usually take notes during the game. In baseball, there is time to record each play if you use a shorthand notation (for example, FB = first base, HR = home run). In football, jot down a short description after each play. Riley comments, "Keeping track of the plays can get tricky at times. This is where newcomers usually have the most trouble in sports photography." (See Chapter 10, "Photo Editing," for more on caption writing.)

SPORTS AS FEATURES

Sports might be as timely and may command as much reader interest as any story in the newspaper. But sports events aren't hard news—they're entertainment. A football game, no matter who wins or loses, is still a game.

You might have a side bet resting on the World Series, but the outcome of the game will not affect your life beyond giving a moment's elation or depression (unless, of course, you've staked your savings on your favorite team).

When looking for features, draw your lens away from the field action to view the fans in the stands. Die-hard fans go to great lengths to show their support for the hometown team. From funny signs to outrageous outfits, fans come prepared to root or rout the players of their choice.

Players themselves can also provide grist for funny pictures. For many athletes, the pleasure of playing has never been lost. During the game, keep your eye on the dugout or the bench.

Try to get into the locker room before or after the contest is over. In the picture on the opposite page, Aristide Economopoulos of the *Jasper* (Indiana) *Herald* found the interaction among the players and coach a more telling summary than most action pictures.

The news approach to sports usually involves getting sharp, freeze-frame action shots of players hanging suspended in midair, grasping for the ball. Sometimes this literal approach robs the sports photo of its most vital element—the illusion of motion. A more impressionistic feature approach can add drama and reinforce motion in a still

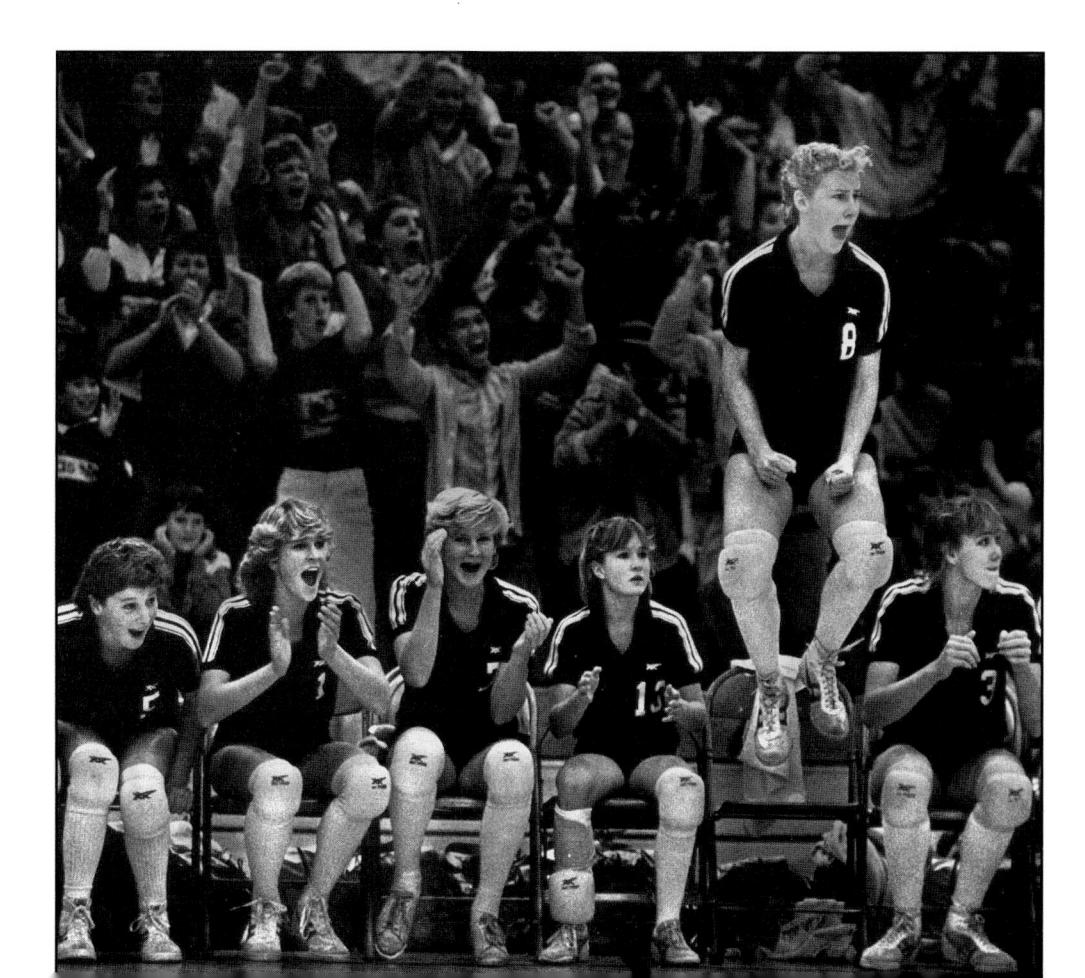

Good sports photographers keep an eye on the bench as well as on the action. (Photo by Lui Kit Wong, Virginian-Pilot.)

Type of Motion	Speed	Camera-to-Subject Distance				
		25 feet	50 feet	100 feet		
Very fast walker	(5 mph)	1/125	1/60	1/30		
Children running	(10 mph)	1/250	1/125	1/60		
Good sprinter	(20 mph)	1/500	1/250	1/125		
Speeding cars	(50 mph)	1/1000	1/500	1/250		
Airplanes				1/500		

photograph. Certain camera techniques can heighten the effect. A sports photographer might pan a cyclist's action by setting the camera on a slow shutter speed and following the subject with the lens, intentionally blurring the background while keeping the subject sharp. (See opposite page.) Such a picture can have more impact than would a traditional news photo of the winner of the bicycle race, in razor-sharp detail, crossing the finish line.

In a sports feature photo, photographers ignore the critical winning moment in favor of capturing the atmosphere of the event. Impressionistic pictures of this kind transcend the actual event and become a universal statement about the sport. A bone-crushing tackle made by a football player may resemble a delicate pirouette when captured by a skilled photographer. In *Man and Sports*, a photo exhibit and catalogue produced by the Baltimore Art Museum, the outstanding sports photographer Horst Baumann said that there is an increasing appreciation for the impressionistic, nonfactual but visually elegant portrayal of sports.

TECHNIQUES OF THE SPORTS PHOTOGRAPHER

FREEZING ACTION

Sports photography requires specialized technical skills because of the speed at which athletes move and because of the limitations of position imposed on the photographer. To stop motion in action sports like baseball, football, and basketball, photographers try to shoot with a shutter speed of at least 1/500 sec.

Says Eric Risberg, a top sports shooter for the Associated Press, "The slowest I ever shoot is at 1/500 sec. At a 1/1000 sec., things get a lot sharper."

Four factors affect the apparent speed of a subject and therefore determine the minimum shutter speed to stop motion:

- 1) the actual speed of the subject;
- 2) the apparent distance between subject and camera;
- 3) the focal length of the lens; and
- 4) the angle of movement relative to the camera's axis.

Speed

You will need a faster shutter speed to stop or freeze the action of a track star running a

Minimum Shutter Speeds Required to Freeze Action													
	Speed of Car		Distance to Car		Direction of Car			Lens Focal Length					
Speed of Car (mph)	25 mph	50 mph	100 mph	50 mph	50 mpt	50 mph	50 mph	50 mph	50 mph	50 mph	50 mph	50 mph
DISTANCE FROM CAR TO CAMERA	100' 50' 25'			((()				(T)					
*	٠	-	-	_	-	-	•	-	-	-	Wide	A Normal	Tele
Shutter Speed		1/250	1/500	1/1000	1/250	1/500	1/1000	1/250	1/500	1/1000	1/250	1/500	1/1000

100-yard dash than you will to stop the action of a Sunday afternoon jogger. To freeze a sprinter, the shutter must open and close before the image of the runner perceptibly changes position on the cam-

A To retain a sense of movement in this still photo of an antique tricycle, the photographer panned the camera and exposed the film for 1/15 sec. as the cyclist pedaled by.

(Photo by Ken Kobré, for the Boston Phoenix.)

era's image plane. Therefore, the faster the subject runs, the faster the shutter speed you will need to stop the action and avoid a blurred image.

Distance

A second factor affecting the final image is the camera-to-subject distance. If you stand by the highway watching speeding cars go by, you may observe them zoom rapidly past you; but when you move back from the edge of the highway 100 feet or so, the apparent speed of the cars is considerably less. Speeding cars on the horizon may appear to be almost motionless. Translated into shutter settings, a general guideline for this effect is that the closer the camera is to the moving subject, the faster the shutter speed needed to stop or freeze its movement.

Lens length

Whether you get the camera closer by physically moving it toward the subject or remaining stationary and attaching a telephoto lens, thereby bringing the subject apparently closer, you must increase your shutter speed to freeze the action. Suppose you are 50 feet away from the track with a 55mm lens. A shutter speed of 1/500 sec. would be adequate to get a sharp picture of a car going 50 miles per hour. However, if you keep the same lens but move forward to within 25 feet of the railing, you must set the shutter at 1/1000 sec. to freeze the car's movement. If you change from a 55mm to a 105mm lens but still remain at the 50-foot distance, you would still have to use 1/1000 sec. shutter speed (see charts on opposite page).

The rule is this: when you halve the apparent camera-to-subject distance, you need to double the shutter speed to get the same representation of motion.

Angle

The angle of the subject's movement relative to the axis of the camera also affects your choice of shutter speed. A car moving directly toward you may appear to be nearly stopped because its image moves very little on the image plane in the camera.

Yet the same car—moving at the same speed, but this time moving across your line of vision—appears to be traveling quite rapidly. This phenomenon means that if you position yourself to photograph a car 50 feet away going 50 mph moving directly toward you, you would need only 1/125 sec. shutter speed to stop the action. From the same distance, the same car moving across your line of vision would require 1/500 sec. to stop the motion.

PEAK ACTION

With some movements, it is possible to stop the action at a relatively slow shutter speed by timing the shot to coincide with a momentary pause in the subject's motion. Athletes come to almost a complete stop at the peak of their movement. Consequently, you can use a relatively slow shutter speed and still get a sharp picture. In track, for example, when a high jumper reaches the apex of his leap directly above the bar, his vertical motion is over. He can't go any higher, and, for a split second, his vertical motion ceases before gravity pulls him back to earth. A basketball player shooting a jump shot follows the same pattern: he leaps into the air,

A To freeze the action for this head-to-head soccer shot, the photographer needed a shutter speed of at least 1/500 second. (Photo by Pete Erickson, Dubuque [lowa] Telegraph Herald.)

reaches his peak, hesitates, and then shoots the ball before he begins dropping back to the floor. A pole vaulter's leap is another example. You can use a slower shutter speed to stop action at the peak of the vault by anticipating where the peak will occur and waiting for the athlete to reach the apex of the arc.

PANNING

While a fast shutter speed allows you to catch the action of the play, the resulting frozen figure may not capture the essence of the sport. Freezing a player in midair can rob the photo of any illusion of movement.

To solve this problem, you can use a technique known as panning: use a slow shutter speed and follow the subject during the exposure. This technique produces a picture with a relatively sharp subject but a blurred and streaked background. A pan shot is dramatic and can make even the proverbial "Old Gray Mare" look like a Triple Crown winner running at breakneck speed.

On sports assignments for *Life* magazine and *Sports Illustrated*, Mark Kauffman has used the panning technique on several different events. In *Photographing Sports*, a book about his work, Kauffman said, "Panning is something like shooting in the dark. It's practically impossible to predict the final result. Background colors will move and blend together giving shades and tones and creating hues which we cannot predict."

If you don't follow the subject smoothly, the image won't be sharp enough. Many photographers can't afford to risk a pan shot because the editor counts on having at least one tack-sharp photo of the principals in the event. Therefore, it's wise never to gamble solely on a pan shot for an important assignment.

"When on assignment," Kauffman cautions, "get the picture the editor needs first—then, if you have time, experiment with a pan."

The choice of lens is critical in panning. A long lens allows you to back off from the

Because of the inherent delay caused by reaction time, a photographer could have missed a key moment like this without realizing it. For more on reaction time, see page 129.

(Photo by John Coley, Palm

Beach Post.)

subject. The farther the camera is from the subject, the slower you can pan—thus achieving more control.

The lens, however, must allow a field of view that is wide enough to accommodate the anticipated action.

In panning, use your viewfinder to spot the subject as it moves into view. Pivot your head and shoulders so that you keep the subject in the viewfinder at all times.

When your subject is in front of you, release the shutter without interrupting your pivot. Be sure to follow through after you snap the shutter. The trick is to have the camera moving at the same speed and in the same direction as the subject.

FOCUSING: HOW TO GET SHARP IMAGES

MANUAL FOCUS

Whether you use a slow shutter speed to pan or a fast shutter speed to freeze the action, your subject will not be sharp unless the lens is critically focused. Focusing a lens on a rapidly moving subject takes considerable practice.

Follow-focusing requires eye-hand coordination. As the runner moves down the field, you must move the lens' focusing ring to maintain a sharp image on the ground glass. When the runner is near, you must completely rotate the focus ring to keep the subject

sharp. When the runner speeds into the distance, a little twist of the ring suffices to pop the runner in or out of focus.

To follow-focus, use the ground glass on the edges of your viewfinder, not the split image or micro screen in the center. For most shooters, these focusing aids are too slow for the continuous movement of sports action.

Photographers must adapt eye-hand coordination to each lens length and camera brand. Each lens requires a different amount of movement to achieve sharpness. Like a musician playing the same note on a base fiddle, cello, or violin, the photographer must learn different eye-hand motor skills, depending on whether he or she is using a 100mm, 400mm, or 600mm lens. Even more confusing is the difficulty of switching among brands of cameras. Some focus clockwise, others counterclockwise. Whenever possible, try to stick to one camera brand to avoid this confusion.

One veteran shooter always advised new photographers to practice follow-focusing on cars coming down a highway. Select a car, he said, and try to keep its license plate in focus as it moves down the road. Track car after car, and soon, without thinking about it, your hand will move the lens barrel the exact amount necessary to hold focus as the speeding car passes in front of you, zooms down the highway, and recedes from view.

Shooting at 1/1000 sec. from a bouncing flat bed truck with a 400mm lens, the photographer focused on the lead runner but, at f/5.6, still kept the pack clear enough to be read to the pack by the county of the length of the pack of th

(Photo by Jim Collins, Worcester [Massachusetts] Telegram & Gazette.)

Don't be discouraged if every negative of your sports action is not tack sharp. Few sports photographers bring back thirty-six perfectly focused exposures. However, with practice, the number of razor-sharp frames will increase.

For many assignments, sports shooters use lenses in the 200mm to 600mm range. From the perspective of sharpness, the bad news is that long lenses have narrow depth of field even at small apertures. This means that unless the lenses are exactly focused, the pictures will look blurry.

The good news is that when you peer through long lenses, the image pops in and out of focus very cleanly and dramatically on the viewfinder's ground glass. Critically focusing a long lens is actually easier than focusing a wide-angle lens. (See Chapter 11, "Cameras & Film.")

ZONE-FOCUSING

In sports like auto racing or track and field, when photographers can predict exactly where the subject will be—at a finish line or a specific hurdle—they use a method called zone-focusing. To zone-focus, manually prefocus the lens for the point at which you expect the action to take place, and let your lens' depth of field do the rest. As the subject crosses the predetermined mark, frame and shoot your picture. Your picture will be sharp not only at the point at which you have focused but for several feet in front of and behind that point—depending on the depth of field of your lens, the aperture, and the distance from the subject. (See page 92.)

Once you have prefocused and determined your depth of field, you know the zone in which you can shoot without refocusing. When the subject speeds into the framed area,

Only a motor drive would have caught this sequence of Mary Decker tripping during the Olympic games. (Photos by Bruce Chambers, Long Beach [California]

Press-Telegram.)

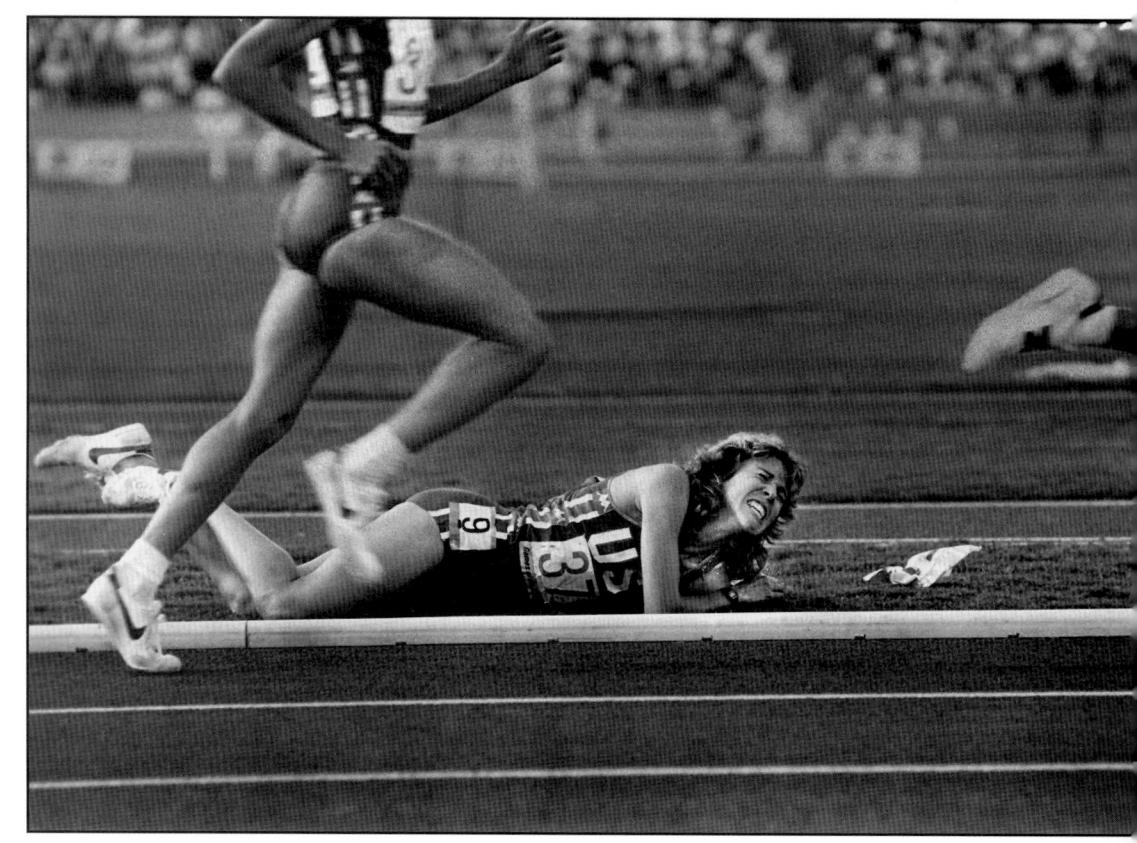

you can take several shots as long as the subject is within that zone. At an equestrian event, for example, you can prefocus on the hurdle and wait for the horse and rider to jump.

In baseball, the action occurs in definite places—on the bases and at home plate. Baseball is ideal for zone-focusing, and some baseball photographers even label the base positions on their lenses. First, they sit in a fixed position between home plate and first base. Then, they put a strip of white tape around the lens barrel next to the footage scale. They focus on each base, home plate, the pitcher's mound, and the dugout, and mark each point on the tape. When a runner breaks to steal second, they can quickly rotate the lens to the "2" position, and the lens will be in sharp focus to catch the player sliding into second base. If the action suddenly switches to third base, a short twist of the lens to position "3" and they are ready for the new action. Some long lenses provide adjustable click points for this purpose. With the click stops, you don't have to peer through the lens, spending time to find the optimum focus.

AUTOFOCUS

With some of the latest camera-lens combinations, the equipment's autofocus option can outperform even the most practiced photographer's eyes and hands.

Once you've set the camera and lens on autofocus, you can frame a runner within the etched lines of the viewfinder indicating where you can autofocus. Now that you've aimed at the moving target, you activate the autofocus feature on most cameras by partially depressing the shutter release. As the runner moves toward the camera, the lens will automatically rotate, and the athlete will remain in focus. A good autofocus system will smoothly follow the runner without searching hesitantly.

Some of the most advanced autofocus systems have a coreless motor built into the lens that not only turns to the correct point of focus quickly—quicker than a photographer could manually turn it—but comes to a complete halt when the image is sharp without any fine-tuning.

These systems were devised to fire and continuously advance at many frames per second while tracking a fast-moving subject.

Manual follow-focusing is easy when you're not firing off many frames. But when you want to shoot a rapid sequence of shots, the mirror is up more than down, which interrupts viewing and makes it difficult to manually follow-focus.

Some autofocus lenses will even work

under low light conditions. They can track a runner coming toward or moving away from the photographer at practically any speed in a poorly lit indoor gym. While the autofocus systems do depend on contrast (i.e., a light/dark image in the area of the focusing sensor), almost any situation short of a completely blank wall or perfectly clear sky will provide enough contrast.

You should be aware, though, that with some systems, you must center the athlete in the middle of the viewfinder for autofocus to work. But systems with multiple focusing sensors in the viewfinder allow the primary subject to be off-center while the camera lens stays on track. With these models, the photographer can select the designated off-center areas in the viewfinder for autofocusing. If you want to follow-focus a runner who is on the left side of the frame, you can do that automatically. To shift to a runner on the right-hand side, you can readjust the target autofocus area. Other camera systems advertise a wide-area autofocus sensor that allows for continuous autofocus without any need for sensor selection. Some cameras advertise a "lock-on" feature that assures that the player will stay in focus.

No autofocus system produces sharp pictures every frame, but the new generation of equipment comes closer than ever before. With some systems, the camera will focus on the closest object in front of the focusing sensor.

If you are tracking a halfback running down the field and a ref gets in the way, the camera will switch focus to the interloper and lose track of the halfback. When the halfback appears again, the lens has to search for the new point of focus.

However, with the "lock-on" feature and faster motors in some new systems, the ref's momentary interruption won't cause the focus to shift. Even if the player briefly moves out of the autofocus sensor's area, the system will return to the prime subject.

Many of today's sports shooters have switched from manual to autofocus systems. The *San Francisco Chronicle*, among other newspapers, has sold its entire inventory of pool (shared) equipment to invest in the latest autofocusing systems. Photographers report as much as a 30 percent improvement in the number of sharp pictures they can bring back from an event using autofocus compared with manual-focus lenses.

Even shooters who cover only sports—and who are accustomed to bringing back sharp images of swiftly moving athletes—claim to get even better results using the new autofocus technology.

"In a sequence of eight to ten frames, I get seven or eight that are sharp," says George Tiedemann, a contract photographer with *Sports Illustrated*, in describing his conversion to the new technology. "That's better than the four or five I used to get." John Iacono, a *Sports Illustrated* staffer, is another of the converted. "Before, when I had a sequence of a guy running with the ball, I'd have one or two shots in focus," he testifies. "Now every frame is sharp."

Tiedemann says that the new technology has dramatically increased his odds even when shooting car races. "I was shooting cars coming diagonally across, flying by me at speeds well over 100 miles per hour. I put the 600mm on autofocus and just nailed those guys."

While not a necessity, autofocus lenses and cameras seem like the best tools for those who don't want to miss a sharp picture of the critical play. (See also Chapter 11, "Cameras & Film.")

THE SPORTS PHOTOGRAPHER'S BAG OF SOLUTIONS

FIXED-FOCAL-LENGTH TELEPHOTOS A sports photographer can't just run onto the playing field with a wide-angle 20mm lens and snap a picture of the action. To get an image large enough to see clearly, the sports specialist usually must use long telephoto lenses. The telephoto adds drama to the drama and heightens the impact. With these long lenses, whether manual or autofocus, you magnify what you want to show by eliminating all other distractions.

In addition, using these lenses helps to pop the key player out of the pack, leaving a distracting background lost in an out-of-focus blur. In fact, some photographers always use the widest lens aperture to achieve minimum depth of field, therefore knocking out, as much as possible, the distracting background. (See pages 114, 117, 122, and 131.)

Long lenses also can be a creative tool because they pull things together in a way the human eye never sees. Because a telephoto lens appears to compress space, objects appear much closer together in depth than they really are. (See page 117.)

Unfortunately, telephoto lenses are not the sports photographer's cure-all. The telephoto lens itself has inherent problems. For instance, the longer the lens, the less the depth of field; therefore, focusing becomes even more critical. With extreme telephoto lenses like the 500mm f/4, the 600mm f/4 and f/5.6, and the 800mm f/5.6, there is no margin of error. The focus must be perfect, or the shot is lost.

Critical focusing is just one challenge when you use a telephoto lens. Another is the exaggerated effect of camera movement on the picture's sharpness. The lens length exaggerates any camera movement and, thus, slight camera-shake can result in a blurred final image. A 200mm telephoto, compared to a normal 50mm lens, magnifies the image four times, but it also magnifies camera-shake by the same amount. With any very long lens, it is sometimes necessary to use a monopod, a one-legged support.

Additionally, if your eye is not perfectly aligned with the optics of the lens, one-half of the split-image focusing circle will tend to go dark when you use a long telephoto lens. If possible, use a focusing screen without a split-image circle on the ground glass.

Even though telephoto lenses are difficult to use, they do put the viewer right in the middle of the action. Many photojournalists carry the 300mm f/2.8 lens as standard equipment.

ZOOM LENSES

Rather than carry a satchel of different lenses, some sports photographers prefer to use zoom lenses. With the zoom, you can continually change the focal length of the lens, so that one lens is doing the work of several. Because you can zoom to any millimeter within the range of the lens, your framing can be exact. Sports photographers also like the zoom because it lets them follow a player running toward the camera while it keeps the player's image size constant in the viewfinder. Another advantage of the zoom is that you can get several shots from a single vantage point without moving. For instance, you can zoom back and catch all the horses at the starting line of a race; then, after the horses leave the gate, you can zoom in to isolate the leader of the pack—all this by just a twist or push of the lens barrel.

But this versatile lens does have drawbacks. First, a zoom is usually heavier than a single-length telephoto lens. You can balance this increased weight, however, against not having to carry as many lenses to get the same effect.

Second, the zoom lens' widest apertures are sometimes smaller than the maximum aperture on an equally long fixed-focallength lens, so the zoom is less useful in low-light situations such as in indoor arenas or at night games. Manufacturers, on the other hand, have introduced midrange (80–200mm), relatively fast (f/2.8) telephotos, but the lenses are still fairly expensive.

Third, focusing and zooming simultaneously as the subject moves can be difficult to

coordinate. You can develop this skill with practice, of course, but it does take time. Autofocus cameras help a lot in this situation.

Although zooms aren't a cure-all, the Associated Press's Risberg maintains that they are "one of the best tools for sports photography."

Iacono of *Sports Illustrated* uses both fixed-length and zoom lenses. He mounts a fixed-length 300mm, a 400mm, and a 600mm on monopods, slings an 80–200mm zoom on his shoulder, and hangs a 55mm on his chest. He keeps the 55mm handy in case a play develops right in front of him. If it does, he quickly grabs the camera with the 55mm and gets off a couple of quick one-handed "Hail Mary" shots. (Here, the photographer lets the lens focus without looking through the viewfinder and prays that it comes out.)

THE MOTORIZED CAMERA

A motor drive, attached either to your camera or built into its body, allows you to fire a series of frames without manually advancing the film between each shot. Every sports photographer interviewed for this book uses a motor drive, but several mentioned that, in

some instances, depending on a motor drive caused them to miss the peak action of a play.

As sports photographer George Riley points out, "Motors can throw your timing off, and sometimes the best pictures come between the frames." However, Riley quickly adds that, on a controversial play, you need the motor drive to fire off a sequence that shows how the play developed.

Pressing the motor drive trips the shutter, advances the film, and cocks the shutter again for the next picture faster than you can blink an eye. If you use the motor drive semi-automatically—one frame at a time—you need not remove the camera from your eye to advance the film. Or you can shoot rapid-sequence pictures, depending on the make of the camera, at a rate of two to five frames per second—or even faster with some cameras—without taking your finger off the shutter. This rapid-fire pace increases your chances of capturing peak action.

As in working with all photographic equipment, you must learn the technique of using a motor drive. With the motor drive set on "continuous," you should begin shooting before the action starts and continue holding down the shutter release until after it stops.

Combining the actionstopping effect of the strobe with a relatively long available-light exposure (1/4 sec.) leaves ghosting around the riders and imparts a sense of action to this bike race photo.

(Photo by Dave Eulitt, *The Topeka* [Kansas] *Capital Journal*.)

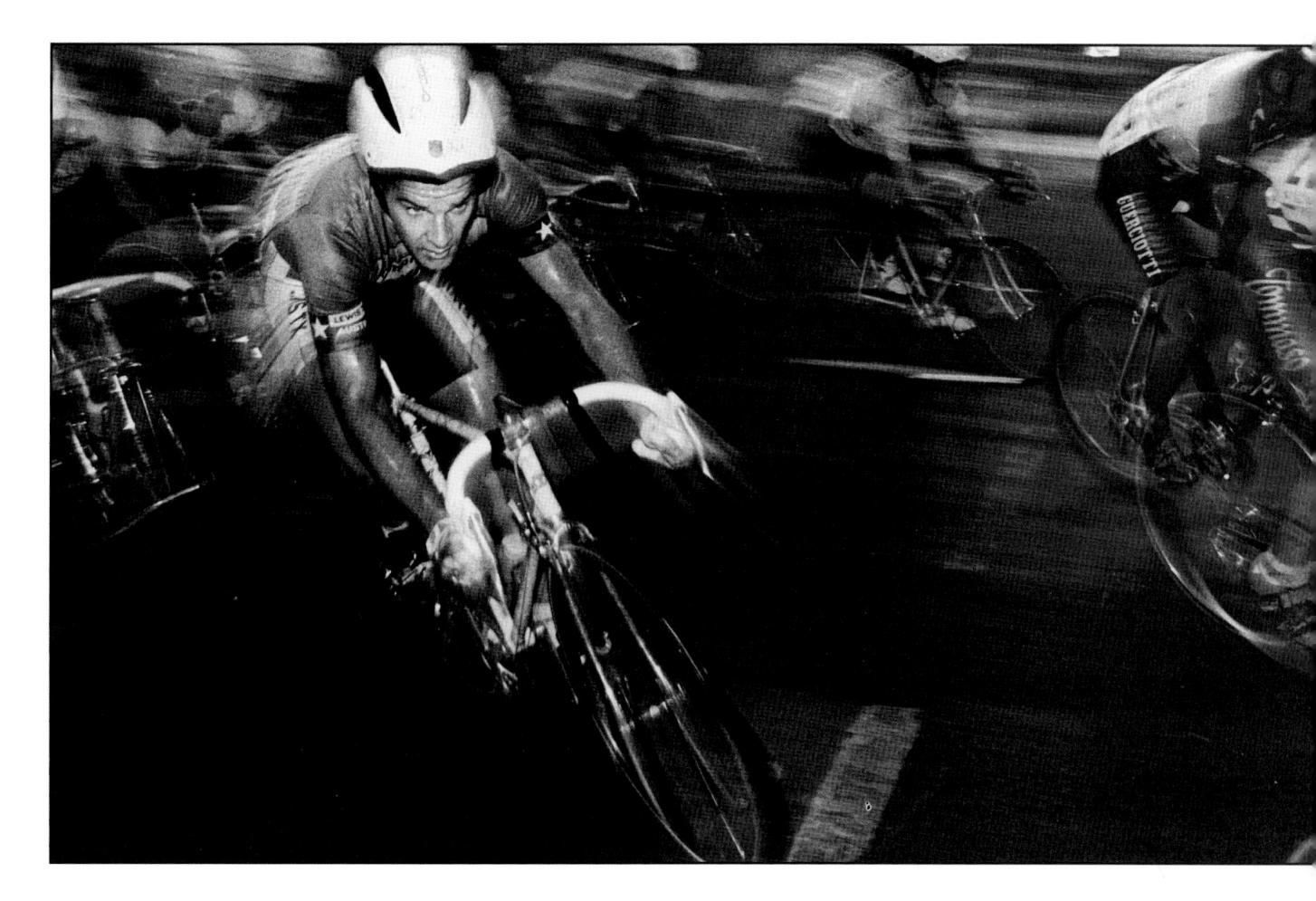

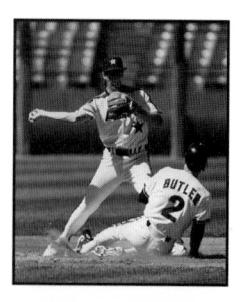

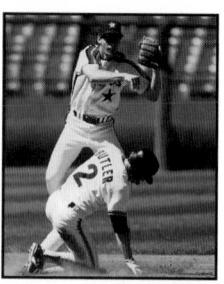

When using a motor drive, start shooting before the action starts and keep shooting until the play is completed. (Photos by Brad Mangin.)

This will expose a series of frames that encompasses the complete play. From the sequence, you can choose the best frame, one you might have missed had you advanced the film manually.

Because no sane photographer wants to be subjected to a barrage of speeding hockey pucks or powerful slam-dunks, a motor-driven camera also can be placed in a remote location such as inside a hockey goal or behind the plastic of a backboard. The camera can be activated either by an electrical wire or by a radio control. Firing the camera remotely can give you a unique vantage point, almost in the middle of the melee.

DEVELOPING FILM FOR DIMLY LIT SPORTS

Outdoor daytime sporting events present few lighting difficulties, but indoor and night sports can be tricky to shoot because of low light. First, poor light means that you must set your lens on its widest aperture. Unfortunately, this narrows the depth of field and reduces the chances for a sharp picture. You also might have to turn your shutter dial to a slower speed to compensate for the low light conditions, but this, too, may blur the image in the final picture.

Sports photographers shooting in poorly lit gyms, dark hockey arenas, or unevenly lit outdoor stadiums at night, select the fastest film available. The introduction of 1600 ISO color and 3200 ISO black-and-white film has saved the day for many sports shooters.

But sometimes even these fast films are not sensitive enough for shooting high school football, where half the stadium's light bulbs are burned out, or in dungeon-like basketball gyms. In these situations, photographers overrate their film, effectively underexposing it, and then partially compensate for the lack of exposure by increasing development. (See Chapter 11, "Cameras & Film.")

DON'T HOCK YOUR STROBE YET!

A few sports situations demand electronic flash, whereas others merely benefit from the use of this lighting source. The electronic flash from a strobe begins and ends so fast that the flash will stop just about any action you might encounter.

Although the lighting effect from a single strobe on camera looks harsh and unnatural, the resulting image will be sharper than a blurred shot taken with available light at a shutter speed too slow to stop motion.

Sometimes, flash even enhances a sports picture. David Eulitt was shooting a bicycle race for the *Indianapolis News* when he combined strobe and available light in one expo-

sure. The strobe stopped the racers' motion and produced a sharp image. The slow shutter speed, which let in the available light, added a ghosting effect that gave the photo a feeling of motion.

Some photographers like to set up strobes for a spectacular multilight photo at indoor and night sports events. Two lights can be synchronized with a connecting wire or photoelectric slave cell that fires both units at the same time. Some large newspapers, and several major magazines such as *Sports Illustrated*, light entire sports arenas with a battery of huge strobes.

Photographers connected to these systems can shoot with slow, fine-grain color film and still get outstanding results. The elaborate multilight installations require a great deal of money and time but provide photographers great flexibility and increase the number of quality images. (See Chapter 13, "Strobe.")

ANTICIPATION IN BASEBALL

KNOWING WHERE THE BALL WILL BE BEFORE IT GETS THERE

At one time, photographers actually were allowed to work on the field of major league baseball games. But this freedom was curtailed because of the antics of photographers like Hy Peskin. An outstanding photographer, Peskin was covering a close game between the Giants and the Dodgers from a spot behind first base when he saw a ball hit into right field. He realized there would be a close play at third base.

With the volatile Leo Durocher coaching at third, Peskin knew there would be a scene. As the right-fielder chased down the ball, Peskin took the shortest route to third base—over the pitcher's mound and across the infield. Peskin, the runner, and the ball all arrived at third base at the same moment.

Peskin got his pictures, but after similar incidents, photographers were barred from the playing field of major league games.

Had Peskin anticipated third-base action before the play began, he could have positioned himself near that baseline, or he could have focused with a long lens on third.

The key to getting great sports photographs is anticipation. Anticipation means predicting not only what's going to happen but where it's going to happen. You must base these predictions on knowledge of the game, the players, and the coaches.

Anticipation in football, for example, means that you must know the kind of play to expect—run, pass, or kick. Then you must predict who will be involved in the play—quarterback, running back, or pass-receiver.

And finally, you must guess where the play will take place—at the line of scrimmage, behind the line, or downfield.

Basing your position on these predictions, you would station yourself along the sidelines, usually at the point nearest the expected action. Choose the appropriate lens and follow-focus the player you expect to get the ball. Then wait—and hope the action will follow the course you have predicted.

COUNTERACTING REACTION TIME Besides anticipating the action of key players, you must also press the shutter before the action reaches its peak. In baseball, for instance, if you hit the trigger of your camera when you hear the crack of the bat against the ball, your final picture will show the ball already headed for left field. You would swear that you squeezed the shutter at the same instant the bat met the ball, yet the picture clearly demonstrates the shutter was delayed. Why?

As David Guralnick, who shoots sports for the *Detroit News*, points out, "If you saw it, you missed it." What he and shooters have observed is that a lag-time occurs between the moment you hear the crack of the bat and the moment you press the shutter. Psychologists have termed this lag period "reaction time," and they are able to measure precisely its duration. The delayed reaction is caused by the amount of time it takes you to do the following: first, to recognize that an important play is in progress; second, to decide if a picture should be taken; third, to send a positive signal to the muscle group needed for the movement, in this case the index finger; and, fourth, to contract the muscles in the forefinger and thereby release the camera's shutter.

Even after the shutter trigger is depressed, there's another delay while the camera itself responds. Even the most sensitive shutter still takes time to function. This shutter reaction time is the fifth step. All five steps added together account for the reaction time between seeing the action and capturing the picture.

You run through these same steps every time you take any picture, but the cumulative length of reaction time becomes critical when the subject is a baseball moving at 90 mph.

When you suspect the play is going to take place at home plate, prefocus on this base and wait for the slide. Capturing catcher, runner, and umpire at the base, this photo contains all the needed story-telling elements of a good sports photo. (Photo by Dale Guldan, Milwaukee Journal.)

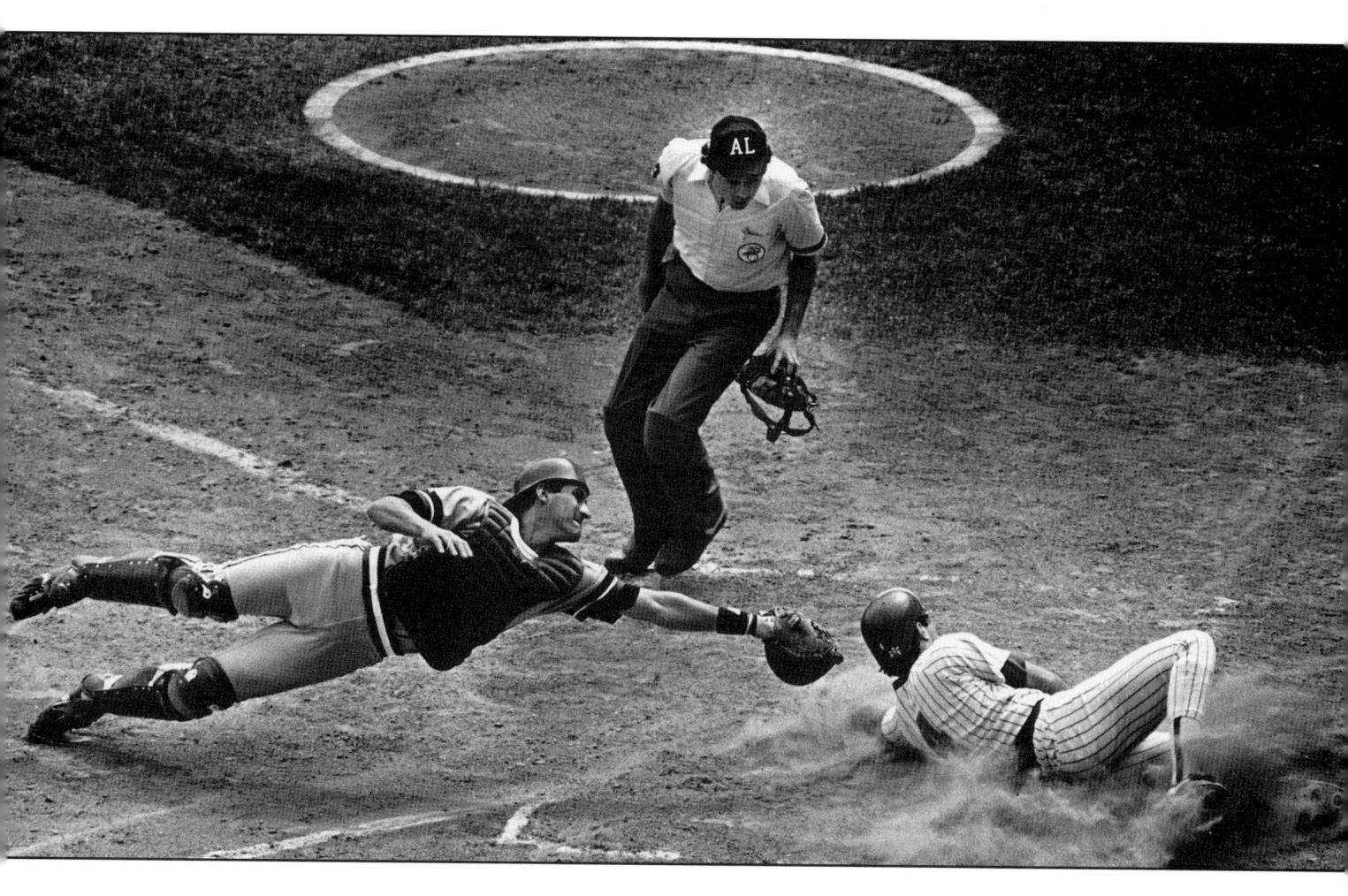

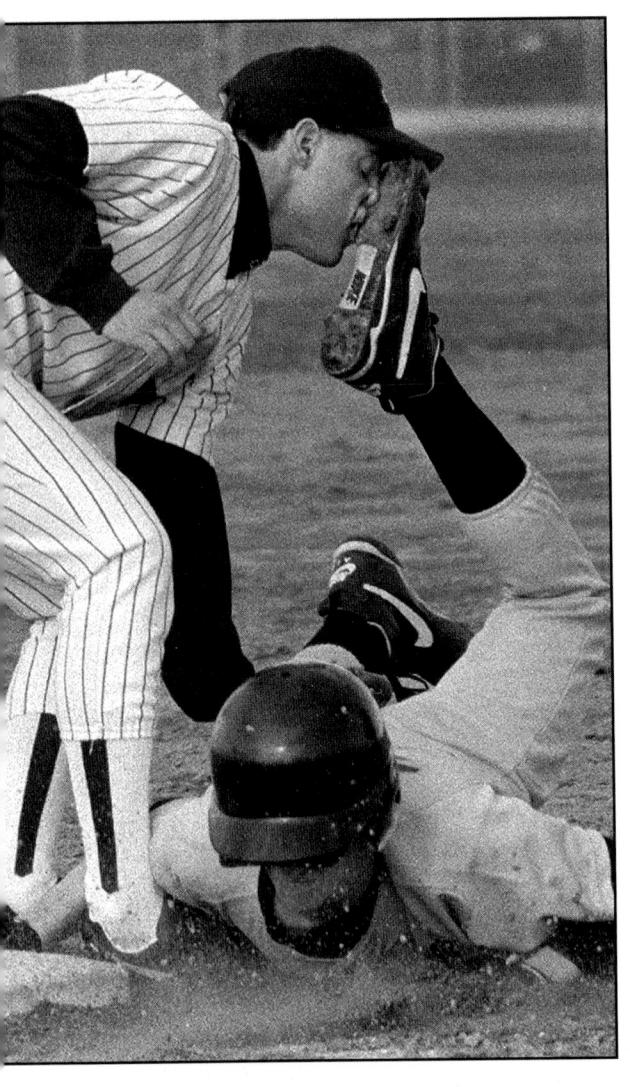

The accidental kick in the face gives this slide photo its extra appeal. Although the baserunner was tagged out, he managed to give the third baseman a gash on his lip that required three stitches to close. (Photo by Patrick Ryan, Press [Elmhurst, Illinois]

Publications.)

WAITING 'TIL "ALL HELL **BREAKS LOOSE**" The AP's Pam Schuvler describes baseball as a "Zen sport" that requires infinite patience to photograph because the action erupts in spurts, and instant response is needed. "You wait and wait, and nothing happens. Then, all of a sudden, all hell breaks loose," says Schuyler. "I get bored easily at a baseball game and then I lose my concentration. That's when the big action always seems to occur!"

It does appear sometimes that nothing ever happens in baseball. In fact, the perfect game from the standpoint of a baseball afficionado is a "no-hitter." Sports writers still refer to the "great" game in the 1956 World

Series when Don Larsen of the Yankees pitched a no-hitter. Not only were there no hits but there were also no walks and no errors. Twenty-seven Dodgers went from the dugout to the plate and back again without reaching first base.

Unfortunately, there was no action for the photographer to shoot in this "perfect" baseball game. The picture that is remembered shows Larsen pitching his last ball, with a row of Dodger zeroes on the scoreboard in the background.

SLIDING SECOND

Luckily for photographers, a no-hitter is rare. Most games have at least some action at the bases, and baseball, like all sports, has its standard action shot. In baseball, the standard photo is the second-base slide.

When the play is going to take place at second base, train your telephoto lens on the base, focus, and wait for the action. With a motor drive, the timing does not have to be so exact because the camera fires several

frames per second. If you press the release as the slide begins, and hold it until the umpire makes the call, one frame is likely to coincide with the peak of the action.

Often a good series of pictures results. If any of the photos in the series show the intense expressions on the players' faces, these pictures will have additional human interest.

STEALING BASE

When the key play is a second-base slide, photographers simply zero in on the base and concentrate.

A more difficult situation occurs when a notorious base-stealer ventures into no-man's land between first and second. The pitcher could try to pick off the runner at first if he thinks the runner has too daring a lead-off, or the catcher could peg the runner if he breaks for second.

Cover this split action by prefocusing one camera on second base and setting this camera aside; then focus another camera on first base and keep the camera to your eye. You can snap a picture of the pick-off on first, or, if the runner heads for second base, you'll have time to raise your other prefocused camera and catch the slide at second.

When a runner gets to second base and is officially "in scoring position," you should prefocus on home plate. On the next fair play, the runner might try to score.

RUNNER VS. THE BALL

One general rule is to follow the runner, not the ball, with your lens. A routine catch in the outfield makes a routine picture. Except with a short fly, when either the infielder has to catch the ball in back of him, or the outfielder has to dive for it, keep your camera focused on the base path runners.

AP's Risberg, however, says he has taken exciting pictures of outfield play with an extremely long telephoto lens. He also points out that, during slow games, shooters should watch the reactions of batters. For games without much action, he says, the dugout provides good picture opportunities.

Photographers position themselves several yards back from the base path between home and first base, or home and third base, or in the press gallery.

From these positions, especially when shooting high school, college, and professional baseball, sports photographers prefer a 300mm or 400mm lens to cover the infield and a 600–800mm to cover the outfield.

A sandlot or Little League playing field measures a shorter distance, hence a 135mm lens covers the infield easily.

THE UNUSUAL

Baseball is a team sport played by individuals, each with his own strengths and his own repertoire of favorite stunts. One ballplayer might hold the season's record in stolen bases, while a pitcher might lead the league in pick-offs at first.

With this combination, the smart photographer has the camera lens focused and aimed squarely at first. One batter might be a consistent bunter; another might consider a bunt below his dignity under any circumstance.

The more you know about the idiosyncrasies of the players, the better your forecasts and your pictures will be.

Although the dust-swirling second-base slide is a sports photographer's guaranteed "bread-and-butter" shot, sometimes the shot can be overworked. "You can almost take the slide shot out of the files, the situation starts to look so similar," says one shooter.

When shooting for *Sports Illustrated*, Brad Mangin will position himself in the photographers' box behind first base and shoot with either a 600mm lens or a 400mm f/2.8 with a teleconverter. "This is a basic, good, safe angle for shooting second base, home, and the outfield," he says.

For a different shot, he sets up a remote camera before the game. He clamps it on the backstop behind home plate, points it toward third base, and prefocuses a little past home to anticipate the slide at the plate. He con-

nects the remote camera to his box position with a long wire, uses either a foot switch or a button to trip the remote camera, and reloads between innings.

When a play occurs at home, he activates the remote and also shoots with his long telephoto because sometimes the batter in the on-deck circle blocks the camera.

"You can go ten games with no play at the plate," he says, "but when you get the head-on shot, it's got a lot of impact."

The antics of the team manager also may provide a rich source of photographic material. When he strides onto the field, you can bet sparks will fly whether he harangues the umpire or yanks out the losing pitcher.

You can shoot baseball without being a Zen master. Just remember that you will never go hungry if you consistently catch your bread-and-butter action picture, the second-base slide. But you are more likely to be eating steak and lobster if you cover all the important action on the field.

FINDING THE FOOTBALL

When you cover a football game, you face some of the same problems as does a 250-pound defensive tackle. Before each down, you and the football player have to predict which way the quarterback will move on the next play.

After the center hikes the ball, you and the tackle must react quickly and make

Using a long telephoto lens at its widest aperture helps to blur the background and separate the receiver from distracting elements behind him. No pass interference was called on this play. (Photo by Rich Riggins, Patuxent [Maryland] Publishing Co.)

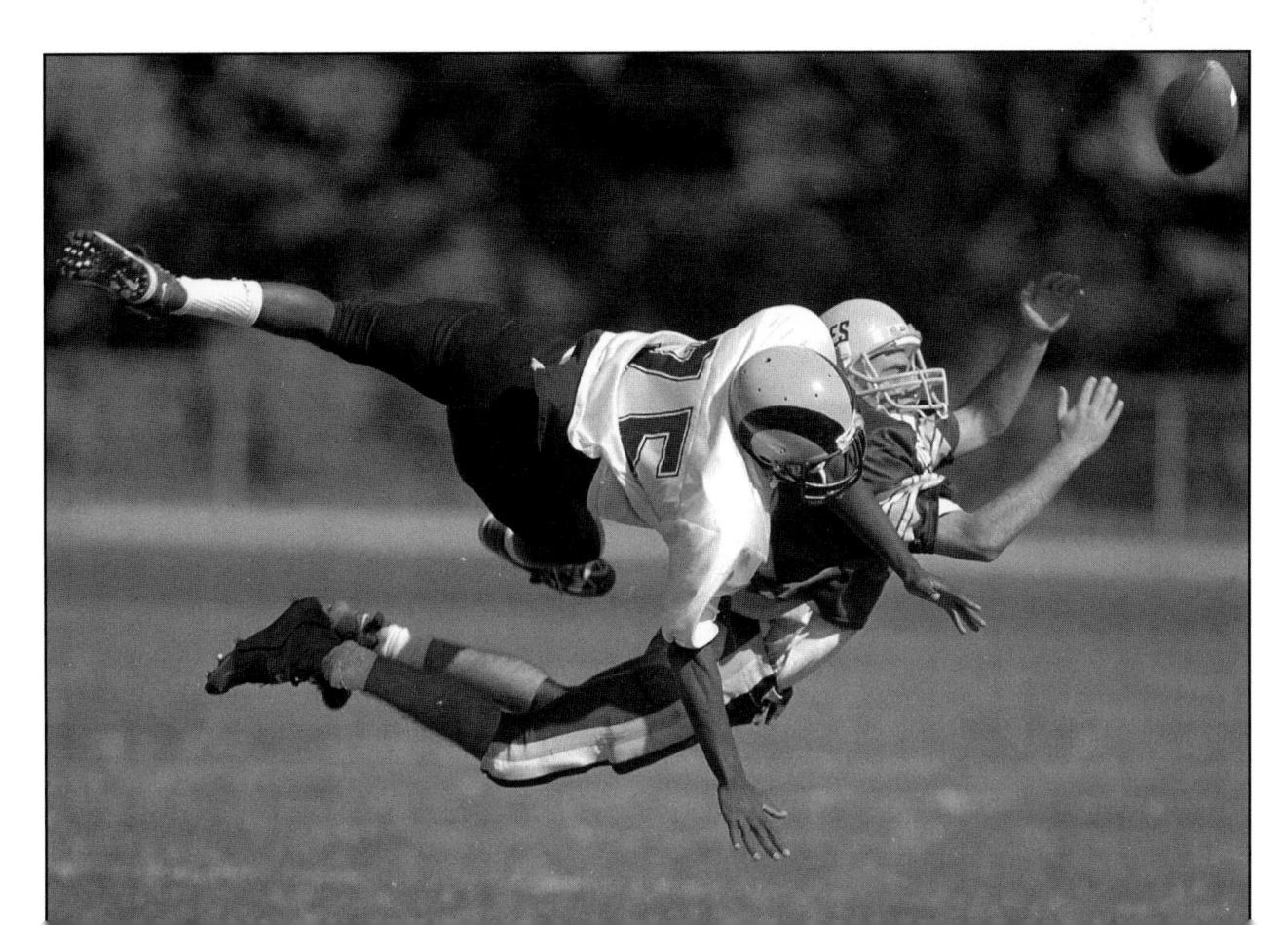

adjustments as the play unfolds. Will the quarterback hand off to a speedster for an end-run or to a powerful halfback for a bruising plunge through the center? Or will the quarterback throw a quick spike for short yardage or a long bomb to the end zone?

As the defensive player considers the options, sports photographers likewise anticipate the call and prepare for the play. You must be in the right place at the right time, with the right equipment, ready and waiting for the action: runs, passes, and punts.

WATCHING FOR THE RUN

On a run, photographers track the football as it is snapped by the center and either carried by the quarterback or handed to another backfield player.

Most teams tend to run the ball on the first down because a run is generally considered a safer play than a pass. Or as former Ohio State coach Woody Hayes put it, "Only three things can happen when you pass, and two of them are bad." Therefore, cautious quarterbacks like to keep the ball on the ground on the first down, less a pass get intercepted or dropped. Caution also dictates the use of a running play on a third down when the team is just one or two yards shy of a first down. Some teams, particularly the Big Ten power squads with their strong running backs and blockers, carry the football not only on the first and third down, but are very likely to run on the second down as well.

SHOOTING THE "BOMB"

Photographers can anticipate a pass on the first down instead of a run only if the team is behind on the scoreboard, needs long yardage on the play, or wants to stop the clock. A quarterback might go to the air on the second down if the team is just a few yards short of first down; he knows he still has two more downs to pick up the necessary ground. You can bet with good odds on a third down pass if the team has lost ground or failed to advance the ball on the first two downs.

You can predict the "Big Bomb" by noting the score and watching the quarterback's body language. If the quarterback drops back far behind the line of scrimmage, firm-

Plays in which something goes wrong, like this assistant coach intercepting a pass, are often more interesting than plays executed successfully.

(Photo by Scott D. Weaver, *The Independence* [Missouri] *Examiner.*)

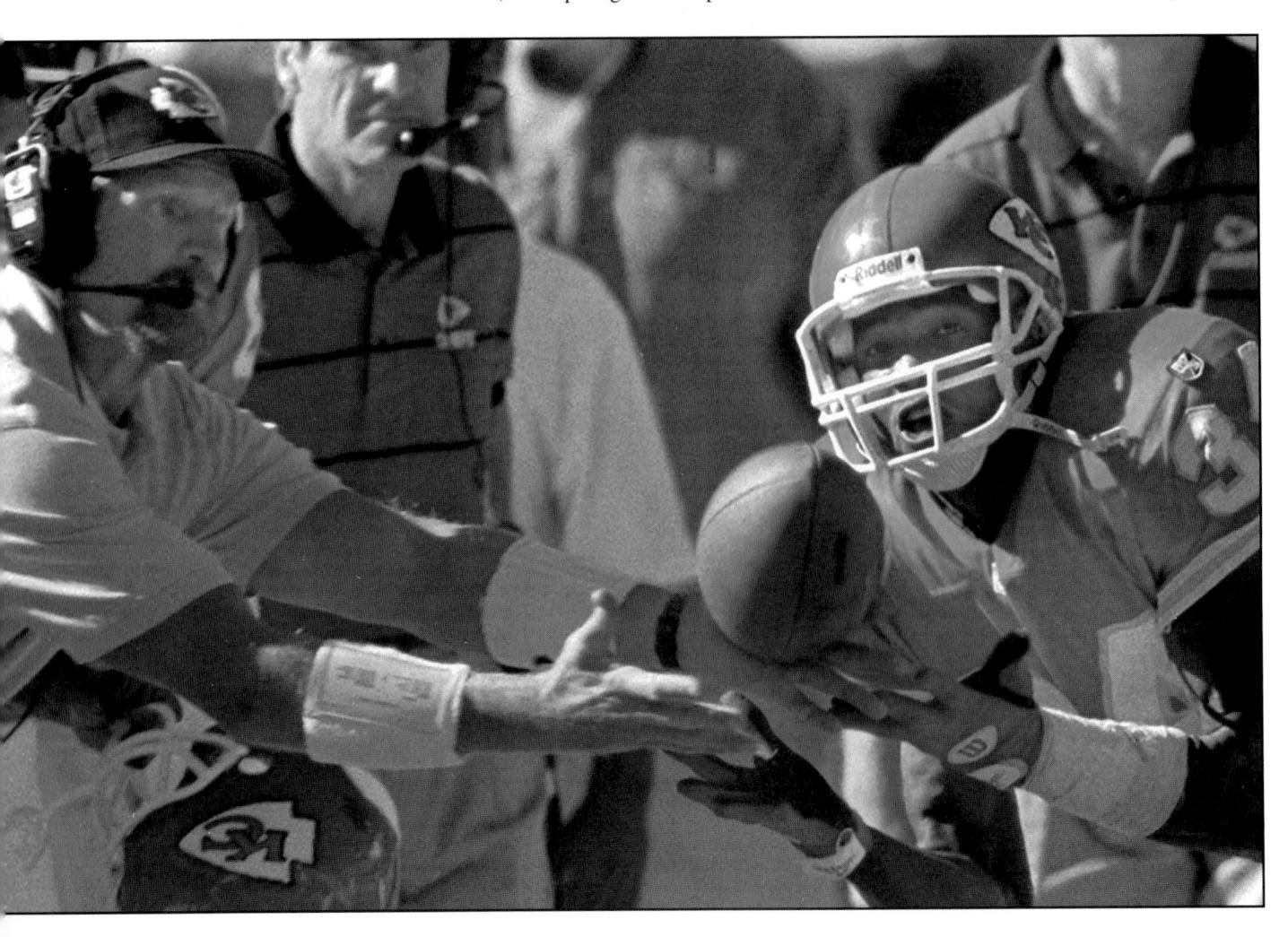

ly plants his feet, pumps the ball a few times, and then cocks his arm way back behind his head, he is very likely winding up for a long throw.

Once you read these cues and see a "bomb" in the making, you should immediately swing the barrel of your telephoto lens downfield, focus on the expected receiver, and follow his pass pattern. Do not try to track the ball as it flies through the air; you couldn't focus fast enough to keep the ball sharp. Observe the direction of the quarterback's gaze for a tip off on which downfield receiver will get the ball. Good sports photographers know that even the best quarterback has to look where he's throwing the ball.

ADJUSTING YOUR POSITION

At each down, station yourself a few yards ahead of the scrimmage line. Then, when the play begins, wait for a clear, unobstructed view of the ball carrier before you press the shutter release. At most stadiums, photographers are permitted to roam freely from the end zone to about the 35-yard line on either end of the field. To avoid distracting the coaches and sidelined players, photographers are prohibited from moving in front of the benches at the center of the field.

Photographers must stay behind the sideline boundary strip at all times and never get between the player on the field and the yardage marker poles. If you had to jump back quickly as the thundering pack of players heads toward the sidelines, you could trip on the marking chain and get trampled—a high price to pay, even for the most dramatic action shot.

All 50,000 pairs of eyes in the stadium are searching for the pigskin. The ball itself is the center of interest because everyone wants to know who has the ball and what's happening to it. Therefore, you have an obligation to get the brown leather ball in your picture as often as you can. The players, however, trained by their coaches to protect the ball at all times, will make your task difficult.

But not every picture must involve the ball carrier. After all, when one 250-pounder, with an indestructible frame and shoulder pads, meets another human impasse capped by an impact-resistant helmet, something has to give. The confrontation scene might be spectacular—even if it occurs ten yards away from the ball.

A 400mm lens will cover the action. If you try to cover midfield action with a shorter lens, the final image size will be too small for a high-quality enlargement. With a versatile 80–200mm zoom, you can photograph from the end zone when the team is on the

ten-yard line and goal to go. In addition to the 200mm and 400mm lenses, some photographers carry an extra body with a 50mm or 35mm wide-angle attached for moments when the play runs toward them. Also, the wide-angle comes in handy when, at the end of the game, the team carries the coach on their shoulders or slumps off in defeat.

AVOIDING THE "STANDARD STUFF" When Pam Schuyler covered football for the AP, she looked for dramatic catches, fumbles, collisions, and flagrant penalties such as face-masking or illegal holdings. She always searches for the unusual football picture. "You get only a half-dozen super pictures a year if you are lucky," she says. "The remainder is standard stuff."

DON'T BE FAKED OUT IN BASKETBALL

The ball travels so lightning-fast in basketball that following the ball is like keeping Shooting with an 85mm lens, the photographer caught this unusual moment as a defense player flipped upside down.

(Photo by Tom Copeland, Greensboro [North Carolina] News & Record.)

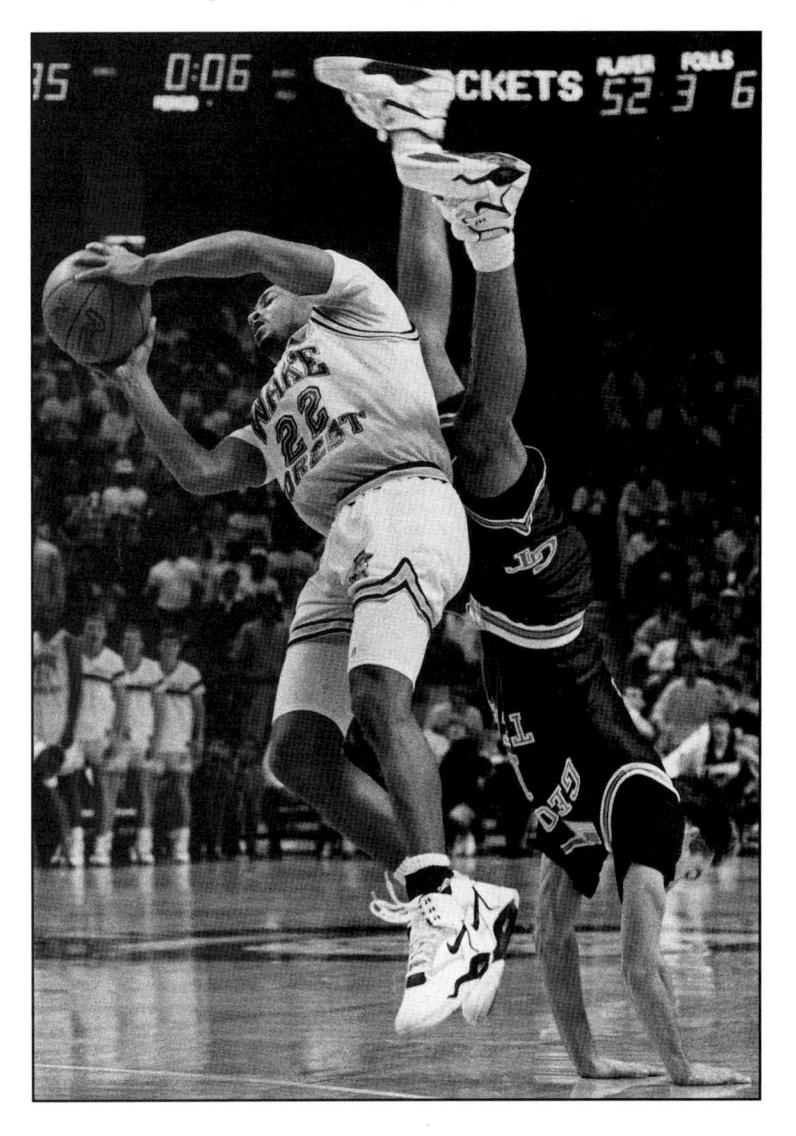

While you might not use a photo like this from every game, shooting from a high vantage point gives a refreshing angle on this sport. Here a team member cuts down the net after the game.

(Photo by Charlie Riedel.

Hays [Kansas] Daily News.)

your eye on the pea in the old shell game. Unlike football with its discreet downs, and baseball with its clearly defined plays, the basketball game rolls on at full speed until a point has been scored, a foul called, or the ball goes out of bounds. The basketball might be bigger than a baseball or a football, but keeping track of it can be just as tough.

The AP's Risberg says that he concentrates on watching the ball and the players' arms. They tip him off when he is trying to anticipate action.

Pam Schuyler spent two intensive years covering the world-champion Boston Celtics for a picture book she photographed and wrote called *Through The Hoop: A Season with the Celtics*. She says that the key prob-

lem in photographing basketball is learning to read the "fake," the quick twisting and jerking movements that players use to "fake out" their opponents and get a clear shot at the basket. As Schuyler says, "They often fake out the photographer as well."

SIDELINE POSITIONS

Many basketball photographers sit on small stools or kneel on the floor behind and a little to either side of the basket. Then they shoot with their 50mm or 85mm lens about ten to fifteen feet into the court and wait. Schuyler, however, prefers to gamble on more unusual shots. She follow-focuses the ball as it is tossed around the court. "You get more bad, out-of-focus shots when you follow-focus,

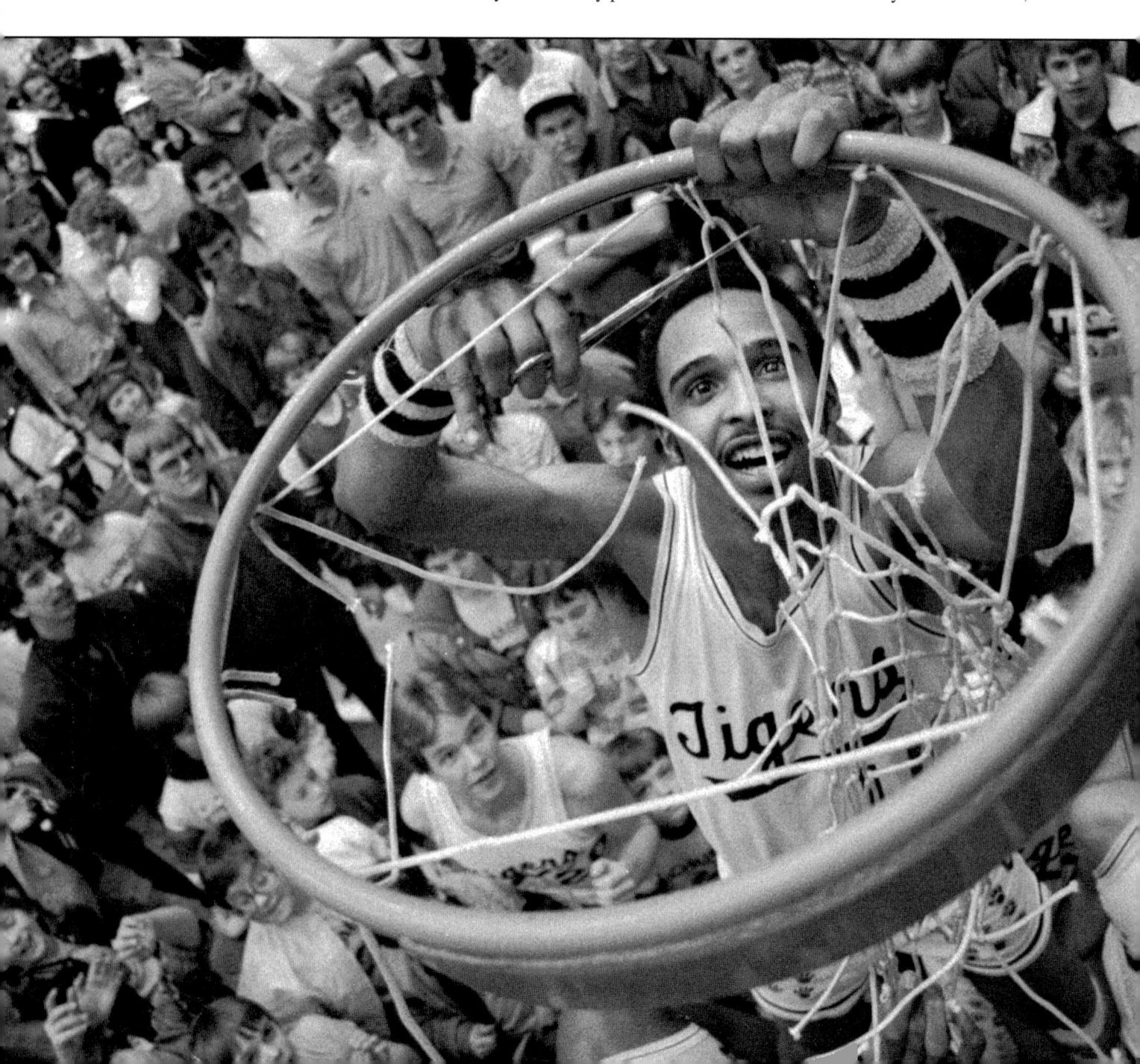

but your good shots are usually worth it," Schuyler says.

After the first few minutes of the game, Schuyler identifies the key players and notes where they execute most of their plays: under the backboard, to the right of the foul line, and so on. She then positions herself as near as possible to this focal spot. If the action spot changes as the game progresses, she shifts her sideline position.

With her two favorite basketball lenses, the 85mm and the 180mm, Schuyler covers the entire court. From a vantage point under the basket, she shoots with the 85mm; from midcourt, she works with the 180mm. She always sets the shutter speed at 1/500 sec. to freeze movement. "At slower speeds, I've found the players' hands move so fast they tend to blur." Detroit's David Guralnick uses an 80-200mm zoom under the basket and a 300mm f/2.8 to cover the far court.

THE "ARMPIT" SHOT

The standard bread-and-butter basketball photo, nicknamed the "armpit" shot, shows the lanky basketball player jumping off the floor with arms extended over his head, pumping the ball toward the basket. Pro players use the jump shot so often that conscientious photographers actually have to work hard to avoid taking this standard photo.

SKIPPING THE CLICHÉ

For unique basketball pictures, Schuyler is always on the lookout for loose basketballs on the court. "You can bet when a ball's free, there will be a scramble for it, and then a fight to gain possession of it," she explains. "Players fouling one another always look funny in pictures, and these seem to be the pictures people remember longest. When a ball bounces loose on the court or a foul is committed, the rhythm of the game is broken. A mistake was made. The game gets interesting, and so do the pictures."

When you can't attend the practice sessions of a team, or when you don't have time to learn the team's basic patterns, concentrate your coverage on the player with the star reputation. Stars tend to score the most points and snag the majority of rebounds. Also, stars don't sink baskets like regular folk; they exhibit individual styles and almost choreographed moves. Michael Jordan, for example, would seem to counteract gravity as he floated through the air, passed the basket, and, as if it were an afterthought, changed direction in mid-flight to sink a hoop. A good sports photographer tries to capture in pictures the style of the star.

The photographer followed the action right off the court to catch this surprising shot of a player retrieving a loose ball off the media table. (Photo by Glenn Asakawa, *The Rocky Mountain News*, Denver.)

Watch for fouls committed during the game, like this one between the Seattle Supersonics and the L.A. Lakers. This moment reveals the intensity of the game. (Photo by Larry Steagall, The Bremerton [Washington] Sun.)

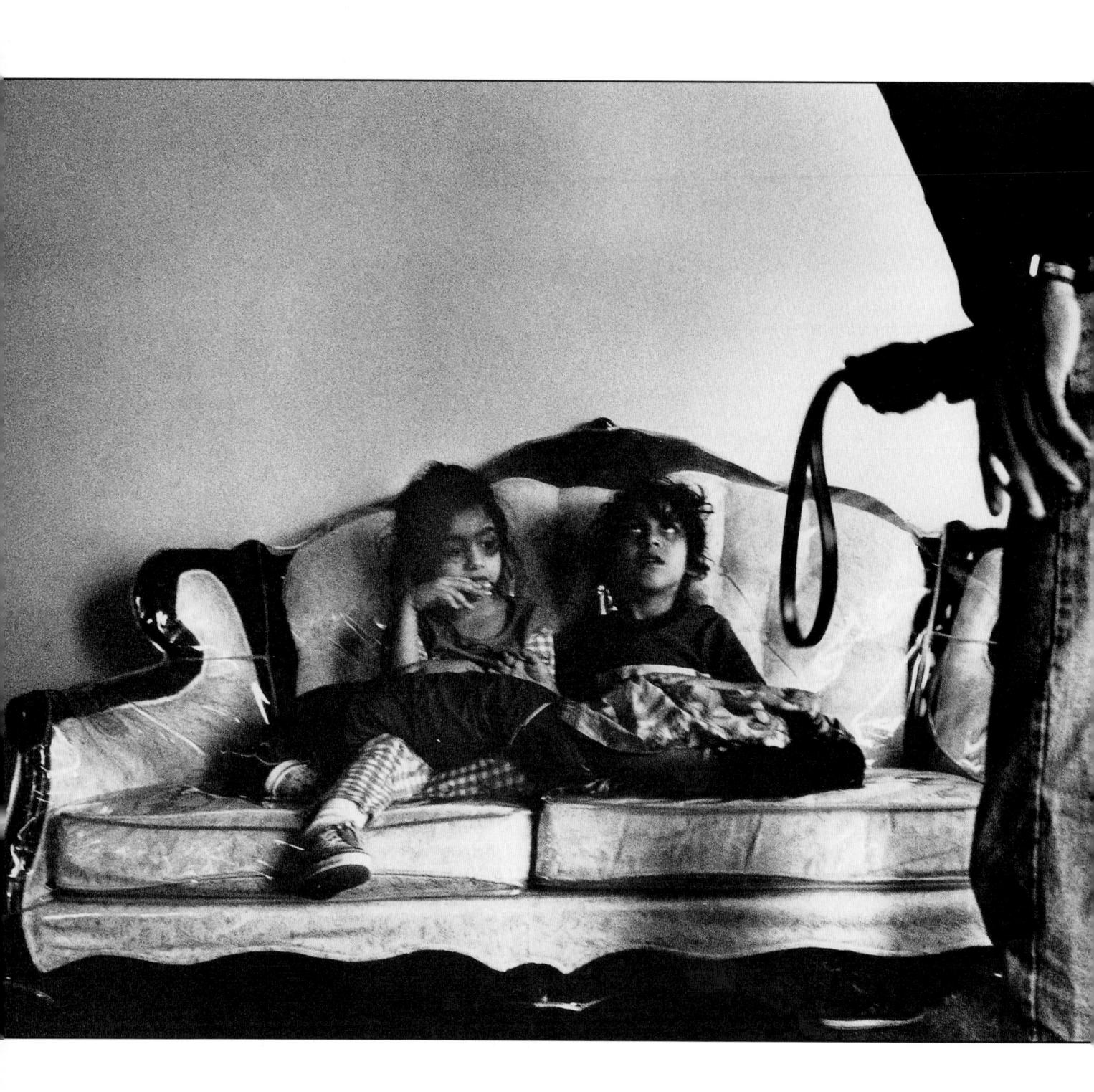
The Photo Story

TELLING STORIES WITH PICTURES

CHAPTER 8

or many photographers, telling whole stories with pictures is the ultimate professional experience.

Sometimes stories can be built in a matter of minutes;

sometimes storytelling can take years. Although Jim MacMillan of

the Philadelphia Daily News photographed his story about a

hostage situation in fewer than five minutes (see page 27), Alan

Berner shot his essay about the New West (pages 76–77) during a

A lack of formal education, resulting in few job opportunities and poverty, leads to frustration and sometimes even violence in American Gypsy families.

(Photo by Cristina Salvador.)

six-month sabbatical from the Seattle Times.

Brian Plonka, of the Spokane (Washington)

Spokesman Review, spent two years documenting

Cotton choppers in Sherard, Mississippi, 1992.

Shirley Clark, 30 years old, on Sherard Plantation, has been chopping cotton since she was 13. Sherard, Mississippi, 1992.

A PLACE UNSEEN

Photos by Ken Light

his curiosity aroused by African-American colleagues at the University of California, Berkeley, where he teaches, documentary photographer Ken Light began traveling to the Mississippi Delta region of the South in 1989.

"It seemed to me to be a place unseen by newspapers, magazines, and television." Light says

television," Light says.
By networking in the community, Light met various people who acted as guides, introduced him into people's homes and helped him to understand the political and social workings of the area.

He emphasized his role as professional photographer by shooting with the medium-format Hasselblad camera so that people would not mistake him for a tourist.

Completely selfsupported, Light pursued the project for three years. Smithsonian Institution Press published his work as a book, *Delta Time*.

After the book's publication, Light says, he sold many original prints. The book and those sales have allowed him to continue working on independent projects.

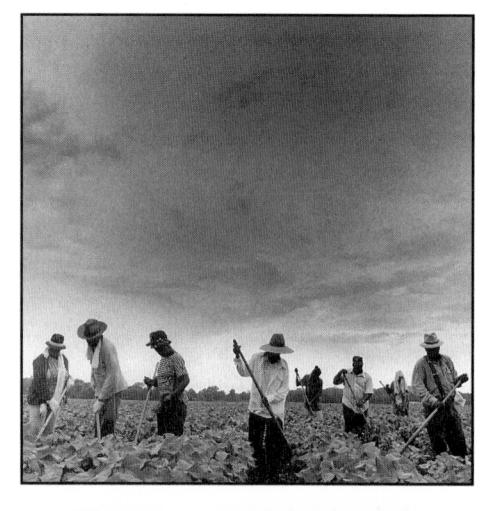

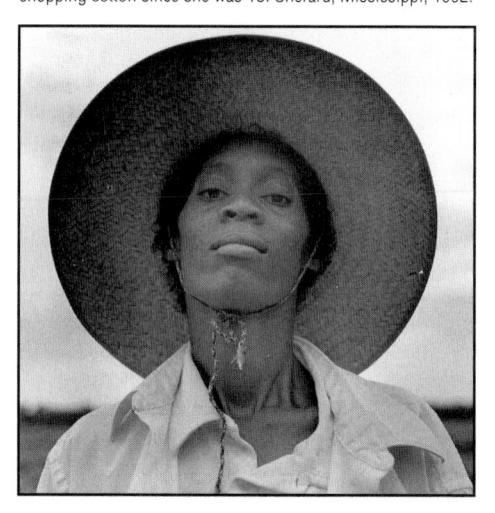

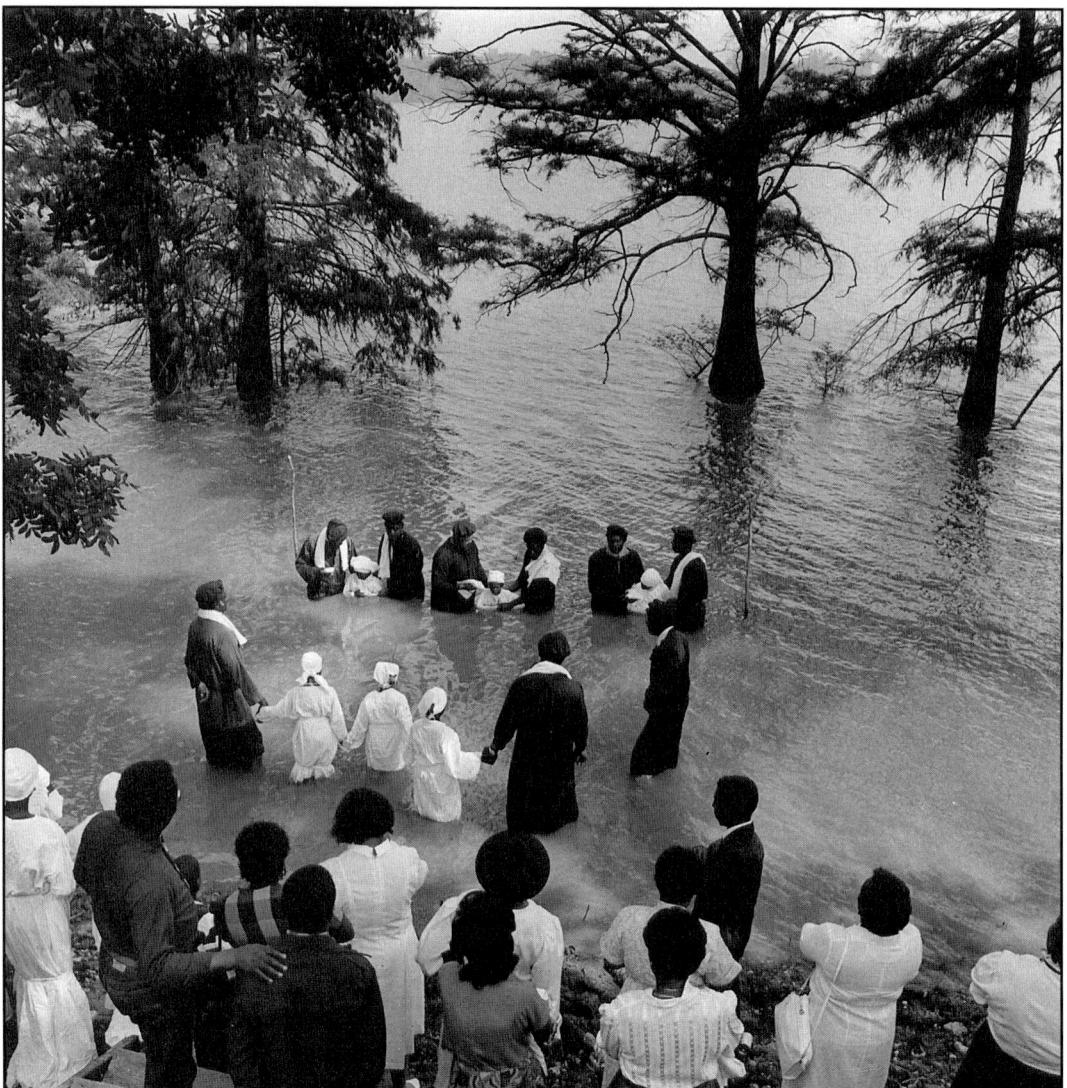

Baptism, Moon Lake, Coahoma County, Mississippi, 1989.

how alcoholism is passed from one generation to another (pages 64-67). Showing perhaps the ultimate dedication to a picture story project, Cristina Salvador photographed "Gypsies in America" on her own dime and on more than four years of her own time. To reduce expenses, she moved from spacious living quarters into a tiny one-room apartment. To devote more time to the story, she quit her job at the Long Beach Press-Telegram. Ultimately, her pictures appeared in Aperture, a prestigious art photography magazine. (See pages 152-157 for part of the project.) Salvador eventually married a Gypsy, the subject of one of her photos.

Why do photographers spend such time, effort, and money to shoot photo stories, essays, and documentaries? Whether personally financed, grant-supported, or underwritten by a newspaper or magazine, these sets of pictures are the avenues through which photographers document ways of life, explore topics in depth, present a point of view, or show with pictures the many sides of an issue.

THE ERA OF THE MODERN **PHOTO STORY**

With the advent of high-speed presses that could quickly dry the ink on glossy coated paper, Henry Luce published the first issue of Life in 1936. Inspired by the success of Life, other large picture-dominated magazines with names like Look, Click, Scoop, Peek, Pix, and Picture hit the stands. (See Chapter 16, "History," page 350.) These magazines also ran pages of pictures on a single topic.

FOLLOWING A SCRIPT

Though some stories in these competing magazines were candid, most were heavily scripted. Even after World War II, magazines continued to produce highly scripted picture stories. Look magazine, for example, published on January 8, 1946, a story on quickfrozen, precooked, ready-to-serve meals (today's TV dinners). The opening picture featured a "family" in their living room reading and playing records. The following overly lit pictures show "mom" taking a frozen meal from the refrigerator, putting it in the oven, and then taking the food out after fifteen minutes. The final shot shows "family members" seated around the table, prepared to eat the new cuisine. The photographer's shooting script, which specified opening and closing shots as well as a record of the preparatory steps in between, obviously left no room for real people or candid moments to interfere with the slick look of the pictures. The photos look like stills from an ad.

Picture magazines in the 1940s often published highly scripted stories like this one. The editor and photographer preplanned each photo as if it were a scene from a movie. (Look magazine.)

SMITH INTRODUCES THE MODERN PHOTO STORY

Toward the end of the 1940s, photographers began experimenting with a freer form of picture story development. W. Eugene Smith, working for Life magazine, broke with the typical prescripted story line. Smith's pictures of country doctor Ernest Ceriani of Kremmling, Colorado (population 1,000), actually documented the physician's lifewithout a New York editor predetermining the story's look and point of view (Life, September 20, 1948). By staying with the doctor for six weeks in all, and by recording the doctor's everyday activities as well as the emergencies and traumas he faced, Smith built a realistic story about the dedicated health worker. The story still had cohesion, but was based on Smith's observations, not the preconceived idea of a New York editor who demanded an overall and a close-up for the script. Staying close to his subject and observing carefully, Smith fashioned a revealing story about the life of the rural doctor.

Today, though they usually work independently and not for magazines, photographers follow in Smith's tradition in pursuing longterm photo projects. (For more on W. Eugene Smith, see pages 354–355.)

FINDING STORIES

PERSONAL EXPERIENCE

Sometimes a picture story comes from the photographer's own experience. When Brian Plonka's father, an alcoholic, celebrated ten vears of sobriety, Plonka decided to explore alcoholism with his camera (see pages 64-67).

PHOTO STORY INDEX

America's Shameful Export

by Donna DeCesare pages 74-75

The American West in the '90s

by Alan Berner pages 76–77

Bounty Hunters

by Dave Yoder pages 160-163

California's Nursing Homes: No Place to Die

by Judy Griesedieck page 62

Commuting by Rail

by Jim Gensheimer page 209

Crack: The Next Generation

by Ken Kobré pages 72–73

Delta Time

by Ken Light page 138

Everyday is Father's Day

by Nancy Andrews pages 144–145

Finley's Gym

by Aristide Economopoulos pages 212–213

Generations Under the Influence

by Brian Plonka pages 64–67

Gypsies in America

by Cristina Salvador pages 152–157

Haitian Street Justice

by Carol Guzy pages 78–79

Hostage Hero

by Jim MacMillan page 27

CONTINUED -

Talking with other people also alerts you to good picture story ideas. In a casual conversation with the author, a professor of special education at San Francisco State University described the effects of crack cocaine on children exposed to the drug while still in the womb. The professor pointed out that a behavioral epidemic was brewing in public education as these crack-exposed children started to enter the schools. More questions and additional research led to a story about the impact "crack kids" were having in the classroom. (See page 72–73.)

ASSIGNMENTS

Some stories develop when the photographer takes an assignment from an editor or follows a call on the scanner radio. Jim MacMillan responded to a scanner radio exchange about a car chase that ended in a hostage situation. When MacMillan arrived at the scene, he found that the gunman had grabbed a bystander and was holding him hostage as cops with drawn pistols surrounded the two. While MacMillan was documenting the action, the hostage managed to grab the gun, the cops arrested the man, and the hostage sank down in relief and a moment of prayer. Within minutes, MacMillan had recorded an entire story (page 27).

Carol Guzy's earlier trips to Africa made her the logical choice for the *Washington Post* to send to cover the return of Rwandan Hutus to their home villages; they had fled Rwanda to Zaire when their people were being slaughtered by their enemies, the Tutsis. Guzy sent back daily photographs for the paper, but she also accumulated images for a powerful story about the mass return of the population (pages 82–83).

Nancy Andrews, also of the *Washington Post*, was given what could have been a routine assignment to photograph a single dad for Father's Day. Through interviews with the dad, Clyde Jackson, she learned about his relationship with his six-year-old daughter and the kinds of activities they shared. She returned four times to photograph their lives together. What could have been a simple portrait evolved into a moving story about a special relationship (pages 144–145).

TOPICAL TRENDS

A trend story identifies a gradual but demonstrably real change that might include shifts in the public's buying preferences, lifestyles, or a technological shift in an industry. For example, a news story might read, "The First National Bank went bankrupt yesterday." By comparison, a trend story might announce,

"The number of two-income families increased dramatically during the past ten years." A trend doesn't start in one day; it happens gradually over time.

Perhaps an issue addressed in a topical book or movie might stimulate a photographer's interest to investigate the subject with his or her camera. A trend story can be localized for a photographer's particular area. Judy Griesedieck, who worked for the San Jose Mercury News at the time, used her camera as an investigative tool to expose the conditions in nursing homes in her area. (See page 62.) Guns and their relationship to violence, another controversial topic, led Hal Wells, who was the picture editor of the *Long* Beach Press-Telegram at the time, to direct his team to cover the effects of one bullet in the life—and death—of a young man in their community. (See pages 164-166.)

Like any good journalist, the photo reporter must rely on basic journalistic research, a highly sensitized nose for news, and a trained sense of whether what smells like news can be reported visually as well.

Spotting trends

Surprisingly enough, the Wall Street Journal is an excellent source for picture story ideas. Although the international business newspaper reproduces few photographs itself, the Journal does report on interesting trends in the business world, trends that photographers can translate into highly visual photo stories. Not only are the Journal reports often the first to spot a trend, but the stories are also well researched. For major trend stories, which appear on the left, middle, and right-hand columns of the front page, Journal staffers spend months researching and gathering data before they begin to write.

After reading a *Wall Street Journal* story, you then must find visual verification of the trend. Your job is to transform economic charts and abstract statistics from the *Journal*'s article into eye-catching pictures.

TELLING STORIES WITH PICTURES

How does a picture story differ from a collection of pictures on a topic? A picture story has a theme. Not only are the individual pictures in the story about one subject, but they also help to support one central point.

TEST YOUR THEME WITH A HEADLINE Headlines for stories without a theme might begin in the following ways:

- •"All you ever want to know about . . . "
- •"A day in the life of . . ."
- "Aspects of . . ."
- "Scenes from . . . "

140 • Photojournalism: The Professionals' Approach

Stories with these headlines might contain beautiful or even powerful pictures, but the pictures don't add up to a story. They remain the photographer's observations without a story line or central message.

On the other hand, a theme story such as crack cocaine's lasting effect on children (pages 72–73) tries to visually identify only the specific behavioral reactions that the drug has on children who were exposed to crack in their mother's womb. This set of pictures does not tell the reader everything about crack or how to take care of newborns. Rather, the story tries to show the special behaviors crack-addicted infants and children exhibit—such as constant crying, painful expressions, the need for soothing motion, violence in the classroom. The headline for this story might read, "Crack: The Next Generation."

Here are some headlines for stories with a theme:

- "Every Day is Father's Day," a story about a single dad.
- "Generation Under the Influence," a story about how alcoholism is passed from one generation to the next.
- "Living with Breast Cancer," a story concerning a woman who is confronting the disease.
- "Teenage Marriage: An Awesome Responsibility," a story about a young couple who have a child and get married. Each of these headlines suggests a specific

story with a defined theme.

Once you have decided on a story and started to shoot it, try writing a headline for it. Nailing down a headline indicates that you have a clear focus for the story. Make sure your headline is specific to the story and differentiates your point of view from other stories on the same topic.

"Generations Under the Influence" helped to define Brian Plonka's project on alcoholism. His story investigated not only excessive drinking but also how this problem affects different age groups and how it is passed from one generation to another.

The headline "Living with Breast Cancer" helped focus Rod Lamkey's story on the impact of cancer on Peggy Wright's life. The photographer eliminated any pictures from the story, such as Peggy shopping or going to the movies, that did not explore the effects of cancer on her life.

Once you have a headline, see if you can include or reject pictures on the basis of whether the photos fit the story's headline. If the headline is so encompassing that all the photos fit, your theme is probably too broad and the headline not specific enough.

You can devise many themes and therefore many headlines from a single situation. Even after you have finished shooting, you might find that by rewriting a headline and then reediting your pictures, you could produce a different story line. Each theme or headline demands a different edit, for the opener and all the pictures that follow. Just for fun, try changing the titles on any of the stories in this book, and see how you might change the pictures that you would include in the edit.

FIND A "NEWSPEG"

Whether you are an employee or a freelancer, an editor is more likely to use your picture story if it has a "newspeg." A newspeg tells the reader why the story is being seen now instead of six months ago or six months in the future. If you can tie your picture story into a front-page news item, then your story will take on more immediacy.

Suppose your story revolves around the life of a family doctor. You might peg your pictures on a recent study showing that the number of general practitioners is decreasing nationally. Or suppose your story concerns your town's emergency medical squad. If a squad member died last month while trying to save a child's life, your timeless story about the unit's general operations can be pegged to this recent news event.

Some magazines commission picture stories and then hold them until a related news event takes place. The news sections of the daily newspaper, therefore, provide excellent sources for story ideas because the news leads are timely. Dave Yoder, now a staffer for the *Orange County Register*, followed the dangerous lives of several bounty hunters. (See pages 160–163.) The photos might find a home in the paper when a reporter writes about the high number of bail jumpers.

TYPES OF PEOPLE STORIES

Maitland Edey, who was an editor at *Life* magazine, once observed, "Great photo essays have to do with people: with human dilemmas, with human challenges, with human suffering." People's lives, even if they are not in crisis situations, still provide the basis for most of the best photo stories.

Photo stories about people usually break down into three categories: the well-known, the little-known but interesting, and the littleknown who serve as an example of a trend.

THE WELL-KNOWN

Photo stories about well-known personalities provide the primary content for several larger circulation magazines. The best-read section of *Time* magazine, called "People," gave

PHOTO STORY INDEX

(continued)

Julie: Lifestyle of a Punk

by Donna Terek page 240

Leap for Life: A Fire in Boston

by Stanley Forman pages 36–37

Living with Breast Cancer by Rodney A. Lamkey Jr.

by Rodney A. Lamkey, Jr. pages 148–149

Path of a Bullet

Photo staff of the Long Beach Press-Telegram pages 164–166

Philadelphia's Homeless: How They Survive

by Tom Gralish page 8

Rwandan Exodus

by Carol Guzy pages 82–83

Helpers in the War on AIDS: She's There When Men Die

by Sibylla Herbrich page 71

Show of Hands

by Robert Cohen page 142

Teenage Parents: An Awesome Responsibility by Mindy Schauer

pages 167-169

SHOW OF HANDS

Mose Vinson Piano Player

Bored during a long press conference, Robert Cohen found himself watching the hands of the mayor of Memphis. "I thought about the concept of people's hands and the stories they might tell, and I filed the idea away." Later, he decided to follow through. "I wanted to photograph a myriad of folks. Well-known people, unknown people, and those in between were fair game."

Photos by Robert Cohen The Commercial Appeal (Memphis, Tennessee)

Diane Long, Obstetrician

Larry Wright, Tattoo Artist

Ernest Withers, Photographer

Farris Hodges, Jr.
Purple Heart

▲ Louise Hardaway Grandmother of Penny Hardaway, basketball star

Time, Inc., editors the idea for a picture magazine featuring personalities as the sole subject. Naturally, the editors called the magazine People. This popular weekly publishes a steady diet of photos showing the lives of the famous and the infamous. Not only People but also an assortment of other magazines—from Vanity Fair to Esquire—publish an endless variety of stories about movie stars, TV personalities, media moguls, and politicians. (See behind-the-scenes photos of politicians by Diana Walker and P.F. Bentley of *Time* magazine, pages 46–58; also see Hollywood portraits by Michael Grecco, pages 108-109, 271, 272, 280, and 281, and by Annie Leibovitz, page 112.) Today, in fact, celebrity stories dominate the contents of most mass-circulation magazines.

THE LITTLE-KNOWN BUT INTERESTING

In addition to the famous, *People* magazine prints photo stories about little-known people who either do something interesting or exhibit eccentric characteristics.

As a hero or not, the person must do something to fascinate readers. The stuntman who climbed the outside of the World Trade Center and the champion stacker of bowling balls (page 264) are examples of people with unusual accomplishments. Cristina Salvador's story about Gypsies surely qualifies as an example of a group of people living an unusual lifestyle (pages 152–157). Dave Yoder's in-depth look at bounty hunters reveals, to say the least, an unusual occupation (see pages 160–163).

THE LITTLE-KNOWN BUT REPRESENTATIVE

One person as an example of a trend Another type of personality story investigates the life of a little-known person who is an example of a new trend or developing style. For example, a growing number of children in America have only one parent. Nancy Andrews explored this trend in her story about single fatherhood. At the same time, she countered the conventional image of the absent African-American father. (See pages 143–144.)

One person represents an abstract topic At times, photographers want to explore abstract topics. But abstract topics often don't lend themselves to pictures. Again, photographers can use one person who is not famous to personify an abstract topic. Focusing on one person affected by atomic radiation or on one person living on the streets dramatizes the general problems of

nuclear power or homelessness. Readers identify with the woes of a little-known individual much more than with the problems of a political group or a sociological class.

For photographers, converting a topic into human terms provides a visual clothesline on which to hang the individual points of the picture story.

Mindy Schauer's photo story about one "typical" teenage marriage helped to illuminate the difficulties with many of these premature bondings (pages 167–169). Rod Lamkey's story about one "average" woman with cancer helped tell the story of many women who are living with and sometimes, sadly, dying of the disease (pages 148–149).

VISUAL CONSISTENCY HOLDS PHOTOS TOGETHER

Regardless of their subject matter, pictures take on an additional quality when they appear on a printed page. In a successful layout, the photos interact with one another and form an eye-catching, compelling picturestory. When the layout is unsuccessful, the pictures remain separate units simply coexisting on the page. What suggests to the reader that a group of pictures interacts as a story rather than functions independently as individual images, such as the ones you see on a gallery wall?

To link pictures together visually photographers use pictorial devices. With a visually unified essay, the viewer sees in almost every picture the same

- 1) person,
- 2) object,
- 3) mood,
- 4) theme,
- 5) perspective, or
- 6) camera technique.

SAME PERSON

The easiest way to tie pictures together into a photo story is to concentrate on one person. Restricting the scope to one individual helps to define the focus of the series. The person's identity, repeated in each photo, threads the story together and gives the layout continuity. (See "Every Day is Father's Day," pages 144–145; "Julie: Lifestyle of a Punk," page 240; "Living with Breast Cancer" pages 148–149; "Teenage Parents: An Awesome Responsibility," pages 167–168.)

With a picture story, the camera, like a microscope, magnifies the subject's daily routine. The results of the visual probe depend on the subject's accessibility and cooperation. The photographer shadows the subject as long as the person doesn't object, and as long as the paper or magazine will

EVERY DAY IS FATHER'S DAY

CLYDE JACKSON IS A PROUD DAD

Photos by Nancy Andrews, ©1997 The Washington Post A special bond exists
between a father and a
daughter—particularly
when the daughter is the
youngest child. Clyde
Jackson, a divorced father

of three, shares such a relationship with his five-year-old daughter, Tiffany. From early morning, when he helps Tiffany get ready for preschool, until evening when he shares her bedtime prayers, Jackson is a man dedicated to his fatherly duties. On the third finger of his left hand, he wears a golden band engraved with the word "Dad"—an outward and visible sign of his commitment as a father.—The Washington Post

Nancy Andrews, of *The Washington Post*, goes into situations seen by others as average and finds something of interest. "The term used around the office is that I 'make chicken salad out of chicken shit,'" she says.

Andrews believes that it is often easier to take great photographs of people undergoing trauma or working hard to seek triumph. But, she notes, "If we're constantly photographing communities in their extremes, we don't portray a complete picture. The story of Clyde Jackson isn't typical of the tons of stories in our database about African-American males....Those stories aren't necessarily inaccurate. But they are incomplete because they represent extremes. Clyde Jackson isn't the Father of the Year. He's not struggling to

overcome adversity. He's just trying to be the best father that he can be."

(BELOW) Jackson gives Tiffany's face one last scrub before taking her to school.

(RIGHT) Tiffany grasps the finger on which her father wears the ring that identifies his most important role: "Dad." Clyde Jackson bought himself this "DAD" ring for Father's Day one year.

(LEFT) Every night, father and daughter kneel by the sofa and recite the 23rd Psalm: "The Lord is my shepherd . . . "

(BELOW) Tiffany puts on her father's shoes while the fam-ily visits their minister after church on Sunday.

(LEFT) Seemingly barely awake, Jackson tries to prepare Tiffany for school. At breakfast, Tiffany spilled food on her skirt so he had to wash it. Now he irons it again while the little girl dances around.

Life Formula for Visual Variety in the Photo Story

For an assignment at the old Life magazine, editors expected photographers to shoot at least eight basic types of photos to ensure complete coverage of the situation and to guarantee enough good pictures for a layout.

INTRODUCTORY OR OVERALL: Usually a wide-angle or aerial shot to establish the scene.

MEDIUM: Focuses on one activity or one group.

CLOSE-UP: Zeroes in on one element, like a person's hands or an intricate detail of a building.

PORTRAIT: Usually either a dramatic, tight head shot or a person in his or her environmental setting.

INTERACTION: People conversing or in action.

SIGNATURE: Summarizes the situation with all the key story-telling elements in one photo—often called

the decisive moment.

SEQUENCE: A how-to, before and after, or a series with a beginning, middle, and end (the sequence gives the essay a sense of action).

CLINCHER: A closer that would end the story.

CONTINUED -

finance the effort.

In the heyday of the big glossy picture magazines and their lavish photo budgets, photographers were given considerably more time to shoot personality stories than they are today. When John Dominis was on the staff of *Life* magazine, he worked on his story about Frank Sinatra for four months before the story was finished. Later, as picture editor of *People* magazine, with its much smaller photo budget, Dominis assigned photographers to personality profiles and expected the job done in half a day.

For a story about Julie, a Midwestern punk who still lives at home, photographer Donna Terek wanted to go beyond a series of pictures of weird-looking kids who sport outrageous hairdos. The photojournalist tried to explain one young person's way of rebelling against her middle-class upbringing. The story shows Julie wearing a ring in her nose and a tattoo on the side of her shaved head. Other pictures catch Julie working, partying, kidding around with her boyfriend, and sitting stiffly on a couch next to her straightlooking younger sister and mother. To drive home the contrast between family and daughter, a final photo shows the orangehaired punk carrying her boom box and sporting a black leather jacket and spiked boots as she returns home to her parent's runof-the-mill suburban house. With this final picture, the reader has a surprisingly rounded picture of this young woman's life. (Part of this story is reproduced on page 240.)

Rod Lamkey spent a year documenting the twists and turns faced by Peggy Wright for his story, "Living with Breast Cancer" (pages 148-149). When he met her at a prayer service meeting for breast cancer survivors, the two "clicked." The first thing Peggy said to the photographer was, "Guess which one is missing?" as she stuck out her chest. "She was laughing, and I was blushing," Lamkey recalls. Peggy had undergone a mastectomy just a few weeks before. Through both a series of portraits that he took at regular intervals, and an incredible set of candid, intimate images, Lamkey recorded the life, the illness and, ultimately, the death of Peggy Wright. In each image Peggy Wright's face helps provide the visual tie that holds the story together.

SAME OBJECT OR PLACE

Sometimes the same object appears in all the pictures. In a story about rats, photographed by James Stanfield of the *National Geographic* (July 1977), for example, each photo featured a rat of some kind—a trained rat, rats as objects of worship, rats as lunch.

These kinds of stories tend to document the most amazing or most photographic aspects of a subject. The story is not about the life of one rat. It does not detail a day in one rat's life. Nor does it show the impact of rats on one family or town. Rather, it tries to portray interesting aspects of rats around the world.

Place stories often fall into this category. A travelogue that shows the most interesting stops on a visit to Paris would be held together by the visual consistency of the city even if no other connecting device were used. The images in Aristide Economopoulos' picture package on Finley's Gym (pages 212–213) are cohesive because the same poster-covered walls appear in the background of every picture along with the gloved boxers.

Brian Plonka's powerful essay, "Generations Under the Influence," goes beyond documenting the problem of drinking to excess. His story attempts to show how the young people get started on the path to alcohol and then how, as adults, they pass the habit on to their children. The essay tries to show both the camaraderie of drinking and its aftereffects. The pictures in the essay visually lock together because most contain beer cans, beer bottles, liquor ads, beer cups, or other alcohol-related paraphernalia. While some of the images—such as the photo of the line of coffins—don't show the beverage, these nondrinking pictures make sense in the essay because of their close association with the other supporting images that hammer home the visual theme of alcohol abuse.

Sometimes a group of pictures attempts to compare and contrast an aspect of life. André Kertesz compiled an entire book, *On Reading*, showing all the ways people read. He showed people reading on benches, lying down, and standing up. The pictures documented people reading in the library, in the park, and on rooftops. Each picture added an element to the central theme. Kertesz provided the visual link between the pictures by showing a book, magazine, or newspaper in almost all the images.

CONSISTENT TECHNIQUE, PERSPECTIVE, OR VISUAL MOOD

A uniform technical approach can also add a coherent thread to a picture story. Robert Cohen's essay "Show of Hands" (page 142) gives attention to a common but often overlooked and forgotten subject—hands. Cohen photographed a Marine holding up a medal. All the viewer sees in the picture is the Marine's metal, two-pronged prosthetic gripping the Purple Heart. Other pictures in the essay show a tattoo artist's hands, an obstetrician's hands genty holding an infant's

head, a grandmother's hands holding a photo of her grandson, a piano player's hands, and even a photographer's hands. Cohen not only omitted the subjects' face and body, but he photographed his subjects' hands against a stark white background, which further stylized the images. The consistent technique, hands alone against a white, shadowless background, visually cemented the elements of the essay.

To capture a child's view of the world, a photographer might shoot the pictures from two feet above the ground. The same perspective in each picture interlocks the images. Other photographers have shot photo stories from the air. The unique perspective gives the pictures a consistent "look." W. Eugene Smith took an extended series of pictures from the window of his downtown New York loft. The pictures of the street below were connected not just by the fact that they were all taken in the same place, but also by the restricted view of the camera.

Holding a topic together by shooting a series of portraits also provides a consistent perspective, whether the people are the royalty of Europe or the homeless of America. Sometimes, the photographer uses a consistent background—perhaps just seamless paper or a portable piece of painted canvas. Irving Penn, the famous fashion photographer, shot portraits of indigenous peoples in remote areas against a gray backdrop—regardless of how exotic the outside location might have been. The resulting series of photographs lock together as a united whole.

Of course, sometimes photographers shoot each subject in his or her environment. Even with the environmental portrait, however, you need to use a consistent approach to lighting and subject placement for the photographs to coalesce into a unified story. San Francisco Business assigned the author to photograph unique hotel rooms. Providing visual consistency, a white-faced mime representing a hotel guest appears in each picture. While each room in the series was distinctly different, each image shared the mime, which gave cohesion to the story. (See page 234 for one picture from the essay.)

NARRATIVE STORYTELLING

Multiple pictures remain individual images unless they are integrated into a cohesive narrative in which the selection, theme, and order of presentation transforms individual images into stories that grab and then hold a reader's attention.

All short stories share a common structure, argues Pulitzer Prize-winning author Jon Franklin, in his book *Writing for Story*.

Franklin, who twice won the prestigious award for feature writing, says that stories revolve around a complication and its resolution. He defines a complication as any problem that a person encounters. Being threatened by a bully is a complication. Having a car stolen or being diagnosed with cancer is a complication.

Complications are not all bad, Franklin says. Falling in love is a complication because you may not know whether the other person is in love with you. Winning the lottery means you have to figure out how to spend the money—and pay the taxes.

Complications that lend themselves to journalism must tap into a problem basic enough and significant enough that most people can relate to it. When a mosquito bites you, you have a complication, but one that reflects neither a basic human dilemma nor a significant problem. Discovering you have cancer and might die, on the other hand, is a fundamental problem that would be significant to most readers.

The second part of a good story involves a resolution, which, Franklin says, "is any change in the character or situation that resolves the complication."

Whether you are cured of cancer or die from the disease, the complication is resolved. (See "Living with Breast Cancer," pages 148–149.) Franklin points out that most daily problems don't have resolutions and therefore don't lend themselves to good stories.

COMPLICATION ALONE

Photojournalists sometimes concentrate on the complication but never present a resolution. While they document a social ill like poverty or drug addiction, their documentaries don't turn into narrative stories. Tom Gralish's moving photographs of homeless men sleeping on the streets of Philadelphia highlight a social problem but don't suggest a cure. (See page 8.) Without a resolution to the homeless problem, the group of photos does not have a narrative thread.

Photographs like the sad pictures of the homeless men legitimately document the complication of living on the streets, but they don't show how someone finally earns money to survive or kicks the habit—how someone resolves the problem.

RESOLUTION ALONE

Sometimes photographers shoot the resolution without ever showing the complication. Pictures of awards ceremonies record someone's success without ever showing why they got the award or what they went

Life Formula, continued

Life photographers who took all eight types of photos for a story had a high probability of bringing back a set of pictures worth publishing.

Because the formula helped to assure visual variety, the designer had many layout options.

But keep in mind that following the Life formula does not necessarily produce a newsworthy or narrative story. Instead, the formula helps assure that all the pictures a photographer takes won't just be portraits or medium shots. The Life formula does not guide the photographer in the content or the structure of a story.

LIVING WITH BREAST CANCER

(BELOW) This picture sets up the complication for the narrative story. Peggy lies on a cold table as she is measured for radiation treatments after her mastectomy for cancer.

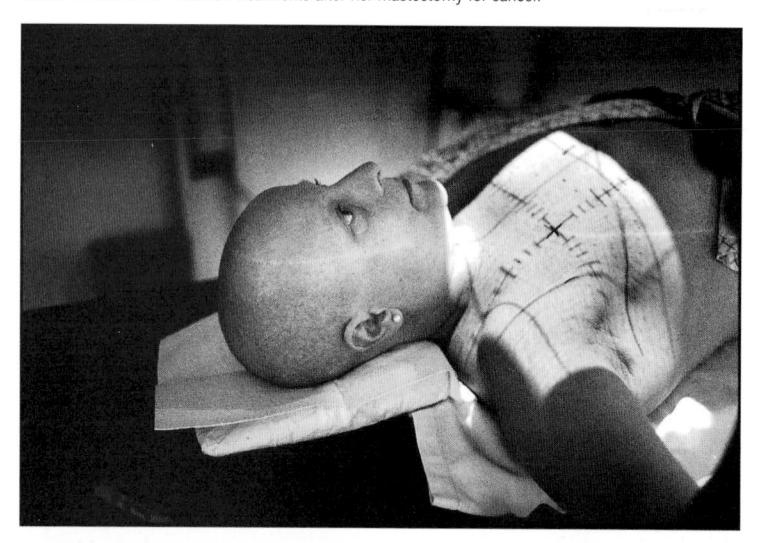

(BELOW, BOTH PICTURES) To support Peggy during her chemotherapy, Kevin has her shave his head so that he will be bald, too. These photo shows one of the ways Peggy and her husband are dealing with the problem of cancer and the treatments for it.

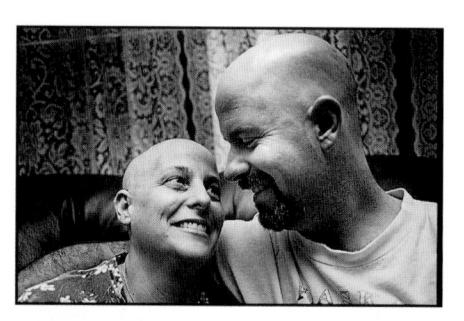

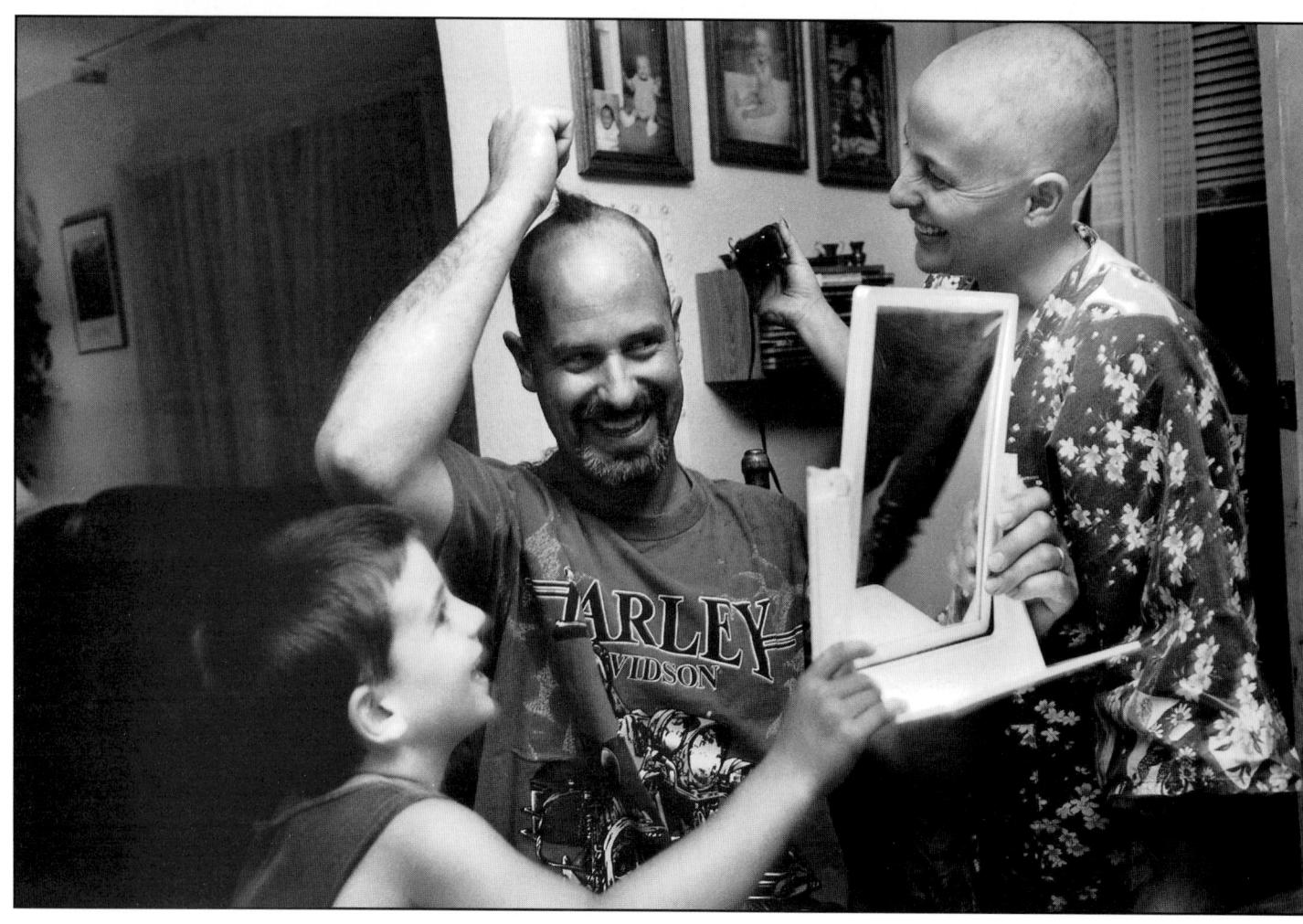

PEGGY'S

Photos by Rod A. Lamkey Jr., Alameda Newspaper Group, Fremont, California.

Rod Lamkey's story about the impact of breast cancer on Peggy Wright and her family is an example of a narrative story with a complication and resolu-

tion. The story began as a routine assignment to cover a prayer service for breast cancer survivors, their families, friends, and caregivers. Rather than stop with the routine, Lamkey and writer Kimberly Winston teamed up to do a story that would show how the disease affects one individual and her family.

Lamkey "clicked" with Peggy Wright, one of the survivors at the service that night, and all but became a part of the woman's family over the next year.

"I've been with them through hard times and good times and not once have they asked me to put my camera away," Lamkey reported just before Peggy died. Almost a year after Lamkey began photographing Peggy and her family, she finally died at home, in the arms of her husband, Kevin.

"To this day," Lamkey says, "I am still photographing Kevin, Dillon, and Dustin [the couple's sons], and will probably do so the rest of my life."

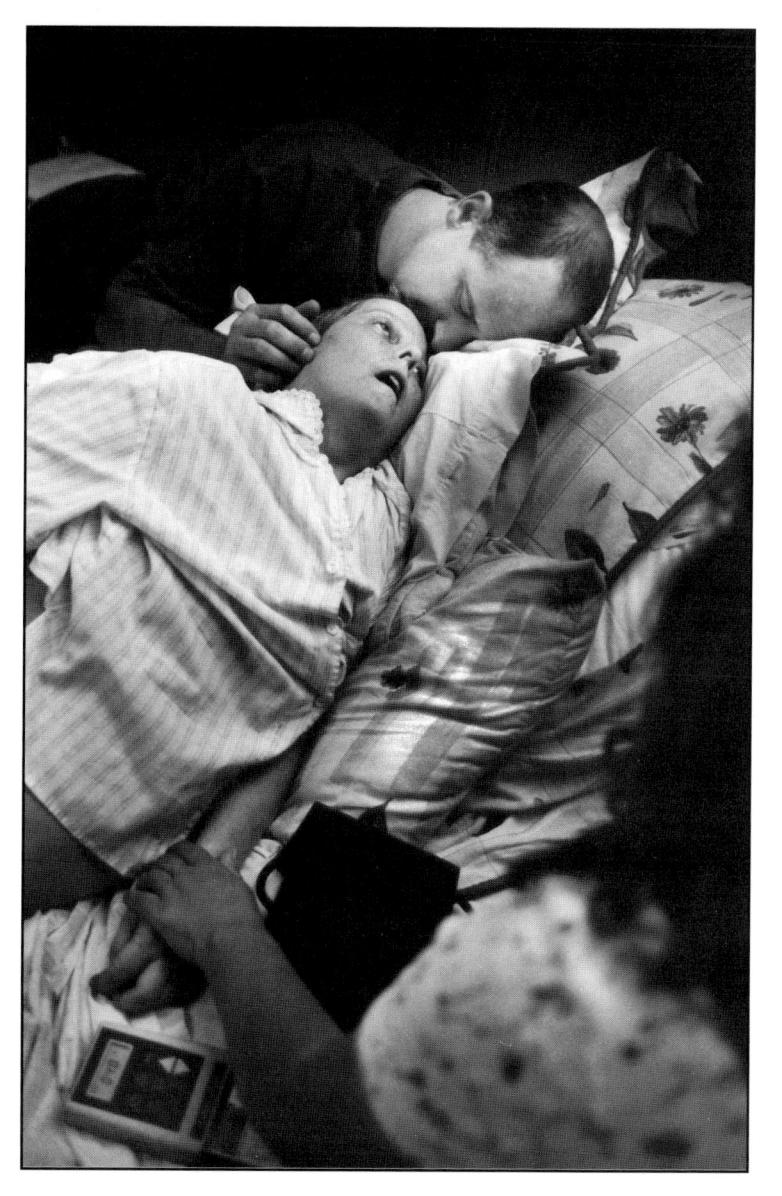

(ABOVE) Following Peggy's death, Dustin, 2, spots his mom in a family portrait that had been taken on Mother's Day-about two months before she passed away.

(LEFT) The resolution of the cancer story occurs as Peggy is dying. Kevin, her husband, stays with Peggy through the hours leading to her death. She died exactly nine years to the day after they had met.

through to deserve the medal. A cheering politician doesn't make a picture story.

The photograph of the outcome (resolution) of the campaign doesn't show the trials and tribulations (complications) it took the candidate to get to this goal.

While complications often don't have resolutions, resolutions almost always have complications. When John Doe wins the Olympic track and field award, you know that he faced many hurdles to get there. The photos become a narrative story only when the photographer shows both the challenges on the way to the top (the complication) as well as the final victory (the resolution).

EXTERNAL ACTION NEEDED FOR PHOTO NARRATIVE

Unlike a written story, a compelling photo story requires not only complication and resolution but also action that can be photographed. The complication must be visual and not just internal. The subject must try to resolve the complication with action.

A woman sitting in a wheelchair presents a complication. The reader can see that the woman is faced with a problem. However, her sitting there alone doesn't provide the subject matter for a story. If the wheelchair-bound woman tries to walk, then the photographer has a potential narrative photo story.

Showing the woman's actions such as struggling to get out of the chair and finally learning to stand and walk with crutches would provide a possible resolution. After many attempts, photos of her walking alone would complete the story.

The story is not a *description* of a handicap but a *tale* of her efforts to overcome her physical limitations. Rather than being "a story about a disabled person," the story's really about the human effort to overcome an obstacle—and every reader has had to overcome obstacles.

The outline, with an emphasis on the action, might read:

- At first, after the accident, the subject is confined to her wheelchair.
- Then she exercises and swims for therapy.
- Next, she **steps** haltingly.
- Finally, the subject walks alone.

COMBINATION OF COMPLICATION AND RESOLUTION

Stanley Forman, three-time Pulitzer Prize winner, photographed a complete narrative story with an obvious complication and a built-in resolution when he covered a fire in Boston. (See pages 36–37.)

Forman was cruising the city with his

scanner radio turned on, looking for spot news, when he actually smelled smoke. He pulled up next to a house as flames were billowing out of the first floor. As Forman arrived, police cars came screeching to a halt with their sirens blasting and lights flashing. Stranded on the roof of a burning porch, a man and a woman clutching a baby looked desperately for help.

Flames curled up from the porch below. The family was trapped (complication). Firefighters had not arrived with a ladder. The father bent over the edge of the roof and delicately dropped his child into the arms of a waiting policeman, who safely caught the child. Then the mother panicked. Afraid to jump, she froze. The man literally pushed her off the roof to save her life. She fell to the ground, slightly injuring her leg. Then the man himself leaped to safety.

To complete the narrative news story, Forman photographed the medics carrying the mother away on a stretcher as the building blazed in the background and also caught a picture of the policeman hugging the child he had saved (resolution).

Rod Lamkey's story about Peggy Wright (pages 148–149) living with cancer follows the classic narrative model. When readers of the *Argus* (Fremont, California) met Peggy, they did not know the story's outcome. She had just undergone a mastectomy. Her photo on the X-ray table sets up the complication.

No one—the readers, the photographer, or the subject—knew if Peggy would survive. Peggy's life had a clear complication. The rest of the photo story explores how she handled her disease. For example, the photo of Peggy clipping off her husband's hair so that they both would be bald showed her resilience and humor in the face of cancer.

The reader stays glued as the story unfolds image by image, its outcome unknown. In fact, when Peggy Wright's story was first published, Peggy still maintained, "I am not going to let cancer get me. I look at it as another hurdle my family has to get over." However, in a sequel publication, the photographer showed the moment of her death as well as the funeral, and later, the children looking at a portrait taken shortly before her death.

Like the story of Peggy's battle with cancer, the teen marriage of Dee, sixteen years old, and Tim, eighteen, also has a natural narrative order that develops over time (pages 167–169). The plot line of the narrative story leads from dating, to pregnancy, to marriage. But the tale does not end there. The photographer goes on to show the enormous responsibility of caring for a demanding newborn.

Photographer Mindy Schauer, of the *Orange County Register*, tracked the couple through their wedding (with the bride eight months pregnant), photographed their many arguments, captured the young mother's frustration, and even followed their move to Texas and then back to California. The photographer was there when the couple fought as well as when they made up. As the narrative of the couple's life unfolds, the reader never knows what will happen next. Will the husband leave? Will the wife kick him out? Where will they live? What will happen?

Like any good saga, readers had to look to the next picture and then the next page to see the drama unfolding.

NATURAL NARRATIVES

Some stories lend themselves to the narrative approach. Consider those about an athlete preparing for the big match. Here the complication is the athlete's desire to win. The story follows the athlete through the rugged, sweaty training regime. Finally, the athlete wins or loses the big contest (resolution).

Many adventure stories have a built-in complication as well as a resolution. Keith Philpott photographed an exploratory raft trip down Africa's Omo River for *National Geographic*. Starting in the Omo's headwaters near Ethiopia's capital city of Addis Ababa, the trip ended 600 miles later at the river's destination, Lake Turkana. The built-in complication involved overcoming the river's perils, including fighting off hippos. The rafters also experienced adventures along the way and witnessed the lives of people living near the river. The story's natural resolution showed placid Lake Turkana.

Other stories with a natural narrative include Jim MacMillan's pictures of a hostage situation (page 27). The story of the hostage overcoming the gunman that was holding him makes for an obvious narrative with complication and resolution taking place in a few minutes. Stanley Forman's "Leap for Life" (pages 36–37) also has this natural built-in narrative.

COMPRESSING NARRATIVE TIME

Writers can reconstruct past events with an interview. For the photographer, the biggest problem with shooting narrative stories is that many complications faced by potential subjects simply don't take place in the relatively short time allotted for most assignments. Sometimes, months or even years go by before a person resolves a complication. Rod Lamkey followed Peggy Wright for more than a year (pages 148–149). Magazine and newspaper editors sometimes allot

today's photojournalists only a few days to work on stories. Here are a few ways you might compress time in a narrative story.

Resolution near at hand

Pick a story in which the resolution is near at hand. To shoot a story about a political new-comer running for mayor, zero in on the subject a few weeks before the primaries or before the actual election. At this time, you will be able to show how the candidate grapples with the complication of getting into office: glad-handing potential voters, strategizing, chain-smoking, meeting late at night, preparing for television interviews.

The narrative story will resolve itself on election eve or perhaps the mayor's first day in office. Starting too early or too late, however, means you may miss the complication or resolution.

With a May deadline, Ron Bingham set out in February to shoot a story on open adoption, an arrangement in which a pregnant woman planning to give up her newborn selects the parents who will adopt the child. Bingham did not want to take pictures of couples playing with their recently adopted child or shoot a series of portraits of mothers who had given up their children at birth. He wanted to shoot a narrative story in which he was present at all the important emotional moments that a birth mother and adoptive parents go through.

To show the relationship developing between the biological mother and the adoptive parents and to pull off the story by his deadline—mid-May—he knew he had to pick a woman who was near term.

Unlike prescripted Hollywood stories, reallife stories don't always end as you might expect. After following the relationship between the birth mother and the prospective adoptive parents for three months, a dramatic change occurred.

Following the labor and delivery, the adoptive parents first held the child. Then the birth mother held her . . . and did not want to let her go. The adoptive parents left the hospital empty-handed.

A small resolution will do

Within a story, you might zero in on a small resolution rather than the ultimate resolution to the complication. You might follow a heart attack victim through an operation and track his or her recovery. You might end the story with dismissal from the hospital even though this juncture might only be the first step in an eventual cure. Although you will not have recorded the ultimate victory over death, you will have told a unified story.

GYPSIES IN AMERICA

AN ANCIENT CULTURE HIDDEN IN AMERICA

Photos by Cristina Salvador Long Beach Press-Telegram Nestled deep
within most
American cities yet
invisible to most people is a culture rich in
tradition, language,
and family ties.
Within its closely knit
group of extended

families consisting of various tribes, or "vitsi," the members have known one another for hundreds of years as Rom. Their mysterious lives have been the subject of storybooks, myths, and songs, says photographer Cristina Salvador, but few have ventured into the complex world of the people known to most as "Gypsies."

Salvador is one of the few outsiders ever to

penetrate the protective shield that American Gypsies have built around their culture.

Although she stresses that her photographs do not depict all Gypsies, she spent more than four years getting to know and photographing four different tribes of American-born Rom living in California. These groups of people, she says, are descendants of Romanian slaves who were freed in the 1850s and 1860s.

American Gypsies came here from Europe like other immigrant groups, says Dr. Ian Hancock of the University of Texas-Austin (a Gypsy himself). Hancock wrote a comprehensive piece that accompanied Salvador's photographs when they were published in Aperture. However, he says, Gypsies are not European but actually originated in India. While they have lived in the West for nearly

eight centuries, the heart of their language (two-thirds of which has been determined to be based on ancient Sanskrit) and culture is Indian.

Since that ancient emigration, Gypsies have been landless, a status that has subjected them to persecution to this day, Hancock says. As recently as 1992, the *New York Times* published a poll that surveyed the American general pubic toward fifty-eight different ethnic and racial groups. Gypsies were perceived as the most "undesirable."

"This is surprising," Hancock writes,
"because most Americans have no first-hand
contact with Gypsies—and equally unsurprising, as historically, Gypsies have been
harassed for being outsiders, for being wanderers, for their dark skin, and 'foreign' ways."

(BELOW) Mara sits for a portrait, which the woman wanted to have enameled for her tombstone. Though she was not ill at the time, Mara died about a year later.

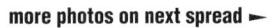

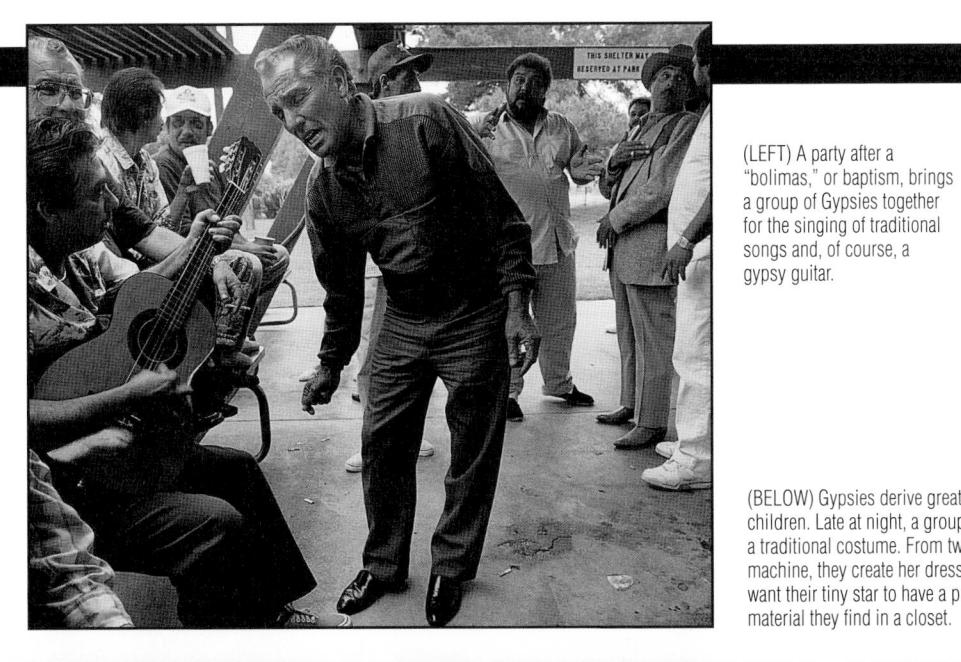

(BELOW) Gypsies derive great pleasure and entertainment from their children. Late at night, a group of women spontaneously dress Susie in a traditional costume. From two yards of material and without a sewing machine, they create her dress and scarf in about fifteen minutes. They want their tiny star to have a proper photo background, and use more material they find in a closet.

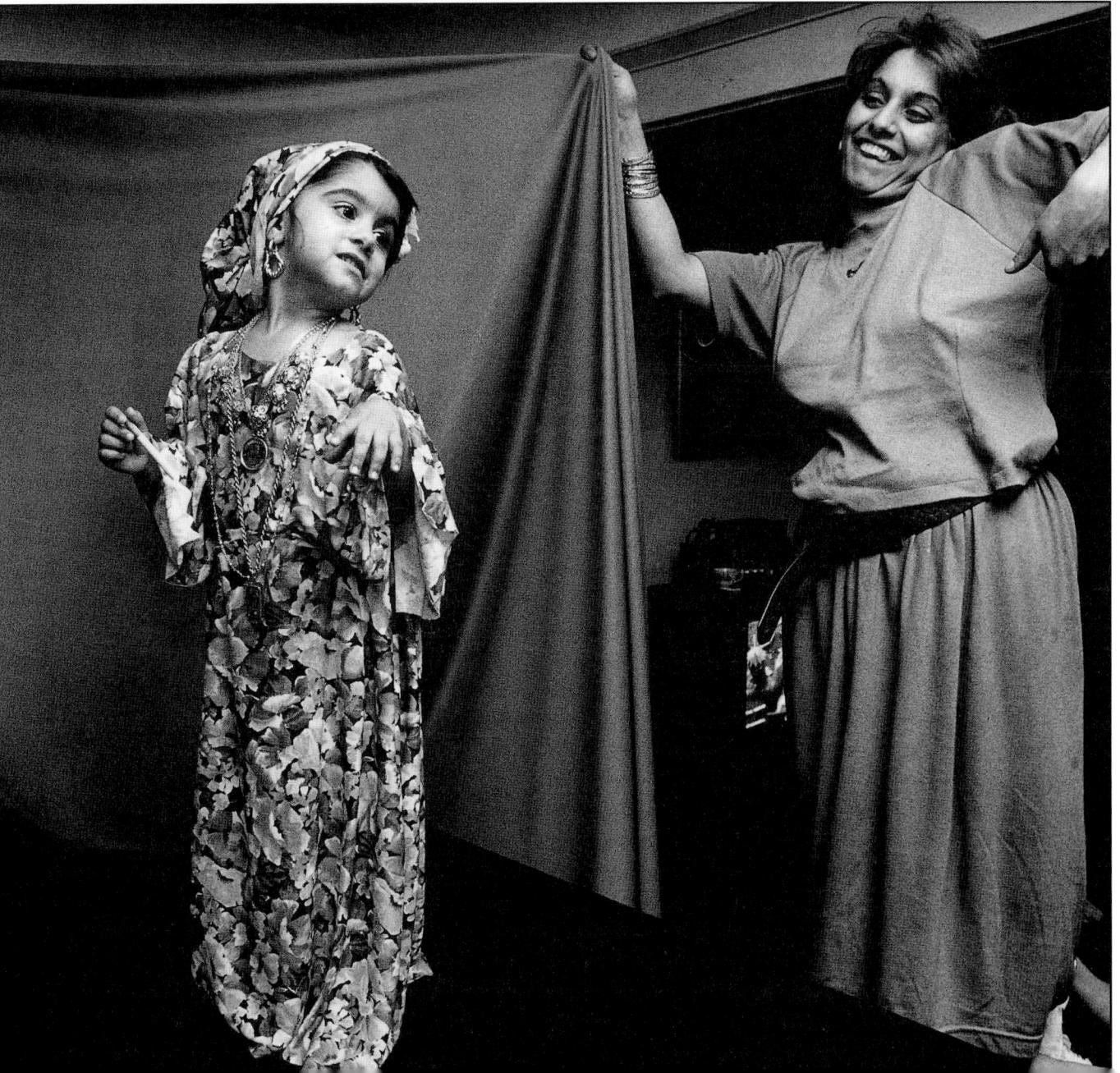

GYPSIES IN AMERICA

(BELOW) A group of friends celebrate after an engagement party.

Strong social bonds, necessary for "protection," exist within the families. Time spent among outsiders is considered debilitating and upsetting to the natural balance of things. Being with other Gypsies counterbalances outside influence.

FAMILY: THE CENTER OF LIFE

For Romani Americans [Gypsies], the family is the basic essence of the individual. It molds his character, prepares him for life, and gives him a connection with the past. To live alone without knowledge of one's traditions is to live a life of endless emotional wandering and isolation.

— Cristina Salvador

(ABOVE) Marriages are arranged for Gypsy adolescents. Weddings often last three days and are open to attendance by anyone in the culture. One of the legacies inherited from India and rigorously practiced in the United States, says Gypsy scholar Dr. Ian Hancock, is the belief in ritual pollution, and in

the importance of maintaining spiritual harmony or balance in one's life—a balance that can be easily upset by not observing proper cultural behavior. Socializing too intimately with non-Gypsies is a serious transgression that can lead to defilement and spiritual disharmony, perhaps even to illness.

(BELOW) Word of mouth brings together hundreds of Gypsies for an elaborate wedding in a hotel banquet room. Each family is expected to give a monetary gift to help the groom's family pay for the wedding. Among the Gypsy groups that Salvador photographed in California, family and community are central to daily

life. Although there are lawyers, teachers, restaurant owners and such among the groups, these occupations are unusual. Jobs having less direct involvement with the American establishment and also allowing freedom of movement are preferred. This willing isolation results partly for fear of defilement, and partly

because it is important to be able to leave and visit another community at any time—for a wedding, a funeral, or a saint's day banquet. Communities are not usually located near one another because doing so would put families' economic opportunities in conflict.

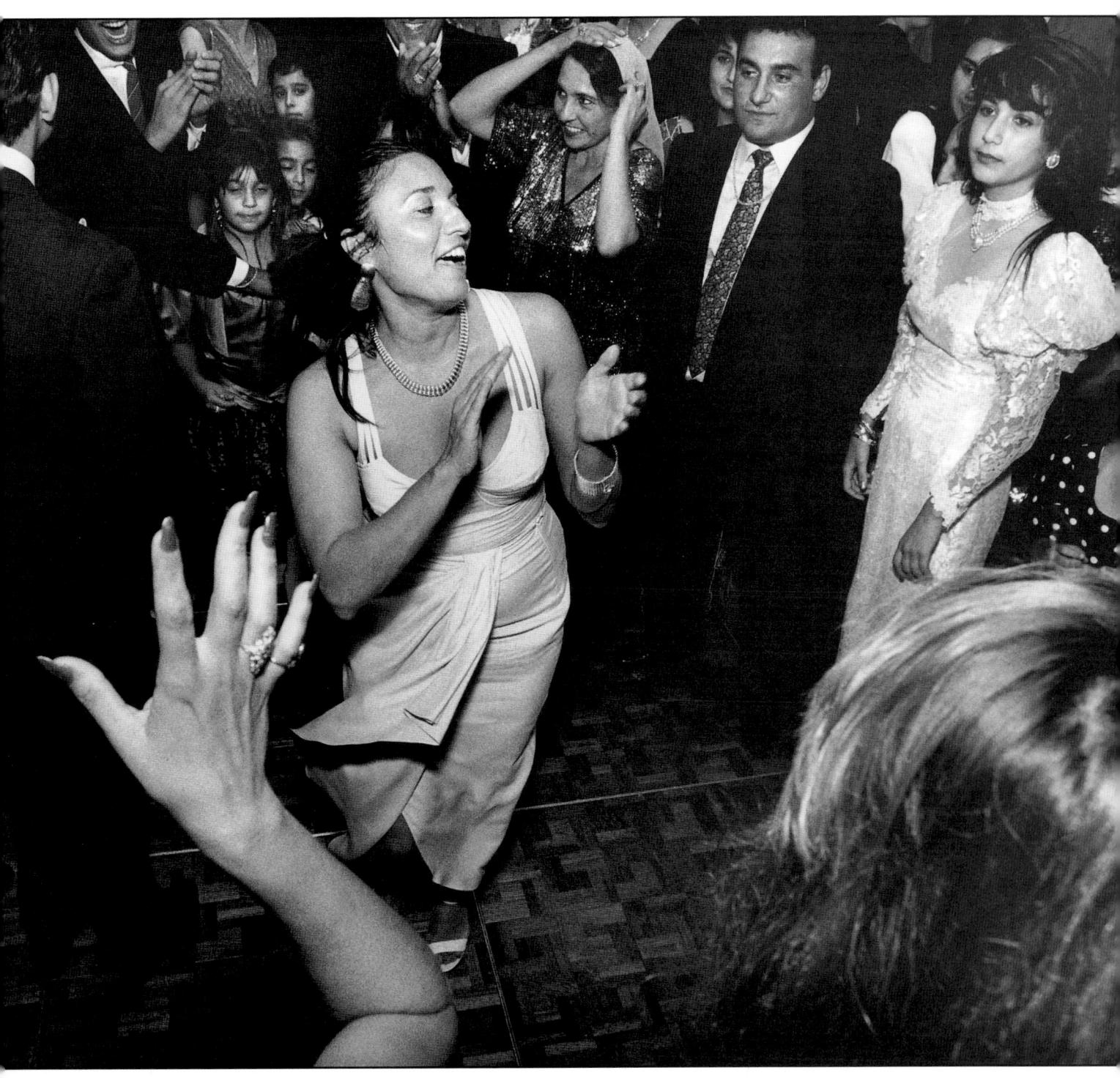

THE PRICE OF SECLUSION?

As I became more involved, I realized that the Gypsy traditions were not as important to my essay as were the interactions among family members. I began to focus on questions like "What happens to a culture than has been persecuted and ostracized for so many

centuries?" "How does this discrimination affect the way they interact with each other?" "Do they treat each other the same way society has treated them?" . . . Most of all, I learned that life is so difficult if one cannot read or write. [Most Gypsy children leave school in junior high.] I also realized for the first time how difficult it is to solve everyday problems without knowledge or education. . . .

Most books about Gypsies focus on their history, but none really analyze what has happened to the culture from a sociological or psychological perspective. Many of the Romani Americans I met have become hardened, insensitive, and frustrated with daily life. Many have nerves of steel; an excellent tool for survival. Yet amid all the chaos, there are often acts of kindness and an ever-present atmosphere of joy and festivity, and a feeling that life is full and that no situation is too difficult to overcome. — Cristina Salvador

(ABOVE) Traditional culture does not permit involvement with the non-Gypsy world beyond the minimum required for social and economic survival. Typically, youngsters are taken out of school in junior high. Many do not even go that far. The young man above is showing off his muscles.

(ABOVE) A lack of formal education, resulting in few job opportunities and poverty, leads to high frustration and even violence in some Gypsy families.

(BELOW) A newborn, brought home for the first time, is kept under close watch by grandparents. As with many ethnic minorities in the United States, the older generation fears that the group's

identity is threatened by American influences, and that young people are losing their heritage. However, most children are brought up speaking Romani, a sign the culture is intact.

Mindy Schauer followed the story of teen parents for more than a year (pages 167–169) but, of course, could not follow the lives of this couple and their child until the baby reached adulthood.

A telling picture shows the teen mom overwhelmed with the responsibility of caring for not only her child but also a friend's baby. In the picture, the friend's child is looking at *Parents* magazine. Clearly, the implication of the image is that the problems faced by one generation will be passed onto the next.

Use existing pictures

Investigate photo albums or archives to show what your subject or location used to look like. If your story is about a successful banker who has overcome a poverty-stricken past, can you show the complication with photos of the person as a youngster living in a cold-water flat or a run-down shack? Without these pictures, the banker's success (resolution) would seem unearned.

If your story is about a neighborhood, can you find old pictures from the historical society or your paper's morgue that indicate whether the neighborhood used to be wealthy or poor, or perhaps even farmland or forests?

Look at different developmental stages Photographing a narrative story on the long-term impact of crack cocaine on newborns does not require following one child from birth through preschool. To address this impact at different critical stages, the author photographed infants suffering withdrawal at San Francisco General Hospital, (complication) toddlers in a testing program (partial resolution), and then crack-affected youngsters in an early intervention program in an East Palo Alto school (partial resolution.) Part of the project is reproduced on pages 72–73.

THE INHERENT APPEAL OF A NARRATIVE STORY

Shooting narrative stories takes research, scheduling, and time. Narrative stories often require the patience of Job and the planning of an air traffic controller. Sometimes the end is not predictable when you start. However, all the difficulties are worth it. Rather than presenting an interesting collection of pictures that holds readers for a few minutes, the narrative story draws the viewer into the subject's predicament.

With a narrative story, readers start to care about the subject and want to know how the person is going to solve the dilemma. What is going to happen? When picture stories are done well, readers remain on the edge of

their chairs, waiting to see the last picture that reveals the story's outcome. The story has a plot line—not an invented, preplanned script typical of early picture magazines, but a real story line in which people face problems and overcome them in some way.

Most important, the reader comes to care about the story's protagonist. Whether you are telling a story about Peggy, who has cancer, or Dee, the teenage mom, the subject is not shown just once but is repeated in picture after picture. The reader gets involved in the subject's life. Will Peggy live or die? Will Dee's eighteen-year-old husband abandon her and the newborn? And, perhaps, if the story has merit and is well-photographed, the reader won't just give a passing glance to the pictures and move on but will remember the story, repeat it, and, perhaps, show it to others.

COMPARING THE DOCUMENTARY AND PHOTO ESSAY TO THE NARRATIVE STORY

Editors, photographers, writers, and readers apply the term "picture story" to just about any group of pictures. One can divide the picture story into several categories.

NARRATIVES CONVEY A PLOT

The narrative story as described above has a complication and resolution. In writing, whether it's a short story or a book-length story, the plot usually involves some form of complication and then resolution.

EDITORIAL ESSAYS: A POINT OF VIEW Some groups of photos don't set out to tell a narrative story. Rather, like a magazine opinion piece or newspaper editorial, they set out to make a point. These editorial photo essays clearly have a point of view. For instance, Brian Plonka does not tell the tale of one alcoholic in a narrative style. Rather he exposes the highs and lows of alcohol addiction. He has a clear point of view. He is certainly not an advocate of alcohol consumption. His pictures look nothing like the ones shown on the Budweiser beer commercials. Nor is he neutral, just recording everything about the beer industry from growing hops to bottling the product. Rather, his pictures all have a clear point of view. His photo of a father trying to get his son to taste beer makes this reader want to recoil. Plonka is not making an impartial statement about drinking. He is presenting an editorial essay with a clear point of view.

Likewise, Alan Berner has some interesting observations about development in the western United States. (See pages 76–77).

Ironic juxtapositions in his photographs force readers to think. His picture of a line of abandoned refrigerators in front of a mountain range contrasts the ugly, disposable world of modern society against the naturally beautiful vista of the West. The line of appliances in the foreground and the mountains in the background share eerily similar silhouettes.

Berner finds another ironic contrast when he combines a city skyline and the tops of Native American tepees. He makes readers confront the old and the new. His picture of a mall opening, complete with dignitaries sitting outside in folding chairs to watch the eruption of a fake Mt. Ranier, pokes fun at the artificiality not only of this event but of development in general. Each picture in Berner's essay, to a greater or lesser extent, conveys his distinctive sensibility.

DOCUMENTARIES OBSERVE

Photographers don't always have a point of view about their subjects. They don't always want to tell a narrative tale with a complication and resolution. Sometimes photographers just want to show their readers something that they find fascinating. Often they want to remain neutral, to present a range of unfiltered observations that let viewers judge for themselves.

Documenting a lifestyle

After meeting some Gypsies while traveling abroad, Cristina Salvador set out to document the life of Gypsies in America. Her documentary (pages 152–157) presents an even-handed view of this usually private. closed-off culture. She photographed the familial joy of Gypsies dancing and singing at a wedding, but she also photographed one of the men threatening his children with a belt. The variety—and intimacy—of Salvador's images allow readers a glimpse at the lifestyle of this rarely seen sub-culture.

Documenting a place

Other photographers document a whole country, a region, or perhaps a single building in a city. Steve Raymer documented many aspects of Russia for a story titled "Mother Russia on a New Course" for National Geographic. Raymer's pictures included a retired colonel confronting a demonstrator at a May Day rally in Red Square (page 238), a late afternoon picture of Leningrad (the cradle of the revolution), as well as a group of elders at the Pskov-Pechory monastery sharing a meal. Raymer did not try to tell a narrative story or photograph with an editorial point of view. Rather he tried to accurately describe

in pictures what was happening in the country at the time.

Documentarian Ken Light photographed the Mississippi Delta, an often forgotten, impoverished region in the United States. During a series of trips to the area, Light photographed an outdoor baptism as well as laborers bent at work in the fields. He photographed a range of activities that give a sense of the area and its inhabitants for people unaware of the isolated and area. His pictures, published in his book *Delta Time*, also document for future generations a way of life that is likely to disappear soon. A small part of the project is reproduced on page 138.

Aristide Economopoulos, on the other hand, documented the life and times of a single structure—Finley's Gym—and the people who use the building. (See pages 212–213.) Every picture, loaded with tactile information, reveals another aspect of this great old local institution. From pictures of "wannabes" to contenders, the images take the viewer behind the scenes of this old-fashioned male fight club. The pictures catch the fighters' intensity as well as the managers' concern. The photos show how men pass down the ancient art of boxing through the generations.

Documenting an issue

The photographers of the Farm Security Administration (FSA) documented the severe poverty resulting from the Depression and Dust Bowl. These photographers also photographed government aid in the form of work programs and housing provided by President Franklin Delano Roosevelt's Works Progress Administration (WPA). Roy Stryker, director of the FSA photo project, never intended to tell a narrative story. FSA photographers did not follow one family or even a set of families through their trials and tribulations on the way to economic self-sufficiency. Rather, Stryker's photographic corps created an important documentary historical record of the times.

Much more recently, Donna DeCesare set out to document a problem of which many people in the United States are unaware. During the 1990s vigorous enforcement of U.S. immigration laws returned many streetgang members from American cities to native countries they barely know. The policy has not destroyed gangs but has franchised America's gangs in Latin America and the Caribbean. The United States is exporting its violent crime all over the world-and DeCesare has the pictures to prove it. (See pages 74–75 for part of the project.)

Likewise, Melanie Stetson Freeman in "In

Darkness: The Exploitation of Innocence," has shown how children around the world work as beggars, as laborers in factories, or as conscripted soldiers even before they reach their teens. Taken in countries all over the world, her pictures for the *Christian Science Monitor* provide irrefutable evidence of this tragic condition. (See one picture from this project on page 60.)

PICTURE ORDER VARIES

Written narratives typically have a fixed story line that proceeds from one moment in time to another. With a photo narrative, you don't know the end when you start, so the story line determines the sequence of pictures in the layout. Rod Lamkey's story about a woman's struggle with cancer has a natural order (pages 148–149). The lead picture of Peggy getting an X-ray following her operation was taken early in the project.

On the other hand, Alan Berner's essay about the West (pages 76–77) does not have a natural order. An editor can organize those pictures in many ways, starting with almost any of them. The last picture that Berner shot could be the first in the essay.

In general, the lead picture in a documentary is not necessarily the first or last one that was taken but rather the one that best summarizes the story. Steve Raymer's picture of a retired Russian colonel holding a Soviet flag while arguing with anti-Communist demonstrators during May Day celebrations in Red Square captured the country's old and new attitudes and provided a visual synopsis for his story "Mother Russia on a New Course." No timeline determined that this picture needed to lead the article. Rather, the editors felt that this image (page 238) best encompassed the story that would follow.

SELECTING AN APPROACH

Some stories lend themselves to the narrative form with a complication and resolution. For others, the documentary approach best conveys an objective record of a place or lifestyle. Still other stories lend themselves to the editorial photo essay—a story that has a clear point of view. Each way of shooting and packaging a photo story is difficult in its own right. Selecting the best approach is the first step in producing a powerful package.

BOUNTY HUNTERS

OUTSIDE THE LAW

Photos by Dave Yoder Orange County [California] Register Bounty hunters are, literally, hired guns. They pursue indicted fugitives who flee before their trial dates. When an accused person fails

to appear in court, bail bondsmen, who actually loan the money for defendants to make bail, often hire bounty hunters to find and arrest the "skip."

Unlike law enforcement officers who work for the government, bounty hunters are free agents—unlicensed and often untrained—who have the right to carry firearms, enter private homes without a specific search warrant, and arrest fugitives. In California, they don't even need a license for their guns as long as they can show they are pursuing a fugitive. There is no recourse, either, for the citizen whose home the bounty hunter enters by mistake. A nineteenth century law (Taylor v. Taintor) even gives bounty hunters the right to travel anywhere within the United States to capture fugitives, something ordinary police cannot do.

Luckily, though his subjects did draw their guns, no shots were ever fired while photographer Dave Yoder accompanied different bounty hunters in Indiana and California over a four-year period.

While still a student at the University of Indiana, Bloomington, Yoder began photographing the story after seeing several bounty hunters interviewed on television. A few phone calls later, and he was accompanying a "skip tracer," as they like to be called, on a stake-out of a fugitive's home. This was the first of more than one hundred and fifty nights that Yoder spent with bounty hunters.

Often, nothing happened. Just a lot of sitting in the car, eating donuts, and drinking coffee. Sometimes, Yoder went three or four nights in a row without taking a picture. But then, he says, "All hell would break loose."

Photographically, Yoder learned when to shoot and when not to. He didn't want to make life more dangerous for his subjects, he says. In return, he got full access. During arrests, he followed the bounty hunters as they broke down doors or pushed their way into houses.

"You can't wait until they have the situation all calmed down," he explains. "You have to be there ready, anticipating. You have to be in the right position to get the photo."

Yoder says that only on one occasion did a property owner ask him to leave. He complied. With the Supreme Court having decided that police cannot invite journalists to enter a house while they are serving a warrant (pages 291–292), it is likely that few photographers will enjoy the kind of access Yoder had on this project—even though bounty hunters are almost a law unto themselves.

more photos on next spread -

(LEFT) Brian Uptgraft kicks in the door of an East Los Angeles apartment where he thinks a "skip" is hiding. As it turns out, he has mistaken the light from a partner's flashlight as someone being inside the empty dwelling. After finding no one inside he walks away, leaving the wrecked front door as it is.

(BELOW) Brian Uptgraft orders a "skip" out of the man's East Los Angeles attic where he was hiding. Uptgraft takes no chances, as the man had earlier been convicted of homicide for a drive-by shooting.

BOUNTY HUNTERS

NOWHERE TO HIDE

(RIGHT) Benny Hoppes finds a "skip" hiding underneath a bed in Indianapolis.

(RIGHT) Bounty hunter Ray Meredith readies his revolver .

(BELOW) A boy is witness to the rushed search of an Indianapolis home by Ray Meredith, who is sure the fugitive he seeks is hiding somewhere in the house because of how long it took for someone to answer the door. He is right, the man is upstairs hiding in a shower.

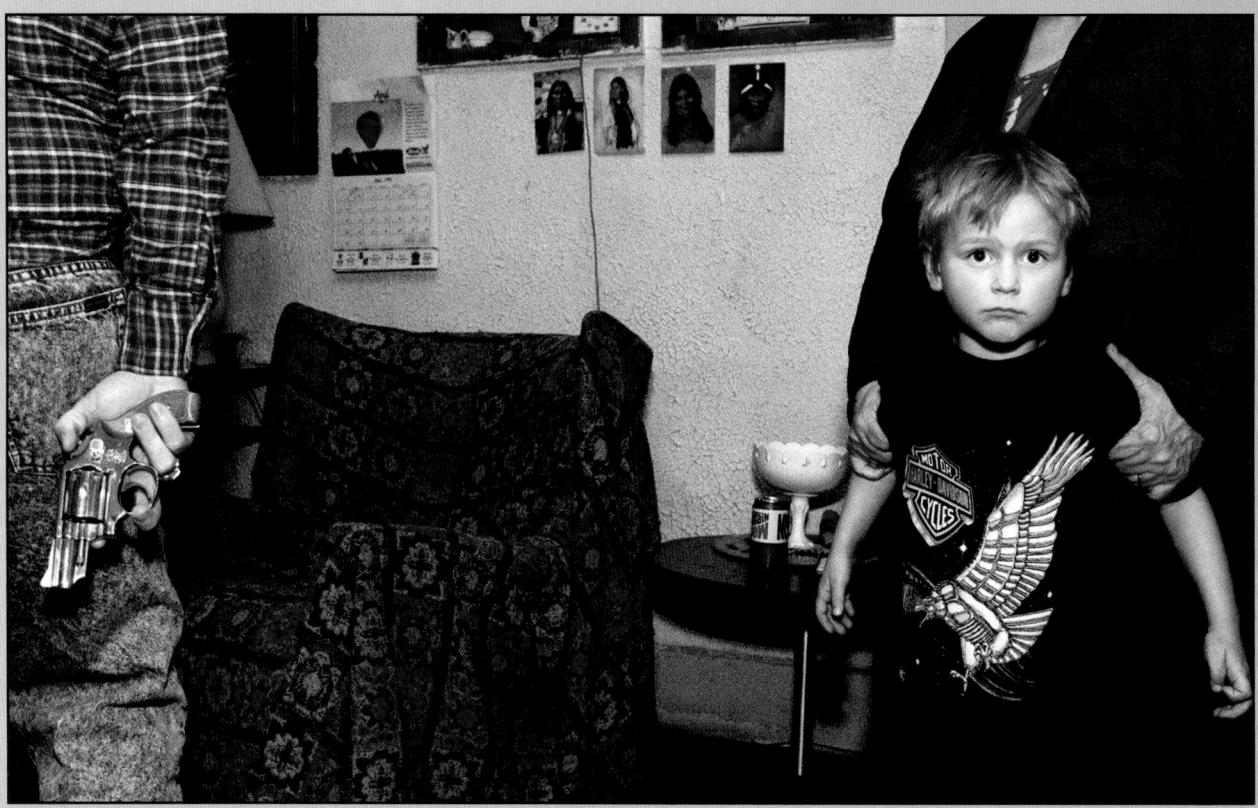

162 • Photojournalism: The Professionals' Approach

(ABOVE) Al "Colt" Schlegal interrogates the father of a "skip" at 3 a.m. in South Central Los Angeles. The questioning, which took more than two hours, scares and confuses the man, who is not the subject of the search.

(LEFT) A "skip" gets a last hug and some water from his girlfriend before he is taken to jail from his East Los Angeles home.

PATH OF A BULLET

THE COST OF A LIFE: TWENTY-TWO CENTS

The goal of this project was to show readers that there is a price we all pay when a bullet rips into flesh. To tell that story, the Long Beach Press-Telegram received cooperation and access from the police and fire departments as well as from St. Mary Medical Center and Memorial Hospital. Staff photographers agreed to work long hours waiting for a suitable subject to appear. The subject would have to be a shooting victim, would have to make it to the hospital for treatment. And, with luck, relatives would cooperate.

The journalists received support from and access to the victim's closest relatives-his father, Jack Perry, and his stepsister, Alicia Smith. The Press-Telegram committed more than twenty journalists, including seven photographers, to the project. The cover photo of Martine Perry as he lay dying received the most discussion. It was not a photo the paper would display of a "routine" shooting. But this coverage was anything but routine. That photograph displayed the horror that paramedics, police, and emergency rooms face all too often.

— The Long Beach [California] Press-Telegram

Long Beach Press-Telegram photographers who participated in the project:

Suzette Van Bylevelt Leo Hetzel Juanito Holandez Paul Hu Ken Kwok Matthew J. Lee Hillary Sloss

Photo Editor: Hal Wells

(ABOVE)

SATURDAY, SEPTEMBER 7, 1996: Martine Perry, 16, longtime Boy Scout, gang member, and beloved family member, lies unconscious, surrounded by paramedics' equipment and trauma dressings after a bullet has ripped through his skull. (Photo by Paul Hu.)

(RIGHT) **5** A Long Beach police identification technician photographs the crime scene. He is just one of forty-eight officers and other personnel who work on the shooting case that night. (Photo by Leo Hetzel.)

3 An X-ray of Martine's shattered skull. The young man does not survive.

(ABOVE)

4 Dr. Doug McConnell of Long Beach
Memorial Medical Center holds a
spent bullet fragment. Young people,
he says, do not comprehend the savage
damage these fragments can cause.

(LEFT)

2 SATURDAY, 8:55 TO APPROXIMATELY
9:20 P.M. Doctors and nurses labor to resuscitate Martine with oxygen, CPR, and an incision in his larynx to clear air passages—all while assessing bullet damage. (Photo by Paul Hu.)

(ABOVE)
Police officers question the occupants of the first five houses in every direction from the shooting. They try to learn what the neighbors might have seen or heard, and what they might know about the shooting, the victim, the attackers. Conducted in English and Spanish, the process takes hours. (Photo by Leo Hetzel.)

Tevine and the trigger. (Photo by Jaunito Holandez.)

more photos on next page ►

PATH OF A BULLET

THE COST OF A DEATH: STILL COUNTING

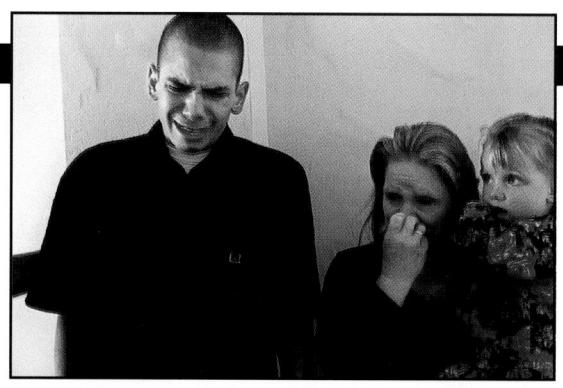

(LEFT)
AT THE WAKE Michael
Delgado grieves after viewing his friend's body.
Accompanying Delgado are his aunt and her three-year-old daughter. (Photo by Paul Hu.)

(RIGHT)

THE PROCESS
OF GRIEVING
The day before the funeral, members of the East Side
Langos, a local street gang, attend their friend's wake.
(Photo by Paul Hu.)

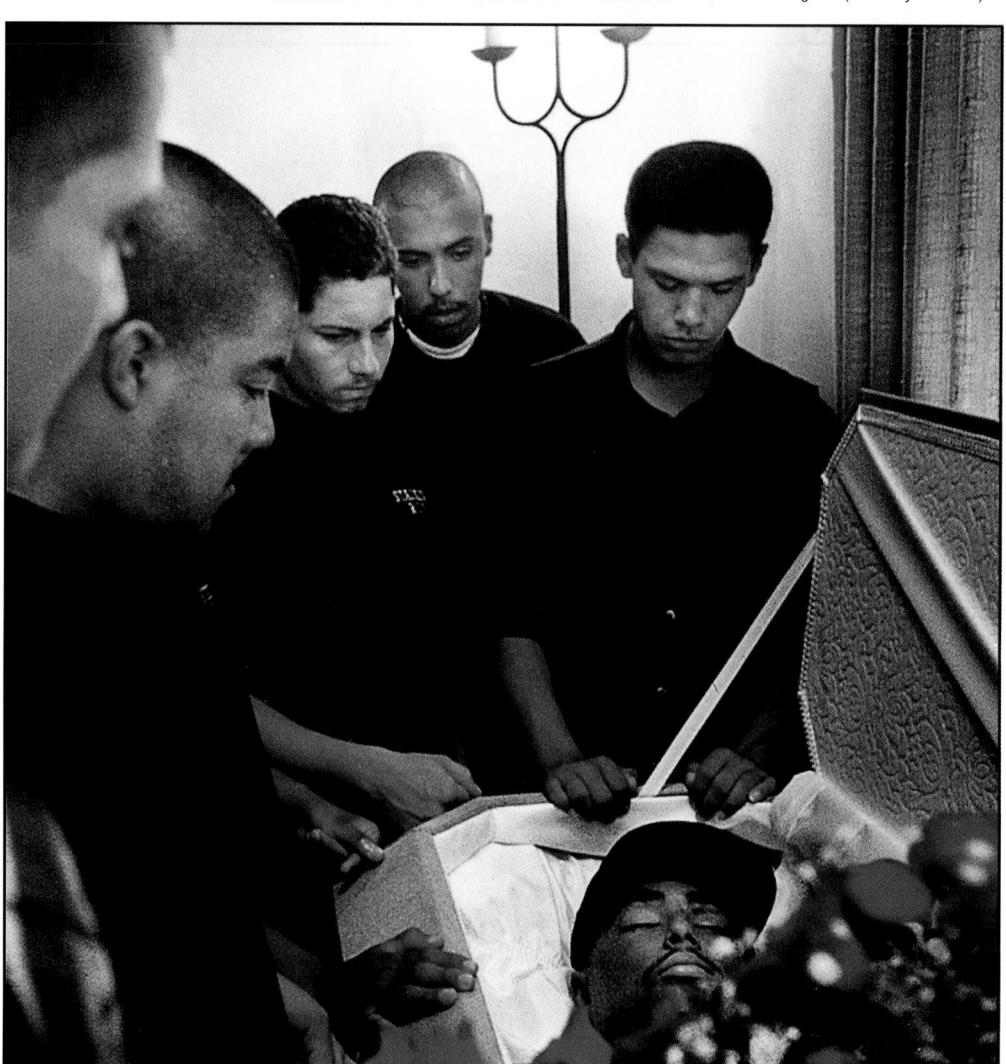

(RIGHT)

10 TUESDAY,
SEPTEMBER 25, 1996.
Valu Eliu Majiao,
Aldo Hernandez, and
Fatua Frank Utu are
charged with the
murder of sixteenyear-old Martine.
(Photo by Juanito
Holandez.)

TEENAGE PARENTS: AN AWESOME RESPONSIBILITY

YOUNG LOVE Mindy Schauer 4-EVER

Orange County [California] ple for a solid year. Register

turbulent marriage Photos by Mindy Schauer of this teenage cou-Neither she nor they knew how the

story would turn out. Fifteen-year-old Dee and seventeen-year-old Tim had been dating for six weeks when they broke up. Two months later, when Dee told Tim she was pregnant, he proposed. They married when she was eight months pregnant.

Despite the moves from one state to another, lost jobs, frayed tempers, and angry fights, as their story was being set to run in the The Orange County Register, photographer Schauer learned that Dee was pregnant again.

The project ran as an eight-page special section. "So many copies of the paper were requested by police, schools, and the judge of the juvenile court that The Register had to do a second printing," Schauer says. "But what made me happiest was that kids read and responded to the story. Parents told me that kids read the story from cover to cover."

more photos on next spread -

(BELOW) Tim, eighteen, and Dee, sixteen, with their son, four-month old Hawk.

(BELOW) As high school sweethearts, Tim courted Dee with binder paper filled with messages saving "I love you."

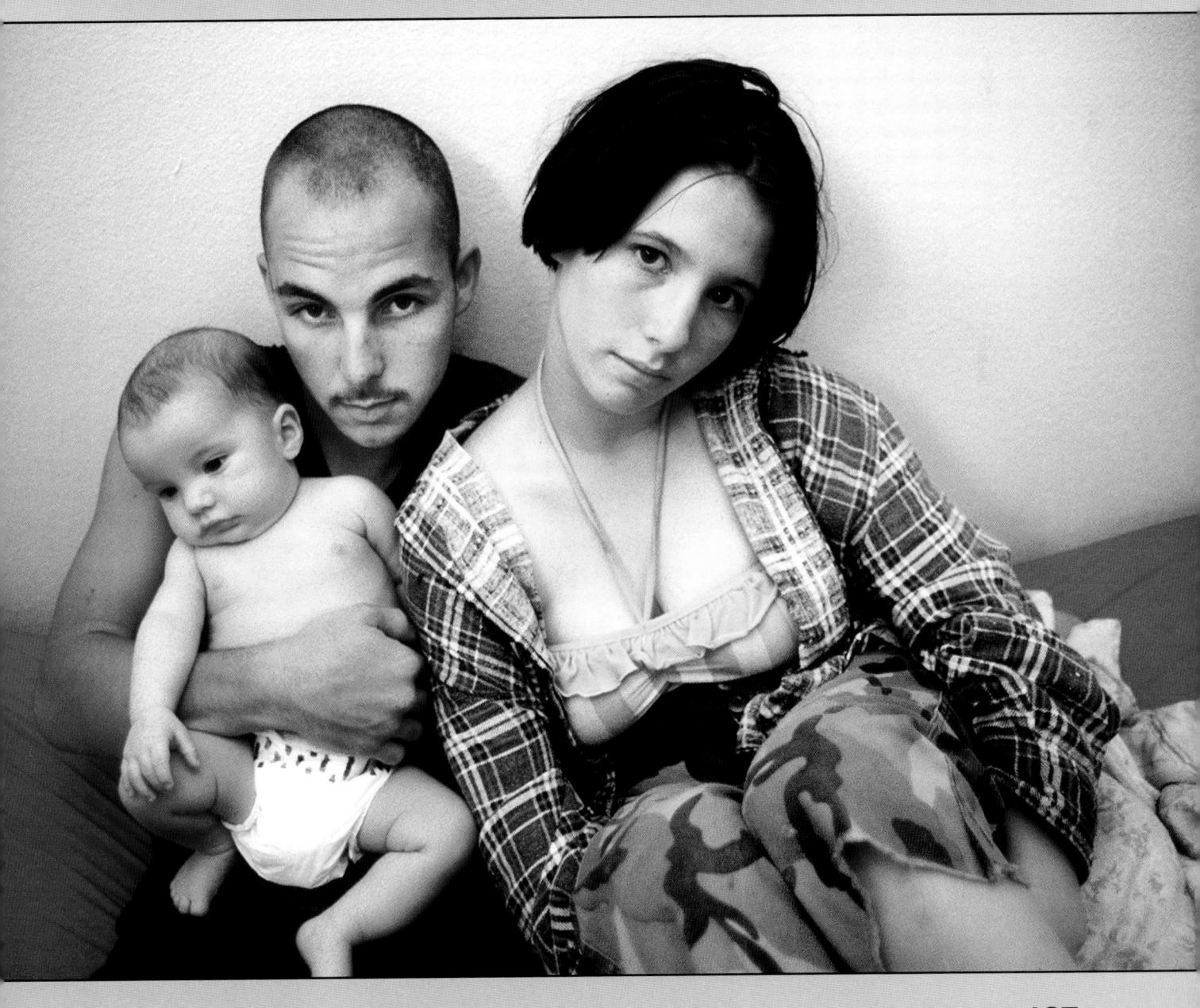

TEENAGE PARENTS: AN AWESOME RESPONSIBILITY

REALITY 4-EVER

(BELOW) Tim and Dee, eight months pregnant, exchange their first kiss as husband and wife. Dee's parents are at right. Tim's parents were more than two hours late and arrived just after the kiss.

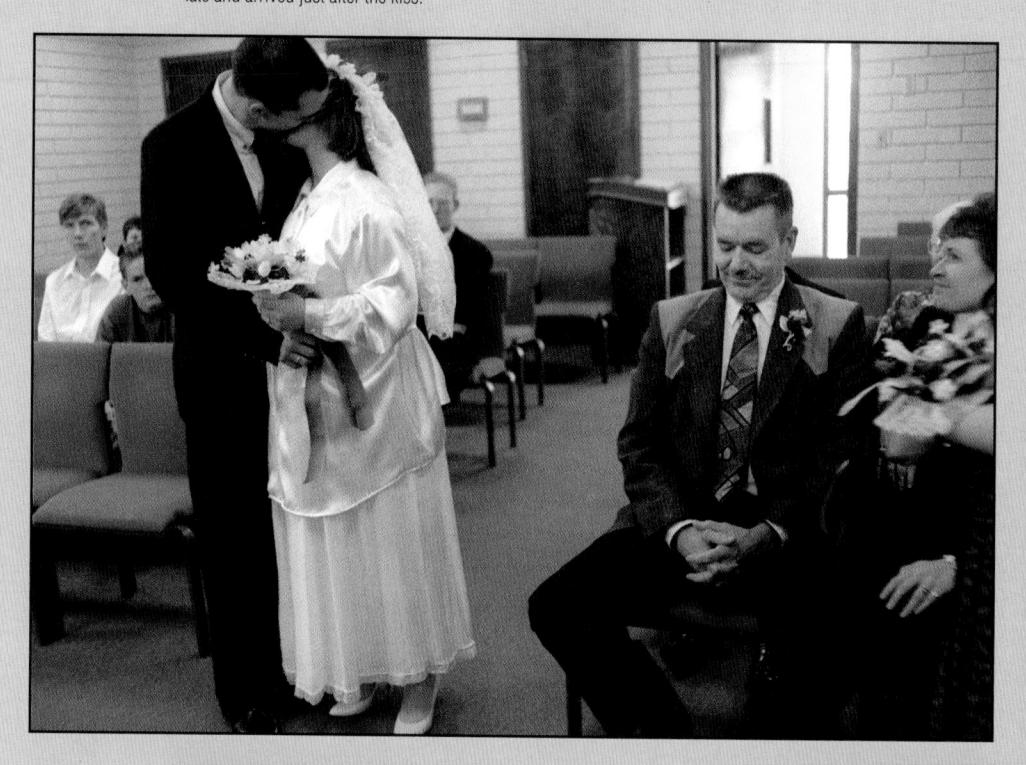

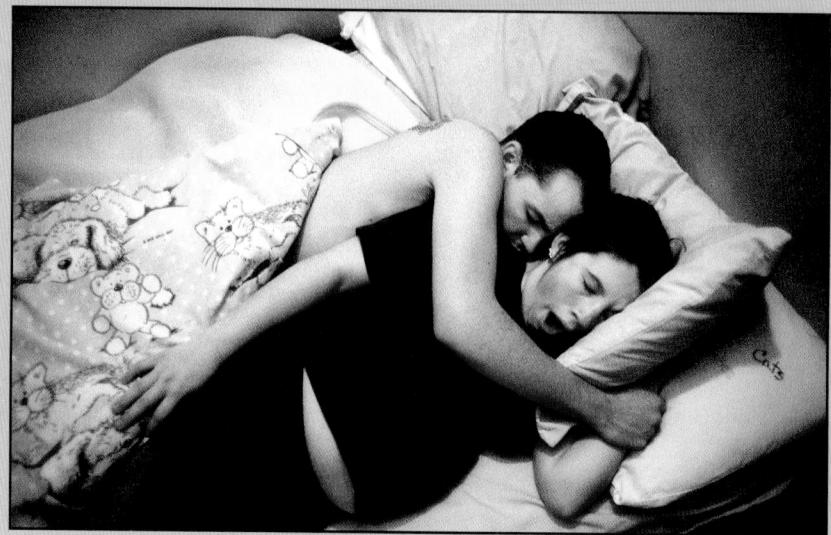

(ABOVE) The couple retires for the evening on bedding Dee has had since she was a child. In her ninth month, she is hot and uncomfortable, especially at night.

(RIGHT) Hawk's cries from the sofa go unanswered while Dee and Tim try to resolve an argument.

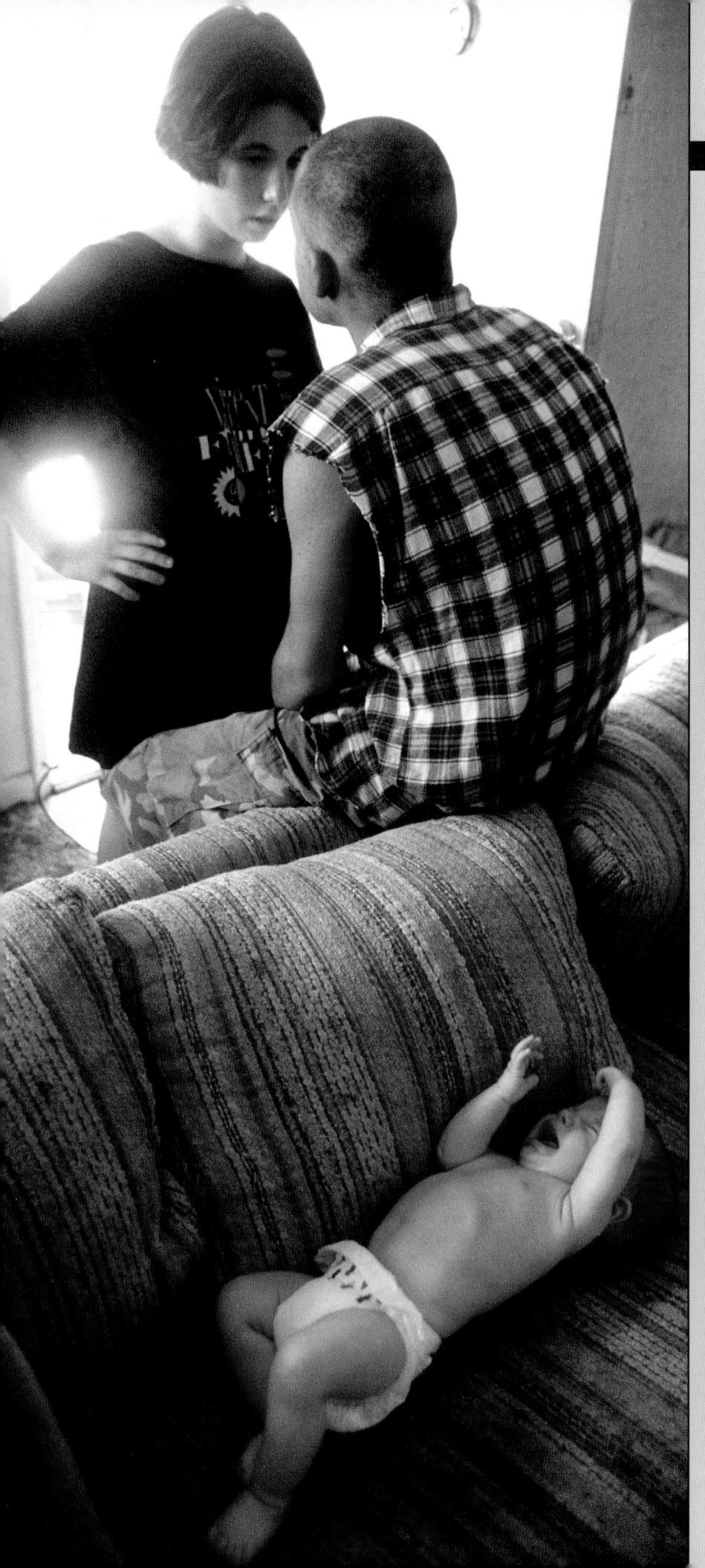

(BELOW, TOP) Unable to afford their own place, Dee and Tim live with friends in Texas. Dee often watches the friends' children along with her own baby, Hawk (in her lap). Here, she orders her friends' child to bed. (BELOW, MIDDLE) Holding her head in exasperation, Dee is overwhelmed with caring for Hawk and her friend's child (holding the magazine). (BELOW, BOTTOM) A surprise gift from their friends, the cake celebrates the couple's fivemonth anniversary. "The first year is always the hardest," Dee reasons.

Chapter 8, The Photo Story **■ 169**

Illustrations

ILLUSTRATE THE ABSTRACT

CHAPTER 9

oday's photojournalists are borrowing the techniques of the advertising photographer to illustrate stories based on issues and abstract ideas. This blend of advertising technique and photojournalism—the editorial photo illustration—came about as newspapers and magazines shifted from the "simple account of what happened yesterday" to analysis of what happened over a period of time and to evaluations of what may happen in the future. This change in journalistic emphasis from

A product illustration (below, top) is often an attractive still life that simply shows what an object looks like. An editorial illustration (below, bottom) depicts a concept. Here, the concept is how to protect yourself against the vapors of the odoriferous onion.

(Photo illustrations by Joseph Rodriquez, *Greensboro* [North Carolina] *News & Record.*)

In this visual metaphor, a TV set becomes the head—and brains—of a television addict.

(Photo illustration by Peter Haley, the *Tacoma* [Washington] *News Tribune*.)

immediate reaction to longer-term

interpretation of the news has led

This classic illustration of aging was created by photographing two women who strongly resembled one another, cutting their photos, combining them, and then having the resulting combination retouched by an artist. Today, the effect could have been achieved by combining the images with a computer. (© Photo illustration by

Carl Fischer.)

To illustrate an article about Andy Warhol, who turned ordinary objects—including soup cans—into art, Carl Fischer portrayed the artist as being consumed by his own icons.

(© Photo illustration by Carl Fischer.)

to stories about more abstract—and nonvisual—issues, such as those dealing with economics, psychology, and science. Stories might include causes for a bull or bear stock market, cures for manic-depression, or potential results of gene splicing. To satisfy an increasingly visually literate readership, editors who understand photography's appeal often assign illustration photos rather than pen-and-ink drawings to accompany these difficult-to-visualize stories.

Photo illustrations work best when used to communicate concepts, feelings, and the

intangibles for which a literal picture is not always possible, says Jay Koelzer, who specialized in photo illustrations for the *Rocky Mountain News*. "The photographer needs to take the reader somewhere outside the bounds of reality and the printed page," says Koelzer. "The photo illustration is the chance for the photographer to make people think."

According to a survey conducted by Betsy Brill for a master's thesis, more than threefourths of the newspapers in the United States use photo illustrations. Almost every magazine, particularly Time, Newsweek, and U.S. News & World Report, uses editorial photo illustrations, especially on their covers. In fact, the rise of the issue-oriented photo illustration may be the most significant change in the history of photojournalism since the 35mm camera introduced the era of candid photography more than a half century ago. Today's photojournalists are creating pictures from whole cloth. Subjects are actors, backgrounds are sets, lighting is artificial. Yet these pictures run on the same newsprint and often on the same page as documentary photographs, in which the photographer has traditionally remained only an observer, not a participant.

DIFFERENT KINDS OF PHOTO ILLUSTRATIONS

PRODUCT PHOTOS

The product photo is a photograph of a real object, usually involving food or fashion. For example, the food editor might assign a photo to accompany a story about the lowly onion. To show how onions differ, the photographer might artfully arrange a number of different onions, ranging from white to red.

Illustration fashion photos, too, are product photos that simply record what an outfit looks like. Some newspapers and magazines run fashion photographs of average people on the street—candids that accompany a story about new trends in hemlines or the new look in pleats. These types of photos are not illustrations. Instead, they are like other candid features a photographer might take. While the setting of a fashion show is staged, the photos document a real event.

A fashion illustration, on the other hand, might show off a new clothing line. Almost all pictures in fashion magazines result from photographers working with models to create idealized photographs of new clothing trends.

The setting might be a seamless background or an empty beach, but the pictures never look real. Stylists prop the photos so that the situations look better than real life. The photographer is not trying to illustrate an abstract editorial concept or imitate reality.
Whether the photograph is of an onion in soup or a swimsuit on a woman, the photographer tries to accurately and attractively record the object. The photographer is not trying to create a concept or dupe the reader into thinking the picture is really a candid.

EDITORIAL CONCEPT ILLUSTRATIONS As the visualization of an idea, the editorial concept illustration may employ actors or models to create the photographic image, but the total effect is that the viewer instantly recognizes fantasy, not reality. By using subjects out of proportion with other props, backgrounds apparently reaching into infinity, and other trompe l'oeil, the concept photo (also called the issue photo illustration) lures the reader, like Alice, into a surreal Wonderland of ideas. No reader would mistake Wonderland for reality.

Carl Fischer's startling photo illustration of aging, for example, combines photographs to create an image of a woman's face—halfyoung, half-old. (See opposite page.) Fischer, through his covers for *Esquire*, pioneered the use of the modern photo illustration for magazines. He also used the concept illustration approach for a story about Andy Warhol, the pop artist famous for transforming everyday objects into paintings. One of Warhol's most famous images showed row after row of Campbell's red-and-white soup cans. Fischer

created a picture that gave the impression that Warhol was drowning in a huge can of tomato soup. (See opposite page.)

To illustrate a story about "latchkey children" (youngsters who come home to an empty house while their parents work), Jeff Breland created a collage for the *Columbia Missourian* that conveyed the concept of children—perhaps perilously—alone. In Breland's cut-and-paste image, a little boy dangles from a huge key ring in the lock to a gigantic door. (See page 187.)

The subject of an editorial photo illustration might be about aging, latchkey children, or it might involve politics or food. But if you create a concept photo about onions, you won't produce a photo of the onion itself. Rather you may try to show how people defend themselves against the vegetable's vapors. A photo of a chef wearing a gas mask while cutting onions would illustrate the concept of protection against the odoriferous onion. (See page 171.)

DOCUDRAMA

The docudrama photo illustration, by contrast, actually appears to be real. Here, the photo looks just like a candid but is really a complete creation or recreation. Rather than abstracting or idealizing, like the product photo or the concept illustration, the docudrama photo imitates reality; intentionally or

To illustrate a story about new braces for teeth that require less wire and come in cool colors, the photographer constructed an image made up of a huge mouth and a tiny dentist. The reversed size lets the reader know that this image is an illustration and not an actual documentary photo.

(Photo by John Burgess, Santa Rosa [California] Press Democrat.)

 To illustrate a story about changing from adolescence to adulthood, the photographer used the metaphor of a caterpillar in its cocoon transforming itself into a butterfly. To achieve the visual effect. the photographer painted with light—individually exposing each element of the picture, including every butterfly, to a narrow incandescent beam during a long exposure. (Photo by Jay Koelzer, for the Rocky Mountain News,

Denver.)

not, it fools the reader. Avoid this approach at all costs. The docudrama approach is a tempting one to photographers with little time to establish contacts for a documentary story or to conceive and prop a concept photo. To set up a real-looking photograph may not seem so

far from what an artist does to "illustrate" a story, but such photographs threaten to undermine a publication's credibility.

Breland's picture of a latchkey child dangling from a key chain, mentioned earlier, is clearly unreal.

When another newspaper ran a story about latchkey children, the accompanying "photo illustration" showed a lonely-looking child sitting on a doorstep.

While this young model surely was not

really alone or lonely, the reader's only clue to the deception was the tiny tag line "photo illustration."

The reader had no way of knowing from the picture that the image was a fake.

And, equally important, do latchkey children really look lonely? The one thing we know is that they do in the imagination of this docudrama photographer. (See page 186.)

PRODUCING EDITORIAL ILLUSTRATIONS

Often, after a photo illustration appears, you can hear the following conversation in the newsroom.

The writer whines, "This headline doesn't go with the gist of my insightful story."

The copy editor replies, "When I wrote that head, the story wasn't ready, and I never saw the picture."

From the photo department: "The ugly headline type runs across the model's face. How can I create great art surrounded by insensitive people?"

And, from the page designer's corner of the room: "The inept photographer didn't leave

Perhaps human-looking robots will serve food in the future. Using silver spray body paint and a waitress' outfit rented from a costume shop, the photographer created a robot chef/server of the future. The red eyes were added in the computer. For more about how this picture was created, see page

(Photo by John Burgess, Santa Rosa [California] Press Democrat.)

A This shocking photo illustrates cryonics, the practice of freezing people who have just died in hopes of reviving them with future medical advances.

(Photo by Susan Gardner)

(Photo by Susan Gardner, Ft. Lauderdale [Florida] Sun-Sentinel.) room for type on the picture. And anyhow, the vertical picture didn't fit into the horizontal hole on the page left me by the copy desk." Avoid this scenario.

When producing an editorial photo illustration, get all the players together from the beginning. The advertising world calls a group like this a creative team. Businesses in Japan call it a quality circle. Regardless of what you call it, get everyone together who will participate in the creation and execution of the photo illustration. By communicating, not only will all team members perform their own creative tasks better, but knowing what others are doing will also help dissolve territorial battles.

BRAINSTORM THE CONCEPTS

Alex Osborn, a partner in Batten, Barton, Durstine, and Osborn (BBD&O), a large New York advertising firm, formulated the brainstorming method for bringing workable, productive ideas to the surface. He recommends getting a group of people in a small room where everyone can voice their ideas, no matter how foolish-sounding. Each suggestion stimulates and generates another suggestion. A brainstorming session can produce more than a thousand ideas, Osborn claims. Brainstorming works even if you just talk over your ideas with another person.

Philippe Halsman, who produced more than one hundred *Life* covers, explains why he uses the brainstorming technique in his book *Halsman on the Creation of Photographic Ideas*. "You are not alone, you face someone who serves you as a sounding board, who prods you and who expects you to answer. . . . Your system is stimulated by the challenge of the discussion. There is more adrenaline in your blood, more blood flows through your brain and, like an engine that gets more gas, your brain becomes more productive."

One cardinal rule prevails when working in a brainstorming session: never put down anyone else's ideas. Like turning on the lights at a high school dance, a negative comment will be inhibiting. By the end of the brainstorming session, surprisingly, good ideas will float to the surface and poor suggestions will sink out of sight from their own weight.

WRITE A HEADLINE

After each member of the group has read the story or heard a presentation of the central

To illustrate the problem of population growth in Colorado, the photographer shot an overall of downtown Denver with the mountains in the background. In the studio, keeping the light from the same direction as the overall, he photographed two models holding umbrellas. With the computer, he cloned the models, obliterating their faces so that they would become generalized figures representing all newcomers. Finally, he melded all the elements together into one image.

(Photo by Jay Koelzer, for the Rocky Mountain News, Denver.)

With St. Sebastian, who died from arrows shot into his body, symbolizing martyrdom, the photographer illustrated a story about college students who volunteer for money to test new drugs. With the help of the computer and an out-of-copyright painting of the martyred saint, the photographer replaced the arrows with syringes and used the traditional symbol of the medical profession for a background above the figure. (Photo by William Duke for

Spy magazine.)

theme, everyone should try to write a headline. Compared with writing headlines for a news story and documentary picture, writing headlines for a photo illustration requires the writer to take a different approach.

In a traditional news headline, the desk editor tries to summarize the story in a few words. The headline usually includes an active verb: "The president proposed new legislation today."

verb. In fact, the headline might consist of only a phrase or sentence fragment. The headline might be a play on words, like a pun, or it might work off a movie, play, or song title. Or the words might raise a question.

- "Is There a Hare in Your Soup?" for a story about rabbit stew.
- "M-M-M Mail Order" for a story about buying food through the mail.
- "Making the First Move" for a story about women asking men on dates.

A photo illustration headline might have no

The metaphor for

danger-walking a

fraved tightrope-

helped illustrate this story about day traders.

who use the computer

to bet on minute-by-

minute swings in the

(Photo by William Duke for Time magazine.)

stock market.

Once all group members have read the story, the group must try to write several headlines. Don't stop to analyze each one. Never reject any idea at this stage of the process. Let your thoughts flow. Then read over each one to see if the idea lends itself to

Almost always, the best idea pops out.

TRANSLATE WORDS INTO IMAGES Symbols

Once you have the headline you must translate words into pictures. When you translate to picture language, you speak with symbols, analogies, and metaphors. You are trying to find visual ways to express amorphous, sometimes theoretical ideas and concepts.

For photography, however, concepts must become something concrete.

For example, how do you say America or American without words? You might use a generally accepted visual representation of an idea—a symbol like the Stars and Stripes. You could use an actual flag or turn something else into a flag. You might decorate a cake in red, white, and blue to symbolize America's birthday. The Statue of Liberty also serves as a symbol of the United States, as does the "Uncle Sam Wants You" recruiting poster from World War I. Grant Woods' painting, "American Gothic," which shows a farmer and his wife staring stoically out at you, also has become a U.S. symbol.

Photographs themselves can become symbols. Joe Rosenthal's photograph of the flagraising at Iwo Jima has been reproduced and transformed so many times it has become a symbol of American patriotism.

If you were trying to illustrate a story about France, you might use an Eiffel Tower, a baguette, or a bottle of wine.

Balanced scales suggest justice; a dove represents peace; a gun symbolizes war. A lightbulb often stands in for abstract concepts like thinking or ideas.

Carl Fischer, who produced many famous Esquire magazine covers, says that some symbols come to exist in our subconscious, like those which the psychoanalyst Carl Jung described as archetypes. Some of these symbols, although they may originate in one culture, become cross-cultural icons that people instantly recognize. The multiarmed Hindu god, Shiva, appears over and over as a symbol for handling multiple tasks.

Literature, too, can provide visual symbols. The nose of Pinocchio, which grew longer with each lie he told, turns the act of lying into a concrete object. In an illustration for Spy, a humor magazine, William Duke played off the image of St. Sebastian, who has come to symbolize martyrdom. The story concerned college students who, to earn money, participate in tests for new compounds for drug companies (see page 177).

Symbols can be reinterpreted or newly invented. As pointed out by Steven Heller and Seymour Chwast in The Sourcebook of Visual Ideas, smokestacks were used at one time to symbolize progress. Today, they represent pollution. Still, the skull and crossbones, an ancient symbol for poison, continues to evoke the message "hazardous to your health."

Will computers, which today convey the idea of technology, someday be associated with obsolescence?

Visual metaphors

When you use a metaphor, you replace one image with another to suggest a likeness of some characteristic. For instance, you might substitute an hourglass for an old person to suggest aging. In this situation, the hourglass becomes the passing of time. The sand at the bottom of the hourglass represents age. Sand can also become power. Sand sifting through hands could become a metaphor for disappearing power.

In an illustration for *Time* magazine, William Duke used walking a tightrope as a metaphor for danger. His picture (opposite page) shows a man in a suit walking a fraying tightrope. The businessman uses a pole, on the ends of which hang dollar signs, for balance. The rope is attached between two computers. Other walkers, further down the rope have already fallen off. The story is about day traders, who use the computer to make quick trades betting the stock market will go up or down within a few seconds or minutes. While the practice can be lucrative, many traders have quickly gone broke with this approach to the stock market.

The metamorphosis from caterpillar to butterfly could represent the change from childhood to adolescence as in the photograph created by Jay Koelzer for the *Rocky Mountain News* (page 174). A TV screen becomes the head of a television addict (page 170).

SELECT THE MOST WORKABLE IDEA Simplicity and practicality come into play when you are pondering a list of headlines to illustrate. Sometimes, the least number of props, models, backgrounds, and special effects give the best chance of producing a successful photo illustration. For instance, suppose you have selected the following headline: "The Nuclear Family Crumbles."

You could illustrate this idea by breaking apart clay figures in the form of a family. Great idea, but . . . You don't know how to work in clay, so you call a sculptor friend. She says, "Great idea, but . . . I'll need five days and \$500." Your editor says, "Great idea, but . . . I need the illustration in three days, and we have a \$20 prop limit."

It's time either to rethink the visual for the headline or to continue down the list to find a different headline that can be illustrated more easily. Remember, the nuclear family can unravel just as easily as it can crumble, and knitting a family portrait just might be easier than sculpting it.

PRODUCE THE PICTURE

Once you have a headline to accompany a visual and have drawn a sketch, you need to plan the location, props, and models. On a big-budget ad shoot, you might hire a stylist to find the props, call a casting director to locate models, and ask a location specialist to scout the best backgrounds. On a low-budget shoot, you probably will play all the roles.

Props

Remember that precise propping can perfect the picture, whereas inappropriate props can destroy the desired illusion. For example, a photographer was assigned to illustrate a story about an English butler serving tea. The sketch called for the butler to wear a bowler hat. The photographer returned from the local

Via the Internet. thieves are stealing individuals' personal information to access financial accounts. To represent unique personal numbers and private codes like a social security number, driver's license, and birth date, the photographer selected a mask as a metaphor for individual identity. (Photo by William Duke for *Newsweek* magazine.)

theatrical prop shop with a hat that was black like a bowler but round on top like a hat worn by the Amish. No self-respecting English butler would be seen serving tea (or much else) in such a piece of headgear. While viewers of the picture might not spot the exact error, they would sense something was wrong about the high-tea scene.

On a low budget? Here are some ways to find props for a limited outlay of cash. You can find period props in antique and second-hand stores. High schools and colleges maintain costumes for their theater departments.

They, too, will often lend out period clothing for photo shoots.

For his daytrading illustration, William Duke needed to show a man on a tightrope. For one piece of the composite, he photographed a frayed rope against a white background. He then had a model stand on a stack of boxes in front of a white seamless and photographed him from a low angle. The desert in the picture came from a snapshot Duke had taken many years ago. The clouds were added from another stock photo Duke had previously photographed. Duke composited all the elements together in the computer to create the photo illustration, "The Daytrading Tightrope" (page 178).

John Burgess based his idea for "Are Robot Chefs in our Future?" (page 175) on the old Woody Allen movie, "Sleeper." Burgess found a maid's outfit and silver body paint in a local costume shop.

He sprayed the willing subject in silver, except for her lips, which he later colored in the computer. He also painted silver a child's football helmet, purchased in another outing. The oven knob on the subject's chest came off his own stove, and the photographer painted the background himself. With a little touchup in the computer, including adding red to the subject's eyes, Burgess produced a human-looking robot that might serve food in the future.

Models

You don't need a trained Shakespearean actor to model in your photo illustration. Most illustrations don't depend on facial expressions or acting. They do, however, depend on stereotypes. You need a person who fits the part.

For an editorial photo illustration about runners hitting "the wall" at twenty-two miles, you may not need a world-class marathon runner, but don't pick a couch potato, either. Save your couch potato friend for the story on the dangers of being sedentary.

William Duke often uses himself as a low-cost model in his illustrations. For example, the photographer constructed his illustration of St. Sebastian from an out-of-copyright painting of the martyr's body topped with Duke's own face.

Backgrounds

A background is a photograph's most important layer when you are creating the mood of a photo illustration. To avoid the confusion between true and manufactured pictures, photographers have shot a great many successful photo illustrations against seamless paper backgrounds. The seamless paper adds

an abstract quality to a photo since almost nothing in the natural world is ever seen against the purity of simple black or white.

Award-winning photographer Jay Koelzer, however, says that photographers can "look at the background not as something to make disappear but rather as something to add to the image so that it will carry a stronger statement." Koelzer frequently combines realistic backgrounds shot on location with subjects photographed in the studio to produce eye-catching, intellectually challenging images. For example, he photographed Denver's skyline for an illustration about population growth in Colorado (page 176). In the studio, he photographed two models holding umbrellas. Using the computer to assemble the final image, he replicated the photos of his models, erased their faces, varied their sizes, and positioned them on the background. Like images from a René Magritte painting, the faceless characters appear to be gently rising and falling over Denver's cityscape with the Rocky Mountains in the background. Although the background is real, no one would mistake the final picture for a documentary photo.

The bottom line with all photo illustration, including use of the background, is that the reader should instantly know that the image is created, not recorded. Don't confuse the reader. Here is one place you can cross the line from editorial illustration to docudrama.

Time

Allow time—lots of time—to conceptualize, prop, and photograph an editorial photo illustration. Editors are accustomed to asking photographers to run down to Castro and 14th Streets to take a quick shot before the 5:00 P.M. deadline. Unfortunately, editors frequently maintain the same mindset when they request editorial photo illustrations.

Most photo illustrations, though, require much longer than two hours. Photo illustrations can take hours that stretch into days. Dreaming up concepts takes time. Rarely do the first headline and visual that come to mind result in the final photo. Propping takes shopping. Without the right props, the picture will look amateurish. Finding the perfect model can be as difficult as finding the perfect spouse. Then comes shooting. With the patience of Job, the meticulousness of a watchmaker, and the flair of a set designer, you will build the picture. The clock ticks as you move the props from left to right. Each change requires an adjustment of the lights. After you've taken many Polaroids to check each detail, the time finally arrives to expose the film. The moment is almost anticlimactic.

When the editor at the *Sun-Sentinel* in Fort Lauderdale, Florida, assigned Susan Gardner to illustrate an article on cryonics—freezing corpses in the hopes of reviving them in the future—the photographer knew to allow time for the whole production. First, Gardner commissioned a fake block of ice from Plexiglas. (See page 176.)

She sprayed this with fake snow, lit it with blue gels, and created a mist with dry ice. A hole in the bottom of a table allowed the model to slip her head inside the cube.

The first model, however, took one look at the set and backed out, saying it would be "detrimental" to her career. Her replacement, an elderly woman, was touched up with some white and blue makeup. One month elapsed from the original concept to the final exposed 21/4 chrome on Fujichrome 50D.

Melanie Rook D'Anna, shooting for the *Mesa* (Arizona) *Tribune*, wanted to illustrate the return of the movie *101 Dalmatians*. She contacted the local Dalmatian kennel club and persuaded the members to bring their dogs to a movie theater—all at the same time. She positioned several highly trained dogs in the front row. These dogs followed the commands of their owners to stay.

The rest of the dogs were not so well-

behaved, so their owners hid under the seats with their dogs resting comfortably above. The photographer filled the theater with more than eighty-one Dalmatians, all sitting in their seats at the same time.

The addition of popcorn, colas, and careful lighting gave this picture its striking look.

THINKING CREATIVELY: A STRUCTURE

John Newcomb's *The Book of Graphic Problem-Solving: How to Get Visual Ideas When You Need Them* is based on the premise that visual problem-solving starts with words. He suggests that the starting point is the editor's working title for the story.

Take a story about men who are losing their hair. The editor's working title: "Are You Worried about Balding?" Start by analyzing the nature of the subject.

LIST THE FACTS

What is balding? How would you describe balding to someone from another planet? What words might you use? Round, smooth, hairless. List some of the characteristics of the subject, including:

Theater distributors were bringing back the movie 101 Dalmatians. For an illustration, the photographer propped an entire movie theater with dogs from a local kennel club. The welltrained dogs in the front row sit unattended, but the less wellbehaved animals in succeeding rows are firmly held in place by their owners, who are hiding under the seats. (Photo by Melanie Rook D'Anna.)

First, write sample headlines for the story. Next, draw a rough sketch to go with each headline. Then select the best headline and sketch. Finally, locate the right props, costume, and background before taking the picture.

(Photo illustration by Marilyn Glaser; sketches by Ben Barbante.)

Source

What is the source of the problem or item you are illustrating? In this example, where does balding come from? What causes it? Balding in men is a hereditary trait that comes from their mothers, grandmothers, and great-grandmothers.

Delivery

If the topic is about a service or object, describe how it is delivered. If the story is about a new cure for balding, how would the patient get the cure? By pill, surgery, or diet?

Size

How large is the object or problem—both physically and emotionally? In the balding assignment, is the hair loss partial or complete? Does balding make men feel like jocks or like jackasses?

Weight

Is the subject of the assignment physically or emotionally heavy or light? Is it a crushing burden, or is it a minor irritant? Do those with only a few wisps of hair left on their heads feel dragged down or light-headed?

Winners or losers

Who gains and who loses with balding? Most stories requiring illustration have a winner or loser, a survivor, or a victim in the plot. At first, you might not think anyone gains from balding. But charlatans with patent cures gain, as do pharmaceutical companies that develop cures for baldness. Doctors who perform transplants gain. Wigmakers gain. Psychiatrists gain. Who loses? When hair falls out, men lose hair, and sometimes they lose their wives or girlfriends, too.

FACTS BECOME PHRASES

As you have just seen, Newcomb's method requires you to identify the facts about your topic. Write each answer down without worrying about being creative. Just start listing information.

Next, try sayings, phrases, proverbs, or any other bits of traditional wisdom. In the list of facts, we noted that the source of balding is genes inherited from the mother—not the father. Try the headline "Balding—Not Dad's Fault After All." To illustrate this idea, you could photograph a bald man holding a hairless baby.

In the fact list under weight, we noted that some bald men feel like jocks and others feel like jackasses. Think about twisting the emphasis. To suggest that bald men are not burdened by their hair loss, twist the line "Blondes Have More Fun" to "Balds Have More Fun." Now illustrate this line with a photo of a Telly Savalas-like character, bald and proud of it, surrounded by women.

PLAY WORD GAMES

Now take the key words from each of the facts above and play word games with them. For instance, in describing the nature of a bald man's head, we listed the word "smooth." Smooth as a balloon, as a billiard ball, as a bowling ball. Imagine a bowling ball looking like a bald man's head. The phrase "Balding, Anyone?" could evolve into a photo of a bald man with his head in a rack of bowling balls.

From the editor's original working title, "Are You Worried about Balding?" came first a set of facts about baldness. The facts led to plays on words and phrases. These sayings, puns, and double entendres produced visual ideas that could easily illustrate the story.

The final photograph, by the way, of the man's head lined up next to bowling balls,

has since been shown to hundreds of editors, photographers, and others. The photo has never failed to bring the house down with appreciative laughter.

ELECTRONIC CUT AND PASTE

To create a surreal effect, you might want the picture's subjects to appear completely out of proportion. Perhaps you want the mayor of New York towering over the **Empire State** Building, or a sailor carrying the OE II under his arm.

To do so, you might need to photograph each element separately and then combine them. If you can't photograph all the subjects and props at the same time in the same location. remember to keep the light consistent for each image you plan on combining later.

For example, if the light appears to be diffused and coming from the upper left side of the scene, keep the same effect on all subsequent photos. Then, when you put all the elements together, the final picture will have natural-looking light that appears to be coming from only one source.

Computers have come along to make life simpler for the photo illustration photographer. In today's high-tech age, you can scan in old images or new ones. Rather than physically cutting and pasting images, you can electronically alter them to your satisfaction.

Once you've scanned the pieces, you can easily change the size, color, and left-right orientation of each separate image. You might place the subject into another setting (see pages 173, 176, 178, 184) or take the head off one subject and put it on another (see page 177). In fact, just about any effect you can imagine can be accomplished with

Business travelers using their laptop computers on airplanes have become ubiquitous. To illustrate a story about the phenomenon, the photographer combined three images to create a photo of a computer user tethered to an airplane. The photographer gave both the airplane and the man's legs the effect of movement by applying a computerized blur filter to that part of the image. (Photo by William Duke for Fortune magazine.)

the computer. (See Chapter 12, "Digital Images.")

The computer usually speeds up the mechanics of creating a photo illustration. Having shot or gathered the individual pieces for the illustration and scanned them into the computer, you can manipulate and combine all the parts seamlessly.

Beware, however, that combining pictures with the computer can absorb much more time than originally planned. Even powerfully fast computers can take a long time to process complex images.

DON'T INFRINGE COPYRIGHTS One word of caution. Copyright protection extends to "found" images in magazines, newspapers, and on the World Wide Web.

Unless the image is one you have shot or one that you have express permission to use, don't be tempted by the ease of scanning it into a computer to use someone else's

• Photojournalism: The Professionals' Approach

MOON PIES: COOKING UP A DIGITAL **ILLUSTRATION**

To illustrate a story about the saucer-sized. chocolate-covered sandwich cookies known as a "moon pies," Jerry Wolford of the Greensboro (North Carolina) News & Record combined seven separate images. In the studio, he photographed a child with his hand raised (A) and then later used the computer to digitally erase the background (B). To achieve the proper perspective, he also digitally stretched the child's image at this point.

Also in the studio, **Wolford photographed** the cookie (D) and later in the computer superimposed the moon's image onto the cookie's surface (E).

With photographs of the earth (C), sun (H), planet (I) and star-filled sky (G) in the computer. Wolford was ready to assemble all the parts. He manipulated the size of the cookie and placed it so that it appeared to be in the child's hand (F). He then added a dark area to the child's hand as if the cookie had cast the shadow. Using the software package Photoshop, Wolford was able to seamlessly combine all the elements into an eye-catching final image. The original was in color.

(Photo illustration by Jerry Wolford, Greensboro [North Carolina] News & Record.)

photograph or work of art to enhance your photo illustration. Doing so is illegal—regardless of how much you "change" the original.

SOME WORK. SOME DON'T

Some editorial photo illustrations cause the reader to say, "Dear, you have to see this. It's just too funny.' Others don't stop the reader at all, or, even worse, they cause the reader to ponder the strange picture, wondering why anyone would go to the trouble to publish it.

Why do some photo illustrations hit the reader like a sledgehammer and others leave no mark at all?

WEAK PHOTOS Sometimes the photo is weak. Everyday, readers see slick ads produced by highpriced ad agencies. Consequently, readers are accustomed to illustrations that appear flawless. Poorly planned editorial photo illustrations look unpro-

fessional. If the models look like they were grabbed right out of the newsroom, if the set looks like it was a corner of the darkroom, and if the whole production looks like it was thrown together between assignments, then the final photo will look amateurish.

For an illustration titled "Sitters Can Be a Pet's Best Friend," the photographer had a subject pretend she was reading comics to two German shepherds. The scene, however, took place on a beat-up old couch. The rundown setting distracted from the concept.

One newspaper ran a photo illustration showing a man's handwriting on a chalkboard with the words "American education stumbles." The foreground contained a few books sitting vertically on a desk. The strong headline in this instance was not supported by an imaginative visual. The photographer failed to find a symbol for American education or to play off the idea of stumbling.

POOR HEADLINES

While editorial illustrations often fail because of poor photography, they also fail because of poor headlines. Rather than "leaving 'em laughing," an unclear or confusing headline leaves readers scratching their heads.

Sometimes, even clear headlines are not enough—if the headline is clear but dull. Beware of headlines that start out "Everything You Ever Wanted to Know about Pizza" or "The Entire History of Bicycles."

Sometimes the writer has provided a label headline like "Potatoes." A headline like this probably came from a story that had no theme or focus. When the headline and story lack a clear focus, the photographer winds up taking a generic picture of a potato rather than illustrating a concept about the potato. Suppose the story had focused on the role of the potato in the Irish famine or had described the many nutrients contained in potatoes. Either article would lend itself to a possible editorial photo illustration. If the story has no focus, however, the photographer is left to photograph the potato itself, a vegetable all too familiar to most readers.

Sometimes headlines are too news-oriented. Photo illustrations work best with ideas, not events. Avoid headlines like "Stock Market Drops for Third Straight Day."

HEADLINE AND PICTURE DON'T MESH Still, the headline might be great. The photo might be eve-popping. But if the two do not mesh, then the final package looks like an afterthought. Sometimes the reader gets the impression that the headline was written without the editor seeing the photo.

Or the page looks like the photographer never saw the headline or story before snapping the shutter.

One copy editor wrote this catchy headline: "When Marriage Seems Like War." The photographer produced a strong photo showing a couple having a highly stylized argument. The man's tie is blowing out behind him. Both models look like they are talking with their hands. The problem: they don't look like they are at war. The couple appears to be arguing in the wind, not battling. The words and pictures, like the married pair depicted in the picture, don't communicate.

WHY DON'T THESE ILLUSTRATIONS WORK?

This headline and this picture leave the reader wondering just what the central theme of the story is. The headline, not the subhead, should tie the picture and the words together.

A nicely executed photo loses its impact with a weak headline.

A good image in this example was matched with a weak headline. A better head might read "Picture Perfect Pears."

This illustration combines an unimaginative headline, "Super Bowl Snacks," with a picture that is too literal. Try thinking of some alternatives for both words and pictures.

WORDS OF CAUTION

DOCUDRAMA CONFUSION

Like editorial photo illustrations, docudramas are created situations. However, as we've seen, docudramas look natural rather than surreal. By mimicking reality, docudramas cause confusion in readers' minds.

Look at the tearsheets on the opposite page. Isn't it conceivable that a photographer could have happened upon this attack and photographed it on the spot? Some poor woman might well be standing at her door, afraid to leave her home—but not this one.

Even with the words "photo illustration" published beneath the picture—which not all carry, by the way—photographers should avoid docudramas. Docudramas detract from a paper's credibility. The reader should never have to ask, "Did that picture really happen that way?"

The job of the photojournalist is to show the world as it is, not as the photographer imagines it is.

Editorial photo illustrations, by contrast, add to the reader's understanding and fun. A picture should either be real or so outrageous that no reader is fooled. Don't leave the reader in the twilight zone of the docudrama.

Problems in placement and identification While most editorial photo illustrations are likely to appear on the lifestyle, food, and fashion pages of newspapers, the Brill survey found that a sizeable majority (nearly 67 percent) do occasionally run on the front page. According to the survey, in fact, only about 23 percent of the responding newspapers "never" run editorial photo illustrations on page one.

Furthermore, nearly 78 percent of newspapers use editorial photo illustrations on the same pages as documentary-style photos—leading to possible confusion among readers as to what is real and what is not.

Further leading to a possible credibility gap, the survey found that almost half the newspapers failed to identify editorial (excluding food and fashion) photo illustrations as created images.

They did not even label the pictures with a special phrase like "Photo illustration by . . . "

Imagine for a moment a newspaper that sprinkles its editorials and analysis—unidentified—throughout its pages, including the front page. How would a reader, accustomed to the straight news on page one, know where fact ends and interpretation begins?

Failing to identify created photographs is every bit as serious as failing to properly identify written editorial comment—and playing editorial photo illustrations on the

front page or alongside documentary photographs is as questionable as mingling editorials with unbiased news stories.

While newspapers prior to the Civil War did not hesitate to mix fact and opinion on the front page, most modern newspapers shy away from this practice and carefully limit opinions to a well-marked editorial page or clearly designated opinion column. The same stringent rules should be applied to editorial photo illustrations. Regardless of how unreal they may appear, they, too, should be labeled and segregated from straight photo reporting.

Practical and ethical guidelines The following are practical and ethical guidelines for using photo illustrations:

Eliminate the docudrama. Never set up a photograph to mimic reality, even if it is labeled a photo illustration.

Create only abstractions with photo

illustration. Studio techniques, for example, can help to make situations abstract—the use of a seamless or abstract backdrop, photo montage, or exaggerated lighting. Contrast in size and content, juxtaposition of headline and photo—all can give the reader visual clues that what appears on the page is obviously not the real thing.

Always clearly label photo illustrations as such—regardless of how obvious you may think they are.

DOCUDRAMA VS. CONCEPT PHOTO

Avoid docudramas such as the one located top left. They fool the reader. Instead, create a concept photo like the one at the bottom left, which is so abstract that no one will mistake it for real.

(Photo illustration at bottom by B. Jeff Breland.)

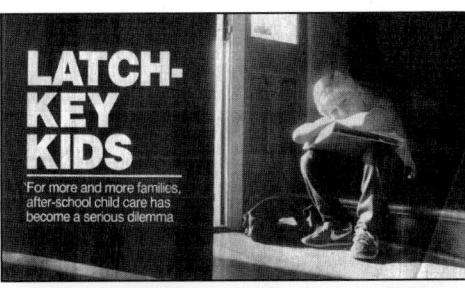

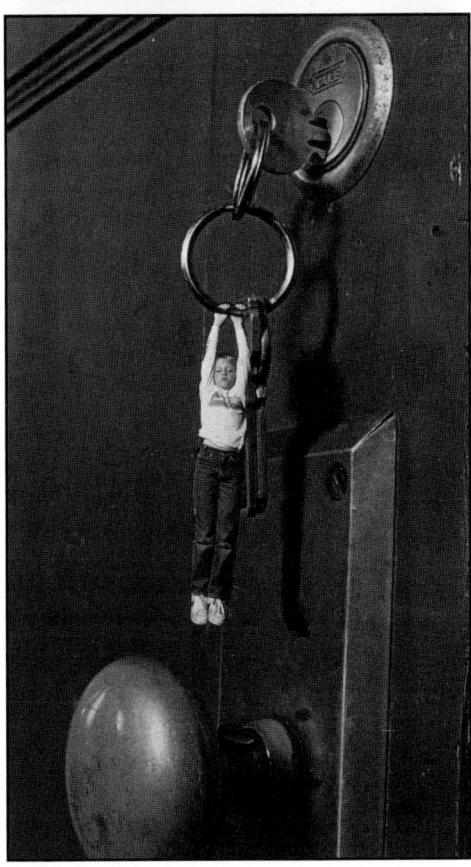

REAL OR CREATED? AVOID PICTURES LIKE THIS

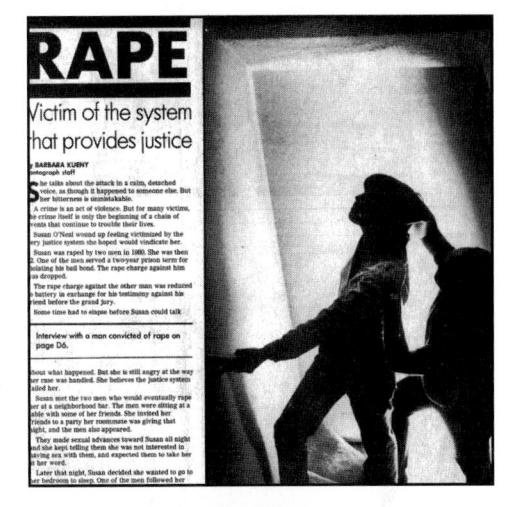

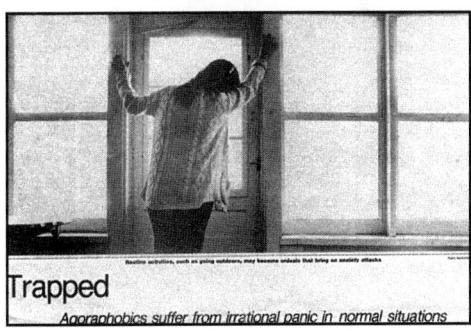

Pictures like these docudramas are too real-looking to be effective photo illustrations. Unintentionally or not, they can mislead the reader. Of the published pieces above, only the photo "Trapped" carried the tag line "photo illustration." Even with the identification, few readers would notice or even understand its meaning.

Never play photo illustrations on news pages. Restrict them to feature pages or to section fronts. Display them so that they are obviously distinct from news or feature pictures.

If you haven't the time to do a photo illustration right, don't do it. Suggest another solution. ■

Photo Editing

THE ROLE OF THE PICTURE EDITOR

CHAPTER 10

three-quarters of one second to capture a reader's attention with a photograph. Using an innovative research tool, Sheree Josephson followed readers' eye movements as they looked at a variety of published pictures. The device she used consists of two tiny television cameras mounted on the sub-

ject's head that record where, how long, and in which order a subject looks at photos in a newspaper, a magazine, or on a Web site. The startling result, revealed in her doctoral dissertation, was

Much detail would be lost if this photo were run small. Here, a church member faints at the peak of a faith healer's sermon. (Photo by Sandra Shriver.)

Eve-Trac data enable researchers to record the path the eye follows when it looks at a page. In this situation, the person started at the middle of the page, then was drawn to the headline beginning "sponsorship . . . and then noticed the motorcycle picture. Readers spent an average of less than three-quarters of a second looking at each picture in this ten-second test. (Sheree Josephson, Weber

State University.)

that readers spend an average of 71/100 of a second looking at a photograph—less than three-quarters of a second.

Now that is a challenge for any picture editor. How do you assign photographers and then select pictures that will communicate to the reader in less than a second?

Not surprisingly, photo editing takes strong eyes, a steady hand on the computer mouse, and the psychological strength to reject thousands of pictures while seeking the one frame or part of a frame that tells the story and has visual impact that will—literally—engage a viewer in an instant.

START WITH IMAGINATIVE ASSIGNMENTS

Striking pictures result from solid assignments. Daily, weekly, or monthly, picture editors at magazines, newspapers, agencies,

or Web sites peruse lists of news stories to determine which lend themselves to pictorial reporting, which need an inked illustration or computer graphic, and which need no accompanying artwork at all. With limited staff and resources—and most newspapers, magazines, and Web sites fall into this category—editors must choose to cover articles or frontpage stories with a certain amount of intrinsic visual interest.

When Bruce Baumann was assistant managing editor in graphics for the Pittsburgh Press, he warned that a photo department should not become a "service station." He pointed out that a photographer's job is not just to provide the service of illustrating a writer's story.

The enlightened photo editor, therefore, not only assigns the news stories of the day, but also generates pictorial story ideas.

Good photos, like this one, start with good assignments. The members of this family, who wear no clothes at home, had been featured on "The Donahue Show."

When the photographer's newspaper followed up the family's TV debut with a local story, he exposed carefully without revealing too much.

(Photo by Doug Kapustin, Patuxent [Maryland]Publishing Co.)

190 - Photojournalism: The Professionals' Approach

For example, a news conference is called to announce a \$4 million grant for retirement homes. Although a picture of the press conference may be necessary, it has little chance of producing exciting photos and less opportunity for providing valuable information about aging or the crisis in care for the elderly. The story is about statistics—the percentage increase in care costs—and about the number of dollars spent on nursing home facilities.

A photo editor, on the other hand, might try to interpret these statistics visually by instructing the photographer to spend several days in a nursing home. These kinds of photos would help translate the dull, itemized costs into more human terms. Readers would see the conditions of the facility and the regressive effects of aging on the home's clientele. Finally, photos showing an elderly

patient slumped in a wheelchair in an empty hallway can bring the dollars-and-cents issue home to the reader. (See Chapter 4, page 62.)

SELECT THE PHOTOGRAPHER

A perceptive photo editor realizes the strengths and weaknesses of staff and free-lance photographers. Not all photographers like sports; only a few take funny pictures. Some photographers notice subtle shadings of light and shade, whereas others have an eye for action. Some photographers have a lot of experience traveling overseas, speak different languages, and can figure out how to transmit their pictures from any phone jack in the developing world. Matching the correct photographer with the appropriate assignment can be a complex task. Picture editors at magazines look at photographers' portfolios each week, searching for fresh

The photographer borrowed a ladder from a nearby store to get this bird's eye view of children drawing self-portraits. Some photographers have a special knack for features.

(Photo by Nick Carlson,

(Photo by Nick Carlson, *The* [Fargo, North Dakota] *Forum.*)

Joe Sheid plays football even though he is missing his hand and part of his arm. The photographer used a motor drive to follow the action.

Which picture would you have selected from this take?

(Photos by Dave Guralnick, Detroit News.)

work that represents new trends in photography. They also know the skills and talents of photographers associated with each picture agency, and they scan current magazines, as well, to see the styles in the field. In fact, the primary way a magazine editor controls "the look" of the publication is through the selection of photographers with different styles, says Peter Howe. Howe has been photo editor of the *New York Times Magazine*, director of photography at *Life* magazine, and is currently director of photography and sourcing for Corbis/Bettman, an international picture agency and archive.

When making an assignment, the photo editor should provide the photographer with all the available information on an upcoming story. The more information about an assignment, the better a photographer will cover it. Clips of previous and related stories help put the story in context; names and numbers of additional contacts may lead the photographer to further information.

And, of course, if the story is expected to run with a photo layout rather than a single picture, then the editor should forewarn the photographer about the number of pictures that will be needed.

RESEARCH, RESEARCH Sometimes a magazine or Web editor can't afford to send a photographer to China for a photo of the Forbidden City.

Other times, the publication needs a picture from the Civil War. In situations like these, photo editors sometimes turn to picture researchers.

These specialists comb the publication's files or scour picture agencies' libraries to find the perfect images to accompany a story. Researchers can find some royalty-free pictures on the Internet, on CD-ROMs, or through the public library or the Library of Congress.

They can identify pictures to purchase by searching online databases maintained by agencies like Corbis/Bettman, Magnum, Black Star, or Saba Press Photos, as well as by wire services such as Wide World Photos, Reuters, and Agence France-Presse.

Today, many individual photographers also post stock pictures on their own Web sites.

CAMERA SKILLS UNNECESSARY

Surprisingly, one skill that is not necessary to be an outstanding photo editor is the ability to take pictures. Many of the best-known photo editors never learned to use a camera; others, although they know the basic techniques, never practiced photojournalism.

The late John Durniak, who worked at various times for Time, Look, and the New York Times, and Tom Smith, who was National Geographic's illustrations editor, both spent most of their lives handling pictures, not lenses. Roy Stryker of the Depression-era Farm Security Administration, who produced probably the most complete and lasting stillphoto documentary of any era, never took pictures himself. The most famous example, however, is Wilson Hicks, an executive editor of Life magazine. He sent photographers to every point on the globe; he hired and fired the best photojournalists; and he set the direction of the field for years to come. Yet he never took a picture that was published in his own magazine.

THE HAZARDS AND SATISFACTION OF DO-IT-YOURSELF PICTURE EDITING

Should photographers edit their own work? Some editors say that photographers are too emotionally involved when taking pictures to evaluate their photographs objectively during the editing process. The photographer, who might have dangled from the top of a mountain in subzero weather to get a particularly evocative picture, might attach more significance to the image than would an impartial photo editor, who evaluates the picture's merits without considering the conditions under which the photo was taken.

Sometimes freelancers or staffers have no choice about who edits their pictures. On some magazines and newspapers, for example, photographers receive an assignment, cover the story, turn in the film, and wait until the story runs to see which of their pictures has been selected and how they have been played. These photographers have almost no control over stories after shooting them.

Some of the great photo editors were never photographers. Assigning and selecting pictures like this accidental slip of the skirt during a rehearsal do not require technical skills.

(Photo by Scott Eklund. Bellevue [Washington] Journal American.)

On the other hand, many photographers feel that since they were on the scene, they know the story best. Because they are journalists, they feel that they should decide which pictures best reflect the story. Rather than an editor viewing the negatives or transparencies, some photographers also edit their own film. On many small newspapers, magazines, and Web sites, the photojournalist gets the dual position by default—there is no one else to handle the job.

What the do-it-yourself picture editing system gains in efficiency, however, it loses in objectivity. While it isn't necessary for an editor to view the negatives, the photographer should find someone who wasn't present at the news scene to offer an impartial opinion on the take.

STRATEGIES FOR SELECTING PHOTOGRAPHS

THEORIES OF PICTURE SELECTION
Back in 1939, Laura Vitray, John Millis, Jr., and Roscoe Ellard tried to develop a mathematical formula for determining reader interest in pictures. As the authors of *Pictorial Journalism*, a book on news photography of the day, they assigned points for the degree of an event's news value, the subject's notoriety, and the amount of action in a picture. But few editors adopted the formula because it failed to define news, provide a yardstick for measuring the subject's notoriety, or a means to quantify the degree of action in the picture. Also, editors felt limited when judging all pictures on only three scales.

Stanley Kalish and Clifton Edom, in their classic book *Picture Editing*, added several new criteria. They advised editors to look for pictures that not only had news, notoriety, and action, but also eye-stopping appeal. By "eye-stoppers," the authors meant pictures with interesting patterns, strong contrasts in tonal value, or those that could be uniquely cropped (like extra-wide horizontals or slim verticals). Then, once readers were engaged, the pictures should hold interest. What galvanized readers' attention, they said, depended on subject matter. A picture about love or war was more likely to maintain attention than was a photograph about farming or economics. Some topics, the researchers concluded, are intrinsically more interesting than others, regardless of the quality of the photo.

THE WASHINGTON POST'S HIERARCHY OF PICTURES

Joe Elbert, assistant managing editor for photography at *The Washington Post*, along with his photographic team, have won practically every award the profession has to offer—

from Newspaper Photographer of the Year to the Pulitzer Prize. Elbert himself has won the Pictures of the Year Contest's highest editing award. What is Elbert's secret?

Yes, the *Post* has an outstanding photo staff. But Elbert has a carefully considered and defined approach to editing pictures. He divides photographs into four hierarchical categories:

- 1) informational,
- 2) graphically appealing,
- 3) emotional
- 4) intimate.

Purely informational pictures fall into Elbert's lowest category, while intimate pictures represent the ultimate photojournalistic challenge.

Informational

Informative pictures represent the "lowest common denominator" of photos, Elbert says. Like the standard five W's (Who, What, Where, When, and Why) that lead in a written story, informational pictures report the facts without flavor.

Graphic

Better, but still not great in Elbert's eyes, are graphically appealing pictures. Good photo-journalists, he says, will go to a routine assignment and try to find a way to make interesting pictures in a boring situation. They might frame by shooting through a window or a keyhole to give the picture a more interesting dark foreground, for example, or use the distorted perspective of a 24mm lens to add visual interest to an otherwise ordinary subject.

Elbert says that professional photographers tend to use the same techniques over and over, assignment after assignment, knowing that these pat approaches will bring back better-than-average, usable images from standard situations.

Emotional

Elbert tries to help photographers take and ultimately select emotionally appealing photos as often as possible. These photos cause the reader to feel something about the subject, not just intellectualize about the story. These photos add dimension to a story rather than repeat what is already written.

Some photos capture the subject's emotion. People crying, laughing, hitting each other or hugging each other result in emotionally appealing photos.

But in the end, the test of the picture is with the viewer. Does the picture cause the viewer/reader to laugh, cry, get mad, or come away curious or shocked?

THE WASHINGTON POST'S HIERARCHY OF PICTURE SELECTION

INFORMATIONAL.
White House aide Sidney Blumenthal follows attorney Jo Marsh from federal court in Washington, D.C. (Photo by Larry Morris, ©1998 *The Washington Post.)*

2 GRAPHICALLY APPEALING.
A man selling his wares winds his horse and veg-etable cart through the Sandtown neighborhood of West Baltimore. (Photo by Dudley M. Brooks,

©1997 The Washington Post.)

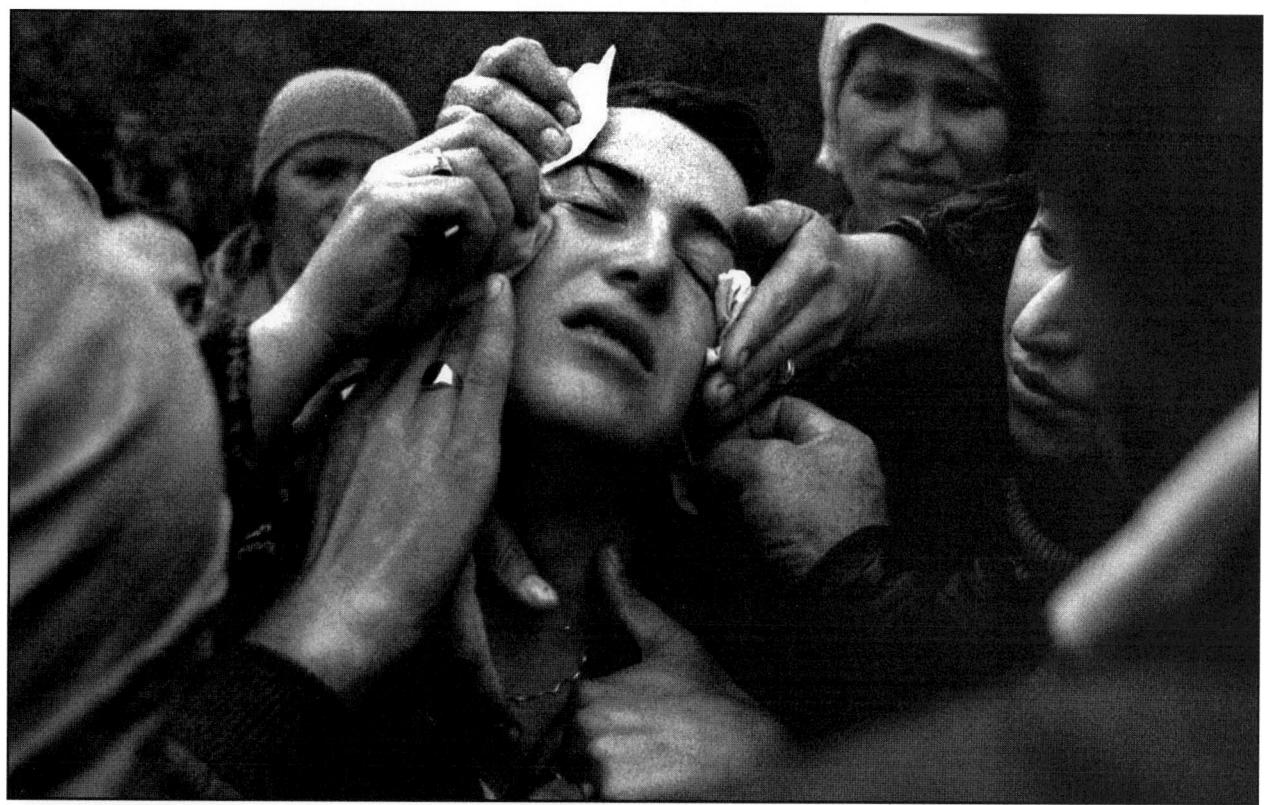

3EMOTIONAL. A Kosovar woman is revived by friends and relatives at the funeral of her husband, a KLA soldier killed by Serbian police. (Photo by Dayna Smith, ©1998 The Washington Post.)

4 INTIMATE. Six-year-old Tiara gets two baths a day from water drawn from a nearby hand-pump well. Most of the homes in this area on Virginia's eastern shore do not have running water. (Photo by Michael Williamson, ©1998 The Washington Post.)

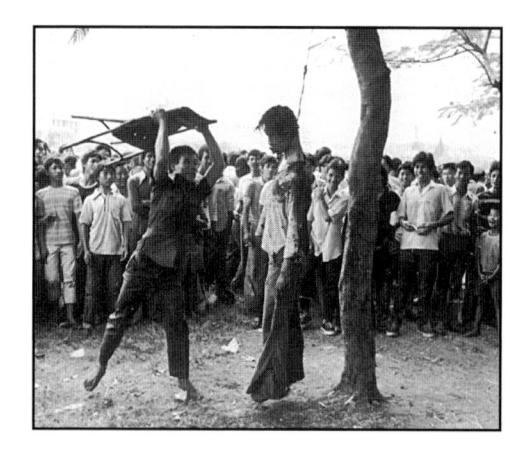

Which picture is your favorite? In an Associated Press survey, editors selected the hard news shot of a rightist striking the lifeless body of a hanged student in Bangkok, Thailand. Readers preferred the feature picture of a Saint Bernard and child. (© Wide World Photos.)

To identify pictures in this category, Elbert says, editors must be open to their natural reactions toward the pictures. The reactions can't be anticipated, assigned, staged, required, defined, or prescribed. Sensitive editors must be in touch with their inner responses to pictures and, in the end, be willing to follow those instincts.

Intimate

Ultimately, Elbert looks for intimate pictures. Intimate pictures are the most private. This category, he says, is the hardest to define, but it includes pictures that make the reader feel close to the situation or in-tune with the subject. For just a moment, this kind of picture transforms the reader into a participant. Of course, as Elbert says, what is intimate for one reader might remain on the emotionally appealing level for another.

Photographers who don't care about their subjects bring back pictures with no feeling, Elbert maintains. He looks at the eyes of the subject in the picture to know if the photographer connected with that person.

BUILDING BLOCKS OF PICTURE SELECTION

Going beyond Elbert's four categories, consider an adaptation of the approach that looks for pictures combining at least two of the qualities. Emotional pictures that contain information about the story would be better than simply emotional pictures. Most readers would find informational pictures with graphic appeal better than purely graphic pictures that do not tell a story. Perhaps photographs that reach the highest rung of Elbert's hierarchy would combine information, graphics, emotional appeal, and intimacy.

While few images might achieve this level, the search for these combined qualities would guide first the shooter, then the photo editor, and finally the managing editor in deciding which images to play.

In the end, these categories help orient photographers in what to look for when shooting. They require the photographer to go beyond the routine or even the technique that has worked in the past. Simply making a factual picture is not good enough. Finding the "right light" or a clever angle is still insufficient. Discovering emotional pictures requires the photographer to really look hard and to have the patience to wait for a revealing moment.

A NEW DIALOGUE

If editors, photo editors, and photographers use Elbert's rankings, the conversation immediately forces everyone to start looking at their own emotional reactions to the images. Rather than arguing about whether this or that element is in the picture, the discussion switches to how the pictures make the editor/photographer/reader respond. The picture editing decisions are instantly less cerebral and more heartfelt.

Putting informational pictures on the lowest rung of the picture ladder quickly puts these images aside. By not valuing graphic or pretty pictures, Elbert's system raises the bar and demands that pictures go beyond mere decoration. Elbert is saying that great pictures should hit you in the gut not in the head.

Once the conversation among decision makers focuses on which picture is most emotional or intimate, the battle for good photojournalism is won.

When everyone buys into this ranking scheme, the hard work for the photo editor is over. Strictly informational or solely graphic pictures have long since been left in the editing room. The task of finding the ultimate,

intimate picture begins. Then, the only question left for the editing team is which picture approaches this prized status.

RESEARCH INDICATES READERS' PREFERENCES

FIRES, DISASTER, AND HUMAN INTEREST

Researchers over the years have conducted several surveys to determine subjects that have intrinsic interest for readers. Though most were conducted many years ago, the results are still interesting. The first study of any size was conducted in the 1950s by the

Advertising Research Foundation, which surveyed readers of 130 daily newspapers varying in size, circulation, and locality. Researcher Charles Swanson found that among 3,353 photos in the eleven-year "Continuing Study of Newspaper Reading," fire, disaster, and human interest were among the top-viewed categories. Least-viewed picture categories included sports, fine arts, and the family.

Researchers Malcolm S. MacLean and Anne Li-An Kao a decade later studied the responses of thirty-two people to a variety of photos and determined that test subjects gen-

Surveys indicate that editors are more willing than readers to run disturbing pictures like this photo of a gunman holding another man hostage. During a tense seven-hour standoff, the gunman secured his shotgun with duct tape against the back of the hostage's head and taped his own hand to the rifle's trigger. The hostage eventually was rescued unharmed. (Photo by Cory Lum. Honolulu Advertiser.)

erally liked "celebrities, children, happy old ladies, roses, and animals." They disliked pictures they were shown of "Mussolini and his mistress hanging by their feet, dead American soldiers, and dead bodies in general."

Yet liking photos and being interested in them are not the same. Because the respondents did not like what was in the pictures doesn't mean they weren't interested in the subject matter. Photographs at the extreme ends of the scale also tended to be those that respondents said aroused the most emotion.

In general, readers say they don't like to look at dead bodies. In a clever study conducted in the 1980s, James Roche altered captions to observe how readers would react if they thought the person in a photograph was dead vs. whether they thought the person was alive. Most respondents appeared more accepting of the "victim-lived" than of the "victim-died" photograph.

More recently, Gretchen Farsai asked whether newspaper editors, as compared with the general public, would run controversial photographs. The researcher showed to both editors and lay people controversial photos, including the Kent State shooting of a student by a National Guardsman, crowdfilled stands collapsing at the Indianapolis Speedway, a Buddhist monk burning himself

in Vietnam (page 300), an execution in the streets of Saigon (page 326), and children fleeing napalm in Vietnam. Not surprisingly, the twenty-two editors were more willing to publish the shocking pictures than were the noneditors. Women, interestingly, viewed the highly charged photographs more negatively than men, yet were more willing to see them published.

FEATURES PREFERRED

Joseph Ungaro and Hal Buell of the Associated Press (AP) polled 500 readers in 1977 to find out what types of pictures they liked. The AP survey found that readers liked human interest and feature pictures most. Readers found general news and sports least interesting. Out of the many photos presented in the AP picture survey, readers selected as their favorite a photo of a big fluffy Saint Bernard kissing a little child (page 196).

A more recent—and more high-tech—study using Eye-Trac Research Systems supports the older AP findings that readers prefer features to news. Whereas older studies asked readers what they liked or remembered about pictures, this equipment actually recorded the amount of time a subject gazed at a given photo.

Sharon H. Polansky, vice president of

readers want to see more up-beat feature pictures like this mom playing with her son. (John Kaplan, cover of Mom and Me, Scholastic,

Surveys indicate that

Gallup Applied Science Partnership (Princeton, New Jersey), says that the majority of subjects reading newspapers gravitate more to feature than to news photos, although she qualifies her statement by restricting her conclusions to "some newspapers and audiences." She says feature photos have a slightly higher "attention" factor.

WOMEN MORE PICTURE-MINDED

Surveys indicate that all readers do not have the same taste in pictures. Charles Swanson's analysis of the early preference data found that women have a greater interest in a larger number of picture categories than men do, and they also differed from men in their preference of specific categories. In a survey published in Search magazine, Randall Harrison found that men tend to prefer photographs of events, whereas women prefer pictures of people. Both sexes looked more at pictures of women than at pictures of men.

Forty years ago, researchers Malcolm MacLean and William Hazard found that women rated "blood-and-violence" pictures lower than their male counterparts—a finding supported by Roche's more recent study, which showed that women more often than men tended to reject photographs containing dead bodies.

The new Eye-Trac research, however, which actually measures how long people's eyes remain on images, did not find gender differences when the testers presented news and feature pictures.

One category in which men and women do differ is in their reaction to sports pictures. Although the overall statistics of the picture surveys indicate that sports is a low-preference category, this finding results from the fact that women look at baseball, basketball, and football pictures only half as much as men, according to Swanson's analysis.

Other recent Eye-Trac research demonstrates that males look at black-and-white sports photos more often than females do. Surprisingly, however, the Eye-Trac researchers also found that, when the pictures ran in color, men and women paid equal attention to sports photos. This is an important finding, if editors realize that color on the sports pages—more so than in any other section of the paper—may help attract a wider readership to that section.

CONCLUSIONS

With so few studies available, and the studies themselves conducted years apart and differing in sampling and survey techniques, generalizations have to be limited. Several conclusions, however, do seem justified. Human

interest pictures consistently receive high reader ratings. Not surprisingly, people like to look at pictures of people engaged in funny or unusual activities. Sports actually appeared at the bottom of all the surveys. One Lou Harris survey found that newspaper editors overestimated the general public's interest in sports stories.

CAN PROFESSIONAL EDITORS PREDICT READERS' **PREFERENCES?**

Who knows what kinds of pictures people like? Logically, you might assume that photo editors know their audiences, but another study by MacLean and Kao, published in Journalism Quarterly, suggested that editors are just guessing when they predict reader response to pictures. The researchers asked average newspaper readers to sort through pictures and to arrange them in order-from most favorite to least favorite photos. Then the researchers asked a group of experienced photo editors and a group of untrained students to sort through the same photos. The editors and students arranged the photos in the order they expected readers would have organized the photos. The editors and students based their predictions on statistical information they had about the readers. MacLean and Kao hypothesized that, the more information (such as age, sex, and occupation) the editors and students had, the more accurately they could predict the likes and dislikes of readers.

Surprisingly, the researchers' hypothesis was wrong. Professional photo editors performed little better than even chance when given detailed information about their readers. Furthermore, photo editors did no better at predicting than did the students. However, once the professionals had seen how their readers sorted one set of photos, the editors could anticipate how readers would sort a second set. These predictions were even better if the editors knew more about the reader, including the person's age, hobbies, and lifestyle.

Until the editors had seen the picture selections of the readers, however, they could not predict an individual reader's preferences. Clearly, more editors should find out what pictures their readers are actually looking at, rather than base editorial decisions on their own biases.

THE BUS SURVEY

Robert Gilka, former director of photography for the *National Geographic*, tells a story about Charlie Haun, an oldtime newspaper picture editor in Detroit who used to make

his own surveys: "Every couple of days, Haun would ride the bus in Detroit and look over the shoulders of bus riders who were reading the paper. He would note which picture their eyes stopped at, how long they dwelt on each photo, and see if they read captions." Gilka points out that although Haun's method was primitive, "Charlie probably knows more about pictures than most of us today." Haun, from his bus rides, came to the same conclusion that MacLean and Kao did from their research. Identifying what pictures people have picked in the past is the best determinant of what pictures they will choose in the future.

DO READERS AND EDITORS AGREE? To discover if editors and readers agree on what constitutes interesting and newsworthy photos, the Associated Press Managing Editors photo survey mentioned earlier was designed to determine which kinds of pictures readers liked, as well as which type editors preferred, and whether readers and edi-

The results indicated a surprisingly close agreement between readers and editors. Both selected the same photos in the sports, general news, and feature categories.

Editors' and readers' opinions, however, differed radically on the use of dramatic

tors shared the same taste.

news pictures. By a two-to-one margin over readers, editors chose action-packed, often violent, and sometimes gruesome news pictures. A majority of the readers not only disliked such pictures, but also thought that violent pictures should never be published. As the pictures became successively more gruesome, fewer readers voted for photos in this category.

As MacLean and Kao discovered, editors cannot predict an individual's photo preferences. Yet, as the AP survey indicated, except for spot news, editors' and readers' tastes are generally similar.

When it came to picking a favorite picture, however, editors and readers diverged. Readers chose the Saint Bernard-kissing-child picture. Editors, by comparison, chose as most interesting the photo of the lifeless body of a hanged Bangkok student being beaten by a right-wing opponent.

The AP's Hal Buell tried to draw some conclusions from his picture survey. Newspapers and magazines have to be all things to a lot of different people, he said. Editors must print what people want and also what the editors think is significant.

In the end, a publication has to print some of both in order to present a complete picture of the world: pictures of dogs kissing kids as well as pictures of political violence.

Some newspaper editors overlook feature photo situations that include people who are physically challenged. (Photo by Jason Clark, *The* [Spokane, Washington]

Spokesman-Review.)

WHAT READERS DON'T SEE

Pictures in the media should reflect our society. Sounds good.

Unfortunately, editors tend to ignore, on purpose or through benign neglect, whole population segments, including African Americans, gays and lesbians, Hispanics, Asians, and women of all races.

Researchers Paul Lester and Ron Smith found that in 1942, only 1.1 percent of the pictures in *Life*, *Newsweek*, and *Time* included African Americans.

Today, while these magazines run more images of African Americans (8.8 percent), this number does not match the 12.3 percent of the American population this group constitutes. Lester and Smith demonstrated that although coverage has increased, African-American content categories typically cluster around three primary topics—sports, entertainment, and crime. Such emphasis maintains the stereotypical assumptions of readers and viewers that the media often communicate. Researcher Michael Singletary came to the same general conclusions when he looked at how often African Americans are portrayed in newspapers.

In a 1974 study of the *Los Angeles Times* and *The Washington Post*, Susan Miller found that pictures of men outnumbered pictures of women in both papers. Roy

Blackwood replicated Miller's study in 1980 and found that the imbalance had actually worsened over the intervening years. Men clearly dominated page one, inside news pages, business pages, and the sports section. Ratios of photos of men to photos of women ranged from more than twenty to one for sports, to about two to one for entertainment. Overall, pictures of men outnumbered pictures of women nearly four to one in the Post and nearly three to one in the Times. Barbara Luebke came to the same conclusion when she studied four Connecticut newspapers in 1989. She found that men are shown not only more often, but also usually as professionals and sports figures, whereas women are portrayed as spouses—despite the fact that 23.8 percent of professional athletes in the United States at the time were female.

Besides African Americans and women, newspapers tend to ignore gays and lesbians. When Gail Fisher shot a photo story about two lesbian women in the late 1970s, the *San Bernardino* (California) *Sun*, where she worked at the time, thought the topic too dicey to run in the paper. As recently as 1992, Joseph Bernt and Marilyn Greenwald found that 25 percent of the senior editors at daily newspapers would not run pictures of two people of the same sex kissing. A series about teen gays titled "Growing Up Gay: A

As recently as 1992, Joseph Bernt and Marilyn Greenwald found that 25 percent of the senior editors at daily newspapers would not run pictures of two people of the same sex kissing. This photo was from a project about elderly gay people in long-term committed relationships.

(Photo by Pavlos Simeon, for MA Thesis, "Elderly Gay Couples.")

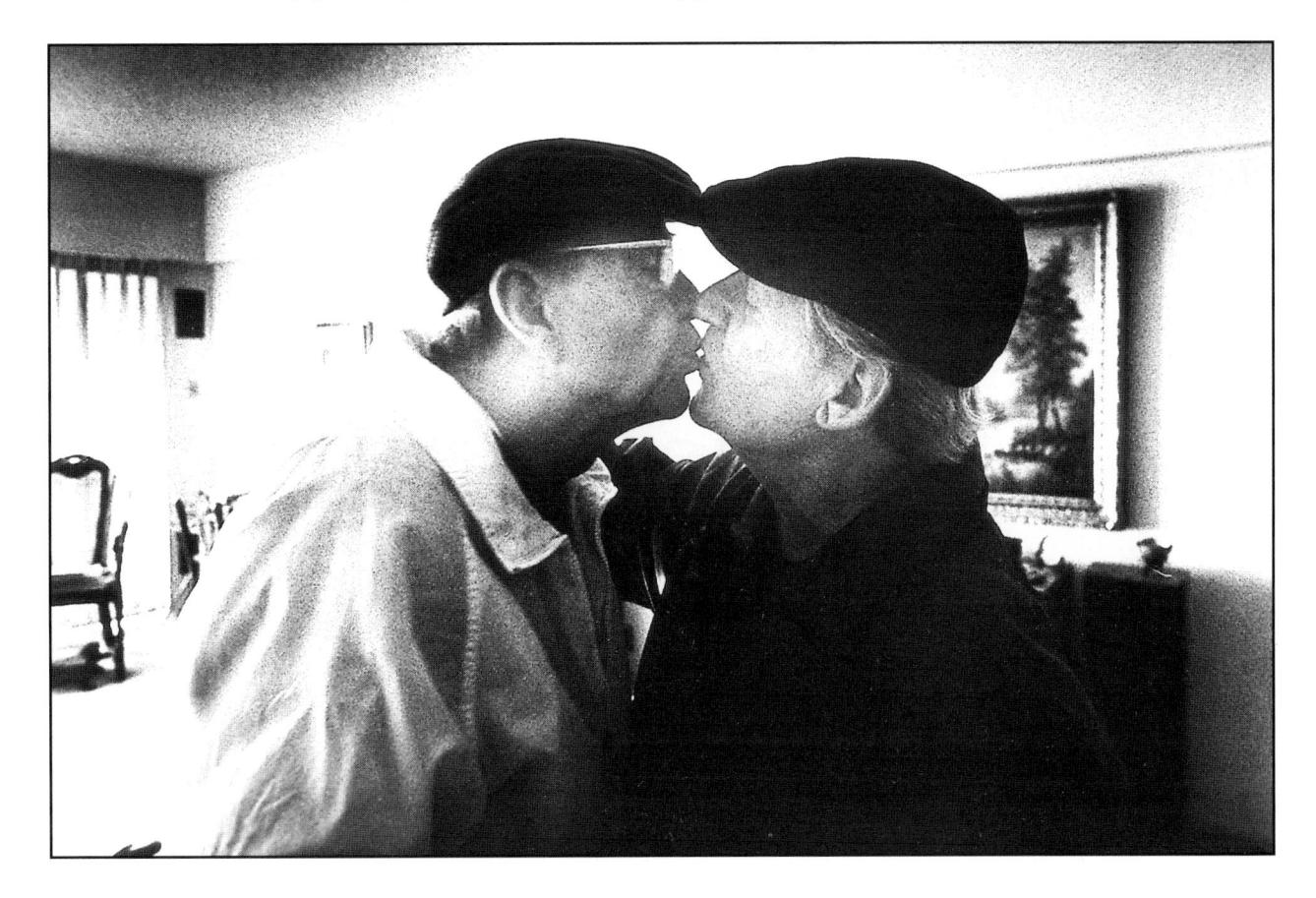

Crisis in Hiding," shot by Rita Reed and published in a fourteen-page, ad-free section of the *Minneapolis Star Tribune*, is a notable exception.

Readers rarely think about pictures they don't see. "Out of sight, out of mind." Editors, therefore, should be especially aware of the pictures they are not assigning or are omitting from their publications or Web sites. Readers depend on the news media for a balanced picture of the world. Leaving out whole segments of the population presents a notably biased view, even if editors believe their readers might not like seeing certain pictures. (See page 326, Chapter 15, "Ethics," for more on this issue.)

WORKING WITH IMAGES

CROPPING: CUTTING OUT THE FAT Regardless of how good the original is, if a photo is butchered on the cropping table or reduced to the size of a postage stamp, no one will see the picture. Newspapers do this every day. Says Roy Paul Nelson, author of *Publication Design*, "The typical daily or weekly newspaper is not designed, really; its parts are merely fitted together to fill all the available space, sort of like a jigsaw puzzle." To save their photographs, more and more camera journalists are getting involved in layout, at least on newspapers. These photographers want a say in how their pictures are cropped and sized.

Perfect framing is rare
When you take a picture, you must decide

what to include in the viewfinder and what to leave out. The impact of a picture often depends on this decision. By including too much, you run the risk of distracting the viewer from the main subject. By framing too tightly, on the other hand, you might leave out important storytelling elements. Photographers carry a variety of lenses to enable them to zoom in or draw back to include only the important pictorial elements.

Even with tight in-camera framing, every subject does not fit neatly into a 35mm format. For that matter, all subjects do not fit naturally into a 2 ½" x 2 ½" square or a 4" x 5" rectangle. Some subjects are low and wide, like a classroom chalkboard, whereas other subjects are tall and skinny, like the Washington Monument. Consequently, no matter how carefully you compose the picture in a 35mm viewfinder, the image from the real world may not completely fill the frame. In these situations, all you can do is shoot and then crop the image later.

Crop the excess

Like a writer editing copy, the picture editor, designer, or photographer should emphasize significant elements in the picture by eliminating extraneous material that carries little meaning. If a person's expression gives the picture sparkle, zero in on the face and cut out the peripheral material.

Light, bright areas of the picture, like windows and lights, tend to attract the eye. If these windows and lights are extraneous to the main subject, they will pull the reader's

attention away. Avoid a competing area that might distract a reader's interest from the photo's primary subject. Crop out these irritating sidelights from the picture. Bob Jackson, of the *Dallas Times Herald*, took a remarkable photo in the Dallas County jail of Jack Ruby gunning down Lee Harvey Oswald, the accused assassin of President John F. Kennedy. Jackson's strobe, used to take the photo, burned out the person standing near the camera. The unidentified person was bleached white on the print. Cropping this distracting element in the foreground greatly improved the historic picture.

If the action occurs in one corner of the picture, focus on that area. There should be a good reason for leaving in each area of the picture. No corner of the picture should remain just because it happened to be in the original negative. The rule is save the meat of the photo by cutting out the fat.

Crop ruthlessly

"Crop ruthlessly," advises Edmond Arnold, a pioneer of modern newspaper design. "Cut out anything that's not essential to the picture, so that the reader's attention won't be distracted or wasted. Ruthless cropping leads to stronger images."

Research supports the notion that eliminating extraneous details helps a picture. Gallup's Sharon Polansky, recording eye movement as subjects perused printed material, found that the simpler the picture's background, the more attention the photograph received.

But preserve the mood

Cropping can improve a picture by eliminating irritating details. But mindless cropping can ruin a picture's intent by slicing off areas that give the image its mood. The sensitive "slicer" preserves the ingredients that give a photograph its arresting look by leaving the brooding gray sky in a scenic or including the messy bookshelves in a college professor's portrait.

Sometimes a blank area in the picture balances an active area. Leaving a little room on the print in front of a runner helps create the illusion that the athlete is moving across the picture. Similarly, some blank space in front of a profile portrait keeps the subject from looking as if he or she is peering off the edge of the print.

Besides mood, insensitive cropping can rip away parts of the picture that give it context. Sometimes it's important to know that a riot occurred in the ornate foyer of city hall or in a barren, dusty field. Overzealous cropping could eliminate these informational, telling details.

REDUCED QUALITY: THE PRICE OF CROPPING

A perceptive editor can improve a photo's impact using thoughtful cropping, but sometimes at a price. Enlarging only a very small portion of the original negative or blowing up just a part of the final glossy magnifies any defect in the original picture. If the original negative lacked perfect sharpness, then the published picture will look soft and

Cropping this picture into a slim horizontal and running it across two pages gives it added impact.

(Photo by Jim Clark, Springfield [Oregon] News.)

CROP THE EXCESS

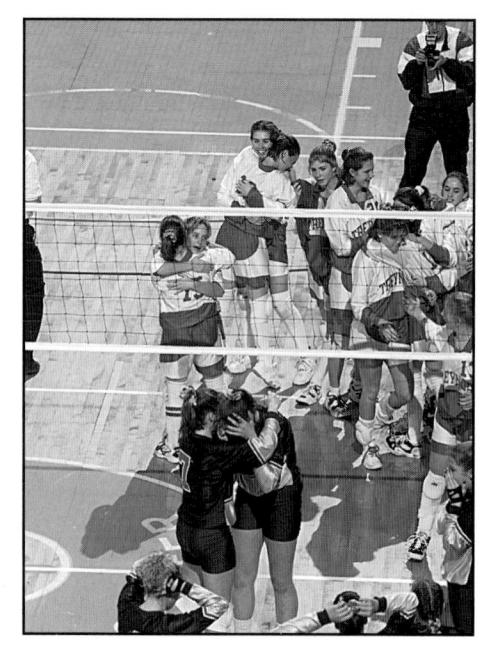

Careful cropping of the image transformed this chaotic scene into a strong, easy-to read picture of victory and defeat.
(Photo by John Martin, *Cedar Rapids* [lowa] *Gazette*.)

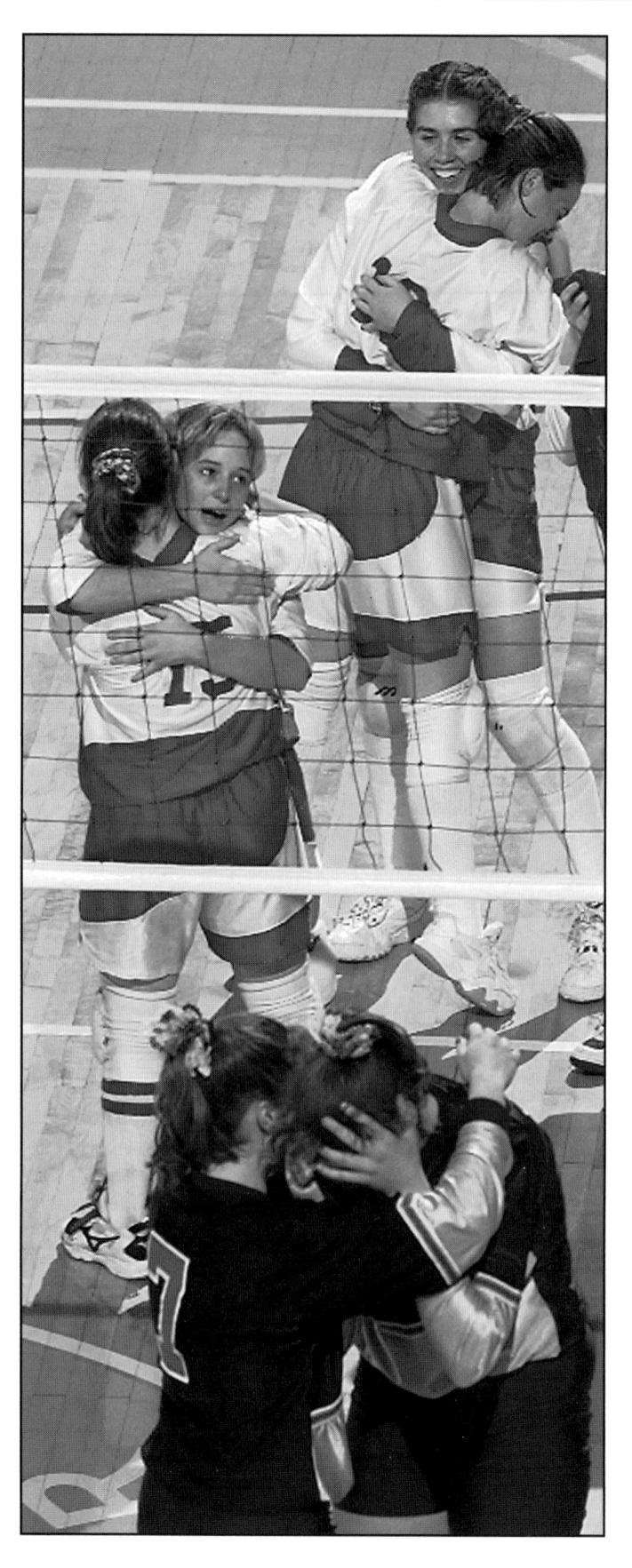

204 • Photojournalism: The Professionals' Approach

DON'T AMPUTATE AT THE JOINTS, PLEASE

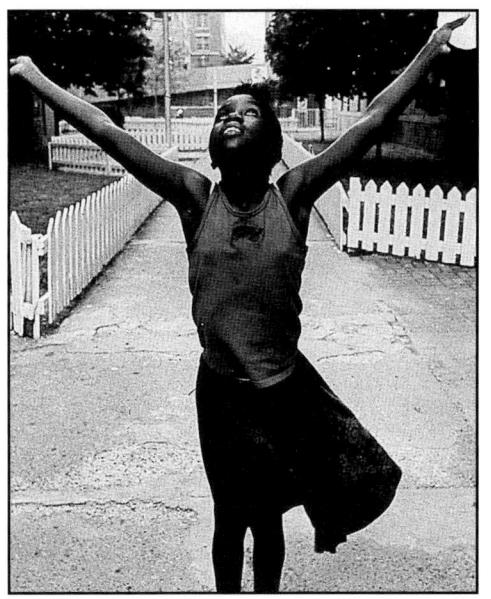

he editor's most perceptive skills come into play when cropping a picture containing a person. The editor must be careful to operate, not amputate. Parts of the body can be cropped off, but usually the crop mark should not fall on a joint like an elbow or knee. If the editor divides the head from the neck in a photo, some of the shoulder should be left so that the head will have a platform to sit on. The layout person can crop into the face of a person, but should not leave half an eye or just part of a mouth. Look at the pictures of the dancer and decide which crops seem natural and which crops seem arbitrary and absurd.

Some insensitive designers dream up pages before

they even see photos for the spread. When they receive the glossies, they slice and dice them into the preplanned shapes of their layouts, regardless of the photos' content. If these designs call for thin verticals running down the right-hand side of the page, these graphic artists care not if they have to chop up a perfectly composed horizontal shot and leave in only one eye and the tip of a nose—as long as the picture fills the predetermined space. These thoughtless people crop pictures to fit their designs, not to tell stories with photography.

(Photo by Kim Johnson, Sacramento Bee.)

PRESERVE THE MOOD

indistinct. Even if the original is sharp, enlarging a portion of the negative expands each grain of the film, thereby decreasing the photo's resolution. The more the image is enlarged, the more the grain is visible. Enlarged grain can obscure a photo's detail to the point the print takes on the texture of rough sandpaper. The photographer faces a dilemma, then. While the technical quality of the picture decreases when a photo is drastically cropped and enlarged, the visual impact of the photo often is improved. Cropping, therefore, involves a trade-off between poorer quality and better composition. Taking a 1" square segment of an 8" x 10" photo and publishing it as a half-page spread in the newspaper or magazine might produce a perfectly composed picture that is too fuzzy to

Few situations merit an extreme blow-up from such a tiny portion of a picture. Generally, however, a good photo editor will opt for a dramatic image at the expense of some sharpness and grain. The editor reasons that it is better to catch the reader's attention with an exciting photo than lose the reader with a technically sharp but dull image.

SIZING UP FOR IMPACT

appreciate.

A battle between writers and photographers rages daily on many newspaper and magazine staffs. Its outcome determines the size of the pictures in the next day's paper or next week's magazine.

SPACE: THE FINAL FRONTIER

Wordsmiths, backed up by the copy and managing editors, fight for small pictures to leave room for plenty of type. Reinforced by the photo editor, the photographer demands that the pictures be printed large enough so that readers will not miss them.

The camera contingent argues that, the larger the picture, the more powerful its impact.

Be careful when you crop not to cut out story-telling, environmentally important elements that give the picture its impact. The beautiful hall would be lost with a tight crop that just included the ballet students giving their performance.

(Photo by Cloe Poisson, *The Hartford* [Connecticut] *Courant.*)

And, in fact, ample evidence supports this claim. According to a study by Burt Woodburn, the average story is read by only 12 percent of a newspaper's subscribers. In the same paper, Woodburn found. the average onecolumn picture attracts 42 percent of the readers. Woodburn, in his

Journalism Quarterly article "Reader Interest in Newspaper Pictures," concluded that as the size of a photo increases, the number of readers grows proportionately. The 42 percent, for example, grew to 55 percent when the photo ran across two columns. A four-column-wide picture caught the attention of about 70 percent of the readers. Both Seith Spaulding, in his paper "Research on Pictorial Illustration," and Hyun-Joo Lee Huh, in "The Effect of Newspaper Picture Size on Readers' Attention, Recall and Comprehension of Stories," confirmed Woodburn's findings.

When all other factors were equal, not surprisingly, Gallup's Sharon Polansky came to the same conclusion using Eye-Trac research. She confirmed in her report "Eyes on the News" that increasing size also increases attention to a picture. She found that one reason "mug shots" receive little attention is because editors play these portraits so small. The research demonstrated

The price of extreme enlargement is increased grain and decreased quality. Only for news as unusual as this airplane stowaway falling to his death should poor quality photos be enlarged to this extent. (Photo by John Gilpin, Wide World Photos.)

the detail in a close-up shot like this one of a woman replacing a contact lens. (Photo by Ken Kobré, for the

The picture must be displayed large to see

Boston Phoenix.)

that 44 percent of the subjects looked at a one-column mug shot whereas the rate increased to 92 percent when readers viewed the same photo at three columns wide.

Even this axiom—bigger size gets more attention—has exceptions. The axiom's corollary might read: if the subject matter is exceptionally galvanizing, even small pictures will be noticed. Polansky noted during one of her studies that a tiny ad showing a female mud wrestler (with lots of torso showing)—played on the inside of a sports section—got much more attention than its size would have predicted. When it comes to sex, at least, picture size is not the only determinant for reader attention.

In addition to eliciting reader attention, bigger pictures draw readers into stories and also aid them in recalling the stories. A study by William Baxter, Rebecca Quarles, and Hermann Kosak found that, although a small, two-column picture accompanying a story does not help the reader remember the story's details, a large picture, six columns wide, measurably improves readers' recall of details in the accompanying article.

Hyun-Joo Lee Huh replicated those findings in a study at Syracuse University but went on to show that a larger photo also improved readers' comprehension of the story. When asked about the outcome of a story with no accompanying picture, only 13 percent of the readers gave a correct answer. However, comprehension increased with the addition of photographs, with well over 75 percent of those who read the same story accompanied by a large photograph understanding the text and explaining its significance. The picture's size influenced readers to finish reading the article as well as understand its implications.

According to the Syracuse researchers, the presence of a larger picture probably causes readers to read more of an accompanying story, which then results in greater recall and better comprehension. What's the message for reporters and editors? Reporters should be begging editors to run large pictures with their stories if they want readers to notice their writing, understand its implications, and recall the information later. Large pictures don't just decorate the page.

Reporters, editors, educators, and almost anyone else involved in communications constantly complain that the MTV generation does not read. Even for people more familiar with changing channels than with turning pages, editors have at their disposal a tool that influences reading. Like a magnet, big pictures draw in readers of all ages to the associated story.

Increasing a picture's size gives an editor more "bang for the buck." True, editors will need to sacrifice the number and length of stories to handle larger pictures. However, subscribers will read, remember, and understand the remaining stories rather than overlook those well-crafted, carefully researched words altogether.

The never-ending battle between the word and visual camps continues, but the photographer can gain space if he or she is willing to sacrifice a few weaker pictures so that stronger ones can be printed larger.
ACHIEVING CONTRAST WITH SIZE IN A LAYOUT

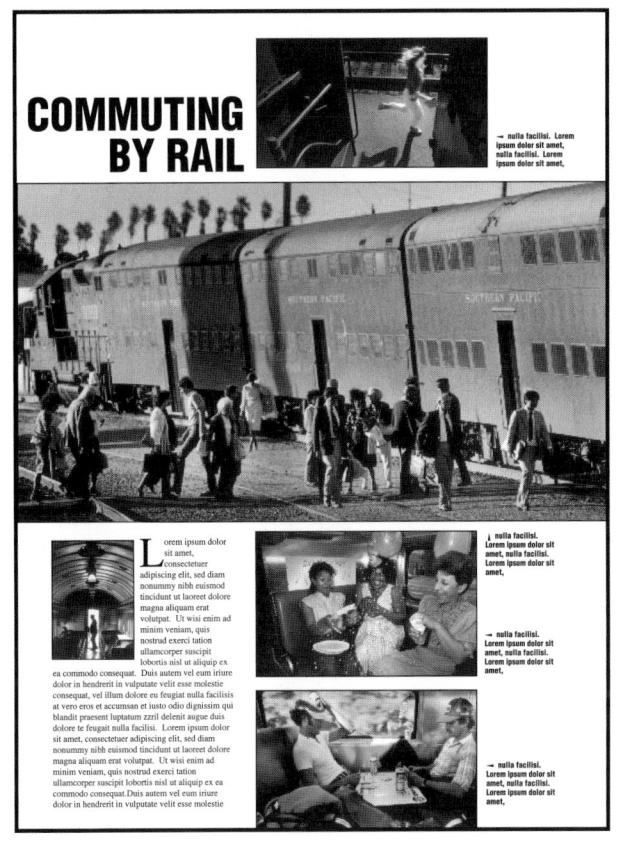

Photographers should fight for space when their images are striking. Bad photos, of course, should not appear in the paper, but if they must be printed, play them small. Oversizing a technically poor photo calls attention to its deficiencies.

On the other hand, underplaying an exciting, technically sharp photo does a disservice to photographer and reader alike.

WHEN SIZE IS IMPORTANT Drama

Armed with research and Arnold's axioms, the photographer fights for larger photos so that the audience can easily see the textural detail of the original image. A one-column "head shot" is so small that it communicates almost nothing. The person is barely recognizable. With a four-column portrait, the reader can examine the two-day-old whiskers on the mayor's face, or the size of a contact lens on a woman's finger. (See opposite page.)

Detail

A long shot, such as an overall of a church interior or an aerial shot from a plane, also demands space. Compressed into one column, all the details blend together and lose the bits of information that give the

picture meaning. "Exquisite," remarks the reader who sees a larger-than-life, oversized photo. A common object, like a pencil or pen, a contact lens, or even a media-worn face, becomes fresh and exciting when magnified beyond its natural size.

Pictures of large crowds also need considerable reproduction size, according to Tom Ang, author of Picture Editing: An Introduction. Ang notes that "the richness and intricacy of detail can make a fascinating pattern when the picture is used small but when used large, another layer of detail and meaning can be made out. A crowd scene that's an abstraction of color and pattern when seen small becomes full of individual human beings when enlarged."

Contrast in a layout

Running some pictures small and others big heightens the contrast between them, adding interest to the page. Publishing all pictures in a 3" x 5" size produces a deadening effect. No individual photo dominates. Just as a reporter or copy editor emphasizes certain points of an article by putting them in the lead, the photo editor or page designer spotlights certain pictures by playing them larger than others on the page.

Good page layout usually involves playing pictures so that one image dominates. Dominance is achieved through size. The dominant picture seems large especially when it is played alongside considerably smaller images. If the dominant and subordinate images are too close in size, they compete for the reader's attention.

(Photos by Jim Gensheimer, San Jose Mercury News.)

A risqué fashion show for women (RIGHT) is paired with a photo of a beauty contest (BELOW RIGHT). Played together, the pictures deliver a stronger editorial message about the sexes than either could alone.

(RIGHT: Photo by Curt Johnson, Long Beach [California] Press-Telegram. BELOW: Mike Smith, Detroit [Michigan] Free Press.)

MULTIPLE IMAGES

PAIRING PICTURES FOR THE THIRD EFFECT Sometimes one picture can sum up an event. The flag raising at Iwo Jima or the explosion of the Hindenburg needed only one photo to tell the story. Other situations require several. Pairing photos, according to Wilson Hicks in his landmark book *Words and Pictures*, causes a third effect. The reader looks at the two pictures separately and then mentally combines them. The effect is different than what any picture alone can produce.

UNRELATED PICTURE PAIRING Different pictures—similar meanings
In written language, different words can have similar meanings. With pictures, different images can carry similar messages.
Words with related meanings are called synonyms. A thesaurus is filled with examples of synonyms. Pictures with similar messages could be called visual synonyms.

Pairing pictures taken at different times and places that carry the same editorial statement allows the reader to see the common elements in the different images. The reader draws comparisons between the different photos. For example, you could publish sideby-side pictures of a man judging a beauty contest and women watching husbands and boyfriends stage a risqué fashion show. While the two pictures were photographed at widely different times and places, one in Texas and the other in California, and taken by different photographers, pairing them makes an editorial statement about the sexes. Similar in editorial content and point of view, the two pictures might be considered visual synonyms. They look different, but their underlying meaning is the same.

Visual homonyms

On the other hand, some words—like "to," "two," and "too"—sound the same but carry

completely different meanings. These are called homonyms. Likewise, some pictures look superficially similar but carry dissimilar information. For example, a picture of an Egyptian pyramid and a photo of a pile of oranges might look similar-both are triangle-shaped. Some pairs may be entertaining, but, because the pictures share no editorial relationship, a reader trying to find their common thread may be confused. The pictures share no real journalistic commonality.

Be careful, then, of visual homonyms, photos unrelated except by looks. Pairing such pictures can lead to editorial abuse, intended or not. Pairing pictures that are not intrinsically connected editorially can lead to silly or, in even worse situations, offensive results.

The author once saw a collection of unrelated pictures of overweight people - shot by different photographers for different purposes—published together on a page in a photo book. The editor must have thought it clever to assemble these editorially unrelated pictures together because they shared a common visual element: overweight people. What was the message of this tasteless and insensitive pairing?

PICTURE SEQUENCES AND SERIES Sometimes a story takes place over time. For example, Olympic competitor Mary Decker was tripped by another runner during the much-awaited race. The sequence of events—running, tripping, and falling required a sequence of pictures to tell the whole story. The unfortunate accident, which Bruce Chambers recorded for the Long Beach Star-Telegram with his motor drive, needed a beginning, middle, and ending picture to tell the complete story. (See the series of photos on page 124.)

PACKAGING PICTURES

Some situations are multifaceted. One photo just won't explain all the diverse elements.

For example, Aristide Economopoulos wanted to document a boxing gym called Finley's Gym. Although the facilities are simple, the atmosphere is caring and familylike—and produces some of the top boxers in the world.

A picture of one boxer alone wouldn't tell Economopoulos' story. Nor would a single picture of one fighter training. Packaged together, though, pictures of a young boy looking up at a fighter, an athlete jumping rope outside the gym, and older boys yelling advice and encouragement at a young fighter in the ring, gave a more complete vignette of the gym's activities. (See pages 212-213.)

THE CAPTION: STEPCHILD OF THE BUSINESS

Some pictures - such as Norman Rockwell's cover illustrations for the Saturday Evening *Post*—need no words. The idea portrayed is so simple or its emotional content so powerful that the illustration tells the story clearly and immediately without any captions.

But most photos do need words. The old Chinese proverb relates that a picture is worth a thousand words, but the corollary to the proverb is that a picture without words is not worth much. A picture raises as many questions as answers. Look at the pictures on these two pages and ask yourself if, without captions, you would know who is in the pictures, what is happening, when the events took place, and why the action occurred. Pictures usually answer these questions only partially. A picture that can stand alone is rare. The point is not whether photographs can survive without words or words without pictures, but whether pictures and words can perform better when they are combined.

WORDS INFLUENCE PICTURE MEANING

When Jean Kerrick was assistant professor of journalism at the University of California, Berkeley, she conducted research to determine the influence of captions on readers' interpretations of pictures. Captions, she found, can at least modify and sometimes change the meaning of a picture, especially when the picture itself is ambiguous. A caption can change the viewer's interpretation of the same picture from one extreme to another.

Kerrick presented a profile shot of a welldressed man sitting on a park bench to two groups of subjects. She asked the groups to rate the picture on several subjective scales. The scales ranged from "good to bad," "happy to sad," "pleasant to unpleasant," and so forth. Then the first group was shown the same picture with this caption: "A quiet minute alone is grabbed by Governor-elect Star. After a landslide victory, there is much work to be done before taking office." The second group was shown the same picture with a different caption: "Exiled communist recently deported by the U.S. broods in the Tuileries Garden alone in Paris on his way back to Yugoslavia." Both groups were again asked to evaluate the picture.

Kerrick found that, after the first group read the positive caption, they rated the picture "happier," "better," and "more pleasant" than they had originally judged it. The second group of viewers, who read the caption about the exiled communist, changed their rating of the picture in the opposite direction—the

Running a three-picture sequence tells the story of Bo Jackson breaking a bat over his knee better than any single image in this set. (Photo by Brad Mangin, for Sports Illustrated.)

FINLEY'S GYM

THE PICTURE PACKAGE

Finley's Gym, located in a back alley on top of an auto repair garage, was founded in 1960. The gym has been a gathering place for different generations, working together to pass down the techniques and skills of prizefighting. It's a place where one can see a young child sharing the ring with a veteran professional to train. Although the facilities are simple, the atmosphere is caring and family-like. Finley's Gym provides a source of stability and structure in the chaos of urban Washington, D.C., while producing some of the top boxers in the world.

(Photos by Aristide Economopoulos, for *The Washington Post Sunday Magazine*.)

(RIGHT) By 5 P.M. the gym can get very crowded.

(RIGHT) Chance Burges, a promising young boxer, has a serious talk about life with his trainer Mike Hodge. Hodge's own boxing career was cut short by a drive-by shooting.

(ABOVE) Hector Martin works on his jab while using the heavy bag.

(LEFT) Because the gym can get very crowded sometimes, Gary Smith jumps out-side in the back alley by the gym's entrance.

(LEFT) Four-year-old Joshua Fitzhugh hugs his dad during his training. Joshua claims that his dad is his champion.

(ABOVE) A sparring match between two younger boxers draws a crowd.

photo now seemed "sad" and "unpleasant." In this example, the caption completely reversed the impression initially given by the picture alone.

In a similar study, Fred Fedler, Tim Counts, and Paul Hightower used high-impact news photos and varied just one or two words in their captions. They did not find striking changes when they varied just a few words with this particular set of pictures. Perhaps changing captions influences neutral pictures but not those that tell a clearer and more dramatic story like the ones in their study.

Pictures appear to serve as a primitive means of communication but carry out their task instantly. Words function as a sophisticated means of communication, but lack the impact of the visual message. Pictures transmit the message immediately, but words shape and give focus to that message.

WRITING CLEAR CAPTIONS

The need for clear and concise caption-writing is obvious. Readers often determine whether they are going to read an entire article based on what they gleaned from a picture and caption. If you glance through some newspapers and magazines, however, you may get the impression that the first person to walk into the room wrote the captions in the paper or magazine that day. Writers polish their story leads, and photographers polish their lenses, but no one shines up the captions. Writers claim that caption-writing is beneath them, while photographers often seem to find an important blazing fire to cover when the time comes to compose captions. The caption—the stepchild of the media business—is the most read but least carefully written text in the publication.

Poor captions sometimes result when photographers fail to get adequate information at the time they take the pictures or forget to include the information when they write the captions. The late Howard Chapnick, who ran the Black Star picture agency for many years, once said, "One cannot err on the side of providing too much caption information. The editor who finds a photographer who understands the importance of detailed captioning will figuratively embrace him bodily and professionally."

One photographer even lost his job because of writing poor captions. After ten years of shooting for his paper, Victor Junco was released by the *St. Petersburg Times* because of caption errors.

Former *People* magazine photo editor John Dominis once told the story of holding up the magazine's production because a photographer did not send in one critical

identification. Lights in the New York headquarters burned past midnight as the editors carried out a desperate search by telephone for the forgetful photographer. Editors, writers, layout artists, designers, and production staff all waited hour after hour for the missing caption, costing People magazine thousands of dollars in overtime.

PUTTING THE FIVE Ws IN A CAPTION "A caption is a verbal finger pointing at the picture," wrote John Whiting in his book *Photography Is a Language*. Captions, like fingers, come in many sizes and shapes. The opening words of a caption must capture the reader's attention just as do the lead words of a news story or feature. The caption writer starts off the sentence with the most newsworthy, interesting, or unusual facts. Copy desks have developed several varieties of captions, each emphasizing a different element of the story.

What

The reader wants an explanation of what is happening in the picture; hence, the first words of the cutline should explain the action. Unless the situation in the picture is obvious, the cutline must describe what is going on. After two years of drought, it rained in the southern part of the state yesterday.... Further down in the cutline, the writer can fill in the other details of the story by giving the remaining four Ws.

Who

The who may be emphasized in the caption when the person in the news is featured. **President Clinton said yesterday that he will spend the weekend at Camp David.**

In this situation, the newsworthy aspect of the picture is the person, President Bill Clinton. The fact that the president was speaking outweighed what he had to say or where he said it.

A person's name should lead the caption only when that person is well-known to the readers of the magazine or newspaper. Do not start the caption, **John Doe said yester-day that the budget should be slashed**. No one knows John Doe, so placing his name prominently in the cutline neither adds to the picture's interest nor explains its news value. However, if John Doe's face is recognizable in the photo, he should be mentioned somewhere in the caption. People's names are always included in the caption even if they are not famous. Someone—spouse, parents, friends—certainly will recognize them.

Also, readers can misidentify the person in the photo if the name is left out of the

caption. Often you may hear, "That woman in the picture in the paper looks just like...."

Many editors will not run a picture unless the caption includes the names of all recognizable people. The wire services, whose pictures go around the world, write in the person's first and last name, regardless of the individual's national prominence.

If a child is pictured, the photographer should get the name and the age of the voungster. This information often adds additional human interest to the picture. The collie pup would have drowned if the Selleck girls (left to right) Debbie, 3, Heidi, 5, and Becky, 7, had not pulled their dog, Sam, from the stream in time.

Note that readers are given clear directions about which girl is which with the phrase "left to right." Sometimes the words "top row," "wearing the tie," or other identifying features will help readers match the faces in the photo with the names in the cutlines.

When and where

Photos rarely tell readers exactly when or where a picture was taken. If this information helps readers understand the picture, supply the location and the time of the news event. Use the day of the week, not the calendar date. José Canseco hit the home run yesterday that gave the A's their win over the Giants. (Not "Canseco hit the home run July 6.")

The writer should begin the cutline with time or place only when that fact is significant or unusual. At 3 A.M. Mayor Ted Stanton finally signed the zoning bill. Or, Standing in the sewer, the water commissioner, Edna Lee, explained the new drainage system.

Whv

Some caption writers claim that explaining why the action occurred in a picture takes away the reason for reading the story and thus causes readers to skip the adjoining article. Other news photographers and editors argue that extensive captions pique reader interest for the main body of the story. Because of the transit strike, highways leading into the city were jammed at the early morning rush hour today. Without answering the "why," this photo and caption would not make sense.

Filling out the detail

The caption is the place to tell readers if the subject in the picture was posed. If the photographer took the picture with a special lens or manipulated the print in the darkroom, this should be noted.

In fact, anything about the scene in the picture that differs significantly from the actual event and, therefore, might distort the facts, should be explained in the caption.

This fascinating but complicated vignette becomes clearer when the caption explains that these were bored kids entertaining themselves while waiting in line for their turns to kick the ball at soccer practice.

Photo by Scott Eklund, Bellevue [Washington] Journal American.)

Small detail

Casually glancing at a photo, readers might miss an important but small detail. The cutlines can focus attention on various parts of the picture, emphasizing the elements the photographer thinks are important. The cutlines can supply details about the four senses that the picture does not convey. How something tastes or feels might explain a subject's reaction in a picture. Without an explanatory phrase in the caption, the picture might not make sense. David Krathwohl, 10, Jerry Lazar, 9, and Lou Madison, 11, struggle to climb an oil-covered plastic pole....

Quote

Sometimes this purpose can be accomplished by telling what the subject said with a catchy quote. "Some days I wish I had never left Kansas," said rock star Dorothy Oz on the eve of her thirty-fourth record-breaking performance.

Color

Even though black-and-white photos record the world in almost infinite detail, one visual element is left out: color. When color is an important aspect of the scene, the cutline must supply this missing dimension. The Franklin High Majorettes, dressed in bright pink uniforms and matching pink tennis shoes and carrying pink batons,

detail marched and twirled in front of the lly glancing at a photo, readers might Franklin County Courthouse yesterday.

Before and after

A camera shutter, open for 1/500 sec., results in a photo that accurately describes what happens in that brief span of time. But the photo does not inform the readers about what happened before or after that split second; the causes of the event and its effect are absent. Cutlines must supply the befores and afters.

Special camera or computer effects
Whenever your picture's overall look is the result of a special photographic effect, your caption should let the reader know how you accomplished this. When Marshall Spurrier was assigned to photograph the farmers who grew a large pumpkin, he placed the vegetable on the ground, attached an ultra-wide lens to the camera and positioned the man and his wife on either side of the frame, several feet back. The resulting picture (below) made the vegetable look as if it were as big as a house. Spurrier used the picture's caption to explain how he achieved the effect.

Besides the distorting effects of the wideangle lens, sometimes you might need to point out the compression effect of an extralong telephoto, color shifts produced when shooting in mixed lighting, or elements

Special effects such as the close placement of the wide-angle lens (28mm) used in this picture should always be explained in a caption. (Photo by Marshall Spurrier, Chanute [Kansas] Tribune.)

changed with digital manipulation. (For a full discussion of ethical issues regarding computer-manipulated photos see Chapter 12, "Digital Images.")

CAPTION-WRITING STYLES

Write short, declarative sentences with as few words as possible. Avoid complex sentences. Don't put unrelated facts in the same sentence. Keep facts separated with periods, not commas or other punctuation.

The AP's Hal Buell says, "Skip the adjectives and adverbs in a caption. Let the picture speak for itself."

Two schools of thought differ on the question of the tense of verbs in captions. The first group advises putting everything in the present tense, because the words in the caption are describing a photo immediately in front of the reader. The present tense also involves the reader more than does the past tense. Says Karen Cater of the *Seattle Times*, "Present-tense captions give a sense of action, immediacy, and life to a photo."

The opposing view advocates using the past tense because all the action in the picture has already taken place. John Brown tags [tagged] the runner to make the last out in yesterday's game.

Avoid the obvious. Phrases like **firefighter fighting blaze** or **basketball player going for hoop** are unnecessary because readers can see that, in the first picture, the people are firefighters, and, in the second, the athlete is a basketball player. Phrases like **pictured above** also add no new information when accompanying a single image. Captions should avoid telling readers what they can find out for themselves by looking at the picture.

Avoid speculation about what the subject might be thinking. Such guessing can be inaccurate and give a wrong impression. Claire Katz smiles with happiness as she receives a check from the president. For all we know, she might really think that the check was far too small for her efforts. You have no way of looking into a subject's mind.

And, of course, no one, even a photographer, can read an animal's mind. Don't fall into this trap: **These pigs seem to be wondering if....** Write simply.

And don't forget to identify old photos from the morgue as "file photos." Otherwise the reader might think they were taken yesterday.

FINAL ADVICE

Caption writers—both neophytes and old hands—must always remember to start with the picture. If the writer looks at the picture,

at least he or she will avoid the mistake that one caption writer made. The caption read, "Police seized a quantity of opium." But in the picture, there were no police and there was no opium.

Joseph Kastner, who was the head copy editor and caption writer for *Life* magazine, said that the discipline of caption writing is of an order that no other kind of journalism requires. "And when this discipline is exerted, it produces writing that is as taut, as spare, as evocative, and as cogent as any writing in journalism today."

Sometimes pictures capture great emotion but, without a caption (which in this case the photographer supplied), readers may be unable to determine just what emotion they are seeing. Are these women happy or sad? Did they win or lose the event? (Photo by Paul Chinn, Los Angeles Herald Examiner.)

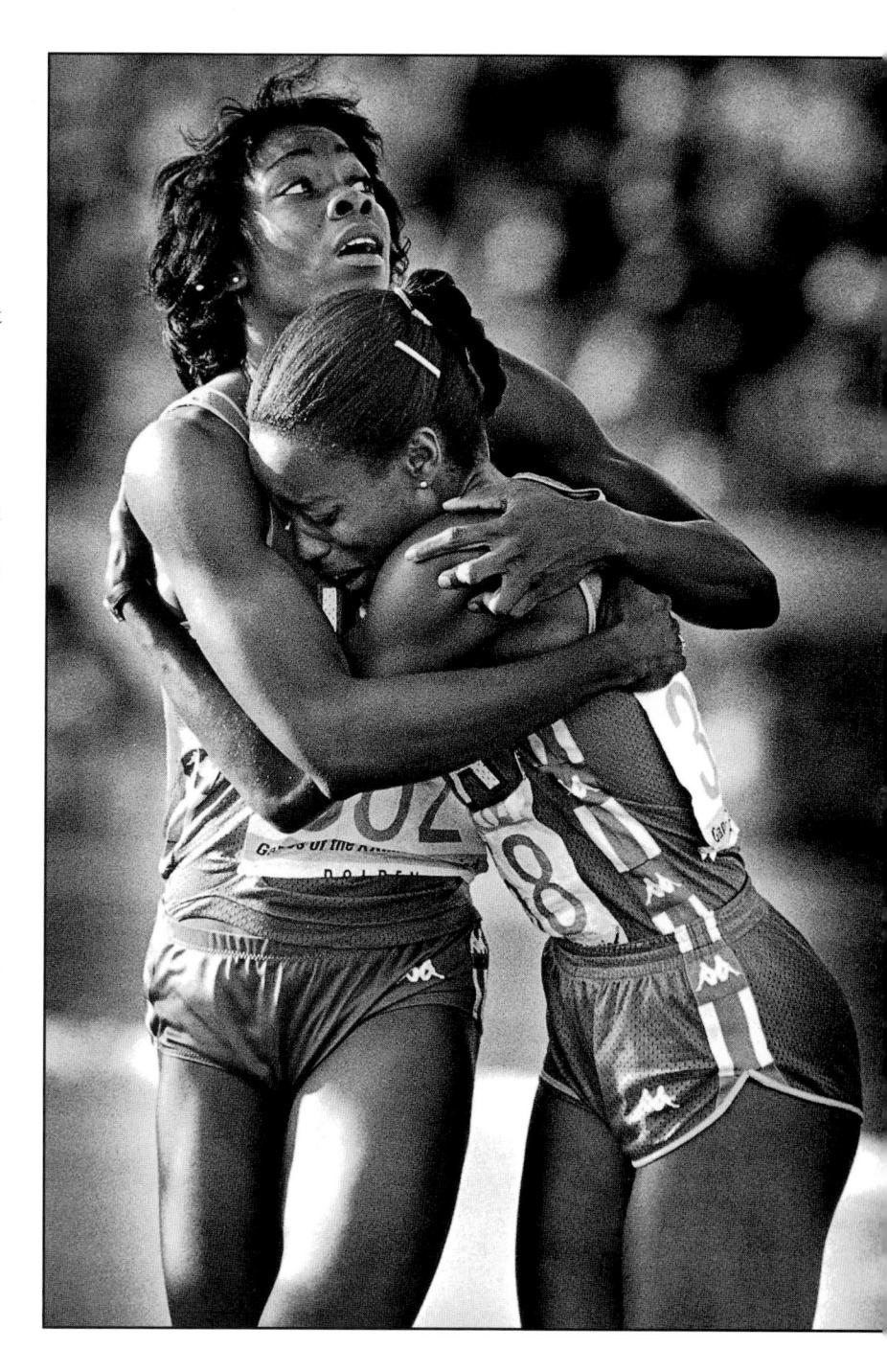

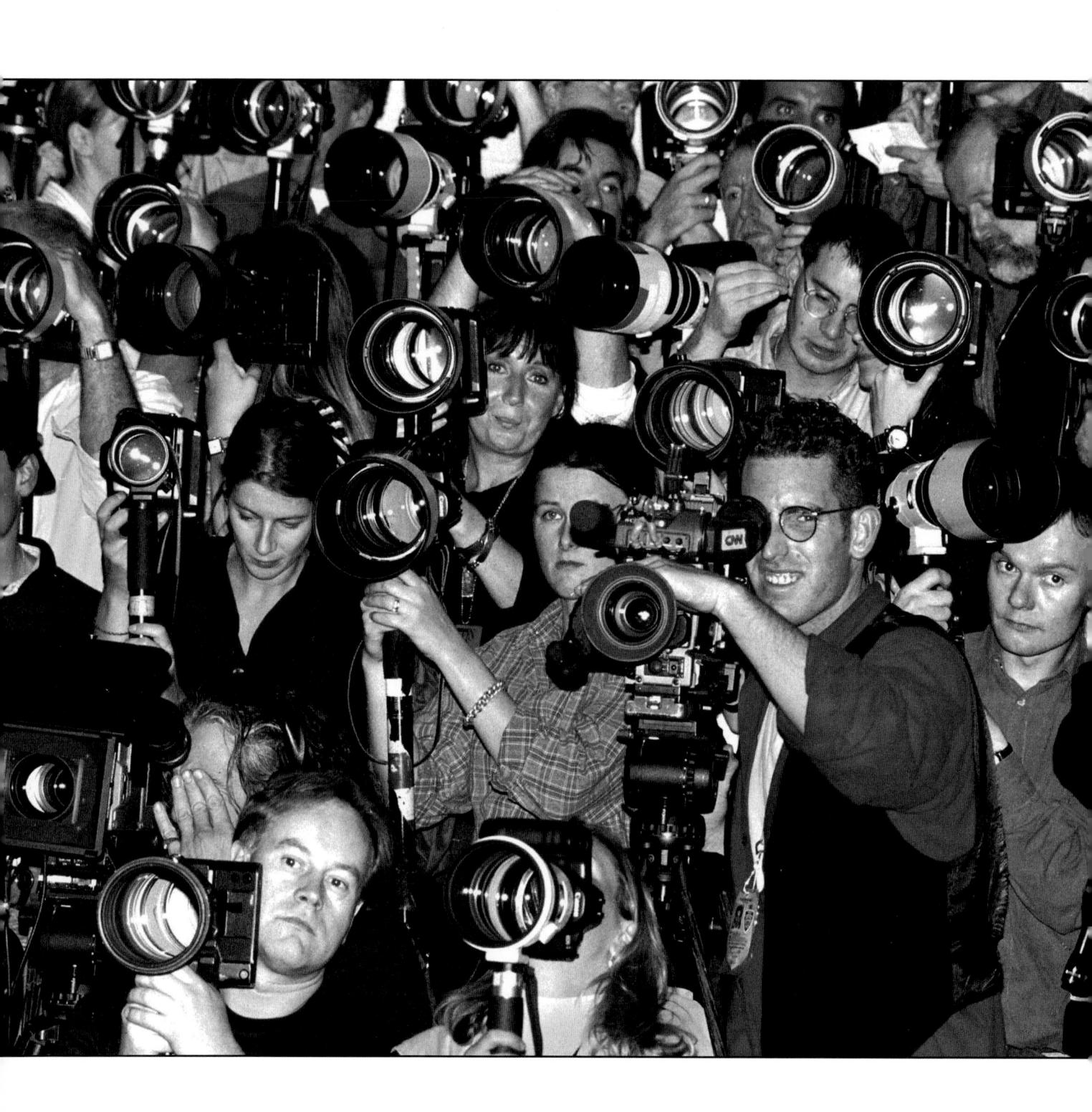

Cameras & Film

OUTFITTING THE PHOTOJOURNALIST

CHAPTER 11

photojournalist's bag is like a physician's—each
contains the essentials for handling any emergency
the professional might face. Like each doctor, each
photographer carries different equipment, depending on profession-

al needs and personal taste. Some photographers are partial to extra-

long lenses, whereas others like wide-angle lenses. But all news

photographers pack enough gear to handle any assignment, whether

It takes a lot of telephoto lenses, sometimes called "long glass," to cover a fashion show. Photographers at the end of the runway get the head-on shots of models coming down the runway. (Photo by Lucian Perkins, *The Washington Post*. The picture appeared in his book *Runway Madness*, Chronicle Books, 1998.)

the event they cover takes place in the brilliant

light of day or the pitch black of night. A news

photographer must have a sturdy camera, a

KEEPING YOUR CAMERA DRY

arty Forscher, who spent more than 50 years in the camera repair business, always warned photographers "to keep your camera dry." His advice still holds true today, given cameras' reliance on electronic circuitry. Electrical contacts can corrode on exposure to moisture, especially salty moisture at the beach. Forscher always told the story of how well-known war photographer David Douglas Duncan shot great pictures in Korea under the worst rain and mud conditions possible—using a simple underwater camera.

Today, there are also various "rain hoods" available commercially that fit over photographer and camera and help keep both reasonably dry. These fold up easily for storage in a camera bag.

Forscher suggests that if you're caught in the rain without a raincoat for your camera and have neither an underwater camera nor waterproof housing, wrap your regular lens and camera body in a plastic bag sealed with a rubber band. Cut one hole in the front of the bag to let the lens stick out, and another in the back of the bag to enable you to see through the viewfinder. Put the lens and eye-piece through the holes and secure them with rubber bands. Now you can operate the camera through the bag, but you can shoot and view through a clear area. Remember to keep the front element of the lens dry because drops of water on this element will distort the image on the film.

variety of lenses, a strobe, and, of course, film—lots of film (or memory cards for electronic cameras!)

THE NEED FOR RUGGED EQUIPMENT

The most expensive piece of equipment a photojournalist will buy will be his or her camera system. Cameras and lenses can cost from hundreds to thousands of dollars. Working photojournalists want a camera sturdy enough to take the bashes of the business yet light enough so that the photographer can carry at least two bodies at the same time Photojournalists need a camera that can be subjected to freezing weather one day and melting temperatures the next. Yet they want that camera to continue to function

perfectly, frame after frame.

No perfect camera system exists. Each photographer weighs the trade-offs of weight, ruggedness, and, of course, cost when outfitting his or her bag of camera tricks.

AUTOMATIC FEATURES

AUTO-EXPOSURE

Built-in auto-exposure light meters are amazingly accurate. Some can read the brightness of a tiny pinpoint in the scene while others can average the whole vista contained in the viewfinder.

These built-in meters are accurate except when the majority of the picture is either allwhite or all-black. Backlighting also presents a challenge to automatic exposure meters.

Joel Draut switched to manual reading when he shot a funny face carved in the snow (opposite). With an automatic light meter reading, the snow would have turned gray. Draut opened the aperture about two stops above the light meter's reading to compensate. Richard Koci-Hernandez who shoots for the San Jose Mercury News, took a careful reading of Carolivia Herron (opposite), the author of the controversial children's book Nappy Hair. The woman was wrapped in a dark cape in front of a dark, unlit wall. On automatic, the camera's light meter would have given a false reading and overexposed the picture.

By taking an in-camera reflected reading of the woman's face or by using an incident light meter, you can avoid an incorrect exposures in situations like this.

AUTOFOCUS

Most *Sports Illustrated*, ESPN, stock, and wire service photographers shooting football and basketball use autofocus at some point during the game. Cameras can now autofocus faster than the human eye-hand combination can adjust the lens barrel. Using autofocus cameras and lenses, novice shooters can hold their own with experienced pros.

Autofocus has even helped journeyman shooters. Steve Rice, director of photography at the *Minneapolis Tribune*, estimates that sports shooters who were getting 60 sharp pictures out of every 100 are returning to the paper with 90 to 95 sharp images when they use the latest autofocus equipment.

Yet autofocus is not a cure-all for producing sharp pictures under all circumstances on every frame. It works great when you are tracking an isolated player. You can expect sharp pictures as long as the ball handler does not get lost in a gaggle of supporting players or is blocked by the referee.

You'll get the highest number of sharp pictures in sports like track and field, where the focusing mechanism can lock onto a single runner and follow that person to the finish line. (See Chapter 7, "Sports.")

Tracking across the viewfinder

With some autofocus systems the camera keeps the subject in focus even if the subject moves from one side of the frame to the other. Called "dynamic autofocus" by some manufacturers, "predictive autofocus" by others, once the camera locks onto a subject, it "remembers" the contrast and brightness of the object or person.

When the quarterback starts running, for example, the photographer locks onto the player in the viewfinder. As the athlete moves toward the camera, the camera's tiny on-board computer "recognizes" the player even if he has moved from the original target to a different area in the viewfinder. When the player crosses over to a different part of the field, the camera continues to track him.

WHEN TO OVERRIDE YOUR AUTOMATIC EXPOSURE METER

In a predominantly dark scene like this one, the camera's automatic light meter would be fooled into overexposing the final picture. In this situation, take a meter reading off the subject's face.

(Photo by Richard Koci-Hernandez, San Jose Mercury News.)

A camera's automatic exposure meter would see this predominantly white scene as 18 percent neutral gray and underexpose the final picture. For proper exposure in similar situations, increase your exposure about two stops or take a reading off something in the same light that reflects a neutral gray. (Photo by Joel Draut, Houston Post.)

Personalizing the autofocus controls
Learning to shoot with autofocus requires the skills and agility of a twelve-sting banjo player. Autofocus requires eye-hand coordination as well as nimble fingers and thumbs to stay targeted on the subject at all times. Autofocus shooting actually requires as much attention, concentration, and dexterity as manual focusing, but with autofocus, you'll bring back more sharp pictures.

Some cameras enable you to customize the autofocus setup for your personal preferences. You can set it so that autofocus operates only when you press lightly on the

shutter release, for example. Or you can have it go into action when you press an alternative button on the camera back. These options help you set up the camera to your own shooting style.

With some cameras—even in extremely low light or total darkness—you can still use autofocus to shoot. These cameras use a dedicated strobe that emits near-infrared light, which allows the camera to focus the lens accurately and automatically even in total darkness. You can take pictures in a dark alley at night—without focusing the camera. Just point, shoot, and get well-exposed, sharp

Most sports shooters now use autofocus to follow the action in football games. The lenses respond so quickly that the shooter can swing from the quarterback to the receiver and still get a sharp picture of the play. Fast motor drives also help.

(Photo by Sung Park, Austin [Texas] American-Statesman.) pictures (as long as you've steadied the camera on a tripod or are also using strobe).

Shooting the Hail Mary

Photojournalists agree that the autofocus feature offers one clear advantage over manual focus. Sometimes photographers are caught in situations when, with nothing in the vicinity to provide height, they must shoot over the heads of a crowd. For instance, at the end of a football game, everyone on the field crowds around the winning coach. Before autofocus, sports photographers used to prefocus the camera and then hold it high above their heads—pointing at the coach, firing,

and praying that the focus was correct. This shot was called a "Hail Mary"—after the prayer many photographers offered when they took a picture in these less-than-ideal circumstances. With autofocus, you can shoot a "Hail Mary" over the top of a crowd and have more assurance of getting a sharply focused picture of the winning coach.

Doing it yourself

Photojournalists must decide carefully when to leave focusing to the camera and when to take over manually. Even sports photographers don't select autofocus all the time. For baseball, many shooters still prefocus on second base or home and wait for the action. Of course, autofocus plays a less helpful role in the studio, although it can prove handy for snatching candid photos of unaware subjects on the street.

With autofocus, the photographer selects a then locked in, the picture should be sharp. However, the factor providing the major clue to the autofocus machinery is contrast. The autofocus mechanism, therefore, gets fooled when shooting in extremely low light or in low contrast situations. In addition, autofocus tends to break down when shooting through a cage at an animal or through a window. The autofocus does not know whether to concentrate on the bars or the animal; the window or the scene outdoors. Heavy background light will also throw off autofocus. When using autofocus, watch out for times when the subject is in shadow but the background is very bright.

sensitized area of the viewfinder and locks onto a target subject. Provided the focus is

LENSES

Zoom

Today's camera engineers have developed an array of fast, sharp zoom lenses that cover the range of focal lengths most photographers regularly carry in their bags. Unfortunately, fast, wide-aperture zoom lenses also will snare a significant portion of your first paycheck—maybe your first few. Of course, using a single zoom lens does save the cost of owning two or three individual lenses.

Buyer beware, however. First, some zoom lenses change apertures as you zoom through the focal length range. For instance, an 80mm to 210mm zoom lens might have a maximum aperture of f/4 at 80mm, but when you zoom it to 210mm, the maximum aperture has decreased to f/5.6.

In general, you will find these variableaperture zooms too slow for practical work when shooting in low light.

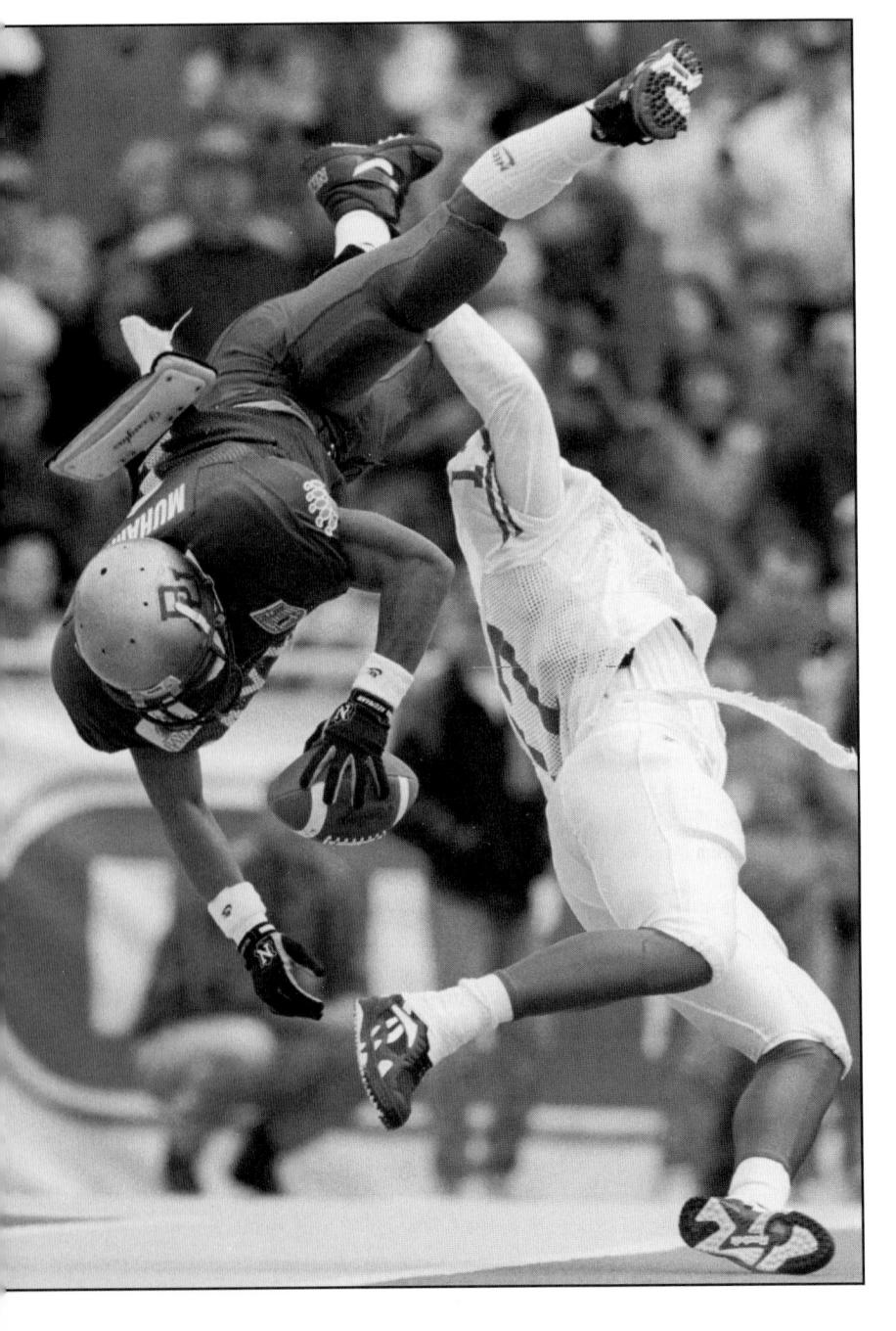

You usually need at least an f/2.8 mm lens for available-light indoor photography.

Second, zoom lenses are internally complicated and more prone to alignment errors when the lenses are knocked around at a football game or in a street riot. Treat zoom lenses with extra care, and check their sharpness at regular intervals.

Stabilization lenses

Generally, if you are hand-holding a 300mm lens, you need a shutter speed of at least 1/500 sec. or faster to avoid "soft" (not sharp) pictures caused by camera movement. New stabilization lenses, however, allow you to shoot at slower shutter speeds without introducing camera movement. With a 300mm stabilization lens, for example, you can shoot at 1/250 sec. or slower and still get crisp images. Because you can shoot at slower shutter speeds, these lenses tend to have smaller maximum apertures and are therefore lighter in weight and easier to hand hold.

ONE BLACK-AND-WHITE FILM FOR MOST OCCASIONS

STANDARDIZING WITH ONE BLACK-AND-WHITE FILM Photojournalists working in black-and-white use one type of film to shoot most of their assignments. With a versatile ISO 400 film, they can handle everything from an outdoor rally at noon to an indoor press conference in a dingy City Hall office without wasting time rewinding and changing to a different film.

Standardizing on one film minimizes the chance for mistakes when covering multiple assignments and meeting tight deadlines. Also, one film simplifies a camera bag. Photographers don't have to pack different emulsions for every event or change of weather.

Most cameras today have shutter speeds above 1/1000 sec., and many reach 1/8000 sec. This allows photographers to use even wider apertures outdoors—which, in turn, allows them to blur the background—while continuing to shoot with the same fast film.

SHOOTING IN LOW LIGHT WITH BLACK-AND-WHITE FILM Overrating film

For low light, many photographers continue to use their standard film but adjust its speed and then its development time. This combination of overrating the film and adjusting development is often called "pushing" the film—something photographers do so they can use either a higher shutter speed or wider aperture.

For instance, when the AP's Eric Risberg

ONE PRO'S CAMERA BAG

Dave Guralnick, who was lowa Photographer of the Year, switched from shooting with film to using digital cameras when he went to the *Detroit News*. Guralnick shoots a lot of night sports assignments and is able to shoot more of the game without having to spend time processing film or driving back to the office. He uses his laptop and its internal modem to transmit pictures back to the office from the site of the match—right on deadline. Here Dave tells about what he has in his camera bag.

- CAMERA BAG: This particular bag is actually a backpack. Its dimensions allow storage of everything in this photo (except the computer). When traveling, I can stow the bag in the overhead bin of an airplane.
- COMPUTER: A laptop computer is essential for shooting on the road. Not only can I transmit my images back to the paper, but the computer can store the images, allowing me to erase the digital memory cards when they get full.
- DIGITAL CAMERAS: In this case, two NC2000s made by Kodak from Nikon N-90s film cameras.

LENSES

- 4. 300mm F/2.8
- 5. 80-200 F/2.8 zoom
- 14mm F/3.5: Digital cameras increase focal length by approximately 1.5 times.
 Wider-angle lenses are now needed. This lens translates to a 21mm.
- 7. 20-35mm F/2.8
- 8. STROBES: In this case, one SB-27 and one SB-28.

- MONOPOD: To help support 300mm lenses and larger.
- 10. CHARGERS: To charge the internal batteries of the digital cameras.
- FILTERS: In this case, a hotmirror filter, which is helpful with some digital cameras to correct for color imbalances made by infrared light.
- 12. PC Cards: To store the images made by a digital camera. They come in a variety of shapes, sizes, and capacities.
- 13.LIGHT METERS: For now, it's still a helpful tool. But with most digital cameras being equipped with a view screen, allowing photographers to immediately see the results of their shots, this tool may become obsolete.
- 14. CELLULAR PHONE: To stay in touch with the office, and in some cases, to transmit digital images.
- 15. PAGER: So the office can stay in touch with me.

IS IT MAGIC?

In the photo to the immediate right, Dizzy Gillespie, performing at the Monterey Jazz Festival, appears sharp as a tack with Kodak's "Magic" film rated at 1600.

(Photo by Eric Risberg, Associated Press.)

Below, left.
The photographer rated
Kodak's T-Max 3200P
film at its normal 3200
ISO to get this candid
photo of an adoptive
father holding his new
son for the first time.
(Photo by Eric Slomanson,
San Francisco.)

Bottom, right.
To photograph this
homeless youth having
fun at night by lying in
the middle of a busy
city street, the
photographer used
Kodak T-Max P3200 and
rated it at 6400.

(Photo by Jennifer Cheek Pantaléon, Pacifica, Calif.)

was assigned to cover a match between the L.A. Lakers and the Golden State Warriors, he used Kodak Tri-X film, which is rated at ISO 400. At that speed, the exposure in the Oakland Coliseum would have been 1/125 sec. at f/2.8. To capture the moves of L.A.'s center, Risberg rated his ISO 400 film at 1600. He set his light meter accordingly and got a new metering of 1/500 sec. shutter speed at the same aperture.

Simply giving the overrated film longer development in a standard developer, such as Kodak Developer D-76, is not satisfactory if the film was shot under normal or high-contrast lighting conditions. The overdevelopment will only produce more contrast without a true gain in sensitivity.

Overdevelopment will build up the negative's highlight areas but will not provide more detail in its shadow areas.

To compensate in the darkroom for overrating the film on assignment, use high-energy developers. For normal and high-contrast lighting conditions, developers such as Acufine, Diafine, Ethol's UFG, Kodak's T-Max, and Edwal's FG-7 with sodium

sulfite specifically compensate for shadow detail.

3200 "Magic" Film

For times when you need really high film speed, Kodak T-Max P3200 comes to the rescue. Originally dubbed "Magic" film by the photographers who tested it, the film can be shot at 1600, 3200, or even 6400 and beyond with excellent results.

Eric Slomanson rated the film at 3200 to capture the expression of a wheelchair-bound father holding his adopted son for the first time. Other photographers are using the film under even more adverse conditions. (See examples on opposite page.)

Ilford also has manufactured a fast blackand-white film, Delta 3200, with similar capabilities to Kodak T-Max P3200.

COLOR

TRANSPARENCIES
VS. COLOR NEGATIVE FILM
A debate rages in photo labs from Seattle

A debate rages in photo labs from Seattle, Washington, to Miami, Florida. The debate centers on two options—shooting with This photo at the World Cup soccer matches at Pasadena's Rose Bowl was shot on ISO 400 color negative film. (Paul E. Rodriguez, Orange County [California] Register.)

The soft color palette in the photo to the left gives it added impact. When the photographer arrived at the stadium, he realized that a low-angle picture as the runners went into the tunnel would make a perfect shot.

(Photo by Rich Abrahamson, Fort Collins Coloradoan.) transparency film (also called color reversal, chrome, or slide film) or shooting with color negative film.

Editing ease Chrome supporters prefer what they call the richness of transparencies and

point out that you can edit slides as soon as they have been processed—no need for contact sheets and then color prints. They also argue that you get better reproduction from transparencies.

Proponents of negative film respond that, once you get used to looking at color negatives, you can read them as easily as you can a black-and-white negative.

However, Sandra Eisert, a former *San Francisco Examiner* director of photography and also a former picture editor at the White House and at the *San Jose Mercury News*, notes that, even after years of reading color negatives, she can rarely evaluate the expression on a person's face without the aid of a contact sheet. Not only are color negatives in

reverse, with each tone different from how it will appear in print, but the negatives have an orange mask.

The editor's eye and mind must perform a series of complicated transformations to imagine how the image will look when it is finally printed.

To solve the difficulty of editing color negatives, some publications own viewers that use a video camera to transfer each frame onto a TV monitor. This then displays the colors reversed to positive. The picture on the screen looks normal, but editing with this device is still slower and a bit more cumbersome than viewing contacts or slides.

Of course, once the negatives have been scanned into a computer, they can easily be edited on a color monitor.

Grain and saturation

While the quality debate between chrome and negatives has proponents in both camps, most photographers agree that negative high-speed films have less grain and more saturation than chromes. High speed color negative film like Kodak's PJ 800 ISO and Fuji's 800 ISO extend photojournalists' ability to shoot documentary-style images under the most severe lighting conditions.

The photographer below achieved the subtle colors in this photograph by shooting just after sunset. To the boy on the beach on the Gaza Strip in Israel's West Bank, the fish in a bottleis a toy.

(Photo by Wendy Sue

(Photo by Wendy Sue Lamm, Contrasto.)

Repro quality

Besides editing ease, grain, and saturation, reproduction quality also is central to the debate over shooting with chromes or negatives. As more and more publications use computers to scan in and separate both original transparencies and color negatives, the truth is that either a transparency or a negative is "first generation"—which means that there will be little technical difference in how either medium will reproduce. A color negative actually has a wider brightness latitude—more "stops" of color information. Depending on the publication and how its equipment is set up, color negative film can reproduce as well or even better than slide film. (See Chapter 12, "Digital Images.")

Shooting style

The chrome/negative debate also focuses on shooting style. Chrome shooters must contend

with getting their exposures exactly right—difficult during a riot—and also must add filters or gels under different light sources.

Negative film has a wide tolerance for under- and overexposure. Some photographers say that they can expose one to two stops under and up to three stops over the meter reading, depending on the film speed, and still produce an image. If the photographer's exposure is more than a third of a stop off with transparency film, however, the final image will be washed out or muddy. (See below). In fast-breaking news situations when photojournalists have trouble producing perfect exposures on every frame, the inherent forgiving latitude of color print film could save the once-in-a-lifetime shot.

With transparency film, what you see is what you get. Even with the ability of computers to adjust color balance digitally, most correction for transparency film still must be

COLOR NEGATIVE FILM VS. COLOR TRANSPARENCY:

Exposure tolerance comparison

▼ COLOR NEGATIVE CONTACT: Exposures varied by one stop for each photograph

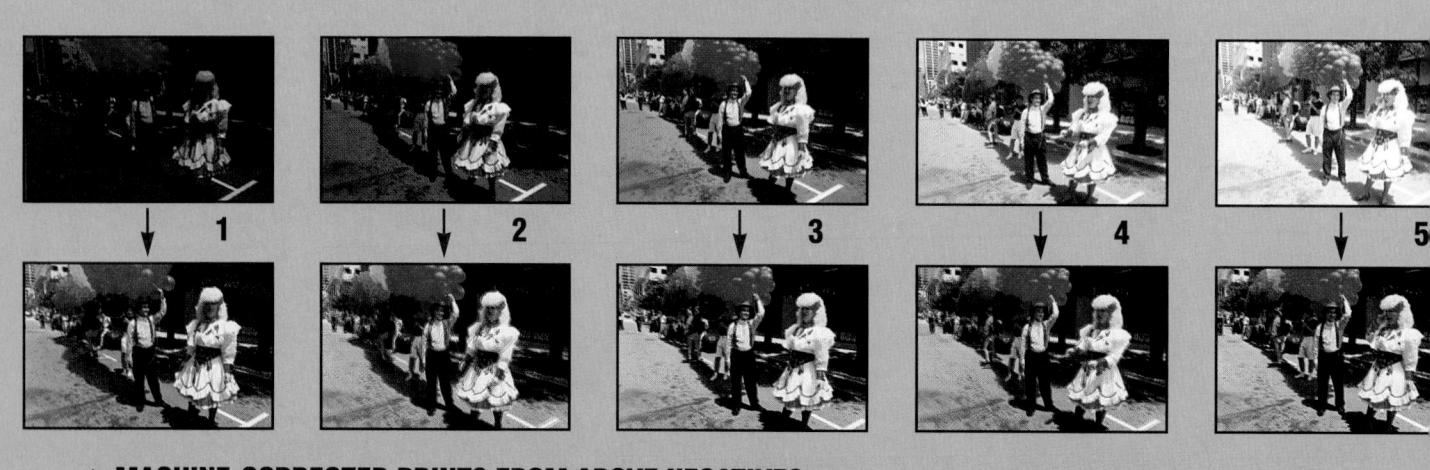

▲ MACHINE-CORRECTED PRINTS FROM ABOVE NEGATIVES

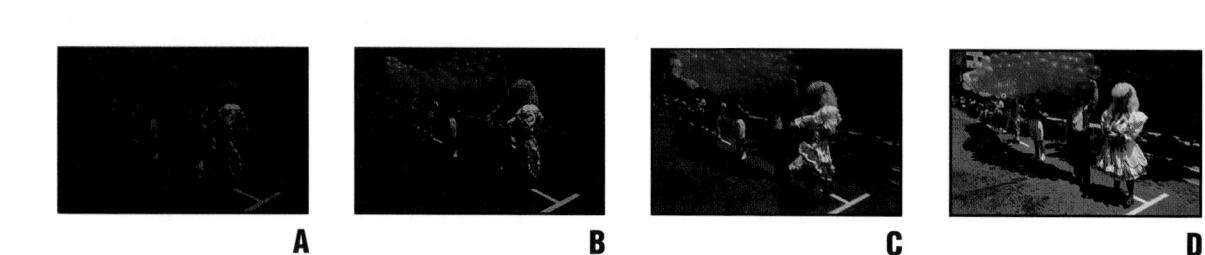

▲ COLOR TRANSPARENCY FILM: Exposures varied by one stop for each photograph

done while shooting, whereas color negative film can be filtered either in the computer or in the enlarger.

The colors of different light sources—outdoor noonday sun compared to indoor tungsten light, as one example—affect the overall hue of the final image. (See page 232). Photographers using transparency film must go to great lengths to match film to light sources, filter out unwanted colors with gels, or shoot aided by strobes to achieve attractive, color-balanced photos. Because the transparency has a limited exposure tolerance, correcting after the original exposure can be difficult or impossible, leaving photographers little opportunity to adjust color after the film has been shot. (See below.)

Consequently, because of transparencies' narrow exposure latitude and sensitivity to color temperature balance, the photojournalist shooting with transparency film cannot

shoot quietly and unobserved from the corner of a room, using only available light and a few rolls of high-speed film. Today, the shooter with chrome in the camera often rolls into a shooting assignment with 100 pounds of lighting gear on a cart. After unpacking the lights, setting up the light stands, plugging in the power pack, putting together the soft box and umbrellas, test-firing the strobe, and exposing a Polaroid, the photographer turns to the subject and says, "Now let's have some candid shots."

In her survey "How the Use of Color Affects the Content of Newspaper Photographs," Cindy Brown found that several photographers stated they create more "set-up photos" once they set up lights. The photographers observed that people's reactions are not as spontaneous when strobes are going off and that strobes limit their own movement around a room. These concerns

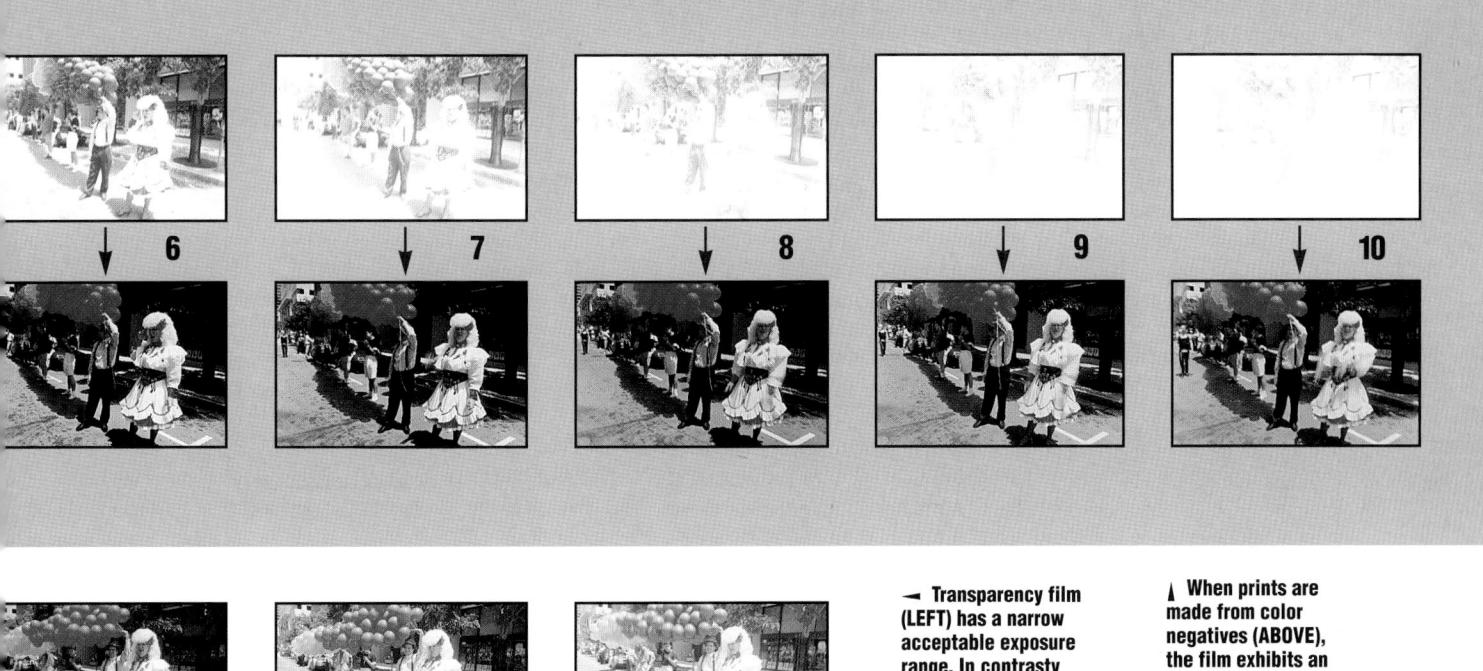

(LEFT) has a narrow acceptable exposure range. In contrasty lighting situations, the film does not handle detail well in both shadows and highlights. Although exposure F has the best overall exposure, its highlights are still a bit "hot." The ideal exposure probably lies between E and F.

when prints are made from color negatives (ABOVE), the film exhibits an impressive tolerance range for under- and overexposures that nonetheless produce acceptable enlargements.

TRANSPARENCIES: A PRIMER

Fill flash used outdoors helped to bring out detail in these backlit subjects while still preserving the highlights in the picture. (Photos by Daryl Wong.)

For more on fill flash, see pages 274–276, Chapter 13, "Strobe."

EXPOSE FOR THE HIGHLIGHTS Still, some photographers, particularly those working for magazines, prefer slides that are a little richer and therefore regularly underexpose their film by a third of a stop. Other photographers stick with the film's ISO rating because they like their slides on the brighter side. In general, when important parts of a scene are both in sun

HANDLING EXTREME BRIGHTNESS WITH TRANSPARENCY FILM

Color transparency film has a low tolerance for contrasty situations in which important subjects are located both in bright light and in deep shadow.

At a midday parade, for example, a group holds a rainbow of balloons that shadow some of the group's members. One person, however, is backlit by bright sunlight. The trees in the background are in deep shade. Shooting this scene on color transparency film requires precise exposure. (See pages 228-229.) A half-stop over or under can wash out or dull down the final slide (see frames E and G).

and shade and have extreme brightness differences, your transparencies will look better if you expose for the lightest area important to the picture. With transparency film, overexposed highlights look terrible (frames G and H) but underexposed shadows look acceptable (frame F). With transparencies, the general rule is to expose for the highlights. Exposing for the highlights will produce a transparency in which the content of the shadows will be dark but still recognizable, while the overall transparency will be color-rich.

When shooting under a contrasty situation, consider using flash, even outdoors on a sunny day. "Fill flash" helps to fill in dark shadows on the subject's face and to reduce the brightness difference between the highlights and shadows.

were especially true from photographers using transparency film.

Super-saturated chrome film
Photographers can select not only standard chrome film that tends to reproduce the world as the eye sees it but also can chose films that make the world look brighter and more saturated than normal. These chrome films, like Fuji Velvia or Kodak's Ektachrome E100VS, accentuate the reds or greens in a photograph to produce a highly intense, almost 3-D slide. Landscape photographers in particular like the visual bang from these highly saturated emulsions. People photographers, though, find that sometimes Caucasian skin tones don't come out looking as natural with these films.

COLOR CONSIDERATIONS

TIME OF DAY IS CRITICAL
Editors often disregard the hour of the
assignment when they set up a photographer's schedule. They ignore the angle and the
color of the light. For an indoor job, timing
might be less crucial, but for an outside
assignment, timing is everything.

From 5 A.M. to 5 P.M., color changes, intensity changes, and mood changes. A routine shot of a building taken at noon becomes an *Architectural Digest* photo at 6 P.M. A common mug shot photographed at 10 A.M. becomes a gallery portrait taken at sunset. The selection of time to photograph is as important as the choice of lens or film.

A painter picks oils from a palette to create mauves and maroons. Likewise, a photographer picks the time of day to capture the delicate pinks of morning or the bold reds of late afternoon. By selecting one time of day over another, you can determine the color of light striking your subject when shooting outdoors.

When working on a book about the Russian city of St.

Petersburg, former National Geographic staffer Steve Raymer photographed Palace Square, scene of revolution and bloodshed during both the reigns of the Czars

Color negative film, on which the picture to the right was taken, has wide exposure latitude (see pages 228–229), which makes it ideal for spot news, like this freak accident. Remarkably, no one was hurt. (Photo by Craig Hartley, for the Houston Post.)

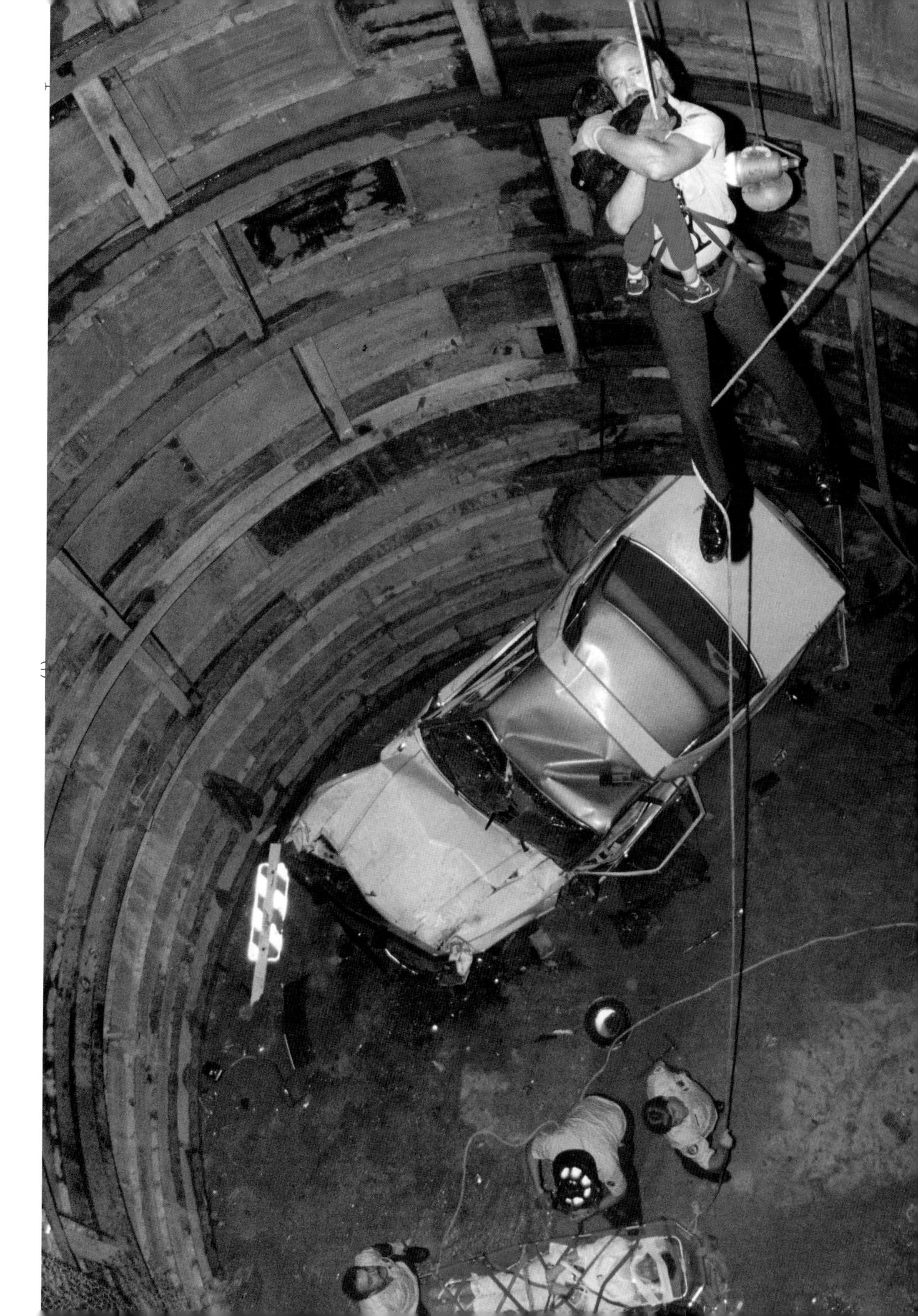

TRANSPARENCIES: A PRIMER **MATCHING FILM TO LIGHT SOURCE**

ver notice that when you meet a friend for dinner by candlelight, the person seems to radiate a warm glow?

Walk outdoors, and you'll see that your friend loses that radiant, reddish color. The color on your friend's face was caused not by the wine but by the candlelight's red wavelengths. The candle glowed red, with little green or blue light mixed in.

Almost every light source—whether a candle in a nightclub, a fluorescent tube in an office ceiling, or the sun outdoors-casts a light that is not purely white but rather has a hint of color to it.

The color cast of most light sources is not as pronounced as that of a candle, so you rarely observe radical color shifts when you move from one light source to another. After all, you know that a white shirt looks white, regardless of the kind of light illuminating it. Transparency film, however, does pick up these color changes.

Scientists measure the color of light emitted by a light source on a Kelvin scale. Color films are balanced either for daylight (5500 Kelvin) or tungsten light (3200 or 3400 Kelvin).

FILMS

DAYLIGHT FILM. Noontime daylight contains relatively large amounts of blue wavelength light. Daylight-balanced color film is designed to filter out this excess blue. Generally, use daylight film when most of the light comes from the sun.

TUNGSTEN FILM. Light from a common tungsten-filament light bulb (2900 Kelvin) or photo flood (3200 or 3400 Kelvin) contains an overabundance of wavelengths in the red portion of the spectrum. Tungsten-balanced color film filters out this unwanted red cast and is designed for use with common light bulbs or 3200 Kelvin photo floods. A few Type A color films are designed for use with 3400 Kelvin photo lamps. In general, use tungsten film for availablelight shots indoors when most of the light comes from light bulbs. These situations include theaters and some sports arenas.

DIFFERENT FILMS FOR DIFFERENT LIGHT SOURCES

Daylight Film

Tungsten Film

Daylight-balanced film used in daylight produces natural colors

Tungsten film used in daylight produces a blue cast. Use a #83 amber filter to shoot tungsten film.

Daylight-balanced film used under tungsten light gives an orange cast to the picture. To shoot daylight film under tungsten light, use a #80 filter.

Tungsten film used with tungsten lights produces normal-looking color transparencies.

MISMATCHED FILM AND LIGHT SOURCE Using a tungsten-balanced film outdoors results in a blue cast to the photo. Except when used at night, this effect rarely looks natural or pleasing.

Shooting with a daylight-balanced film in a room lit by tungsten bulbs will give an orange hue to everything in the picture. Sometimes this effect looks odd. Other times. the orange hue gives a picture a warm glow.

SHOOTING UNDER FLUORESCENT LIGHTS

Although most office buildings, hallways, classrooms, and other public spaces are lit with fluorescent tubes, no manufacturer makes a color transparency film specifically designed for use under fluorescent lights.

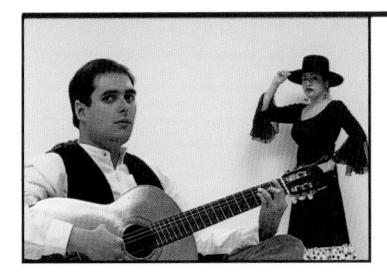

AVAILABLE LIGHT, NO FILTER ON LENS This transparency was shot with only fluorescent light. Note the green overall hue.

AVAILABLE LIGHT, LENS FILTERED Adding a #30 magenta color correcting filter to the camera eliminates the picture's green cast.

AVAILABLE LIGHT

When shot under fluorescent lights with daylightbalanced film, pictures come out with a decidedly green cast.

Shooting under the same conditions with tungsten film washes the pictures with a strong blue tint.

To complicate things further, each type of fluorescent tube, whether warm white or cool white deluxe, emits a slightly different color. The name says white, but the resulting color on your transparency film won't be.

Because most photographers don't want to scale ladders to verify the make of each fluorescent tube before shooting, they use a standard filter or filter pack to subtract unwanted tints. The standard filter or pack adequately subdues the green of fluorescent lights in most locations. Some photographers use an FL-D filter with daylight film. Many, however, have found a #30 magenta color-correcting (CC) filter used with daylight film works well for handling most fluorescent-lit situations. When using tungsten film, an FL-B filter should do the trick.

STROBE AND LENS, FILTERED
To use strobe and balance with
available light fluorescent bulbs at the same
time, put a #30 magenta filter on the lens and a
window-green filter on the strobe.
(Demo photos by Daryl Wong.)

BALANCING FOR FLASH PLUS FLUORESCENT Sometimes photographers shooting with daylight film need to combine strobe and available fluorescent light. By placing a window-green gel over the strobe, both the light from the flash and the available light will have the same tint.

The addition of a #30-magenta CC filter in front of the camera's lens eliminates the green wavelengths from both the fluorescent lights and the green wavelengths from the filtered strobe, leaving correctly balanced light to reach the film. The resulting transparency will look perfectly normal.

and Lenin's Bolsheviks. Searching for just the right combination of dramatic light and editorial content—in this case horses ambling across the square that suggested a bygone era—he returned a dozen or more times until he found the perfect moment. "This picture took compulsive attention to light and color," Raymer says.

Raymer also photographed the broad and muddy Red River as it flowed across the mountainous border between China and Vietnam. "I actually waited until after sunset . . . when the sky was filled with a reddishpink afterglow," he explains.

In this situation, the reddish hues in the final image added to the message of tranquility he was trying to convey and also played off the river's name.

SHOOTING FROM DAWN 'TIL NIGHT While you can't control when a peace demonstration or a car wreck will occur, you

TRANSPARENCIES: A PRIMER MATCHING FILM TO LIGHT SOURCE

STROBE LIGHT IS LIKE DAYLIGHT

An electronic flash emits a color approximating daylight. When you use electronic flash, shoot with daylight transparency film. And because your electronic flash has a color balance similar to daylight, you can use your strobe as a fill light when taking pictures outdoors without affecting the final photo's overall color balance.

The early evening sky, just after sunset, offers a warm afterglow for a background. To capture both the mime and the view outside her luxury hotel, it was necessary to balance the exposure of the electronic flash with that of the outside available light.

(See Chapter 13, "Strobe," for more on balancing strobe and available light.) (Photo by Ken Kobré, for *San Francisco Business*.)

The time of day a subject is photographed—particularly a building—affects the mood of the final picture. The mood shifts from stark at noon (ABOVE LEFT) to rich in late afternoon (ABOVE RIGHT).

(Photos by Ken Kobré.)

often can select the time of day for shooting an outdoor portrait or a building exterior.

Dawn

For soft shadows and monochrome colors, shoot at dawn.

Midday

Some photographers try to avoid the harshness of the midday sun. Although colors might appear bright in transparencies or prints, people photographed on a sunny afternoon often have shadows running across their faces. These unflattering shadows can turn eye-sockets into billiard pockets.

When you must shoot portraits on a bright, clear afternoon, try (1) moving your subjects into the shade of a building or tree, or (2) turning your subjects so that their backs face the sun. Here is where you can use fill flash to your advantage. (See Chapter 13, "Strobe.")

Late afternoon

As the sun falls lower in the sky, its rays travel farther through the atmosphere. Molecules of water in the sky tend to scatter the short, blue wavelengths of light. The long, red wavelengths pass freely toward earth. This is why, as the sun sets, late afternoon light turns redder and redder. Also, shadows stretch as the sun drops. The long, picturesque shadows lend a sculptured look to a scene. Greens and reds seem more saturated under this waning light. This time of day is the choice of many photojournalists working in color.

Although the reddish light of late afternoon usually flatters a subject, you will occasionally need a more technically correct picture at this time of day.

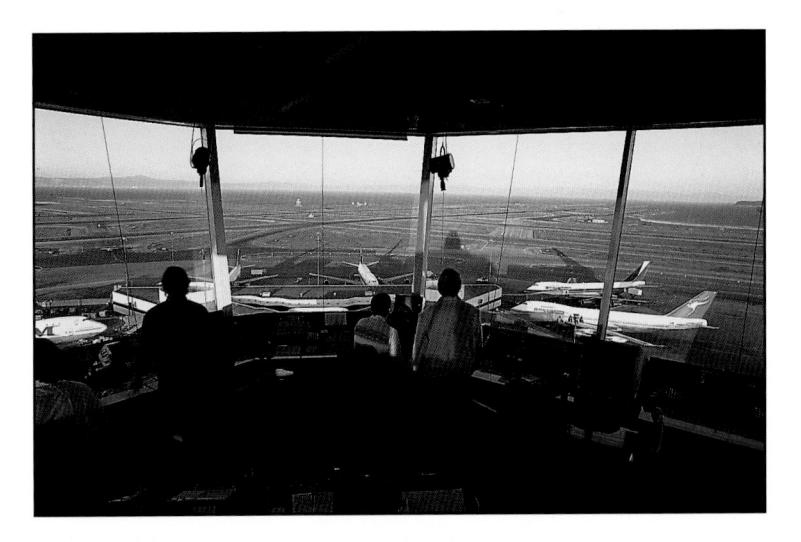

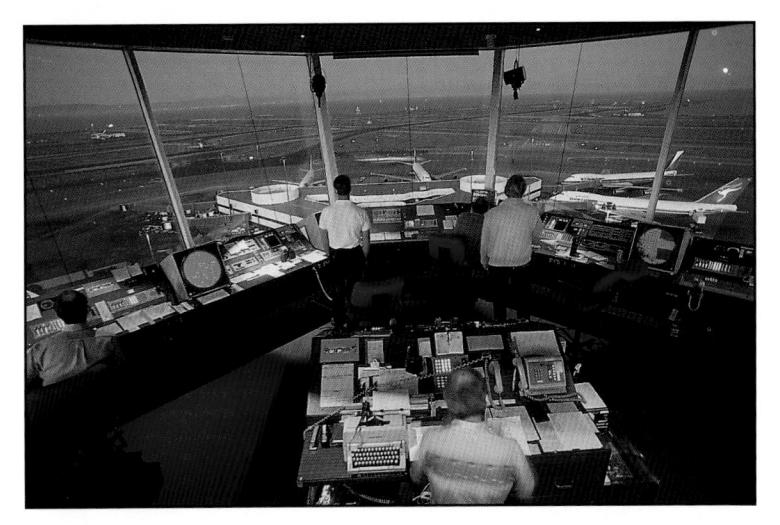

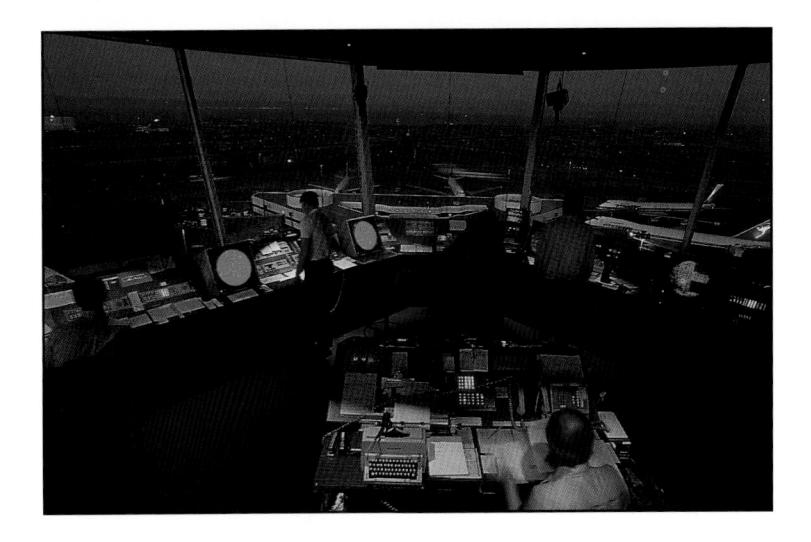

To show both the landing strip outside and the air controllers inside, the photographer waited until the waning afternoon light matched the exposure of the indoor light. Note also in this series of pictures how the color and quality of light changes as the time of day changes.

(Photos by Ken Kobré, for San Francisco Business.)

→ The late afternoon light leaves a crisp, distinct shadow of a child and her friend jumping rope "double dutch." The warm glow in the picture comes from the reduced number of blue wavelengths in the sky as the sun sets. (Photo by Brian Plonka, the Joliet [Illinois] Herald-News.)

As sunset approaches, the sky takes on its most flamboyant corals and oranges.

You can silhouette subjects against this richly colored background. If you want to avoid a silhouette but still use the sky's palette, try balancing your strobe with the early evening sky.

In this situation, your strobe would become the dominant light source for the subject. The ratio of strobe light to the sky light would be equal. Many photojournalists shoot portraits and fashion using this balanced-light technique. (See pages 234, 266, 267, and 272 for examples of this technique used in various circumstances.)

Evening

Evening light is cold and blue. Sometimes streets and buildings that look as bland as white bread during the day look haunting by night. Don't overlook the possibility of using flash to illuminate the foreground and a long shutter speed to pick up ambient light in the background. Also, tungsten film turns the nighttime sky a rich blue.

PUSHING COLOR FILM

Film manufacturers have produced both color negative and transparency films specifically designed for "push" processing. With some films, the manufacturers claim good results when even when underexposing the film up to three-and-one-half stops and compensating with increased development.

Many photographers find that they get better results pushing a slower film to a higher rating than they do using a high speed film in the first place. With color films, y Using a long exposure, the photographer was able to capture the feeling of Dante's inferno as these fires burned in Northern California. The red trail of lights in the lower section of the picture occurred because a car drove by during the exposure.

(Kent Porter, Santa Rosa [California] Press Democrat.)

photographers find grain and contrast hold despite the combination of underexposure and overdevelopment.

HOW READERS REACT TO COLOR

Although many photographers prefer to shoot in black and white, readers prefer color photos, according to different studies by J. W. Click and G.H. Stempel and by the Poynter Institute Color Project, conducted by Drs. Mario Garcia and Robert Bohle.

Readers think color photos are more realistic, an International Newspaper Advertising and Marketing Executives survey concluded. Not surprisingly, the researchers also discovered that readers dislike poor color reproduction.

Readers remember color better, the Newspaper Advertising Bureau discovered in a test of recall as opposed to attention. Color ads were recalled more frequently than were black-and-white ads. Readers, however, did remember black-and-white ads in greater detail and for a longer period of time.

According to *Eyes on the News*, by Drs. Mario R. Garcia and Pegie Stark, readers pay attention to single color and black-and-white photos about equally for feature subjects, but color news and sports photos get more attention than their black-and-white counterparts.

In research using an Eye-Trac device developed by the Gallup organization in Princeton, New Jersey, researchers found:

Black-and-white news pictures got 77
percent attention, which rose to 88
percent when the same picture was shown

in color. For sports pictures, the differences were even greater.

- A black-and-white sports picture grabbed the reader's attention 64 percent of the time, whereas the same photo in color got 80 percent attention. Further analysis showed that this jump occurred because women pay attention to color photos of athletes but not to black-and-white photos of sports figures.
- Running features in color or black-andwhite made no difference in readers' attention. Features with or without color nabbed readers' attention about 78 percent of the time.
- Color does seem to stand out in photo packages. With a group of photos, the researchers found, subjects paid more attention when the same pictures were reproduced in color.

In follow-up research, Sheree Josephson used similar technology in her study "Questioning the Power of Color." She found that in the first ten seconds of viewing a page, readers paid equal attention to color compared to black-and-white photos. However, if their only other choice was a black-and-white photo at the top of the page, readers went first to a color photo at the bottom of the page.

The difference in the number of times or the length of time readers looked at either black-and-white or color photos was about the same, according to Josephson's research.

During the first ten seconds, readers on average looked at photos two to three times

the photographer caught this retired **Russian colonel arguing** with anti-Communist demonstrators during the May Day celebration in Red Square. The picture captured the country's old and new attitudes and provided a visual synopsis for his story "Mother Russia on a New Course." The red flag adds to both the visual and storytelling power of the picture. (Photo by Steve Raymer, for National Geographic.)

While on assignment for National Geographic,

for a surprising total of less than one second. In a post test, the study found that readers could recognize color photos they had seen previously in the newspaper more often than they could black-and-white photos they had also seen.

Josephson's research seems to conclude that when a person looks at the printed page for the first ten seconds, color pictures don't necessarily attract or hold the reader's attention more than their black-and-white counterparts but that these color images are remembered longer.

Overall, readers prefer color photos and think they are more realistic but often blackand-white photos grab the reader's attention just as well as a color photo except for sports pictures and picture packages. Readers, though, do seem to remember photos with color better than those without any hues.

(For more details on Eye-Trak research see Chapter 10, "Photo Editing" and Chapter 12, "Digital Images.")

COLOR VS. BLACK-AND-WHITE

Can you imagine Van Gogh painting sunflowers without knowing whether his yellows would be seen as shades of gray? Or Ansel Adams photographing "Moonrise over Hernandez" in color and black-and-whitejust in case? Yet this is what editors ask of photographers, who must visualize the scene simultaneously—with and without color. They try to take pictures that work both ways. While many news organizations today run

all their photos in color, others have all assignments shot in color, which they convert to black-and-white, if necessary. So photographers sometimes face the challenge of shooting pictures that might run in either color or black-and-white. Photographers faced with this problem usually choose to shoot for one medium or the other. They try to "think in color" or "think in black and white" and hope that editors in the office don't second-guess the decision.

Thinking in color requires photographers to develop a special eye. Color is a different language, points out Steve Raymer, the former National Geographic staffer. "I pass up pictures when the color gets in the way. It's a matter of learning to read color, light, and subject in a new way."

New photographers often make pictures filled with bold primary colors that can detract from the a photograph's editorial content. Red, for example, is a color that produces strong emotions. Like the bull attracted to the matador's red cape, photographers are equally drawn to anything bright red in the scene they are photographing. The color, unfortunately, tends to dominate a visual message so much that you must be extremely careful in how much red you include in a picture. If your assignment is an environmental portrait of a race car driver, for example, be careful that the driver's red Ferrari doesn't take over the picture. On the other hand, if you're in Red Square, as Raymer was in Russia, including the country's red flag in a

A radio station fan is catapulted by a friend into a "mosh" pit during an outdoor musical performance. This picture reads easily whether it's reproduced in color or black and white.

(Photo by Al Schaben, © Los Angeles Times.)

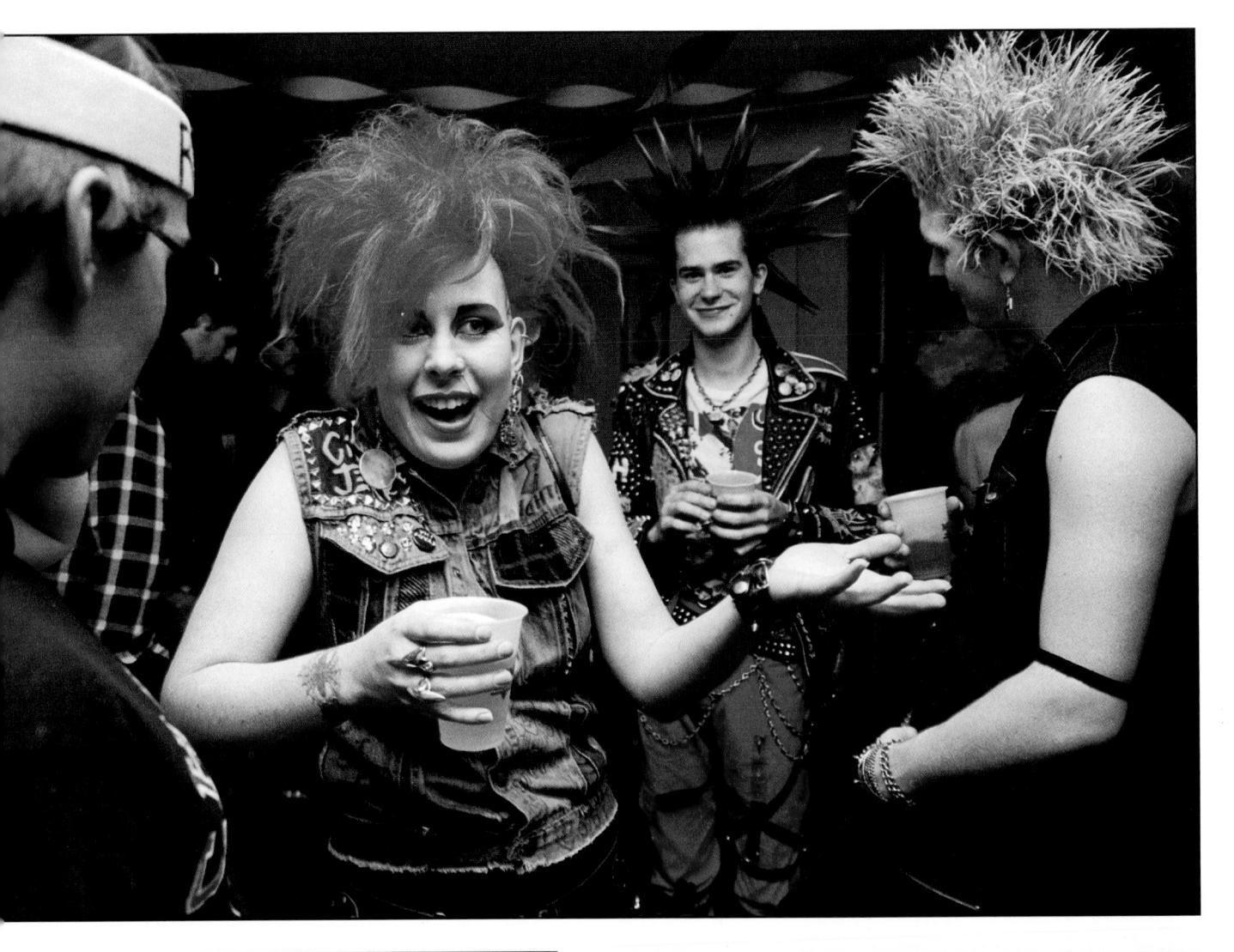

SHOOTING A STORY WITH COLOR NEGATIVE FILM

Julie: Lifestyle of a Punk

Donna Terek spent nine months "just hanging out" with punks—getting accepted into the group, looking for an appropriate angle, and convincing someone to reveal his or her lifestyle to the mainstream press.

Although she began the project for her master's thesis, Terek was a part-time staffer for the *Minneapolis Star-Tribune* by the time she started shooting Julie. After six weeks of actual shooting, Terek wrote the story herself for the paper's Sunday magazine because the punks felt they'd get a raw deal from anyone else. Negative film allowed Terek to shoot candidly under changing light

- ↑ Julie says she doesn't care "if I look good or not, just so long as I look cool. Something really off the wall, something nobody else does. That's cool."
- → Julie's parents live in a ranch-style house. Both parents work day jobs, while Julie works a graveyard shift. The family eats dinner and watches a few hours of TV together.

sources and lighting conditions. The only additional lighting she needed was on-camera bounce flash. These pictures are just two from her extensive project.

(Photos by Donna Terek, now with the Detroit News.)

picture makes both visual and editorial sense.

Raymer recommends searching out colors that complement one another, that create a mood. "Start with the concept of harmony," he says. "Before moving to dominant primary colors like red and blue, learn that when it comes to color 'less' is usually 'more."

COLOR FOR COLOR'S SAKE?

When the *St. Petersburg* (Florida) *Times and Independent* began using color in the 1960s, editors often would send a photographer to the beach to photograph a pretty woman with a brightly colored beach ball for the Monday morning color project. In the past, supposedly, some *National Geographic* photographers would make sure that someone in their picture had on a red shirt or skirt to add a little color to the scene and provide a central point of interest.

Thane McIntosh, a long-time shooter for the San Diego Union-Tribune, says he thinks editors are still in the "comic book era" of picking bright colors. In an interview for the National Press Photographers Association's "White Paper on Color," McIntosh observed, "Sure, in the old days, you had to go for those bright colors, but I still hear editors picking pictures for color, not for content. And I find myself, when setting up pictures, adding color to make the scene more 'complete.'"

Barry Fitzsimmons, another *San Diego Union-Tribune* veteran, recalls the old days: "For many years, color pictures were picked for bright colors. If it wasn't bright, they wouldn't use it."

Back then, he said, photographers carried along red clothing, which they included in the pictures so that later the pressmen could match the reds when they adjusted the inks. Today, Fitzsimmons says, "It's with news that editors and readers have a hard time with color. It shows the reality . . . while black-and-white covers it up. In black and white, blood can just blend in with the street. In color (the blood) jumps out, and the editors are left to deal with it more than ever before. Same goes for fires. In color they're unbelievable, but in black and white they're practically nonexistent."

BLACK AND WHITE BUT READ ALL OVER?

In a colorful world, black-and-white images sometimes stand out. Even though publications today can easily run color, some are choosing to publish black-and-white images instead. Black-and-white images convey an air of dignity and seriousness. Shades of gray connote the traditional, respected, documentary style. Black-and-white journalistic photos stand out against competing, colorful advertisements.

While both *Time* and *Newsweek* magazines run mostly color photos throughout their magazines, they each publish behind-thescenes political stories as black-and-white photo essays.

Time had dropped the traditional black-and-white photo essay when it went all color, so bringing it back wasn't easy, recalls P.F. Bentley, a *Time* contract photographer.

"The hardest part was to get the managing editor to understand the impact black and white can have," he says. "Once he looked at the first take and once they printed it, the essays got rave reviews. They have not questioned it at all since. Now it is being done not only by me but also by Diana Walker, Jim Nachtwey, Chris Morris, and others."

To create this swirl effect, the photographer tripped the camera and strobe but kept the shutter open. She rotated the camera during the relatively long exposure and thus picked up the background lights, which created a circular pattern. Because Santa and Mrs. Claus were lit only when the strobe fired, they appear sharp and are not included in the swirl.

(Photo by Silvia Flores, Riverside [California] Press-Enterprise.)

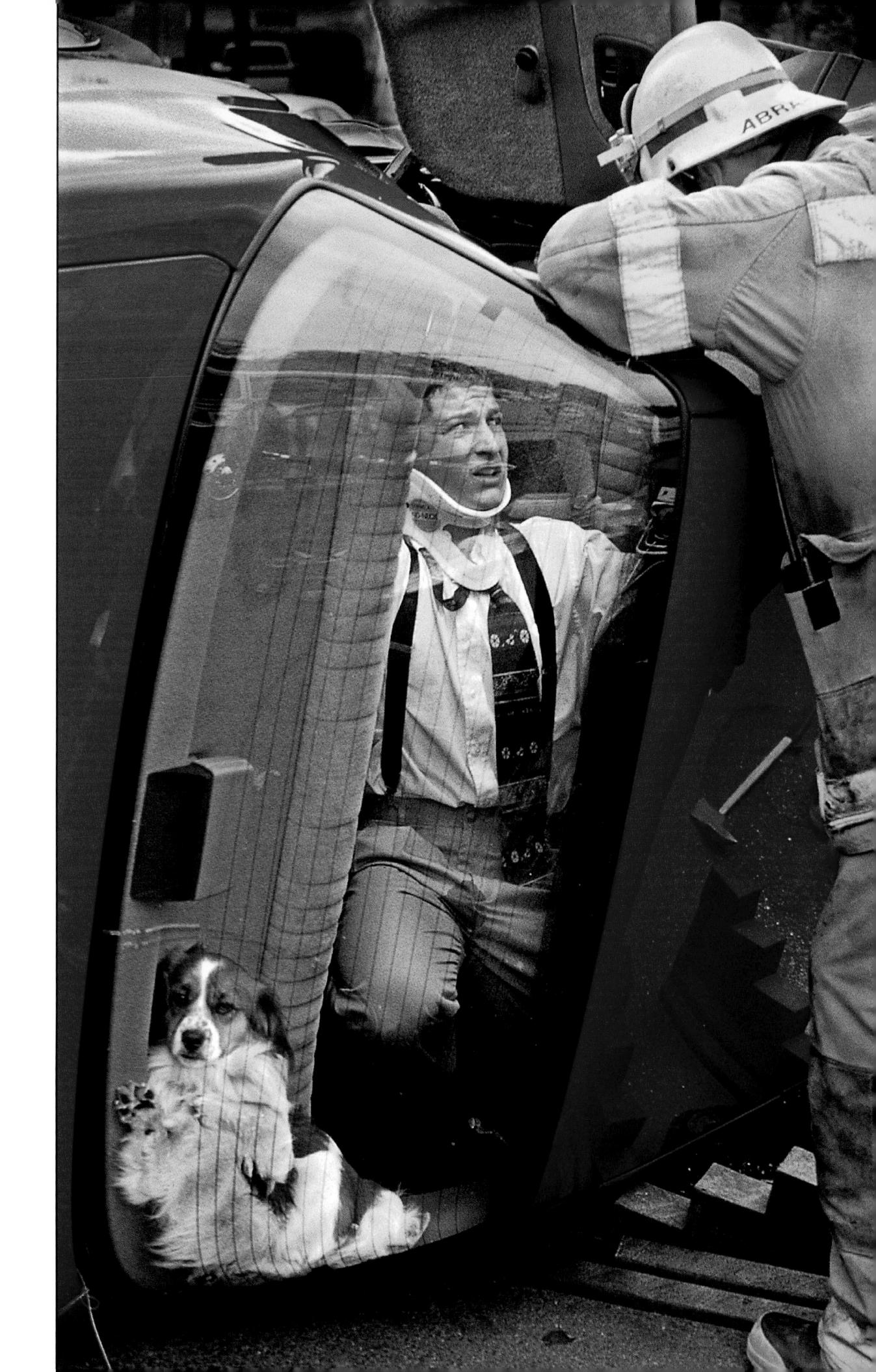

Missing the jump, the horse rammed into the rail and fell onto the jockey. The rider lived, but the horse was put away. Readers were furious that the paper ran the graphic picture, particularly with the horse's gushing red blood, on the front page.

(Photo by Jeff Vendsel, Santa Rosa [California] Press Democrat.)

Color in this picture carries a layer of information unavailable with black-and-white film. Color information is important for some photos, but not all. (Photo by Ken Kobré for Mercury Pictures.)

Diana Walker, who covers the White House for the newsweekly, shoots her behind-the-scenes exclusives on black-and-white film. Black and white allows her to shoot in low light situations easily, she points out. She also doesn't have to worry about balancing color for fluorescent light or watching the color of the background. Nor does she need to use a strobe to guarantee a

Shot on transparency film, this photo has excellent color saturation. A firefighter/paramedic helps extricate a sixteen-year-old boy and his dog. They had been trapped in the vehicle following a two-car traffic collision. The dog was shaken up, but appeared to be fine. (Photo by Al Schaben,

© Los Angeles Times.)

well-exposed, color-saturated image. Finally, she says, she believes that black-andwhite film actually produces more interesting images than color film in low light situations.

(See black-and-white photos shot for *Time* by Diana Walker and P.F.

Bentley in Chapter 3, "General News," pages 44 and 46–49.)

Carol Guzy, a two-time Pulitzer Prize winner for *The Washington Post*, says, "I love black and white, and I've been with black and white all my life. Color can be distracting." She points out that her photograph of two nomad women carrying a baby between them (page 79) would not have worked in color because of the colors of the women's garments. "They were horrible colors that clashed really badly," she explains. "You lost the baby."

CONCLUSION

While editors should not use photos just because they are as multi-hued as Joseph's proverbial coat, neither should they forget that color carries a great deal of information that would be lost on black-and-white film. Journalists are in the information business. Giving readers more information usually adds to their understanding of a story.

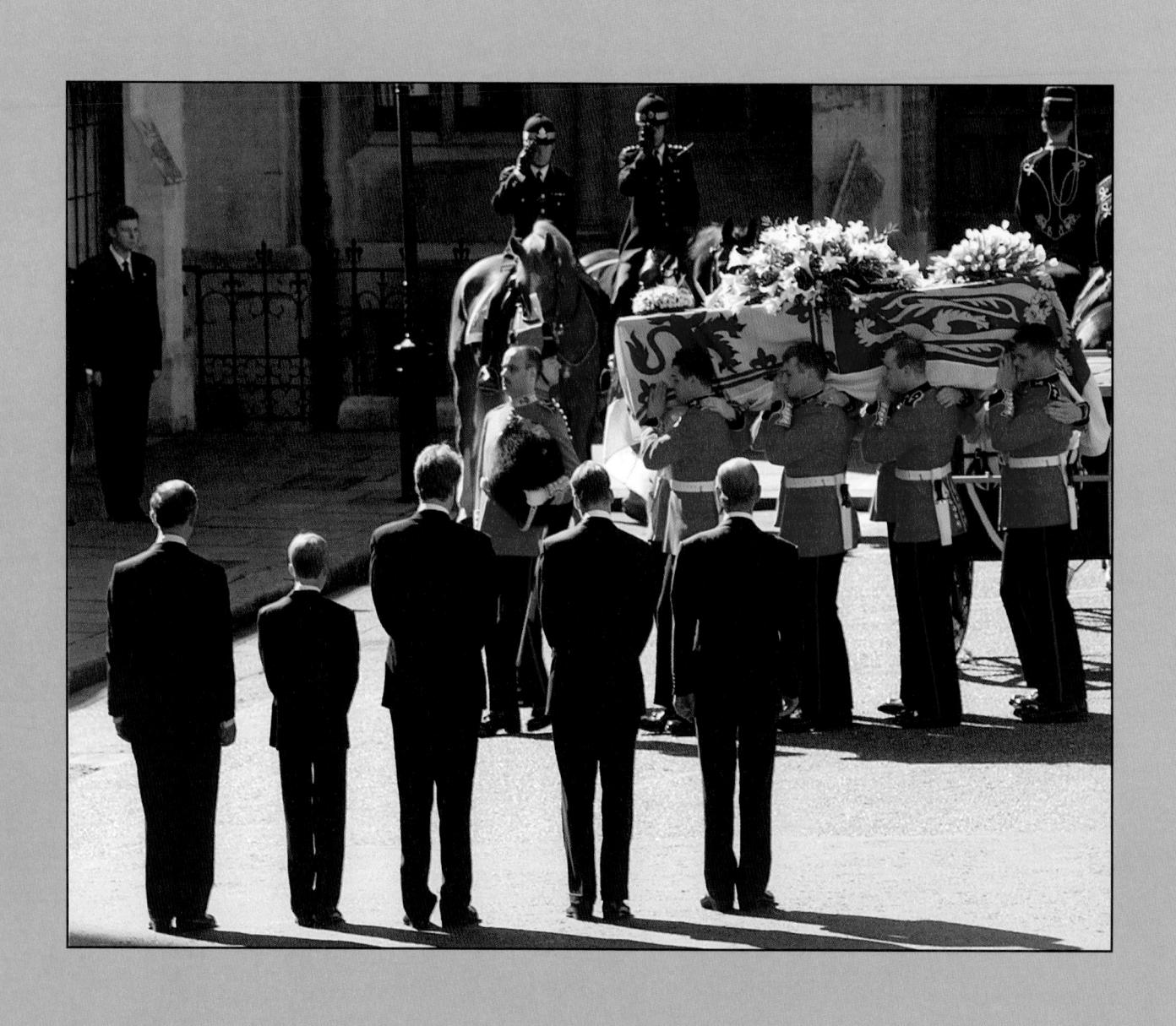
Digital Images

OTALLY DIGITAL

CHAPTER 12

ssociated Press staff photographer John Gaps III has gone filmless for more than five years. Shooting exclusively with AP's electronic camera,

he was one of the first photojournalists to go completely digital.

Following the tragic death of Princess Diana, which captured

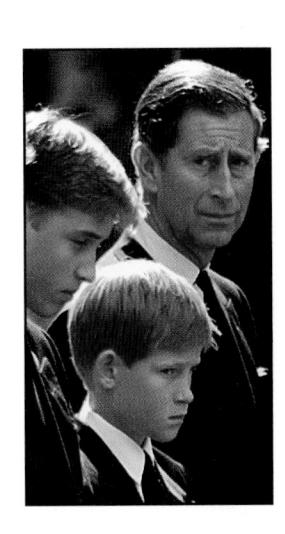

worldwide headlines, Gaps used an electronic camera, portable computer, and cell phone to cover her funeral. The Associated Press had assigned several photographers along the funeral procession route but stationed only Gaps and

Shooting with a digital camera, the Associated Press photographer transmitted the picture of the Princess Diana's coffin as soon as it was carried into Westminster Abbey. He was able to move the picture immediately using a laptop computer, modem, and cell phone. When the casket came out of the church, he used a 500mm lens, which effectively converts to 800mm on a digital camera, to photograph Prince Charles and his two sons.

(Photo by John Gaps, III, Associated Press.)

one other staffer to the critical position in front of Westminster Abbey, where the services were to be held.

Gaps staked out his position at midnight before of the services. "I thought there was one place to make the picture—perpendicular to the door of Westminster Abbey. My instinct was that I would be able to get the coffin, the four Princes, and Di's brother in one picture."

Gaps had to wait nearly eleven hours before the funeral began. He continued holding his position, and at 11:00 A.M., the pallbearers carried in the Princess' casket. He shot with a 200mm lens (effectively a 320mm on a digital camera (page 244) as the casket was carried into the Abbey.

"I shot my pictures and had my laptop computer ready under the tripod," says the AP photographer, whose computer was connected to a cell phone. "I had thrown my coat over the tripod so that I could see the computer screen. The coat worked just like the hood on an old-time 4x5 Graphflex."

By the time the casket came out of the Abbey, Gaps already had transmitted four pictures. With freshly shot film in his hand, a competing Reuters photographer looked over toward Gaps and moaned to his colleague, "He's f_ing me, Nigel. He's f_ing me." Gaps, with his electronic camera, computer, and cell phone, had already transmitted pictures around the world, while the Reuters photographer was still holding exposed, undeveloped film in his hand.

When the casket came out, Gaps focused tight with his 500mm lens (effectively an 800mm on the digital camera), and captured the despondence of Princess Diana's former husband, Prince Charles, and their two sons as her casket was carried by.

"You don't see the casket," says the AP photographer. "I just stayed on their faces. It was a big gamble. Nobody else really shot that tight."

Gaps' gamble paid off. His pictures ran on the cover of *People* magazine and in newspapers around the world.

Kosovar refugee children wait behind a locked gate for their chance to eat at a refugee center in Lecce, Italy. The digital camera has freed globe-trotting photographers from processing or even scanning images. (Photo by John Gaps, III, Associated Press.)

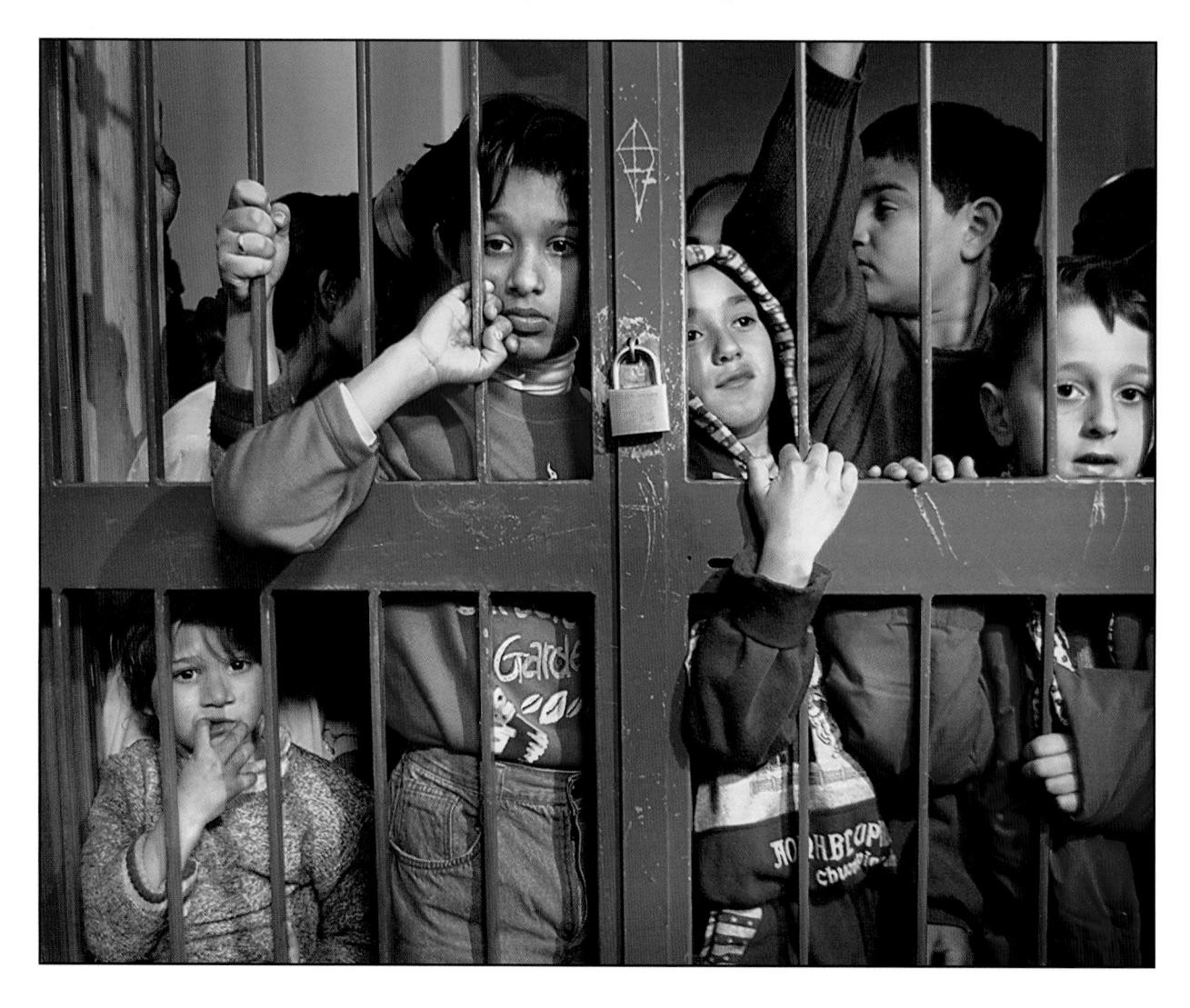

The digital camera, computer, and cell phone allow journalists like Gaps with tight deadlines to stay at assignments longer, shoot more images, and transmit from the very site of the event. No more racing to the office or to a one-hour lab to process. No more shipping film from the nearest airport to home offices in New York or London.

David Guralnick, of the *Detroit News*, knows about tight deadlines. His newspaper needed a picture from the Rolling Stones concert, which was scheduled to start at 9:00 P.M. His deadline was 9:15. "I shot the first three songs, then went to my car in the parking lot and transmitted by cell phone," he recalls. While the Stones sang "I Can't Get No Satisfaction," Guralnick had the satisfaction of knowing that his pictures made the A.M. cycle's deadline. (See page 250.)

At the *Detroit News*, the three bureau photographers no longer even come into the downtown office. Shooting exclusively with digital cameras, they send in all their pictures by telephone. Transmitting directly from the

dugout, *San Francisco Chronicle* photographers can now shoot six innings of a night baseball game and still meet their deadline. Two innings max was the norm in the past.

USING THE DIGITAL CAMERA

As for shooting, if you can use a 35mm camera, you can shoot with a digital camera. All the electronic flash, shutter speed, f-stop, and light metering features found on the traditional camera work in a similar fashion.

SHAPE OF VIEWFINDER AND MAGNIFICATION FACTOR

In digital cameras, the proportionate size of the CCD (charge-coupled device) sensor is smaller than traditional 35mm film.

This has led to some differences that photographers must consider when using the digital equipment.

The smaller chip size means that standard lenses used on digital cameras have a magnifying effect. On a digital camera, for example, a 50mm lens provides the coverage of an

The photographer shot "The Precision Lawn Chair Marching Dads" with a digital camera. To save money previously spent on film, even small- to mediumsized newspapers and magazines are using digital cameras.

(Photo by Sean Connelley, The *Dubuque* [Iowa] *Herald Telegraph*.)

80mm; a 200mm effectively becomes a 320mm. To get the wide-angle look of a 20mm lens, you need to shoot with a 14mm lens.

On the other hand, while the effective reach of the lens increases on the digital camera, the lens retains the same depth-of-field as when it was used on a film camera. For example, a 300mm lens gives you the equivalent of a 480mm lens but with the same depth-of-field as the original 300mm lens.

ELECTRONIC "GRAIN"

The digital camera provides other flexibility, as well. With conventional cameras and film, you must change film when lighting conditions change. With the digital camera, you can shoot each frame at a different ISO (film speed), selecting the ideal ISO for any given lighting situation. On some cameras, ISO ratings range between 200 and 1600.

Unfortunately, just like the increased grain that occurs with film at higher speeds, increased "noise" in the pictures occurs with the electronic cameras at higher ratings. "Over ISO 400, you start to notice the noise," says the AP's John Gaps. "After that point you start to lose quality."

The "noise" looks like tiny purplish squares in areas of the picture. Photographers find these purple flecks more objectionable to the eye than old-fashioned grain. (See page 250.) In a low-light situation, Gaps recommends

using on- or off-camera flash rather than increasing the ISO beyond 400.

Matt Rogers, a Kodak applications engineer, notes that shooting in a situation of high contrast (a wide brightness range) requires that you think as if you're shooting with transparency film. Just as they do on transparency film, very bright areas in a scene shot with the digital camera tend to wash out. (See pages 228–229, Chapter 11, "Camera & Film.")

What does this limited brightness range mean in the field? Brian Whittier, a freelance photographer from Chapel Hill, North Carolina, reports that the camera handles shadows fine but that it has a hard time with the highlights. You can underexpose pictures by a stop and get excellent results, but you can overexpose by no more than a quarter stop and still hold detail. In other words, meter for the highlights when using the digital camera.

In his book *The Digital Photojournalist's Guide*, Rob Galbraith recommends using fill flash outdoors (see pages 230 and 276) even on bright sunny days when the light is contrasty. He suggests setting the basic camera exposure for skin tones in bright light and using flash to fill in the shadows.

"I shoot everything I possibly can with fill flash because the printed results are dramatically improved by doing so," he says. This technique avoids bleached highlights, also

At the World Cup soccer match, the photographer shot the action on color negative film, processed the film normally, scanned the selected frame, and used a laptop computer and a modem to send the image over phone lines back to her newspaper. (See pages 249-251 for more on scanning images.)

(Photo by Annie Wells, Santa Rosa [California] Press Democrat.)

eliminates purple noise in the underexposed areas, and produces better color requiring less correction in the computer.

ELECTRONIC "REACTION" TIME

Photographers also report slight delays between when they press the shutter release and when the camera takes the picture. This can throw off your timing if you're shooting sports, warns Deanne Fitzmaurice of the San Francisco Chronicle.

Digital cameras can take a burst of pictures—anywhere from six to twelve frames for different cameras—but then the camera stores the information. While it's storing, the camera won't allow new images to be shot.

Detroit's Guralnick, for example, can shoot a burst of only six frames before his camera goes into transfer mode. "I was at the girls' semifinal basketball championship," he recalls. "The girls all piled on, and I ran up and started to click away. I used the six frames—and then the peak moment occurred. I just sat there and watched it with the rest of the spectators."

"You have to learn to pace yourself," warns Gaps of the AP.

OTHER TECHNICAL DIFFERENCES Strobe sync

The digital camera brings one significant advantage to strobe photography. You can use a higher than normal sync speed—some newer model cameras will sync as high as 1/500 sec. (See Chapter 13, "Strobe.")

Shutter speed

Some digital cameras no longer have a traditional shutter at all. Instead, for an instant, the camera turns the chip (CCD) on and off during the exposure. No longer requiring a mechanical device, these cameras are boasting "shutter speeds" as high as 1/16,000 sec.

LCD image display

Some digital cameras have a tiny 2" x 2" display screen on their back panel. As soon as you shoot a picture, you can bring the image up on the display to see if you like the image you've just taken. If you don't, you can erase it and take another.

DIGITAL IMAGES USING A SCANNER

OK, you don't have thousands of dollars to spend on your first digital camera. You can still enter the digital revolution with your present camera and traditional film. You can take pictures with your trusty Nikon, Canon, Minolta, or any other camera using silverbased black-and-white or color films.

Once you have shot the pictures, you will need to develop the film as you have always done. Nothing new yet.

Next, however, you will translate your negatives or slides into the digital information

AP photographer John Gaps III covered the U.S. invasion of Haiti with a digital camera. While the camera is easy to use, highlights tend to bleach out. See the shoulder of the man's white shirt.

(Photo by John Gaps, III, Associated Press.)

that the computer reads. A scanner does the translation for you.

Scanners turn images into digital signals that the computer can use. The scanner acts just like a digital camera, although it doesn't photograph a scene. Instead, it takes a very precise picture of your negative, slide, or print and passes the digital image, now in the form of ones and zeroes, into the computer. Once the image is in the computer, the picture can be sent by telephone across the world or by a direct cable to the presses in the back shop.

Many photographers today shoot with 35mm cameras and film, process their film (often in a mini-lab that develops the film dry-to-dry in twelve minutes), and then scan their negatives into the computer. The photo editor at the Santa Rosa (California) Press Democrat assigned Annie Wells, who was on staff there at the time, to shoot the World Cup soccer match between Brazil and the United States. The match took place at Stanford University stadium, which, at 80 miles away, was too far to make the paper's deadline. Wells shot her photos on color negative film, processed them at the stadium using a Fuji mini-lab processor on site, and then scanned her negatives on a high-quality

Kodak scanner controlled by her Apple PowerBook computer. She initially scanned ten pictures at low resolution to create small, contact-sized images. Then, using the computer's internal modem, she plugged into the telephone lines and sent the pictures back to the newspaper's computer. There, photo editor John Metzger viewed and selected the images that would run on the front page and on a picture page inside. Wells then transmitted only the selected photos, which she, in turn, had scanned at high resolution for highquality, sharp reproduction. These high-resolution images ran in the Press Democrat's next edition in color, five columns wide.

SCANNING CONSIDERATIONS

Scanners and software packages vary, so the publication where you work will provide specific technical directions on how to get the best scanned images. However, for background purposes, there are two things to keep in mind.

The final resolution at which you scan depends on how the image will be reproduced—in traditional printing terms, it will depend on the fineness of the halftone dot screen. Newspapers, printed on coarse newsprint, traditionally used an 80- or 85-

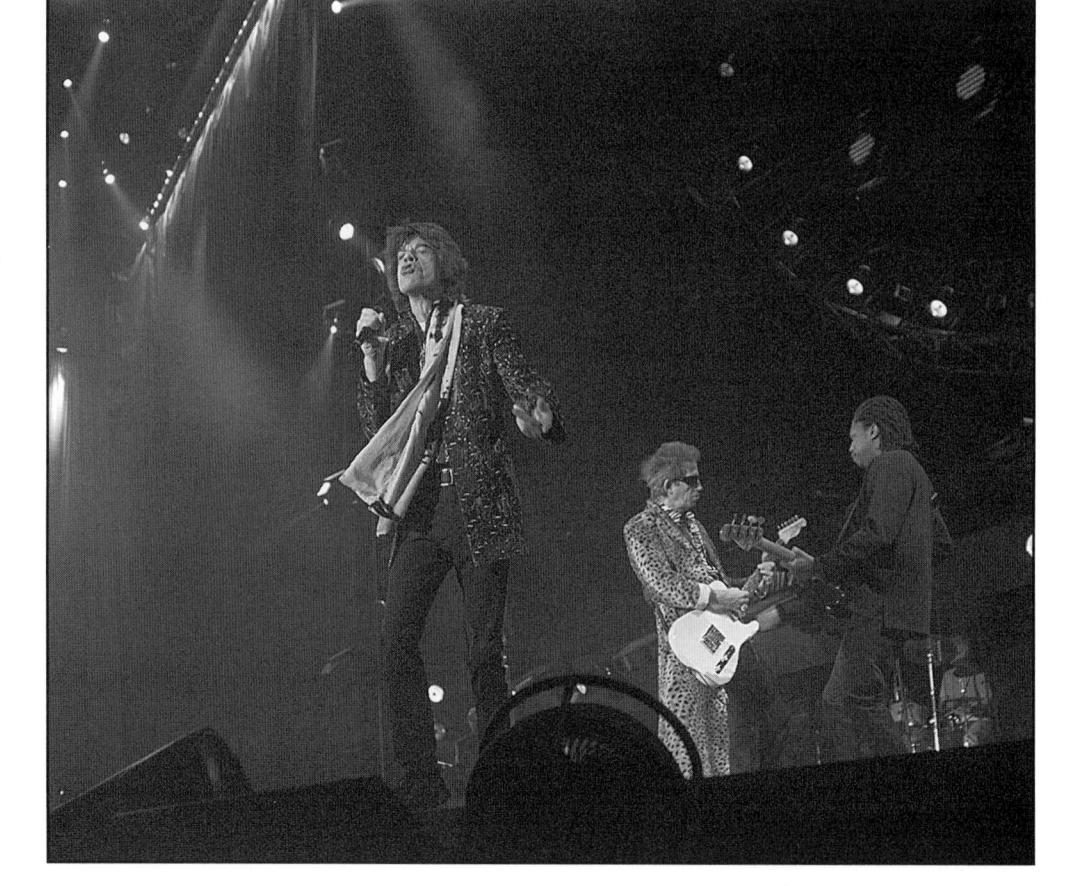

(Photo by David Guralnick, Detroit News.) dot-per-inch (dpi) screen. The paper quality is such that finer screens don't produce finer reproductions. Magazines and books, which use smoother, often coated paper, may use up to 150 or even 350 dpi to print fine reproductions. Publishing on the Web, on the other hand, needs only 72 dots per inch.

If the final printed image appears on newsprint or the Web, you are wasting time and computer storage space if you scan at too high a resolution. The image won't look any better, but it will take longer to scan and then to print—or in the case of the Web, to load. The finer the scan, the more computer memory is required.

The other important variable is the final size at which the image will appear. Scan the picture either to size or to a size slightly bigger than you anticipate it may appear. If it's scanned and saved at a size equivalent to a two-column picture, for example, but it's run at four columns wide, it will look jagged and unattractive. In "computer speak," there's not enough "information" for the image to be enlarged after the scan has already been completed. If you've scanned it to run four columns wide, but then it's only three, you're okay. All the information is available to run it at a larger size, so there will be enough information to run it smaller, as well. Your best bet is to provide a scanned image at exactly the size at which it will run. But deadlines don't always allow the best of all worlds.

USING THE COMPUTER TO CREATE PHOTO ILLUSTRATIONS

Photo illustrations often involve combining parts of images from several pictures. (See Chapter 9, "Illustrations.") To combine images into one picture, photographers in the past had to either cut out each picture with scissors and then paste them together, or try darkroom tricks such as multiple exposures or combining negatives. All these techniques were difficult, time-consuming, and usually somewhat obvious.

Today, photographers use computers to combine images easily, quickly, and seamlessly. For photo illustration, photographers usually take pictures in the field or in the studio and scan them into the computer.

There they vary the relative size of each image to correct or to distort proportions. Finally, they combine the images in an infinite number of ways to make an editorial point or to illustrate a concept.

Jerry Wolford's illustration of a child standing atop the earth and reaching for the chocolate-covered cookie known as a "moon pie" is an example of combining seven separate images to form one. (See page 182.)

HOW THE COMPUTER TRANSLATES PICTURES INTO NUMBERS

Do you remember paint-by-number canvases from your childhood? So that you could paint a picture of the Eiffel Tower, the canvas would indicate a specific number for each color of paint. When a segment of the picture needed a blue sky, the canvas would call for a number five (blue). When a section of the tower needed to be red. the canvas would call for a number three (red). On the original canvas, the area representing the sky was covered with number fives, and the Eiffel Tower itself was filled with number threes. All you had to do was match the paint color on the little jar with the number printed on the canvas. Even if you didn't know what the canvas was supposed to show, you would eventually produce a painting of the Eiffel Tower if you painted in all the numbers correctly.

Now, imagine a paintby-number canvas in

which sections are of equal size, like graph paper, but smaller than a pinpoint. These tiny squares are called picture cells-or pixels. Each pixel is assigned a number indicating its location and it brightness. Now imagine if, instead of a few jars in your paint set, your canvas called for 16.7 million jars, each a different shade, level of brightness, or saturation. Each square (pixel) on your canvas could be any one of these sixteen million plus colors. If the squares (pixels) are small enough and if you have enough paints, you can accurately represent in the computer any picture you might take. Now you can appreciate how many numbers the computer is crunching whenever it deals with a color image. Basically, a computer is selecting from millions of iars of colors to paint by number millions of tiny, evenly spaced squares.

Using other tools in the electronic photo editing program Adobe Photoshop®, you can twist images or make them look wavy or rippled. You can even change the apparent location and color of the original light source in the picture. The computer can free a photographer from the confines of reality and in mere seconds accomplish in many instances what could never have been achieved in the studio.

Keeping this in mind, see pages 255–259 for a discussion of ethics when manipulating photographs with the computer.

MEMORY STORAGE, TRANSMISSION, AND OTHER MECHANICS

Storing images

A hard disk drive for a computer is like a bank for your money. Both are relatively safe places to store your valuables. While a thief can break into a bank and steal your money, your hard-drive problems will generally come not from a two-bit criminal but from

the drive itself. Sometimes hard drives stop working, jumble information, or just seem to lose things for unexplained reasons. Everything, including your favorite picture files, could be lost. Tech types call this a "crash." For the best protection, copy your picture files onto yet a second drive or a Zip™ disk. "Backing-up" images this way has saved many a photographer from an unhappy calamity. For more permanent storage, many photographers transfer or "burn" their images onto a compact disc (CD).

COMPRESSION

Because detailed, sharp color or even blackand-white pictures require so much data, they hog storage space and require tremendous time to process, print, or send over a telephone line. Experts have found a way to squeeze these picture files into a smaller space by eliminating redundant information. For example, let's say you have a picture with a large blue sky. To represent the blue, the computer stores hundreds of individual identical numbers, each representing the color blue. With compression, the program counts up the number of blue pixels that are exactly the same and stores the total count rather than a number for each individual pixel. When you decompress the image, the program lays out the exact number of blue pixels that represents the sky. If X stands for "blue" then the original file looks like this

A World Wide Web page on the international network of computers known as the Internet can show text, graphics, and photos in black and white or in color. Individuals as well as news organizations are using the Web to deliver pictures and stories directly to computers in your home. The address of this page is www.metalab.unc.edu/ nppa/.

Some methods of compression that are called "lossless" lose no data. The reconstituted picture is exactly the same as the original. With other methods, you lose some picture quality but, depending on the degree of compression, the loss can be so slight that you won't notice any degradation.

A standard way to compress pictures is called JPEG, short for Joint Photographic Experts Group. JPEG allows high-, medium-, and low-quality compression. High compresses a little but leaves the image looking almost perfect. Low, on the other hand, compresses a lot, and the loss will be obvious if the image is reproduced in a magazine but not when posted to a Web site.

THE INTERNET: DELIVERING PHOTOS TO VIEWERS WORLDWIDE

While newspaper circulation per household has declined steadily since 1953, and most general interest magazines have folded, the number of individuals owning computers has soared. "Home pages" on the World Wide Web developed by individuals and organizations provide a supplement or alternative to traditional print journalism.

Almost every newspaper, magazine, and television network in the country has a Web site. Some recycle material from their print or broadcast versions while others provide new content, including photos. Web sites that feature original reporting and photography are providing new jobs for photojournalists.

Some sites on the Web have no print counterpart. Anyone—from an individual with a computer and modem, like freelance sports photographer Brad Mangin

(http://www.manginphotography.com/), to a large company like Black Star Publishing (http://www.blackstar.com/)—can have a Web site. Some photographers use their sites to display their portfolios. Others display their stock collections so that buyers from magazines or ad agencies can more easily "shop." Still others just want people to see what they currently are shooting. By searching for the word "photojournalist" at such sites as Yahoo (www.yahoo.com), Alta Vista (www.altavista.com), or Ask Jeeves (www.askjeeves.com), you will find a slew of personal and professional Web sites.

Jim MacMillan, a staffer on the *Philadelphia Daily News*, started a Web site (http://www.netpictures.com/macmillan) as part of a job search but has maintained the site for more than five years. "My favorite

thing is that I have heard from photographers all over the world," MacMillan says. "This month, I've seen hits [electronic visits] from Iceland, the Netherlands, and the Philippines." Photographers write to MacMillan saying that they have seen and enjoyed his pictures and, in turn, asking him if he would like to see their sites.

The Web is also a great tool for researching a photo story topic. On practically any subject you can dream up, you can find interest groups, professional groups, chat groups, and commercial sites on the Web. Scientists are putting their findings on the Web. Through E-mail, you can even contact experts around the country—and around the world. You can read the texts of most of the major magazines and newspapers if you or your library subscribes to a database like Lexis/Nexis. You can check the card catalogues of libraries ranging from your local college to the Library of Congress without leaving the comfort of your chair. And, of course, you can send and receive photos via the Internet.

WHY THE WEB NEEDS PICTURES Pictures have the same power on the Web as they do in print, according to researcher Sheree Josephson. In her paper "The Readability, Recall, and Reaction to On-Line Newspaper Pages with Visuals and Those Without," she found that subjects looking at Web pages with pictures spend 31 percent longer studying stories on those pages than they do on pages with the same content but no images. People reading stories accompanied by pictures also could recall the articles 20 percent more often (see Chapter 10, pages 207 and 208 for similar findings regarding pictures in print). And finally, all the subjects reported preferring the visual version to the nonvisual version of the Web page. Photographs are just as important on the computer screen as they are on the printed page. The Web, therefore, is not only an ideal outlet for photojournalism, but it also needs images to hold readers' attention and improve what they remember about stories.

SHOOTING PICTURES FOR THE WEB Many people viewing Web sites have relatively slow modems (56k or less) and look at the pictures on small monitors. Therefore, the pictures you shoot need to be high impact. Keep in mind that subtle details will get lost. Larry Dailey, who was a picture editor with MSNBC Online, says pictures he rejected for use on the site were those that would take too long to download.

"A good picture for MSNBC is like an icon," Dailey adds. "It makes you click

PHOTOJOURNALISM WEB SITES TO EXPLORE

American Society of Media Photographers (ASMP)

Site for ASMP, a professional trade association promoting photographers' rights. http://www.asmp.org/

The Digital Journalist

Digital photojournalism site maintained by Time photographer and digital video pioneer Dirck Halstead. Interesting information and links to other photojournalism sites. http://www.digitaljournalist.org/

Editorial Photographers (EP)

An international discussion group for photographers who earn at least part of their income in the editorial market. Members share experiences and information related to the business of editorial photography. http://www.netspace.org/edphoto/indexpage2.html

Focal Point

A photojournalism site featuring interactive photo essays. http://www.f8.com/

lournal F

Dirck Halstead calls it "one of the finest Web sites to feature multimedia photojournalism, period." http://www.journale.com/

LIFE's "Virtual Gallery"

Features classic photo exhibitions and provides links to similar sites, including photo archives and interactive museums. http://www.pathfinder.com/Life/virtgal/virtgal.html

MSNBC Photo Gallery

Top photojournalists cover everything from the birth of a nation to the birth of a child. http://www.msnbc.com/news/173305.asp?cp 1–1

National Press Photographers Ass'n

Online home of the NPPA, with lots of information of interest to photojournalists. http://www.metalab.unc.edu/nppa/

The Reporter's Internet Guide

A massive resource for journalists. Links to most major papers around the world, and a comprehensive list of information providers. http://www.crl.com/~jshenry/rig.html

The TIME LIFE Photo Sight

Drawing on its collection of more than 20 million photographs, the TIME LIFE Photo Sight features an extensive Photo Gallery, photo essays, and more. http://www.pathfinder.com/photo/index.html

through, but it is not necessarily a good piece of photojournalism."

Tom Kennedy knows intimately the differences between shooting for print and for the Web. He was the director of photography for the *National Geographic* and now is the director of design and photography for the *Washington Post/Newsweek* Web site. He says the *National Geographic* photographer will shoot thousands of frames to bring back one powerful image to sum up the whole experience. While such a summary can be accomplished, says Kennedy, in a certain sense it is always incomplete. "One single image misses the nuances and the complexities," he says.

Better than running one summary picture as he had to at *National Geographic*, Kennedy can now run an unlimited number of pictures on the Web site. This allows stories to be told on many different levels.

Additionally, Kennedy points out, photographers receive much more feedback from the reading public. Web readers' responses are more immediate and more visceral, Kennedy says. People see a story on the Web and don't hesitate to immediately send an E-mail with praise or condemnation or, even more likely, a suggestion for the future.

In addition to pictures, many sites are incorporating sound and video (page 254).

Using a mini digital video camera. the photographer recorded the military clampdown following riots in Jakarta, Indonesia. On assignment and for their own self-generated photo stories, some photographers are shooting both still images and, with a separate camera, digital video. Small digital cameras using mini DV (digital video) tape produce professional quality, transmissiongrade images and sound for the World Wide Web and for television. As this book goes to press, however, individual frames from a digital video camera are not yet sharp enough for high-quality reproduction in a newspaper or magazine.

Photographers not only are shooting stories with still images, but also are recording natural sound and even collecting interviews. Many experts predict that the future of the Web resides in its multimedia capabilities. Photojournalists, in the future, will have to shoot compelling pictures as well as record high-quality sound and even shoot video for a complete Web package.

DIGITAL VIDEO

In fact, many photojournalists today are telling stories with digital still cameras and are also using digital video cameras to shoot, write, and edit pieces for the Web and for television. Dirck Halstead, an early advocate of still photographers using video, calls this new crossbreed of photojournalist a "platypus," for the Australian creature that has characteristics of both a bird and a mammal. Like the platypus, the new video journalist has traits of both a still photojournalist and a videographer.

Several intersecting factors have given rise to this evolution. From an economic point of view, magazines are running fewer photo stories. Even magazines like *National Geographic*, which still run photo stories, primarily hire freelancers rather than maintain a photo staff. Only seven staff photographers remain on the *Geographic*'s masthead.

Perhaps most influential is the dramatic decrease in the cost of the technology. Digital video cameras that cost less than \$3,000 now perform as well as ones costing \$50,000 just a few years ago. The new digital video cameras have excellent image quality as well as professional sound capabilities when used with high-end microphones. With a lightweight camera, a microphone, and a tripod to steady the camera, you can start shooting your first news story on video.

The other technology shift is in editing, where you can now outfit a personal computer for editing video for less than \$5,000, including software that relatively easily combines many of the functions that in the past had to be handled by separate experts. Until

recently, technology allowing the same functionality ran in excess of \$100,000.

Finally, experts predict that the demand for independently produced video stories will grow in the future. The World Wide Web will need multimedia news, Halstead predicted in his definitive article for *Visual Communications Quarterly*. Visit Halstead's Web site at http://www.digitaljournalist.org/.

Eventually, you will send and receive pictures and sound on your computer as easily as you tune your television set. Some Web sites already display still pictures, text, and short video clips. As transmission speed on the Web increases, you will see more and more video packages, says Brian Storm, lead multimedia picture editor for MSNBC Online. In fact, Storm predicts that Web sites will will require multimedia elements like video and sound in addition to still images, articles, and captions.

MAKING THE TRANSITION

The skills of the photojournalist are ideally suited for this new role. A good photojournalist already conceives an idea, conducts research, makes contacts, shoots the story, edits the film, and suggests a layout for a coherent package to run in a newspaper or magazine. The new video journalist must serve as correspondent, photographer, sound person, and producer. The platypus journalist can also edit the piece, provide the voiceover, and, finally, upload the finished segment onto his or her own Web site or provide it to a local or national Web site or TV station.

Former *Newsweek* photographer Bill Gentile, for example, produced an Emmy Award-winning documentary on the Ebola virus for the Discovery Channel. P.F. Bentley, who shoots on contract for *Time*, used video to report on Haiti and Cuba for ABC's "Nightline."

Technically, shooting video is fun and an easy transition from stills. After all, still photographers are already shooting overalls, called establishing shots in the video world, as well as mediums and close-ups. Still

photographers are accustomed to framing and following action.

DIFFERENCES EXIST

Still photographers will find, however, some clear differences between shooting stills and video. "The fact is that, in most cases, still and television moments exist in a separate time-space continuum," Halstead says.

The still photographer waits and watches for revealing candids. Henri Cartier-Bresson called that split second in which all the elements come together the "decisive moment."

The video photographer craves action that continues in time. Repetitive action, like a carpenter sawing a piece of wood, is the easiest to shoot, since it can be photographed from several angles, but the videographer must also track the movement of a subject through a crowd or follow unplanned breaking action. The last thing a videographer wants is one critical, split-second moment.

THE SOUND OF SUCCESS

To make the transition to video, the most important new technique the photojournalist must master is the use of sound. "If you close your eyes while watching '60 Minutes," says Halstead, "you will find that you can absorb the story with no problem. The images enhance the story, but it is the sound that is vital to understanding." The sound bites provide the narrative.

THINK AHEAD

To prepare for a cross-disciplinary career as a "platypus" journalist who shoots stills and video, take courses using both media. Sometimes video courses are located in a university's journalism or mass communications department. Other times video is taught in the broadcast or film department. A number of good books and videos are also available that will help you become a better switch-hitting shooter.

ETHICS

COMPOSING PHOTOS ON THE **ELECTRONIC LAYOUT TABLE**

In a now-famous incident at the National Geographic, editors puzzled over what could have been a terrific cover shot of the great pyramids of Giza. Unfortunately, the foreground's camels and the background's

pyramids were not lined up to fit correctly on the vertical cover. The answer: Send the picture to the scanner and computer. Through the magic of computer manipulation, the computer operator actually moved the pyramids in the photos. The final picture left no trails.

Rich Clarkson, who became director of photography at the Geographic after the incident, defended the magazine's digital alteration of the picture.

"It's exactly the same as if the photographer had moved the camera's position," he is quoted as saying in an article by Shiela Reaves in the NPPA special report, Ethics of Photojournalism.

Clarkson's argument, however, made no distinction between acceptable and unacceptable methods to obtain a photo. Is fudging a photograph electronically really the same as moving the photographer—even if both methods result in photos that look the same?

As if moving pyramids was not enough, Collins Publishing Company, which published A Day in the Life of America, found moving the moon a necessity.

Reviewing their take from a shoot, editors decided that an evocative picture of a cowboy, tree, and crescent moon would make a perfect cover. Like the Geographic's uncooperative photo, however, the horizontal shot would not fit on the full-bleed vertical cover—so a computer technician moved the cowboy and moon nearer to the tree and then finished composing the picture by adding branches and a bit of extra sky.

So, although more than one hundred photographers submitted thousands of frames of film, editors determined that only the picture of a cowboy who was too far away from a tree would succeed as a cover. And instead of redesigning the cover to accommodate the photo, they redesigned the photo.

ADDING OR SUBTRACTING ELEMENTS Editors don't have to stop at moving the moon or just limit themselves to rearranging pyramids. They even can add or subtract elements from the original picture.

Some newspapers have used the computer to remove small distracting items from a picture, others to change the background color of the picture. The St. Louis Post-Dispatch removed a Coca-Cola can from a portrait of its Pulitzer Prize-winning photographer. The Louisville (Kentucky) Courier-Journal extended a stripper's sweatshirt when her high kick proved a little too exciting.

The Orange County (California) Register increased the saturation of the blue sky in some of their prize-winning Olympics

CAN YOU BELIEVE YOUR EYES?

The head on the woman in the picture is the former governor of Texas, Ann Richards. The body belongs to a model.

The picture of Nicole Simpson is real, but in this published image, it was the *National Enquirer* that battered her.

Associated Press

The competing ice skaters had not practiced together, so *Newsday* editors used the computer to combine two separate images for the page one picture. Had the editors waited one more day, they could have had a picture of the real thing.

Reuters

pictures. On another day, employees in the back shop of the same newspaper changed the color of a swimming pool to blue not realizing that the point of the picture was that someone had dumped red dye into the pool. On a more mundane level, the *San Francisco Examiner* once changed the color of a wall behind the mayor to enhance the appeal of a front-page picture.

The list goes on and on.

Did these newspapers cross the ethical boundary between normal picture handling and doctoring photos?

Long Island's *Newsday* featured a picture of ice-skating rivals Nancy Kerrigan and Tonya Harding practicing together for the Olympics. The two athletes, however, did not skate in practice together until the day after the paper ran the photograph on its front page.

The computer-combined montage was fake.

Newsday had one photo of Harding going through her routine and a separate picture of Kerrigan practicing. Fueled by public interest in the rivalry, in which Harding had been accused of engineering an attack against Kerrigan, editors used the computer to seamlessly meld the pictures of the two separate practices into one—and presented the result as if the two rivals were skating simultaneously. The decision was made against the protests of the photography department, and had editors waited another day, the newspaper could have published a real picture of the two skaters on the rink together rather than printing a day-early-but-fake photo.

Texas Monthly went even further when it depicted then-governor of Texas Ann Richards in a white, leather-fringed outfit atop a Harley Davidson motorcycle. Although Richards does ride a motorcycle, the picture actually showed Richards' face melded onto a professional model's body. (Richards retorted that she was glad the magazine found a model with good thighs.)

Perhaps one of the most shocking instances of computer manipulation was when the *National Enquirer* used the computer to add bruises and a black eye to a photograph of Nicole Brown Simpson, O. J. Simpson's murdered ex-wife. With the former athlete on trial for his ex-wife's murder, the *Enquirer* doctored the photo to "illustrate" how the victim would have appeared following an earlier instance of abuse by her ex-husband. Labeled as a computer manipulation, the image nonetheless stunned shoppers in grocery stores everywhere. How many people, do you suppose, knew what the *Enquirer* meant by computer manipulation?

HOW FAR WILL MAGAZINE EDITORS GO?

Curiously, some magazine editors have shown little hesitation in altering cover photographs. "Magazines, I think, can get away with a little more," said Rocco Alberico of *Sports Illustrated for Kids.* "I mean, they can fool around a little bit more than newspapers."

In her paper "Digital Alteration of Photographs in Magazines: An Examination of the Ethics," Shiela Reaves found that all thirteen of the magazine editors and art directors she interviewed said emphatically that they would never digitally manipulate a news photograph. However, most had no problem in "cleaning up" a photograph by removing indistinguishable "blobs" or extending the sky or a background tone so a news photo could fit the layout.

Michele Stephenson, *Time* picture editor, noted that it was like cropping people out of a picture. "You crop a picture, there's a corner of an elbow, and somebody says 'We'd better take that out. It looks funny.' We do that sort of thing . . . everybody does that."

Newsweek went a bit further when it became the digital dentist for Bobbi McCaughey, the new mother of septuplets. The smiling mom on Newsweek's cover enjoyed straighter and whiter teeth thanks to careful computer manipulation.

Surprisingly, readers approved of this digital dental work, according to a survey by researcher Edgar Huang. Sixty-seven percent of surveyed readers approved the editor's digital dentristry in a feature photo or as a photographic illustration because they loved the new mother and did not want her to be presented with crooked teeth.

As part of her survey, Shiela Reaves asked Bob Furstenau, director of magazine production for Meredith Corporation (publisher of *Better Homes and Gardens* and other magazines) what kinds of things he would change in a picture. "Anything," he replied, "that interferes with the ultimate aesthetic of the picture—spots, telephone wires, people, whatever." He estimated that forty-five of the forty-eight covers he had worked on at the time had been digitally manipulated.

Sports Illustrated for Kids featured one of the NBA's shortest basketball players dribbling through the legs of a large player.

"We do a lot of that, especially on covers, but it's pretty obvious that they're basically fantasies," said the magazine's art director. "That's such an obvious fake; kids know people that size really don't exist."

Do they?

Reaves found that newspaper picture editors were significantly less tolerant of digital manipulation. She also discovered that only 22 percent of the magazine editors had a photojournalism background, whereas 85 percent of those at newspapers had previous professional photojournalism experience. Perhaps this difference in professional background accounts for the stricter standards regarding digital manipulation held by daily newspaper photo editors.

HISTORY OF ALTERING PICTURES

In the 1920s, manipulation of photos was not only a standard procedure but was considered a high art. (See pages 341–342 for more on the topic.) In a fascinating paper, "Altered Plates: Photo Manipulation and the Search for News Value in the Early and Late Twentieth Century," Wilson Lowrey showed how conditions that encouraged photo faking

in the 1920s have, with the advent of the digital darkroom, reappeared in the 1990s.

In the early days of photojournalism, art departments controlled photography. Artists didn't (and still don't) hesitate to rearrange a sketch or creatively interpret events with a painting or drawing. This thinking overlapped into their use of photographs, which they saw as just another artistic medium.

As the profession of photojournalism matured, photojournalists began controlling the use of photography, and higher standards for the treatment of journalistic photographs evolved. Unfortunately, Lowrey reports, photo departments at many publications today have again reverted to the control of art directors and designers, who often have little regard for the integrity of the photojournalistic approach to photography.

Also, Lowrey observes, photography in the 1920s was still a novel addition to newspapers. Publications had no set policies about when and how to use photographs.

In the 1990s, he says, magazines and newspapers had established no industry standards when they began digitally manipulating pictures. As with any novel technique, editors and art directors experimented. Always on the search for a new way to lure in readers and tickle their curiosity, these editors turned to photo manipulation much like their counterparts enthusiastically cut and pasted photographs some eighty years ago.

LOSING CREDIBILITY?

What will happen as the public discovers that news outlets alter images electronically? Will the profession lose credibility? Will people believe photographs if they know that editors can easily alter images?

In part, the credibility of the photograph depends on the reputation of the photographer and the publication that produces it,

The Evening Graphic's staged hanging nearly cost the life of the art department assistant when he accidentally kicked over the stool on which he was posing for a "composograph." Combining images did not start with the invention of the computer. Editors created composographs by cutting and pasting posed photographs to create staged scenes. (For more about the Evening Graphic and composographs, see pages 341-342.)

(Harry Grogin, New York Evening Graphic.) observes Paula Habas in her thesis, "The Ethics of Photojournalistic Alteration: An Integrated Schema of Determinants."

In another study, James Kelly and Diona Nace compared how much subjects believe a photograph before and after being shown a video demonstrating the techniques of computer manipulation. After watching the video, the subjects, perhaps surprisingly, maintained their trust in photos. Seeing the computer's wizardry does not automatically destroy the believability of a photographic image.

Based on a 1996 survey of 350 college students, Tom Wheeler found that respondents held newspapers to a higher standard than general interest magazines like Cosmopolitan, Esquire, MacWorld, and National Geographic. They found digital manipulation by newspapers more unacceptable than manipulation by general interest magazines. The researcher also discovered that while some types of manipulation, like removing a distracting tree from the background, were not offensive to the majority of subjects, more extensive photo manipulation, like retouching a picture of an actress by altering her facial blemishes, increasing her cleavage, and enhancing her nipples, was unacceptable. Finally, Wheeler discovered, women were consistently more critical of photo manipulation than were men.

Researcher Edgar Huang found that 57 percent of surveyed Bloomington, Indiana, residents thought that digital retouching of cover photos on Time magazine and the Day in the Life of America book was acceptable. Only 31 percent objected. Huang reported that readers found that removing a cola can from a picture was fine if journalists erased it for editorial purposes. Not surprisingly, study participants found digital alteration of photos like photo illustration more acceptable than for hard news photos.

THEORY IN PRACTICE

When readers saw a real-life comparison of altered and unaltered photos on newsstands, they reacted strongly and loudly. Time magazine electronically altered a police mug shot of O.J. Simpson, who had been arrested for the alleged murder of his former wife. Labeling the image a "Photo Illustration," Time ran it on the cover the same week that Newsweek published the untainted original. The American public joined a loud debate about the use and misuse of digital alteration.

On every newsstand across the country, the

numbers. Time editors thought they had covered themselves by using the label "Photo-Illustration for *Time*" in the table of contents.

Shocked at public outrage—including 70,000 messages on America Online (a commercial online service) as well as articles in the New York Times and Associated Press-a Time editor pondered, "but we do illustrations all the time. Why is this different?"

While Kelly and Nace demonstrated that just knowing about digital manipulation does not cause readers to disbelieve photos, Wheeler has shown that readers object to certain kinds of manipulation. The reaction to the *Time* cover indicates that if people care about the event or the person, and if they can see both the altered and unaltered photos, they will respond—loudly.

In almost all cases, viewers do not realize that photographers or, more likely, editors have manipulated some of the photos they see on magazine covers and on newspaper pages. The studies mentioned above show that when told, some viewers find certain kinds of manipulation of pictures objectionable. However, that does not mean that viewers doubt pictures they see in publications. The New York Times photography critic Andy Grundberg once predicted that, "In the future, readers of newspapers and magazines will probably view news pictures more as illustrations than as reportage, since they can no longer distinguish between a genuine image and one that has been manipulated." No evidence to date demonstrates that this depressing forecast is coming true.

two covers sat side-by-side—each with the same image. Yet the covers were different. Time hired an illustrator who darkened the image and reduced the police identification

GOING TOO FAR?

While few photographers object to dodging and burning a negative in the darkroom, most are outraged at digitally retouching a person into or out of a news picture. How far should electronic retouching go? Should it:

- remove a distracting branch behind a person's head?
- tone the sky to a deeper blue?
- smooth out wrinkles from a star's face?
- alter a news picture if the manipulation will produce a more telling picture?
- change a feature photo?
- electronically sharpen an image?

Digital manipulation has not been around long enough for the photojournalism community to form agreed-upon standards. In coffee shops, at national meetings, and in newsrooms, the topic has been hotly debated since National Geographic moved the pyramids for its 1982 cover.

Photojournalists who take the absolutist's position argue that editors should not digital-

While Newsweek ran an unaltered police "mug shot" of former football superstar and accused murderer O.J. Simpson, Time digitally darkened the photo and made him look more foreboding. Readers saw the two images side-by-side on newsstands and were shocked by Time's decision.

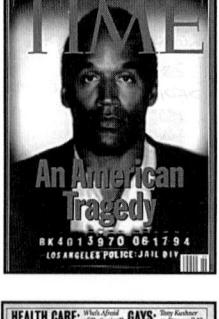

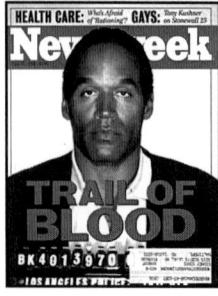

ly retouch or manipulate photos at all. They say that the final picture should look as near as possible to the original slide or negative. They maintain that the original is "truth" and any change from that is categorically wrong. Bob Gilka, who was the director of photography at National Geographic when the pyramids were moved, now argues that limited electronic manipulation is like a limited nuclear war. There isn't any such thing.

Others hold that editors should only make "global" changes—changes made to the entire photo similar to the way photographers in the field switch filters on the camera. This group says that shooters and editors should not electronically manipulate parts of the photo after it's been taken because photographers cannot do that in the field.

A less stringent position holds that editors should restrict manipulation to the same techniques practiced in the traditional darkroom—dodging, burning, lightening, darkening, and changing contrast. In an extensive survey of 511 picture editors, Shiela Reaves found they were intolerant of computer alterations or manipulations, with the overwhelming majority disapproving of any computer alterations other than burning and dodging.

One respondent summarized the feelings of most other editors: "The philosophy at our newspaper is not to publish any image which we cannot produce in negative form. Thus, the only manipulation is lightening and darkening, boosting the colors, dodging/burning, and spotting scratches and dust spots. No cloning pixels. No moving elements. No combining different negatives. No sanitizing images after the shutter has clicked."

John Long, a past president of National Press Photographers Association and a photographer for the *Hartford* (Connecticut) Courant, falls into this category. He says there is nothing wrong with fixing flaws using the computer. "These are merely technical in nature and have nothing to do with the actual content or meaning of the photo." Dodging and burning, he says, are integral to the medium of photography—part of the "grammar" of how we communicate. "The public understands this (at least unconsciously), so it is not wrong."

But Long argues that photographers should not try to improve a photo by eliminating even minor elements like distracting phone lines. Long uses this test, "Does the electronic change in the photo deceive the reader?"

Some editors, though, hold that the computer should be used to "clean up" a photo—to remove a distracting wire or a protruding telephone post from behind a subject, or close an open, embarrassing pants zipper.

Finally, some photographers argue that if the photographer could have taken the picture with a different lens or from a different angle, then manipulating the electronic image to get the same result passes muster. (See Rich Clarkson's comments, page 255.)

Tom Wheeler and Tim Gleason, in a paper titled "Photography or Photofiction," define the latter as photography that is "manipulated enough during processing to change readers' perceptions of its meaning—whether material elements are altered, added, removed within the frame or rearranged and regardless of the method employed."

WHO BENEFITS?

How should the profession resolve this dilemma? Perhaps photojournalists should consider who benefits by altering photos. The photographer? The editor? The reader?

Consider this. In the situations where National Geographic moved the pyramids and Collins Publishing Company moved the cowboy and the moon, editors and designers sought to fit a horizontal picture onto a vertical cover format. Could another picture have sufficed? Could the cover design have been changed to fit the shape of the image? Who benefited? Editors and designers. Was the reader any better off? Not really.

Removing a cola can from a picture cleaned up the image for an editor. But did the reader gain anything from this move?

In all of these instances, electronic manipulation eased the jobs of editors, designers, or publishers. None were carried out to benefit readers.

Digitally "imagining" a victim's injuries or electronically bringing people together in one image goes beyond making jobs easy to simply fooling the reader because there's technology available that makes it easy to do so. Here, the reader not only fails to benefit but becomes the butt of a joke, as well.

FACILITATE, DON'T FOOL THE READER On the other hand, when a photographer burns or dodges a print in the darkroom or similarly darkens or lightens the print in the computer, the reader benefits by seeing more clearly items in the picture that might have been missed with an unaltered picture. In the same way, the computer's ability to sharpen pictures or blur backgrounds to make the subject stand out more distinctly and legibly also benefits the reader.

Perhaps an ethical guidepost might read: "Electronically alter pictures only when doing so clearly benefits the reader. Avoid altering pictures when doing so fools the reader in any way." ■

Strobe

SUNSHINE AT YOUR FINGERTIPS

CHAPTER 13

riginally, photographers were limited to picture-taking only when the sun was out. Not all news, however, happens in the light of day. From flash powder through flash bulbs to electronic flash, photojournalists have searched for a convenient light source that would enable them to take pictures under any circumstances. Today, possessing a com-

pact strobe is similar to having a pocketful of sunshine at your fin-

Photographers covering the Academy Awards use the strobe light's quick duration to catch the celebrities as they enter and leave the pavilion. (Photo by Deanne Fitzmaurice, San Francisco Chronicle.) gertips. In the 1970s, manufacturers brought out

miniaturized, lightweight, high-powered strobes.

With a thyristor (energy-saving) circuit, the

strobes used only the power they needed for a correctly exposed picture. With the advent of strobes with automatic exposure control, the number of over- or underexposed negatives was reduced. The photographer no longer had to estimate the flash-to-subject distance then calculate the f-stop. The strobe's automatic eye, coupled with the unit's internal computer, released just enough light from the device to produce perfectly exposed pictures most of the time.

The next generation of electronic flashes was called "dedicated." The manufacturers designed each unit to work with—be dedicated to—one particular camera system. The strobe and camera work in tandem, both using the same information about film speed, shutter speed, lens length, and aperture.

With some dedicated flashes, the camera measures both available and strobe light directly through the lens (TTL). With a through-the-lens dedicated flash system, the camera can read the available light of a scene and automatically set the strobe to dominate

the available light, equal it, or just provide a fill light, according to how the photographer has set the controls.

Some camera systems employ what's called 3D matrix metering. This piece of technology lets the camera compare exposures reflected off the subject with distance information and combines the data for a correct flash exposure even if the subject is off center or wearing an all-black or all-white outfit.

ELECTRONIC FLASH CONTROVERSY

Although designers have engineered a compact and convenient strobe, flash critics still point out that the strobe's light looks artificial in photos. These purists note that the strobe throws an unnatural black shadow behind the subject's body, producing pictures with the look of a police line-up. True, flash pictures can look stark. In the old days, photographers, who kept their flashguns mounted to the sides of their Speed Graphics, churned out these unnatural, stylized pictures.

Following the not guilty verdict in the trial of police officers who beat Rodney King, rioters broke into stores and shops in San Francisco and hauled out stolen goods. The photographer used a relatively slow shutter speed (1/30 sec.) to take a picture of this looter. The photographer balanced the strobe's light with that coming from the store's interior. (Photo by Ken Kobré, Mercury Pictures.)

The cause of harshly lit pictures does not lie with the flash but rather with the flash photographer. When the photographer uses techniques like bounce and multiple-flash, almost any lighting effect that occurs naturally can be created with the strobe.

The light from a strobe, when used creatively, can give a photo the even feeling of fluorescent light, the dramatic effect of direct sunlight, or the moody flavor of window light. But when the flash photographer leaves the strobe on the camera and aims straight ahead, the harsh effect is unavoidable.

People who dislike flash argue one persuasive point, however. Initially, when a flash goes off, it does tend to draw attention to the photographer. The burst of light can throw cold water on a hot discussion.

However, just as a mayor becomes accustomed to being followed by a photographer clicking off pictures, most subjects eventually will pay little attention to the firing of the strobe.

Strobe advocates point to the advantages of a portable light source for the photojournalist. A strobe can boost the overall quantity of light in a room, thereby enabling you to set a smaller aperture for greater depth of field, which is needed, for instance, when shooting an overall picture of a meeting in progress.

Also, the strobe light lasts for only a brief

instant, usually 1/1,000 of a second or less. This allows you to take a picture at an effective speed of 1/1,000 of a second, freezing both subject and camera movement.

As a photojournalist, you must weigh the strobe's advantages against its disadvantages. In many circumstances, you would not be able to get any pictures without your strobe. Without the light from the strobe to expose the thief (opposite page) and freeze the motion, the author would not have been able to stop the action of the criminal fleeing the store with goods in hand.

In other situations, you can produce a technically improved or visually more interesting picture when you fire a portable light source. Keith Philpott, on assignment for People magazine, used two strobes in a cross-light setup to photograph a man who has mastered the art of stacking bowling balls. Without flash, the subject would have blended into the background. The strobes also helped add highlights to the black bowling balls. (See page 264.)

Sometimes the strobe, especially in a sensitive situation such as a funeral, can be disruptive. Other times, natural light can add more visual variation to pictures.

However, few spot news photographers would leave their offices without their electronic flash equipment in their camera bags. With the strobe in his left hand, the photographer reached under the arm of the person pouring the champagne and aimed the strobe so that light came from an unusual direction.

(Photo by Tom Duncan, the Oakland [California] Tribune.)

SELECTING THE SHUTTER SPEED

STOPPING ACTION

The super-short flash duration of the strobe appears to freeze a subject's movement, no matter how fast the person is running or jumping. The strobe freezes the gymnast as she leaps in midair, the motorcyclist as he bends into a turn, or the skateboarder as he appears to hang, suspended in time and space.

In addition to stopping subject movement, because the flash is almost instantaneous, strobe light avoids blurry pictures caused by camera movement. Even if you are clicking pictures as you chase a city council member up the stairs of city hall, your pictures will come out sharp if you shoot with a strobe.

SYNC SPEED

Note, however, that a flash picture will not come out correctly if you set your shutter speed too fast. On some cameras, the upper limit is only 1/60 sec. Other cameras synchronize with the flash up to 1/250 sec. Some even sync as high as 1/500 sec. If you use too fast a shutter speed, only part of the image receives the strobe's light. Some camera/strobe systems prevent the operator from using an incorrect sync speed. Check your camera instructions. (See demonstrations on pages 266–267.)

COMBINING FLASH WITH AVAILABLE LIGHT

Each camera model does have an upper limit sync shutter speed. However, selecting a slower shutter speed often results in a more natural-looking flash photo. Indoors or outdoors at dusk, many photographers use slower shutter speeds to pick up available light from the environment and combine this with light from the flash. While the electronic flash light captures a moving subject in midair, the available light from the longer shutter speed lightens the background. Because the shutter stays open longer than the flash duration, the photographer can adjust the shutter speed to let in more and more available light. Up to a point, the

For this shot of a man who balances bowling balls, the photographer used strobes positioned on either side of the subject to separate him from the background. The highlights from the strobe also help to add definition to the black bowling balls.

(Photo by Keith Philpott, for *People* magazine.)

greater the amount of available light the photographer lets in by slowing the shutter speed, the brighter will be the background behind the subject (see pages 266–267). Beware, however, that some dedicated flash-camera

combinations allow for limited or no variance in setting the shutter speed. Again, check your manual.

Many professional photographers also like the effect that the combination of strobe and a slower shutter speed has on moving subjects. Although the strobe freezes the subject's movement for one instant, the long exposure also captures the subject's continuing movement, adding a ghost-like blur. The result is a sharp image combined with the blur of motion (below).

When Tom Duncan photographed a boxer in a dimly lit gym, he stopped the boxer's punch—with a strobe. So the gym wouldn't go black, he combined the strobe's light with ambient light, which he picked up by using a slow shutter speed. The combination of strobe and ambient light gives a sharp but natural-looking picture. The little bit of "ghosting" around the boxer adds to the feeling of movement and power in the picture.

While the author was photographing a riot, looters began breaking into storefronts and carting off armloads of leather coats and

sporting goods through the broken plate glass windows. The photographer used a strobe to light the looters but also used a slow shutter speed to pick up the light from inside the pillaged stores. (See page 262.)

DETERMINING APERTURE

Strobe manufacturers build their strobes in different ways. Hence, a brief check of your instruction book will indicate how to operate your particular unit. Some basic principles, however, do apply.

MANUAL

To determine the aperture, measure the distance from the flash to your subject, and then check the distance scale on your strobe. Watch out. Some dials are marked in both meters and feet. Also, be careful to set the dial or read the scale for the particular film speed you are using.

AUTOMATIC EYE

The automatic sensor works well as long as the subject is neither exceptionally dark nor The short duration of the strobe light stops the boxer's punch. A relatively slow shutter speed (1/15 sec.) lets in available light from the gym. The ghosting highlights give the picture its dynamic feel.

(Photo by Tom Duncan, the Oakland [California] Tribune.

CONTROLLING THE BACKGROUND WITH SHUTTER SPEED

You can use the flash at any shutter speed at or below your camera's flash/sync speed. In these photos, the flash output remained constant. The flash was on manual.

For flash pictures, the f-stop is determined by the amount of light emitted by the flash that reaches the subject.

In this case, the photographer measured the amount of light with a strobe meter.

THE F-STOP ON THE CAMERA REMAINED AT F/5.6. With the camera on a tripod, the photographer simply varied the camera's shutter speed from 1/500 sec. to 1 sec.

To demonstrate the full range of shutter speeds, the photographer shot at dusk. He also had the subject jump in every frame.

Notice how changing the shutter speed influences the picture. The choice of shutter speed controls the amount of available light reaching the film.

As the shutter speed slows, the background gets progressively lighter in each picture. (Photos by John Burgess.)

• 1/500 sec. You can see that most of the subject is dark. The focal plane shutter on this camera drops from top to bottom like a guillotine. The curtain on the shutter was about half open when the strobe fired. F-STOP STAYS AT F/5.6.

• 1/250 sec. (sync speed) Here, the shutter's curtain was fully open when the flash fired. Some camera models sync with the strobe no higher than 1/125 sec. or 1/60 sec. The subject is correctly exposed, but the background is dark because at this exposure, the scene behind the subject is completely underexposed. The flash froze the subject in mid-air. F-STOP STAYS AT F/5.6.

 1/125 sec. The background lightens as the shutter speed lengthens. The subject remains frozen. F-STOP STAYS AT F/5.6.

 1/60 sec. The subject remains correctly exposed while the background gets yet lighter. By keeping the exposure on the subject constant and varying the shutter speed, you can control the background's brightness. F-STOP STAYS AT F/5.6.

• 1/30 sec. Here, the subject "pops" out of the background, which is about two stops darker but still readable. F-STOP STAYS AT F/5.6.

• 1/15 sec. The moving subject produces two images, the sharp one frozen by the electronic flash, the other blurring in the available light. The strobe's light lasts only a split second, thereby freezing the subject in mid-air, while the available light remains constant—lighting the subject's motion —throughout the entire exposure. The "ghosted" blur from the available light becomes noticeable only when the subject is moving. When the subject is stationary, the strobe and available light images exactly overlap. F-STOP STAYS AT F/5.6.

• 1/8 sec. Strobe/available light balance point for this lighting situation. As the shutter stays open longer, the available light image (the ghost) gets stronger. Here, the flash and ghost images become equal. At the point of equality, the picture is said to be balanced for flash and for available light. F-STOP STAYS AT F/5.6.

• 1/4 sec. As the shutter speed slows further, the available light begins to overpower both the background and the subject. The available light is washing out the flash picture. F-STOP STAYS AT F/5.6.

• 1/2 sec. At this exposure, the available light further overpowers the light from the strobe. The subject's face is starting to disappear. F-STOP STAYS AT F/5.6.

• 1 sec. The flash exposure leaves just the subject's legs and dress.
The darker image is the subject's body after the jump. F-STOP STAYS AT F/5.6.

To check the flash exposure, an assistant holds the incident strobe meter in front of the subject and points it back toward the camera.

exceptionally light. The sensor adjusts the strobe's light as if the subject were a neutral gray tone (18 percent gray). The light meter in the camera and in the strobe function similarly. Both the strobe's sensor and the camera's light meter give correct

readings most of the time because the average brightness of most subjects is equivalent to approximately 18 percent neutral gray. For the exceptionally light or dark subject, however, most strobes with automatic sensors require adjusting the f-stop on the lens to compensate for incorrect exposure information. The sensor on the strobe considers a small 5 to 10 percent angle of view in the center of the picture. The sensor eye is geared to read neutral gray correctly. If, for example, a subject is wearing jet-black leotards while standing in front of a dark brick wall, the sensor eye will be fooled. To compensate, close down the lens' aperture one or two stops to avoid overexposed negatives.

For a subject wearing wedding-white, perhaps standing in front of a chalk-white chapel, the sensor eye will be misled once again. To compensate in this situation, open up one or two stops to avoid underexposed pictures. (See page 221 for examples where the camera's automatic light meter is fooled. Similar situations would fool the strobe's sensor.)

THROUGH THE LENS (TTL)

With some dedicated strobe/cameras, the flash sensor is located in the body of the camera. With this setup, the flash is informed of the film's ISO automatically. You can select almost any aperture on the camera because the sensor is located behind the lens. When the flash fires, the light returns through the lens' aperture and strikes the film. The light then bounces off the film, so when the internal sensor gets enough light, it will shut off the strobe. Also, because the sensor is in the camera and not in the strobe, you can point the flash in any direction, and the sensor will record the amount of light that returns to the film or CCD chip.

A new generation of strobes using 3D matrix metering, however, measures light reflected from the subject and compares this information with the subject's distance from the camera. If the through-the-lens (TTL) reading is wildly off the mark when

compared with the subject's distance, the camera will use the preprogrammed distance exposure instead. If, for example, the subject is only a few feet away but is wearing black, the sensor would mistakenly direct the strobe to put out a lot of light, thereby overexposing the picture.

However, with 3D matrix metering, the camera would recognize that, at this close distance, the light needed is much less than the reflected light meter reading is reporting. The strobe, instead, would deliver the appropriate amount of light for a correct exposure at the close distance. The sensor, in other words, is not fooled by a subject wearing extremely light or dark clothes or standing out of the frame's center.

HAND-HELD STROBE METER

Unlike standard light meters, strobe meters can measure the fantastically short burst of light emitted by a strobe. Often the meters are accurate to within one-tenth of an f-stop. Most strobe meters measure incident lightthe light falling on the subject. You'll recognize an incident light meter by its white sphere that looks like a Ping-Pong ball cut in half. The photographer or assistant holds the meter about where the subject will be standing, pointing the meter back toward the camera. When the strobe is fired, the meter measures the light falling on the sphere—light that would have struck the subject. The meter indicates the correct f-stop for a particular film. Leaving the strobe on manual, the photographer adjusts the f-stop on the camera to the setting indicated by the light meter.

Using a strobe meter works fine if the subject is a celebrity sitting for a portrait, but the measuring device proves more difficult to use if the subject is a crook running down the courthouse steps. For fast-moving, slippery subjects, the internal sensor in the strobe or the through-the-lens sensor in the camera works best.

PROBLEMS TO AVOID WITH DIRECT STROBE

SHADOW ON THE WALL

The strobe mounted on the top or side of the camera produces a direct light aimed at the subject. At night, outside, or in a big gymnasium, direct strobe-on-camera works satisfactorily. Direct strobe-on-

camera, however, creates a harsh shadow

268 • Photojournalism: The Professionals' Approach

POSITIONING THE STROBE

FRONT-LIGHTING. When the main light is placed close to the lens, few shadows are visible. Forms seem flattened and textures are less pronounced.

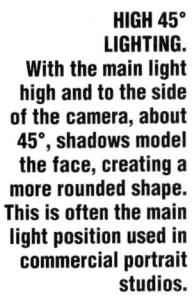

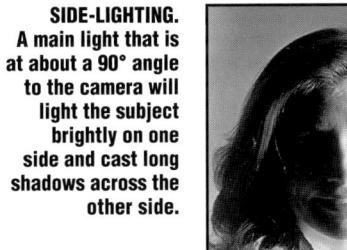

BACK-LIGHTING. Here the light is moved almost to the back of the subject. If the light were directly behind the person, her entire face would fall into shadow.

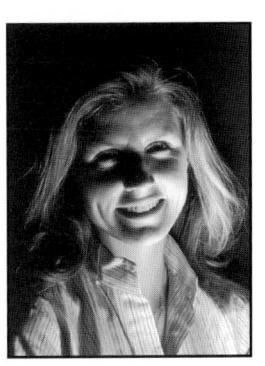

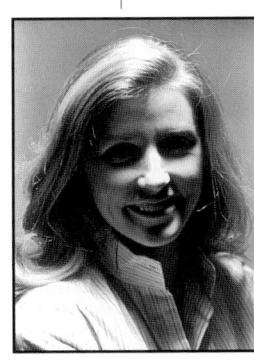

TOP-LIGHTING. The light is directly overhead and is casting dark shadows into the eye sockets and under the nose and chin. Few portrait purchasers would pick this lighting arrangement. behind the subject in a normal-sized, white-walled room.

To get around the lurking black shadow problem, move the subject in front of a dark wall if possible. Now the black shadow created by the strobe will blend somewhat with the dark wall and be less prominent.

Or move the subject away from the wall. If you and the subject move away from the wall, keeping the same distance between the two of you, the subject will receive the same amount of light, but the wall behind will get less. Again, the wall will darken and the obtrusive shadow will merge with the darkened wall and disappear.

REFLECTIONS OFF GLASS

If you face someone wearing glasses to take a picture using strobe, often you will get an

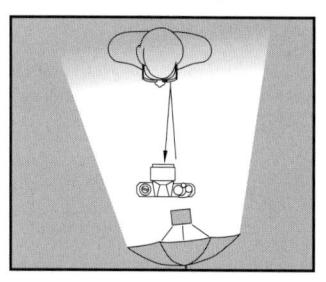

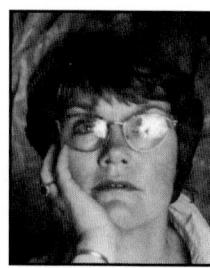

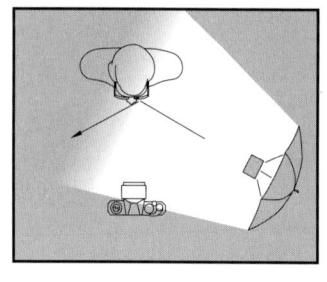

annoying bright reflection off the subject's lenses. To avoid reflections of polished metal, glass, or eyeglasses, keep the strobe at an angle to the reflective surface you are shooting.

INCOMPLETE COVERAGE AREA

Some strobes have automatic zoom heads that allow you to adjust the area the light covers to match the lens on the camera. These units change the light pattern to coincide with the wide-angle or telephoto lens you might have on the camera.

Most strobes, however, are designed to light only an area no wider than a 35mm lens. When you use a wider lens on your camera, you need to spread the light out farther. For telephoto lenses, it helps to focus the light on a smaller area. Some strobes do have an attachment that will spread the light so the scene will be evenly illuminated

(down to 20mm-lens coverage), or focus the light so that it will be more efficient.

UNEVEN LIGHTING

Sometimes you must photograph a group of people with direct strobe. A flash on the

camera may overexpose group members nearest the light and underexpose those farthest from the light source. To avoid this problem, arrange the participants so they are approximately equidistant from the strobe light. When all the group's members are the same distance from the strobe, they will get the same amount of light and, therefore, be equally exposed.

CREATING DIFFERENT EFFECTS

OFF-CAMERA LIGHTING FOR BOLD EFFECT

Sometimes side lighting with direct strobe can add drama to a picture. To achieve this effect, remove the flash from the top of the camera. Attach the flash to the camera with a PC extension cord or other remote-triggering device (see page 272). Hold the flash to the side of the subject. Moving the flash away from the camera will dramatically change the picture's light. (Also see pages 104 and 270 for pictures taken with strobe off camera.)

BOUNCE STROBE FOR SOFTER LIGHT To avoid the harsh effects of direct strobe, a photographer can bounce the strobe's light off a room's ceiling, walls, or any other light-colored surface.

When the *Boston Globe*'s Joanne Rathe Strohmeyer accompanied sheriffs from a Boston Drug Task Force on a raid, she needed the extra light provided by her strobe once inside the dark apartment. Crouched on

one side of the room, she framed the picture to include a baby in the foreground, the sheriffs in the middle, and a man on the couch in the background (page 274).

Direct strobe on camera would have correctly lit either the child in the foreground or the adult in the background, but not both at the same time. So Strohmeyer bounced the light from her strobe off the ceiling, which provided even illumination so that the entire scene received the same amount of light.

When the light leaves the strobe, it comes out in a bundle of rays the size of the strobe face—about three inches in diameter, depending on the size of the flash.

To achieve a broad, relatively soft, lighting effect for this photograph of Jack Lemmon, the photographer used a single large soft box in front and slightly to the left of the actor.

(Photo by Michael Grecco, Inc., for Jack Lemmon.)

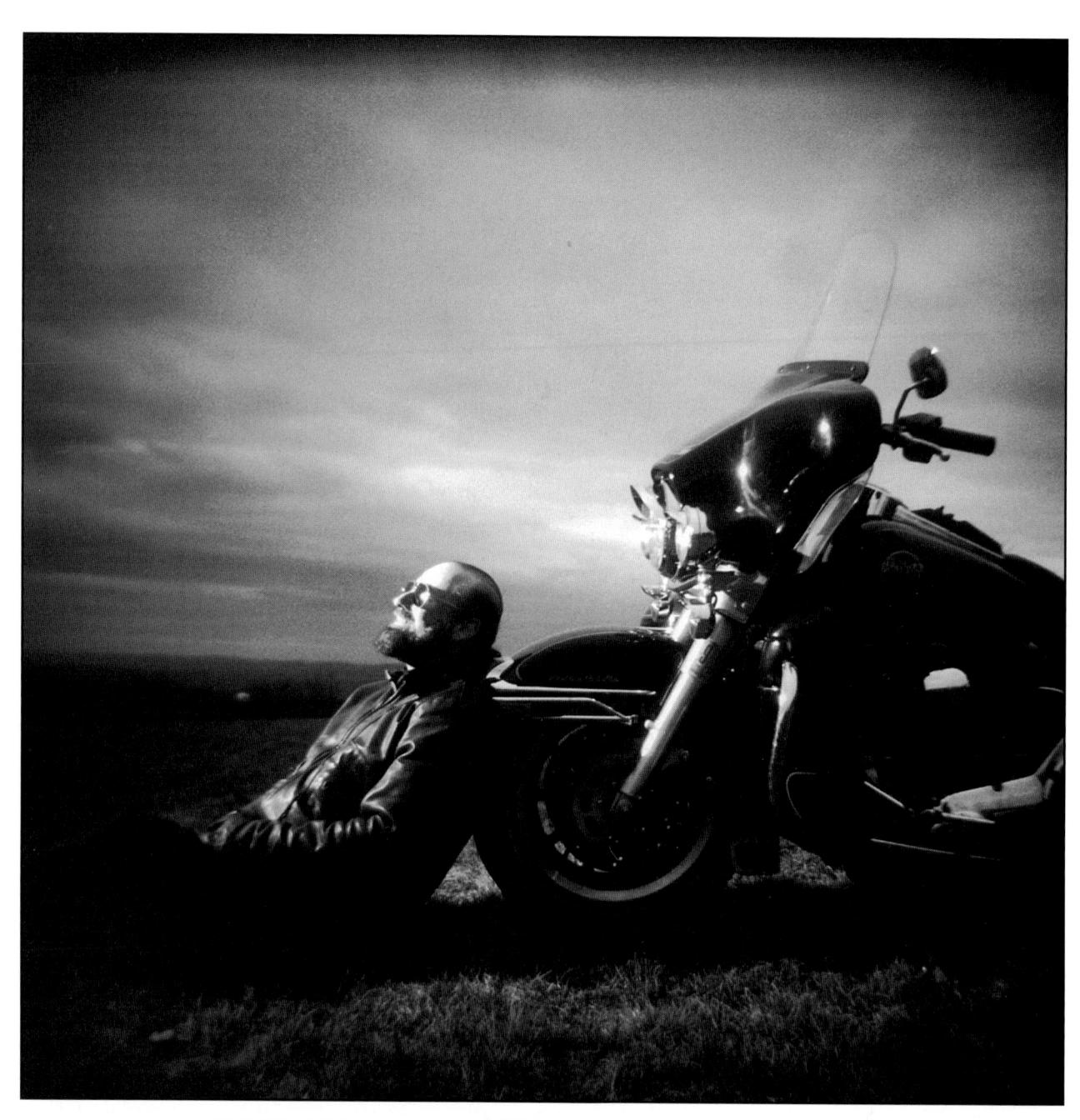

To light this picture, the photographer used a single off-camera strobe placed to the left of the camera and aimed at the face of the subject. Light from the strobe was balanced with the exposure for the sun setting over the ocean. For more about the picture, see page 276. (Photo by Michael Grecco, Inc., for Worth magazine.)

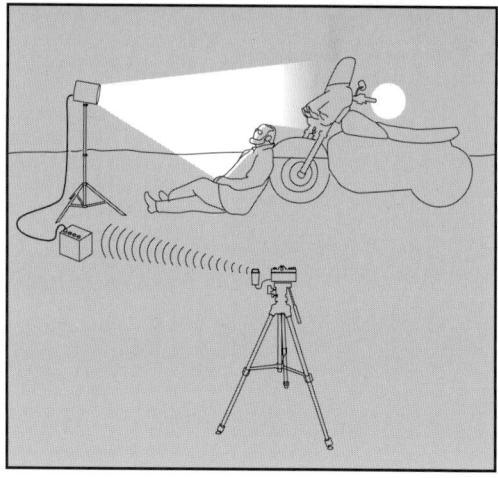

The rays spread out as they head toward the ceiling. By the time they reach a typical ceiling, the rays cover an area about ten feet across. Because the surface of the ceiling is rough, the rays bounce off it in all directions, evenly lighting a much larger area below and leaving few shadows.

Bounce light has at least two advantages over direct strobe. Bounce light eliminates unattractive shadows, and it helps light a group of people evenly, removing the danger of burning out those in front or letting those in back go dark.

Not only can you bounce light off the ceiling, but you can also bounce light off a wall, partition, or any other large, opaque object.

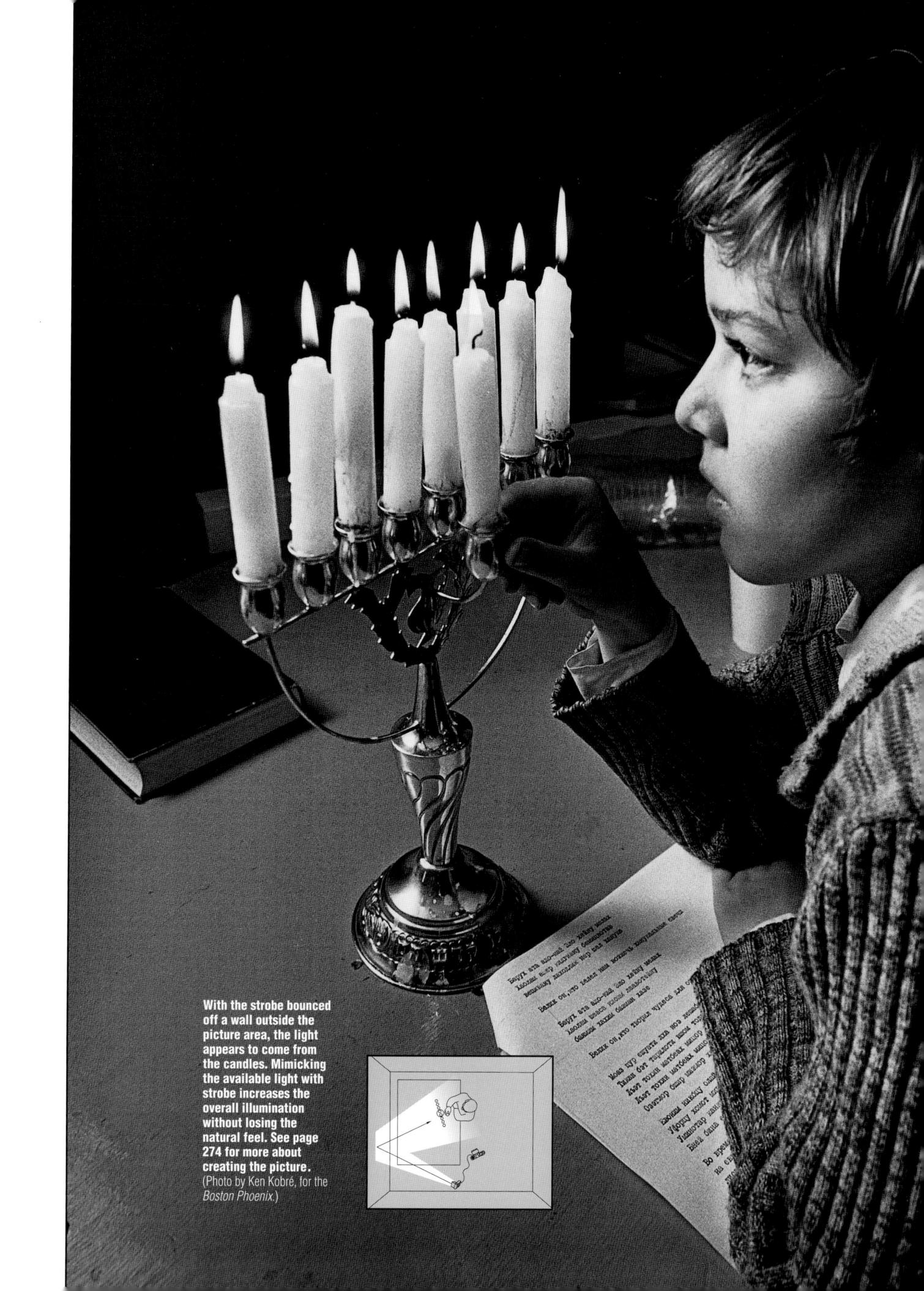

To photograph this drug search, the photographer used the light from a small portable strobe bounced off the ceiling. Bounce strobe spreads an even, almost shadowless light throughout the room. For more about the situation, see pages 270 and 271. (Photo by Joanne Rathe

Strohmever.

the Boston Globe.)

Light bounced off the ceiling results in a soft, relatively shadowless effect similar to that produced by fluorescent tubes found in most modern buildings. Light bounced off a wall or partition gives a more directional effect, such as light that comes from a window. The directional effect becomes more prominent the closer the subject and the flash are to the wall.

Many photographers attach a small white card behind and up about a quarter of an inch from the top of the strobe head. This card picks up a little light when the strobe goes off and reflects this light into the subject's eye sockets. This reflected light from the white card avoids the raccoon look you can get with bounced light if you are standing near the subject.

When photographing a child lighting candles for Hanukkah, the author could have taken the picture by the available light from the candles. He knew, however, that in the final image the candles in relation to the boy's face were so bright that they would wash out. The rest of the picture would fall into deep shadow. Bouncing a strobe's light off a nearby wall gave the impression that the light was coming from the candles. The

effect leaves both the candles and the young boy in sharp relief. (See page 273.)

Rather than bouncing the strobe off a wall, photographers find it more convenient to bounce the strobe light off the inside of a specially constructed white or silver lined umbrella. A large umbrella on a light stand is easy to move around and position. The light bouncing out of an umbrella emulates the light you might get from a north window. The demarcation between shadow and highlight on the subject is gradual rather than the abrupt line produced from a direct bare strobe. The shadow on the background becomes indistinct (pages 279 and 280, top).

For a soft effect with even more control photographers use a "soft box." The box consists of material held together with tension rods. The box contains several layers of diffusion material inside and a white cloth bottom. The soft box gives a light effect similar to the umbrella, but the photographer can control fall off at the edges of the light source more precisely (pages 271 and 279).

FILL-FLASH HANDLES HEAVY SHADOWS At noon on a sunny day, the sun's harsh light

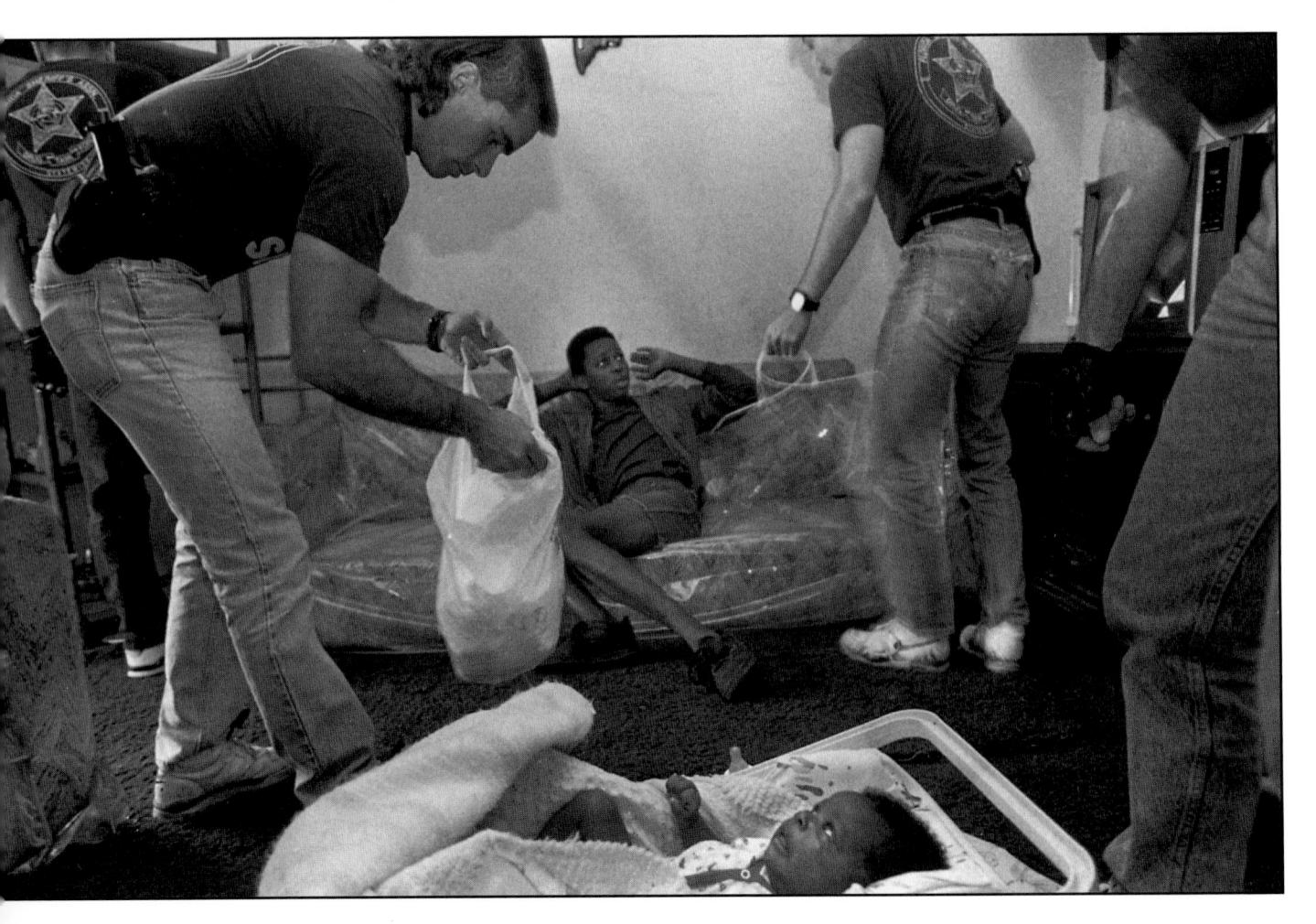

can leave some subjects buried in shadow while others scorch in the sunlight. Shadowed eye sockets on faces turn into raccoon-like masks. Fill-flash to the rescue.

The light from the strobe opens the shadow areas of subjects within ten or fifteen feet of the strobe. With fill-flash, light from the strobe fills in the shadows without overpowering the highlights. You will find fill-flash particularly useful when you shoot color transparencies, which can record hue and texture in either brightly lit areas or deeply shad-

owed ones, but not both at the same time.

If important shadow areas meter more than one or two stops darker than highlight areas, adding fill light will probably improve your picture. (See page 278.)

Many portable strobes today have a fill-flash setting that automatically balances the available and strobe light. In fact, some strobes allow you to dial in just the amount of fill-flash you might want to use. You can have the strobe balance or put out one to three stops less than the available light.

CAUTION WITH BOUNCE FLASH

he light leaving the face of your strobe is spread over a wide area when it reaches the bounce surface. When it strikes a ceiling, wall, or umbrella, the light is partly absorbed by the bounce surface. Finally. once reflected off that surface toward the subject, the light scatters in many directions. With bounce strobe, therefore, much less light reaches the subject than when you are using direct strobe. With bounce strobe, use caution:

- Save the bounceflash technique for medium to small
- In an auditorium or gymnasium, the ceilings are usually so far away that not enough light will return from the ceiling to light up your subject adequately.
- Bounce your strobe off a light-toned surface. A dark wall, for example, will absorb the light rather than reflect it back toward your subject.
- · Small, cigarette

- pack-sized strobes don't put out enough power to produce an efficient bounce light in most rooms.
- With color film, don't bounce your strobe light off a pink, blue, or any other colored surface. The tint will color the strobe's light, giving the whole picture a color-cast that you may not like.
- When you bounce a strobe that has a sensor eye, make sure the eye remains pointed toward the

- subject. Don't try to bounce with a unit that has a sensor that points only at the bounce surface.
- When bouncing, always set the strobe for its widest automatic aperture. Bounce works perfectly with a medium to large portable strobe, in a normal room, with eight- to ten-foot high white ceilings and a subject standing within three to twenty feet of the photographer.

AIM CORRECTLY . . .

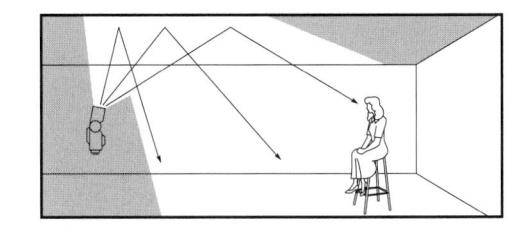

 When bouncing, aim the strobe carefully so that all the light bounces off the ceiling.

... OR PAY THE PRICE

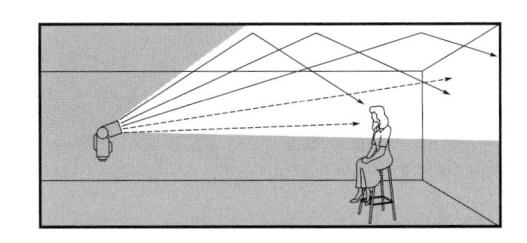

→ Do not aim the strobe too low, or direct light from the strobe's head will hit the subject, producing an uneven and unwanted lighting effect.

FILL-FLASH

You can use strobe outdoors on a bright day to help fill in deep shadows on a subject if the person is within ten or fifteen feet from the camera. Some of the dedicated flash combinations will allow you to select the ratio of fill-flash to available light. The camera and strobe do the rest automatically.

AVAILABLE LIGHT left the subject's face obscured in shadow.

FILL-FLASH ONE STOP LESS bright than the available light from the sun leaves open but delineated shadows as well as catchlights in each eye. The subject looks well-lit but natural.

FILL-FLASH BALANCED with the available light from the sun eliminates almost all shadows but looks overly lit in this situation.

On assignment for *Worth* magazine, Michael Grecco was hired to photograph an investor in a relaxed mood (page 272). He shot the motorcycle owner leaning on his two-wheeler on a cliff with the Pacific Ocean in the background. To incorporate both the face of the subject and the setting sun, Grecco placed a strobe to the left of the camera but pointed at the subject's face. By selecting the shutter speed that matched the light in the background, Grecco was able to balance the strobe's light with the setting sun.

POWERING THE STROBE

SHOE-MOUNT STROBES

Most shoe-mount strobes are powered by AA batteries. Lithium batteries last the longest but are the most expensive choice.

Alkaline batteries are easily available, but rechargeable Alkalines are cheaper over the long haul.

Rechargeable nickel-cadmium batteries (NiCads), which store the least amount of juice, do provide a consistent recycle time before they completely and suddenly lose their charges. Lithium and Alkaline batteries, on the other hand, run down gradually, resulting in excessively long recycle times as they wear out.

Note: always carry backup batteries. Nothing is more frustrating than waiting eons for dying batteries to recycle the strobe.

While Lithium, Alkaline, and NiCad batteries designed for shoe-mounted strobes are convenient, none provide enough electricity for more than a few rolls of 36-exposure film when the flash is used at full power.

As Jon Falk says in his book Adventures in

Location Lighting, "Throw away all wimpy AA and NiCad battery clusters." Many photojournalists who need power continuously over an extended time turn to external rechargeable batteries. You can recharge these external low- or high-voltage batteries repeatedly.

Some of these batteries fit on your belt, screw onto the bottom of the camera, or attach with Velcro onto the strobe back. What they all have in common is the ability to provide 100 to 350 flashes at full power—some with less than a two-second delay between complete strobe recharge. These external batteries have become a mandatory part of most working pros' flash kits.

MEDIUM-POWERED STROBES

The typical battery-powered strobe most photographers use has a maximum output of

50 watt-seconds of light. For slow transparency films, many photographers have turned to more powerful portable strobes that can generate

anywhere from 200 to 1,200 watt-seconds.

Although heavier and more costly, these strobes provide the needed light power for using umbrellas or soft boxes with slow films. With some of these medium-powered portable strobes, you can add on batteries for more power.

AC-POWERED STROBES

Using small portable strobes, you can't see the lighting effects until you have developed the film—hours or sometimes days later. With most AC-powered strobes, a modeling light is built into the strobe head, allowing the photographer to see where the light will fall.

Manufacturers have built AC-powered

strobes with tremendous light output—an important consideration when working with slow color films.

Also, for large-format cameras like the 4" x 5" or 8" x 10" view camera, the photographer needs this quantity of light. Much of the photography shot in studios requires high-output power supplies. You can buy an AC-powered strobe with 500, 1,000, 2,400, 4,800 or more watt-seconds of light. The AC-powered units can drive two or more strobe heads at the same time.

Many photographers regularly haul medium-sized AC units on assignment. These

strobe units allow photographers to shoot color film at small apertures—and they also provide fast, dependable recycling. Highwattage strobes with modeling lights allow photographers to light a room and see where all the shadows will fall. While these strobes usually have more power than a portable strobe, they also require AC power and are consequently less convenient than their smaller counterparts. These strobes always operate on manual, so you'll always need a handheld light meter to determine exposure.

Also, when shooting outdoors, photographers must remember to bring along either a long extension cord or a portable generator. However, the strobes' fast recycle times, practically limitless number of flashes, and powerful light output make them ideal for multiple-light photography.

PHOTOJOURNALISM GOES HOLLYWOOD

With the increasing use of color, photographers often are lighting scenes with several

To achieve this distinctive look, the photographer used the strobe off camera and set it to "telephoto" so it would emit a defined cone of light. He controlled the background light by using a fast shutter speed. Without the strobe, the subject would have been as dark as the person on the left. However, if the photographer used no flash and exposed for the subject on the left, the background with its dramatic clouds would have washed out.

(Photo by David Leeson, Dallas Morning News.)

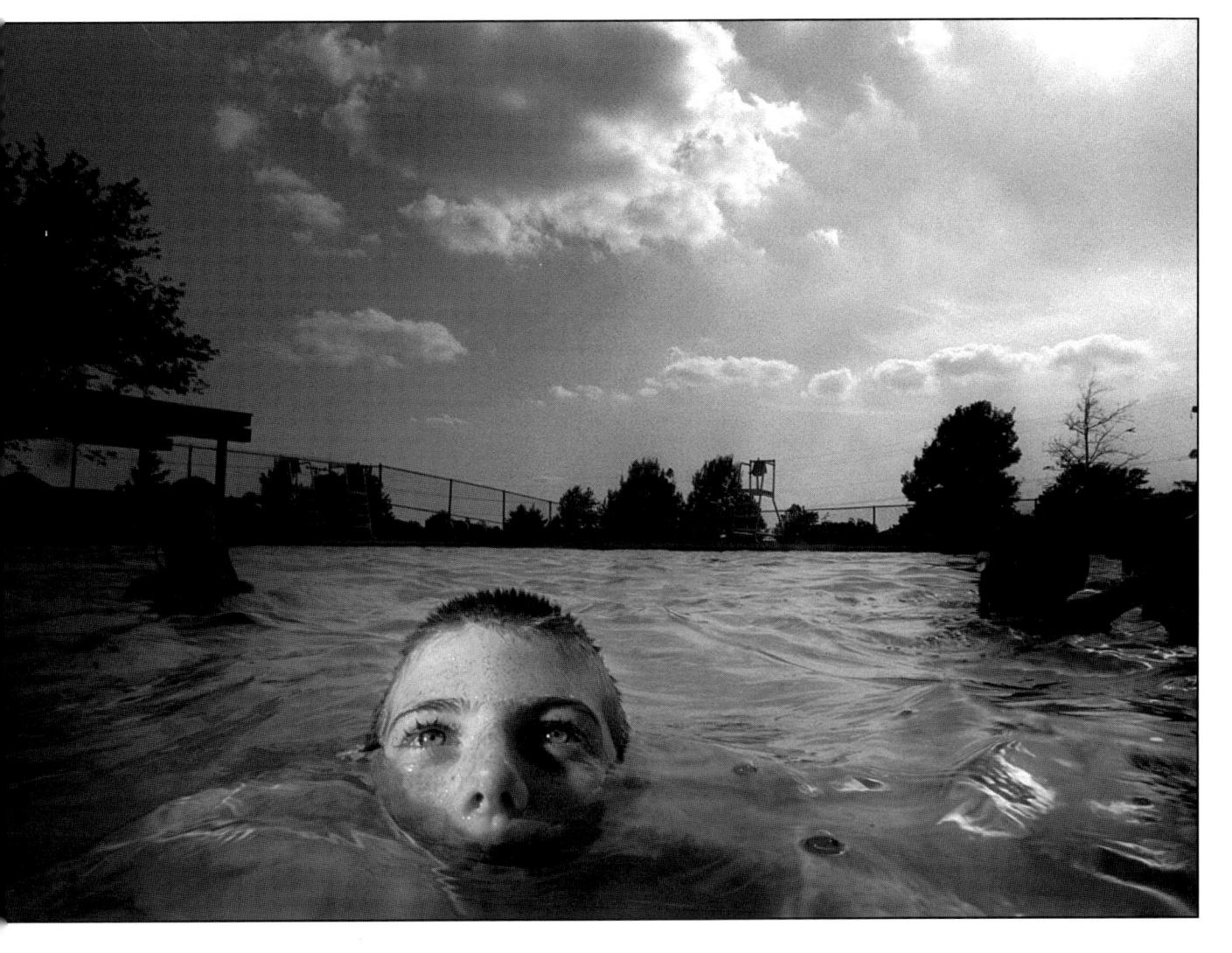

COMPARING STROBE ACCESSORIES

The harshest light comes from a camera-mounted strobe aimed at the subject. So photographers use a number of accessories to soften the light and reduce harsh, dark shadows behind the subject.

Generally, the larger the effective light source, the softer the light will be. The light from a $3' \times 4'$ soft box will produce softer light than the light from a 2" \times 3" direct strobe. When you bounce light off a ceiling, the effective light source becomes the wide spot on that ceiling. Photographic umbrellas, whether you are shooting through them or reflecting off them, also provide a relatively large light source, depending on their size.

Although smaller devices such as the Omnidome and Lumiquest Pocket Bouncer are not as effective as the larger light sources, many of the smaller items do work well indoors. In a lightcolored room, some light rays bounce off the ceiling, walls, and floor. This extra scattered light helps soften the shadows when the devices are used within a small room.

However, outdoors or in a large ballroom or gymnasium, all the accessories work less well at softening shadows. The scattered light rays coming from the accessories have few surfaces to bounce off. Notice, in the outdoor series, that the shadow behind the model is darker in almost each situation. For these tests, the strobe was located nine feet from the subject.

INDOORS

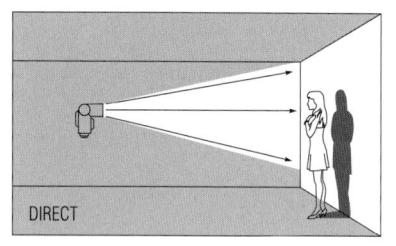

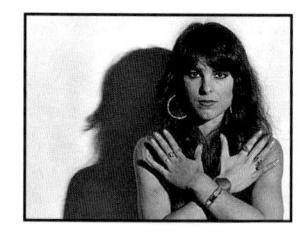

INDOORS

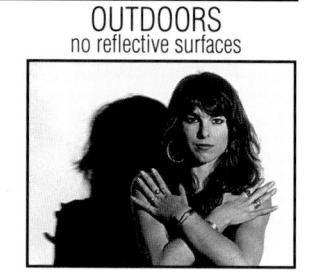

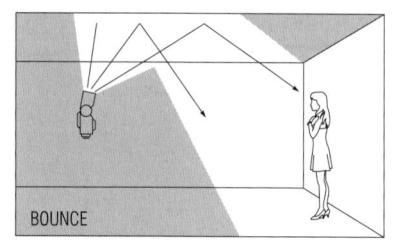

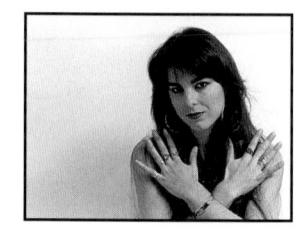

NO CEILING OUTDOORS

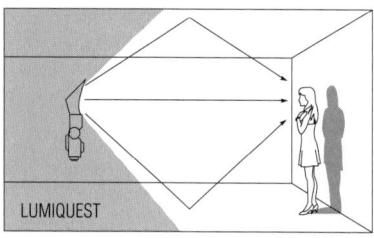

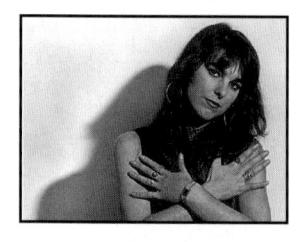

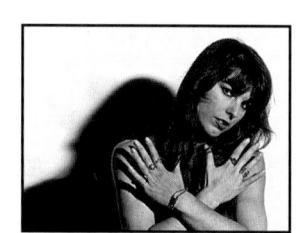

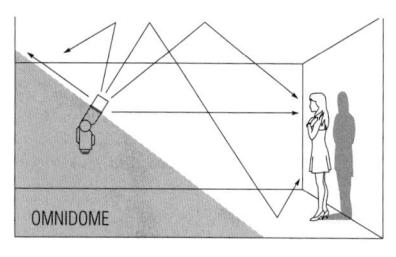

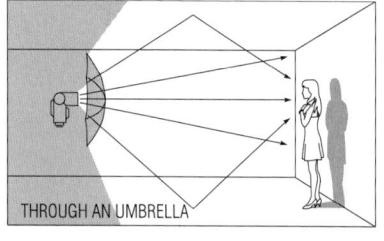

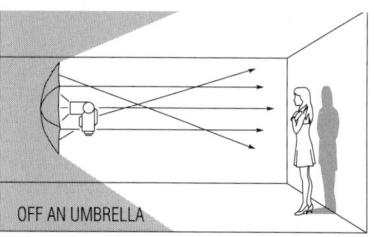

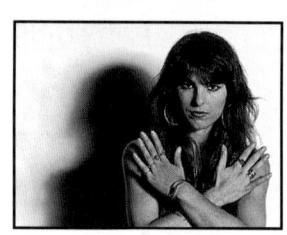

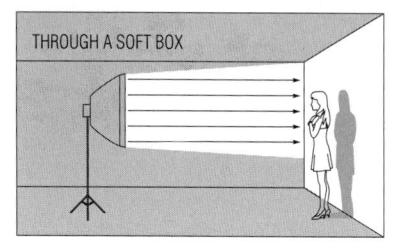

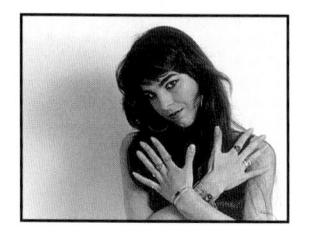

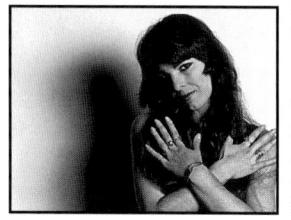

Photos by John Burgess, Santa Rosa [California] Press Democrat.

strobes. Fine-grain transparency film requires lots of light. And, as discussed earlier, transparency film cannot handle great brightness differences within a scene. Suppose you are taking pictures that include the corporate president inside his fifty-second floor office and the sun-drenched, spectacular view outside his window. Our eye has no trouble seeing both the wrinkles on the president's face and the sparkling bay out-

side. But your film cannot handle this brightness range. You may need to set up several lights to bring the two worlds into brightness balance.

Sometimes you may simply want more control of a scene than the light from one strobe can produce. You want to produce a special effect. Perhaps you seek to add a highlight to a person's hair, or you want to feature one member of a group more than the

STROBE ACCESSORIES TO DIFFUSE LIGHT

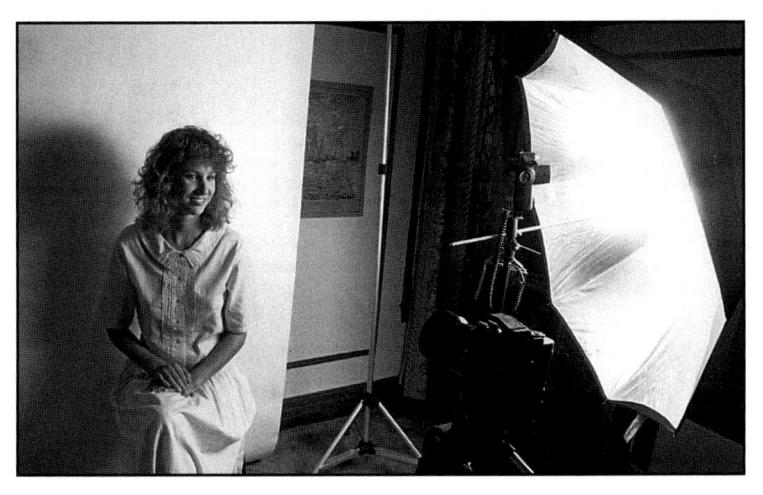

UMBRELLA

Because direct strobe light comes from a small light source, it produces a harsh effect on the subject. Light bounced off the ceiling is soft but produces somewhat featureless pictures. Many photographers use photographic umbrellas as alternatives.

The photographic umbrella is similar to a standard rain umbrella, only the inside is covered with a white or silver material, and the handle can easily be attached to a light stand. When the photographer aims the strobe into the center of the umbrella, out comes a soft white blanket of light that wraps around the subject.

Because the umbrella is on a light stand, the photographer can move it easily from side to side or up and down—allowing for total control of the light's direction. The nearer the photographer brings the light to the subject, the more the rays will encircle the person.

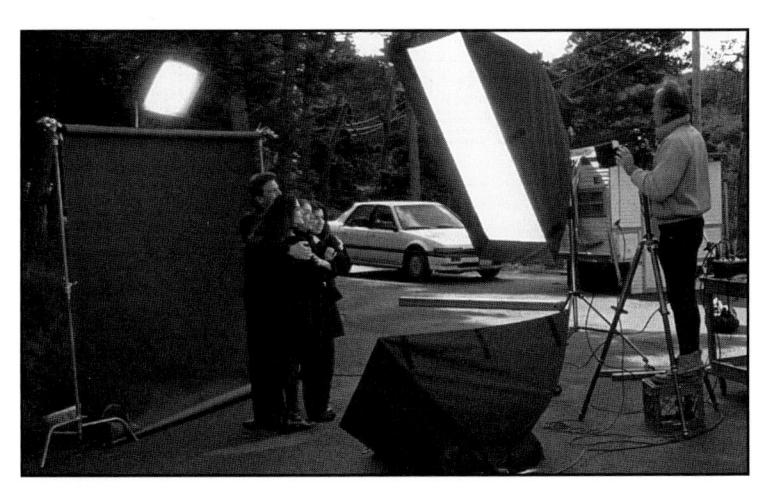

SOFT BOX

The photographer attaches the strobe to a lightweight cloth box that contains diffusion panels to evenly spread the light. The result is a window-like light that is portable. Compared to reflecting light off an umbrella, the soft box gives more even light with a defined edge. (Photo by Deborah Whitney Prince.)

When a wall or ceiling is not available for bouncing the strobe light, photographers use a number of other techniques and devices to attempt to soften the light and reduce shadows. However, as you can tell from the demos on the opposite page, some of the devices are not effective when you are shooting outdoors or in a large indoor space such as a gymnasium or auditorium with high ceilings.

Each tool is supposed to take the concentrated bundle of light
coming from the
strobe's face and broaden it before the light
heads toward the subject. The larger the
effective light source,
after it has been broadened, the softer will be
the light that reaches
the subject. (See demos
on opposite page.)

DIFFUSERS ON THE STROBE.

Small devices placed over the strobe increase the effective light area somewhat. The Omnidome works like a bare tube. It combines the characteristics of direct and bounce light simultaneously. The indirect light bouncing off the ceilings and walls is supposed to help soften the direct light coming straight from the dome. The Lumiquest Pocket Bouncer is supposed to enlarge the effective light source by reflecting light off the angled hood, which is supposed to help scatter light so that the rays will bounce off nearby surfaces and further soften the light on the subject. If you look at the tests on the opposite page, though, you will see that there is not much difference among the diffusers and how they work.

SIX AND A HALF FEET FROM SUBJECT

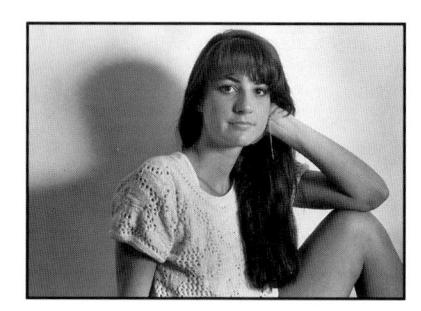

ELEVEN FEET FROM SUBJECT

Whether the light is from an umbrella (like these examples) or from a soft box (see pages 278 and 279), the shadows it produces will be softer and less distinct when the source is near the subject, and sharper and more defined as the light source is moved away.

> (Photos by Ron Bingham. Edging West magazine.)

rest, or you want to use a light on either side of a dancer to emphasize the person's form.

Michael Grecco was assigned by Rolling Stone to photograph the band "Dead Can Dance." To get an edgy effect reflective of their music, he lit the performers with two separate strobes, each outfitted with a "grid" spot. In the background, he added dead tree branches and lit them with a regular light that was aimed to throw a haunting shadow on the background. (See opposite page.)

To handle complicated photo situations, you might set up several strobes on light stands and fire all of them simultaneously. The camera's sync cord can be connected to a three-way plug, and cords from strobes can be attached to this plug. Then, when you trip the camera's shutter, all three strobes fire at

once. With portable strobes, alternatively, you might use a cordless triggering device.

WHERE TO PLACE THE LIGHTS Lighting a whole room

To light an entire room, you can set up several strobes around the room and bounce all of them off the ceiling or off umbrellas. Even if the room is not perfectly evenly lit—a common problem in this circumstance—you can still shoot freely by taking a reading with your handheld strobe meter at different parts of the room ahead of time. With predetermined exposure readings, you can leave the lights in one place, and as you move from one area to another, adjust the aperture for each section of the room. This technique of lighting and predetermining exposure allows

> you to shoot, in a relatively candid manner, with slow

color film and multiple lights.

Multilight setup While you will find no two lighting situations identical, you often can use a basic lighting combination (see below) for shooting portraits: set up a main light and reflect it into an umbrella or through a soft box. Set the light about 45 degrees to one side of the camera. Bring the light as near as possible to the subject while still evenly lighting the person. Next, use a large reflector card to bounce light into the shadow side of the subject's face.

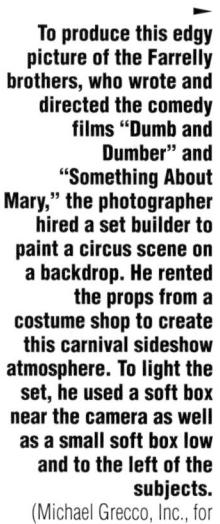

Entertainment Weekly.)

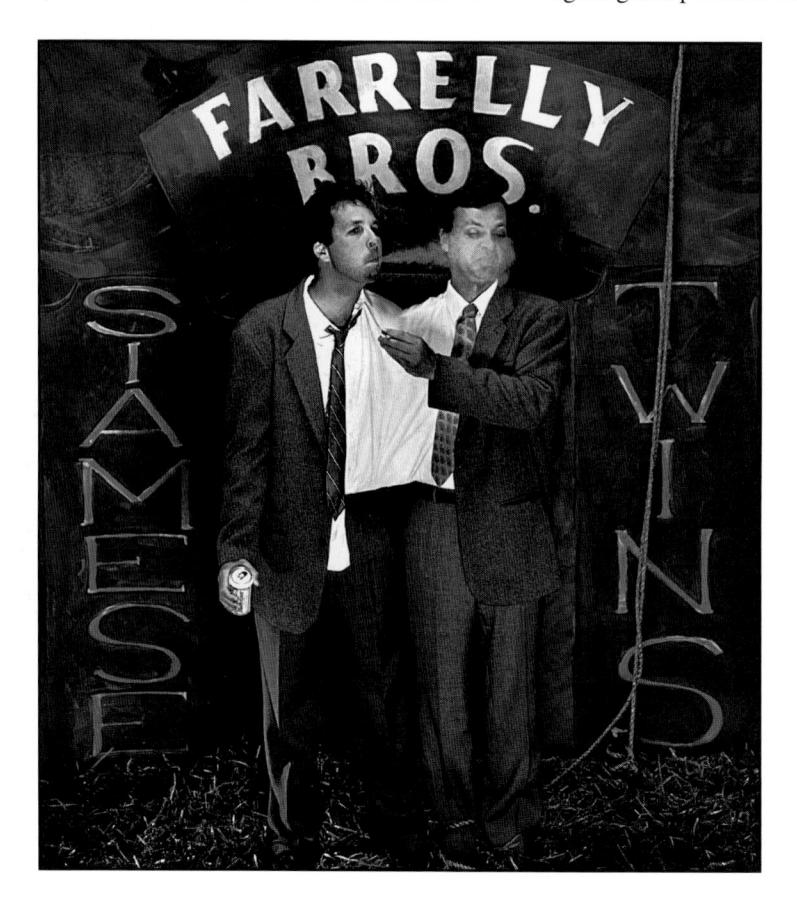
Finally, attach a second strobe to a boom, a weighted arm that extends over the subject's head. Locate the strobe above and behind the subject to provide a hair light.

Photojournalists observe that setting up multiple lights can cause time delays as well as accidents caused by the cords running from the camera to the strobes. To eliminate the need for long cords between your camera and strobes, you can use a "photo slave." Attach the "slave" to your strobe either through the hot shoe or PC connection. Then put a second strobe on your camera. Now the light from the camera's strobe will activate the photo slave and trip the remote strobe.

Instead of a strobe on your camera, you can use an infrared trigger that functions like a strobe but puts out infrared light instead of strobe light. High-sensitivity photo slaves, such as those made by Wein, will pick up this infrared light and fire the remote strobe from distances as great as 500 feet.

Not only can you operate one remote strobe, but a photo slave allows you to fire as many strobes as you like, as long as you have a photo slave attached to each. You also can fire multiple strobes without cords by using a "radio slave," but most photographers find that the infrared setup is more reliable.

One note of caution. The slave-eye, unless it has a special frequency, can be tricked. If any other strobe or flash in the area goes off, the slave-eye might fire the remote strobes accidentally.

The setup works best when other pros are not firing their strobes and, even more irritating, when amateurs are not around using their instant cameras.

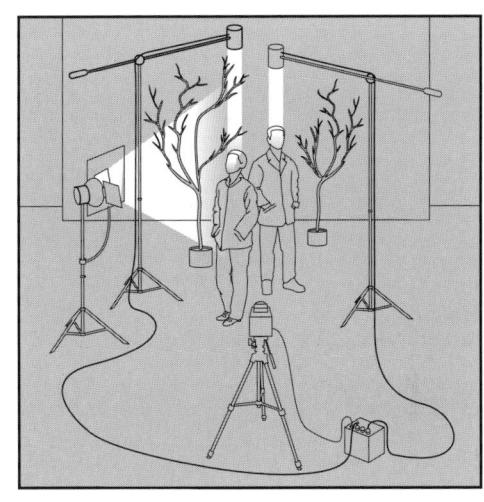

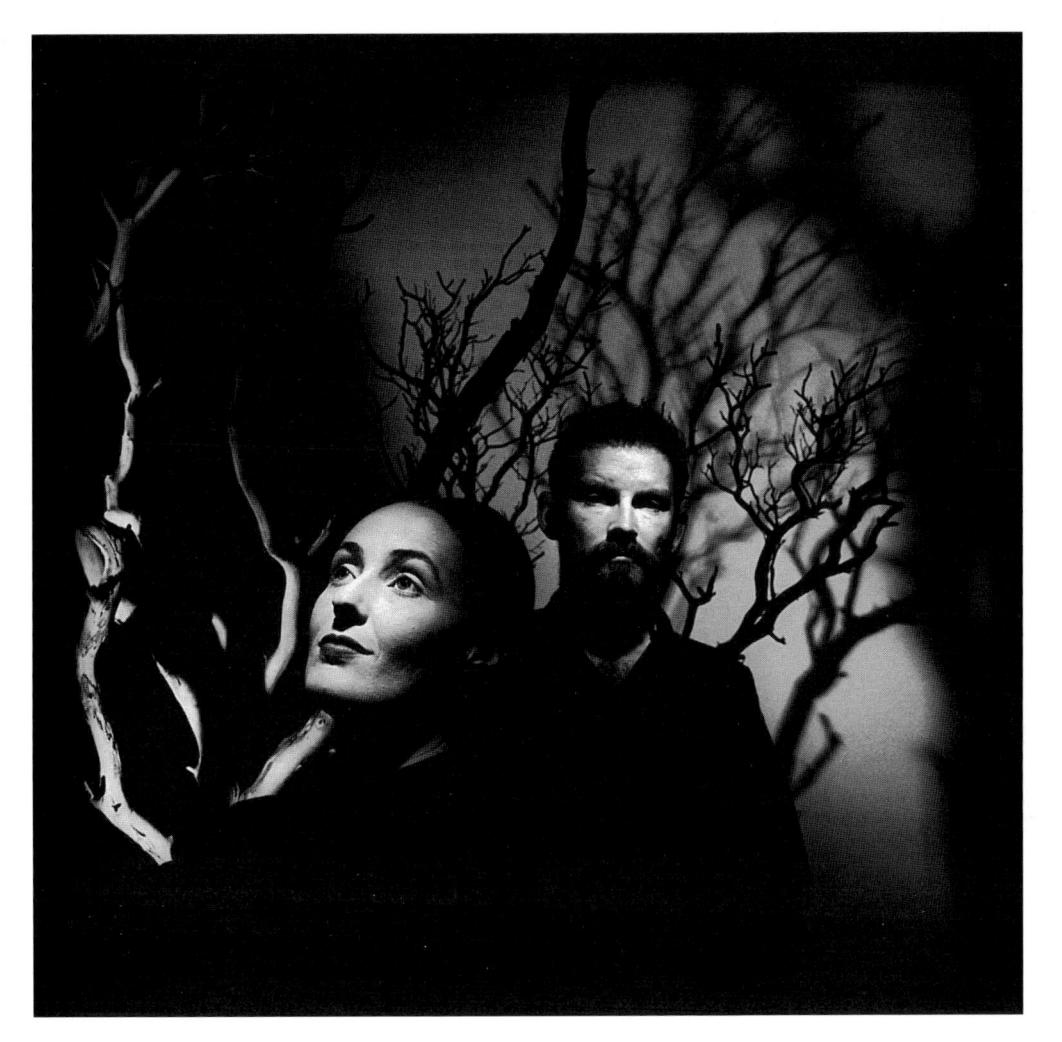

To light this picture of the musicians "Dead Can Dance," the photographer used a strobe head fitted with a grid spot. The grid spot, which looks like a miniature car grill, helps to focus the light to a small spot without producing harsh shadows while preventing the light falling onto areas other than where it is directed. The tree branches were lit with a third light that stayed on during the whole exposure. By changing the shutter speed, the photographer could control the brightness of the branches and their shadows.

(Photo by Michael Grecco, Inc., for *Rolling Stone*.)

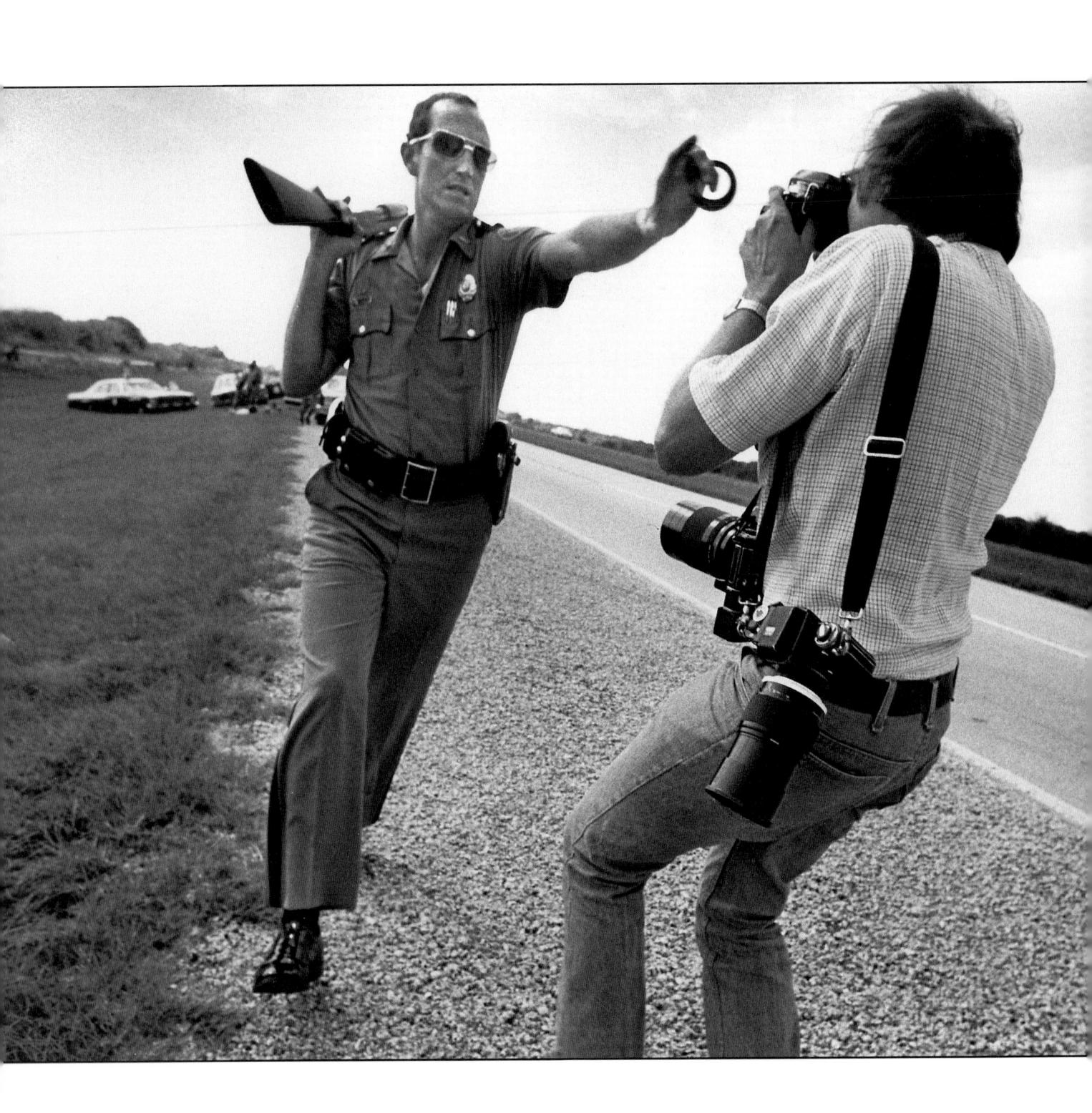

The Law

THE PUBLIC'S RIGHT TO KNOW VS. OTHER LEGAL RIGHTS

CHAPTER 14

hen people talk about "privacy," they usually mean the "right to be left alone." But privacy is simply not a broad constitutional right

This chapter was revised with the help of Dr. Michael Sherer, **Department of** Communication. **University of Nebraska** at Omaha.

basic to American citizens. The U.S. Constitution does not explicit-

left alone. In fact, most analysts believe that there never will be an explicit, expressed constitutional right of privacy similar to the right

outlined in the First Amendment that

ly grant us this general right to be

A state trooper illegally tried to block the cameras of two photographers from the Palm . Beach Post who were covering the arrest of an armed robber. (Far left C.J. Walker, and near left top and bottom

photos by Ken Steinhoff, the Palm Beach Post.)

A Life photographer took pictures of Antone Dietemann in his house without him knowing it.
Dietemann sued the magazine and won.
(Courtesy of Life magazine.)

protects and guarantees free speech and a free press.

Over the years, however, some commonly recognized legal principles of privacy have evolved, based on federal and state laws and court cases. These principles protect individuals from anyone:

- intruding by taking pictures where privacy could be expected;
- using a picture to sell a product without consent;
- unfairly causing someone to look bad; and
- taking truthful but private or embarrassing photos.

At first glance, this list might appear somewhat intimidating. You may ask yourself, "May I ever take a picture of anyone, anywhere?" In practice, though, the courts have severely limited the meaning of each of the four principles of privacy.

INTRUDING WHERE PRIVACY COULD BE EXPECTED

SHOOTING SURREPTITIOUSLY INSIDE SOMEONE'S HOME

When do you need an invitation into someone's home to take pictures? Take the case of Antone Dietemann, a West Coast herbalist who had achieved a considerable amount of public recognition and was newsworthy, but declined to be photographed in his home-laboratory garden.

Life photographer Bill Ray posed as the husband of a patient and visited the herbalist along with Ray's wife-for-a-day, also a Life staffer. She complained of a lump in her breast and asked to be examined. With a hid-

den camera, the photographer snapped pictures of the herbalist as he became engrossed in his therapy. Dietemann placed his hand on the patient's breast. He claimed that he could cure people by simply laying hands upon them. Bill Ray discreetly and quietly clicked off several frames. *Life* editors published the photos without Dietemann's permission. He sued the magazine because he claimed his privacy was invaded. He won on the grounds that the photographer took the pictures surreptitiously. Dietemann had not given his permission for the pictures to be taken. Individuals do have privacy rights in their own homes.

OUTSIDE THE HOUSE

The case of Ron Galella, self-styled paparazzo and pursuer of Jacqueline Kennedy Onassis for most of her public life, exemplifies the problem of intruding into someone's privacy outside the home. The former First Lady was newsworthy. Almost anything she did appeared in newspaper gossip columns. Like Princess Diana a generation later, any photo of Jackie a photographer could grab soon appeared on the cover of a national magazine.

Ron Galella is a full-fledged, full-time paparazzo who specialized in photos of Jackie. The word paparazzo means an insect similar to a mosquito in Italian. Director Federico Fellini, in his movie "La Dolce Vita," named the freelance photographers who covered the movie stars and other celebrities paparazzi "because they buzzed like mosquitoes."

Galella, who made his living buzzing after the stars, started tracking Jackie Kennedy Onassis in 1967. Galella hung around her New York City apartment and waited for her to step outside the door. When she bicycled in Central Park, he and his camera were tucked into the bushes. As she peddled by, he would shoot her picture. When she shopped at Bonwit Teller's, he ducked behind a counter and snapped away. When she ate at a restaurant in New York's Chinatown, he hid behind a coat rack to get the first photographs of the former First Lady eating with chopsticks. He even dated her maid for a few weeks in an attempt to learn Jackie's schedule.

Onassis sued Galella, charging him with inflicting emotional distress. The court had to balance Onassis' right of privacy against Galella's right to take pictures.

The court found in Onassis' favor. Galella was restricted from coming closer than 100 yards of her home and 50 yards from her personally. This ruling was later modified to prohibit him from approaching within 25 feet of her.

Note, however, that the court did not stop Galella from taking and selling pictures of the former First Lady, as long as the pictures were used for news coverage and not advertising. Few cases of this kind have arisen since the Galella-Onassis proceeding.

USING SOMEONE'S IMAGE TO SELL A PRODUCT

The law holds that you cannot publish a photo of a person for commercial purposes without obtaining consent from that individual. A company can't sell a product by identifying that product with someone without getting permission first.

Publishing someone's picture on the cover of a magazine or the front page of a newspaper is permissible if it is newsworthy. The court does not consider the newspaper or magazine itself a product. However, printing the same picture as part of an advertisement. without the subject's prior consent, is a violation of the person's right of privacy.

For instance, let's say that famous movie personality John Starstruck is driving down the street in a new Ford Thunderbird. Thinking your editor at the Daily Sunshine might want to use the photo because no one knew Starstruck was in town, you snap a picture of the movie star. You were right. Your editor runs the picture of Starstruck in his new car on page one. No problem. You've done nothing wrong, nor has your editor done anything illegal.

Ford Motor Company, however, seeing the picture, recognizes its advertising value because the photo shows a famous movie star driving in a Thunderbird. The company, after legally obtaining a copy of the photograph

 After Marion Brando broke photographer Ron Galella's jaw. Galella began wearing a football helmet to protect himself whenever he snapped pictures of the actor. (Photo by Paul Schmulbach.)

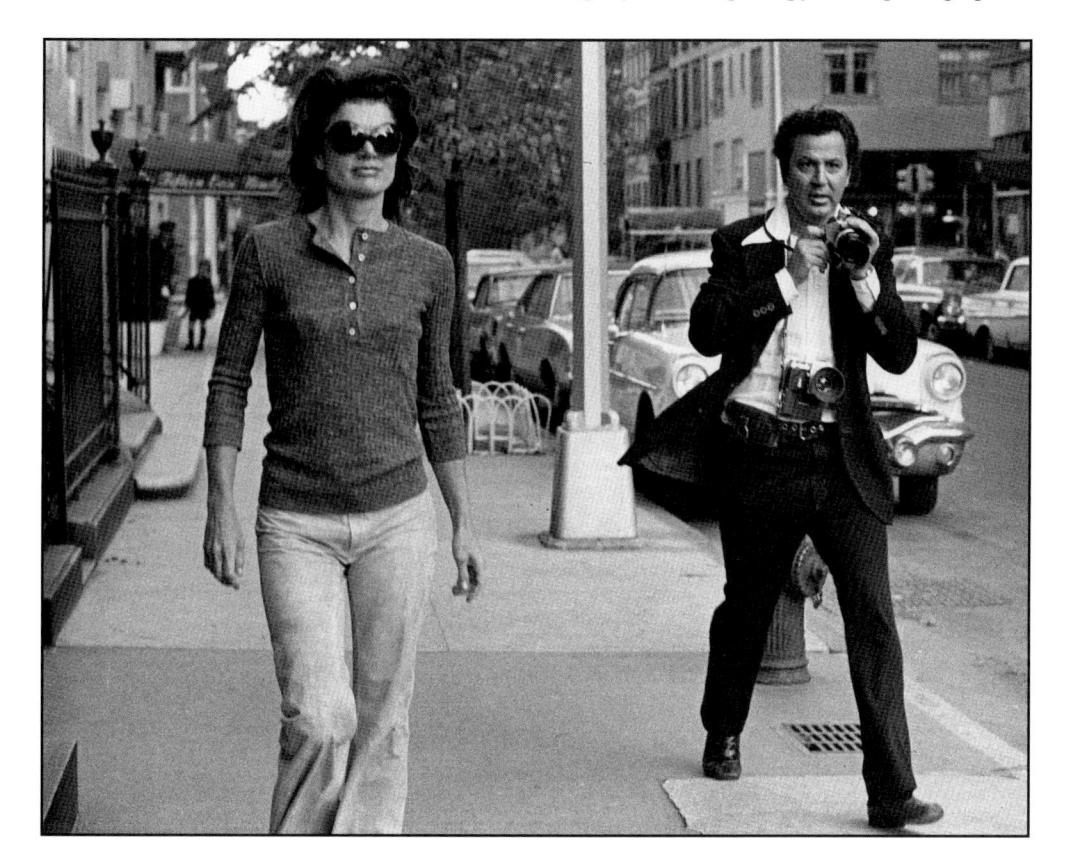

■ The late Jackie Kennedy Onassis sued Ron Galella, self-styled paparazzo photographer, for harassment, and she won. The court eventually restricted Galella from taking pictures within twenty-five feet of Onassis. (Photo by Joy Smith.)

There are no problems publishing this picture of President Bill Clinton in a newspaper or magazine story. But without Clinton's written permission, the photo could not appear in an ad selling saxophones.

(Photo by P.F. Bentley, for *Time* magazine.)

from your newspaper, uses the picture in an advertisement. If the viewer can recognize Starstruck in the Ford advertisement, then the movie star's privacy—in the sense of commercial appropriation—is violated. Ford is using Starstruck's image to sell its cars. Starstruck may sue the Ford Motor Company, and unless Ford can produce a consent form in court, the movie star will win. The consent form, signed by the subject, gives the photographer or publication the right to use the photo in an ad.

Reserving the commercial use of a person's image is not limited to just the famous. All individuals have the right to protect themselves from this form of commercial exploitation. When you take a picture for the newspaper, you do not need a consent form from the subject, famous or unknown. But when you take a picture that you want to sell to a company for use in an advertisement, brochure, fundraiser, and the like, then you must get a consent form signed, even if the subject is unknown.

UNFAIRLY CAUSING SOMEONE TO LOOK BAD

The law holds that people have the right of privacy not to be placed in a "false light." In other words, photos can't make a person look bad without cause. For example, a photographer photographed a child who had been struck by a car, and the picture appeared in a newspaper. No problem so far. Two years later, the *Saturday Evening Post* ran the same picture under the title, "They Ask To Be Killed," with a story about child safety. The

original use of the picture was a legitimate publication of a newsworthy event. But when the *Saturday Evening Post* used the headline with the picture and placed the subhead "Do You Invite Massacre with Your Own Carelessness?" next to the photo, the parents claimed that the words and photo implied carelessness on their part. The words and photo gave the impression that the child had willingly run out in front of the car. The court decreed that the photo/headline combination placed the parents in a "false light." The parents won the lawsuit.

Saturday Evening Post editors used a picture from their old photo file to accompany this new story. They used the old picture as an illustration of a general, ongoing problem. Often, this use of file photos provides the grounds for later lawsuits.

In another such incident, John Raible even signed a consent form allowing *Newsweek* magazine to publish his picture with a story about "Middle Americans." The editors, however, chose the headline "Troubled American—A Special Report on the Silent Majority," and printed Raible's picture below the headline. Raible felt that the headline, associated with his picture, implied he was troubled, thus putting him in a "false light." He sued and collected damages.

Both the Saturday Evening Post and the Newsweek cases show a picture's meaning can be affected drastically by the words associated with it. Although the picture itself might have been legal when it was taken, after captioning or headlining, the photoplus-word combination can be considered

illegal. Robert Cavallo and Stuart Kahan, in their book *Photography: What's the Law?*, say that "Pictures, standing alone, without captions or stories with them, generally pose little danger of defamation. However, an illustration is usually accompanied by text, and it is almost always that combination of pictures and prose which carries the damaging impact."

The *Newsweek* case points up a second legal danger for the photographer to watch for. The consent form signed by Raible did not protect the photographer. The consent form is not a carte blanche; it is a limited authorization given by the subject to the photographer, warning the photographer to use the picture in an understood and agreed-on manner. A consent form does not give photographers or picture editors the right to use a picture in any way they see fit.

TAKING TRUTHFUL BUT PRIVATE OR EMBARRASSING PHOTOS

The right of privacy does include some restrictions on printing truthful but private or

embarrassing information about a subject. Generally, if the information is newsworthy and in the public interest, the press can photograph and publish the facts. The courts have liberally interpreted "public interest" to mean anything interesting to the public—and there are few things that won't interest some people.

PUBLIC BUT EMBARRASSING

The courts, however, have put certain limitations on the right of the public to know and see true but confidential facts about a person. Photographs, even if taken in a public place, should not ridicule or embarrass a private person unless the situation is patently newsworthy. The photos should not be highly offensive to a reasonable person and must be of legitimate concern to the public.

A Ms. Graham went to the Cullman, Alabama, county fair. After several rides, she entered a sideshow fun house. In the fun house, she walked across a grate that blew up her dress. At that unlucky moment, a photographer from the *Daily Times Democrat*, Bill

They Ask to Be Killed

By DAVID G. WITTELS

Do you invite massacre by your own carelessness? Here's how thousands have committed suicide by scorning laws that were passed to keep them alive. The parents of this child claimed that the combination of words and pictures implied that they were careless, thus placing them in a false light. When they sued the Saturday Evening Post, the court decided in their favor.

(Reprinted from the

(Reprinted from the Saturday Evening Post, © 1949, The Curtis Publishing Co.) Even though John Raible had signed a consent form, he sued Newsweek and won because he felt the headline and this picture put him in a "false light."

(Reprinted from Newsweek.)

Ms. Graham was in a public place and her face wasn't even visible when she was photographed at the **Cullman County Fair.** She said her children were recognizable, and the courts agreed with her that this picture, though truthful, was embarrassing, and therefore, she could collect damages. (Reprinted from the [Alabama] Daily Times

Democrat.)

Without Dorothy
Barber's permission, a
photographer took her
picture in her hospital
room. When the photo
ran in *Time* magazine,
Barber sued for invasion
of privacy and won.
(International News
Pictures.)

McClure, was on his first photo assignment for the paper—looking for "typical" features at the fair. With his Speed Graphic, he snapped Graham's picture just as her skirt blew up around her hips, exposing her underwear. After the picture was published, Graham called and complained. Getting no satisfaction from the photographer with an apology or retraction, Graham hired an out-of-town lawyer and successfully sued the *Democrat* for damages. The picture was truthful, but the jury found that the photo was

embarrassing and contained no information of legitimate concern to the public.

SPECIAL CHILDREN

You may take pictures of children; however, if they are in a special education class, and you take a picture, their parents may consider that photo truthful but embarrassing. They could sue you and your newspaper. Getting the teacher's permission is not sufficient. To run the picture of a mentally or physically disabled child, you must have the consent of the parent or legal guardian.

You can take and publish pictures of children in schools and public parks. You are open to suit only if the photo might be considered embarrassing or derogatory.

HOSPITALS

In 1942, an International News Photo photographer entered the hospital room of Dorothy Barber, who was in the hospital for a weight-loss problem. Without Barber's consent, the photographer took a picture of her, which *Time* magazine bought and ran under the headline "Starving Glutton." Barber sued the magazine, and *Time* lost the case. A Missouri court said, "Certainly if there is any right of privacy at all, it should include the right to obtain medical treatment at home or in a hospital without personal publicity."

Dorothy Barber had what the court considers a "private medical condition." Therefore, a photographer could not take her picture without her permission.

ACCIDENTS

If someone is injured in an automobile accident or plane crash, falls out of a tree, nearly drowns, or is struck by lightning, that person would have a "public medical condition." Or, if a person has been shot by someone committing a crime, the victim's condition would be considered "public." People who are victims of a crime, accident, or an "act of God" are considered newsworthy, and they can be photographed outside the hospital.

If an accident happens at the corner of Pacific and Hyde Streets, the photographer can begin taking pictures of the victim upon arriving at the scene because the victim has a public medical condition and is not in the hospital. As the rescue team places the victim on the stretcher and slides the body into the ambulance, the photographer is still within legal rights to continue to photograph.

Once the victim enters the emergency van, however, the person is covered by the right of privacy and is off limits to photographers. The same off-limits rule inhibits photographers once the victim enters the hospital.

If a person's condition is newsworthy, interesting, and historic, but was not caused by crime, accident, or an "act of God," the person's medical condition is considered "private." Barber's treatment was "private." The first heart and kidney transplants and the first test-tube baby were both "private medical conditions," even though they were newsworthy. Photographers could take pictures inside the hospital only if the patients involved granted permission.

THE LAW OF TRESPASS: THE HOME AS CASTLE

Without going onto a person's property, you may, from the street, photograph someone in her yard, on her porch, or even inside her house if you can see the person. You don't need the owner's permission. For instance, the courts consider people sitting on their verandas, mowing their lawns, or standing behind a picture window in their living rooms to be in "public view" and therefore legitimate subjects for photography.

The photographer still should be somewhat cautious when shooting onto private property, however, and should not step onto the grounds to get the picture. Nor should the photographer use an extremely long telephoto lens, which would capture more than the naked eye could see.

In fact, the court says you shouldn't go to any extra trouble to get this porch-sitting, lawn-mowing, or window-standing shot. You shouldn't even climb a tree to gain a better

view. Although not all photographers follow these guidelines, all are limited essentially to the view of an average passerby, according to the courts.

ACCESS VS. TRESPASS: **CHANGES OVER TIME**

Common practice for police to "invite" in photographers

Cindy Fletcher, fourteen years old, died in a house fire in Jacksonville, Florida. Her mother, who was away at the time, learned about the tragedy in the next day's edition of the Times-Union. Alongside the story appeared a picture that showed where her daughter's burned body had left a silhouette scorched on the floor. Newspaper photographer Bill Cranford had entered the Fletcher home to take the photo. Mrs. Fletcher sued the Florida Publishing Company, owner of the Times-*Union*, on grounds that the photographer had invaded her home, hence her privacy.

This actual court case serves to illustrate the problem of access for the working photographer. Did the photographer, as a representative of the news media, have the right to enter the house? Which right comes first: the right of Mrs. Fletcher not to have someone trespass in her house, or the right of the public to know what happened in that house? Would you have entered Fletcher's home if you were the photographer?

In *Florida Publishing Co.* (Times-Union) v. Fletcher, the court found in favor of the photographer. He had the right to enter the house and take the pictures. Yet, in other cases, the courts have recognized the right of

A photographer has the legal right to take this picture because the accident occurred on a public street.

(Photo by Carolyn Cole for the Sacramento [California]

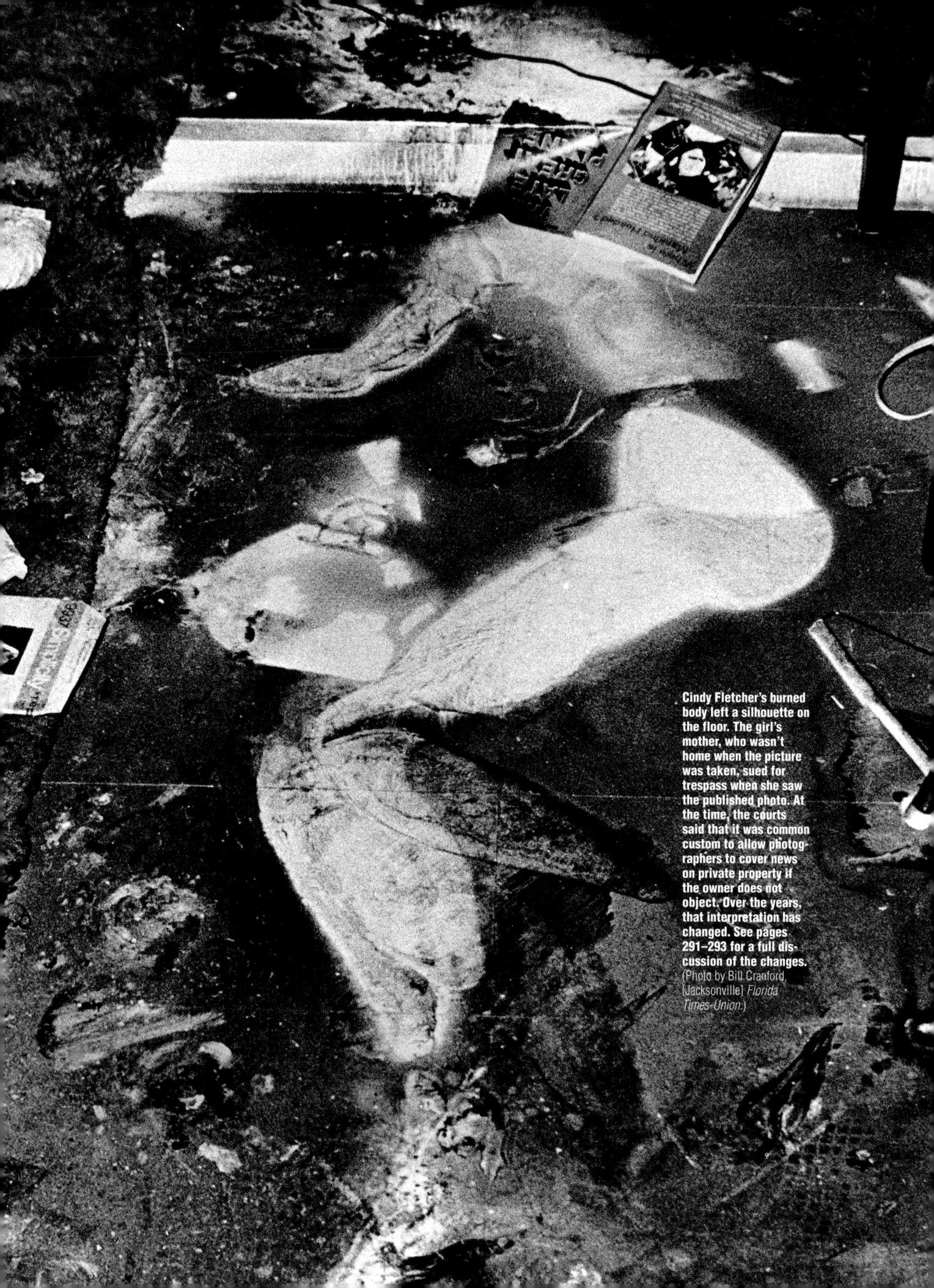

private ownership over newsworthiness.

Trespass generally means entering someone's home, apartment, hotel, motel, or car without permission. This right of private ownership prohibits someone from walking in and taking pictures inside a house, without the permission of the resident.

Why, then, did the court find that the *Times-Union* photographer had the right to enter the Fletcher house and take pictures of the silhouette left from Cindy Fletcher's burned body?

Why was this not a case of trespass? In the Fletcher case, the police and the fire marshal had invited the news photographer into the home. No one objected to the cameraman's presence. In fact, the authorities had asked the photographer to take pictures because they needed photos for their investigation, and the fire marshal's camera was out of film. Mrs. Fletcher's suit was dismissed because it was "common custom" for the fire department or police department to permit the press onto private premises for the purposes of covering such newsworthy events.

Also, in the Fletcher case, no one had objected to the photographer's presence. Immediately, one asks, "How could Mrs. Fletcher object when she wasn't there?" That's the "Catch-22"—a legal dilemma. Had she been there and had she said "no," the photographer, despite official invitation, would have been trespassing. But Mrs. Fletcher did not say "no," and the fact that she couldn't say "no" wasn't relevant, according to the courts... at the time.

CBS' Street Stories

"like rogue police," says judge
More recent court findings, however, call
into question the "common custom" of the
Fletcher case (Tawa Ayeni v. CBS Inc.,
and United States of America v. Anthony .
Sanusi, et al.).

The facts. A CBS camera crew was shooting an episode for "Street Stories," a real-life cop show, when police invited the news team to participate in a raid on a suspect's home. The police were looking for evidence of credit card fraud.

However, the suspect was not at home when the raid occurred. Only his wife, Tawa Ayeni, and her small child were there when the police officers pushed their way into the apartment—with the CBS video crew right behind them. The woman, clad only in her nightgown, implored the all-male crew, "Please don't take my picture."

She cowered, covered her face with a magazine, and directed her preschool son not to look at the camera. "Why do you want to

take a picture?" she asked. When the raid was over, law enforcement officials found nothing they had sought, but the CBS crew had footage of the raid, including shots of personal letters and paycheck stubs.

Tawa Ayeni sued CBS and won at both the trial level and in the Federal Court of Appeals. Judge Jack Weinstein wrote, "Allowing a camera crew into a private home to film a search-and-seizure operation is the equivalent of a rogue policeman using his official position to break into a home in order to steal objects for his own profit or that of another."

Although law enforcement officials generally have a right to enter private property to conduct a reasonable search, Judge Weinstein maintained that this privilege does not extend to photojournalists invited along for the affair. Judge Weinstein wrote that inviting a camera crew into a private home is an unreasonable violation of the Fourth Amendment, which protects private citizens against the state conducting unlawful searches.

Note that this finding runs counter to the "common custom and practice" concept that was established in the Fletcher case, where fire officials had invited the photojournalist into a private home to shoot the aftermath of a fatal fire. In the ruling against CBS, Judge Weinstein's views are more in line with contemporary court opinions that generally find little support for a police officer's "right" to invite photojournalists and reporters onto private property.

Supreme Court:

Ridealongs violate Fourth Amendment
The question of ridealongs has now reached
the Supreme Court. In the early morning
hours of April 16, 1992, a special team of
U.S. Marshals called the "Gunsmoke Team"
had invited a reporter and photographer from
The Washington Post to accompany them as
part of a Marshals Service ride-along policy.

At around 6:45 A.M., with media representatives in tow, the officers broke into Charles and Geraldine Wilson's home while the couple were still in bed. The Marshals were looking for Charles Wilson's son, who was not at home. The father, dressed only in a pair of briefs, ran into his living room to investigate the noise. Discovering at least five men in street clothes with guns in his living room, he angrily demanded that they state their business, and repeatedly cursed the officers. Believing him to be the subject of the warrant, the officers quickly subdued Wilson on the floor. Geraldine Wilson next entered the living room to investigate, wearing only a nightgown.

When their protective sweep was completed, the officers learned that Dominic Wilson, the son, was not in the house, and they departed. During the time that the officers were in the home, *The Washington Post* photographer took numerous pictures, although the newspaper never published the photographs of the incident.

Mr. and Mrs. Wilson sued the law enforcement officials (*Wilson v. Layne*). They contended that the officers' actions in bringing members of the media to observe and record the attempted execution of the arrest warrant violated their Fourth Amendment rights.

The case wound its way to the Supreme Court, which came to unanimous agreement. "While executing an arrest warrant in a private home, police officers invited representatives of the media to accompany them," wrote Chief Justice William Rhenquist. "We hold that such a 'media ridealong' does violate the Fourth Amendment."

In all probability, this Supreme Court finding will have a discouraging effect on opportunities for photographers to accompany police when they enter a house to execute a search warrant.

Most police will not want to violate the Fourth Amendment or have their cases thrown out of court in the future because they invited or allowed photographers to go along on a drug bust or police raid inside someone's home. However, the ruling does not stop the police from allowing photographers to cover their activities on public property like streets or sidewalks.

Challenging customs

Can you photograph a newsworthy event in a person's home if the owners do not object, and the police have not yet arrived? If you were riding down the street and heard a gunshot followed by a scream coming from a house, you could park your car, enter the house, and begin photographing the victim and the assailant.

If the homeowner realized what you were doing and didn't like it, the owner could ask you to leave. You would have to obey or be arrested for trespassing. Even if the police were there, you would have to leave if the homeowner objected to your presence.

The Florida Highway Patrol, after a strong protest from the *Palm Beach Post Times* about the harassment of two staff photographers (see opening spread of this chapter), issued a policy statement regarding "Journalists' Right of Access to Crime, Arrest, or Disaster Scenes." The statement said, in part, "It is the long-standing custom of law-enforcement agencies to invite repre-

sentatives of the news media to enter upon private property where an event of public interest has occurred . . . " *Wilson v. Layne* (see above) certainly challenges that long-standing custom.

"Invite," in this case, means to allow the photographer to enter. The common custom had existed for photographers to cover news events and not be harassed or otherwise blocked by the police. Still, photographers should not wait for an engraved invitation from the cop at the scene before beginning to photograph. But neither should photographers expect to be "invited" to follow police into people's homes during searches or arrests, especially following the Supreme Court's decision.

The Florida Highway Patrol's policy statement goes on to say, "the presence of a photographer at an accident, crime, or disaster scene and the taking of photographs at the scene does not constitute unlawful interference and should not be restricted."

Unfortunately, this position is a policy statement of the Florida Highway Patrol, not a national or even a state law; therefore, the policy is not followed by police and fire-fighters in every state. In fact, only California has a specific law that states "accident and disaster areas shall not be closed to a duly authorized representative of any news service, newspaper or radio or television station or network." Even this law, however, does not protect the photojournalist if the police claim that the photographers will interfere with emergency operations.

PRIVATE PROPERTY OPEN TO THE PUBLIC

Do you have the right to take pictures on private property that is open to the public, such as a restaurant or grocery store? This area of the law is murky. Some authorities hold that you can take pictures unless the management has posted signs prohibiting photography or unless the owners object and ask you to stop. However, CBS was sued when its photographer entered the Le Mistral restaurant in New York, with cameras rolling, to illustrate a story about the sanitation violations of the establishment. The management objected, but CBS kept filming.

Although no signs prohibiting photography were posted, CBS lost the suit on the ground that the photographer had entered without the intention of purchasing food and was therefore trespassing. Although CBS was covering a legitimate news story in a private establishment open to the public, the network was found guilty of trespassing.

In a 1972 case (Lloyd Corp., Ltd. v. Tanner)

the court ruled that "the public's license to enter a private business establishment is limited to engaging in activities directly related to that business and does not normally extend to the pursuit of unrelated business, e.g., news gathering."

Camera journalists have no right to enter the property, even in a spot-news situation, if they are prohibited to do so by the owners of the establishment. Photographers must take their pictures from the public street, or they can be sued for trespass.

This means that, even if a fire is raging inside a business, the management can exclude photographers. If the management asks you to leave, you must comply with the request, or you can be arrested for trespassing. You can, however, still publish any pictures you have already taken. The proprietor can stop you from taking more pictures, but he can't restrict you from printing the ones you already have.

Retired California Appeals Court Justice John Racanelli points out that penalties for trespass are usually "nominal" if there is no intent to "do actual harm or injury."

Sometimes a manager will demand the film you have taken inside the store. On this point the law is clear. You do not have to give up your film. The owner or manager can ask you to stop taking pictures but can't take away your film. That film is your personal property, and you have every right to keep it.

RESTRICTIONS EVEN IN PUBLIC

You may photograph in public places and on public property. You can take pictures on the street, on the sidewalk, in public parks, as well as in the public zoo. You can photograph in a city-owned airport as well as in public areas of schools and universities. However, without the teacher's permission, you can't take pictures of a class in session.

You may take pictures of elected officials or private citizens in public places, such as the street or the park. The person may be the center of interest in your photo, or just part of the crowd. If a news event occurs on public property, then you may cover that event as long as you do not interfere with police or the flow of traffic.

There are times when bystanders or relatives try, by physical assault, to prevent photographers from taking pictures. In such instances, the courts have generally protected photographers when they shoot in public places, according to George Chernoff and Hershel Sarbin in their book *Photography and the Law*. They note that, some years ago, the state of New York even made it unlawful to damage the equipment of news

WHERE AND WHEN A PHOTOJOURNALIST CAN SHOOT				
	ANYTIME	IF NO ONE Objects	WITH RESTRICTIONS	ONLY WITH PERMISSION
PUBLIC AREA Street Sidewalk Airport Beach Park Zoo Train Station Bus Station	X X X X X X		X	
IN PUBLIC SCHOOL Preschool Grade School High School University Campus Class in Session	х		X X X	х
IN PUBLIC AREA— WITH RESTRICTIONS Police Headquarters Government Buildings Courtroom Prisons Military Bases Legislative Chambers			X	X X X
IN MEDICAL FACILITIES Hospital Rehab Center Emergency Van Mental Health Center Doctor's Office Clinic				X X X X X
PRIVATE BUT OPEN TO THE PUBLIC Movie Theater Lobby Business Office Hotel Lobby Restaurant Casino Museum Shopping Mall Store in Mall		X X X	х	X X X
PRIVATE AREAS VISIBLE TO THE PUBLIC Window of Home Porch Lawn	X X X			
IN PRIVATE Home Porch Lawn Apartment Hotel Room Car		X X X X X		

photographers engaged in the pursuit of their occupation in public places.

Difficulties arise when police authorities try to stop photographers from shooting on public property. In many situations, an overeager police officer may block a photographer's lens. In Iowa, photographers were once prevented by highway patrol officers and the National Guard from taking close-ups at the scene of a civilian airline crash. When airline officials arrived, photographers were given a free hand. In Philadelphia, police forcibly prevented photographers from taking pictures as officials bounced a heckler from a political rally. Philadelphia's city solicitor issued a formal opinion in which he told the police commissioner, "Meaningful freedom of the press includes the right to photograph and disseminate pictures of public events occurring in public places."

Police and fire officials have the right to restrict any activity of a photographer that might interfere with the officials' action. But taking pictures and asking questions do not constitute interference. Unfortunately, if a police officer stops you at the scene of a breaking-news event, you might find it hard

to argue a fine point of law with an insistent cop. Photographers who disregard police directives—even if they have the right to be where they are—can be arrested for disorderly conduct or for interfering with a police officer in the performance of duty, which could be constituted as a possible felony.

The National Press Photographers Association (NPPA) and some of its chapters have for years worked with fire and police academies to improve the graduates' understanding of the role of news in society. NPPA members have written police/press guidelines designed to reduce the conflict between working photojournalists and law enforcement officers. The result has been improved cooperation between photographers and fire and police personnel.

GOVERNMENT BUILDINGS: PUBLIC BUT UNDER SPECIAL RULES Although facilities may be publicly owned, a photographer does not have unlimited access to government buildings, such as the U.S. Senate and House of Representatives, the state legislature, or the chambers of the city council. The mayor's office and city hospital

During Bruno Richard Hauptmann's trial for kidnapping and killing Charles Lindbergh's baby, the judge prohibited photographers from taking pictures while court was in session. On January 3, 1935, Lindbergh himself took the stand. Despite the judge's orders, a photographer snapped the picture during the trial. With only a few exceptions, after this trial cameras were barred from the courtrooms until the 1970s.

Accused of bending over to "bare it all" during their show, exotic dancers demonstrated for the judge that their underwear covered up anything "illegal." Pictures are now possible in most courtrooms. The photographer in this instance got a tip that an interesting performance might take place in court.

(Photo by Jim Damaske.)

also fall under the special-rules category. Military bases and jails also are strictly controlled.

As mentioned above, hospitals, even if they are publicly owned, publicly supported, and publicly operated, occupy a special place under the law. It's true that the admission list to hospitals is public information, but that's about all. You might be allowed to photograph scenes in a hospital for, say, a feature story. But check your pictures. Are there people in the pictures? Yes. Are some of the people in the pictures patients? Yes. Are they identifiable? Yes. Do you have a release form? No. You say the people in the photo are "incidental"? For instance, a picture taken of a corridor or waiting room shows several people sitting and reading magazines. No matter. You must either (a) get a release form; (b) not run the picture; or (c) make the subjects unidentifiable in the darkroom or with the computer.

The halls of the U.S. Congress are certainly public places, as are meeting rooms of state legislatures and city councils. But such places are generally run by their own unique rules. Even though the House of Representatives does allow television cameras limited access to debates, this legislative body will not allow photographers to take still pictures at a regular session of Congress. Politicians are afraid that the uncensored film of the still photographer will catch one of the members of this august body taking a nap, reading the newspaper, or, as is more often the situation, absent from his or her

seat. Photographers are usually allowed in the U.S. House or Senate chambers only during ceremonial sessions, such as the opening day of Congress.

Photographers can snap legislators in committee meetings, elected officials in the halls of Congress, or legislators in their offices. Certain buildings—the Capitol and its grounds, all the House and Senate office buildings, the Library of Congress, and the General Accounting Office—are controlled entirely by the rules passed by Congress. The Constitution grants Congress the right to formulate special rules for operating these buildings. These rules are not subject to judicial review.

THE COURTROOM: ANOTHER SPECIAL SITUATION

The U.S. Supreme Court does forbid the presence of photographers in federal court-rooms but not in state courts. The effort of photojournalists to obtain access rights to both federal and state courtrooms has had a turbulent history.

A low-water mark in photographing in the courtroom occurred during the trial of Bruno Richard Hauptmann for the kidnapping and murder of Charles Lindbergh's infant child. Lindbergh had captured the admiration of the entire world for his nonstop, solo, trans-Atlantic crossing. The kidnapping and murder of his child attracted international interest, and an estimated 700 reporters, including 129 photographers, came to the old courthouse in Flemington, New Jersey, to

cover the trial. Photographers were allowed to take pictures in the courtroom only three times each day: before court convened, at noon recess, and after court adjourned. Early in the trial, however, a photographer took unauthorized pictures of Lindbergh on the stand. The photographer claimed that he was "new on the job, having been sent as a relief man, and he did not know the rulings."

Another illegal picture was taken at the end of the trial. Dick Sarno of the *New York Mirror* concealed a 35mm Contax camera when he entered the courtroom on February 13, 1935, the day the verdict and sentence were announced.

At the key moment of the proceedings, Sarno, who had wrapped his Contax in a muffler to conceal the noise, took a one-second exposure of the courtroom. Sarno later related, "As Hauptmann stood up and faced the jury, you could hear a pin drop. I tilted the camera, which I had braced on the balcony rail. The judge was directly in front and below me. If he looked up, I was sure he could see me."

As the foreman of the jury stood to recite the verdict, Sarno recorded the instant.

Prejudicial press reports, contemptuous statements by trial attorneys and police, the

rowdy behavior of the 150 spectators and numerous reporters added to the holiday atmosphere of the proceeding, according to extensive research by Sherry Alexander in "Curious History: The ABA Code of Judicial Ethics Canon 35." The raucous atmosphere created by photographers and reporters covering the trial outside the courtroom as they mobbed each witness, as well as indiscretions by still and newsreel cameramen inside the courtroom, shocked a committee of the American Bar Association (ABA) that reviewed the legal proceedings in 1936.

Nevertheless, Alexander found, the original ABA Committee did not recommend a total exclusion of photography and broadcasting in the courtroom.

Instead, it was the 1937 convention of the group that adopted a flat ban on cameras in

Instead, it was the 1937 convention of the group that adopted a flat ban on cameras in court as the 35th Canon of Professional and Judicial Ethics. Many states, but not all, adopted these canons, effectively slamming the courtroom door shut on photojournalists for forty years.

Courtroom restrictions easing

Florida's judicial system and legal code are viewed as the model by many states. In the late 1970s, when the Florida Supreme Court opened the courtroom to photographers and television equipment on a limited basis for a one-year period, the event was significant. The Florida test allowed nationwide broadcast of the trial of fifteen-year-old Ronnie Zamora, who was charged with killing his eighty-two-year-old neighbor.

Zamora's attorneys tried to blame television for the murder committed by their client. Noting that he avidly watched Kojak, a popular detective program, defense attorneys claimed the boy was under "involuntary subliminal television intoxication."

While the defense proved unsuccessful, the experiment allowing photographers to cover the trial worked well. With modern fast films and compact electronic television cameras, photographers did not require excessive lighting, and their behavior did not interfere with the trial's progress. Florida permanently opened its courts to the camera.

In 1980, the Supreme Court upheld the constitutionality of Florida's open courts law. In *Chandler v. Florida*, two police officers convicted of burglarizing a restaurant claimed that the presence of TV cameras denied them a right to a fair trial because local stations broadcast only highlights of the prosecution's case.

But when the Supreme Court considered the officers' appeal, the Justices ruled unanimously that states are not prohibited from allowing still and television cameras in their courts. The decision was a major victory for photojournalists' First Amendment rights.

By 1999, all states except Mississippi and South Dakota had opened their courtrooms to the camera. There is even a cable television channel devoted to covering trials. Each state, however, continues to have unique and individual restrictions. Check your state's rules and regulations before you shoot.

LIBEL AND THE PHOTOGRAPHER

Libel is a printed, written, or pictorial

Although truth is an absolute defense for libel, and this picture was "true," Mr. Burton sued when he saw what he looked like in this portion of a Camel cigarette ad. Burton had given permission for the ad, yet the court found publishing the picture was libelous.

statement that is defamatory to a person's character and reputation. The image must have been published or shown to another individual due to negligence on the part of the photojournalist or due to a willful disregard for the truth.

Since truth is a defense in libel cases, and since photos represent actual scenes and are truthful, it might seem that a person should not be able to win a libel suit against a photographer. However, a number of successful libel suits have been based on photographs, which can subject someone to ridicule, contempt, or hatred just as effectively as words can. Photographs can lie, or at least appear to lie, and photos in conjunction with print may form the basis for a libel suit.

Usually, a photo alone is not libelous, although such cases have occurred. The most famous involved a Mr. Burton, who was paid for a cigarette endorsement (opposite page). For the advertisement, Mr. Burton was photographed holding a saddle in front of him. In the photograph, quite by accident, the saddle's wide girth strap appeared to be attached to the man, giving, in the court's words, a "grotesque, monstrous, and obscene" effect. The photo was deemed libelous.

In some situations, when words have been added to photos via headlines, captions, or stories, the photo/word combination has resulted in libel. The photograph itself may be harmless, but the accompanying words may add the damaging element. For example, the *New York American* once printed a photograph of a wrestler, a Mr. Sbyszko, next to that of a gorilla, with the caption: "Not fundamentally different in physique." The photo-plus-word combination was libelous. As in cases involving privacy, photographers must be particularly careful how their pictures are associated with words.

Many photographic libel suits have involved individuals arrested as robbery suspects, according to Michael Sherer's report, *No pictures please: It's the law*. Sherer notes that individuals allegedly involved in murder, illegal drugs, smuggling, police corruption, financial misdealing, illegal gambling, organized theft rings, and organized crime have sued for libel when their pictures appeared in print. In addition, he notes, people have sued because they felt photos of them implied sexual promiscuity or abnormal or illegal sexual activity.

To prove that a photo is libelous, the defendant must show that the photojournalist acted with willful disregard for the truth or was unprofessional. By using proper reporting procedures in gathering and publishing the photos, several media defendants have suc-

cessfully defended themselves in libel cases.

Sherer notes that problems arise when courts discover that proper reporting techniques were not used to obtain the photos. For instance, photographers failed to verify that individuals who were photographed during arrests were indeed suspects in the robberies or suspects accused of prostitution.

Finally, Sherer cautions that, if you have any doubt that the subjects pictured are not the same people as those mentioned in the accompanying caption or news story, find another way of illustrating the story.

PRESS CREDENTIALS USEFUL BUT LIMITED

Press credentials issued by the newspaper or magazine for which you work are a means of identification and nothing more. Press passes entitle you to nothing. Authorities use press credentials to determine if you are an official media representative and then may "invite" you to the scene of a crime or disaster.

Essentially, your press pass gives you no more rights than those held by the public. The press credential does not give you a right to break the law, even if you are in hot pursuit of a big news story. Sergeant Carl Yates of the Louisville, Kentucky, Police Department characterizes the situation this way: "You have no more right of access than the general public. What you do have, and what you hope the police will recognize, is that you have more of a reason to be there than the general public."

Credentials issued by the highway patrol or the state police carry no legal weight other than providing proof you work for a newspaper or magazine. Official credentials can be ignored or recalled at any time by the law enforcement agencies that issued them.

On the other hand, authorities cannot discriminate against you or your newspaper at the scene of a crime or disaster. All reporters, photographers, and TV camera operators must have an equal opportunity to cover the story. The police cannot select one newspaper photographer and reject another. Nor can police choose to let in television camera crews and keep out still photographers. If the crime scene is crowded, however, they can ask photographers to cooperate and form a pool. One pool representative will photograph in the restricted area, and then share the pictures with the other photographers.

SUBPOENAS FOR NEGATIVES

A reporter for the *Louisville* (Kentucky) *Courier-Journal* wrote a story about making hashish from marijuana. The article included a photograph of a pair of hands working

Press credentials provide identification but do not supply any special legal rights.

(© Wide World Photos.)

Police subpoenaed the photographer's images for possible use in court after this student riot occurred in Bloomington, Indiana. To avoid having the appeals court set a negative precedent in his state, the photographer finally turned over his pictures. (Photo by Richard Shultz.)

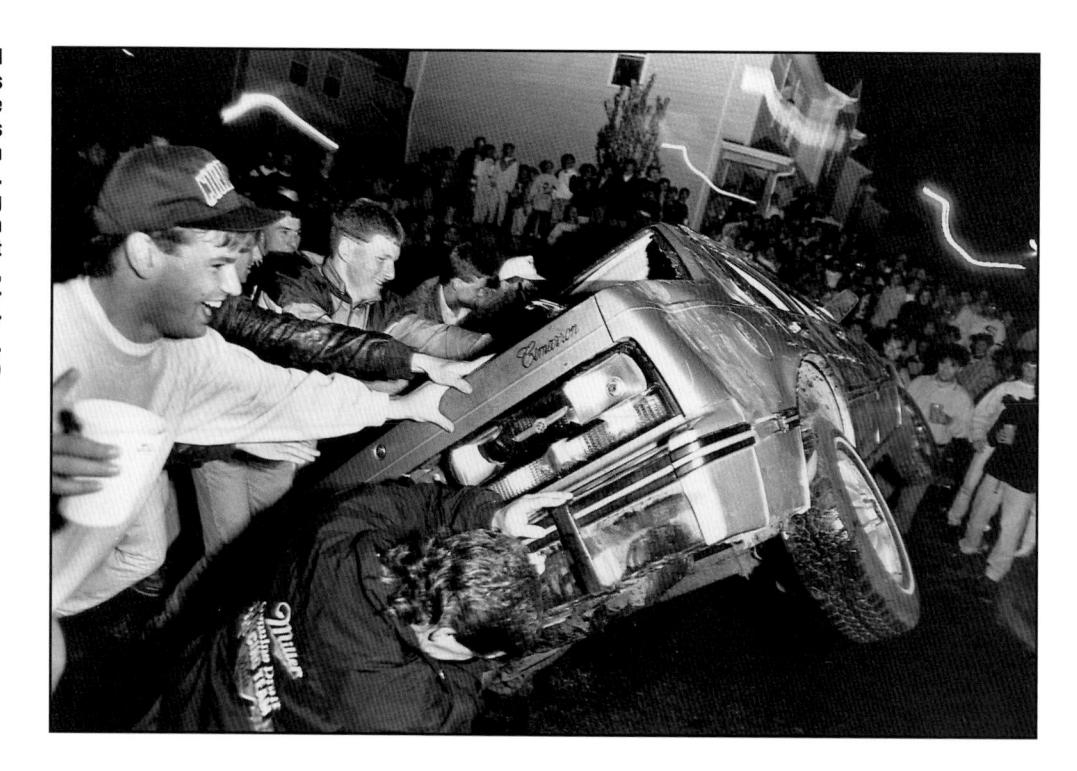

AUTHOR'S NOTE

Laws differ from state to state. States pass new laws and drop old ones as courts set precedents. These laws and precedents are fairly clear about what is restricted, but they are usually unclear about what is permissible. No chapter on photojournalism law is totally comprehensive or definitive. This chapter should be read as a guide to your rights as a photojournalist. For more specific information about the laws in your state, check with a media specialist from your local bar association.

over a laboratory table with the caption identifying the substance in the photo as hashish. After the article and photograph were published, the reporter was subpoenaed to appear before a grand jury and ordered to testify about whose hands had appeared in the photograph. The reporter claimed that both the First Amendment of the U.S. Constitution and a state law protected his confidential source of information. The U.S. Supreme Court said the reporter had witnessed a crime and that the sources did not receive special protection (*Branzburg v. Hayes*).

While a number of states have laws that, to some extent, shield reporters and photographers from courts subpoenaing negatives and notes, each state's laws are different. Unfortunately, the federal government has no shield statute that protects journalist-source confidentiality. And existing state laws provide only limited protection, especially when the photojournalist witnesses a crime. As the Supreme Court ruled in the marijuana and hashish case, "The crimes of news sources are no less reprehensible and threatening to the public interest when witnessed by a reporter than when they are not."

A subpoena for negatives and prints, surprisingly, is the number one legal problem faced by news photographers, according to a survey of NPPA members by Michael Sherer of the University of Nebraska at Omaha.

He found that 25 percent of the survey respondents had been subpoenaed for photographic materials in incidents similar to one

faced by Richard Schultz after he photographed a street riot (above). Sherer recommends not complying with a subpoena without first consulting with a lawyer and your editor. Finally, he cautions against destroying photographs sought by a subpoena, which can result in a citation for contempt of court.

In the end, Schultz did turn over his negatives because he feared a ruling against him would set a precedent in his state.

COPYRIGHT: WHO OWNS THE PICTURE?

WHEN AN EMPLOYER OWNS PHOTOS When you are an employee, the copyright for your photos is owned by your employer. The employer holds the rights to the pictures and can reprint or resell the photos. Protecting those rights is the employer's concern. Usually an entire newspaper or magazine is copyrighted, including all material contained in each issue. For your company to own your work, you must be a full-time employee, and your employer must pay benefits as well as give you specific assignments. If you fit this definition, you have a "work-for-hire" arrangement with your employer.

You may, however, form other specific contractual arrangements with your employer. For example, when a company hires you for a staff position, you can agree to take the job on the condition that you own your images, along with the rights to sell the photos after the company has published the originals. In fact, you can negotiate any contract you like with your employer as long as you arrange

the details before you sign on the dotted line.

Your right to sell pictures you originally took for your employer differs among companies. Some organizations keep the images permanently. When some outlets sell a picture, they retain the profits but often give the photographer a credit line. Others give the photographer a percentage of the profits from any sales. Some give the images to the photographer after a fixed period of time; others let the photographer retain the images immediately after publishing the photos the first time.

As a freelancer, though, remember that if you agree in writing to a "work-for-hire" contract, your client can reuse or resell the photos without your permission. You no longer own the images. Absent a contract, however, you own the images.

WHEN YOU RETAIN THE COPYRIGHT If you are not a full-time employee, however, and have not signed a "work-for-hire" agreement, the company does not own the copyright to your photos. Unless you make a special agreement, you keep the copyright. When you accept an assignment from a newspaper, magazine, Web site, CD-ROM manufacturer, or any kind of company, you are not an employee of that organization. When you turn over your photos to the assigning editor or art director, you are granting one-time rights. The pictures can be published or used only once. Any other use the company wants to make of the photos is up to you—and all slides, negatives, and prints should be returned to you.

If you take pictures on your own without an assignment, even if you are a full-time employee, you own the negatives and the copyright.

When you sell a picture that was shot on your own time with your own film, you can form several arrangements with the organization buying the picture—as long as you form the agreement at the time of the sale.

If you sell one-time rights, you can resell the image elsewhere after it has run.

In a second type of arrangement, you can sell the picture along with exclusive rights to it for a specified period of time. In a third type of agreement—for a lot more money, one hopes—you can sell your copyright. This means that only the agency or publication has the right to distribute and sell the photo. You no longer have that right.

Remember, if you formed no specific agreements when you sold the picture, you automatically retain your copyright. The agency or publication has first rights, but you can resell the photo to other outlets later.

COPYRIGHTING YOUR OWN PHOTOS If you don't work full-time for a news organization, how do you protect yourself from someone reprinting your photos and not giving you credit or paying you? How do you prove the printed photo is yours if it does not carry your credit line?

To protect your rights, put your copyright notice on the back of each print with either of the following notations: ©, or the word "Copyright," with your name and the date you shot it. Although not required, it is a fairly common practice to include a statement that reflects the concept of "all rights reserved" or "permission required for use."

After you've placed the copyright notice, you can immediately register the print with the U.S. Copyright Office in Washington, D.C., by filling out a form, sending two copies of the print, and paying a fee, or, after the photo is published, by sending two sheets from the publication and paying a fee. But you do not have to register the print with the Copyright Office immediately, as long as you mark the photo with a copyright notation.

In fact, you never have to register the photo with the Copyright Office unless someone prints your picture without paying you, and you want to sue. Registration of the copyright is not necessary to maintain your rights, only to defend against infringement of them.

If you feel that someone is using your pictures in a manner that constitutes infringement, you must register your work as a prerequisite to filing an infringement suit. The advantage to registering your material as close to the original publication date as possible is that the type of damages you can collect is tied to the registration date. For infringement prior to the registration date, the law allows only the award of actual damages and an injunction barring further infringement. However, for proven infringement after registration date, the law allows for the assessment of additional statutory damages and legal fees. Regardless of whether you decide on immediate or delayed registration, remember that registration must occur within five years of original publication, and that no suit may be filed and no damages collected without registration.

RESPECTING OTHERS' COPYRIGHTS
Finally, the ease of scanning images and
incorporating them into photo illustrations
makes it easy to forget that other photographers or artists enjoy the same copyright protection you do. Remember not to employ
"found" images from newspapers, magazines, or the Web without express permission
to do so.

LAW REFERENCES

Barber v. Time, 1 Med. L. Rep. 1779 or 159 S.W. 2d 291 (Mo. 1942).

Branzburg v. Hayes, 408 U.S. 665 (1972).

Burton v. Crowell Publishing Co., 81 Fed. 154 (2d Cir. 1936).

Chandler v. Florida, 449 U.S. 560 (1981).

Daily Times Democrat v. Graham, 276 Ala. 380 162S. 2d 474 (1964).

Dietemann v. Time, 449 F. 2d 245.

Estes v. Texas, 381 U.S. 532, 536.

Florida Publishing Co. v. Fletcher, 340 So. 2d 914.

Galella v. Onassis, 487 F. 2d 986.

Le Mistral v. Columbia Broadcasting System, N.Y. Sup. Ct., N.Y. L.J. (1976).

Leverton v. Curtis Publishing Co., 192 F. 2d 974 (3d Cir. 1951).

Lloyd Corp. Ltd. v. Tanner, 407 U.S. 551, 92 S. Ct. 2219, 33 L. Ed. 2d 131 (1972).

People v. Berliner, 3 Med. L. Rep. 1942.

People v. Zamora, 361 So. 2d 776.

Raible v. Newsweek, Inc., 341 F. Supp. 804 (1972).

Sbyszko v. New York American, 1930: 239 NYS, 411.

Tawa Ayeni v. CBS Inc., 848 F. Supp. 362 (E.D. N.Y. 1994).

United States of America v. Anthony Sanusi, et al., 813 F. Supp. 149 (E.D. N.Y. 1992).

Wilson v. Layne, 27 M.L.R. 1705 (1999).

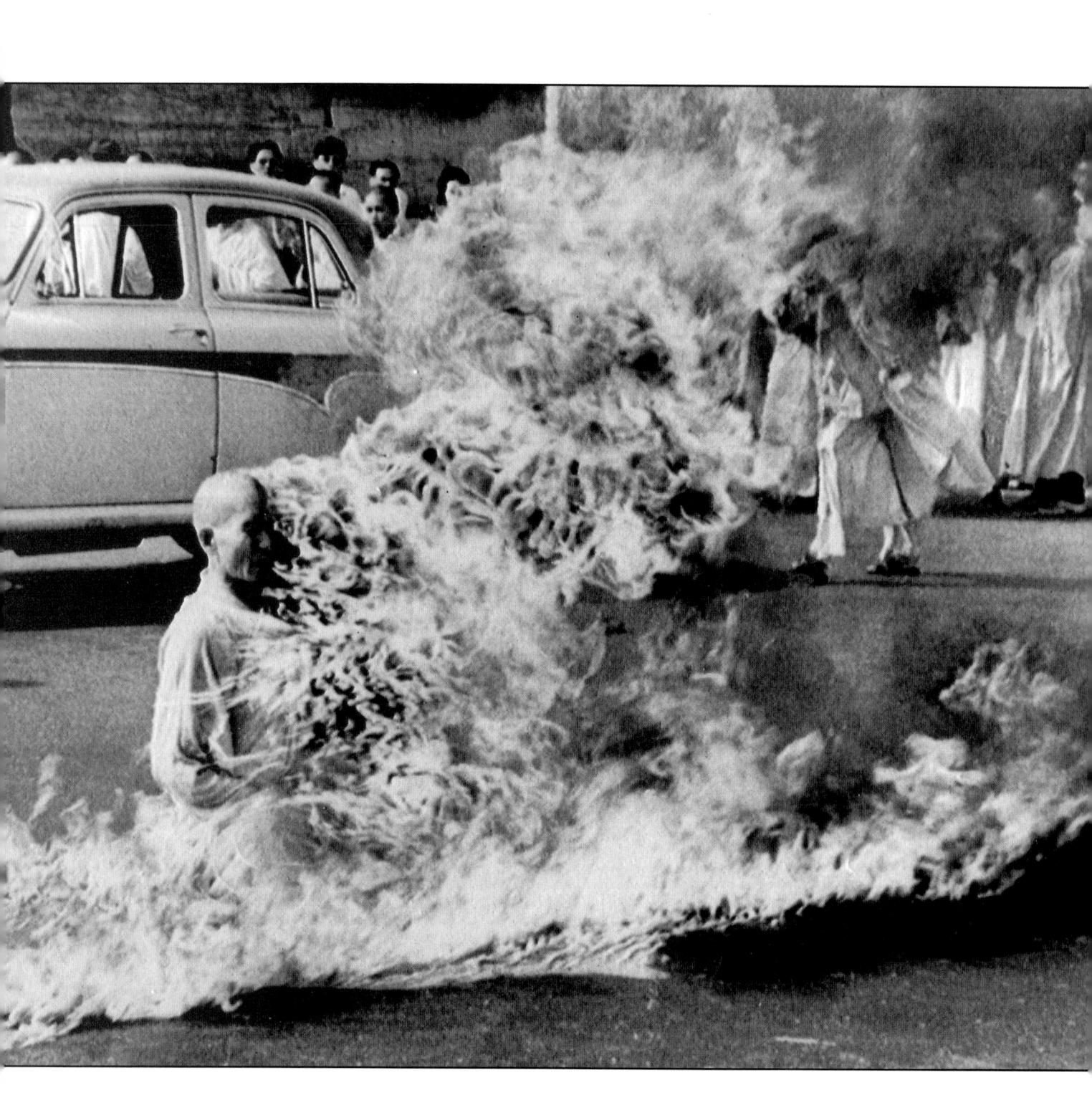

Ethics

DOING THE RIGHT THING

CHAPTER 15

hotojournalism as a profession imposes a set of responsibilities. Some are fairly routine and fall neatly into the "daily duties" category: get to the scene,

frame and focus the shot, collect the caption info, and so forth.

Beneath these functional tasks lie broader ethical considerations.

Confronting these issues is often more challenging than the assign-

To protest the South Vietnamese government in 1963, a monk set himself afire after notifying the news media. Should the photographer have tried to stop the monk from committing suicide? Should American newspapers have run the picture? See page 316 for a discussion of this picture. (Photo by Malcolm Browne, Wide World Photos.)

ment itself. At times, these ethical issues pit the

photographer's professional duties against his or

her own conscience, that internal barometer that

guides behavior and ultimately maintains social

order. Photographers may, in the course of completing their assignments, be forced to choose between how they might act as individual citizens and how they feel they should act as visual journalists.

This dilemma—personal choice vs. professional responsibility—is certainly not unique to photojournalism. Consider, for example, the plight of the public defender charged to represent a rapist whom he knows is guilty. Or the doctor who has the resources and training to artificially prolong the life of a suffering patient. In these examples, the Constitution and the Hippocratic oath, respectively, are compelling codes, but what about the individual rights of the attorney? Or the private conscience of the physician?

Now consider the less dire but still clouded situation of a photographer shooting a story about suburban high schools. While scanning a clattering lunchroom scene, the photographer spots a trio of students exchanging twenty-dollar bills for bags of white powder.

Does the photographer, acting as a genuinely concerned citizen, try to stop or at least to disrupt the deal? Does he or she report the incident to the principal and offer a description of the players? Or, does the photographer take the picture and publish it?

Almost every day, photojournalists face decisions of morality—ranging from removing a distracting item from a photograph to taking a gruesome picture at a murder site.

But a looming deadline or the logistical challenge of a six-site assignment sheet can pressure the photographer into making snap judgments about even the most morally delicate situations.

Thus, thinking about issues ahead of time may allow the photojournalist to avoid a crisis on the scene or regret after a picture has been published.

Photojournalists use several arguments to explain their decisions to shoot or print controversial pictures. One argument, which sometimes fails to distinguish between practices and standards, relies on the familiar "Other Guy" argument: "I did it because that's the way other photojournalists do it."

These photographers are comparing their actions with a perceived industry "standard." Whether the action is inherently right or wrong is irrelevant to their argument.

"This is the way everyone does it." While such a decision-making strategy might reflect professional practices, it does not create a standard grounded in the norms of ethical decision making.

FOUNDATIONS OF ETHICAL DECISION MAKING

Many photographers, whether they realize it or not, turn to an established ethical framework to try to guide their decisions.

UTILITARIAN

That framework includes the "utilitarian" principle as defined by ethicists. Here the overriding consideration is "the greatest good for the greatest number of people."

The utilitarian position recognizes that photojournalism provides information critical to a democratic society. Photography might show the horrors of war, the tragedy of an accident, or the hardship of poverty. Therefore, it is right to take and publish pictures. Without information, in general, and pictures, specifically, voters cannot make informed decisions. Seeing accident pictures, for example, might cause voters to pass laws requiring air bags in every car.

ABSOLUTIST

However, the utilitarian principle of "the greatest good . . ." bumps up against a competing ethical principle that says, "Individuals have certain rights . . . ," among them, the right to privacy. These rights are absolute and inviolable regardless of the benefits to society, says this principle.

Taking a picture of the distraught family of a drowned child and then publishing it might cause others to be more cautious, but invading the privacy of their grief—regardless of the benefits—is not acceptable, according to the absolute rights argument.

THE GOLDEN RULE

Another of the ethical cornerstones is the Judeo-Christian precept, "Do unto others as you would have them do unto you." This rule, too, sometimes conflicts both with professional standards and with actions that might benefit a democratic society in need of information.

In the last example, if you put yourself in the place of the grieving parent, you might not want your picture taken. On the other hand, if you are trying to save children from drowning in the future and think that running the picture might

caution parents or affect funding for extra lifeguards, you might run the photo anyway.

Without providing a behavioral prescription for the photographer, The young boy in the body bag had just drowned. His family was grief-stricken. Might running the picture in the paper help prevent future drownings? For a discussion about the photo, see page 321.

(Photo by John Harte, Bakersfield, California.)

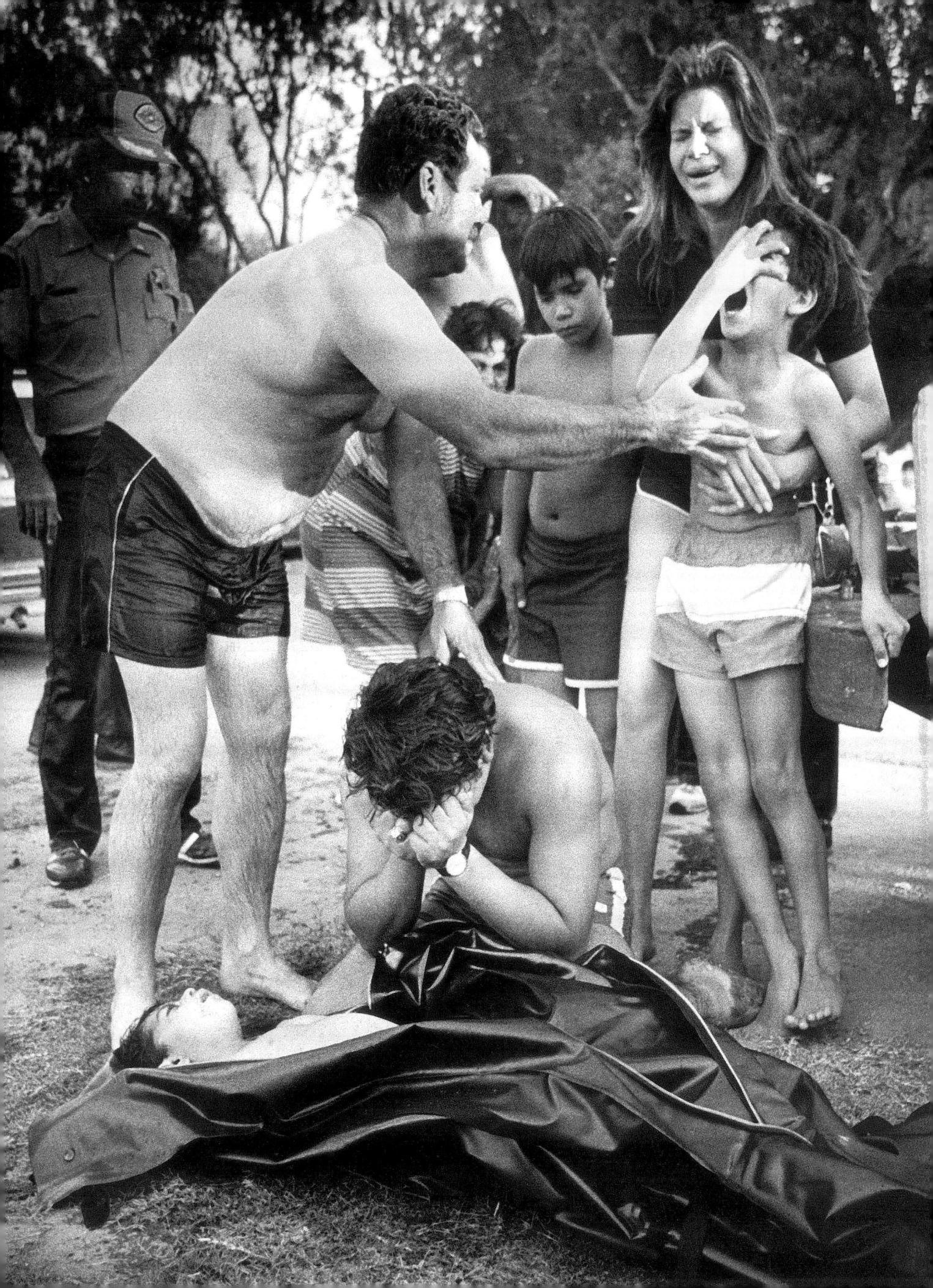

dilemmas faced by the professional photojournalist and the picture editor. Rather than deal with cases of obvious fraud, fakery, and patent sensationalism, the chapter tackles the gray area between right and wrong-the zone that troubles photographers on an almost daily basis. SET UP OR JUST CLEAN UP?

Would it be wrong to stage-manage a publicity event like this ground-breaking ceremony? Do readers care?

(Photo by George Rizer. the Boston Globe.)

this chapter will lay out some of the ethical

The author once saw the well-known photo editor of a national magazine—and one of the most respected elders in the business remove a Coke bottle to improve the scene before he took a picture. While removing a pop bottle is a fairly trivial act, the incident does illustrate a basic ethical question: when can the photographer alter the scene without altering the message and creating an untruth? When does a comment become a stage direction? And, if some set-up is permissible. when does "some" become too much?

WHEN DO PROFESSIONALS POSE PICTURES?

In a precedent-setting study in 1961, Walter Wilcox, then-chairman of the Department of Journalism at the University of California. Los Angeles, designed a study to determine the attitudes of readers, photographers, and editors toward staging news pictures. He sent questionnaires to three groups of subjects: general readers, working photographers, and managing editors.

On a three-level scale, each group evaluated sample situations that a photographer might face as "definitely unethical," "doubtful," or "not unethical." Here are three sample situations from Wilcox's study:

Murder trial: A photographer attempts to get a shot of a defendant, but she consistently evades him by shielding her face or ducking behind her escorting warden. The photographer spots another woman who looks like the defendant and by diffusing the light and adjusting the focus, he gets a striking picture, which no one will challenge as being fake.

Ground-breakers: A photographer covers a ground-breaking ceremony for a new church. Local dignitaries have already turned the first bit of earth before the photographer arrives. He asks that the ceremony be repeated. The dignitaries cooperate, and he gets his picture.

Cricket plague: A plague of crickets is devastating the hinterland. A photographer goes out to cover the story, but he finds the crickets are too far apart and too small to be recognizable in a photograph. He thinks he could get a better picture if the crickets were shown in a mass, and, to that end, he builds a device that brings crickets through the narrow neck of a chute. He gets his shot of closely massed crickets on the march.

Wilcox found that the general public, managing editors, and working photographers agreed to a remarkable extent on what was ethical and what was not. In the survey, 92 percent of the public, 93 percent of the photographers, and 99 percent of the editors said the court photographer was wrong to photograph one person and claim it is another, even if the two look similar.

By comparison, 83 percent of the public, 88 percent of the photographers, and 94 percent of the managing editors said it was not unethical to restage the ground-breaking ceremony.

Thus, it seems that these three groups operate within the same ethical framework that allows "set-up" pictures but rules out clearly faked photos.

The third scenario, however, in which the photographer collected and choreographed the crickets, sparked disagreement within each of the three groups. The general readers were almost evenly divided along the threepoint ethics scale: 29 percent considered the photographer's actions "definitely unethical," 39 percent considered it "doubtful," and the remaining 32 percent considered it "not unethical." Managing editors were similarly split between definitely unethical (23 percent), doubtful (34 percent), and not unethical (44 percent).

Photographers, however, who probably have faced similar problems, were much more likely to consider amassing the crickets part of a photojournalist's routine job. Only 7 percent of the photographers polled felt the photographer in the example was definitely unethical; 30 percent considered his behavior doubtful; but a whopping 63 percent said that the cricket photographer was not wrong. One could assume that two-thirds of the photographers polled would have rigged the shot if faced with the same situation.

In a 1987 study for the National Press Photographers Association (NPPA), Ben Brink found that re-creating a situation was acceptable to more than a third of the professional photographers he surveyed. However, staging a scene from scratch was acceptable to only 2 percent of the working pros.

The staging-from-scratch vignette: A hypothetical photographer is assigned to cover the aftermath of a big storm. She notices a phone booth turned over in about two feet of water. She asks a child riding a bike in the water next to the phone booth to pick up the phone and pretend to make a call. The photographer hands in the photo without telling the editor it was a set-up photo.

Only 2 percent of the photojournalists responded that this situation was acceptable. On the other hand, 91 percent said they would definitely not stage this picture without telling their editors.

A second scenario in the NPPA study produced a different result, however. For this one, a hypothetical photographer is doing a picture page on a visiting nurse in a rural farming community. The one element she lacks to tell the story is a shot of the nurse walking across the field to the farm house.

The photographer has seen her walk across the field before, but she's never been at the right place at the right time to get the shot, so she asks the nurse to meet her at the house and walk across the field just as she normally would do. She has the nurse repeat the scene a couple of times to make sure she gets just the right shot.

The survey results, based on the responses of 116 professional photographers, indicated that 38 percent would re-create the scene.

On the other hand, 28 percent of the respondents were not sure how they would handle the situation. Another 34 percent indicated that they definitely would not have the visiting nurse walk across the field just for the camera.

CHANGING VALUES

In fact, photojournalists' ethics are changing. In 1961, Wilcox found that none of the pros he surveyed were bothered by repeating a ground-breaking ceremony for the camera.

Twenty-six years later, Brink's NPPA survey found that a third of the photographers sampled would not repeat or re-create a picture. While the two vignettes, the repeated ceremony and the nurse crossing the field for the camera, are not identical, the radical difference in photographers' responses over time does suggest a shift in photojournalistic ethics.

Re-creations of picture situations that were acceptable to every pro in the 1960s were anathema to a large segment of the professional community by the 1980s.

Also, what is acceptable in other countries might not be permitted in the United States and vice versa. In his book *Picture Editing: An Introduction*, Britisher Tom Ang observes, "In press photography, one can ask demonstrators to face their placards towards the camera but encouraging them to make threatening gestures at a policeman would be widely regarded as going too far." In the United States, most photojournalists would consider asking demonstrators to face the camera a breach of ethics.

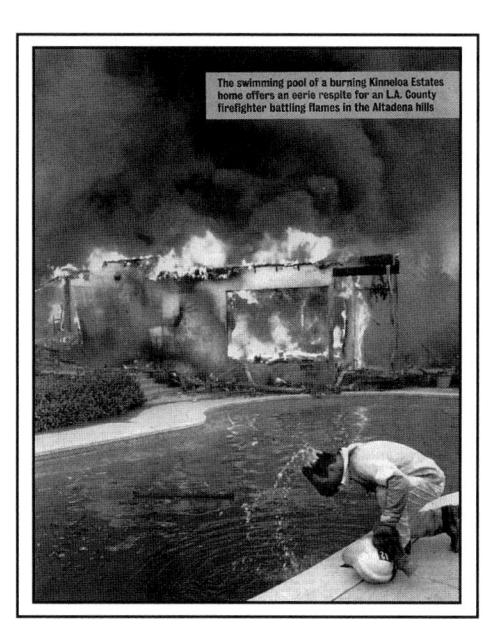

WHOSE RESPONSIBILITY?

Surprisingly, many photographers in the Brink study felt that telling their editors absolved them of ethical responsibility.

In a follow-up question to the staging vignette, the study showed that 33 percent of the photographers no longer found staging the picture unethical if they explained the facts to their editors. Telling a higher authority seemed to eliminate feelings of responsibility on the part of these pros.

Can photographers avoid ethical decisions this easily?

DO READERS BELIEVE THEIR EYES?

Below a headline in the *New York Post* that read NUKE LEAK AT INDIAN POINT, a picture ran showing a woman holding a child covered by a blanket. The mother appeared to be trying to protect her child from radiation from the atomic energy plant. The picture was published not only by the *Post* but also by *Time*, and was carried by the Associated Press and United Press International.

When several newspapers in the Northwest printed the photograph, the editor and publisher of the *Centralia* (Washington) *Chronicle*, Jack Britten, attacked the picture's integrity in an editorial.

"Come on," the editorial demanded.
"Who do they think they're conning? Any discerning reader could quickly see that the photo is very likely staged . . . the photo is an obvious put-on, a misrepresentation of the actual situation, and the editors should have known it. If they didn't know it, they shouldn't be editors."

Mike Meadows, of the Los Angles Times, was covering a major wild fire sweeping southern California. His picture of a fireman cooling himself off from the water in a pool ran not only in the Times but also nationally.

Prior to submitting the photograph for a contest, however, the newspaper's editors contacted the fireman, who said he had been asked by the photographer to go over by the pool and splash water on his head. The photographer responded that "I may have been guilty of saying 'this would make a nice shot,' but I did not directly ask him to do that."

What Meadows did not understand was that even a suggestion to a subject in a news situation is a form of interference-and thus out of place on the continuum of control. The unfortunate photographer's picture was withdrawn from competition, and he left the paper. He was lucky compared to another photographer (pages 308-309) who didn't change with the times. (Reproduced from Newsweek.)

A CONTINUUM OF CONTROL

Between moving an obstructing cola bottle and hiring a model to impersonate a teenage hooker lies a large, gray ethical chasm. This gray zone, with its myriad shadows and shadings, can challenge even the most clear-sighted photographer. Are all situations alike?

Do the same rules apply to features, portraits, and illustrations, as well as to hard news? Far from being a fixed commodity, the photographer's level of control is variable, logistically and ethically. A photojournalist's weekly assignment sheet is likely to represent a continuum of control-from strictly hands-off to complete manipulation.

Photojournalists cover subjects ranging from a war in the Middle East to a fashion shoot in midtown. Like the fashion shoot, some pictures require complete control. Other situations, like accidents or arrests downtown, require the hands-off, fly-onthe-wall approach.

Any time you take pictures, you are affecting the scene to some degree. According to noted physicist Werner Heisenberg, observation itself alters the object being observed. This principle applies to photography as surely as it does to the subatomic world.

For instance, whether a subject consciously thinks about the photographer or not, that person's behavior changes in the presence of a camera. Some subjects exaggerate their behavior; others shy away from the camera. Even thinking a camera might be present can alter some people's behavior.

Even though photographers and their cameras have some influence on the scene they are photographing, the question the working pro must ask is, "When should the photojournalist remain an observer, removed as much as possible from the scene? When should the photographer intervene?"

(Photo courtesy Bank Security.)

- · Hidden cameras represent one extreme of the continuum. The security camera at First Local Bank automatically snaps a picture at regular intervals, regardless of who is standing at the teller window. The bank camera, which exercises no control over the subject, exerts no control at all. Despite its passivity, however, even the bank camera alters the scene being observed: most criminals would take different precautions if robbing a bank under constant photographic surveillance.
- . Sports photography is near this end of the continuum. A hurdler races down the track. Even if she wanted to, the sports photographer could have little influence on the athlete. She would not tell the runner to run to the

(Photo by Michael Meinhardt, UPI.)

right for a better picture. The sports photographer has virtually no control over the subject but does select the moment to release the camera's shutter.

· Hard news. Elsewhere along the continuum you will find the news photographer covering a riot. Most photographers would hesitate to direct a demonstrator or tell a policeman to stand aside to improve a pho-

(Photo by Charlie Fellenbaum, the Hemet [California] News.)

tograph's composition. The photographer could initiate control but refrains in a true hard-news situation.

· Features are where the continuum becomes slippery. Here, photographers disagree about when to intervene and when to merely observe. The action is touching, but the light is not great. Is it okay to ask the subject to move over a few feet so you could get perfect backlighting?

Beach [California] Press-Telegram.)

Different photographers have determined different points where they will draw the control line when faced with a feature assignment. Some photoiournalists would not hesitate to ask the subject to move.

Other shooters would never consider disturbing the moment, even if leaving the situation untouched meant that they would not get a superb picture.

· Portraits usually require some direction on the part of the photographer. If the assignment is to take pictures of the president of the local university, the photographer usually must tell her where to sit and what to do with her hands. The photographer might ask the president to look

(Photo by Pat Crowe, Wilmington [Delaware] News Journal.)

directly at the camera. This way the reader knows that the administrator was aware of the photographer and won't think the picture is a candid photo. An unwritten but probably accurate rule holds that, if the subject is looking at the photographer (i.e., the reader), the subject is aware of the camera.

 Photo illustrations represent the the other extreme, the full-control end of the continuum. Photojournalists manufacture every aspect of an illustrationincluding editorial concept photos, food photos, and studio and location fashion shoots. The photojournalist arranges the props, perhaps builds the

(Photo by Bob Farley, Birmingham

set, and hires and even dresses the models. The viewer has no illusions about the photo or the photographer's role. If the photographer has been careful, the created photo cannot be mistaken for real. Through the use of exaggerated size, seamless backgrounds, and other visual devices, the photojournalist can assure the reader that the picture is constructed and not a slice of real life. (See Chapter 9, "Illustrations.") With photo illustrations, the photographer exercises complete control.

In fact, photographer Martha Cooper and Post reporter Deborah Orin actually found the woman as she was leaving her house, her baby covered with a blanket. Orin interviewed the woman, who had been worried about her year-old daughter's exposure to radiation. She had been ready to climb into her car and leave the area when the Post team found her. Cooper took the pictures during the interview. In a follow-up story in the Washington Star, columnist Mary McGrory confirmed the photo's authenticity.

If a seasoned newspaper editor questioned the photo's truthfulness, how often do readers wonder whether what they see in newspapers, magazines, and computer screens really took place? After all, people watch professional photographers pose pictures at class reunions, bar mitzvahs, and weddings. While such photographers are not photojournalists, how many readers make the distinction?

WHEN FACTS CONFLICT WITH PHOTOGRAPHS

Just how widespread is disbelief in photojournalism? No one knows for sure, but the disbelief extends at least to Waterville, Maine

"Kids for sale," shouted the July 20, 1986, cover of Parade magazine. "It can happen anywhere."

Three small color photos of unidentified and unidentifiable, sultry adolescent "girls of the street" dotted the text-dominated black cover, which announced a "special report" on child prostitution.

Anywhere, according to the picture identification, included New York City, Van Nuys, California, and "placid little towns like Waterville, Maine."

Fortunately, a local Maine newspaper challenged the story. Reporters discovered that the Attorney General's office in the Maine jurisdiction had prosecuted only two cases of prostitution in Waterville, none involving teenagers—and that the young Waterville "prostitute" in the photo was actually a model.

When freelance photographer Dean Abramson was unable to find an actual streetwalking teen in Waterville, his Parade magazine editors told him to hire a model. Abramson complied and eventually snapped the posed picture.

Although Parade editors initially denied the subterfuge, later they recanted, saying that an explanatory line of type had been omitted. In a follow-up article for News Photographer magazine, they further rationalized the situation by telling writer Betsy

On this cover, two of the girls are models. One is not. How would the reader know which is candid and which is set up? Would a reader have known what "photo illustration" means had the disclaimer been included? (© Parade.)

Brill that they routinely used models for stories involving minors.

In interviews with other photographers on the project, however, Brill discovered that, despite editors' claims, only two of the three pictures had been set up with models for the *Parade* cover. A third photographer captured an actual candid moment.

Camera 5 freelancer Neal Preston verified that his assignment from *Parade* had been to find and photograph actual teenage prostitutes (not models). He had done so in Van Nuys, California.

"I could have saved a lot of time and film if I had hired a model," he told Brill, when he learned the other photos had been set up.
"I'm proud that my picture was the one that was real."

Award-winning photojournalist Eddie Adams, who photographed the New York City set-up, told Brill that concern over the staged photos was "a lot of bullshit." He said that the hiring of models for stories involving children is done "all the time"—not just by him, he said, and not just by *Parade*, but by all magazines, especially for cover stories.

"There's a difference," Adams said, "between an illustration and a straight

picture." (See Chapter 9, "Illustrations.") Yet, he admitted, the reader has no way of knowing the difference without words.

Adams, however, begged the ethical question and relied on the familiar "everybody does it" argument.

The question is not, "Do photographers hire models regularly when taking pictures of children?" The real question is: "Should photographers use models—and pose them so that they look as though they're in real situations?"

Whether you're a magazine reader in Waterville or a newspaper reader in New York City, your belief in pictures drops when you discover that some of the images you are seeing are figments in the imaginations of photo editors.

CONCLUSION

For photojournalists, the issue of posing often centers on a photographer's role as reporter vs. his or her role as an artist with a camera, says Shiela Reaves in her article "Re-examining the Ethics of Photo-graphic Posing: Insights from the Rank-and-File Members of ASMP (American Society of Media Photographers)." Editors in

ONE PHOTOGRAPHER WHO DIDN'T CHANGE WITH THE TIMES

Not long after the Janet Cooke affair (see page 310), one St. Petersburg (Florida) Times staff photographer selected a spot on the continuum that proved out of sync with changing times. The results were disastrous for him.

The incident began with a routine assignment for 61-year-old Norman Zeisloft, a veteran photographer and past president of his regional NPPA chapter. He had been shooting for the *St. Petersburg Times* and *Evening Independent* for more than seventeen years.

HELPING ALONG A FEATURE

Zeisloft had been assigned to cover a baseball game between Eckerd and Florida Southern Colleges. "It was quite a nothing event," he recalled for Jim Gordon, who later wrote a comprehensive story about the incident for News Photographer magazine.

Spotting three bare-soled fans with their feet up, Zeisloft approached them and said it would be "cute if you had 'Yea Eckerd' written on the bottom of your feet."

They agreed, and Zeisloft pulled out a felt-tip pen and began writing on the soles of one man's feet. Zeisloft found that his pen was dry and the spectator's feet were too dirty to accept writing. Meanwhile, one fan left the stands, washed his feet and reappeared with "Yea, Eckerd" on his soles. Zeisloft took the photo, and it ran two days later in the *Evening Independent*.

"It was just a whimsical thing, just for a little joke," Zeisloft recounted. "It was just a little picture to make people smile rather than an old accident scene."

But nearby was Phil Sheffield, a *Tampa* (Florida) *Tribune* photographer since 1974 and a photographer for Miami's Associated Press bureau before that. Almost instinctively, Sheffield said, he snapped one frame as Zeisloft originally applied pen to sole.

Posted as a joke on the bulletin board of the *Tampa Tribune*, the photo eventually found its way to the president and editor of the *St. Petersburg Times*—Norm Zeisloft's boss, a judge on the Pulitzer committee

308 Photojournalism: The Professionals' Approach

particular and the profession in general convey a double message, she observes. The message reads "produce both a truthful picture and one that demonstrates artistic merit." Observe an event—and be inventive and creative.

Sometimes those two distinct roles come into conflict.

The key to making an ethical decision is to know which professional role is required in a given situation. If the assignment from the food editor requests a photo illustrating hot dogs as the quintessential American food for the Fourth of July, the photographer's creative juices need to flow. With the studio's seamless backdrop as a canvas, the photographer becomes an artist bringing together hot dogs, American flags, and sparklers into a pleasing and storytelling composition.

On the other hand, if the scanner radio broadcasts that a murder/suicide in a college dorm has just occurred, the photographer's purely observational skills need to kick in. No invention should be needed as the police bring out the stretcher and dorm-mates cry. No studio, no props. No direction.

Reality will suffice. The photographer's role is to record, not to influence. Of course,

the problem lies with assignments that fall between these two extremes.

As they go from assignment to assignment, most working pros find themselves at different points on the continuum of photographic control. Generally, photojournalists find decisions about how to handle the ends of the continuum fairly easy. How the photojournalist approaches a sports event or fivealarm fire is quite different from how that person handles a fashion or portrait assignment. Photojournalists set up some pictures but not others. The question that each photographer must ask is: Where should I be on the continuum of control? At any given time, what part of the continuum should I choose? Which spot along the continuum is appropriate for this assignment?

KEEPING UP WITH SHIFTING STANDARDS

The decision regarding control is a choice often based more on a photographer's time in history than on any established guidelines (see sidebar below). Photojournalism has no Bible, no rabbinical college, no Pope to define correct choices. And although surveys like those by Wilcox and Brink help establish

that had been caught in the web of Janet Cooke's dishonesty.

STANDARD PROCEDURE OR GROUNDS FOR DISMISSAL?

Zeisloft was fired on his first day back from vacation.

Later, in an administrative appeal hearing over denied unemployment benefits, Zeisloft explained that news photographers often set up pictures about society and club news, recipe contest winners, ribbon-cutting and ground-breaking ceremonies, awards and enterprise features.

He took to the hearing pictures that had won professional contests, some from the old *Life* "Speaking of Pictures" department. Others, he explained, had gone "nationwide via AP and UPI wire services. The pictures had won awards plus applause from editors.

"These pictures were not intended to bamboozle the public or to 'distort' the news. They were shot with good humor and were merely designed to give the reading public a good chuckle. They were harmless and entertaining. That and nothing more," Zeisloft said.

"To me," Zeisloft said, "it seemed like cruel and unusual punishment to be fired after seventeen and a half years of faithful service on the basis of one photo that was designed merely to bring a chuckle to our readers. There was not one phone call or letter from our reading public in regards to the picture.

"If a cop shot a person he'd get a suspension.

Doesn't seventeen and a half years count for anything?" he asked.

A CONTINUUM TEMPERED BY TIME

Unfortunately, Norm Zeisloft had selected a spot on the control continuum that was not professionally acceptable for the time and place he was working. Ten years earlier or at another newspaper or magazine, the set-up feature might have been perfectly accepted by the profession and even by the public. Zeisloft found himself out of register with the current dividing line between acceptable and unacceptable practice on the continuum of control.

Because the place acceptable to fellow professionals and the public on the continuum shifts with time and events, all photojournalists should reevaluate their own set points. Do theirs coincide with other members of the profession, with editors, and with the public?

Finally, even if a practice is acceptable in the field, the photographer must answer a more difficult question: is the behavior ethically right? Should I do this even if all my peers are doing it? While photographers should be aware of standards in the field, they should also deal with the more basic question of right and wrong.

current practices in the field, professional values do not remain fixed in time. Professional standards are changing, and so are readers' expectations. Staying abreast of professional standards and evaluating decisions with an eye to the ethical foundations described at the beginning of this chapter should be helpful when faced with difficult moments.

Keep in mind that setting up feature pictures used to be perfectly acceptable to most newspaper photojournalists. New York Post photographer Barney Stein, in his book Spot News Photography, which was written in the early 1950s, proudly described as a routine photojournalistic activity how he went about setting up feature pictures of a cowboy performing for crippled kids or of a Dalmatian firedog wearing the fire chief's hat.

John Faber, historian for the National Press Photographers Association (NPPA), told of traveling around the country as Kodak's professional representative, teaching newspaper photographers how to create imaginative feature pictures.

In his 1961 survey, Wilcox found that no photojournalist objected to restaging a ceremony for a photo. Yet, today, according to the Brink survey, at least a third of the photographers who are NPPA members would object to restaging a situation.

W. Eugene Smith, the famous *Life* magazine photographer, wrote in 1948, "The majority of photographic stories require a certain amount of setting up, rearranging and stage direction to bring pictorial and editorial coherency to the pictures." Smith notes, however, that if the changes become a perversion of the actuality for the sole purpose of making a "more dramatic" or "salable picture," the photographer has indulged in "poetic license."

In his book *Truth Needs No Ally*, Howard Chapnick, long-time head of Black Star Picture Agency, observed that in the 1990s the "changes in camera and film technology have made it a truism that anything we can see we can photograph." He argued that now there is no excuse for the photojournalist to manipulate people in real-life situations.

JANET COOKE

What has caused this change in standards for the profession? Many observers point to one incident as the pivot-point for journalists.

In 1981, Janet Cooke, a reporter for the Washington Post, won a Pulitzer Prize based on a story she wrote about a 6-year-old drug addict. After the prize was awarded, investigators discovered that the child had never existed. The young addict was a figment of

Cooke's imagination—a "composite" of characters and incidents she had come upon in her research. Cooke lost the prize and gained a place of dishonor in journalism history. The journalism profession threw up its arms in outrage and began a hard, soulsearching reexamination of its ethical practices. Professional groups sponsored seminars, authors wrote books, and universities initiated classes in journalism ethics. And the public's view of the press, its practices, and its prizes dropped to a new low.

The outgrowth of this examination was an increased sensitivity, even vigilance, to how the profession performs its work. The profession began to question some of its accepted standards. The spotlight on the Cooke case also heightened sensitivity toward ethical standards within the photojournalism community.

MONITORING ETHICAL STANDARDS For the neophyte photographer or the seasoned pro, the profession does not provide a fixed yardstick, a definitive set of guidelines, or a regular measure of what other photojournalists in the trade are thinking and doing.

In fact, photojournalists disagree among themselves about the correctness of many choices. Craig Hartley, in a national survey of professionals for his thesis on photojournalistic ethics, found that, of nineteen hypothetical problems presented to working pros, almost half the questions resulted in a wide split among respondents. On nine questions, at least a third of the photojournalists did not agree with their other responding colleagues. Clearly photojournalists do not think as a monolithic block when the topic turns to ethics.

Read about the profession

Interested photographers can use the trade media and other resources to monitor the thoughts of their fellow journalists and shape their own ethical touchstones. *News Photographer* magazine, the trade publication of the National Press Photographers Association, reports on controversial issues. Read, in particular, the magazine's "Letters to the Editor" column to check the pulse of the working pro. *Visual Communication Quarterly*, inserted in the magazine four times a year, showcases research in the field.

In addition, magazines like *Columbia Journalism Review*, *American Journalism Review*, and *Photo District News* report on changing professional standards. *Journalism Quarterly* also publishes research on ethics.

In addition to magazines, workshops such as NPPA's Flying Short Course and

A mother is close to hysteria as she watches rescuers try to save her daughter from drowning (see cover of this book). Even in emotional times like this, photographers must take pictures. Photojournalists should get their photos as unobtrusively as possible, preferably using a telephoto lens. If a wide-angle lens is necessary, try not to linger in the subject's face. (Photo by Annie Wells, Santa Rosa [California] Press Democrat.)

the organization's online discussion list, NPPA-L, can help provide valid insights into photojournalism's shifting standards.

Let your subjects guide you

Besides looking to other professionals, photographers should also monitor the reaction of their subjects to gauge shifting values in photojournalism.

In her study "Listening to the Subjects of Routine News Photographs: A Grounded Moral Inquiry," researcher Cindy Brown surveyed individuals whose photographs had appeared in a number of Midwestern newspapers. She asked them about their experiences with the photographer when the original pictures were taken and how they felt about the published images. Happily, Brown reports that the people she questioned generally liked the photojournalists who took their photographs and found the experience positive. Even when the news situations were anything but upbeat, the subjects felt good about the published photos and understood why their pictures were in the paper.

Considering a subject's responses and ethical concerns can help sensitize you to your news outlet's constituency.

A GENERAL RULE

What if you're not abreast of current standards, and you find yourself in a touchy situation on assignment? You might use this test of your own honesty, originally suggested by Elisabeth Biondi, who has been a photo editor for Geo, Vanity Fair, and Stern magazines. She suggests that photographers test their ethical decisions by considering whether they would feel comfortable writing a note to the reader explaining how the picture was taken. For example, would the photographer mind explaining, "I brought these clothes for the subject to wear, and then I told him to make that crazy face"? If the photographer is willing for the reader to know how the picture was constructed, what props were added, and what direction was given, then, Biondi says, the photo is probably ethically acceptable. However, if the photographer would feel uncomfortable revealing to the reader his or her methods, then the picture likely falls on the unethical side of the line.

COVERING TRAGEDY AND GRIEF

When injuries occur at a car crash, a hotel fire, or a natural disaster, bystanders and relatives often block a camera reporter from

taking pictures. Understandably these people are upset. John L. Hulteng, in his book The Messenger's Motives, writes, "Photographers have acquired the reputation of being indifferent to the human suffering they frame in their viewfinders."

While the law gives the photographer the right to take a picture, the law is an institution, not a human being who has just lost a son or daughter.

Using the utilitarian principle of ethical decision making, on the other hand, photographers have a moral responsibility to their readers to picture the world accurately, showing both its triumphs and its tragedies. A democracy in which citizens must be informed to vote intelligently depends on information. Photos provide information. In the long run, individuals cannot make informed decisions without a balanced and accurate picture of the world. This argument says that people will benefit from seeing both the good and bad, the happy and sad, and the joyful and tragic elements that comprise our world.

However, does this case for the "common good" supersede the rights of the grief-stricken individual? Do photographers have the right—or the obligation—to record moments of individual loss? These issues are complex, but there is one clear tenet to guide photographers' behavior in traumatic situations: photographers have a responsibility not to inflict greater suffering than necessary on survivors of a tragedy. "Than necessary" is obviously a troublesome phrase here, one defining that difficult gray zone. Unfortunately, there is no clear measure of necessity.

In the end, photographers must balance the harm to an individual caught in the jaws of tragedy with the long-range needs of society to see an unvarnished picture of the world.

Pictures of grief personalize the news. Statistics about car accidents, wife beatings, murders, and accidental drownings distance the reader from the event. Seeing a picture of a particular person who was hit by a drunk driver gives the issue a face. No matter how large the numbers, issues remain abstract.

When Robert Kennedy was shot, a woman bystander blocked Boris Yaro's camera. He said to her, "Goddammit, lady, this is history!" and took this unforgettable picture. See pages 314 and 315 for a discussion about the situation.

(Photo by Boris Yaro. © Los Angeles Times.) From "Thousands die on the road every year" to "Katy Smith was struck by a Honda yesterday and here is what she looked like," photographs transform an otherwise abstract issue into a personal event. The reader is more likely to care about Katy than all the thousands of other people who died

last year.

Pictures can actually help the victim and the family. Some families understand that running the picture of a tragedy may prevent the same thing from happening to others. The published pictures give the family some rationale for a terrible calamity. Dave LaBelle, in his book Lessons in Death and Life, observes, "Although many cry foul when photographs of grieving subjects are published, often the subjects themselves are helped to deal with their grief." He notes this story: "Two days after the Albuquerque (New Mexico) Tribune published graphic pictures of a burn victim, Sage Volkman, it ran a letter from the girl's parents explaining why they thought the public needed to see the photos. 'We would like you to be

aware of her struggle from when she was first burned and almost through death's door

to her return to us as a 6-year-old girl with feelings who sees life in terms of Barbie dolls and her Brownie troop. When you come upon her unexpectedly in a store or restaurant, your first reaction may be one of sadness. But if you do run into her, we hope you will see her as we do—as a brave little girl." Publication of the pictures helped raise more than \$50,000 toward Sage's medical bills.

DO ALL TRAGEDIES NEED PHOTO COVERAGE?

If you are familiar with your equipment, you can usually take a few quick, available-light, candid shots nearly unnoticed at any accident

PHOTOGRAPHING **TRAGIC MOMENTS**

or an article for News Photographer magazine, Michael D. Sherer collected comments from photographers who had covered tragic events. Here are their guidelines:

ON CONDUCT

Be early, stay out of the way, and don't disrupt what's going on. Be sensitive to your subjects and the situation. Be compassionate. Do not badger or chase subjects to the point of annoyance. "How would I feel if I were the person being photographed?" —Jim Gehrz, the Worthington (Minnesota) Daily Globe.

ON EQUIPMENT

In sensitive situations, carry as little gear as possible, leave the motor drive behind, and use the longest lens possible. Don't become a spectacle.

ON SELECTIVITY

Pick your shots carefully-look for angles and subjects that will not offend subjects' and readers' sensitivities.

ON DRESS

Wear "appropriate" clothing. "Dress is an important part of the way the public perceives us and in their acceptance of us in times of stress. I think many of us can dress better day-to-day without having to wear a three-piece suit."—Mark Hertzberg, the Racine (Wisconsin) Journal Times.

ON FOLLOW-UP

"Consider contacting the subjects sometime after publication to discuss the reason for, and reaction to, publishing the image."—Dave Nuss, Salem (Oregon) Statesman-Journal.

These women are crying over the coffin of their recently murdered sister, Nicole Brown. Brown was the former wife of football legend O.J. Simpson, accused but found innocent of her murder.

When photographing a funeral, call ahead to express your sympathy and to let the family or friends know you are coming. At the grave-side, wear appropriate clothing.

(Photo by Al Schaben, Los Angeles Times.)

scene. Beyond these photos, you must weigh the short-range pain of your presence vs. the long-range value of your potential photos—a difficult judgment each photographer must make. Neither photographers at the scene nor editors back at the office are clairvoyant. Neither can look into a crystal ball and predict a picture's effect.

Photojournalists must maintain a belief in the overriding long-range importance of photos and the specific contribution of their particular image. Emotion-laden events lead to a cautious, continuous balancing act.

Eddie Adams, who won the Pulitzer Prize for his photograph of a Viet Cong suspect being assassinated in the streets of Saigon (see page 326), told the author about a photo he didn't take while covering that war:

"On a hilltop in Vietnam, I was pinned down with a Marine company. Machine guns were going off. Dead bodies were lying on either side of me. Rocket fire seemed to be coming from everywhere. I was lying on the ground five feet away from an 18-year-old Marine. I saw fear on that kid's face like I had never seen before. I slid my Leica, with its preset 35mm lens, in front of me. I tried to push the shutter, but I couldn't. I tried twice more, but my finger just would not push the button. Later, I realized that I was just as scared to die as that kid was. I knew my face looked exactly like his, and I would not have wanted my picture seen around the world. I think his and my face said WAR, but I still think I did the right thing by not taking

that picture."

Adams chose to invoke the "do unto others . . ." Golden Rule. However, the photographer might also have considered the possible value to society from seeing the censored image. Adams' Pulitzer Prize-winning picture of the Vietnamese colonel executing a suspected Viet Cong did help to change the course of the Vietnam War. In the execution situation, society's greater good was served by photographing the scene.

Adams' hesitation at taking pictures on the hilltop in Vietnam was rare. Most professional photographers don't hesitate to take pictures when faced with a gut-wrenching accident or tragic murder.

In fact, many photographers say that, because the critical moment is fleeting, they shoot instinctively. They point out that you can always decide not to use the picture, but you can't revisit the moment. The consequences of taking someone's picture, the momentary disturbance or embarrassment, is relatively minor. Publishing the picture, which will be seen by friends, colleagues, and strangers, has a different and perhaps longer lasting impact on the subject.

Finally, hesitating to take pictures can conflict with the professional role of the photo-journalist. In most circumstances, professional standards would support the "shoot now—edit later" approach.

Boris Yaro, a *Los Angeles Times* photographer, had no trouble making the decision to take pictures when he photographed Senator

Robert Kennedy's assassination at the Ambassador Hotel. Later he told the story to John Faber, author of *Great News Photos*.

"I was trying to focus in the dark when I heard a loud Bang! Bang! I watched in absolute horror. I thought, 'Oh my God it's happening again! To another Kennedy!' I turned toward the Senator. He was slipping to the floor. I aimed my camera, starting to focus, when someone grabbed my suit coat arm. I looked into the dim light, seeing a woman with a camera around her neck screaming at me. 'Don't take pictures! Don't take pictures! I'm a photographer and I'm not taking pictures!' she said." For a brief instant, Yaro was dumbfounded. Then he told her to let go of him. "I said, 'Goddammit, lady, this is history!"" He took the photographs. (See page 312.)

RESPECTING PRIVACY AT FUNERALS Funerals are sad, stressful, and emotionally draining. They provide a context for grief and a forum for sharing sorrow among family and friends—not photographers. But sometimes they are newsworthy.

The decision to cover a funeral generally rests with an editor, but once that decision is made, it's the photographer's responsibility to complete the assignment. And it is the photographer, not the editor in the office, whom mourners notice, resent, and berate.

Photographers and the public have widely differing views about professional ethical conduct at these ceremonies. Craig Hartley surveyed NPPA members and citizens of Austin, Texas. He wanted to find out how each group viewed a number of ethical situations, one of which involved the funeral of a slain police officer, an event that an uninvited photographer attends and photographs even after being asked to leave.

Hartley found that although 63 percent of the news photographers he surveyed found the photojournalist's behavior at the funeral "ethical," 85 percent of the public found the behavior "unethical." Readers, who vehemently denounced the actions of the photojournalist at the funeral, did not perceive the picture's value as meriting this intrusion into the private ceremony.

PROFESSIONAL VS. GOOD SAMARITAN

When should the photographer act as a professional photojournalist, and when should the cameraperson act as a responsible citizen? What happens when the roles conflict? Consider these scenarios:

You are driving along the street and see a man running out of a pawn shop carrying a

television set under his arm with the proprietor in hot pursuit. Do you try to stop the thief with the intent of holding him for the police, or do you take a picture of the scene as the criminal escapes around the corner?

Later in the day, you see an accident by the side of the road. A child, stuck behind the car's dashboard, cries inconsolably. Do you take the little girl's picture, or sit and comfort her?

A terrorist group has agreed to let you photograph their activities. They take you on a secret mission to plant a bomb. Do you take their pictures or try to stop them from activating the explosive? How would you handle the situation if you were photographing a similar raid, only this time the group was a U.S. army unit, not a terrorist gang?

The argument for professionalism often parallels the utilitarian principle of ethics. The photojournalist has a role in society just as a doctor or lawyer has. That role is to inform the public. Information allows this country's citizens to make intelligent decisions. By actually seeing what is going on including a thief in the act of stealing a television set, terrorists planting a bomb, a person committing suicide, or even the agony of a child caught in a car wreck—citizens can perhaps learn enough, or be moved enough, to prevent such things from happening to others in the future. Information can lead to changes in public policy, laws, funding, or perhaps just improved behavior.

A photographer's job is to record the news, not to prevent it or to change it. Like an anthropologist observing a foreign culture, the photojournalist should look, record, but not disturb what is going on.

The Good Samaritan argument, on the other hand, is absolutist: a photojournalist is, first and foremost, a human being. A photojournalist's primary responsibility is to the human being needing immediate help. Journalism comes second. No one can measure the good a photo will do later, but you can see the immediate needs of the present.

Joe Fudge, of the *Newport News* (Virginia) *Daily Press/Times Herald*, had no problem making the ethical choice between being a Good Samaritan and a professional photojournalist when he saw smoke pouring from the third floor of a house.

First asking the newspaper office via twoway radio to notify the fire department, Fudge charged into the burning house and alerted residents that their attic was ablaze. "I went into the house and found three people sitting around eating. They didn't know that a fire was burning off the top of their house. The woman said, 'Oh, my God, my husband

COVERING FUNERALS

MAKE **ARRANGEMENTS** IN ADVANCE. When you get a funeral assignment, contact the family or close friends to let them know you are coming. Express your sincere sympathy by simply saying you are sorry about their loss. If you are unable to speak with a family member or friend, the funeral director is your next best choice.

DRESS SOBERLY.
Photographers must dress as if attending the funeral—a suit or dress in dark color.

ARRIVE EARLY. You will be situated and a part of the scene when everyone else arrives.

LIMIT THE
MOTOR DRIVE.
Don't unload with
your motor drive.
Even if the family
has said okay, you'll
offend those who are
also grieving and
who don't know
you have family
permission.

NO LIGHTS, PLEASE. Avoid using strobes. Nothing is more offensive than a strobe flashing in the face of a crying person during a funeral service.

> Mary Lou Foy The Washington Post

At a press conference called by Bud Dwyer, Pennsylvania's state treasurer, he proclaimed himself innocent of a kickback scandal and then killed himself. No photographer could have stopped him.

Should these pictures have been published? (Photos by Gary Miller (LEFT) and Paul Vathis (BELOW), Associated Press.)

is asleep in the third-floor bedroom.' By this time, the flames were coming through the ceiling of the third floor. We went up and woke him up. Then all of us escaped."

When Fudge jumped out of his car after spotting the fire, he did not take in his cameras. Rather than photograph the burning house, Fudge decided to save lives first. Later, he returned for his equipment and photographed the father saving the family dog.

A group of photographers faced ethical decisions when presidential candidate Bob Dole fell through a platform railing during an appearance in Chico, California. In the split second when Dole tumbled through the weak stage banister, Agence France-Presse (AFP) photographer J. David Ake prevented Dole's head from hitting the ground in the four-foot fall. Ake didn't get the picture, but he saved the candidate from a potentially disastrous head injury. Reuters photographer Rick Wilking, too far away to help, recorded the accident. Said Ake, "If someone is falling toward you, the human thing to do is to try to help him, not stand back and let him crash." Wilking, on the other hand, was not in a position to assist Dole, so he did not have to choose between aiding the candidate and shooting pictures. Luckily, Wilking did cover the sequence photographically. The photograph of Dole grimacing in pain after the fall from the campaign stage became a visual icon of Dole's slipping campaign.

SUICIDE: A SPECIAL CASE?

Photographer William T. Murphy, Jr., when he worked for the *Oregon Journal*, faced the dilemma of taking pictures or trying to help a woman stop her husband from killing himself. He tried to do both—by taking five shots as he attempted to talk the man out of jumping one hundred feet into the Columbia River and as he yelled at another motorist on

the bridge to go for help. But the man soon struggled free from his wife's desperate grip and jumped to his death in the swirling river.

Few readers sympathized with Murphy's ethical dilemma. According to "Ethics of Compassion," an article by Gene Goodwin in *Quill* magazine, many readers complained about Murphy's photo of the suicide, which went out over the UPI (United Press International) wires.

"Don't the ethics of journalism insist that preservation of human life comes first, news second?" asked a reader from Philadelphia. A New York reader wrote, "He let a man die for the sake of a good photograph."

Murphy replied to the criticism, "I don't know what I could have done differently. I am a photographer, and I did what I have been trained to do. I did all I could."

Suicide as a form of protest

No one attempted to stop a Buddhist monk who set himself on fire protesting the 1963 Diem government in South Vietnam. The shocking picture showed readers dramatically and convincingly how serious the country's problems were. The monk used his death as the ultimate form of political expression. (See page 300.) Peter Arnett of the Associated Press, who reported the event, said that he could have prevented that immolation by rushing at the monk and kicking the gasoline away. "As a human being I wanted to; as a reporter I couldn't."

One person's private turmoil resulted in a national issue when Pennsylvania State Treasurer R. Budd Dwyer called a press conference just hours before he was to be sentenced for his conviction in a \$300,000 kick-back scandal. Dwyer, forty-seven, was facing up to fifty-five years in prison. After thirty minutes of proclaiming his innocence to reporters and photographers, Dwyer picked up a large manila envelope and pulled out a long-barrel, blue-black handgun. He placed the gun in his mouth and pulled the trigger.

Could photographers, reporters, or TV camera crews have stopped Dwyer? The consensus was no. Once the gun was out of the envelope, only fifteen seconds elapsed before Dwyer shot himself. Also, Dwyer had built a barricade of chairs and tables between himself and the press.

Should photographers have stopped Budd Dwyer if they had the opportunity? Was Dwyer making a political statement? In any case, are the pictures so upsetting to the public that they cause the reader to look away rather than consider the underlying issues?

At least on the front page, according to one study, almost every editor surveyed
(95 percent) thought that the photo of Dwyer's body slumping after he fired the shot was too shocking for their readers.

Robert Kochersberger surveyed newspapers in three states to see how they used the photos. He found that most newspapers (66 percent) used the photo of Dwyer holding out his hand, but exercised restraint by not publishing either the photo of the pistol in Dwyer's mouth or the one of his body slumping to the floor.

Suicide as mental illness

Beyond the political question of suicide as a form of expression, photographing suicide raises the issue of documenting severe mental problems.

In Wichita Falls, Texas, a former mental patient committed suicide with a twelve-gauge shotgun. In this situation, the photographer had no chance to stop the man. Don James, the executive editor of the normally conservative *Record News*, explained the picture to readers by saying, "We felt the story leading up to the suicide illustrated a shocking failure on the part of our system."

In the United States, mental illness remains hidden behind closed doors. Yet half the deaths by gunshot are a result of suicide. Rarely does the problem of mental illness become photographable. The relatively rare pictures of someone in the act of suicide might help to call attention to the failure of mental health policies in the United States.

MORAL DILEMMAS OF A PICTURE EDITOR

GRUESOME PICTURES: SEEN OR SUPPRESSED?

Editors who deal with pictures are also on the ethical firing line. A photographer at the scene of an accident or disaster does not have the time to determine if a particular picture is too gruesome or horrible to appear on the paper's front page. Only when the film has been processed can the photographer and the editor study the images with an impartial eye toward deciding if the photos are too indecent, obscene, or repulsive for publication.

The reader, with the morning edition of the *Republican-Democrat* neatly folded between his coffee and his oat bran, might gag on a gory front-page accident photo (ultimately tossing both the paper and his cereal). Editors sometimes refer to this as the "breakfast test" for hard-to-digest pictures.

Yet editors must not whitewash the world. Murders, accidents, wars, and suicides happen. Eliminating violence presents readers with a false view of their community and the world. (See Chapter 10, "Photo Editing.")

In fact, totalitarian dictators always try to muzzle the press in order to suppress information and hide truth.

Despite the best of intentions, the press also self-censors with written or unwritten guidelines. Newspapers at the beginning of World War II, for example, never showed dead American soldiers, because editors wanted to keep morale high on the home front.

Until *Life* magazine ran a photo showing dead American soldiers strewn on a beach, the public was sheltered visually from some of the war's impact. Is it right or even responsible for the press to protect the public in this way? Is it possible that, by withholding these scenes, the press actually prevented Americans from developing a healthy outrage about events in Europe, a fury that perhaps could have fueled the war effort? (See "Hiding Dead Bodies," on page 321, and Chapter 16, "History.")

The corpseless photos were not inaccurate per se. They were merely incomplete. Arbitrarily editing out death—or any other sign of violence or tragedy—gives readers a false sense of their own security and a skewed view of their world.

Sebastian Balic, an Associated Press stringer, shot a grisly set of pictures of youths stoning, then stabbing, and finally setting a man on fire in Soweto, South Africa. The *New York Daily News* ran the photograph of the stoning. Referring to the pictures in an article by Sue O'Brien, Jeff Jarvis, the newspaper's Sunday editor, said, "I don't think the breakfast test works for the '90s."

Mike Zerby, photo editor at the *Minnea-polis Star Tribune*, agreed. "The standard line," he said, "is 'we don't bleed on your eggs,' but I think at this particular newspaper we've grown past that."

A former mental patient shot himself with a 12-gauge shot-gun. Do the pictures help call attention to the problems of the mentally ill?
(Photo hy Peter Bradt

(Photo by Peter Bradt, Wichita Falls [Texas] Time Record News.)

Curtis MacDougall, author of News Pictures Fit to Print . . . Or Are They?, once spent a full hour soliciting the opinions of everyone in the newsroom regarding the propriety of using a picture of a lynching. The photograph showed a corpse slumped at the base of the "hanging tree." MacDougall recalled the photo and the incident: "No facial expression was visible; nevertheless the decision was made to black out the body and substitute an artist's drawn 'X' to mark

This conservatism was typical of American editors through a century of brutal torture and murder of African Americans. According to MacDougall, plenty of photographs were available to document this inhuman treatment; however, when those photographs reached newsrooms, they were relegated to files rather than to news pages.

Of another lynching picture described as "shocking and unnecessary," Ernest Meyer wrote in the Madison (Wisconsin) Capital Times, "So was the crime. The grim butchery

recalled that, when he was a reporter on the old St. Louis Star Times, the managing editor

the spot."

Initially, readers objected to this picture of a fireman carrying the lifeless child who had been trapped in a building with locked burglar bars on the windows. Many papers will not run any picture that shows a dead body. For more about the photo, see page 321.

(Bill Eisner for the Detroit Free Press.)

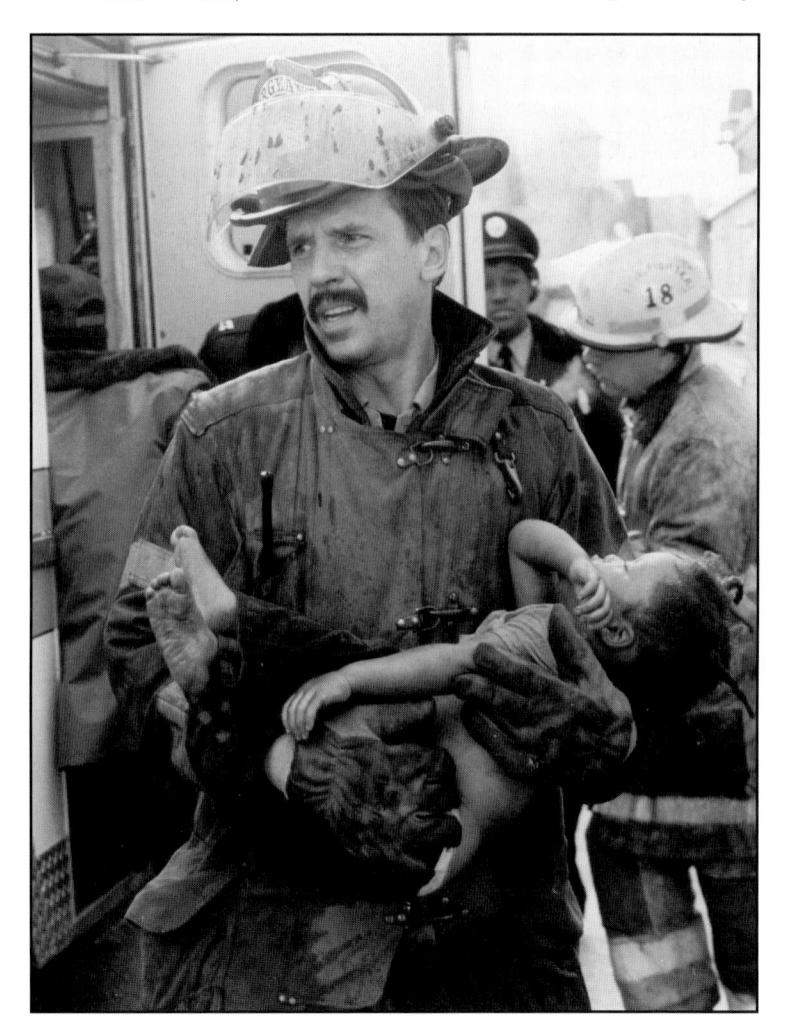

deserved a grim record. And those photographs were more eloquent than any word picture of the event."

At the time, newspaper editors argued that lynching pictures were too grisly to print. However, during that same era, editors did play up horrible pictures of blood-soaked, maimed car-accident victims. Editors rationalized that accident pictures served as a warning to careless drivers and thus improved highway safety. (The same logic today prompts driver's ed teachers to screen a bloody crash site film for novice drivers.) Sadly, no one thought to add that lynching pictures might also have a positive benefit by stirring up moral outrage against mob rule.

Today, the number of accident photos has decreased. Because accidents have become so common, they are less newsworthy. Accident photos, too, are often more difficult to get because the police remove bodies promptly. But the underlying moral question remains: does the sight of mutilated victims in a mangled car frighten readers into caution when they drive their cars? And should this type of picture be published?

The Akron (Ohio) Beacon Journal said in an editorial about accident coverage: "The suddenness and finality of death, the tremendous force of impact, are vividly depicted in crushed, twisted bodies, and smashed vehicles. The picture implants in the minds of all who see it a safety lesson that could not be equally well conveyed in words alone. How long the shock value of such a picture persists, varies. But one can be sure that a majority of those who see photographs of traffic accidents are more concerned with their safety than they had been before seeing the picture. 'This can happen to you!' is the unwritten message of every picture of an accident."

READER COMPLAINTS

In Craig Hartley's survey comparing photojournalists' and general readers' reactions to ethical situations, he found that the two groups differed widely in their reactions to shooting and transmitting gruesome pictures. Hartley found that 58 percent of the professionals he surveyed considered ethical the actions of a hypothetical photojournalist who photographed the removal of a famous actress' body from an automobile crash and the editors' subsequent decision to send the pictures over the wires. However, nearly three-fourths (71 percent) of the public disapproved of the journalists' actions.

Note, however, that readers' approval rating does not always coincide with their curiosity rating. Regardless of their opinion, drivers

On a mission in Africa to provide food for starving Somalians, an American soldier was killed and then dragged through the streets of the city of Mogadishu. The picture was so powerful that it helped to change U.S. policy toward involvement in Somalia. (Photo by Paul Watson,

Toronto Star.)

routinely slow down to "rubberneck" a highway accident.

When editors select and publish strong, compelling, but perhaps hard-tolook-at pictures that include mangled bodies, blood, or victims' or bystanders' tearful reactions, readers often complain. From an economic point of view, editors certainly care what readers do and don't want to see on page one.

However, most readers today subscribe to their newspaper rather than buy a copy on the street. Single-copy sales and, therefore, individual frontpage pictures no longer control circulation sales as they did in the days when competing tabloids would run shocking pictures for the sole purpose of attracting readers. Editors are looking for a sustained readership, not a one-day circulation boost.

From the ethical perspective, however, should editors make decisions based on reader preferences? Do editors have a responsibility that supersedes the likes and dislikes of their audience?

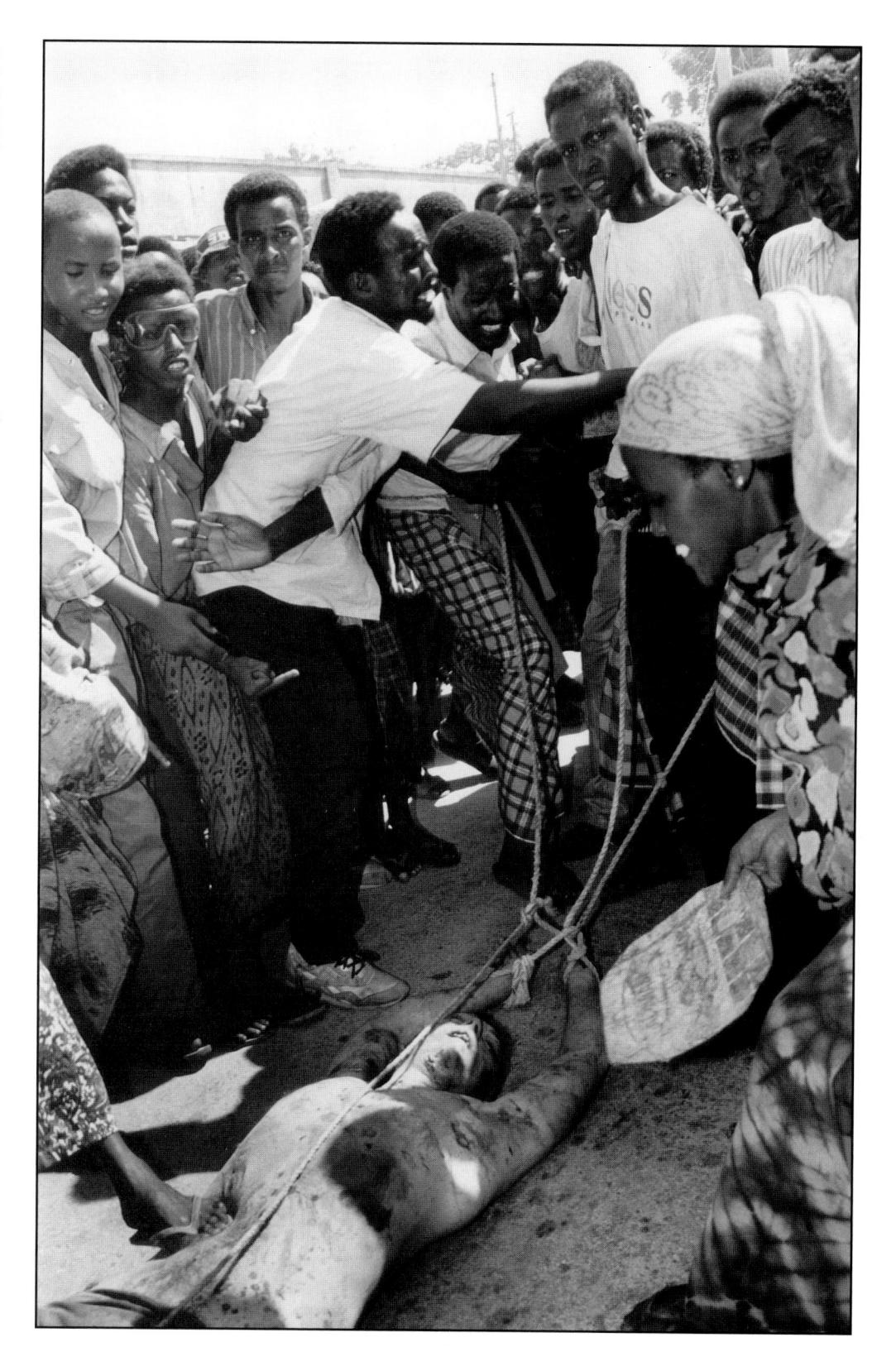

THE "DISTANCE" RULE

For stories involving tragedy, journalists sometimes make conflicting decisions regarding the play of written stories compared to photos. For written stories, geographic proximity is one of the determining

ARE PHOTOJOURNALISTS PAPARAZZI?

Diana, Princess of Wales, danced at the White House with actor John Travolta. The White House photographer was allowed to take this picture. Paparazzi, on the other hand, shot thousands of pictures of the princess during public as well as private moments without her permission.

(Photo by Pete Souza, Reagan Library Collection.) What is the difference between paparazzi, who photograph celebrities, and photojournalists, who cover the news?

Both kinds of photographers use the same cameras, film, and strobes. They look alike, and sometimes their work is even printed in the same publications. However, the purposes of the two breeds of photographers are quite different. Photojournalists hope to inform the public. Paparazzi take pictures to entertain or titillate. (For more on paparazzi, see page 284, Chapter 14, "The Law.")

Unfortunately, the general public often lumps paparazzi and photojournalists in the same category. That is what happened following the death of England's Princess Diana. She died in a horrific car crash during a high-speed chase in which her car's driver was attempting to outrun seven or more photographers. The public was outraged at the paparazzi.

After the tragic accident, photographers who had nothing to do with the accident and, in fact, had never staked out a celebrity in their lives, faced a barrage of insults on their regular assignments. Covering a routine news event, bystanders yelled "Photographers killed Princess Diana" at Scott LaClair of the Herald-Standard in Pennsylvania. One man even started swinging at LaClair with his fists. During the incident, the photographer's glasses were scratched, but he wasn't injured. When Susan Watts photographed the memorial for Princess Diana outside the British Embassy in Manhattan, a passing motorist shouted "Murderer . . . paparazzo assassin . . . You killed Diana."

Photographers killing people? What is this all about?

Diana's death pushed the public's patience over the edge. Even before the tragedy, surveys indicated that the public feels the news media are too invasive. A 1996 poll by the Center for Media and Public Affairs found that 80 percent of those surveyed thought the media ignored people's privacy. After Diana's death, more than 95 percent of respondents to an informal

USA Today online survey thought the Princess had been unfairly hounded by the news media.

Perhaps the public has a right to confuse the paparazzi and the photojournalist. Aside from the use of the same cameras and film, other similarities do exist between them. Sometimes both kinds of photographers cover celebrities.

Few photojournalists, however, spend their lives staking out a Hollywood star or international glamour figure in the hopes of catching a private or risqué moment.

The distinction between the two types of photographers grew narrower during the coverage of Monica Lewinsky, the intern whose affair with President Clinton nearly ended his presidency. When independent counsel Kenneth Starr focused his five-year \$47 million investigation into alleged presidential misconduct on Clinton's relationship with the young woman, photographers of all stripes staked out her apartment and tried to get any image they could of the former intern.

Although the behavior of photojournalists in the Lewinsky situation mimicked that of paparazzi, from an ethical standpoint their purpose was different. Lewinsky was an accidental celebrity for the moment. Though she had not thrust herself into the public eye, her relationship with the President did culminate in an impeachment trial that could have changed the course of history.

The lives of Hollywood stars and glamour figures, the standard subject matter for paparazzi lenses, on the other hand, rarely have an effect on the nation or the world.

Of course, even when photojournalists cover a legitimate news story like alleged presidential misconduct, they should not resort to using ladders to peer over fences into the private homes or engage in high-speed car chases to grab a snap of a reclusive subject, points out David Lutman, past president of the National Press Photographers Association.

Because photojournalists look like paparazzi, and sometimes even act like them, the public naturally confuses legitimate news gatherers with shooters who survive by selling pictures of celebrities. The key difference, however, between these two distinct forms of photography is their intended purpose. Photojournalists take pictures to show readers events that they could not see for themselves. Paparazzi shoot pictures to satisfy the public's insatiable curiosity about the lives and love affairs of the famous. Hopefully, the behavior of the paparazzi will not lead to such a backlash from the public that the work of authentic photojournalists will be further impeded.

criteria in assessing news value—the closer the event, the more importance and, therefore, more prominent play it is given. Yet, because readers are more likely to complain about gruesome local pictures than those from far away, editors often will play down or suppress strong pictures that involve hometown residents but run revealing pictures of atrocities in other parts of the world. In fact, some newspapers, like the *Tampa* (Florida) Tribune, even have policies mandating this practice. Denise Costa of the Tribune says that she wants to "protect the people involved more than she would want to run the photo." This attitude toward photography is counter to traditional news criteria for print stories—top among them, coverage of events that take place near or in a newspaper's community. Editors, however, don't like fielding calls from irate readers.

HIDING DEAD BODIES

When to run and when to hold a photo often comes up when editors must deal with a picture containing a dead body. Readers of the *Detroit Free Press*, for instance, were jolted by a front-page photograph of a Detroit fire-fighter carrying a dead child from a home in which seven brothers and sisters locked alone inside had died in a fire (page 318). Doors and windows had been barricaded or barred to keep burglars out.

Initially, readers complained about the picture, shot by stringer Bill Eisner. But within a few days, calls and letters supporting the paper's decision started coming in. The response was about 50 percent positive, director of photography Mike Smith reports, and about 50 percent negative.

Detroit Free Press columnist Susan Watson wrote: "Callers—some callers, not all—found the picture disgusting. Sickening. Inappropriate. The paper was accused of overstepping the bounds of good taste.

"Well, it's a good thing that I don't make the final call—or any call, for that matter on what runs on page one.

"If I did, I would have spread that picture across the entire page. Heck, I wouldn't have stopped there. I would have made a huge poster out of it and hung the poster from the top of this building and city hall and even the Capitol in Lansing. I would have done it as a chilling reminder of the ungodly price we pay when we take risks with our children. . . . It screamed, loudly and rudely, that we have to stop endangering our loved ones to protect our belongings."

Joan Byrd, a *Washington Post* ombudsman, summarized the counterargument: "the family should not have to see news photos of

someone killed in an accident or a crime. Families of victims have said that years later something haunts them every single day: the picture of the body at the scene, the description of the person in the newspaper. Images on TV are here and gone. Still photos in the newspaper last."

The two columnists eloquently summarize conflicting ethical points of view. Running the picture, the *Detroit Free Press* columnist argues, helps the most people and hurts the fewest. *The Washington Post* ombudsman, on the other hand, takes an absolutist position by pointing out that if the picture hurts just a few relatives and friends, it is wrong to run the picture because the media must protect those few from more pain.

Similar reactions and arguments apply to pictures of drowned children, like John Harte's photo in the *Bakersfield Californian* (page 303.) Harte's photograph of lifeless five-year-old Edward Romero, lying partially exposed in a plastic body bag and surrounded by grieving family members, is a powerful image. The paper received 400 phone calls, 500 letters, and a bomb threat. The editor subsequently ran an apology to the readers for running the photo.

The number of drownings in the Bakersfield area, however, dropped from fourteen in the month previous to the picture's publication to just two in the month after the paper printed the photo.

In another instance, Jonathan Adams photographed rescuers carrying a dead six-year-old child to an ambulance after the child had fallen off a pier and been under water for forty-five minutes. The *Muskegon* (Michigan) *Chronicle* editor, Gunnar Carlson, had two reporters take the photo to the family and ask if they minded if the paper published the photo. When they objected, the paper spiked the picture.

In other situations, editors make decisions by guessing how a family will react but never checking out their assumptions. Based on the "do unto others as you would have them do unto you" principle, editors act in a way they suppose families would want them to. Sometimes, however, relatives or friends of a victim recognize that publishing a picture may be one of the only beneficial outcomes of a tragic situation. When a child fell through the ice and drowned in a pond in Columbia, Missouri, the Columbia Missourian, after much discussion regarding the family's feelings, ran a picture showing rescuers recovering the child's body. The next day, the child's mother came to the office, where she picked up extra copies of the newspaper after thanking the editors for

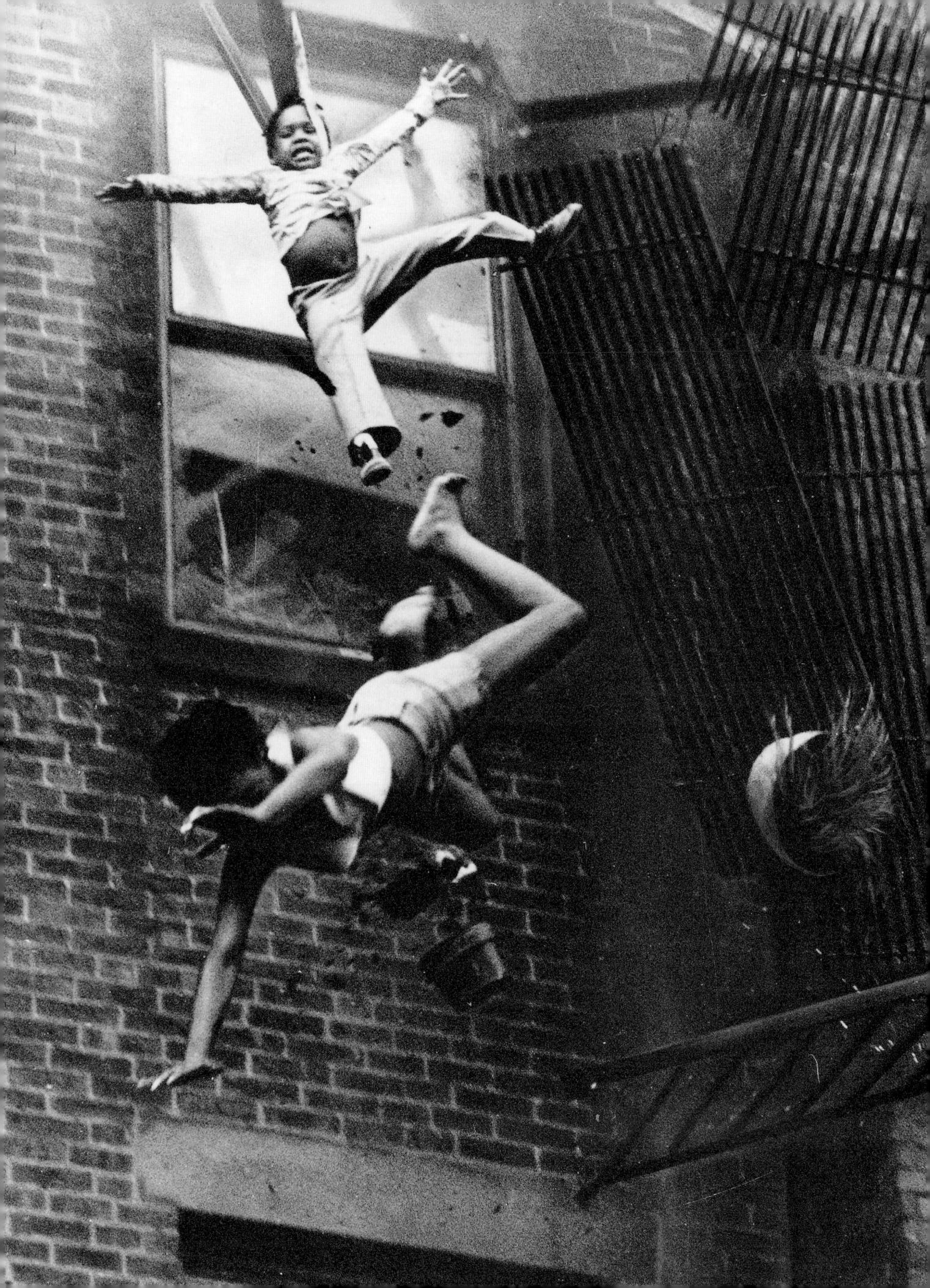

This fire escape collansed during a fire. plunging a woman to her death; the child miraculously survived. After the picture ran on hundreds of front pages around the country, telephone calls and letters deluged newspapers, charging sensationalism, invasion of privacy, insensitivity, and tasteless display of human tragedy-all to sell newspapers. Would you have printed this picture?

(Photo by Stanley Forman, Boston.)

running the photograph. She said she hoped that the frontpage picture of her child would help deter others from playing on the thin pond ice.

Perhaps news outlets should routinely call victims' families to warn them that an emotional photograph will run. This procedure would diminish a family's shock at seeing the image

but would still allow the wider public to be informed in the strongest way possible about the news event. (For more on war censorship, see pages 356–357, Chapter 16, "History.")

PHOTOGRAPHY CAN MAKE A DIFFERENCE

Stanley Forman's photo of a collapsing fire escape during a blaze in Boston—a woman plunging to her death along with a falling child who miraculously survived—was printed on more than one hundred front pages across the country. Later, telephone calls and letters to newspapers charged sensationalism, invasion of privacy, insensitivity, and tasteless display of human tragedy for the purpose of selling newspapers.

Hal Buell, who was AP's assistant general manager for news photos at the time, said he received more reaction to the Forman picture than to any other news photo. Buell wagered that if the woman had survived, there would have been very little reaction.

"The pictures would not have changed, but the fact of death reached into the minds and feelings of the readers," he said.

Most of the nation's editors published Forman's picture on their front pages. Yet in a survey taken by the *Orange County Daily Pilot* in Costa Mesa, California, 40 percent of its readers did not approve of publishing the photo. Wilson Sims, editor of the *Battle Creek* (Michigan) *Enquirer and News*, defended publishing the picture: "The essential purpose is not to make the reader feel pain or to bring the reader happiness. It is to help the reader understand what is happening in the world. Therefore, we ran the picture."

Forman's photograph of the falling woman and child not only won a Pulitzer Prize, but it is also a classic example of how photography can bring about change. That shocking image contributed to a change in fire safety laws in Boston. Forman's editor, Sam Bornstein, said, "Without the picture, the word-story would have been 'page 16.' Only pictures of this magnitude would have resulted in something being done by the safety agencies."

Sometimes pictures not only can change a state's laws but can alter a country's foreign policy. In response to the starvation of Somalians in Africa, the United States sent its troops to help United Nations peace keepers to quell fighting and distribute food in that country. Despite the presence of U.S. troops, warlords continued to pillage. At one point a U.S. soldier was killed by the followers of one of the warlords. At great personal danger, the *Toronto Star*'s Paul Watson photographed the velling and screaming crowd as they dragged the almost nude body of the soldier through the city streets. The horrifying picture of the body of an American soldier being desecrated in the streets of a country halfway around the world was so shocking to the U.S. public that the administration quickly reversed policy and pulled U.S. troops out of Somalia. (See page 319.)

While a single picture alone probably did not change American foreign policy, this image, which generated immediate reaction from the public, commentators, and legislators, certainly played a significant role in hastening the withdrawal of U.S. troops.

MATTERS OF TASTE

Nudity in pictures generates more disagreement among editors than even the most gruesome picture. An editor's judgment about nudity in pictures generally reflects his or her understanding of readers' attitudes and of mores in the host community. In most cases, the standards for pictorial nudity are more a matter of taste than a question of ethics. With the advent of *Hustler* and other "skin" magazines, almost no part of the human anatomy is reserved for the imagination.

Yet most American newspapers and magazines refrain from printing nudity on their pages. AP's Hal Buell says that the wire service won't carry frontal views of nude men or women, except in extreme cases. "Such a story has yet to occur," he observes.

Professionals and the public again disagreed in Hartley's ethics survey when he turned to the question of nudity. Here is the hypothetical situation: Two women athletes collide in a volleyball game, with one falling in such a way that her shorts are pulled down and her bare buttocks are exposed.

While a majority of the professionals surveyed endorsed sending out a photo of the

SHOCKING PICTURE WARNING SIGNS

- If five or more of the following conditions apply to a shocking picture, editors should prepare for reader reactions before the firestorm hits:
- images that show subjects overcome with grief
- pictures
 containing
 dead bodies
- pictures portraying mutilated bodies
- pictures run in color
- photos containing nudity
- photos taken for a local story
- photos taken
 by a staff
 photographer
- images printed in a morning paper
- images printed on the front page
- images with no accompanying story

Paul Lester Photojournalism: An Ethical Approach

Taken by their staffer at the 25th anniversary of Woodstock, this photo was too risqué for Washington Times editors, who refused to run it.Trade magazines News Photographer and Editor & Publisher ran it, uncensored, with stories about the controversy it generated as a contest winner. E&P's headline: "No **Nudes is Good Nudes.**" (Photo by Kenneth Lambert, the Washington Times. For publication in this book, the following special credit note was required by the editor-in-chief: "This photograph did not run in the Washington Times due to

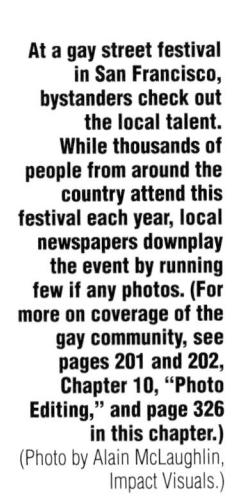

reasons of taste.")

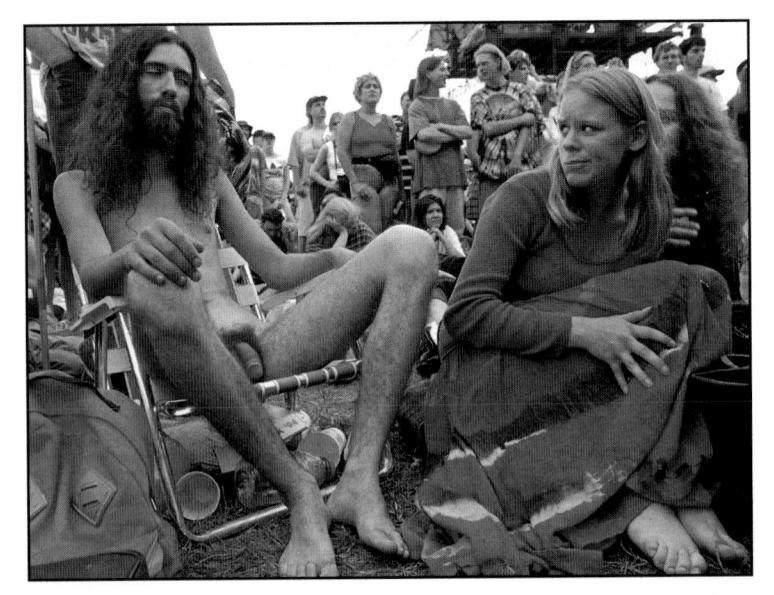

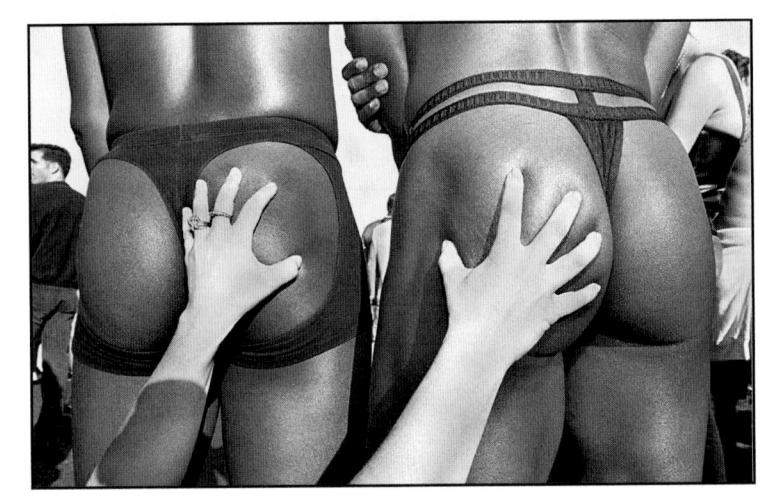

athlete's derriere, a whopping 75 percent of the public turned thumbs-down on the bottoms-up picture.

Robert Wahls, who was a photo editor for the *New York Daily News*, avoided running nudes except under unusual circumstances. Despite the *Daily News*' reputation as a genuine tabloid, Wahls felt that, although nudity is acceptable in film and theater, "it is inappropriate when you can sit and study it." The photo editor made an exception when there was an overriding news value to a picture. The photos from the original Woodstock, a massive outdoor rock concert in 1969, showed members of the audience frolicking in the muddy field without their clothes on. The sheer size of the audience—300,000—gave the activities news value.

Wahls, however, pointed out that, even if nude pictures help push up the circulation of a newspaper, the gain might be useless if advertisers start to consider the paper pornographic. "A newspaper's job is to inform, not to titillate," said Wahls.

Twenty-five years later, the Washington Times' Ken Lambert photographed Woodstock's silver anniversary, which, like the original, gave kids an excuse to party, wear tiedye, and "get naked." Although only a few got naked this time around, Lambert took a picture of a young woman glancing disapprovingly at a longhaired "hippie" wearing only his birthday suit—a true testament to the difference between the times. The picture was too dicey for the Washington Times, whose editor, Josette Shiner, called the Times "a family newspaper." The photo, however, was not too spicy for judges of the White House News Photographers

Association (WHNPA) photo contest, who awarded it a first place for features. But the controversy did not end there.

The president of the WHNPA, Ken Blaylock, was personally offended by the picture and tried to block its exhibition with the other winners in the group's yearbook. The ensuing outcry of censorship caused the *Washington Times* to write a story about its own photographer and the photo they had refused to print—but still without the picture.

The competing *Washington Post* did publish the picture, with a discreetly placed black bar over the offending body part. Finally as a petition protesting the censorship was cirulating, the president of the White House News Photographer's Association relented and allowed the photo to take its place among the winners in the exhibit—without cropping the picture or running a black bar (the modern equivalent of the Victorian fig leaf) to protect the innocent.

"Innocent" readers also might disapprove

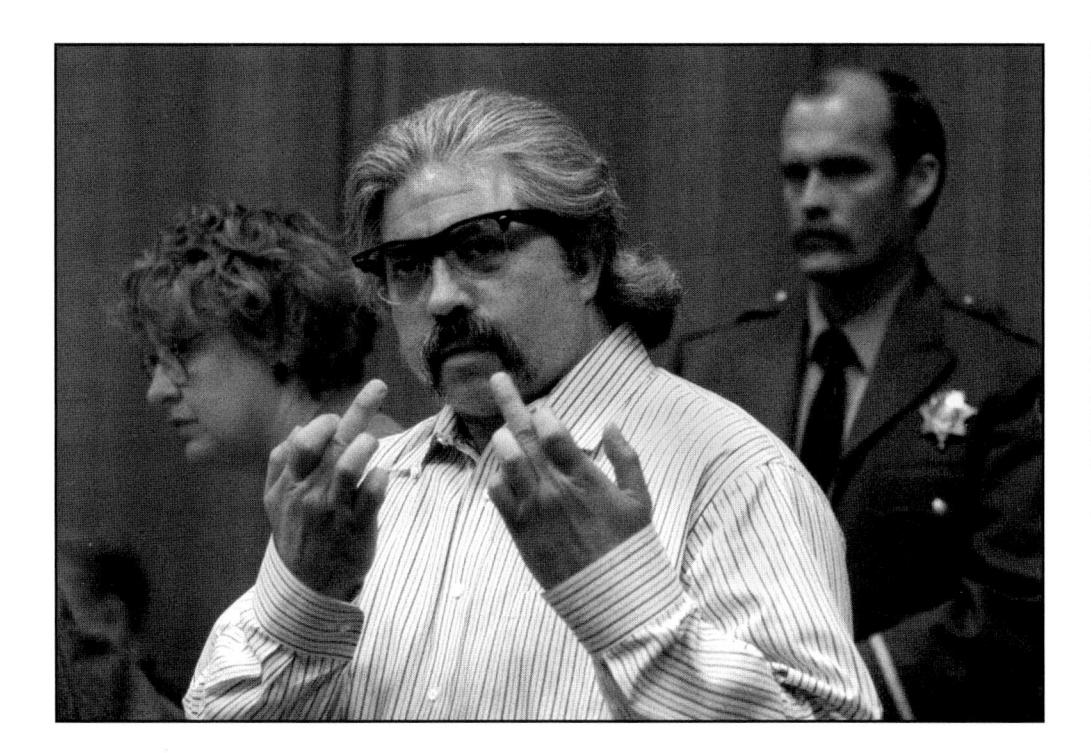

Publication of the photo of this defiant act by convicted child murderer Richard Allen Davis upon hearing the jury's guilty verdict generated a firestorm of negative response for newspaper editors in the San Francisco Bay Area. The shocking picture, however, provided a revealing insight into the man's character. Previously, he had remained quiet and subdued.

(Photo by John Burgess, The Santa Rosa (California) Press Democrat.)

of photos showing obscene gestures. Yet editors in the San Francisco Bay Area published John Burgess' picture of convicted murderer Richard Allen Davis gesturing with upraised middle fingers following the jury's guilty verdict in his trial. Davis' abduction and murder of fifteen-year-old Polly Klaas had horrified citizens of the Bay Area.

Burgess, who shoots for the *Santa Rosa* (California) *Press Democrat*, was the pool photographer in the emotionally charged case. Bay Area papers all ran the photo on their front pages. Executive editor Jerry Ceppos, of *The San Jose Mercury News*, said his newspaper logged 1,284 messages from readers, overwhelming voice mail, E-mail, fax, and online systems. Ceppos said 817 readers agreed with publishing the photo, while 481 did not.

At the San Francisco Chronicle, said editorial page editor John Diaz, "the overwhelming majority" of callers and writers objected to the picture's page one play. Diaz defended running the picture. "The moment captured by Burgess' Nikon added new dimension to the story. It may well have an impact on jurors as they decide whether to sentence the defendant to death or life in prison. It certainly says something about the murderer. . . . The Davis verdict story would have been incomplete without the photo."

FAIR AND BALANCED REPORTING

The experienced professional reporter continues to dig up the facts of a news story until he or she feels prepared to write an unbiased,

balanced report of the event. News reporters take several paragraphs to explain the position of each conflicting party.

Many stories have no clear heroes or villains; hence, the reporter simply extends copy to explain the complexities of the situation. The writer has not only the advantage of several paragraphs, but the subtlety and precision of the English language, with its great store of adjectives and adverbs. These modifiers enable the writer to emphasize an idea or soften a phrase.

Think of the difference between the words "the suspect stared at me" and "the criminal glared at me."

The photographer has no adjectives or adverbs, no pictorial thesaurus to refine an image. A single picture captures only one moment in time, one set of circumstances, one expression or action. If the newspaper's managing editor has allotted space for just one picture to illustrate a complicated story, then the photo editor is faced with a task as difficult as if the writer had to tell a multifaceted story in one monosyllabic sentence. Of the two hundred or so exposed frames shot on an assignment, which single picture tells the whole story?

The Vietnam War presented a constant challenge for photo editors. Each day they had to sum up a complicated, tragic event in a few pictures. Eddie Adams won a Pulitzer Prize for a shocking photo of a South Vietnamese colonel executing a suspected Viet Cong on a Saigon street (see next page). During this war, the South Vietnamese were our allies.

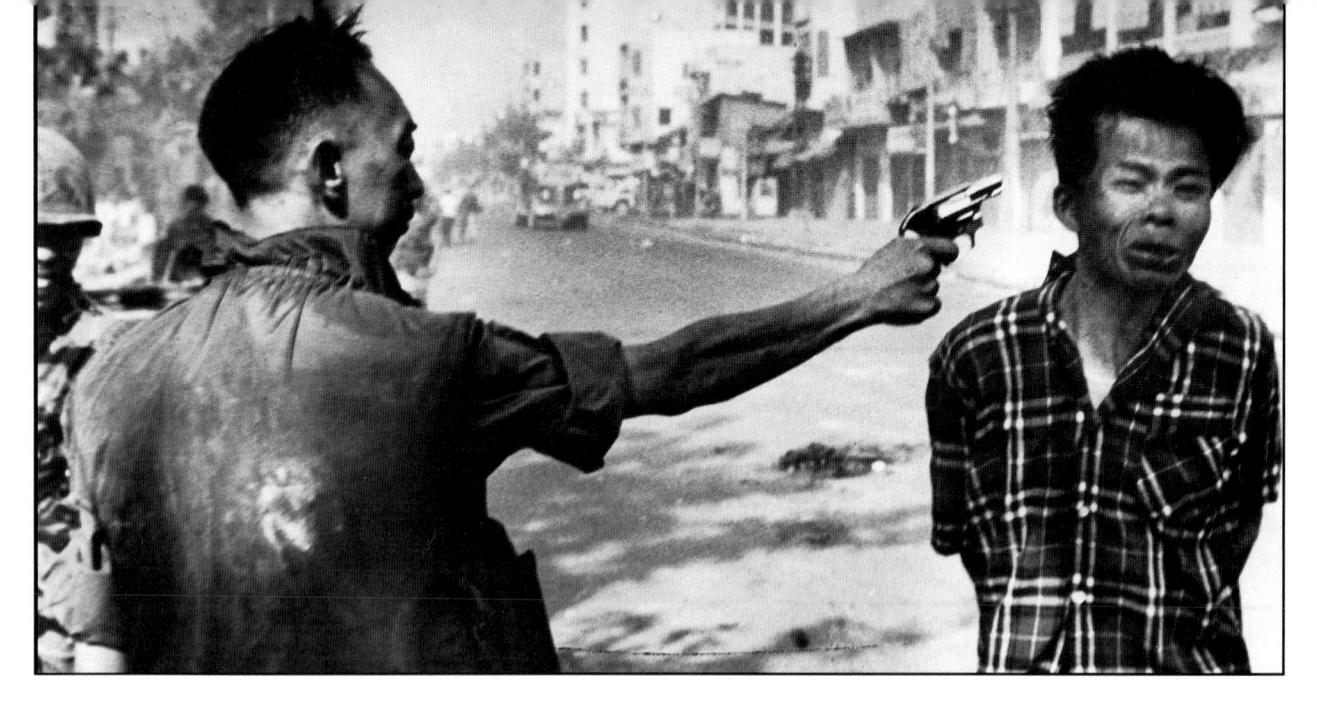

Brigadier General Nguyen Ngoc Loan, police chief of Saigon, assassinates a Viet Cong suspect. Because the South Vietnamese were U.S. allies, this picture disturbed the American public and helped change sentiment about U.S. involvement in Vietnam. (Photo by Eddie Adams, Wide World Photos.)

The overwhelming message of the picture, however, spoke of the cruelty of the South Vietnamese officer.

To balance this view of the war, many editors chose to run, on the same day, another picture portraying the terrorism of our enemies, the Viet Cong. The photo, although not as dramatic as Adams' picture, showed a soldier leaving a civilian house recently bombed by the Viet Cong.

Do the two photos really explain both sides of the conflict? Can any two pictures be balanced?

The question of balance also arises in local stories. Many groups point out they receive scant if any media coverage, and when they do, they see stereotypes of themselves.

Photographer Nancy Andrews, of *The Washington Post*, has won numerous awards, including Photographer of the Year. "I believe a lot of stereotypes are visual stereotypes," she says. "In my own community, as a gay person, [I see how] photographers have often looked for the most arresting pictures. The most arresting are valid—it's valid to show people dying [of AIDS] or dressed in drag at a gay pride parade—but if these are the only pictures used to represent the gay community, then it's an inaccurate picture of the whole community.

"Being aware of how visual images are used to show my own community," she says, "has made me aware of how important it is to show the average people in other communities." (See Andrews' picture story about an African-American single father on pages 144–145," Chapter 8, "The Photo Story.")

SELF-CENSORSHIP

Censorship often occurs before the shutter is ever released or a print ever made. For a variety of reasons, photographers decide not to take or publish photographs. A photographer might not photograph two men holding hands, for fear that the community "is not ready to deal with homosexuality" or that "my paper won't run that." A photographer might not want to "embarrass the person."

In addition to gays and lesbians, newspapers traditionally have ignored various ethnic groups over the years. Through neglect or, perhaps, in deference to a predominantly white readership, newspapers have overlooked large segments of the American population—African Americans, Hispanic Americans, Asian Americans, and others.

Through self-censorship on a conscious or subconscious level, photojournalists can create an artificial reality for their readers. Each journalist must look at his or her biases.

- Who is being protected by not taking or running a picture?
- Are you sure your editor won't publish a picture?
- Are the regulations about acceptable subjects and topics written down or just unofficially passed on to new members of the staff?
- Are you responding to your own fears and prejudices when you hesitate to release the camera's trigger or turn in an image?
- Have you challenged your publication's written or unwritten policy?

The message is this: examine your own motives. Scrutinize your actions for patterns that may reveal your own prejudices. Are elements or groups from your community consistently absent from your shots? Is it coincidence—or choice—that your pictures display these patterns? Then apply the same vigilance to your editor and your organization. A responsible journalist must remain alert to even the most subtle signs of prejudice, at all levels. If you discover that prejudice is part of the "corporate culture" at your

paper, you have three options: accept it, change it, or quit. Each carries a price.

REMEMBER THE READER

Photojournalists don't take pictures for contests, editors, or other members of the profession. They take pictures for readers—pictures that provide information about sad moments as well as happy ones. Without complete and well-rounded reporting, including both written and visual facts, a democratic society cannot function.

Therefore, when faced with a tough ethical question, try phrasing the problem in this way:

First, faced with this problem, what do other professionals in the field do? What is the professional standard for this action?

Next, are the actions of other professionals right or wrong? To borrow an apt phrase from mothers everywhere, "Just because everyone else does it doesn't mean you have to."

Then ask yourself, "Will taking or running a photo serve the greatest good for the greatest number of people?" Although you will find it hard to predict a photo's effect, can you hypothesize a positive outcome from readers seeing the photo? What is the negative impact if readers don't see the picture?

If you decide the photo has potential social significance, you should next ask, "Who will be hurt by taking or running the picture? Is this a situation in which an individual's rights supersede those of society?" You might ask, "How would I feel if I were the person in the photo?" Can you soften the pain with a phone call informing relatives about what they will see in the next day's paper?

Finally, although some individual rights are absolute, some are not. Keep in mind that you must weigh an individual's rights against society's need for correct and complete information.

LOOKING FOR A YARDSTICK

Not all pictures showing dying and death help readers or society. A picture of a man dying at home of natural causes does not provide information that society can use to change anything. No laws can prevent this death. Readers would not be shocked by the passing of another elderly man. No public policy issues are at stake. Pictures of a death that could not have been prevented are not necessarily news or newsworthy. On the other hand, pictures of a drowned child or one falling from a poorly maintained fire escape graphically highlight either behavior that individuals could prevent or laws that should be enacted.

In his book *News Pictures Fit to Print*... *Or Are They?*, Curtis MacDougall struggled to find a common rule to help editors decide when to splash a controversial picture on the front page or when to file the picture in the bottom desk drawer. "My yardstick is the public interest," said MacDougall. "I would run any picture calculated to increase the public's understanding of an issue about which the public is able to act."

MacDougall's yardstick, however, does not take into account competing claims like privacy, which in certain circumstances must also be considered.

Each editor will use a personal yardstick of public vs. private interest, but photographers should not rely on editors to shoulder the ethics burden. Photographers must determine for themselves what they find valuable about taking and then publishing photos.

The photographer provides the first line of ethical defense—and, in the end, the photographer's name runs under the photo. The photographer must take responsibility for the final image that appears.

At the funeral of a fireman killed in the line of duty, the photographer was able to tell the story without intruding on the grief of family members. The child dressed in a fire hat and jacket wants to become a firefighter.

(Copyright, John Beale, *Pittsburgh Post-Gazette*, 2000, all rights reserved. Reprinted with permission.)

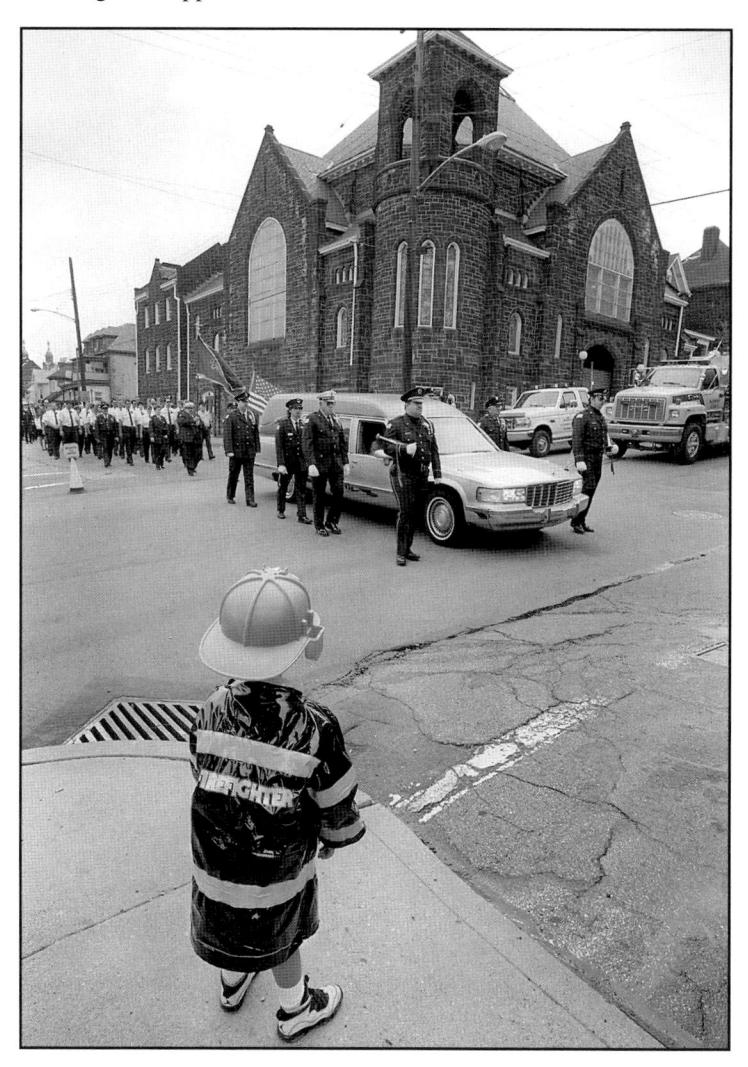

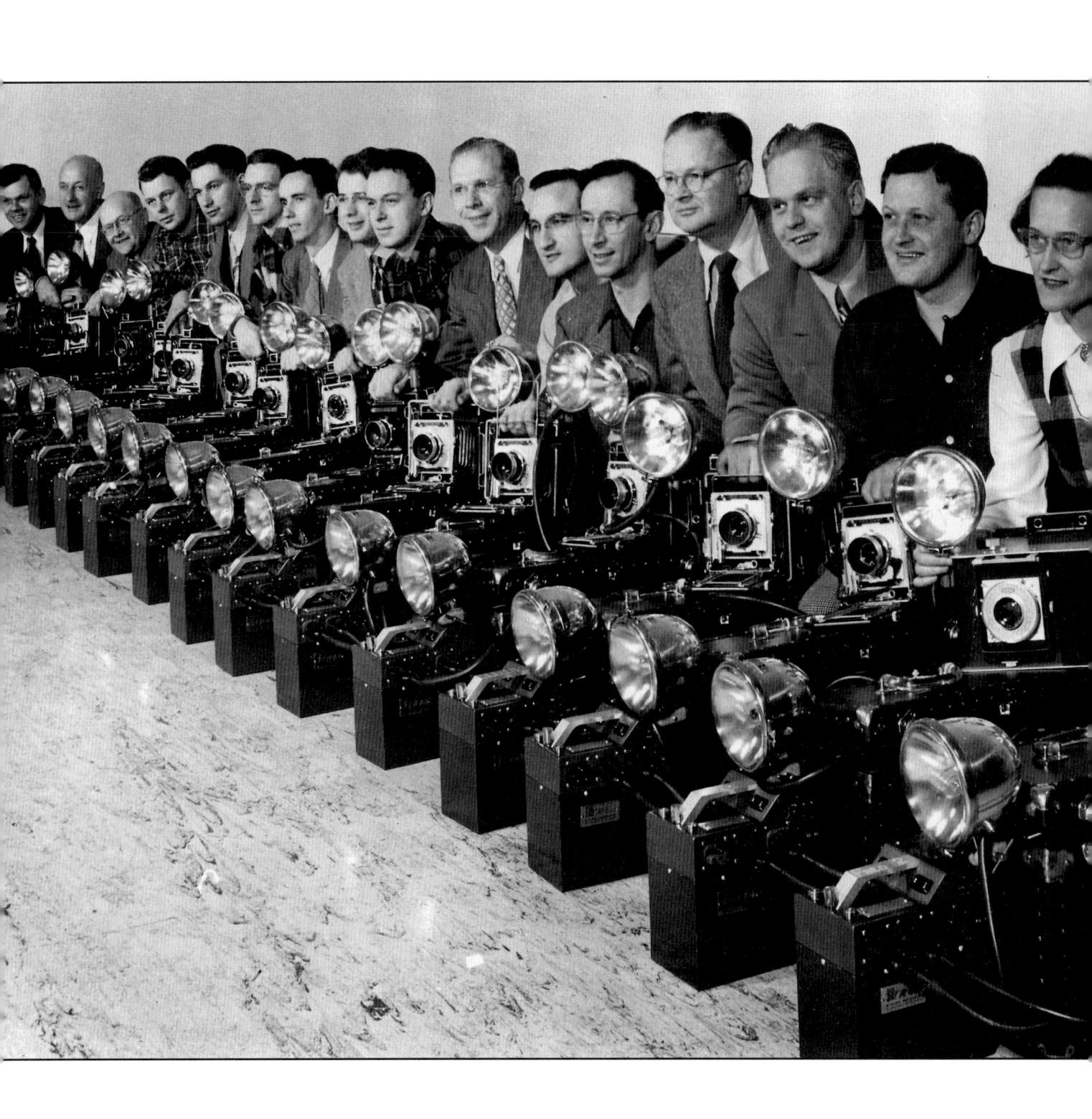

History

THE GOOD OLD DAYS

CHAPTER 16

n a balmy April day in 1877 the staff of The Daily Graphic, the first illustrated daily newspaper in the United States, conducts business as usual.

Written with Julie Levinson, assistant professor, Babson College.

Reporters labor to complete their copy in time for the morning deadline. Artists put the finishing touches to their drawings, which will comprise three and a half of the tabloid's eight pages. In a makeshift darkroom, where a janitor stores mops and brooms, a

The first "portable" strobe for the news photographer was perfected and manufactured by Edward A. Farber for members of the *Milwaukee Journal* photo staff.

(Milwaukee Journal.)

lone photographer places 5" x 7" precoated, dry

glass plates into light-tight holders. The photogra-

pher is so engrossed in the delicate operation

that he barely hears the sudden commotion in the newsroom over a passing fire engine. For *The Daily Graphic*'s staff, whose every sense is attuned to such signals, the fire engine's clanging bell tolls news.

Several reporters drop what they're doing, grab pencil and paper, and dash out to cover the late-breaking story. Someone remembers to inform the photographer about the fire alarm. He, too, puts aside his work and carefully balances his cumbersome view camera and tripod on one arm and a case containing twelve previously prepared glass plates on the other arm. The *Graphic* cameraman sets off with his unwieldy load.

By the time he reaches the blaze, it is raging full force. He sets up his tripod and camera as quickly as possible, points his lens at the action, and takes his first exposure. Normally he would take only one exposure, or perhaps two, of a given event. Because this is such a huge fire, however, he decides to expose several of his glass plates. He has only one lens, so if he is to get different perspectives on the action, he must change his position, pick up his bulky equipment, lug it to the new spot, and take the time to set up again. He then covers his head and the back of the camera with a black focusing cloth. Next he opens, focuses, closes, and sets the lens. Following this he loads the plate holder into the rear of the camera body and removes the dark slide. Finally, he takes the picture.

Before he can make the next photo, he must replace the dark slide and carefully put the holder back into his case. If he accidentally knocks the holder too hard, the glass plates will shatter. Unfortunately, the crowd jostles him as he works.

He attracts much attention because a news photographer is still a curiosity. But the *Graphic* photographer doesn't mind; he is particularly excited about the challenge posed by this event. Usually his assignments limit him to photographing portraits of famous people or carefully posed tableaux. Because of the technical limitations of his slow film (equivalent to ISO 24 by today's standards), he can photograph only under optimum conditions, with bright light and minimal subject movement. On this day, he gets some action shots by carefully panning his camera with the movement of a late arriving horse-drawn fire engine.

After several hours, *The Daily Graphic* photographer finishes making his twelve exposures, and by the time he packs his case, camera, and tripod, the firemen finally have the blaze under control. But as the photographer heads back to the newspaper office, weary from his physical exertion, his own

ordeal has just begun. Now he must develop his pictures in chemicals he mixes from a formula he found in a copy of the *Philadelphia Photographer*, one of the country's first photo magazines.

Enlargers are not commonly used. The 5" x 7" negative is large enough for reproduction when it is simply contacted on photographic paper. More than an hour after returning from the fire, the photographer has his first picture. After all that work, however, there is no way to reproduce the photograph in the newspaper.

The photographer now hands his pictures over to an artist, who draws replicas of them. Unfortunately, the artist often changes details from the original if he thinks the new variations improve the picture. The artist, in turn, gives his drawings to an engraver, who reproduces them onto a zinc plate. The plate is then printed on a Hoe rotary press.

Sometimes several days pass between the hour of the fire and the moment when these line-drawn renderings of the photographs appear in the newspaper. Yet the drawings receive front-page play.

EVOLUTION OF THE CAMERA REPORTER

How did the photographer of 1877 evolve into the modern photojournalist? Two major factors contributed to this development. First, the technical innovations: the invention of roll film, smaller cameras, faster lenses, and the introduction of portable light sources enabled the photographer to shoot pictures more easily and get better results. The invention of the halftone process for reproducing photos and the improvement of printing presses led to better reproduction.

Meanwhile, with the expansion of the wire services and the development of picture transmission devices, photos could be sent across the nation and around the world almost instantaneously.

The technological leaps made in photography since 1877 enable today's resourceful photographer to reach virtually any action anywhere and send home a photograph. Because of these scientific and engineering discoveries, photographers can capture events previously impossible to capture with cameras: night pictures, fast action, and successive motion now can all be recorded with the camera.

But technological strides are only half the answer to this evolutionary question. Photographers broadened the scope of news pictures by introducing feature and sports pictures to newspapers. Photographers sought candid photos that revealed natural

In 1877, The Daily Graphic, the first U.S. illustrated daily newspaper, devoted an entire front page to at least seven fire pictures. The Daily Graphic's handdrawn sketches were often based on photographs taken at the news scene. (New York Public Library.)

This is an enlargement of a halftone dot pattern showing an eye.

moments rather than the posed, frozen images typical of early photo reportage. Photographers today do more than just record the news. They have become visual interpreters by using their cameras and lenses, sensitivity to light, and keen observational skills to bring readers a feeling of what an event was really like.

The ingenuity of individual photographers in taking photos also laid the foundations of modern photojournalism. From the days of The Daily Graphic to the present, photographers first have had to figure out a way to get to the news event no matter where it is located—skyscraper or coal mine. They often must work around obstacles, both physical and human. Once photographers have the picture, they face the pressure of the deadline. Whether they transmit electronic images or develop film in a darkroom, they still must deliver the picture in time for the next edition. The daring and cleverness of the early photojournalists are the kinds of traits successful photographers have exhibited throughout the history of photojournalism.

Thus, technical advances and the imagination and resourcefulness of the photographer have gone hand-in-hand. The two have had complementary developments, each contributing to the gradual evolution of reportorial photography.

HALFTONE SCREEN REPRODUCES PHOTOS

SCREENS FIRST USED IN 1880 In 1877, our *Daily Graphic* photographer had little way of knowing that he stood on the threshold of a new age in photography. The next twenty years would see several rapid technological advances that would revolutionize the field of pictorial journalism: light, handheld cameras, faster lenses, improved shutter mechanisms, and roll films.

But perhaps the most momentous technological occurrence in the history of photojournalism was the development of the halftone printing process.

Before the introduction of the halftone process, there was no practical way to transfer the photograph directly onto the printed page. An ordinary press could print only blacks and whites—full tones—and was incapable of rendering the intermediate shades of gray, the halftones. As such, newspaper illustrations, based on artists' original sketches or photographs, consisted of blackand-white line drawings, hand-carved on wood blocks or etched on zinc plates.

After years of experimentation, experimenters found a method that could reproduce the full tonal range of photographic images.

Still employed today, this process involves the use of a screen with an ordered dot pattern. This screen is held rigidly against a sensitized film in the engraver's camera. The engraver's camera copies the original photo through the screen, which breaks up the photo's continuous tones into a series of tiny dots of varying sizes. The darkest areas of the original photo translate into a series of large dots. As the tones in the picture change from black to gradations of gray and white, the dots get progressively smaller.

The engraver develops the film and contact prints it onto a metal plate. The pattern of dots is chemically transferred onto this printing plate. On the press, the dots transfer the ink onto the paper. Where they are largest and closest together, the image is darkest, and where they are smallest and farthest apart, the image is lightest. Thus, the resulting printed image duplicates the shadings of the original photograph.

How much detail can be reproduced depends upon the fineness of the screen and the quality of the paper. By holding a magnifying glass up to any newspaper or magazine picture, you can easily see the tiny dot pattern of the halftone screen. A newspaper generally uses an 85-dots-per-inch (dpi) screen. This book uses 133 dots per inch.

THE FIRST HALFTONE

In Canada, the *Canadian Illustrated News* has the distinction of printing the first halftone in a magazine. Using glass plates ruled with a diamond point, engraver William Leggo produced a series of halftone pictures for the magazine.

The first halftone image published directly from a photograph was of His Royal Highness Prince Arthur. The *American Newspaper Reporter* in November 1871 described the accomplishment. "The photographic lens was employed in each instance, and not a square inch of boxwood, or one stroke of the graver, was needed."

Leggo later moved to New York, where he helped to start an illustrated newspaper called *The Daily Graphic*. *The Daily Graphic* published the first halftone in an American daily newspaper on March 4, 1880: a picture of Shantytown, a squatter's camp in New York City. Stephen H. Horgan, the photographer in charge of *The Daily Graphic*'s engraving equipment, produced the halftone. Although Horgan had been perfecting this process for several years, his successful experiment in 1880 did not immediately affect the look of the newspaper. His halftone invention, however, did encourage further experimentation.

OPPOSITION TO PHOTOS

In 1893, four years after the demise of *The Daily Graphic*, Horgan was working as art editor for the *New York Herald* when he again recommended the use of halftones to James Gordon Bennett, the paper's owner. After a brief consultation with his pressmen, Bennett pronounced the idea unfeasible.

Similarly, Joseph Pulitzer, who had been publisher of the *New York World* since 1883, initially expressed reluctance to print halftones. In fact, Pulitzer feared that widespread use of any pictures, including line drawings, would lower the paper's dignity, so he tried to cut down on the extensive use of woodcuts, which already had made his paper famous. When circulation fell as a result, Pulitzer reconsidered his decision and reinstated the drawings.

As Pulitzer recognized the paper-selling potential of such illustrations, he began to increase their size from the original one-column to four- and five-column spreads. When the halftone was finally perfected, the *World* was one of the first newspapers to make liberal use of the new process. The daily's circulation rose rapidly. Other publishers and editors soon jumped onto the pictorial bandwagon. One such newsman, Melville Stone, investigated the potential of newspaper illustrations for the *Chicago Daily News*. He ultimately concluded, "Newspaper pictures are just a temporary fad, but we're going to get the benefit of the fad while it lasts."

Today we know that newspaper pictures were neither temporary nor faddish, but, in the closing years of the nineteenth century, the halftone continued to struggle for legitimacy. By the late 1890s, the process had yet to achieve daily use, although the New York Times did print halftones in its illustrated Sunday supplement begun in 1896. Skeptical publishers still feared that their readers would lament the substitution of mechanically produced photographs for the artistry of hand-drawn pictures; also, artists and engravers were well-established members of the newspaper staff. Thus, long after the halftone was perfected, carefully drawn copies of photos continued to appear in many papers. Gradually, however, papers adopted the halftone process. By 1910, hand engraving was becoming obsolete and the halftone, in turn, had became a front-page staple.

THE MAINE BLEW UP, AND JIMMY HARE BLEW IN

While these technological strides were taking place in the latter part of the nineteenth century, several photographers were setting photojournalistic precedents. Jimmy Hare, one of the most colorful of the pioneer photojournalists, wrote the handbook for future photographer-reporters.

During his career, Hare covered nearly every major world event, from the wreckage of the U.S. battleship Maine in Havana harbor during the Spanish-American War in The first photograph reproduced on a printing press using the halftone process: on March 4, 1880, this photograph of Shantytown dwellings appeared in a special section of The Daily Graphic in New York. Notice that this first halftone used different sized lines to create shades of gray rather than the varying-sized dots of modern halftones.

(Henry J. Newton, New York Daily Graphic, courtesy of the New York Historical Society, New York City.) 1898 to the closing days of World War I in Europe. His ingenuity and his no-holds-barred attitude when it came to getting the picture set a standard for the new profession of photojournalism.

London-born Hare, whose father crafted handmade cameras for a living, came to the United States in 1889. One magazine, the Illustrated American, committed itself to using halftone photographs. From 1896 to 1898, Hare worked as a freelance photographer, supplying the magazine with photos of events ranging from presidential inaugurations to sporting matches. A month after he left the *Illustrated American*, the battleship Maine exploded, thus signaling the start of the Spanish-American conflict. The everenterprising photographer promptly presented himself to the editors of Collier's Weekly, and offered to take pictures of the wreckage. Twenty years after the Maine episode, theneditor Robert J. Collier was to recall, "The Maine blew up and Jimmy blew in! Both were major explosions!" Jimmy continued "blowing in" to important world events for the next several decades.

So successful were his pictures of the Maine and of Cuba, where American soldiers

fought the Spanish in the Spanish-American War, that the publisher named Hare special photographer for *Collier's*, thus beginning a long and productive association.

Whether trekking over the Cuban country-side, touring battlefields with Stephen Crane, author of *Red Badge of Courage*, or following Teddy Roosevelt's Rough Riders, Hare remained intrepid and resourceful in his coverage of the Spanish-American War. Hare made use of the new folding cameras (with lenses as fast as f/6.8) and of roll film (with twelve exposures per roll). His lightweight equipment gave him more mobility than his competitors, who were shooting with fragile glass plates and awkward 5" x 7" Graflexes, the popular news cameras of the day.

Regardless of his folding camera's light weight, Hare still had to get to the middle of the action to take a picture. In one battle during the Spanish-American conflict, a soldier spotted Hare snapping away as wounded bodies dropped all around him. "You must be a congenital damn fool to be up here! I wouldn't be unless I had to!" the soldier shouted. Hare's even-handed reply: "Neither would I, but you can't get real pictures unless you take some risks."

Jimmy Hare (BELOW LEFT), with his two folding cameras carried in their leather cases, covered the globe for Collier's Weekly. He photographed everything from the Spanish-American War (RIGHT) to the closing days of World War I in Europe. (Jimmy Hare Collection, Humanities Research Center, University of Texas at Austin.)

In addition to the Spanish-American War, Hare's photographic escapades brought him to the combat lines of the Russo-Japanese War, the Mexican Revolution, the First Balkan War, and World War I. Hare described these experiences as "one-sided adventures in which it was always my privilege to be shot at but never to shoot." But shoot he did—with his camera, that is—and his pictures contributed greatly to *Collier's* rapidly rising circulation and national prominence.

HARE COVERS FIRST FLIGHT

Not all of Hare's exploits took place on the battlefield. The story of how Hare managed to record on film the experiments of the Wright brothers in 1908 is indicative of his tenacity and his skill. The Wrights' first successful flight had taken place in 1903 but, five years later, the public remained unconvinced that men had actually flown. Rumors abounded but no one had documented proof of any flight. The brothers refused to allow reporters to witness their experiments at Kitty Hawk.

Hare was determined to check out the rumor for Collier's, however, and, along with four reporters from various newspapers, he secretly went to the Wright brothers' testing area. The five intrepid men spent two days hiking over the sands of Kitty Hawk, North Carolina. Approaching the site of the rumored flights, the newsmen took cover in a clump of bushes and anxiously waited for something to happen. Covered with mosquito bites and tired of lugging his camera, Hare was tempted to dismiss the rumors as false and head back home. But suddenly an engine noise was heard, and, as the reporters watched in disbelief, an odd-looking machine glided across the sand and gradually rose into the air. Hare ran out of the bushes and managed to snap two photographs of the airborne machine. The party of reporters then sneaked back to their base and prepared to reveal their booty to the world.

Because Hare was far away from the plane, the image in his photo was small and indistinct. But *Collier's* was proud to publish the picture in its May 30, 1908, issue. The photo proved at last that man could indeed fly. Hare had the distinction of taking the first news photograph of a plane in flight.

Hare began chronicling his world during photojournalism's infancy. When *Collier's* first published his photos, editors considered pictures mere embellishments of the text. But through his dogged efforts to capture, with his camera, a sense of immediacy and excitement, Hare served as a catalyst in the evolu-

tion of the photographer into a full-fledged "reporter with a camera."

WOMEN ENTER THE FIELD

Since 1900, female photojournalists have made their mark in the newsroom. Frances Benjamin Johnston, an indomitably spirited person, managed to transcend the constraints usually imposed on Victorian women. She documented early educational methods in black, white, and Indian schools. She shot a series of photographs on the activities in the White House and on the visits of foreign dignitaries. Then Johnston sold her pictures to the newly formed Bain News Service (see pages 358-359) and became its photo representative in Washington. Johnston was considered the unofficial White House photographer, according to C. Zoe Smith's article "Great Women in Photojournalism." D.C. Bain, the agency's owner, suggested that Johnston photograph Admiral George Dewey aboard his battleship after his successful takeover of the Philippines. With great ingenuity she made her way to Italy, where Dewey's ship first docked. She managed to endear herself to the crew and, when it came time to fill out an enlistment record, she earned five out of five possible points for everything from seamanship to marksmanship, but only a "4.9" for sobriety.

Jessie Tarbox Beals was another photojournalistic pioneer. She started out as a schoolteacher but soon discovered the lure of photography. In 1902 the *Buffalo* (New York) *Inquirer and Courier* hired her as a press Frances Benjamin Johnston, an early photojournalist around 1900, represented the Bain News Service in Washington, D.C. (Library of Congress.) With flash powder lighting the way, Jacob Riis exposed New York's slum conditions endured by recent immigrants. This man slept in a cellar for four years.

(Jacob Riis Collection, Museum of the City of New York)

photographer. Early on, she exhibited an important skill of the photojournalist—the "ability to hustle," as she once put it. Before her career ended, Beals sneaked photographs through a transom at a murder trial, rode the gondola of a balloon above the St. Louis World's Fair for a photo, and photographed Mark Twain.

THE CAMERA AS A REFORMER'S TOOL

Social-documentary photographers, notably Jacob Riis and Lewis Hine, demonstrated that the camera could not only provide a record of events but could also serve as a potent tool for social change. Hine once summarized his goals as a concerned photographer: "There were two things I wanted to do. I wanted to show the things that had to be corrected. I wanted to show the things that had to be appreciated." As America moved into the new century, crusading photographers chose to concentrate on Hine's goal to correct social injustice. Riis and Hine were among the first to press the camera into service as an agent for social awareness.

Their photographic pleas for reform placed them in the ranks of such late 19th century and early 20th century social muckrakers as Upton Sinclair, Lincoln Steffens, and Ida Tarbell. Together with these writer-reformers, the camera journalists probed the underside

of city life, exposed the unimaginable, and brought into the open what had previously been shielded from view.

The tradition established by Riis and Hine carried through to the 1930s with photographers like Dorothea Lange, Walker Evans, Marion Post Wolcott, Gordon Parks, and Arthur Rothstein of the Farm Security Administration (FSA), who used their cameras to record Depression-ridden America. Under the direction of Roy Stryker, the FSA photographers recorded not only the devastating effects of a prolonged drought on farmers but also the Roosevelt administration's New Deal programs that were helping farmers and workers get back on their feet. The agency gave the photographs to newspapers and magazines to publicize the problems of the farm worker and to show how government money was helping. The pictures also were used to persuade congressional representatives to allocate more money for the Farm Security Administration programs. The FSA photo project not only helped at the time but has left us with one of the greatest photographic records of any period of our past.

RIIS EXPOSES SLUM CONDITIONS Neither Riis nor Hine, in fact, began as a photographer. The Danish-born Riis started out in the 1870s as a carpenter and then got a

job as a reporter for the New York Sun. He wrote firsthand accounts of the indignities and inequities of immigrant life. When he was accused of exaggerating his written descriptions of life in the city slums, he turned to photographs as a means of documenting the human suffering he saw.

For Riis, the photograph had only one purpose: to aid in the implementation of social reform. Pictures were weapons of persuasion that surpassed the power of words and the absolute veracity of the photographic image made it an indispensable tool. As Riis stated, "The power of fact is the mightiest lever of this or any other day."

But Riis was up against many obstacles as a photographer. The crowded tenements were shrouded in darkness and shadows. To show the perpetual nighttime existence in the slums, Riis pioneered the use of German Blitzlichtpulver—flashlight powder—which, although dangerous and uncontrollable, did sufficiently illuminate the scene. Lugging a 4" x 5" wooden box camera, tripod, glass plate holders, and a flash pan, Riis ventured into the New York slums with evangelical zeal. With a blinding flash and a torrent of smoke, he got his pictures. The scenes he recorded of immigrant poverty shocked and goaded the public into action for reform.

The Riis pictures are remarkably poignant glimpses of ghetto life. Grim-faced families stare at the camera with empty eyes. Shabbily clothed children sleep amid the garbage of a tenement stoop. A grown man stands in the middle of the street and begs for someone to buy one of his pencils. An immigrant sits on his bed of straw. In a coal bin, a newly arrived American citizen prepares for the Sabbath.

Unfortunately, when Riis was photographing, the halftone had yet to achieve widespread use. Consequently, his actual pictures were not directly reproduced in printed sources and so were seen by only limited numbers of people, such as those attending his lantern-slide shows. At these talks, he used his pictures to buttress his plea for attention and reform.

When Riis' first book, How the Other Half Lives, was published in 1890, it consisted of seventeen halftones and nineteen hand drawings modeled on his photographs. The halftones were technically poor—somewhat fuzzy and indistinct—but the pictures exerted a powerful influence that drew attention to slum conditions. They remain moving documents of human suffering.

HINE'S PHOTOS HELP BRING ABOUT CHILD LABOR LAWS

Lewis Hine began as an educator and, like Riis, turned to photography as a means of exposing "the things that had to be correct-

Lewis Hine photographed the sootblackened faces of children who worked in the coal mines. In part because of Hine's photos, Congress passed protective child labor laws. (Photo by Lewis Hine, Library of Congress.)

ed." In turn-of-the-century urban America, many conditions begged to be noticed and changed. The influx of immigrants into the cities and the simultaneous growth of industrialism were important characteristics of the new century. With the reformer's commitment, Hine set out to catalogue how people survived in this new way of life.

In 1908, the magazine *Charities and the Commons* published a series of his pictures of immigrant life. The series included some of Hine's most famous pictures: portraits of newly arrived immigrants at Ellis Island. The power and eloquence of these pictures attracted much attention. With the further refinement of the halftone, Hine, unlike Riis before him, published his work in books and magazines and gained a good deal of public exposure for his social issues.

That same year, Hine began to work as an investigator and reporter for the National Child Labor Committee. His work took him everywhere, from St. Louis slums to California canneries. To get through the doors of offending factories and mines, Hine posed as every type of worker, from a fire inspector to a Bible salesman. One time he packed his camera in a lunch pail, filed with the workers into a clothing factory, and surreptitiously snapped pictures of sweatshop conditions. Hine juxtaposed diminutive chil-

dren against huge machines. The weary stares of young knitting mill operators and seamstresses spoke more eloquently than words. The impact of these photographs, along with others he took, such as the sootblackened faces of child coal-miners, helped facilitate the passage of Child Labor Laws restricting exploitation of youth.

PHOTOS FILL MAGAZINES AND "ROTO" SECTIONS

PICTURES COME IN HANDY AT NATIONAL GEOGRAPHIC

National Geographic did not start out as a picture magazine. In fact, its first issue in 1888 contained no photos. It wasn't until 1903 that National Geographic magazine ran its first halftone—a photo of a Filipina woman at work in the rice fields.

Not until 1905 did the magazine try a photo spread unbroken by text. As it happened, the photo display was unintended.

On the day the magazine was scheduled to go to the printer, the editor, Gilbert Grosvenor, was faced with eleven open pages and no material whatsoever to fill the space. By coincidence, he had received that same day a package of photographs from the Imperial Russian Geographic Society.

These pictures of the previously unphotographed Tibetan city of Lhasa had been

HAPPY ACCIDENT AT THE NATIONAL GEOGRAPHIC

(IMMEDIATE RIGHT)
On deadline at National
Geographic and faced
with eleven open pages,
editor Gilbert Grosvenor
used free pictures from
Lhasa, Tibet, to fill the
space for the magazine's first extensive
photo layout.

(Photos courtesy of National Geographic.)

(IMMEDIATE RIGHT) George Shiras III took the first night nature photos for National Geographic.

(FAR RIGHT) Readers were so delighted with the magazine's first picture layout that editor Grosvenor ran 32 pages of pictures about the Philippines in the following issue.

338 Photojournalism: The Professionals' Approach

taken by two Russian explorers and were being offered to the *Geographic* for publication. Grosvenor, fascinated by the photographs, decided to take a risk. He laid them out as an eleven-page spread—all pictures and almost no text—and sent them to the printer.

Grosvenor was sure he would be fired for having made this unprecedented and expensive editorial decision. Instead, readers stopped him in the street to congratulate him.

Although Grosvenor had run the Lhasa pictures primarily to fill up empty pages, he repeated the experiment after seeing the stir they created. In April 1905, he ran thirty-two consecutive pages of 138 photographs of the Philippines—a turning point in the magazine's history.

National Geographic contributed many photographic firsts, including the first night-time nature shots ever published, shot by George Shiras, III, in 1906.

The magazine's first color photos, in 1910, were not color photos at all. In fact, they were hand-painted black-and-white pictures from Korea and China by William C. Chapin. Coloring black-and-white pictures continued until 1916, when Autochromes Lumieres, real color photos, made their debut in the magazine's pages.

The first series had no particular theme other than that they were all natural-color photographs. In fact, the magazine invited amateurs to submit photos and ran them alongside pictures made by scientists, writers, and professional photographers. Since those early Autochromes, the magazine has published color photos from every part of the world as well as from the bottom of the sea and from outer space.

ROTOGRAVURE

AND THE PICTURE PAGE APPEAR In 1914, the *New York Times* began publishing the first Sunday rotogravure section, and several other newspapers soon followed. The rotogravure process, which usually used a dark sepia ink, offered a cheap printing process that could print sixteen pages simultaneously and an unlimited number of screened photos.

That same year, the *Times* also started the *Mid-Week Pictorial War Extra* to absorb the flow of World War I pictures pouring in from Europe. In spite of severe censorship, picture agencies managed to obtain photos of trench warfare, poison gas, and the wholesale destruction of small towns taking place in Europe.

Officially, photographers were explicitly forbidden to visit the battlefield. In fact, cen-

sorship was so severe that the Allied command attached an officer to each correspondent to control what the journalist saw and what scenes were photographed.

Photographers covering the war had to be ingenious to circumvent the censors. Many of the photographs that finally appeared were taken by soldiers who happened to be amateur photographers. By 1916, the *New York Times* expanded the coverage of the *Mid-Week Pictorial*, sold it for ten cents, and dropped the words "War Extra."

A highlight occurred in 1924 when the magazine reproduced autochrome photographs of Tutankhamen's treasure. Color reproduction was rare for that time, although color roto had appeared as "tintogravure" in Joseph Pulitzer's *Sunday World* in 1923.

Mid-Week Pictorial took pride in its exclusive photographs, touting "the first photography" whenever possible. Tremendous coverage was given to Charles A. Lindbergh's solo nonstop trans-Atlantic flight in 1927. To show readers the magazine's concern with timely news coverage, one photographic caption read, "A Radio Photograph . . . This picture was taken, was then carried to London by airplane and flashed across the ocean to New York by Radiograph."

The magazine, however, ran far more features than news. Through the 1920s, pictures of movie and theater stars, fashion, sports, and high school beauty queens regularly filled its pages. One had to look below or alongside the oval, circular, and odd-shaped photographs to find minimal caption information. Overall, according to Keith R. Kenney and Brent W. Unger's study titled "The Mid-Week Pictorial: Forerunner of American News-Picture Magazines," the 1920s began a period of slow decline for the Mid-Week. With faster and faster picture transmission and higher quality newspaper reproduction, the best photographs had begun appearing in daily newspapers. Circulation for Mid-Week Pictorial fell every year until 1937, when America's first modern picture magazine folded.

Picture pages

Presses of the period were technically incapable of interspersing pictures with print and still achieving good halftone reproduction throughout the paper. Therefore, almost all the photos were grouped together on one single page. Printers achieved this improved reproduction by putting a specially designed ink blanket on the press cylinder that carried the halftone engravings. Thus, a page-one story would have its corresponding picture printed inside on this special "Picture Page."

The New York Daily News, a tabloid, hired Thomas Howard to get a picture of murderess Ruth Snyder's electrocution in 1920. He strapped a miniature glass-plate camera (above) to his ankle and released the cable as he hiked his trouser leg. He exposed the plate three times, once for each electric shock administered to Snyder.

(ABOVE: Smithsonian Institution; RIGHT: Photo by Thomas Howard, New York Daily News.)

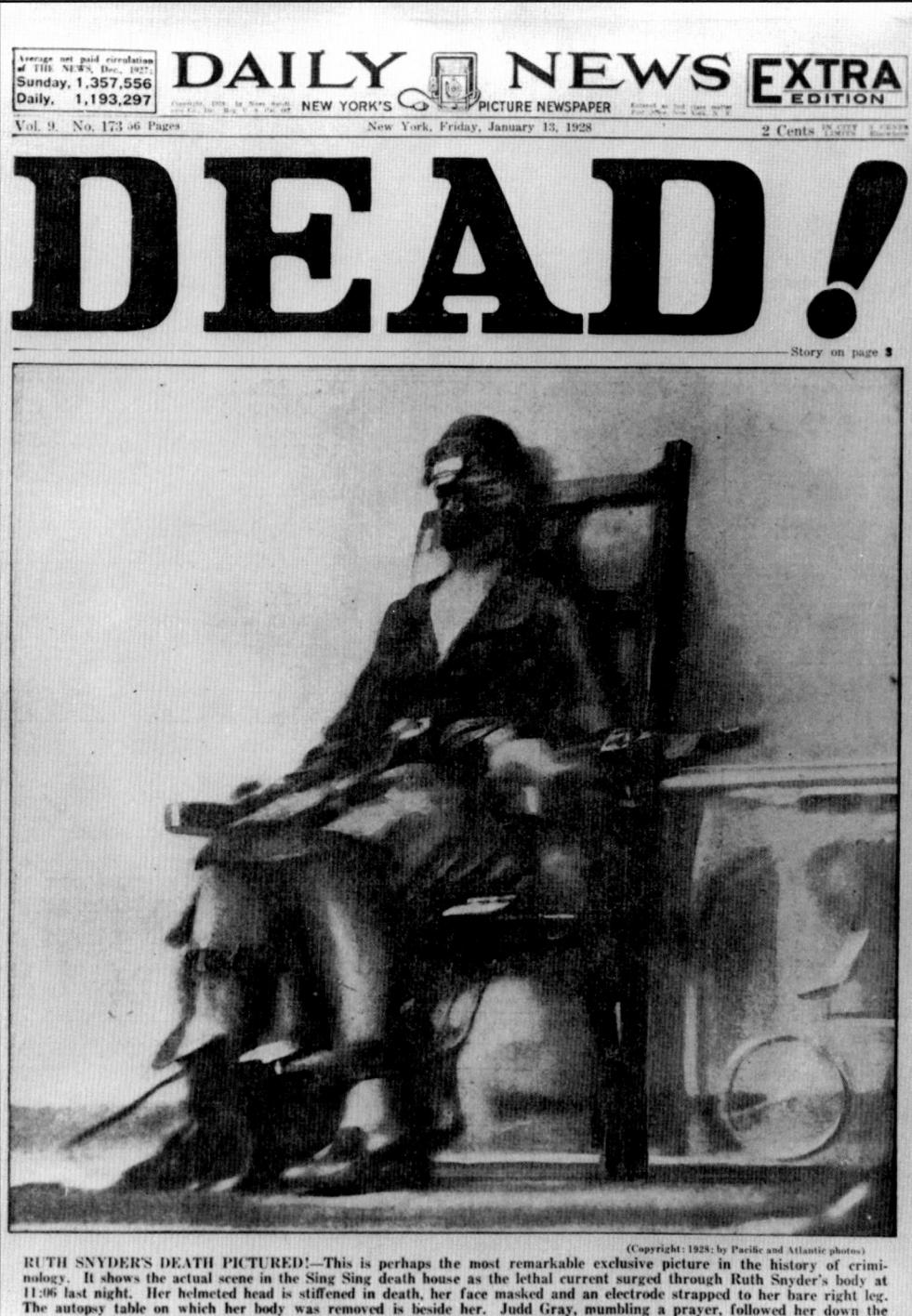

RUTH SNYDER'S DEATH PICTURED!—This is perhaps the most remarkable exclusive picture in the history of criminology. It shows the actual scene in the Sing Sing death house as the lethal current surged through Ruth Snyder's body at 11:06 last night. Her helmeted head is stiffened in death, her face masked and an electrode strapped to her bare right leg. The autopsy table on which her body was removed is beside her. Judd Gray, mumbling a prayer, followed her down the narrow corridor at 11:11. "Father, forgive them, for they don't know what they are doing?" were Ruth's last words. The picture is the first Sing Sing execution picture and the first of a woman's electrocution... Story p. 2; other pics, p. 28 and back page.

TABLOIDS: THRILLS AT THREE CENTS A COPY

IMMIGRANTS

UNDERSTAND PICTURES

The immigrants photographed by Hine and Riis couldn't read English very well, but they could understand pictures. At a time when the country was bustling with non-Englishspeaking immigrants, photographs became a

universal language and, along with movies, a visual handle on the new world. Also, because of the new industrialism, people had more leisure time to spend reading newspapers and magazines. With the wiring of cities for electricity, families could study published pictures long after dark.

In the late 1910s, another journalistic phenomenon caught the public's fancy: the

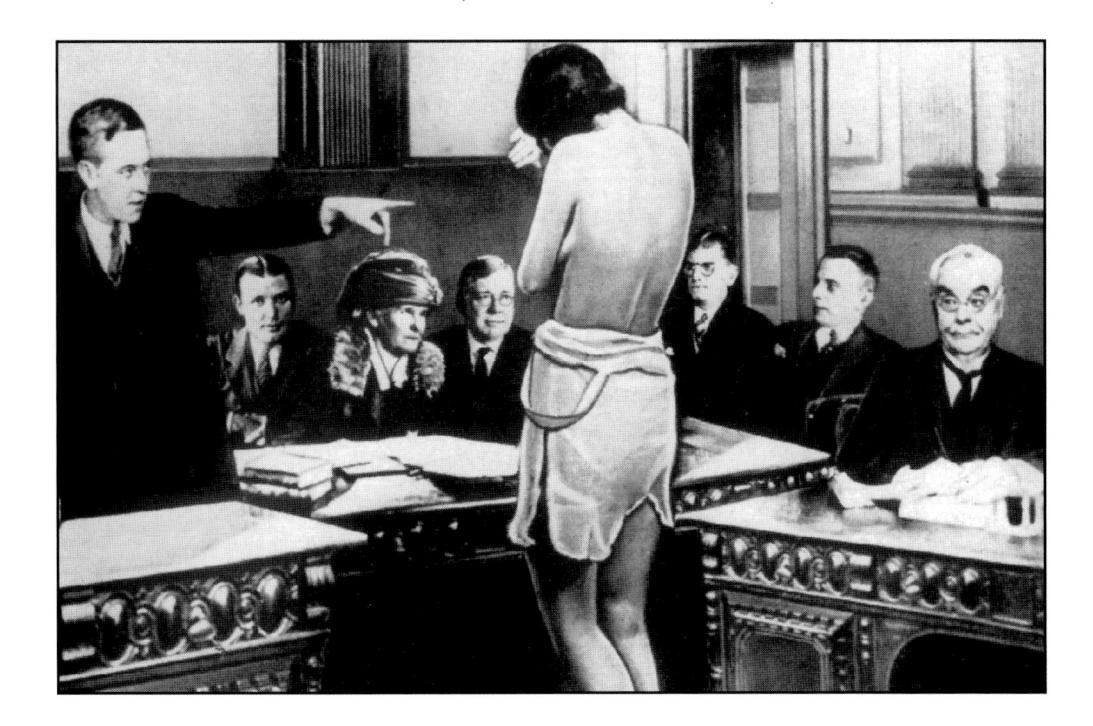

Because they couldn't take a picture inside the courtroom during the sensational Rhinelander divorce trial, the Evening Graphic staged the courtroom scene at the newspaper office with actors playing the parts of real individuals. Faces of actual participants were pasted on later. The new technique was dubbed a "composograph"—and repeated many times. (Harry Grogin, Evening Graphic.)

tabloid, a half-the-standard-size newspaper filled with pictures and brief stories. The tabloid was ideal for the less-educated masses and newly arrived immigrants. And the commuter could easily read the small publication on the trolley or subway.

The first twentieth-century tabloid in the United States was New York's *Illustrated Daily News*, launched in 1919. Circulation of the heavily illustrated *Daily News* soared rapidly, and it became one of the most remarkable success stories in journalism. The name of the paper was changed to *The Daily News: New York's Picture Newspaper*, and survives to this day.

In its early days the News' stock and trade was titillation—crime and sex scandals, vicarious thrills for only three cents a copy. One of the most famous stories, illustrating the lengths to which the Daily News would go to get a provocative picture, involved the electrocution of Ruth Snyder in January 1928. In what was dubbed "the crime of the decade," a jury found Snyder guilty of murdering her wealthy husband with the aid of her lover. The Daily News' editor felt the public was entitled to see Snyder's execution, but photographers were barred. The editor devised a plan to sneak a cameraman into the room. Thomas Howard, a news photographer from the Chicago Tribune, sister paper of the Daily News, was brought in for the occasion. He strapped to his ankle a prefocused miniature glass-plate camera. The camera had a long cable release running up Howard's leg into his pants pocket. Howard aimed his camera simply by pointing his shoe and

hiking his trouser leg. To get sufficient light to the film, Howard, when the time came, exposed the plate several times—one for each shock administered to the body of Ruth Snyder. The following day, Friday the thirteenth, the picture ran full page with a singleword headline: "DEAD!"

The composograph

If the *News* was "a daily erotica for the masses," it still paled in comparison to its fellow scandal monger, the *Evening Graphic*, commonly known at the time as the "Porno Graphic." In the *Evening Graphic*, the composograph, the first staged and faked news photo, was born. The occasion was the Kip Rhinelander divorce trial. Alice Jones, an African American, was sued for annulment by Rhinelander, a Caucasian.

The husband maintained he had married her without knowing her race. The wife's defense attorney had her strip to the waist as proof the husband should have known.

Barred from the courtroom, newspaper photographers brought back no pictures of the sensational display.

The *Graphic*'s assistant art director, Harry Grogin, wasn't upset. "Hell with photographers," Harry is said to have muttered. "What we need 'em for?" He began tearing apart pictures he already had of Alice, of the judge, of opposing counsel, of the stolid, forlorn Rhinelander, of Alice's mother, of Rhinelander's lordly father.

Next, the pictures were put through a process by which they would come out in proper proportion. Meanwhile, Harry sent for

Weegee (Arthur Fellig)
(ABOVE) intuitively
understood people's
fascination for crime,
which attracted the
attention of both the
bystander at the scene
and the reader at home.
Weegee was the first
photographer to use a
police radio to get early
tips about gangland
shootings.
(BELOW:

Photo by Arthur Fellig.)

Agnes McLaughlin, a showgirl, and got her to pose as he imagined Alice Rhinelander had stood before the lawyers and the judge.

For the photo, the art director had the actress wear as little as possible.

Grogin tinted Agnes McLaughlin's skin, faintly, to give the effect of being light-colored. He used twenty separate photos to arrive at the one famous shot, but for the *Graphic*, it was well worth the effort.

The picture was believable. You feel you are looking in on the judge's chambers. With Alice in the foreground, one of the lawyers points at the husband, as if to say, "He knew it all the time!

Emile Gauvreau, the managing editor, and the city desk went wild. What to call it? The headline could be ALICE UN-DRESSES? They settled for ALICE DISROBES IN COURT TO KEEP HER HUSBAND.

So the *Graphic* composograph was born. The *Graphic*'s circulation rose from 60,000 to several hundred thousand after that issue. The composograph was a *Graphic* depiction, posed in the art department, of a sensational real-life scene that, for one reason or another, could not be photographed. It was officially called a "composograph" in the paper and identified as having been made in the art department.

Editor and Publisher, a newspaper trade publication, called the trial picture "the most shocking news-picture ever produced by New York journalism." The "shocking" aspect presumably had to do with putting an almost-nude woman on the front page but not with the cut-and-paste technique, observes Bob Stepno in his paper "Staged, Faked and Mostly Naked: Photographic Innovations at the Evening Graphic (1924–1932)."

As might be expected, the *Graphic* continued to exploit the popularity of the composite picture, while admitting in tiny print at the bottom of the composograph that the pictures were faked. Later, while staging a phony hanging of thief Gerald Chapman, Grogin called on one of his assistants to pose with a noose around his neck, bound hands and feet, and a mask over his head. The man stood on an empty box that later would be blocked out of the picture. (See page 257.) Just as the picture was to be snapped, the stand-in victim accidentally kicked the box away. Luckily, Grogin acted with lightning reflexes and caught the suspended man seconds before the fake hanging became a real one.

Of course, not all of the tabloid pictures were composographs. If a real-life picture was gruesome and lurid enough to satisfy the thrill-hungry public, the *Graphic*, the *Daily*

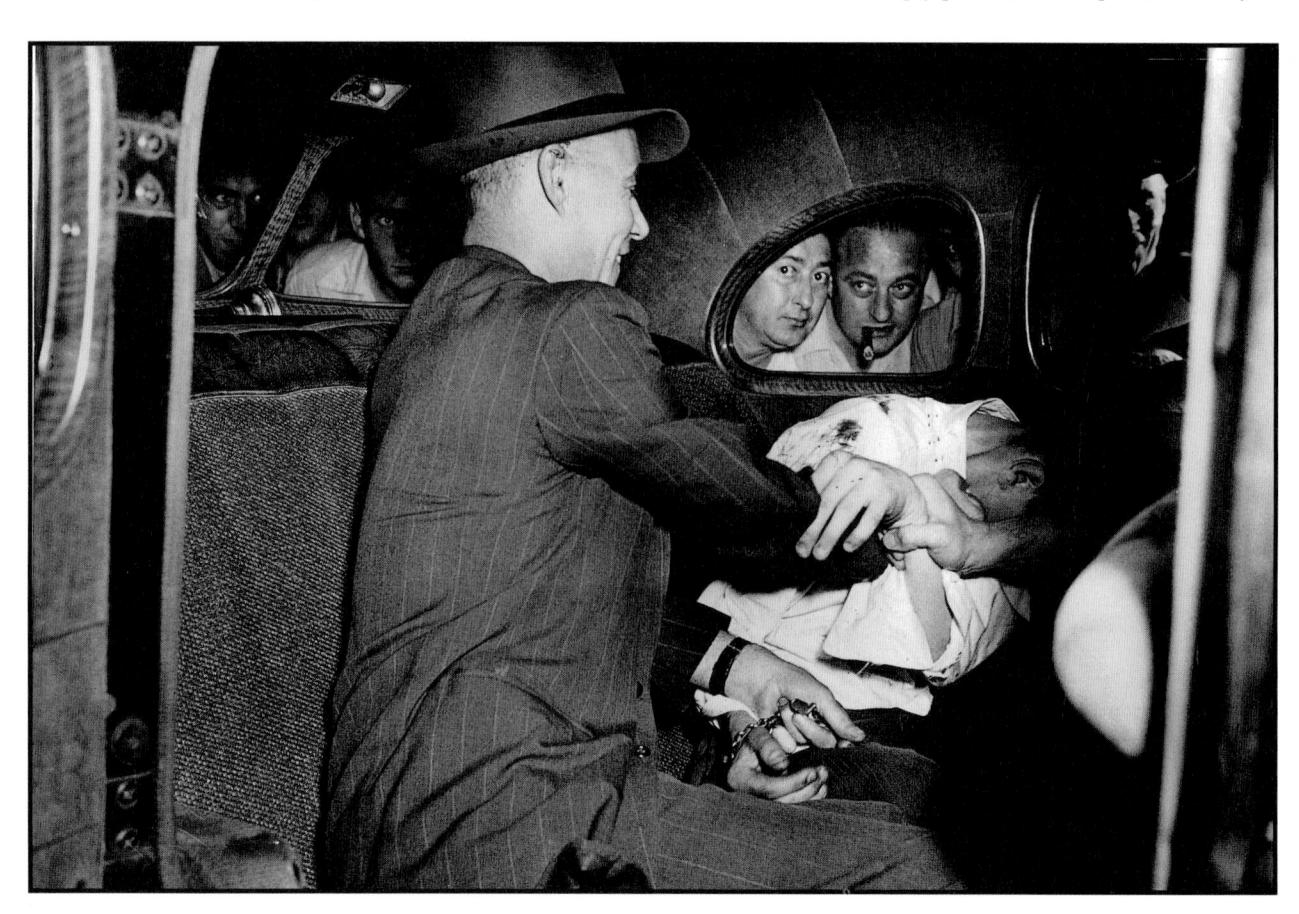

News, and other tabloids were more than happy to run the photo.

At one point, the New York Society of the Suppression of Vice persuaded the police to arrest Gauvreau and several other Graphic staff members for violating the obscenity provisions of the city's penal code. Constant legal hassles and the threat of a citywide boycott organized by religious leaders took a toll on the Graphic. Although the Graphic's circulation averaged nearly 300,000 from 1926 to mid-1931, businesses were wary of advertising in the scandalous publication. Department stores like Macy's and Gimbels would not buy ad space. The paper was a losing proposition in the otherwise profitable empire, according to Michael Carlebach's book American Photojournalism Comes of Age. In 1932, Macfadden pulled the plug on the Graphic.

WEEGEE: KING OF CRIME PHOTOGRAPHERS

The most famous photographer to capitalize on the tabloid mentality and concentrate his energies on the seamier side of city life was Arthur Fellig, universally and simply known as "Weegee." Weegee acquired his name because, like the Ouija board, he supposedly had an uncanny ability to predict what would happen when and where, and he would miraculously be there—often ahead of the police. However, because he was a poor speller he wrote his new name phonetically, "Weegee." His news sense, of course, was a helpful quality for a photojournalist and, with the advantages of his police radio and strategically located living quarters near the police station. Weegee managed to keep on the scent of the city's assorted crimes, auto crashes, and fires. The city was his working space, the night was his time, and violence was his specialty. Too independent to be tied to any one publication, Weegee remained a freelancer and a free spirit for most of his career. He cruised the city streets nightly in his car, always ready to cover the happenings of urban nightlife.

Weegee poked his inquisitive camera into every dark corner of the city, photographing life as he saw it—stark and uncensored. His book, *Naked City*, was later made into a movie and then a television show. Its title is an apt summation of his style and his subject. In his pictures, the city was indeed naked, unadorned, and exposed.

Weegee knew not only how to get a picture but how to sell it as well. He explained his technique, "If I had a picture of two handcuffed criminals being booked, I would cut the picture in half and get five bucks for each." For a photo of a bullet-ridden corpse, he had an entrepreneur's price scale.

Weegee's going rate: \$5 per bullet! Never one for modesty, he would stamp the back of his pictures, "Credit Weegee the Famous."

The stamp was hardly necessary, though, as his direct, unflinching style of photography identified him as much as his signature or his omnipresent cigar.

Weegee reveled in his role as a special character, and he played it to the hilt. With his chewed-up cigar, crushed felt hat, and bulging eyes, he sometimes looked like the popular stereotype of a crime photographer. He gloried in beating the cops to the scene of the action. Rushing from his car he would point his camera at the subject without bothering to focus or adjust the f-stop—ten feet at f/11 with flash covered most situations.

Besides covering violent scenes, Weegee also shot ordinary life—people relaxing at Coney Island, fans at Frank Sinatra concerts, children sleeping on a fire escape. Later in his career he photographed Hollywood stars.

In Weegee's work, the flashbulb's explosion intruded on the night's protective darkness, violating its cover and exposing the startling scenes that he was a party to. In all of his photos, the flashbulb is a real presence. It is evident in the strong tonal contrasts from the harsh light of a flash used on the camera. Somehow, in Weegee's world, everyone looks like a victim, caught unaware by the insistent light of the camera's flash.

Weegee, however, was not above setting up pictures, according to Louie Liotta, who was also a New York street photographer of Weegee's generation. In an article for *People* magazine, Liotta recalled how one famous Weegee picture came to be. Weegee dressed an old woman from the Bowery in a ragged fur coat and had her stand in front of Metropolitan Opera. He waited for two welldressed attendees wearing expensive minks to walk by as he shot the picture of the old woman scrutinizing the wealthy patrons. "They were authentic, he just helped them a little bit," recalled Liotta. Weegee sold the picture to Life magazine, and it has become a classic. (For more on early set-up pictures, see Chapter 15, "Ethics," pages 304–311.)

SEARCH FOR A CONVENIENT LIGHT SOURCE

DANGERS OF FLASH POWDER Although Weegee had to replace the flashbulb after each exposure, flashbulbs proved infinitely more convenient than the flash powder used in Jacob Riis' day. Horror stories about flash powder are legion. Flash photographers in the old days wore special

Flash powder fired in a pan left the room filled with smoke, unfortunately delaying the possibility of taking a second photo. Here, Harry Rhodes demonstrates his flash technique. Rhodes, we hope, never inhaled at the wrong time.

Flash bulbs, which replaced flash powder, were smokeless and safe, but cumbersome and awkward.

Ed Farber of the Milwaukee Journal modified the electronic flash, making it portable and convenient for news photographers.

(Photos above from the files of the National Press Photographers Association, courtesy of John Faber.) cuffs so the powder wouldn't roll down and burn their arms when the chemical was ignited. Eddie McGill, a *Chicago Tribune* photographer, suffered a skull fracture when a big flash pan bent as it fired. Another Chicago photographer, Nick McDonald, of the *Chicago Herald-Examiner*, lost a hand from exploding powder as he poured it from a bottle onto a hot flash pan.

When several photographers were on the scene, they had to decide which one would set off the flash powder. Once the substance was lit, smoke filled the room, eliminating the possibility of anyone taking a second picture. An additional problem, of course, was the subjects gasping for air, sometimes between curses. Needless to say, photographers and their flash pans were not exactly welcome in most places.

Three kinds of flash lamps were available for the photographer: the Caywood, the Imp, and the Victor. The Caywood flash was used for indoor portraits and group pictures. The Imp lamp, manufactured by the Imperial Brass Company, worked well for large groups indoors. Outdoors, at night, when lots of light was needed, the news photographer used a long Victor flash pan.

A photojournalist could choose between three types of flash powder manufactured by the Excel Fire Works Company. The powder in the red-labeled can burned the fastest (1/25 sec.) so it was selected for sports. Yellow-labeled powder fired slower but brighter. Blue-labeled powder, used for portraits, burned the slowest but gave off the most light.

Photographers always filled the flash pan with four times as much powder as needed to make sure they would have enough light, as Frank Scherschel, a news photographer in those days, once recalled. Besides packing his camera and plates, he always carried a tube of ointment in case he burned his hands. With the lens set at f/16, the news photographer fired the flash lamp and prayed.

FLASHBULBS:

SAFE BUT INCONVENIENT

Although smokeless flash powders were developed over the years, it was not until 1925 that a superior method of lighting was found. In this year Paul Vierkotter patented the flashbulb—a glass bulb containing an inflammable mixture that was set off by a weak electric current. Four years later, the flashbulb appeared in an improved form, with aluminum foil inside. Although these bulbs were infinitely preferable to the smoky, noisy, and dangerous flash pans, the flashbulbs still were inconvenient for the

press photographer. Some of the biggest bulbs were close in size to a football. Static electricity or electromagnetic energy could cause them to fire. In addition, the bulbs had to be replaced after each shot, a delay that could cause the photographer to miss important pictures.

Marianne Fulton, in her book *Eyes of Time*, points out that the flashbulb gives an artificial quality to photographs. The light coming from the on-camera flash is always bright. The flash tends to flatten the subject in the foreground, separating it from the rest of the scene, which becomes a separate, darker background. She notes that all flash pictures, regardless of content, tend to take on the same "look."

EDGERTON DEVELOPS THE ELECTRONIC FLASH

Although it did not change the character of the light, the electronic flash was far more convenient than the flashbulb. The forerunner to the modern electronic flash was designed in the early 1930s by Harold Edgerton (see opposite page) of the Massachusetts Institute of Technology (MIT). While investigating motors, Edgerton developed an electronic stroboscope that flashed at repeated fixed intervals, synchronizing with the moving parts of the machine. Edgerton later used his stroboscope to take single and multiple-image photos, not only of moving machine parts but also of tennis players, golfers, and divers, as well as hummingbirds in flight.

Basically, his electronic flash worked by discharging high voltage from a capacitor through a gas-filled tube, producing an extremely brief burst of light. The light was powerful enough for photography despite the relatively insensitive films available at the time. Though an observer would not be aware of it, the light from the electronic flash exceeded the combined output of 40,000 50-watt bulbs.

Edgerton designed his electronic flashes for research. George Woodruff, a photographer with International News Photos (INP), heard about the scientist's invention and dropped by Edgerton's MIT lab. Woodruff asked if the electronic flash had any use in news photography. Edgerton answered by helping Woodruff lug three flash units to the circus playing in town that night.

Each strobe—all of which are still in use, according to Edgerton—had a large capacitor that put out 4,000 volts (9,600 watt-seconds). The flash duration lasted less than 1/50,000 of a second. On successive nights, the pair tried their strobe setup at a variety of

sporting events. With Woodruff on camera and Edgerton on strobe, the team of photographer and scientist stopped the action of runners, boxers, and swimmers in their natural environments.

While working for the *Milwaukee Journal*, photojournalist Edward Farber designed an electronic flash that could be synchronized with the common shutter found on most press cameras. Farber's first working electronic flash weighed ninety pounds and had oil capacitors and an AC power supply. The Journal sent Farber back to the lab to design a more portable model.

By October 1940, Farber had the flash's weight down to twenty-five pounds. Powered by a motorcycle battery, it also had a plug for household current. In fall 1941, Farber found a lighter battery, and around it built a "dream" portable flash weighing only 13 ½ pounds. In the 1950s, the electronic flash design was sold to Graflex Inc., in Rochester, New York, and remained for many years a standard piece of equipment for the news photographer.

CAMERAS LOSE WEIGHT AND GAIN VERSATILITY

About the time the flashbulb was perfected, another invention was being developed that allowed pictures to be taken in dim indoor light without any artificial illumination at all. The candid camera, as it came to be known, was to change the course of news photogra-

phy and redefine the role, as well as the potential, of the photojournalist.

GRAFLEX USED UNTIL 1955

At the beginning of the century, the most widely used press camera was the Graflex and its German counterpart, the Ica. These cameras were portable, although still heavy; they used either a 4" x 5", 4" x 6", or 5" x 7" glass plate. Because of the large size of the negative, the resulting print was of high quality and had adequate detail.

The Graflex looked like a large rectangular box with a hood on top. To view through this oversized single-lens reflex camera, the photographer would look down the hood at an angled mirror that would reflect what the lens saw—except that the image was reversed left to right.

The photographer could attach a forty-inch telephoto lens for shooting sports from the press box. When the Graflex carried the telephoto, the seventy-pound combination was affectionately known as Big Bertha. The large negative produced by the Graflex meant that photographers did not have to frame perfectly on every play—they were secure in the knowledge that if they captured the action on at least part of the film they could make a usable blow up. James Frezzolini, a news photographer, modified the Big Bertha with a notched lever for rapid focusing between first, second, and third bases at a baseball game. John Faber, a

Harold Edgerton (NEAR RIGHT), inventor of the electronic flash, took pictures with local photojournalists at the circus to demonstrate how his equipment could be used to cover events outside the lab. (Courtesy of MIT Museum.)

former historian for the National Press Photographers Association, found that some photographers continued to shoot with the Graflex at sports events until 1955.

To view through the Graflex camera, the photographer looked down into the hood on top of the box. The bulky camera used glass plates.
(Files of the National Press

Photographers Association.

courtesy of John Faber.)

The Graflex camera in the foreground, nicknamed "Big Bertha" when fitted with a telephoto lens, was used by many papers to cover sports until the mid-1950s.

(Photo courtesy of the Associated Press.)

The 4" x 5" Speed Graphic was the standard news camera of the business from the 1920s to the 1950s. Experienced photographers didn't focus: they just guessed the distance. Old Speed Graphic users claimed the camera had only three distance settings: here, there, and yonder.

SPEED GRAPHIC:

A NEWS PHOTOGRAPHER'S BADGE For general news, the Speed Graphic, introduced in 1912 by Folmer and Schwing (a division of Eastman Kodak), replaced the Graflex by the 1920s. The front of the Speed Graphic folded down to form a bed with tracks. The lens slid out on these tracks. A bellows connected the lens to the box of the Graphic and expanded or contracted as the photographer focused. The film was carried in holders, two shots to a holder. Whereas a range finder came attached to the side of the camera, a seasoned pro often removed this device and just guess-focused. While the camera could be used with a tripod, it was more conveniently handheld. The 9 1/2-pound camera could take intensive pounding, and even after the development of the small 35mm camera, many news photographers continued to shoot with Speed Graphics.

Bob Gilka, who later became director of photography for the *National Geographic*, was picture editor of the *Milwaukee Journal* in 1955 when he issued a memo that read in part, "This 35mm stuff may be okay for magazines . . . but we might as well face the facts. We are wasting our time shooting the average news assignment on 35mm."

Robert Boyd, a past president of the National Press Photographers Association, was once asked what the press camera could do that the 35mm couldn't. Boyd put the big camera on the ground and sat on it.

Since editors rarely ran more than one or two images anyway, most newspaper photographers in the 1920s and 1930s saw no need to make additional pictures.

Dickey Chapelle told how photographers shot with the Speed Graphic. "It is so big that snap-shooting, or making a picture casually, can't be done." Instead, the photographer must carefully "plan the picture . . . and move to the vantage point from which to shoot before raising the camera."

The days of the Speed Graphic, however, were numbered.

LEICA LIGHTENS THE LOAD

The earliest miniaturized camera was the Ermanox, a German-designed small camera that took single glass plates and had an extrafast lens. The lens, at f/1.8, had an almost incredible light-gathering capability for the period. The manufacturer of the Ermanox lens proudly claimed, "This extremely fast lens opens a new era in photography and makes accessible hitherto unknown fields with instantaneous or brief time exposures without flash-light."

He was right that the lens opened a new era

in photography. Unfortunately, one major drawback aimed the Ermanox for extinction. The camera used only individually loaded 4.56 cm glass plates—an obvious inconvenience for news photographers. Still, the Ermanox was important in that it was the forerunner to the camera that would revolutionize photojournalism.

Oskar Barnack, a technician at the E. Leitz factory in Germany, invented the Leica. Like the Ermanox, the Leica had an extremely fast lens but, rather than glass plates, the Leica used a strip of 35mm motion picture film with as many as forty frames per roll possible in the original models. Barnack continually worked on his design and, in 1924, the first Leicas were put on the market. By 1932, Leitz mass-produced the camera in fully refined form with extremely fast, removable lenses and a built-in range finder.

The implications of this handy, small-format camera were wide-ranging. Now, with existing light, the photographer could take pictures without bothering with flashbulbs. The Leica's lightness, ease of handling, and fast lens allowed photographers to move freely, unencumbered by heavy accessories, flash attachments, clumsy tripods, or glass plates.

Because the film could be rapidly advanced, photographers could make exposures one after another, thus enabling them to capture an unfolding event without stopping between pictures.

The Leica gave news photographers unprecedented mobility and the ability to take pictures unobtrusively. Photographers no longer had to stop life in its tracks to snap a picture; people no longer posed for the camera's lens. Now, subjects could be more relaxed and natural, leaving photographers free to concentrate on atmosphere and composition rather than on technical matters.

These new capabilities did nothing less than change the relationship between photographers and the world. Because they could use available light and remain unobtrusive, news photographers could imbue their pictures with a new sense of realism, of life in the making.

ERICH SALOMON: FATHER OF CANDID PHOTOGRAPHY

The man who first exploited this photographic impression of life was Erich Salomon. Often called "the father of candid photography," he is credited with coining the term photojournalism to describe what he was doing. Salomon began his photography career in 1928 with the new Ermanox camera. Salomon's arenas of action were diplomatic gatherings and government functions; his subjects were the foremost statesmen and political personalities of Europe. When he initially tried to penetrate these carefully guarded events, the officials refused to let

The early Leica camera.

The man pointing had just learned that press photographers were not being allowed in. The politician said he doubted that and wagered that at least one would be there. Slowly, he peered around the room until he discovered Erich Salomon just as the photographer was taking a picture of him. Salomon was the first photographer to use extensively the Ermanox miniature camera to catch candid photos. Salomon specialized in diplomatic gatherings and governmental functions. If Salomon couldn't get in openly, he hid his camera in the crown of his hat, in a temporary sling around his arm, or in a hollowed-out book. (Photo by Erich Salomon.)

him in, claiming that flash powder and large cameras would disrupt the orderly proceedings. But when Salomon demonstrated his unobtrusive camera, he was not only given entry into these private quarters, but he also became a habitué of diplomatic circles. French Prime Minister Aristide Briand at one time remarked, "There are just three things necessary for a conference: a few Foreign Secretaries, a table, and Salomon."

Even the ingenious Salomon, however, could not charm his way into all top-level, top-secret meetings. When barred from an important conference, the dapper photographer would don his top hat, white gloves, and tails and set to work concocting a scheme to allow him entry into this private world.

Salomon's ruses are legendary. He once managed to take pictures in a courtroom that was off-limits to photographers. He shot his film by cutting a hole in the crown of his hat and hiding his camera there. Following the success of this technique, he used a similar ploy to photograph a roulette game in Monte Carlo. He hollowed out several thick books and hid his camera inside. While he appeared absorbed in the game, he was actually busy clicking away with his concealed camera.

The urbane, multilingual Salomon moved with ease among dignitaries and heads of state, capturing with his camera the personalities of the people who shaped history and the atmosphere of their inner sanctums. With the Ermanox, and later with the Leica, he penetrated the masks of public personae to reveal the very human characteristics that lay underneath—dozing diplomats, bored-looking royalty, down-to-earth movie stars.

There is a remarkably intimate quality to Salomon's work. Because his camera enabled him to catch prominent people off guard, his pictures give the impression that the camera, rather than being an intruder, is simply a watchful observer that happens to be present at the scene. Salomon's candid photography attracted a good deal of attention, and he numbered among his subjects such luminaries as Albert Einstein, Herbert Hoover, and Marlene Dietrich.

Salomon's fame at one point caught the attention of William Randolph Hearst, who brought Salomon to New York to demonstrate his candid technique. The publisher was so impressed that he ordered nearly fifty Ermanox cameras for his staff photographers.

Salomon later died in one of Hitler's concentration camps. As one of the first to demonstrate the possibility of recording events with the candid camera, Salomon truly deserves the title of "father of candid photography."

THE GERMAN PHOTO ESSAY

EUROPEAN MAGAZINES DEVELOP THE PHOTO ESSAY

Salomon's candid style proved that current events could be captured pictorially and naturally. The impact of this discovery was felt strongly in Germany, in such picture magazines as the Muncher Illustrierte Presse (MIP) and Berliner Illustrirte Zeitung (BIZ), and in England, in the Illustrated London News, where the photo essay first appeared in embryonic form. Stefan Lorant, editor of the Muncher Illustrierte Presse, developed the notion that there could be a photographic equivalent of the literary essay. Previously, if several pictures appeared together, they were arranged either arbitrarily or sequentially, with little regard for the conceptual logic of the layout, captions, cropping, or picture size. Lorant and his colleagues began experimenting with a new photographic form, in which several pictures appeared—not in isolation, but as a cohesive whole.

The photo essay developed in German picture magazines was built on multiple images that showed different aspects or visual points of view. German magazine photographers using the small 35mm cameras shot overalls (also called establishing shots) of a scene, middle range shots of the action, and closeups of the participants—shooting from high and low camera angles rather than eye level. In laying out pages, editors varied the sizes of images and used a dominant photo supported by smaller images. The editors created visual flow by making the photograph's dominant lines lead the viewer's eye from one image to another, observes historian C. Zoe Smith (see selected bibliography), who has analyzed early German and American picture magazines.

German and later American magazines did cut pictures into cookie cutter shapes, overlap pictures, and remove picture backgrounds to try to increase impact and interest. Wilson Hicks, long-time executive editor of *Life* magazine, labeled these techniques a "holdover from the past," that amounted to physical abuse of photographs. This kind of manipulation later disappeared from *Life* as the editors came to respect the integrity of each photograph.

Illustrated magazines were not a new phenomenon in the United States. As early as the nineteenth century, *Leslie's Illustrated*Newspaper and Harper's Weekly relied on drawings to elucidate their articles. After the invention of the halftone, such publications as McClure's, Cosmopolitan, and Collier's continued the tradition of adding pictures to supplement their stories.

348 - Photojournalism: The Professionals' Approach

The difference between these early American magazines, the German picture publications, and the great American glossy magazines that followed lay not only in the number of pictures used but also in the way they were used. In the new magazines, several pictures were grouped together with an overall theme and design. Picture editors discovered truth in the old adage, "The whole is worth more than the sum of the parts." Accordingly, the role of the picture editor became all-important. Along with the photographer, the picture editor shaped the story and, with the aid of shooting "scripts," mapped out the photographer's plan of attack. Single photographers would work on stories to give them visual cohesion. These photographers were no longer anonymous but were given credit in the magazine.

AMERICAN MAGAZINES ADOPT PHOTOGRAPHY

"NEWS-WEEK" SPURS

TIME'S USE OF PHOTOGRAPHY
Although Europeans were developing imaginative new uses for photography on the printed page, these developments had not yet affected American magazines. Time magazine, for instance, primarily published poorly reproduced conservative head-and-shoulders portraits. Robert Benchley, a wit of the era, said that the pictures inside Time were reproduced so poorly that they appeared to have been "engraved on slices of bread."

News-Week, as it was first known, started in 1933. By splashing dramatic spot news pho-

tos on its covers, it quickly drained circula-

FORTUNE REVOLUTIONIZES PICTURE USE

tion from Time.

Surprisingly, the first magazine in America to make full use of photography was a business publication. Henry Luce, who founded *Time*, launched *Fortune* magazine in 1930, in the heart of the Great Depression.

While *Time* magazine had used pictures almost as an afterthought, *Fortune* hired photographers like Margaret Bourke-White. To make her pictures dramatic, Bourke-White did not hesitate to bring in multiple flashbulbs to light whole steel mills. She used her large-format camera to glamorize American industrial might from dynamos to skyscrapers.

In *Fortune*, pictures held equal status with words. The respectful treatment of pictures worked so well that by the middle of the decade, though the country was still in a severe depression, *Fortune* had amassed 100,000 readers.

LIFE IS BORN

Life was the brainchild of Henry Luce, the publisher of *Time* and *Fortune* magazines and his general manager, Ralph Ingersoll. Spurred by the success of similar European ventures like *BIZ* and *MIP*, and the development of slick-coated, quick-drying paper, Luce and his colleagues felt the time was ripe in the United States for a new, large-format picture magazine. Kurt Korff, former editor of the

Berliner Illustrirte
Zeitung, consulted
with Luce (1935–36)
on the prototype of
Life magazine.

Life was born in the 1930s. In its manifesto, the new magazine stated its credo:

To see life, to see the world; to eyewitness great events; to watch the faces of the poor and the gestures of the proud; to see strange things—machines, armies, multitudes, shadows in the jungle and on the moon; to see man's work—his

paintings, towers and discoveries; to see things a thousand miles away, things hidden behind walls and within rooms, things dangerous to come to; the women that men love and many children; to see and to take pleasure in seeing; to see and be amazed; to see and be instructed.

For the first issue, November 23, 1936, *Life*'s editors dispatched Margaret Bourke-White to photograph the construction of a WPA dam—the Peck Dam—in New Deal, Montana. In the 1920s Bourke-White had made a name for herself as a freelancer and later as a topnotch industrial photographer on the staff of *Fortune* magazine. Her pictures celebrated the burgeoning machine aesthetic of the time, and her expertise in capturing on film structural and engineering details made her the perfect candidate for the assignment.

When she returned with her pictures, however, the editors of *Life* were in for a surprise. Not only had she captured the industrial drama of the dam under construction, but she took it upon herself to document the personal drama of the town's inhabitants as well. Bourke-White turned her camera on the details of frontier life—the hastily erected

The first cover of LIFE magazine (TOP) was taken by Margaret Bourke-White (BOTTOM). Bourke-White photographed a massive WPA dam in New Deal, Montana, for the cover story. Her essay inside focused on the residents of New Deal. (© 1936 Time Inc., courtesy of Time Incorporated.)

The success of Life and then Look spawned many picture magazines in the days before television.

shanty settlements, the weather-beaten faces of the townspeople, the Saturday night ritual at the local bar—and enhanced her story by adding the human dimension.

On the cover of the first issue of *Life* is a picture of the huge dam in all its geometrical splendor. And inside is Bourke-White's photo essay: nine pages of carefully laid-out, strategically chosen pictures of New Deal's residents. The first issue was a sellout. The editorial offices of *Life* in New York were besieged by phone calls and telegrams asking for more copies. The presses were restarted to meet the demand. "During the first year you had to hurry to the news stands on publication day to grab up a copy before they were all gobbled up," recalled Arthur Goldsmith in an article about the magazine.

The Peck Dam essay became the prototype for a form that flourished in the pages of *Life*, a form that expanded the scope of photojournalism and redefined the way we see.

Aside from Margaret Bourke-White, the other three photographers who appeared on the magazine's masthead were Peter Stackpole, known for his photographs of the construction of the Golden Gate Bridge; Thomas McAvoy, an expert on the use of the 35mm for political candids; and Alfred Eisenstaedt, a specialist in the new German style of candid photography.

During its first few years, *Life* had the reputation of a magazine that ran sensational pictures. The magazine's first real shocker was titled "How to undress in front of your husband." The story, tame by today's standards, was supposed to be "sophisticated satire," but many readers let it be known they thought it indecent.

Several issues later, *Life* ran an article titled "Birth of a Baby." The feature ran four pages and showed in drawings how the unborn child grows in the womb and the progress of the baby from the mother's body. In the actual birth pictures, the only things visible in the frame were the baby's head, the doctor, and masses of sterile dressing. After publication, a furor broke out. The magazine was banned in thirty-three U.S. cities and in Canada, and publisher Roy Larsen was arrested for selling indecent literature.

As Dolores Flamiano showed in her paper "The Naked Truth: Gender, Race, and Nudity in *Life*, 1937," the magazine was not above using sex to attract readers and drive up circulation—even in the 1930s.

COMPETING WITH LIFE

LOOK BASED ON SURVEY

The astounding success of *Life* was matched by that of its fellow picture magazine, *Look*.

Look was founded by the Cowles brothers, a newspaper publishing family who commissioned George Gallup to discover what part of the newspaper was most widely read. When Gallup's poll revealed that the picture page was most popular, the brothers founded Look, which first appeared in January 1937, a few months after Life began. Look quickly developed a reputation for sensational stories. One description at the time claimed that Look was a combination of "gall and honey." Gardner Cowles answered, "Look has been criticized as sensationally thrilling. My only reply is that life itself is thrilling."

Look toned down its sex-and-violence image to concentrate on feature stories. Known for its writer/photographer team approach, Look hired many outstanding shooters, including Arthur Rothstein, Paul Fusco, and Stanley Tretich.

SEE, PEEK, CLICK, SCOOP

The rapid rise in *Life*'s and *Look*'s circulations persuaded other publishers to start picture magazines. Within two years of Life's first issue, the picture magazine field was crowded with thirteen periodicals sporting one-word, punchy names like See, Click, *Peek*, *Pix*, *Picture*, and *Scoop*, and boasting a combined circulation of 16 million per issue. The magazines' content ranged from "girlie" pinups to the social ills of drinking. Stories included the "Truth about Cremation" and "How You Should Tell your Child about Sex." Most stories in these *Life* and *Look* imitators were highly scripted with few candids. Each represented a little melodrama, and sometimes actors even played parts in the photos. The proliferation of picture magazines, starting in 1936 and continuing through the 1940s and 1950s, has caused historians to call the period before television's dominance the "golden age of photojournalism."

PICTURE AGENCIES SUPPLY THE MAGAZINE TRADE

BLACK STAR AGENCY:
HOME TO GERMAN ÉMIGRÉS

Life had a tiny staff of only four photographers when it began publishing. The editors needed photos, lots of them, so they turned to Black Star, a recently formed picture agency that represented many newly emigrated German photojournalists. Three German Jews, who had worked in Germany's publishing industry before immigrating to the States, started the agency. A large file of photographs brought from Europe by Ernest Mayer helped get the firm off the ground. Kurt Safranski, the idea man, stayed in the office, and Kurt Kornfeld,

described by C. Zoe Smith as a gentle salesman, handled the *Life* account. Smith's book *Black Star Picture Agency:* Life's *European Connection*, details the agency's history.

Life needed the agency because it used 200 pictures per issue but had just four staff shooters. Of course, the agency also needed this popular picture magazine. Life accounted for a quarter of the agency's business.

German photographic émigrés who spoke little English turned to Black Star, where the principle owners were bilingual. The agency helped them get assignments and handled the business aspects of freelancing in the United States. Black Star took a 30 to 40 percent commission but paid photographers a weekly retainer against their annual sales.

Many of the agency's émigré photographers, including Fritz Goro, Andreas Feininger, Hebert Gehr, Walter Sanders, and Werner Wolff, became *Life* staffers. Others, like Philippe Halsman, were under contract to the magazine for decades. According to Wilson Hicks of *Life*, by 1952 more than a quarter of the photographers working for *Life* had emigrated to the United States from Europe in the late 1930s and early 1940s. At least half of those European photographers were at one time associated with Black Star.

MAGNUM:

THE LEGENDARY PHOTO AGENCY Magnum, like Black Star, was another picture agency formed by European émigrés. Black Star was owned by three former photo editors who secured assignments for photographers and kept a percentage of their fees. Magnum, by contrast, was formed in 1947 as a cooperative that shared its profits among its photographer-members.

Magnum was founded by Henri Cartier-Bresson, a wealthy French photojournalist; George Rodger, an English photographer who worked for *Life* magazine; David Seymour, known to everyone as Chim; and André Friedmann, a Polish photographer who immigrated to the States and changed his name to Robert Capa. (Friedmann supposedly took the American name so editors would think of him as a successful American photographer rather than a struggling young émigré.)

The agency actually was born as a way for its founders to have a political impact.
Cartier-Bresson, Rodger, and Chim spent many hours at the Café du Dome discussing liberal politics rather than photography. They were interested in how they could use their cameras to examine the social and political problems of the day.

For a long time Capa had been toying with the idea of a cooperative picture agency, so that photographers could hold on to more of their earnings and retain rights to their images. During World War II, Capa met Rodger in Naples when both were taking pictures for *Life*.

Capa: the greatest war photographer By the time Capa and his friends founded Magnum, he was already a legendary war photographer who had covered both the Spanish Civil War and World War II. He took perhaps the most famous war photograph of all time—a Spanish Republican militiaman, arms flung wide, dropping backward at the instant he was killed by a bullet (page 352).

During the World War II, Capa photographed the landing at Normandy on D-Day and produced classic photographs that

Magnum's founders, pictured in the two photos below, created a picture agency in which earnings were shared among all the photographers.

(BELOW LEFT)
Hungarian-American
Robert Capa, perhaps
the world's greatest war
photographer (left), and
Englishman George
Rodger both covered
World War II in Europe.

(Photo by Henri Cartier-Bresson © 1943, Magnum Photos Inc., courtesy of Magnum Photos.)

(BELOW RIGHT)
David "Chim" Seymour
(left) greets Henri
Cartier-Bresson.
(Magnum Photos, Inc. ©
1938, courtesy of Magnum

Photos)

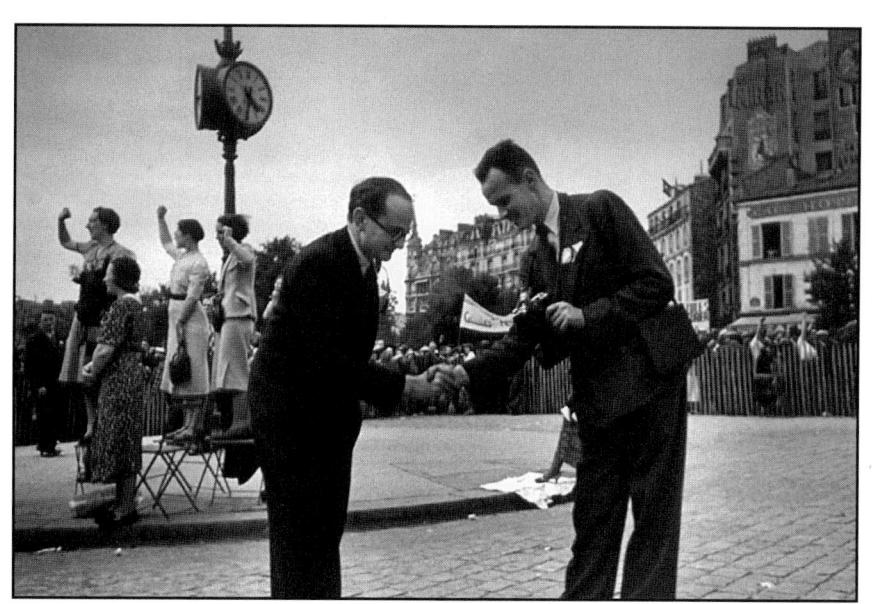

people still associate with that battle. Two thousand men lost their lives that day. Capa landed with the first wave of soldiers.

"The water was very cold and the beach was still more than a hundred yards away. The bullets tore holes in the water around me, and I made for the nearest steel obstacle," Capa later wrote.

Using two cameras, he took 106 pictures of the bloody battle on the beach before rushing back through the surf to clamber onto a landing craft returning to the invasion fleet offshore. A messenger delivered the undeveloped film to *Life*'s London office, where the deadline to send the pictures to New York was rapidly approaching. John Morris, picture editor for *Life*, took the four rolls of 35mm film and gave it to Dennis Banks to develop. In his book, *Get the Picture*, Morris recounts the story:

"A few minutes later, Dennis came bounding up the stairs and into my office sobbing. 'They're ruined! Capa's films are all ruined!" Incredulous, I rushed down to the darkroom with him, where he explained that he had hung the films, as usual, in the wooden locker that served as a drying cabinet, heated by a coil on the floor. Because of my order to rush, he had closed the doors. Without ventilation the emulsion had melted.

"I held up the four rolls, one at a time. Three were hopeless: nothing to see. But on the fourth roll there were eleven frames with distinct images . . . their grainy imperfection—perhaps enhanced by the lab accident—contributed to making them among the most dramatic battlefield photos ever taken. D-Day would forever be known by these pictures."

Capa went on to cover the liberation of Paris, the Battle of the Bulge, and the war between Israel and the Arabs. Later he photographed the war in Indochina, always taking his own advice, recorded by his biographer, Richard Whelan: "If your pictures aren't good enough, you're not close enough."

Henri Cartier-Bresson:

Photojournalist of the decisive moment After joining Magnum, Henri Cartier-Bresson, who during his career shot more than 500 pictures and stories for magazines, sailed for Bombay in the summer of 1947 to cover the partition of India. The political and religious animosities there had turned into a bitter and violent struggle. At least ten million Hindus, Muslims, and Sikhs were abandoning their homes and fleeing in both directions across the new border between India and Pakistan. At least one million

Robert Capa's famous
"falling soldier" picture
was taken in 1936 just
as the man was struck
by a bullet at the battle
of Cerra Muriano on the
Cordoba Front during
the Spanish Civil War.

(Photo by Robert Capa © 1996, Magnum Photos, courtesy of Magnum Photos.)

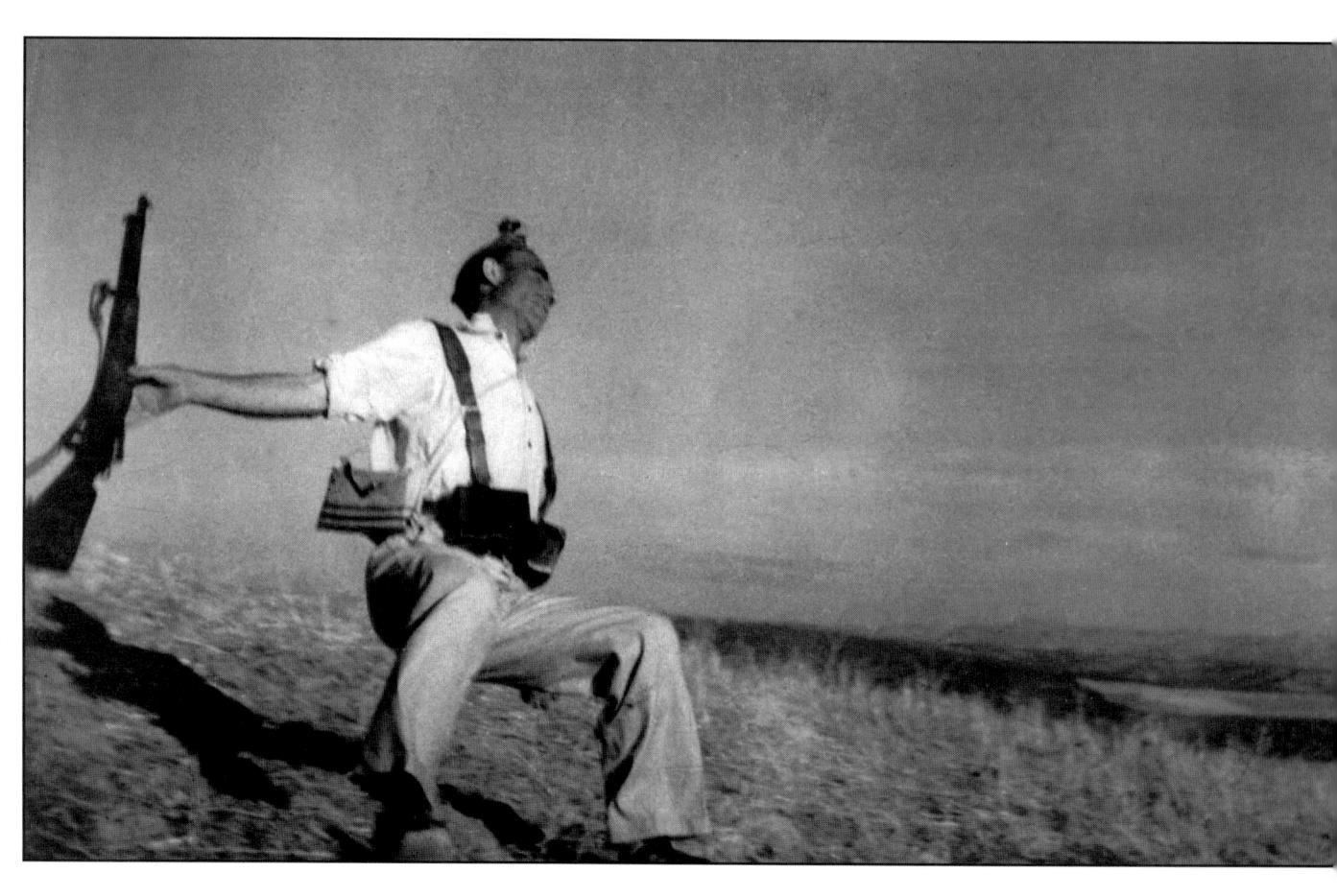
Indians were slain, and hundreds of thousands were made refugees during the exodus.

In January 1948, Cartier-Bresson photographed the Indian independence leader Mohandas Karamchand Gandhi on the day he broke his fifteenth fast. Margaret Bourke-White was also in India to cover Gandhi and the breakup of India for *Life* magazine.

The same day that Cartier-Bresson photographed Gandhi, the world leader was shot and killed by a Hindu opposed to Gandhi's defense of Muslims. When Margaret Bourke-White took a flash picture of the slain Gandhi lying in state, Gandhi's entourage felt that the flash was disrespectful and took the film from Bourke-White. She tried to slip in again but was blocked. She left empty-handed, reports historian Claude Cookman in "The Photographic Reportage of Henri Cartier-Bresson."

Hearing that Gandhi had been shot, Cartier-Bresson, meanwhile, returned to the compound on his bicycle. With his Leica and available light, he succeeded in taking and keeping several photographs of the deathbed scene. "All night the crowds rushed into the garden of Birla House and pressed forward to try and see him," Cartier-Bresson recalled. "I managed to reach one window, greasy from the pressure of many foreheads, and polished

with my elbow a place big enough for the lens of my camera," he wrote in his book *The Decisive Moment*. *Life* magazine eventually paid Magnum a handsome price for the exclusive photos of an event that Bourke-White, their own staffer, had been unable to photograph.

Agency adds new recruits

Magnum, which eventually had offices in both Paris and New York, added several more photographers to its stable. Werner Bishof, an abstract still-life photographer associated with Black Star, joined the agency. Austrian photographer Ernst Haas left *Life* magazine to become a Magnum photographer. Despite the limitations of slow color films of the day, Haas was a color specialist. "I am not interested in shooting new things," he later wrote. "I am interested to see things new—in this way I am a photographer with the problems of a painter; the desire to find the limitations of a camera so I can overcome them."

Aspiring photographers found joining Magnum in the early days a casual, nonbureaucratic experience. Marc Riboud showed his pictures to Robert Capa while the famed war photographer was playing pinball in the café below Magnum's Paris office. Without a

Working with an unobtrusive Leica camera, Henri Cartier-**Bresson roamed the** streets of Seville looking for the combination of the perfect instant within the ideal composition. He called the combination the "decisive moment." **Besides shooting for** himself, Cartier-Bresson took on many magazine assignments around the world.

(Henri Cartier-Bresson © 1933, Magnum Photos, courtesy of Magnum Photos.)

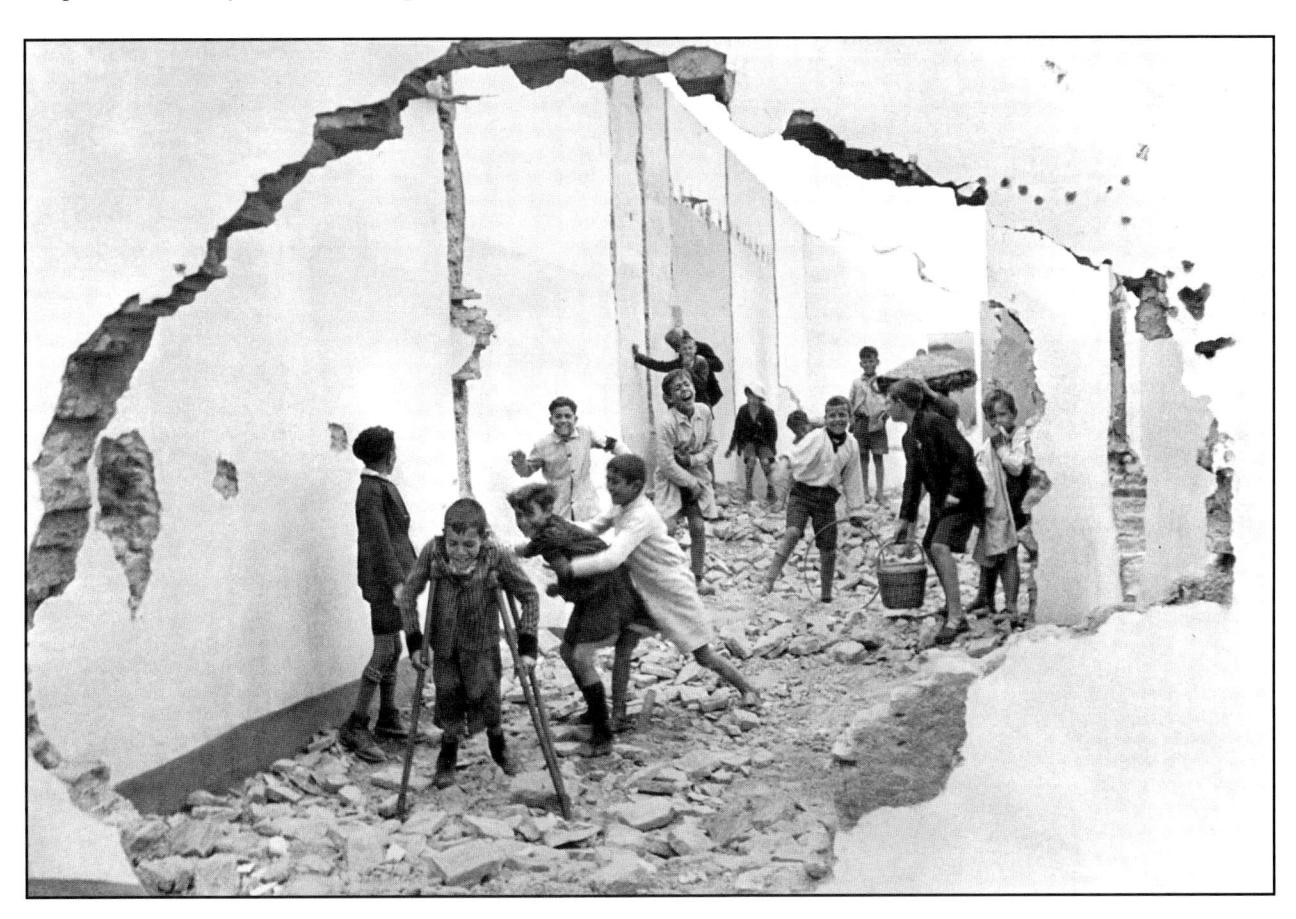

vote, without consulting anyone, Capa took one look at Riboud's portfolio and said, "OK, come with us. Allez!"

Eve Arnold showed up at the New York office with a portfolio containing just two stories—a fashion show in Harlem and an opening night at the Met. She was immediately invited to become a "stringer"—a freelance contributor. After Dennis Stock won a *Life* competition for young photographers, Capa invited him to join the agency.

Today applicants undergo a lengthy process that includes a trial period and a vote by all the member photographers.

AGENCY SURVIVES DEATHS IN THE "FAMILY"

Magnum suffered a tremendous setback in 1954 when, within days of one another, Capa was killed by a land mine in Indochina and Werner Bishof died in an accident in Peru. Two years later, Chim was killed while covering the aftermath of the Suez crisis between Egypt and Israel. After the death of two of its original founders and one of its members, Magnum lost direction, observes Russell Miller in *Magnum:Fifty Years at the Front Line of History*. Robert's brother Cornell then joined the agency and, according to Miller, helped steer it back on course. Magnum went on to attract some of the most outstanding photojournalists in the world.

Burt Glinn covered Fidel Castro's triumphant entrance into Havana after the overthrow of the Batista regime in Cuba.

Philip Jones Griffiths produced a soulsearching book from his coverage of Vietnam that shattered many American myths about the country. He showed that everything happening in Vietnam was being done against the will of the people.

Magnum's Marc Riboud was one of the few outsiders to get into North Vietnam during the war.

In 1968 Magnum produced the book *America in Crisis* that included its photographers' coverage of the assassinations of Martin Luther King and Bobby Kennedy, the rise of black power, and riots at the Democratic Convention in Chicago.

As big picture magazines like *Look*, *The Saturday Evening Post*, and, eventually, even *Life* folded, Magnum photographers survived by shooting corporate annual reports and even advertisements in addition to editorial assignments.

THE COMPLICATED CAREER OF W. EUGENE SMITH

Perhaps the most influential, controversial, and well-remembered photographer ever to

work for *Life* was W. Eugene Smith, who also was associated at different times with both Black Star and Magnum. He signed a contract with *Life* magazine in 1939, and subsequently shot many photos and photo essays for the magazine. He quit the magazine not once but twice. Smith resigned first in 1941 because he felt he was in an assignment rut at *Life*.

He referred to his pictures at this time as having "a lot of depth-of-field but not much depth-of-meaning." He covered World War II at first for Ziff-Davis Publishing Company and then was rehired by *Life*.

Obsessed with the gap between the reality of war and the comfortable headlines about war seen by the people back home, the twenty-four-year-old correspondent hurled himself into the front lines, trying to catch on film the horror of killing. Smith followed thirteen invasions, taking memorable pictures of the war—a tiny, fly-covered, halfdead baby held up by a soldier after being rescued from a cave in Saipan; a wounded soldier, bandaged, stretched out in Leyte Cathedral; a decaying Japanese body on an Iwo Jima beach.

Then, while shooting a story on a day in the life of a soldier, Smith was hit by a shell fragment that ripped through his left hand, his face, and his mouth—critically wounding him. Two years of painful convalescence followed.

In 1947, Smith resumed his work for *Life* magazine. During the next seven years, he produced his best-known set of photo essays: the exhausting dedication of a country doctor; the poverty and faith in a Spanish village; the pain of birth, life, and death being eased by a nurse midwife, Smith's own favorite essay. "In many ways, shooting these photos was the most rewarding experience photography has allowed me," said Smith of the midwife essay.

According to Jim Hughes' extensive biography, *Shadow and Substance*, Smith himself was not an easy photographer to work with. While most *Life* staffers shot their assignments and shipped the film back to New York, Smith developed his own negatives and then held on to them. With control of his negatives, Smith could threaten to withdraw a story if he felt the editors were not going to play the photos accurately.

In 1954 Smith photographed the essay "Man of Mercy," about Dr. Albert Schweitzer and his leper colony in Africa. After carrying the Schweitzer essay back to America, Smith quarreled with *Life*'s editors about it. In a futile attempt to affect the use of pictures and captions, and to expand the

W. Eugene Smith's landmark essay "Spanish Village," for *LIFE* magazine, opens with a young girl preparing for confirmation and closes with a wake for a dead villager.

(LIFE, April 9, 1951.)

Schweitzer layout, Smith resigned from *Life* for the second time.

With the help of his wife, Eileen, Smith later photographed a moving story about mercury poisoning in Minamata, Japan, which was published first in *Life* and eventually appeared as a book, *Minamata*.

PHOTOGRAPHERS COMPETE

RIVALRY AMONG NEWSPAPER PHOTOGRAPHERS

The success and style of the picture magazines had some important effects on newspaper photojournalism. The photo essay layout influenced many newspapers to adopt a similarly simple and direct arrangement of pictures about one subject. Likewise, newspapers began running more feature stories and using larger pictures.

Philadelphia boasted twenty daily newspapers during the 1920s and more than 200 press photographers. During the Depression, however, many papers died. While newspapers competed for readers, press photographers competed for scoops. Photographers were not above sabotaging one another. Joe Costa, who worked for the New York Morning World and later the The Daily News, recalled that photographers never let their camera bags out of their sight. He called it a "dog-eat-dog" business. A competitor might expose the film in a fellow photographer's holders or simply switch holders: the exclusive picture would be in the opposition's newspaper the next day!

Using the basic 4" x 5" Speed Graphic,

photographers of this period covered gangland slayings and bootlegged booze all without the aid of an exposure meter. Photographers determined most exposures by "guesstimations." The effective film index at this time was around ISO 25.

Guessing lighting exposures was just one of the shooting techniques photographers learned from one another, because few went to school to learn photojournalism. In fact, almost no universities prior to the 1940s offered photojournalism as a major. News photographers often got started as copyboys or copygirls on newspapers. If they expressed a leaning toward pictures, they could start an apprentice program in which they mixed chemicals and loaded film holders in the darkroom—progressing then to developing film and printing. They also carried equipment for photographers in the field. Moving from printing in the lab to covering news in the street was a major hurdle that took some photographers five years or more to leap, according to Sam Psoras, who started with International News Photos (INP) before joining the *Philadelphia Daily News*.

One newspaper that maintained a large photographic staff was the *Milwaukee Journal*. Historically, the *Journal* staff worked under a unique setup. They were a part of the engraving department rather than the editorial department. Because they were part of the production team, managers were not shocked by large capital outlay expenses for equipment. As a result, the photo department instigated many technological advances, including the

early use of the 35mm camera. Staff photographer Brownie Rowland brought back a Leica from Germany, and Frank Scherschel was interested enough to borrow the little camera and try it out. History books credit Bob Dumke with inventing a synchronizing switch for his Speed Graphic that allowed him to shoot flash pictures in daylight. Ed Farber developed the portable electronic strobe for covering news events. The *Journal* continued to experiment with running four-color pictures throughout the paper during the Depression.

The Des Moines Register and Tribune was also noted for outstanding use of pictures. In 1928, the paper bought an airplane and hired a pilot to transport pictures from rural areas of Iowa. In the latter half of the 1930s, the trade journal Quill and Scroll ranked this paper first in the number of pictures carried.

A PROGRESSIVE VISUAL NEWSPAPER

PM, a short-lived, liberal tabloid, exhibited the most progressive and modern use of pictures by a newspaper. Founded in 1940 by Ralph Ingersoll, who previously had helped edit Time and Life, the paper combined the textual approach of the newsweekly with the visual approach of the picture magazine in a daily, tabloid newspaper. The squarish-format tabloid hired the best photographers of the day, including Weegee (Arthur Fellig) and Margaret Bourke-White. The paper was beautifully printed with special ink and stapled so that the pages would not fly apart. Its sections, with eight consecutive pages of

PM combined a newsmagazine's approach to writing and a picture magazine's approach to photos into a strikingly different daily newspaper. (Collection of Sidney Kobré.)

full-page pictures, constituted an approach that was unheard of in its day and, in fact, rarely if ever seen since. The crusading paper used photographs to document its exposés, including one series on the unsanitary conditions in the New York poultry market.

Researcher Cindy M. Brown, in "PM: Just Another Picture Paper?" reports that PM not only ran more pictures than its New York rivals—including the Post, Sun, and Mirror—but that it ran them larger and grouped them in a more storytelling way. In fact, the paper approached a fifty-fifty picture-text split, unheard of in today's newspapers. Brown wrote that PM not only ran more visually interesting pictures, but the pictures had stronger compositional elements than did its rivals. Every Sunday, PM's Weekly, the paper's Sunday edition, featured a gallery of full-page photographs. Unfortunately, relying on newsstand sales and subscriptions alone, PM eventually died, because it contained no advertising and thus lacked sufficient revenues to survive.

WAR CENSORSHIP

World War II produced corpses in abundance. Nonetheless, during the war, American citizens saw few dead soldiers. When they did, it was the U.S. government's attempt to influence public opinion. This censorship was not new. During the entire nineteen months of American involvement in World War I, the government prohibited publication of any photographs of dead American soldiers. A similar prohibition lasted for the first twenty-one months of American involvement in World War II.

However, unlike World War I, in which the government tried to completely restrict photographers' access to the front lines, photojournalists during World War II could move freely on battlefields and accompany naval assaults. Photographers could shoot where, when, and what they wanted, but all exposed film was screened by two layers of censors—one in the field and another in Washington. Early in the war, censors placed all photographs of dead and badly wounded Americans in a secret Pentagon file known to officials as the "Chamber of Horrors."

Initially, censors were worried that if the population saw pictures of dead American soldiers they would press for a compromise settlement with Germany and Japan. Later, as government leaders became concerned about public complacency brought on by Allied victories, they released some of these photographs of war's brutality. For instance, *Life* published George Strock's photograph of three American soldiers lying dead on Buna

This World War II photo of a frozen American soldier with a stake driven through him was censored by the U.S. government for fear of discouraging citizens on the home front. (Photo courtesy of the National Archives.)

Beach in New Guinea. After almost two years of American involvement in the war, this photo was the first released to show dead American soldiers. *The Washington Post* said it was time that the government treated Americans as adults, and that photographs "can help us to understand something of what has been sacrificed for the victories we have won." Yet even the *Post* went on to say "an overdose of such photographs would be unhealthy."

But until the war's end and after, the government continued to censor photographs of mutilated or emotionally distressed American soldiers, even though more than a million soldiers suffered psychiatric symptoms serious enough to debilitate them for some period. The censors held back any pictures showing racial conflicts at American bases, and other visual evidence of disunity or disorder. In *The Censored War*, George Roeder tells how American opinions about World War II were manipulated both by wartime images that citizens were allowed to see and by the images that were suppressed.

At the beginning of the Korean War, photographers were under a system of voluntary censorship. However, on November 2, 1950, American troops came into direct contact with Chinese forces as the Chinese Communist army entered the war in full strength. What followed was a long and difficult retreat covered by the media. Embarrassed personally, General Douglas MacArthur ended the voluntary censorship

system and imposed a full military censorship on news.

Before the general clamped down, photographers covered all aspects of the Korean War. Despite relatively free access, and limited only by self-censorship, fewer than 5 percent of the photos published by *Life*, *Newsweek*, and *Time* were actual combat photos.

The same reticence about showing soldiers under fire did not hold true for America's next war. During at least part of the Vietnam War, 40 percent of the published pictures run by *Life*, *Newsweek*, and *Time* portrayed soldiers in the heat of battle, according to a study by Michael Sherer. The American public saw more of the brutal side of combat during the Tet offensive in Vietnam than during major battles in Korea. During the Vietnam War, images of dead and wounded, plus photographs of people in immediate, life-threatening situations, were offered to the public on a regular basis.

PHOTOGRAPHERS ORGANIZE

As the public began to recognize such names as Margaret Bourke-White and Alfred Eisenstaedt, photographers began to achieve parity with writers. Originally, the photographer was a second-class citizen in the newsroom. According to one common story, when a news photographer's job opened up, the editor would find the nearest janitor and hand him a camera, telling him to set the lens at f/8 and shoot. Photographers were thought of

as the people who chased fires and took cheesecake pictures. Taking cheesecake pictures involved meeting incoming passenger ships to take snaps of pretty women with "lots of leg showing."

Along with steamships, cheesecake pictures slowly went out of vogue. Editors began acknowledging the contribution of pictures as a means of reporting the news. The photographer's status gradually rose.

In 1945, Burt Williams, a photographer with the *Pittsburgh Sun-Telegraph*, started organizing a professional association for photographers, The National Press Photographers Association. According to Claude Cookman's history of the organization, *A Voice Is Born*, Williams obtained financial backing for the organization from the Cigar Institute of America and began the groundwork with a ten-city coast-to-coast telephone conference in which leaders in press photography took part.

At a meeting in New York City on February 23 and 24, 1946, the group adopted a constitution and elected officers: Joseph Costa, *New York Daily News*, president; Burt Williams, *Pittsburgh Sun-Telegraph*, secretary; and Charles Mack, *Hearst Metrotone News*, treasurer.

Today the organization holds an annual conference, runs educational seminars, publishes an attractive, well-written magazine, *News Photographer* (edited by Jim Gordon), maintains an informative Web site, and hosts a lively electronic discussion list, NPPA-L, on the Internet. With more than 10,000 mem-

bers, including pros and students, the association also administers a photo contest and sponsors professional workshops in photojournalism and electronics.

More and more college graduates enter the field of photojournalism each year. The first college grad to work on the picture side of a newspaper was Paul Thompson, who graduated from Yale in 1902.

Today many schools offer courses and even degrees in photojournalism. More than ninety colleges and universities offer at least one class in news photography. Some universities even grant a Ph.D. in journalism or communications with an emphasis in photojournalism.

DISTRIBUTING PICTURES ACROSS THE LAND

BAIN CREATES A PICTURE SERVICE In 1898, a newspaper writer and photographer, George Grantham Bain, started the Bain News Photographic Service in New York City. As manager of the Washington, D.C., United Press office in the 1890s, Bain realized that he could accumulate pictures on his own and sell them to subscribers.

After leaving United Press, he began his own photo service. He catalogued and cross-indexed photographs he had bought from correspondents or newspapers that subscribed to his service. From newspapers throughout the country, he received pictures, copied them, and sent the copies to his list of subscribing newspapers. Bain's business expanded rapidly and, by 1905, he had

(Bain Collection, Library of Congress.)

acquired a million news photographs. Many of his pictures were the first of their kind, including the first federal courtroom pictures, the first photos of the Senate in session, and the first automobile race. Although a massive fire in 1908 completely destroyed Bain's archives, he immediately set about rebuilding his collection.

Other picture services developed, including Underwood and Underwood, who started out making stereoscopic pictures. Newspaper editors would call on the Underwoods for pictures to illustrate stories about remote countries where the Underwoods had operators. The Brown brothers, too, saw the possibilities of selling news pictures from their experience as circulation managers on *Harper's Weekly*. Soon the Underwood, Brown, and Bain photographers were all competing for scoops.

By 1919 the Hearst organization formed International News Photos (INP). Wide World Photos followed. In 1923 Acme News Pictures appeared. The Associated Press News Photo service began in 1927. By 1933, some fifty photographic news services were operating in New York.

These services sent their pictures by train, giving a tip to the porter to hand-deliver the package of photos for extra-quick service. Local event photos were no longer limited to the immediate area. If the picture had enough sensational interest or sex appeal, it would be sent around the world. Acme and INP later combined into United Press International (UPI), and Wide World Photos became part of the Associated Press (AP).

INSTANT PICTURE TRANSMISSION Ever since newspapers began publishing pictures, the search was on for a way to transport the images over long distances. As early as 1907, Professor Alfred Korn of the University of Munich, Germany, had demonstrated an electrical system using a photocell, which would transmit and receive a picture over a telegraph wire. His basic principle remains in use today.

In the same year, *L'Illustration* of Paris and the *London Daily Mirror* inaugurated a cross-channel service that later included other capitals of Europe.

Not until 1925 was there a permanent transmission line set up in the United States. In that year the American Telephone and Telegraph Co. (AT&T) opened a commercial wire between New York, Chicago, and San Francisco. It was first come, first served, and cost \$60 to send a picture coast-to-coast.

AT&T sold the wire to the Associated Press in 1934. The AP bought the Bell Lab equip-

ment, leased AT&T wire, and set up twenty-five stations. On January 1, 1935, the AP serviced an aerial picture of a plane wreck in the Adirondack Mountains, and the age of rapid wire transmission began in the United States. Soon other picture services, including International News Photos and Acme, started their own wire photo transmission networks.

For a long time, such uncontrollable factors as weather conditions would influence the quality of pictures sent on long-distance transmission lines. But with today's digital technology, the wire services—and individual photographers—can send photos instantaneously all over the world, with the quality of the final product looking as good as that of the original. The development of portable scanners, electronic cameras, high-speed modems, and laser transmission, as well as the improvement in fast lenses and the introduction of lighter cameras, more sensitive film, and now completely digital, filmless cameras, have all freed the photojournalist from many earlier technical limitations.

Improved technology also has led to a wider range of styles and subjects for the news photographer. Instead of cheesecake and composograph photos taken with flash-on-cameras, today's photojournalist can produce creative and expressive photographs. These in-depth pictures, taken with available light or light from portable strobes, on high-speed film or with an electronic camera, can capture candid moments that were impossible in the days of New York's *Daily Graphic*.

Transmitters like this
Associated Press
machine did for photographers in the 1930s
what the telegraph had
done for writers prior to
the Civil War. The
device allowed photographers to send pictures by wire across the
country and eventually
around the world.

(Photo courtesy of the Associated Press.)

SELECTED BIBLIOGRAPHY

In addition to listings from previous editions of Photojournalism: The Professionals' Approach, this bibliography includes articles and books derived from searches of a number of different electronic databases. Lucinda Covert-Vail, Director of Public Services, New York University Libraries, conducted the searches through Summer 1999.

"About Digital Picture-Taking." News Photographer (September 1998): 47. Abramson, Howard S. National Geographic: Behind America's Lens

on the World. New York: Crown Publishers, 1987. Adams, Jonathan, " . They Should Have

Published It." 4Sight (November/December 1993): 17. Adams, R. C., Copeland, Gary A., Fish,

Marjorie J., and Hughes, Melissa. "Effect of Framing on Selection of Photographs of Men and Women." Journalism Quarterly 57 (1980): 463-67.

Ades, Dawn. Photomontage. Rev. & enlgd. ed. London: Thames and Hudson, 1986. Alabiso, Vincent. "Changing with the Times."

Nieman Reports 52 (Summer 1998): 5-7. Alabiso, Vincent J. "Prospects for Photojournalism." *Media Studies Journal* 13 (Spring 1999): 58-59.

Alabiso, Vincent, Tunney, Kelly Smith and

Zoeller, Chuck, eds. Flash! The Associated Press Covers the World. New York: Associated Press in association with Harry N. Abrams, 1998.

"Albany, NY, Paper Outraged by Assault." News Photographer (January 1995): 12, 14. Alexander, S. L. "Curious History: The ABA Code of Judicial Ethics Canon 35." Paper presented at the Annual Meeting of the Association for Education in Journalism and Mass Communication, Portland, Oregon, 1988. ERIC, ED296422

Alland, Alexander. Jacob A. Riis. Millerton, New York: Aperture, 1974.

"Altering Photo Brings Lab Tech's Resignation." News Photographer (March 1994): 11.

American Photo. May/June 1994. Special issue on the future of photojournalism. "Among the Believers: Is Photojournalism Dead?" (10 article special section). American Photo 7 (September/October 1996): 46-84.

Ang, Tom. Picture Editing: An Introduction. Oxford. Boston: Focal Press.

Angeli, Daniel and Dosset, Jean-Paul. Private Pictures: Photographs. New York: Viking Press, 1980.

Angelle, Linda. "Diversity." News Photographer (May 1999): 4-5

ASMP: 1944-1994 50th Anniversary Bulletin 13 (December 1994). Princeton: The American Society of Media Photographers, 1994.

Associated Press News and Photo Staff, eds. One Day in Our World. New York: Avon

The Associated Press Stylebook and Libel Manual: With Appendixes on Photo Captions, Filing the Wire. 34th ed. New York: Associated Press, 1999

Auer, Michel. The Illustrated History of the Camera: From 1839 to the Present. Translated & adapted by D.B. Tubbs. Boston: New York Graphic Society, 1975.

Baker, Robert L. "Portraits of a Public Suicide: Photo Treatment by Selected Pennsylvania Dailies." Newspaper Research Journal 9 (Summer 1988): 13-23.

Barney, Ralph D. Responsibilities of the Journalist: An Ethical Construct. Mass Comm Review 14(3) (1987): 14-22.

Barney, Ralph D., and Black, Jay. "Toward Professional Ethical Journalism " Mass Comm Review 17 (1/2) (1990): 2-13.

Barnhurst, Kevin G. Seeing the Newspaper. New York: St. Martin's Press, 1994

Barrett, Wayne M. "Margaret Bourke-White: New Vistas in Photojournalism." USA Today 118 (September 1989): 55-63.

Barry, Ann Marie. "Digital Manipulation of Public Images: Local Issues and Global Consequences." Paper presented at the Annual Meeting of the International Communication Association. Montreal, May

Baxter, William S., Quarles, Rebecca, and Kosak, Herman. "The Effects of Photographs and Their Size on Reading and Recall of News Stories." Paper presented at the Annual Meeting of the Association for Education in Journalism. Seattle, Washington, 1978. ERIC, ED159722

Baynes, Ken. Scoop, Scandal and Strife. New York: Hastings House, 1971. "Bearers of Bad News Examine Roles." News Photographer (May 1987): 20-44 (series of articles).

Benson, Harry. Harry Benson on Photojournalism. New York: Harmony Books, 1982

Bentley, P.F. "It's All in the Eyes." Columbia Journalism Review (May/June 1996):

Bergeman, Rich. "Photo Editing: A Neglected Art." Community College Journalist 15 (Winter 1987): 18-20.

Bergin, David P. Photojournalism Manual: How to Plan, Shoot, Edit and Sell. New York: Morgan & Morgan, 1967.

Bernt, Joseph P. and Greenwald, Marilyn S. "Senior Newspaper Editors and Daily Newspaper Coverage of the Gay and Lesbian Community: A Summary of Past Findings and Discussion of New Findings on Reporting Sexual Orientation." Paper presented at the National Conference of Lesbians and Gays in Mainstream Media. San Francisco, California, June 25-27, 1992. ERIC, ED347599.

Bessie, Simon Michael. Jazz Journalism: The Story of the Tabloid Newspapers. New York: E.P. Dutton, 1938

Best of Photojournalism. Annual 1977-present. Publisher varies

Bethune, Beverly. "Under the Microscope: A Nationwide Survey Looks at the Professional Concerns and Job Satisfaction of the Daily Newspaper Photographer." News Photographer (November 1983): R1-R8

Bethune, Beverly, ed. Women in Photojournalism. Durham, NC: National Press Photographers Association, 1986 "Beyond the Killing Fields." News

Photographer (April 1992): 27-31

Bissland, James H. and Kielmeyer, David. "Bypassed by the Revolution? Photojournalism in a Decade of Change" Paper presented at the Annual Meeting of the Association for Education in Journalism and Mass Communication. Montreal, August 5-8, 1992, ERIC, ED349623.

Bissland, James H. "The News Photographer's Career Ladder." An NPPA Special Report (also appears in the October 1984 issue of News Photographer).

Black Star: 60 Years of

Photojournalism. Koln: Konemann, 1997. Blackwood, Roy E. "The Content of News Photos: Roles Portrayed by Men and Women." Journalism Quarterly 60 (1983): 710-14

Blackwood, Roy E. "International News Photos in U.S. and Canadian Papers." *Journalism Quarterly* 64 (1987): 195–99.

Borden, Sandra L. "Choice Processes in a Newspaper Ethics Case." Communication Monographs 64 (March 1997): 65-81

Bourke-White, Margaret. Portrait of Myself. New York: Simon & Schuster, 1963

Bourke-White, Margaret. Margaret Bourke-White: Photographer. Boston: Little Brown, 1998.

Bowden, Robert. Get That Picture. Garden City, New York: Amphoto, 1978.

Bowermaster, J. "Eyes on the Prize (How a Photographer and a Newspaper Turned Iowa's Farm Crisis into a Pulitzer Prize)." American Photographer (January 1988):

Bowers, Matthew. "Following the Yellow Brick Road or how this newspaper in Norfolk won the McDougall." News Photographer (May 1997): 14-20.

Brauchli, Marcus. "Prize Under Glass Chance, Ingenuity, Violence Often Cited as Key Factors in Pulitzer Winners." News Photographer (June-July 1981): 20-23.

Brecheen-Kirkton, Kent. "Visual Silences: What Photography Chooses Not to Show Us. American Journalism 8 (Winter 1991): 27-34.

Brecher, Ellie. "Reporter-Photographer Relationships and How to Improve Them. 4Sight (November-December 1993): 12-13.

Brill, Betsy. "Town Protests Staged Photo, Hooker Image." News Photographer (September 1986): 4–8.

Brill, Betsy. "Pictures Don't Lie . . . or Do They?" Master's thesis, University of Missouri, 1988.

Brill, Charles. "The Early History of the Associated Press Wire Photo: 1926–1935." Paper presented at the Annual Meeting of the Association for Education in Journalism. Madison, Wisconsin, 1977.

Brink, Ben. "Question of Ethics: Where Does Honesty in Photojournalism Begin? 'The Foundation Is Basic, Simple Honesty,' an Editor Says." News Photographer (June 1988): 21-22, 23-33.

Brock, Oliver Eugene. "Digital Imaging in Photojournalism: Technological and Ethical Impact." Master's thesis, University of Mississippi, 1993

Brothers, Caroline. War and Photography: A Cultural History. London: Routledge,

Brower, Kenneth. "Photography in the Age of Falsification." Atlantic Monthly (May 1998):

Brown, Cindy M. "How the Use of Color Affects the Content of Newspaper Photographs." Paper presented at the Annual Meeting of the Association for Education in Journalism and Mass Communication

Washington, DC, 1989. ERIC, ED308525 Brown, Cindy M. "Listening to Subjects' Concerns about News Photographs: A Grounded Ethical Inquiry." Ph.D. diss., Indiana University, 1998.

Brown, Cindy M. "PM: Just Another Picture Paper?" Paper presented at the Annual Meeting of the Association for Education in Journalism and Mass Communication. Visual Communication Division, August 12,

Brown, Cindy M. "The Use of Search Warrants in Canada and the US to Obtain Photographic Evidence from Journalists.' Paper presented at the Annual Meeting of the Association for Education in Journalism and Mass Communication. Kansas City Missouri, August 11-14, 1993. ERIC, ED362918.

Brown, Jennifer E. "News Photographer and the Pornography of Grief." Journal of Mass Media Ethics 2 (Spring/Summer 1987): 75-81.

Brown, Theodore M. Margaret Bourke-White, Photojournalist. Ithaca, New York: Andrew Dickson White Museum of Art, Cornell University, 1972.

Bryant, Michael. "The Problem with Illustrations." News Photographer (July

Buell, Hal, and Pett, Saul. The Instant It Happened. New York: Associated Press,

Callahan, Sean. "The Last Days of a Legend (Margaret Bourke-White)." *American Photo* 9 (September/October 1998): 33–4, 95, 97.

Callahan, Sean, ed. The Photographs of Margaret Bourke-White. Boston: New York Graphic Society, 1972.

Callahan, Sean, and Astor, Gerald. Photographing Sports: John Zimmerman, Mark Kauffman and Neil Leifer. Los Angeles: Alskog, 1975.

The Camera. Rev. ed. Alexandria, Virginia: Time-Life Books, 1981.

Campbell, Gregory D. "A Study of Photo Editing Duties at the Small American Daily Newspaper 1994." Master's thesis, Memphis State University, 1994.

Campbell, W. Joseph. "Not likely sent: The Remington-Hearst 'telegrams.'" Paper presented at the Annual Meeting of the Association for Education in Journalism and Mass Communication. New Orleans, Louisiana, August 4-7, 1999.

Cannon, Brian. "Icon of the Oklahoma City Bombing: Revealing Connotative Meaning in a News Photograph of Tragedy and Heroism." Paper presented at the Annual Meeting of the Association for Education in Journalism and Mass Communication, Visual Communication Division, Anaheim, California, August, 1996.

Cannon, Brian. "Discourse on Philosophical Methods for Determining Ethics in Photojournalism: Analysis of a Pulitzer Prize Winning Photograph." Paper presented to the Association for Education in Journalism and Mass Communication, Washington, DC. August, 1995.

Capa, Cornell. The Concerned Photographer. New York: Grossman Publishers, 1968.

Capa, Robert. Robert Capa, Photographs. New York: Aperture, 1996

Capa, Robert. *Slightly Out of Focus*. New York: Modern Library, 1999. Carlebach, Michael L. *American*

Photojournalism Comes of Age. Washington, DC: Smithsonian Institution Press, 1997

Carlebach, Michael Lloyd. "The Origins of Photojournalism in America, 1839-1880." Ph.D. diss., Brown University, 1988.

Carnes, Cecil. Jimmy Hare News Photographer: Half a Century with a Camera. New York: Macmillan, 1940.

- Carrigan, Michael Andrew. "The Media Print Pool and Censorship as a Department of Defense Public Relations Tool during the Persian Gulf War." Master's thesis, University of Nevada Reno, 1997.
- Carroll, Darren, Cox, Stephanie, Dwyer, Jonathan J., Kenig, Nick, Layton, John and Wind, Andrew. "Sports Photography: Getting Pictures of Action." *Communication:* Journalism Education Today 31 (Summer 1998): 2-7.
- Cartier-Bresson, Henri. The Decisive Moment. New York: Simon & Schuster.
- Cartier-Bresson, Henri. The World of Henri Cartier-Bresson. New York: Viking Press, 1968
- Cartier-Bresson, Henri. *Europeans*. London: Thames & Hudson, 1998.
- Case, Tony. "Photo Illustration on Page One Story." Editor & Publisher (31 August 1996):
- Castello-Lin, Jeanine P. "Identity and Difference: The Construction of Das Volk in Nazi Photojournalism, 1930-1933." Ph.D. diss., University of California, Berkeley,
- Cavallo, Robert M., and Kahan, Stuart. Photography: What's the Law? 2nd ed. New York: Crown Publishers, 1979.
- "Changing Face of America: Gay Teens Project Wins Sabbatical." News Photographer (June 1993): 2, 4, 8.
- Chapnick, Howard. "Markets and Careers: Photographic Captions." Popular Photography (February 1979): 42, 64, 127,
- Chapnick, Howard, "Markets and Careers: Words Tell the Reader What Pictures Can't: They Make a Photographer a Photojournalist." Popular Photography (February 1979): 40, 64,127,143.
- Chapnick, Howard. "Looking for Bang Bang: Photojournalists are Flocking to Trouble Spots Like El Salvador, and Too Many Are Not Returning Alive. Are the Results of War Photography Today Really Worth the Risks?" Popular Photography (July 1982): 65-67, 99, 101-102.
- Chapnick, Howard. "Markets and Careers: Keeping News Pictures Meaningful.' Popular Photography (March 1983): 18,
- Chapnick, Howard. "Markets and Careers: Getting the Pictures is Only the First Worry for Photojournalists; How it Affects Subjects is the Other." Popular Photography (August 1983): 40,93.
- Chapnick, Howard. "Photojournalism Should Work On More Than One Level-and Its Images Should Be Clear, Simple, and Spontaneous." Popular Photography (September 1984): 36-37.
- Chapnick, Howard. "Markets and Careers: American vs. European Picture Editing. Popular Photography (December 1986): 38-39.
- Chapnick, Howard. "Markets and Careers: Changing Views on Picture Editing. Popular Photography (December 1986) 38-39
- Chapnick, Howard, Truth Needs No Ally: Inside Photojournalism. Columbia, Missouri: University of Columbia Press, 1994.
- Chernoff, George, and Sarbin, Hershel B. Photography and the Law. 5th ed. Garden City, New York: Amphoto, 1975.

Cohen, Lester. The New York Graphic. The World's Zaniest Newspaper.

Philadelphia: Chilton, 1964

- Cohen, Stuart. "Focusing on Humanity: The Life of W. Eugene Smith." Boston Phoenix (31 October 1978).
- Cole, Bernard, and Meltzer, Milton. The Eye of Conscience: Photographers and Social Change. Chicago: Follett, 1974. Coleman, A.D. Depth of Field: Essays on
- Photography, Mass Media, and Lens Culture. Albuquerque, New Mexico: University of New Mexico Press, 1998. Coleman, Renita. "Design Characteristics of Public Journalism: Integrating Visual and Verbal Meaning." Paper presented at the
- Annual Meeting of the Association for Education in Journalism and Mass Communication, Baltimore, Maryland, August 5–8. 1998. ERIC. ED423576. Converse, Gordon N. All Mankind:
- Photographs. Boston: Christian Science Publ. Society, 1983. Converse, Gordon N. *Reflections in Light:*
- The Work of a Photojournalist. Boston: Christian Science Monitor, 1989
- Cookman, Claude. A Voice is Born: The Founding and Early Years of the National Press Photographers Association Under the Leadership of Joseph Costa. Durham, NC: Nationa
- Press Photographers Association, 1985. Cookman, Claude Hubert. "The Photographic Reportage of Henri Cartier-Bresson, 1993-1973, Volume I." Ph.D. diss. Princeton University, 1994.
- Cookman, Claude. "Compelled to Witness: The Social Realism of Henri Cartier-Bresson. Journalism History 24 (1998): 2-16.
- Cooper, Guy. "Stock Photography: A Biased View from the Trenches." News Photographer (August 1998): mgr 3, 6.
- Costa, Joseph. Collected Papers. George Arents Research Library. Syracuse University: Syracuse, New York.
- Costa, Joseph, ed. The Complete Book of Press Photography. New York: National Press Photographers Association, 1950.
- Costa, Joseph, "Cameras in Court: A Position Paper." Muncie, Indiana: Journalism/Public Relations Research Center, Ball State University, 1980.
- Coulson, Cotton. "From there to here: Cotton Coulson's Career Profile." *News*
- Photographer (March 1997): mgr 6–7. Coupland, K. "A Focus on the Web: @tlas, a Showcase for Serious Photojournalism and Multimedia." *Graphis* 53 (307)
- (January/February 1997): 32. Covert, Douglas C. "Color Preference Conflicts in Visual Compositions." *Newspaper Research Journal* 9 (Fall 1987): 49–59.
- Craig, R. Stephen. "Cameras in Courtrooms in Florida." Journalism Quarterly 56 (1979): 703-10.
- Craig, Robert. "Universal Pragmatics: A Critical Approach to Image Ethics." Visual Literacy in the Digital Age: Selected Readings from the 25th Annual Conference of the International Visual Literacy Association, Rochester, New York, October 13-17, 1993: 61-72. IR 0550555
- Culver, Kathleen B. "An Open Door with a Big Spring: Cameras in Federal Courts." VCQ (Spring 1994): 17–18.

Daniel, Pete, and Smock, Raymond. A Talent for Detail: Frances Benjamin Johnston. New York: Harmony Books,

- Davidson, Bruce. Subway. New York: Aperture, 1986.
- DeLouth, Tara Nicholle Beasley, Pirson, Brigitte, Hitchcock, Daryl, and Rienzi, Beth Menees. "Gender and Ethnic Role Portrayals: Photographic Images in Three California Newspapers." Psychological Reports 76(2) (1995): 493-494.
- Denton, Craig L. "Supercharged Color: Its Arresting Place in Visual Communication." Paper presented at the Annual Meeting of the Association for Education in Journalism and Mass Communication, Gainesville, Florida, 1984. ERIC, ED244292
- Desbarats, Peter. Canadian Illustrated News 1869-1883. Toronto: McClelland and Stewart Limited, 1970.
- Deschin, Jacob. "W. Eugene Smith Recalls Brutal Beating While Documenting a Poison Scandal." Popular Photography (October 1973): 14, 20, 212,
- Devine, Heather Catherine, "Controlling Digital Manipulation in Photojournalism: An Aggressive Solution to a Contentious Problem." Master's thesis. Carleton University (Canada), 1996. Dick, David B. "'What Did Mr. Dwyer Do,
- Daddy?' 'Well, As You Could See, He Committed Suicide, Darling.'" The Quill
- (March 1987): 18–20. Diehl, Michael. "Viewer Response to Contrivance in Journalistic Photography." Paper presented to the Graduate Office of Journalism, University of Texas at Austin, Autumn 1981
- The Digital Journalist. (http://dirckhalstead.org). (online magazine for photojournalism).
- "Dirck Halstead's 'Platypus Papers'—What's in a name?" News Photographer (July 1997):
- "Don't Just Illustrate Other People's Stories." Editor & Publisher (26 September 1998): 40
- Douglis, Philip N. "The Overhead Shot: Climbing Up and Shooting Down to Make Your Point." Communication World 16 (June/July 1999): 56-57.
- Drapkin, Arnold. "Journalism's idea man, John Durniak, transformed news, picture magazines." News Photographer (January 1998): 28. 32.
- duCille, Michel. "The Use of Front-Page Photography in the *Washington Post.*" Master's thesis, Ohio University, 1994.
- Duggan, Dennis. "Louis Liotta: He was one Duggan, Dennis. "Louis Liotta: He was one from the 'glory days." News Photographer (August 1997): 19–20.

 Duncan, David Douglas. Self Portrait:

 U.S.A. New York: Abrams, 1969.

 Dunn, Philip. Press Photography.

 Sperificial UK Official Will Service (1989)

- Sparkford, UK: Oxford Illustrated, 1988. Dunn, Wayne. "Sports Shots 'How To': Preparation is the Key to Sports
 Photography." Communication: Journalism
- Education Today 29 (Winter 1995): 16–18. Durham, Michael S. Powerful Days: The Civil Rights Photography of Charles Moore. New
- York: Stewart, Tabori & Chang, 1991. Durniak, John. "Focus on Wilson Hicks." Popular Photography (April 1965): 59. Durniak, John. "10 Stories Around You."
- Popular Photography (June 1959): 72. Dykhouse, Caroline Dow. "Privacy Law and Print Photojournalism." Paper presented at the Annual Meeting of the Association for Education in Journalism, Seattle, Washington, 1978. ERIC, ED1655144
- Dykhouse, Caroline Dow. "Public Policy's Differential Effects on News Photographers." Paper presented at the meeting of the Association for Education in Journalism Photojournalism Division. Seattle. Washington, 1978.

- Dykhouse, Caroline Dow. "The Detroit Workshop, 1949–1951: Robert Drew and the Life Photojournalism Essay Formula." MA thesis, Michigan State University, 1980.
- Dykhouse, Caroline Dow. "Shuttered Shutters: The Photographic Statutes and Their Faithful Companion, 18 USC 1382—An Examination of Photographic Access to Military Areas. Paper presented at the Annual Meeting of the Association for Education in Journalism, Athens, Ohio, 1982. ERIC, ED218678.
- Dykhouse, Caroline Dow. "The Response of the Law to Visual Journalism, 1839-1978. Ph.D. diss., Michigan State University, 1985.
- Dykhouse, Caroline Dow. "Privacy Law as It Affected Journalism, 1890–1978: Privacy Is a Visual Tort." Paper presented at the Annual Meeting of the Association for Education in Journalism and Mass Communication, Memphis, Tennessee, 1985. ERIC, ED262399.
- Dykhouse, Caroline Dow. "Prior Restraint on Photojournalists." Journalism Quarterly 64 (1987): 88-93, 118.

- Edey, Maitland. Great Photographic Essays From Life. Boston: New York
- Graphic Society, 1978. Edgerton, Harold E. *Electronic Flash/Strobe*. 3rd ed. Cambridge, Massachusetts: M.I.T. Press, 1987.
- Edgerton, Harold E., and Killian, James R., Jr Moments of Vision: The Stroboscopic
- Revolution in Photography. Cambridge. Massachusetts: M.I.T. Press, 1979. Edom, Clifton Cedric. *Photojournalism:*
- Principles and Practices. 2nd ed. Dubuque, Iowa: W. C. Brown Co., 1980. Edwards, Owen. "A Mover Among the Shakers:
- Arnold Newman's Photographs Are a Tribute to the Staying Power of a Good Idea. American Photographer (November 1985): 68-73
- Eisenstaedt. Alfred. Witness to Our Time. New York: Viking Press, 1966 Eisenstaedt. Alfred. The Age of
- Eisenstaedt. New York: Viking Press, 1969.
- Eisenstaedt. Alfred. People. New York: Viking Press, 1973.
- Eisenstaedt, Alfred. Eisenstaedt-Germany. Edited by Gregory A. Vitiello. New York: Abrams, 1981. Eisenstaedt, Alfred. *Eisenstaedt on*
- Eisenstaedt: A Self-Portrait. New York: Abbeville Press, 1985.
- Fisenstaedt, Alfred, Eisenstaedt: Remembrances. Expanded rev. ed.
- Boston: Little, Brown, 1999. Ernsberger, Richard, Jr.. "The Patron Saint of Channel Surfing." Newsweek (31 May 1993):
- Evans, Harold. *Eyewitness: 25 Years* through World Press Photos. London: Quiller Press, 1981.
- Evans, Harold. Eyewitness 2: 3 Decades through World Press Photos. Updated ed. London: Quiller Press, 1985.
- Evans, Harold. Pictures on a Page: Photo-Journalism, Graphics and Picture Editing. Rev. ed. London: PIMLICO, 1997.

- Faas, Horst and Page, Tim, eds. Requiem, by the Photographers Who Died in Vietnam and Indochina. New York: Random House, 1997.
- Faber, John. "On the Record: Development of the Halftone." National Press Photographer (February 1957).

- Faber, John. "On the Record: Wire Transmission of Photos." *National Press* Photographer (April 1958).
- Faber, John. "On the Record: Birth of *Life* Magazine." *National Press Photographer* (August 1958).
- Faber, John. "On the Record: History of the Photo Syndicates." *National Press Photographer* (December 1958).
- Faber, John. "On the Record: Development of the Electronic Flash." *National Press Photographer* (March 1959).
- Faber, John. "This is How NPPA Came into Being." *National Press Photographer* (June 1960).
- Faber, John. *Great News Photos and the* **Stories Behind Them**. 2nd ed. New York: Dover Publications, 1978.
- Faber, John. "On the Record: The Atomic Bomb, Hiroshima." *News Photographer* (July 1980): 30.
- Faber, John. "On the Record: Sacrificial Protest of Quang Duck." *News Photographer* (July 1983): 10.
- Faber, John. Telephone interview with author. September, 1988.
- "Fake Photo Wins 'Prize' for Magazine." *News Photographer* (December 1992): 27.
- Falk, Jon. Jon Falk Presents Adventures in Location Lighting. Rochester, New York: Eastman Kodak, 1988.
- Fallesen, Gary. "Doing digital." News Photographer (May 1998): 26–27.
- Farsai, Greichen Jeanette. "A Review of Moral Standards Used to Select News Photographs." MA thesis, California State University, Long Beach, 1985.
- Fears, Lillie M. "Colorism of Black Women in News Editorial Photos." *Western Journal of Black Studies* 22 (Spring 1998): 30–36. Fedler, Fred, Counts, Tim, and Hightower,
- Fedler, Fred, Counts, Ilm, and Hightower, Paul. "Changes in Wording of Cutlines Fail to Reduce Photographs' Offensiveness." Journalism Quarterly 59 (1982): 633–37. Feinberg, Milton. Techniques of
- **Photojournalism**. New York: John Wiley & Sons, 1970.
- Ferrato, Donna. "The Eye Behind the Lens: Photojournalists Discuss Their Art. *Why Mag*, no. 30 (Winter 1998): 26–30.
- Finberg, Howard I., ed. Through Our Eyes: The 20th Century as Seen by the *San Francisco Chronicle*. San Francisco:
- Chronicle Publishing Co., 1987. Finberg, Howard I., and Itule, Bruce D. **Visual Editing: A Graphic Guide for Journalists**. Belmont, California:
- Wadsworth Publishing Co., 1990. Fincher, Terry. *Creative Techniques in Photo-journalism*. London: Batsford, 1980
- Fisher, Andrea. Let Us Now Praise Famous Women: Women Photographers for the U.S. Government, 1935–1944. New York: Pandora Press, 1987.
- Fishman, Mark. *Manufacturing the News*. Austin, Texas: University of Texas Press, 1980.
- Flamiano, Dolores. "The Naked Truth: Gender, Race, and Nudity in Life, 1937. Paper presented at the Annual Meeting of the Association for Education in Journalism and Mass Communication, New Orleans, Louisiana, August 4–7, 1999.
- Floren, Leola. "The Camera Comes to Court." Columbia, Missouri: Freedom of Information Center, 1978. ERIC, ED163559.
- Flowers, Jackie Walker. "Life in Vietnam: The Presentation of the Vietnam War in 'Life' Magazine, 1962–1972." Ph.D. diss., University of South Carolina, 1996.

- Fosdick. James A. "Stylistic Correlates of Prescribed Intent in a Photographic Encoding Task." Ph.D. diss., University of Wisconsin, 1962.
- Fosdick, James A., and Shoemaker, Pamela J. "How Varying Reproduction Methods Affect Response to Photographs." *Journalism Quarterly* (Spring 1982): 13–20.
- Fosdick, James A., and Tannenbaum, Percy H. "The Encoder's Intent and Use of Stylistic Elements in Photographs." *Journalism Quarterly* 41 (1964): 175–182.
- Foss, Kurt. "Photojournalism taken to a new dimension." *News Photographer* (April 1997): 36
- Foster, D.Z. "Photos of Horror in Cambodia: Fake or Real?" *Columbia Journalism Review* (March 1978): 46–47.
- Fox, Rodney, and Kerns, Robert. *Creative News Photography.* Ames, Iowa: Iowa
 State University Press, 1961.
- Foy, Mary Lou. "Photojournalism: Covering the Worst and Best." *News Photographer* (May 1993): 14–15.
- Foy, Mary Lou. "Feminine Touch." *Nieman Reports* 52 (Summer 1998): 42–3.
- Franklin, Stuart. "Is Photojournalism Really Dead?" *British Journal of Photography* no. 7152 (19 November 1997): 10–11.
- Frascella, Larry. "The Searchers: Four of Today's Most Committed Picture Editors Talk about How They Hunt Out the Best Photographs, Where Visual Style Is Headed, and Why Photographers Need to be More Original." American Photographer (December 1989): 48–51.
- Fraser, Bruce. "Seven Steps to Superior Scans." *MacUser* (January 1995): 103–105. Freeman, John. "Are Journalism Schools Teaching the Right Skills?" *News Photographer* (March 1994): 23–24.
- Freeman, John. "Job Satisfaction among Photojournalists Past 40: A National Survey Looks at 'The Lifers." Paper presented at the Annual Meeting of the Association for Education in Journalism and Mass Communication, Washington, DC, August 9–12 1995. ERIC, ED392085.
- Fulton, Marianne, ed. *Eyes of Time: Photojournalism in America*. Boston:
 Little, Brown, 1988.
- "Future Stock: Predictions on the Fate of Photojournalism." *American Photo* (September/October 1996): 78–80.

G

- Galella, Ron. *Jacqueline*. New York: Sheed and Ward, 1974.
- Gans, Herbert J. *Deciding What's News: A Study of CBS Evening News, NBC Nightly News*, Newsweek and Time.
 New York: Pantheon. 1979.
- Garcia, Mario R., and Fry, Don. *Color in American Newspapers*. St. Petersburg,
 Florida: The Poynter Institute for Media
 Studies. 1986.
- Garcia, Mario R., and Stark, Pegie. *Eyes on the News*. St. Petersburg, Florida: The Poynter Institute for Media Studies, 1991.
- Garrett, W. E., ed. *Photojournalism* `76.
 Boston: Godine, 1977.
 Gatewood, Worth. *Fifty Years in Pictures*:
- Gatewood, Worth. Fifty Years in Pictures: The New York Daily News. Garden City, New York: Doubleday, 1979.
- Geraci, Philip C. *Photojournalism: Making Pictures for Publication*. Dubuque, Iowa: Kendall/Hunt, 1976.
- Geraci, Phillip C. *Photojournalism: New Images in Visual Communication*. 3rd ed. Dubuque, Iowa: Kendall/Hunt, 1984.

- Gibson, Rhonda, and Zillman, Dolf. "Reading Between the Photographs: The Influence of Incidental Pictorial Information on Issue Perception." Paper presented to the Association for Education in Journalism and Mass Communication. New Orleans, Louisiana, August 4–9, 1999.
- Gidal, Tim N. *Modern Photojournalism: Origin and Evolution, 1910–1933*. New York: Macmillan, 1973.
- Gilbert, Kathy, and Schleuder, Joan. "Effects of Color Complexity in Still Photographs on Mental Effort and Memory." Paper presented at the Annual Meeting of the Association for Education in Journalism and Mass Communication. Portland, Oregon, 1988. ERIC, ED298579.
- Gladney, George Albert, and Ehrlich, Matthew C. "Cross-Media Response to Digital Manipulation of Still and Moving Images." Journal of Broadcasting and Electronic Media 40 (Fall 1996): 496–508.
- Media 40 (Fall 1999): 496–508.
 Gleason, Timothy Roy. "The Development of Standard and Alternative Forms of Photojournalism." Paper presented at the Annual Meeting of the Association for Education in Journalism and Mass Communication. Baltimore, Maryland, August 5–8 1998. ERIC, ED423576. "Going Digital with a Vision." News
- Photographer 54 (1 September 1999): L8+. Goldberg, Vicki. **Margaret Bourke-White: A Biography**. New York: Harper & Row,
- Goldberg, Vicki. **Bourke-White**. East Hartford, Connecticut: United Technologies, 1988. (Exhibition catalog.)
- Goldberg, Vicki. *The Power of Photography: How Photographs Changed Our Lives*. New York: Abbeville Press, 1991.
- Goldberg, Vicki and Silberman, Robert Bruce. American Photography: A Century of Images. San Francisco, California: Chronicle Books, 1999.
- "The Golden Age of the Picture Magazine." Photographic Journal 126 (March 1986): 104–8.
- Golden, Anthony R. "The Effect of Quality and Clarity on the Recall of Photographic Illustrations." Paper presented at the Annual Meeting of the Association for Education in Journalism and Mass Communication, San Antonio.
- Goldsmith, Arthur. "A Lesson in Portraiture from a Master: A Look Over Arnold Newman's Shoulder as He Photographs Dr. Francis Crick for His Notable 'Great British Series." *Popular Photography* (December 1979): 100–107, 123–25.
- Goodwin, James. "There It Is: New Journalism, Photojournalism, and the American War in Vietnam." *Genre* 31 (Summer 1998): 159.
- Gordon, Jim. "Hanging Up the Handcuffs No. 3." *News Photographer* (July 1979): 8–9, 13–14.
- Gordon, Jim. "Question of Credibility: A Western Editor Raises Issue." *News Photographer* (October 1979): 20–22.
- Gordon, Jim. "Judgement Days for Words and Pictures: To Print or Not to Print." *News Photographer* (July 1980): 25–29.
- Gordon, Jim. "Zeisloft Incident: Foot Artwork Ends Career." *News Photographer* (November 1981): 32–36.
- Gordon, Jim. "Nothing But the Real Thing: No Playing with Pixels—Including the Front Cover." *News Photographer* (March 1994):
- Gordon, Jim. "Death of a Photograph: Assaults on Credibility or Much Ado about Nothing?" News Photographer (April 1994): 4.

- Gordon, Jim. "O Thou of Little Faith . . . "

 News Photographer (September 1996): 6,
 10
- Gordon, Jim. "Oops! Again over covers." *News Photographer* (September 1997): 6–7.
 Gordon, Jim. "Here we go—again. A little photo manipulation goes a far piece." *News*
- Photographer (February 1998): 4–5. Gorn, Elliott J. "The Wicked World: The National Police Gazette and Gilded-Age America." Media Studies Journal 6 (Winter 1992): 1–16.
- Gould, Lewis L., and Greffe, Richard. **Photojournalist: The Career of Jimmy Hare**. Austin: University of Texas Press,
 1977
- Grace, Arthur. *Choose Me: Portraits of a Presidential Race.* Waltham,

 Massachusetts: University Press of New
- England/ Brandeis, 1989. Gramling, Oliver. *AP, the Story of News.* New York: Farrar and Rinehart, 1940.
- Greenwald, Marilyn, and Bernt, Joseph.
 "Newspaper Coverage of Gays and Lesbians:
 Editors' Views of its Longterm Effects." Paper
 presented at the Annual Meeting of the
 Association for Education in Journalism and
 Mass Communication. Montreal: August
 5–8 1992. ERIC, ED349621.
- "Grievances Filed Over Set-Ups." News Photographer (Dec. 1992): 8.
- Griffin, Michael, and Lee, Jóngsoo. "Picturing the Gulf War: Constructing an Image of War in Time," Newsweek, and U.S. News & World Report." Journalism and Mass Communication Quarterly 72 (Winter 1995):
- Grigsby, Bryan. "Disappointment at funeral dress." *News Photographer* (October 1995): 16–17.
- Grigsby, Bryan. "Can't stand stand-alone art? For and against discussed." *News Photographer* (February 1996): 10–11.
- Grigsby, Bryan. "People Photos Require Trust, Responsibility." *News Photographer* (July 1996): 10.
- Grigsby, Bryan. "Is it dying or just a bit sick? Photojournalism special issue sparks string of 'net postings." *News Photographer* (November 1996) 10–12.
- Grigsby, Bryan. "Diana's death and public perception." *News Photographer* (November 1997): 16, 18.
- Grigsby, Bryan. "Damned if you do—and if you don't. Reflections upon relationships between photographers and editors." *News Photographer*. (August 1998): 10–11.
- Grigsby, Bryan. "Geezers in the News Room?" News Photographer (September 1998): 14–17.
- Grigsby, Bryan. "Just Photographers or Photojournalists?" *News Photographer* (November 1998): 10–12.
- Grigsby, Bryan. "The wider, the better." *News Photographer* (December 1998): 14–15.
- Grigsby, Bryan. "To See or Not to See." News Photographer (January 1999): 16–18. Grigsby, Bryan. "Helping Police or a Blind
- Grigsby, Bryan. "Helping Police or a Blind Eye?" *News Photographer* (February 1999): 16–17. Grigsby, Bryan. "It's Posed?" *News*
- Photographer (June 1999): 12–13.
 Gross, Deborah M. "Visual Design for the World Wide Web: What Does the User Want?" Paper presented at the Annual Meeting of the Association for Education in Journalism and Mass Communication, Baltimore, Maryland, August 5–8, 1998.
 ERIC, ED423576.
- Gross, Larry, Katz, John Stuart and Ruby, Jay, eds. *Image Ethics: The Moral Rights of Subjects in Photographs, Film, and Television*. New York: Oxford. 1988.

Grossfeld, Stan. The Eyes of the Globe: Twenty-Five Years of Photography from the Boston Globe. Chester,

Connecticut: Globe Pequot Press, 1985. Grossfeld, Stan. "Photo Opportunities: Local Photographers Go Global." WJR *Washington Journalism Review* (May 1986): 39–41.

Grossfeld, Stan. "Trials with Editors." *Nieman Reports* 52 (Summer 1998): 30–31.

Grossfeld, Stan *The Whisper of Stars: A Siberian Journey*. Chester, Connecticut:
Globe Pequot Press. 1988.

"Guidelines: Suggestions for Police/Press Relations Prepared by the National Press Photographers Association, Inc." *News Photographer* (December 1981): 12.

Gutman, Judith Mare. *Lewis W. Hine: Two Perspectives*. New York: Viking Press,
1974

H

Habas, Paula J. "The Ethics of Photojournalistic Alteration: An Integrated Schema of Determinants." Master's thesis, University Of Windsor (Canada), 1996.

Haberman, Irving. *Eyes on an Éra: Four Decades of Photojournalism.* New York:
Rizzoli, 1995.

Hagaman, Dianne. *How I Learned Not to Be a Photojournalist*. Lexington, KY:
University Press of Kentucky. 1986.

Hagen, Charles. "Robert Doisneau Dies at 81; Photos Captured Gallic Spirit." *New York Times* (2 April 1994): 9.

Hale, Donna. "Anatomy lesson: Louisville's cover-up caper; much ado about nothing?" News Photographer (December 1996): 16, 18.

Hale, Donna. "Trapped by riptide, swimmer saved by news photographer." *News Photographer.* (January 1998): 26.

Hale, Donna. "Photo Editor Reprimands Photographer for Helping Firefighter at Barn Fire." *News Photographer* (January 1999): 29, 32

Hale, Donna, and Church, Janet. "Helping hands. News photographer's save of Dole in continuing tradition." *News Photographer* (December 1996): 22–23.

Hale, F. Dennis. "Cameras in Courtrooms: Dimensions of Attitude of State Supreme Court Justices." Paper presented at the Annual Meeting of the Association for Education in Journalism and Mass Communication. Chicago, Illinois, 1997. FBIC. FD415547

Alliday-Levy, Tereza. "The Connotation Dimension of News Photographs." Paper presented at the Annual Meeting of the Association for Education in Journalism, Athens, Ohio, 1982. ERIC, ED217475.

Halsman, Phillipe. *Halsman on the Creation of Photographic Ideas*. New York: Ziff-Davis, 1961.

Halstead, Dirck. "The Platypus Papers Part One." *The Digital Journalist*, http://digitaljournalist.org/platypus/platypus2.html Hamblin, Dora Jane. *That Was the Life*.

Hamblin, Dora Jane. *That Was the L* New York: W.W. Norton, 1977.

Hanka, Harold. *Positive Images: Photographs.* Willimantic, Connecticut:
Chronicle Print, 1982.

Hansen, Mark Alan. "Fundamental Philosophy of Photojournalism Ethics: An Exploration of the Philosophical Underpinnings of Ethical Behavior in Photojournalism." Master's thesis, University of Nebraska, Lincoln, 1996. Hanson, Art. "A Comparison of Documentary Approaches: Margaret Bourke-White and Erskine Caldwell, Authors of You Have Seen Their Faces" and Dorothea Lange and Paul S. Taylor, Authors of An American Exodus. Paper presented at the Annual Meeting of the Association for Education in Journalism. Boston, Massachusetts, August 9–13, 1980. ERIC. ED191075.

Harmon, Jim. "Education and the Future of Photojournalism." *Communication: Journalism Education Today* 30 (Winter 1996): 2–5.

Harris, John. A Century of New England in News Photos. Chester, Connecticut: Globe Pequot Press, 1979.

Hart, Russell. "The Digital Photojournalist." American Photo 9 (September/October 1998): 30–1

Hart, Russell, and Zwingle, Erla. *William Albert Allard: The Photographic Essay*.
Boston: Little. Brown 1989.

Hartley, Craig H. "Ethical Newsgathering Values of the Public and Press Photographers." *Journalism Quarterly* 60 (1983): 301–4.

Hartley, Craig, and Hillard, B.J. "The Reactions of Photojournalists and the Public to Hypothetical Ethical Dilemmas Confronting Press Photographers." MA thesis, University of Texas, Austin, 1981.

Harwood, Philip J., and Lain, Lawrence B. "Mug Shots and Reader Attitudes toward People in the News." *Journalism Quarterly* 69 (Summer 1992): 293–300.

Haworth-Booth, Mark. *Donald McCullin*. London: Collins, 1983.

Hazard, William R. "Responses to News Pictures: A Study in Perceptual Unity." Journalism Quarterly 37 (1960): 515–524

Heartfield, John. *Photomontages of the Nazi Period*. New York: Universe Books,

Heller, Robert. "Photojournalism Education: Contradictions for the Nineties." *Journalism Educator* 46 (Spring 1991): 29–31.

Heller, Steven. "Photojournalism's Golden Age (Through the Great Picture Magazines of the '20s and '30s)." *Print* 38

(September/October1984): 68–79,116,118. Heller, Steven, and Chwast, Seymour, eds.

Sourcebook of Visual Ideas. New York Van Nostrand Reinhold, 1989.

"Helping hands of news photographers." News Photographer (December 1996): 24–25. Herde, Tom. "Editorial Illustration." News Photographer (July 1979): 28–29.

Heyman, Ken, and Durniak, John. *The Right Picture: A Photographer and a Picture Editor Demonstrate How to Choose.*New York: Amphoto, 1986.

Hicks, Wilson. Words and Pictures: An Introduction to Photo-Journalism. 1952. Reprint. New York: Arno Press, 1973.

Hightower, Paul Dudley. "The Influence of Training on Taking and Judging Photos." Journalism Quarterly 61 (1984): 682–86.

Hine, Lewis. *America and Lewis Hine: Photographs 1904–1940.* Millerton, New York: Aperture. 1977

Hobsbawm, Eric, and Weitzmann, Marc, Eds. 1968: Magnum Throughout the World. Paris: Editions Hazan, dist. by D.A.P., 1998. Hockman-Wert, Cathleen. "Images of African Famine in US Newsmagazines, 1968—1993: A Content Analysis and Exploration of Ethics." Master's thesis, University of

Oregon, 1997. Horenstein, Henry. *The Photographer's Source: A Complete Catalogue*. New York: Simon & Schuster, 1989.

Horenstein, Henry. *Color Photography: A Working Manual*. Boston: Little, Brown, 1995.

Horton, Brian. *The Picture: An Associated Press Guide to Good News Photography.* New York: Associated Press,

1989.
Horton, Brian. *The Associated Press Photo-Journalism Stylebook*. Reading,
Massachusetts: Addison-Wesley, 1990.

Howe, Peter. "Wake Me After the Revolution." The Digital Journalist, http://digitaljournalist.org.

Hoy, Frank P. *Photojournalism: The Visual Approach*. Englewood Cliffs, New
Jersey: Prentice-Hall, 1986.

Hoyt, James L. "Cameras in the Courtroom: From Hauptmann to Wisconsin." Paper presented at the Annual Meeting of the Association for Education in Journalism, Seattle. Washington, 1978. FRIC. FD158307

Huang, Edgar Shaohua. "Afterthoughts on the Representational Strategies of the FSA Documentary." Paper presented at the Annual Meeting of the Association for Education in Journalism and Mass Communication. Baltimore, Maryland, August 5–8, 1998. ERIC, ED423576.

Huang, Edgar Shaohua. "Readers' Perception of Digital Alteration and Truth-Value in Documentary Photographs." Ph.D. diss., Indiana University, 1999.

Hughes, Jim. "The Nine Lives of W. Eugene Smith." *Popular Photography* (April 1979): 116–117, 135–141.

Hughes, Jim. W. Eugene Smith, Shadow & Substance: The Life and Work of an American Photographer. New York: McGraw-Hill, 1989.

Huh, Hyun-Joo Lee. "The Effect of Newspaper Picture Size on Readers' Attention, Recall and Comprehension of Stories." Paper presented at the Annual Meeting of the Association for Education in Journalism and Mass Communication. Kansas City, Missouri, August 11–14, 1993. ERIC, FD361672

Hulteng, John L. *The Messenger's Motives: Ethical Problems of the News Media*. 2nd ed. Englewood Cliffs,
New Jersey: Prentice-Hall, 1985.

Hurley, Forrest Jack. *Portrait of a Decade: Roy Stryker and the Development of Documentary Photography in the Thirties.* 1972. Reprint. New York: Da Capo, 1977

Hurley, Gerald D., and McDougall, Angus. Visual Impact in Print: How to Make Pictures Communicate; A Guide for the Photographer, the Editor, the Designer. Chicago: American Publishers Press, 1971.

lanzito, Christina. "Photojournalism: Tobacco Road — Rob Amberg." *Columbia Journalism Review* (November/December 1996): 39–41.

lanzito, Christina. "Photojournalism: A Life's Work — Earl Dotter." *Columbia Journalism Review* (January/February 1997): 40–43. "Illustrations." *4Sight* (May–June 1985): 10.

Images of Our Times: Sixty Years of Photography from the Los Angeles Times. New York: Abrams, 1987.

"Intern Puts Photos on Hold, Helps Save Drowning Child." *News Photographer* (September 1993): 10.

"Interview with Photographer Donna Ferrato." Nieman Reports 52 (Winter 1998): 19–21.

Israel: 50 Years, As Seen by Magnum Photographers. New York: Aperture, 1998

J

Jacobs, Rita D. "James Nachtwey." *Graphis* 50 (November 1994): 48.

Jacobson, Colin. "The Last Picture Show: The State of Photojournalism and Its Publication." *Creative Review* 15 (April 1995): 39–40.

Jaubert, Alain. *Making People Disappear: An Amazing Chronicle of Photographic Deception.* Washington:
Pergamon-Brassey's International Defense
Publishers, 1989.

Jett, Anne. "Diversity and a Local Newspaper: When Photojournalism Becomes Public Relations." Paper presented at the Annual Conference of the Association for Education in Journalism and Mass Communication. Atlanta, Georgia, August 10–13, 1994. ERIC, ED376531.

John, Alun. Newspaper Photography: A Professional View of Photojournalism Today. Marlborough: Crowood, 1988,

Johns, David. "All about Boo-Boos: Is It Ethical to Photograph Embarrassing Moments? Is Prominence Enough Justification?" News Photographer (July 1984): 8.

Jones, Barbara Sue Hemby. "The Photojournalism of Mary Ellen Mark." Master's thesis, East Texas State University, 1904

Josephson, Sheree. "Questioning the Power of Color." *News Photographer* (January 1996): *VCO* 4–7, 12.

Josephson, Sheree. "The Readability, Recall, and Reaction to Online Newspaper Pages with Visuals and Those Without." Paper Presented at SCA. San Diego, California, November 24, 1996.

Juergens, George. *Joseph Pulitzer and the New York World*. Princeton, New Jersey:
Princeton University Press, 1966.

Junas, Lil. "Ethics and Photojournalism: Posed, Set Up, Faked, Controlled or Candid?" *News Photographer* (March 1982): 19–20.

Junas, Lil. "Ethics and Photojournalism: Techniques and 'Bring Back Something'." News Photographer (June 1982): 26–27. Junas, Lil. "Ethics and Photojournalism:

Photographer Qualities and Picture
Selection." *News Photographer* (June 1984):
24.

Junas, Lil. "Ethics and Photojournalism: Code of Ethics: Yes or No?" *News Photographer* (July 1984): 6–7.

Justin, V. "Sports Photojournalism: A Changing Experience." *PSA Journal* 65 (March 1999): 34–35.

K

Kahan, Robert Sidney. "The Antecedents of American Photojournalism." Ph.D. diss., The University of Wisconsin, Madison, 1969. Kalish, Stanley E., and Edom, Clifton C.

Picture Editing. New York: Rinehart, 1951 Kaplan, Daile. Lewis Hine in Europe: The Lost Photographs. New York: Abbeville Press, 1988.

Karsh, Yousuf. *Portraits of Greatness*. New York: Thomas Nelson & Sons, 1959.

Keene, Martin. *Practical Photojournalism: A Professional Guide*. 2nd ed. Oxford, Boston: Focal Press, 1995.

- Kelly, James D. "The Adoption of Digital Imaging Technology at Daily College Student Newspapers and the Credibility of News Photos." Paper presented at the Annual Meeting of the Association for Education in Journalism and Mass Communication, Atlanta, Georgia, August 10–13, 1994. ERIC, ED374494.
- Kelly, James D. "Going Digital at College Newspapers: The Impact of Photo Credibility and Work Routines." Paper presented at the Annual Meeting of the Association for Education in Journalism and Mass Communication. Anaheim, California, August 10–13, 1996. ERIC, ED401533.
- Kelly, James D., and Nace, Diona. "The Effects of Specific Knowledge of Digital Image Manipulation Capabilities and Newspaper Context on the Believability of News Photographs." Paper presented at the Annual Conference of the Association for Education in Journalism and Mass Communication. Kansas City, Missouri, August 11–14, 1993. ERIC, E0362917.
- Kelly, James D., and Nace, Diona. "Digital Imaging and Believing Photos." VCQ (Winter 1994): 4–5, 18.
- Kendall, Robert. "Photo 1978: Some Provisions of the 1976 Copyright Act for the Photojournalist." Paper presented at the meeting of the Photojournalism Division, Association for Education in Journalism, Madison, Wisconsin, 1977.
- Kendall, Russ. "Photographers' personal pages." *News Photographer* (March 1997): 15–16
- Kennedy, Thomas. "Content and Style: How Do Limited Expectations Affect the Creative Process?" MGR (insert in *News Photographer*) (January 1989): 1–3.

Kennerly, David. *PhotoOp: A Pulitzer Prize-Winning Photographer Covers Events That Shaped our Times*. Austin,

- Texas: University of Texas Press, 1995.
 Kenney, Keith. "Mid-Week Pictorial: Pioneer
 American Photojournalism Magazine." Paper
 presented at the Annual Meeting of the
 Association for Education in Journalism and
 Mass Communication, Norman, OK, 1986.
 ERIC, ED271767.
- Kenney, Keith Raymond. "Newspaper Photography in China." Ph.D. diss., Michigan State University, 1991.
- Kenney, Keith. "Ethical Attitudes." News Photographer (November 1991): 12–14.
- Kenney, Keith. "How Groups of People are Portrayed." *News Photographer* (January 1992): 43–46.
- Kenney, Keith. "Forces Affecting Selection of Photos and TV Stories." *News Photographer* (February 1992): 51–52.
- Kenney, Keith. "Effects of Still Photographs." News Photographer (May 1992): 41–42. Kenney, Keith. "Memory and Comprehension
- of TV News Visuals." News Photographer (August 1992): 52–53.
- Kenney, Keith. "Photojournalism Research: Computer-Altered Photos: Do Readers Know Them When They See Them?" *News Photographer* (January 1993): 26–27.
- Kenney, Keith. "Criminal Executions: To Televise or Not? The Debate Goes on. . ." News Photographer (March 1993): 34–35.
- Kenney, Keith. "Fund-Raising Pictures: Do 'Starving Baby' Photos Really Work?" *News Photographer* (April 1993): 46–47.
- Kenney, Keith. "Follow-Up: Ombudsmen under Glass." *News Photographer* (October 1993): 40–41.

- Kenney, Keith. "Building Alliances: Photojournalism Educators and Members of NPPA." Paper presented at the Annual Meeting of the Association for Education in Journalism and Mass Communication, Washington, DC, August 9–12, 1995. ERIC, ED388974.
- Kenney, Keith R., and Unger, Brent W. "The Mid-Week Pictorial: Forerunner of American News-Picture Magazines." American Journalism 11 (Summer 1994): 201–216.
- Kerns, Robert. *Photojournalism: Photography with a Purpose*.

 Englewood Cliffs, New Jersey: Prentice-Hall, 1980
- Kerrick, Jean S. "Influence of Captions on Picture Interpretation." *Journalism Quarterly* 32 (1955): 177–184.
- Kerrick, Jean S. "News Pictures, Captions and the Point of Resolution." *Journalism Quarterly* 36 (1959): 183–188.
- Kessel, Dmitri. On Assignment: Dmitri Kessel, LIFE Photographer. New York: Abrams, 1985.
- Kielbowiez, Richard B. "The Making of Canon 35: A Blow to Press-Bar Cooperation." Paper presented at the Annual Meeting of the Association for Education in Journalism, Photojournalism Division, Houston, Texas, 1979.
- King, John Mark. "Visual Communication and Newspaper Reader Satisfaction." Ph.D. diss., The University of Tennessee, 1995.
- King, John Mark. "Political Endorsements in Daily Newspapers and Photographic Coverage of Candidates in the 1995 Louisiana Gubernatorial Campaign." Paper presented at the Annual Meeting of the Association for Education in Journalism and Mass Communication, Chicago, Illinois, July 30–August 2, 1997. ERIC, ED415547. King, John Mark. "Who Gets Named?:
- Nationality, Race and Gender in New York Times' Photograph Cutlines." Paper presented at the Annual Meeting of the Association for Education in Journalism and Mass Communication, Baltimore, Maryland, August 5–8, 1998. ERIC. ED423576.
- Kobre, Ken. "Last Interview with W. Eugene Smith on the Photo Essay." Paper presented at the Annual Meeting of the Association for Education in Journalism, Houston, Texas, 1979. ERIC, ED178948.
- Kobre, Ken. "Something Different for the *News Photographer*: Illustrations Solve Problems." *News Photographer* (July 1979): 28–30.
- Kobre, Ken. "Unearthing Outtakes." *News Photographer* (July 1994): *VCQ* 13.
- Kobre, Ken. "Not a 'Time' for Illustration." News Photographer (October 1994): VCQ13 Kobre, Ken. "The New York Times is Not What
- Kobre, Ken. "The *New York Times* is Not What She Used To Be." *News Photographer* (January 1995): *VCQ* 15.
- Kobre, Ken. "The Long Tradition of Doctoring Photos." *News Photographer* (April 1995): *VCQ* 14.
- Kobre, Ken. "Good Things Do Come in Small Packages." *News Photographer* (July 1995): *VCQ* 20.
- Kobre, Ken. "Where Have All the Great Portraits Gone?" *News Photographer* (October 1995): *VCQ* 13.
- Kobre, Ken. "Slicing Into the World of Photo Non-Realism." *News Photographer* (January 1996): *VCQ* 14.
- Kobre, Ken. "Progress in Style Does Not Always Accompany Improvement in Substance." *News Photographer* (July 1996): VCO 13.
- Kobre, Ken. "Is the Feature Disappearing?" News Photographer (October 1996): V13+. Kobre, Ken. "Editing for Intimacy." News Photographer (April 1999): VCQ18–VCQ19.

- Kobre, Sidney. News Behind the Headlines: Background Reporting of Significant Social Problems. Tallahassee, Florida: Florida State University,
- Kobre, Sidney. *Behind Shocking Crime Headlines*. Tallahassee, Florida: Florida
 State University. 1957.
- Kobre, Sidney. *Press and Contemporary Affairs*. Tallahassee, Florida: Florida State
 University, 1957.
- Kobre, Sidney. *Modern American Journalism.* Tallahassee, Florida: Florida
 State University, 1959.
- Kobre, Sidney. *The Yellow Press and Gilded Age Journalism*. Tallahassee, Florida: Florida State University, 1964.
- Kobre, Sidney. *Development of American Journalism*. Dubuque, Iowa: Wm. C. Brown, 1969.
- Kochersberger, Robert C. "Survey of Suicide Photos Use in Newspapers in Three States." Newspaper Research Journal 9 (Summer 1988): 1–12.
- **Kodak Milestones: 1880–1980**. Rochester, New York: Eastman Kodak, 1980.
- Kowalski, Shelley Kara. "A Poor Picture: The Failure of Concerned Photography to Arouse Social Change." Paper presented at the Society for the Study of Social Problems (SSSP), 1997.
- Kozol, Wendy. "Documenting the Public and Private in 'Life': Cultural Politics in Postwar Photojournalism." Ph.D. diss., University of Minnesota. 1990.
- Kunhardt, Phillip B., Jr. *The Joy of Life*. Boston: Little, Brown, 1989.
- Kuykendall, Bill. "Inner Eye." *Nieman Reports* 52 (Summer 1998): 46–49.

LaBelle, David. *The Great Picture Hunt*. Bowling Green Kentucky: Western Kentucky University, 1989.

- LaBelle, David. *Lessons in Life and Death*. Durham, NC: NPPA Bookshelf, 1993.
- Lacayo, Richard. *Eyewitness: 150 Years of Photojournalism*. 2nd ed. New York: Time Books. 1995.
- LaClair, Scott. "Attacks, gibes, jeers after Diana." *News Photographer* (November 1997): 14.
- Lain, Laurence B. "How Readers View Mug Shots." *Newspaper Research Journal* 8 (Spring 1987): 43–52.
- Lange, George. "Feature: Riding Shotgun with Annie (Leibovitz)." *American Photographer* (January 1984): 56, 59.
- Lansdown, Trevor. "Is Photojournalism Dead?" British Journal of Photography no. 7095 (25 September 1996): 16–17.
- Lasica, J. D. "Photographs That Lie: The Ethical Dilemma of Digital Retouching." WJR Washington Journalism Review (June 1989): 22–25.
- Lauterer, Jock. "Wrestling with the bear, Photojournalism ethics in your face." *News Photographer* (April 1998): 46–47.
- Leekley, Sheryle, and Leekley, John.

 Moments: The Pulitzer Prize
 Photographs. Updated ed. 1942–1982.
- New York: Crown, 1982. Leggett, Dawn, and Wanta, Wayne. "Gender Stereotypes in Wire Service Sports." Newspaper Research Journal 10 (Spring 1989): 105—114.
- Leibovitz, Annie. *Annie Leibovitz: Photographs*. New York: Rolling Stone Press. 1983.
- Leifer, Neil. *Sports!* Text by George Plimpton New York: Abrams, 1983.

- Leslie, L. Z. "Newspaper Photo Coverage of Censure of McCarthy." *Journalism Quarterly* 63 (1986): 850–53.
- Lester, Paul. "Use of Visual Elements on Newspaper Front Pages." *Journalism Quarterly* 65 (1988): 760–63.
- Lester, Paul Martin. "Front Page Mug Shots: A Content Analysis of Five U.S. Newspapers in 1986." Newspaper Research Journal 9 (Spring 1988): 1–9.
- Lester, Paul Martin. "The Ethics of Photojournalism: Toward a Professional Philosophy for Photographers, Editors and Educators." Ph.D. diss., Indiana University, 1989.
- Lester, Paul. "Computer Aids Instruction in Photojournalism Ethics." *Journalism Educator* 44 (Summer 1989): 13–17.
- Lester, Paul, and Smith, Ron. "African-American Picture Coverage in *Life*, *Newsweek*, and *Time*, 1937–1988." Paper presented at the Annual Meeting of the Association for Education in Journalism and Mass Communication, Washington, DC, 1989. ERIC, ED310460.
- Lester, Paul. *Photojournalism: an Ethical Approach*. Hillsdale, New Jersey: Lawrence Erlbaum Associates, 1991.
- Lester, Paul. "African-American Photo Coverage in Four U.S. Newspapers, 1937–1990." *Journalism Quarterly* 72 (Summer 1994): 380–394.
- Lester, Paul Martin. "Pictorial Stereotypes in the Media: A Pedagogical Discussion." Paper presented at the Annual Meeting of the Association for Education in Journalism and Mass Communication, Anaheim, California, August 10–13, 1996. ERIC, ED401571.
- Lester, Paul Martin and Miller, Randy. "African American Pictorial Coverage in Four U.S. Newspapers." Paper presented at the Annual Meeting of the Association for Education in Journalism and Mass Communication. Anaheim, California, August 10–13, 1996. FBIC. FD401571
- Lester, Paul Martin. "Pedagogical Discussion on Pictorial Stereotypes." *Journalism and Mass Communication Educator* 52 (2) (1997): 49–54.
- Lewinski, Jorge, comp. *The Camera at War: A History of War Photography from 1848 to the Present Day.* London: W.H. Allen, 1978.
- Lewis, Charles W. "From Brady to Bourke-White: An Examination of the Foundations of American Picture Magazine Photojournalism, 1860–1940." MA thesis, Mankato State University, MN, 1986.
- Lewis, David M. "Electronic Cameras and Photojournalism: Impact and Implications." MS study, Ohio University, Athens, 1983. Lewis, Greg. "A Tribute to W. Eugene Smith."
- The Rangefinder (December 1978): 35. Lewis, Greg. **Photojournalism: Content** and **Technique**. 2nd ed. Boston: McGraw
- Hill, 1995. Lewis, Vickie. "The Impact of Technology on Ethical Decision-Making in Photojournalism." Master's thesis, Ohio
- University, 1997. Li, Xigen. "Web Page Design and Graphic Use of Three U.S. Newspapers." *Journalism and Mass Communication Quarterly* 75(2) (1998): 353–365.
- Life 50, 1936–1986: The First Fifty Years. Boston: Little, Brown, 1986. Life, the First Decade, 1936–1945.
- London: Thames & Hudson, 1979.

 Life, the Second Decade, 1946–1955.

 Boston: Little Brown 1984
- Life, Through the Sixties: An Exhibition and Catalogue. New York: Time, Inc. 1989.

- Liotta, Louie, and Wadler, Joyce. "Candid Cameraman: After 50 Years of Shooting for the Front Page, News Photographer Louie Liotta Spills." Time (11 December 1989):
- Livingston, Jane. Odyssey: The Art of Photography at National Geographic Charlottesville, Virginia: Thomasson-Grant,
- Loengard, John. Pictures Under Discussion. New York: Amphoto, 1987 Loengard, John, Life Classic Photographs: A Personal Interpretation. Boston: New
- Loengard, John. "The Role of the Picture Editor." Nieman Reports 52 (Summer 1998):

York Graphic Society Books, 1988

- Loengard, John. Life Photographers What They Saw. Boston: Little Brown, 1998.
- Lopes, Sal. The Wall: Images and Offerings from the Vietnam Veterans Memorial. New York: Collins, 1987
- Lowrey, Wilson. "Altered Plates: Photo Manipulation and the Search for News Value in the Early and Late Twentieth Century Paper presented at the Annual Meeting of the Association for Education in Journalism and Mass Communication, Baltimore, Maryland, August 5-8, 1998. ERIC, ED423576
- Lowrey, Wilson. "Routine News: The Power of the Organization in Visual Journalism. News Photographer (April 1999): VCQ
- Logan, Richard, III. Elements of Photo Reporting. Garden City, New York: Amphoto, 1971
- Luebke, Barbara F. "Out of Focus: Images of Women and Men in Newspaper Photographs." Sex Roles 20 (1989). 121 - 33
- Lukas, Anthony J. "The White House Press 'Club'." New York Times Magazine (15 May 1977): 22,64-68,70-72.
- Lutman, David R. "An invasion of privacy? News Photographer (March 1998) 8.

- MacDougall, Curtis D. News Pictures Fit to Print . . . Or Are They? Stillwater, OK: Journalistic Services, 1971
- MacDougall, Kent A. "Geographic: From Upbeat to Realism." Los Angeles Times (5 August 1977): 1, 8-10.
- MacLean, Malcolm S., Jr. "Communication Strategy, Editing Games and Q." In Science Psychology and Communication. Edited by Steven R. Brown and Donald J. Brenner, 327-44. New York: Teachers College Press
- MacLean, Malcolm S., Jr., and Hazard, William R. "Women's Interest in Pictures; The Badger Village Study." Journalism Quarterly 30 (1953): 139-162.
- MacLean, Malcolm S., Jr., and Kao, Anne Li-An. "Picture Selection: An Editorial Game." Journalism Quarterly 40 (1963): 230-232
- MacLean. Malcolm S., Jr., and Kao, Anne Li-An. Editorial Predictions of Magazine Picture Appeals. lowa City, lowa: School of Journalism, University of lowa, 1965
- Maddow, Ben. Let Truth Be the Prejudice: W. Eugene Smith, His Life and Photographs. Millerton, New York: Aperture, 1985
- Magmer, James, and Falconer, David Photograph + Printed Word Birmingham, MI: Midwest Publications,

- Magna Brava: Magnum's Women Photographers — Eve Arnold, Martine Franck, Susan Meisalas, Inge Morath, Marilyn Silverstone. Munich, London: Prestel, 1999
- Mallen, Frank. Sauce for the Gander. [The New York Evening Graphic]. White Plains, New York: Baldwin Books, 1954.
- Mallette, Malcolm F. "Ethics in News Pictures: Where Judgement Counts." Paper presented at Rochester Photo Conference, George Eastman House, Rochester, New York, 1975.
- Mallette, Malcolm F. "Should These News Pictures Have Been Printed? Fthical Decisions Are Often Hard but Seldom Right." Popular Photography (March 1976): 73-75, 118-120
- Manchester, William Raymond. In Our Time: The World as Seen by Magnum Photographers. New York: American Federation of the Arts with Norton, 1989.
- Manion, B.C. "Faking It! Omaha Daily Fabricates Photo." News Photographer (June/July 1981): 30-31.
- Marcus, Adrianne. The Photojournalist: Mary Ellen Mark and Annie Leibovitz.
- Los Angeles: Seskog with Crowell, 1974. Margolick, David. "PM's Impossible Dream. Vanity Fair (January 1999): 116-132.
- Mark, Mary Ellen. "An Interview with Mary Ellen Mark." Rockport, ME: Maine Photographic Workshops, 1989 (Recording).
- Mark, Mary Ellen. The Photo Essay. Washington, DC: Smithsonian Institution, 1990
- Martin, Peter. "Gene Smith as 'The Kid Who Lived Photography." *Popular Photography* (April 1979): 130,149–150.
- Martin, Rupert, ed. Floods of Light: Flash Photography, 1851-1981. London:
- Photographers Gallery, 1982. Matthews, Mary L., and Reuss, Carol. "The Minimal Image of Women in Time and Newsweek, 1940-1980." Paper presented at the Annual Meeting of the Association for Education in Journalism and Mass Communication, Memphis, Tennessee 1985. ERIC, ED260405
- Mauro, Tony. "The Camera-Shy Federal Courts: Why are Cameras Accepted in State Courts but Dreaded in Federal Courts?' Media Studies Journal 12(1) (1998): 60-5.
- Mayes, Stephen. "Rules of Attraction: The Work of Photojournalists." British Journal of Photography 141 (24 February 1994): 13.
- Mayes, Stephen. "Grim Reflections." (photojournalism captures history) Creative Review 16 (February 1996): 34-5.
- Mayes, Stephen. This Critical Mirror: 40 Years of World Press Photo. London: Thames & Hudson, 1996
- McCullin, Don. Hearts of Darkness. London: Secker & Warburg, 1980.
- McCullin, Don. Unreasonable Behaviour: An Autobiography. New York: Knopf. 1990
- McCullin, Don. Sleeping with Ghosts: A Life's Work in Photography. London: Vintage, 1995.
- McDougall, Angus, and Hampton, Vieta Jo. Picture Editing and Layout: A Guide to Better Visual Communication.
- Columbia, Missouri: Viscom Press, 1990. McNay, Jim. "The Importance of Content, Content, Content." Visual Communication Quarterly 2 (Fall 1995): 3.
- Meltzer, Bonnie. "Digital Photography -Question of Ethics." Learning and Leading with Technology 23 (December/January 1995-96): 18-21.
- Meltzer, Milton. Dorothea Lange: A Photographer's Life. New York: Farrar, Strauss, Giroux, 1978.

- Mendelson, Andrew Lawrence. "Effects of Novelty in News Photographs on Attention and Memory (Photojournalism)." Ph.D. diss., University of Missouri, Columbia,
- Meredith. Rov. Mr. Lincoln's Camera Man Mathew B. Brady. 2nd rev. ed. New York: Dover, 1974.
- Metz, Holly. "Interview: Susan Meiselas." The Progressive 62 (1 April 1998): 36.
- Mich, Daniel D., and Eberman, Edwin. The Technique of the Picture Story. New York: McGraw-Hill, 1945.
- Middlebrooks, Donald M., Jones, Clarence, and Shrader, Howard. "Access: Scope of Privilege in Gathering News Is Vague and Narrow, Scope of Liability Is Far More Certain." News Photographer (December 1981): 10-11, 13-16, 18-19.
- Mili, Gjon. Gjon Mili: Photographs and Recollections. Boston: New York Graphic Society, 1980.
- Miller, Russell. MAGNUM: Fifty Years at the Front Line of History. New York: Grove Atlantic, 1998
- Moeller, Susan D. Shooting War: Photography and the American Experience of Combat. New York: Basic Books 1989
- Moments in Time: 50 Years of Associated Press News Photos. Rev. ed. North Ryde, Aust.: Angus & Robertson, 1984
- Mora, Gilles, and Hill, John T. W., eds. Eugene Smith: Photographs 1934-1975. New York: Abrams, 1998.
- Morgan, Willard D. Graphic Graflex Photography for Prize Winning Pictures. 11th ed. New York: Morgan and Morgan, 1958.
- Moriarty, Sandra, and Shaw, David. "An Antiseptic War: Were News Magazine Images of the Gulf War Too Soft?" News Photographer (April 1995): VCQ 4-8.
- Morris, Desmond. Manwatching: A Field Guide to Human Behavior. New York: Abrams, 1977
- Morris, John G. Get the Picture: A Personal History of Photojournalism. New York: Random House, 1998
- Morton, Robert, ed. Images of Our Times: Sixty Years of Photography from the Los Angeles Times. New York: Harry N. Abrams, 1987.
- Mottern, John. "'...the right thing to do?' News Photographer (November 1997) 12 - 13
- Mraz, John. Uprooted: Braceros in the Hermanos Mayo Lens. Arte Publico Press 1996
- Mraz, John. "The New Photojournalism of Mexico: 1976-1998." History of Photography 22 (Winter 1998): 312-65.
- Mundt, Whitney R., and Broussard, E. Joseph. "The Prying Eye: Ethics of Photojournalism." Paper presented at the Annual Meeting of the Association for Education in Journalism Houston, Texas, 1979. ERIC, ED173863.
- Murphy-Racey, Patrick. "Pictures of the Month-January: A Case of Situation Ethics."
- News Photographer (May 1988): 30–31. Musi, Vincent J. "'Racist' Tag on Richards Won't Hold." News Photographer (July
- Mydans, Carl. Carl Mydans, Photojournalist. New York: Abrams, 1985.

Nachtwey, James. Deeds of War: Photographs. New York: Thames and Hudson, 1989

- Natanson, Barbara Orbach, "Spot the Hyphen? Representations of Immigrants and Members of Ethnic Groups in Illustrated Newspaper and Magazine Stories, 1880-1925 (periodicals, illustrations, immigration, photojournalism)." Ph.D. diss., University of Maryland College Park, 1999.
- Newcomb, John. The Book of Problem Solving: How to Get Visual Ideas When You Need Them. New York: R.R. Bowker, 1984
- Newhall, Beaumont. The History of Photography from 1839 to the Present Day. Rev. & enlgd. ed. New York: Museum of Modern Art, 1964.
- Newman, Arnold. One Mind's Eye. Boston: New York Graphic Society, 197
- Newman, Arnold. The Great British. London: Weidenfeld and Nicolson, 1979.
- Newman, Arnold. Artists: Portraits from Four Decades. London: Weidenfeld and Nicolson, 1980.
- Newman, Arnold. Arnold Newman, Five Decades. San Diego: Harcourt Brace Jovanovich, 1986.
- "News Views: Edward Farber, Portable Strobe Inventor, Dead." News Photographer (April 1982): 3
- "News Views: Milwaukee Sentinel Photographer Helps Firemen in Rescue." News Photographer (March 1988): 4.
- "News Views: Texas Tragedy, Suicide Coverage a Jolt in Newspaper, on TV." News Photographer (June 1983): 4-5, 8.
- Newton, Julianne Hickerson. "In Front of the Camera: Exploring Ethical Issues of Subject Response in Photography." Ph.D. diss., The University of Texas at Austin, 1991.
- Newton, Julianne H. "The Burden of Visual Truth: The Role of Photojournalism in Mediating Reality." News Photographer (October 1998): VCQ 4-9.
- Norback, Craig T., and Gray, Melvin, eds. The World's Great News Photos, 1840-1980. New York: Crown Publishers,
- Nottingham, Mary Emily. "From Both Sides of the Lens: Street Photojournalism and Personal Space." Ph.D. diss., Indiana University, 1978.
- Nowak, Jeffrey R. "Riot Images: Comparing Photographic Coverage of the 1965 and 1992 Los Angeles Riots in Weekly News Magazines." Master's thesis, Marquette University, 1995.

O'Brien, Sue. "Eye on Soweto: A Study of Factors in News Photo Use." Paper presented at the Annual Meeting of the Association for Education in Journalism and Mass Communication. Boston, Massachusetts, August 7-10, 1991. ERIC, ED336795. Olson, Cal. "Fifty Years & Counting ..." News

Photographer 49 (August 1994): SS1+.

- Packer, Lori. "Illiterate Morons and Pretty Pictures: Uses and Criticisms of Early Photojournalism in New York's Jazz Age Tabloids." Master's thesis, University of Washington, 1997.
- Padgett, G. E. "Let Grief Be a Private Affair." Quill 76 (February 1988): 13, 27.
- Paine, Richard P. The All American Cameras: A Review of Graflex. Houston: Alpha Publishing, 1981.
- Panchak, Patricia L. "Issues in Photojournalism Ethics: An Historical Analysis 1865-1987." Master's thesis, Ohio University, 1988.

Paolucci, Christina I. "Visions From Both Sides of the Camera: The Surfacing of Feminism and Photojournalism." Master's thesis, Mankato State University, 1995.

Pasternack, Steve, and Martin, Don R. "Daily Newspaper Photojournalism in the Rocky Mountain West." *Journalism Quarterly* 62 (1985): 132–35, 222.

Pasternak, Steve, and Utt, Sandra H. "A Study of America's Front Pages: How They Look." Paper presented at the Annual Meeting of the Association for Education in Journalism and Mass Communication, Corvallis, Oregon, August 6–9, 1983. ERIC, ED232150.

Pasternack, Steve, and Utt, Sandra H. "A Study of America's Front Pages: A 10–Year Update." Paper presented at the Annual Meeting of the Association for Education in Journalism and Mass Communication. Atlanta, Georgia, August 10–13, 1994. ERIC, ED376533.

Peress, Gilles. *Farewell to Bosnia*. New York: Scalo, 1994.

Perlmutter, David D. *Photojournalism and Foreign Policy: Icons of Outrage in International Crises*. Westport, Connecticut: Praeger, 1998.

Peters, Greg. "Ethics: Covering the Klan: Are the Sensational Photos Accurately Portraying the Event?" 4Sight (Nov-Dec 1993): 10–11.

Peterson, John Charles. "Reader Acceptance of Complexity and Picture Use in Contemporary Newspaper Design." Ph.D. diss., Ohio University, 1991.

Peterson, John C. "Toward a Theory of Picture Editing and Use in Printed Publication." Paper presented at the Annual Meeting of the Association for Education in Journalism and Mass Communication. Boston, Massachusetts, August 7–10, 1991. ERIC, ED336791.

"Photo Essays." *Nieman Reports* 52(2) (Summer 1998): 8–27.

"Photography in Newspapers Issue." Pullout Section. *Editor & Publisher* (24 February 1990): 1P–52P.

"Photography in Newspapers." E&P Special Report. *Editor & Publisher* (21 August 1999): 25–38.

"Photographer fired over captions continues his career." *News Photographer* (September 1998): 26–27.

"Photographers of the Vanguard: Front-line Journalism is a Matter of Life and Death." News Photographer (September 1981): 13–26.

Photojournalism. Rev. ed. Alexandria, Virginia: Time-Life, 1983.

"Photojournalism: Special Report." British Journal of Photography, (21 October 1998): 9–23+. (9 article special issue).

Pictures of the Times: A Century of Photography from the New York Times. New York: Museum of Modern Art distributed by H.N. Abrams, 1996.

Picturing the Past: Media, History, and Photography. Urbana: University of Illinois Press, 1999.

Pierce, Bill. "W. Eugene Smith Teaches Photographic Responsibility." *Popular Photography* (November 1961): 80–84.

Pollack, Peter. *The Picture History of Photography*. New York: Abrams, 1969.
Ponny John *The Persuasive Image: Ar*

Poppy, John. *The Persuasive Image: Art Kane*. New York: Crowell, 1975.

Pozner & Pomeyrol. Leica Story. Publisher and date of publication unknown.

Pride, Mike. "Monitor photographers and paparazzi worlds apart." News Photographer (June 1998): 21–22.

"The Process of Recording Conflict" *Aperture* 97 (Winter 1984): 6–77. (five article anthology).

Professional Photographic Illustration.

Rochester, New York: Eastman Kodak, 1989.
"A Public Suicide: Papers Differ on Editing
Graphic Images." Associated Press
Managing Editors (APME) Report: Photo and
Graphics. New York, 1987.
"The 1907 Pulltage Priza Winners." News

"The 1997 Pulitzer Prize Winners." *News Photographer* (October 1997): 36.

Pyke, Ralph E. "Digital Images and Photojournalism." *PSA Journal* 64 (July 1998): 22–23.

0

"A Question of Ethics." *News Photographer* (July 1983). (multiple article anthology).

R

Rabinowitz, Allen. "Marlene Karas: In a League of Her Own." *News Photographer* (April 1993): 12–16.

Ramos, Betty J. "Digital Imaging, the News Media and the Law: A Look at Libel, Privacy, Copyright and Evidence in a Digital Age." Paper presented to the Association for Education in Journalism and Mass Communication, Atlanta, Georgia, 1994.

Rayfield, Stanley. How Life Gets the Story:
Behind the Scenes in
Bhataloursellers. Codes City New Yorks

Photojournalism. Garden City, New York: Doubleday, 1955.

Reaves, Shiela. "Digital Retouching: Is There a Place for It in Newspaper Photography?" Journal of Mass Media Ethics 2 (Spring/Summer 1987): 40–48.

Reaves, Shiela. "Photography, Pixels and New Technology: Is There a 'Paradigm Shift'?" Paper presented at the Annual Meeting of the Association for Education in Journalism and Mass Communication, Washington, DC, 1989. ERIC, ED310388.

Reaves, Shiela. "Digital Alteration of Photographs in Magazines: An Examination of the Ethics." Paper presented at the Annual Meeting of the Association for Education in Journalism and Mass Communication, Washington, DC, 1989. ERIC, ED310444.

Washingtoil, Dc. 1999. Ent., EDS 10444.
Reaves, Shiela. "The Vulnerable Image: a
Hierarchy of Codes Among Newspaper
Editors Toward Digital Manipulation of
Photographs." Paper presented at the Annual
Meeting of the Association for Education in
Journalism and Mass Communication.
Montreal, August 7, 1992.

Reaves, Shiela. "What's Wrong with this Picture? Daily Newspaper Photo Editors' Attitudes and Their Tolerance Toward Digital Manipulation." *Newspaper Research Journal* Vol. 13/14 (Fall/Winter 1993): 131–155.

Reaves, Shiela. "Re-Examining the Ethics of Photographic Posing: Insights from the Rank-and-File Members of ASMP." Madison, Wisconsin: University of Wisconsin, 1993. Paper presented at the Annual Meeting of the Association for Education in Journalism and Mass Communication, Visual Communication Division, Kansas City, Missouri, July 1993.

Reaves, Shiela. "Magazines vs. Newspapers: Editors Have Different Ethical Standards on the Digital Manipulation of Photographs." News Photographer 50 (1) (1995): VCQ 4.

Reed, Eli. *Eli Reed: Black in America*. New York: Norton, 1997.

Reed, Pat. "Paparazzo, Meet Ron Galella. Nemesis of Jackie O., Brando, etc." *Houston Chronicle Texas Magazine* (15 April 1979): 20. Remole, Mary K., and Brown, James W.
"Ethical Issues for Photojournalists: A
Comparative Study of the Perspectives of
Journalism Students and Law Students."
Paper presented at the Annual Meeting of the
Association for Education in Journalism,
Boston, Massachusetts, 1980. ERIC,
ED191022.

Rhode, Robert B., and McCall, Floyd H. *Press Photography: Reporting with a Camera*. New York: Macmillan, 1961.

Riboud, Marc. *Marc Riboud: Photographs at Home and Abroad.* Translated by I. Mark Paris. New York: Abrams, 1988.

Ricchiardi, Sherry. "Photographer on small Indiana daily restores luster to Pictures of the Year." *News Photographer* (November 1996): 32, 34.

Ricchiardi, Sherry. "Getting the Picture: Women are Coming to the Fore in the Long Male-Dominated Field of Photojournalism." AJR: American Journalism Review 20(1) (1998): 26–33.

Rich, Kathy. "Contact Sheet: Responses of Leading Picture Editors to a Survey to Determine How They Choose Pictures." Camera 35 (April 1979): 34.

Richards, Eugene. **50 Hours.** Text by Dorothea Lynch. Long Island City, New York: Many Voices Press, 1983.

Richardson, Jim. *High School: U.S.A.* New York: St. Martin's Press, 1979. Rigger, Robert. *Man in Sport*. Baltimore,

Maryland: Baltimore Museum of Art, 1967. Riis, Jacob. *How the Other Half Lives*. New York: Scribner, 1904.

Ritchin, Fred. *In Our Own Image: the Coming Revolution in Photography.*New York: Aperture Foundation, 1990.

Ritchin, Fred. "The Web Waits for Photographers, Too." *Nieman Reports* 52 (Summer 1998): 38–39.

Roach, Ronald. "Capped Lenses." *Black Issues in Higher Education* 15 (6 August 1998): 24–27.

Roark, Virginia, and Wanta, Wayne. "Response to Photographs." *VCQ* (Spring 1994): 12–13.

Robaton, John, and Smith, Harris. Photojournalism Basics: An Introduction to Photography for Publication. Ipswich, Massachusetts: Upper River Press, 1994.

Robinson, G. "Interview: Donna Ferrato — Photojournalist." *Media Studies Journal* 10 (Fall 1996): 135–136.

Roche, James M. "Newspaper Subscribers' Response to Accident Photographs: The Acceptance Level Compared to Demographics, Death Anxiety, Fear of Death, and State Anxiety." Paper presented at the Annual Meeting of the Association for Education in Journalism and Mass Communication, Corvallis, Oregon, 1983. FRIC. FD234386

Rodger, George. *Magnum Opus: Fifty Years in Photojournalism*. London: Nishen, 1987.

Roeder, George, Jr. The Censored War: American Visual Experience During World War II. New Haven, Connecticut: Yale University Press, 1993.

Rogers, Madeline. "The Picture Snatchers." American Heritage 45 (October 1994): 66–73.

Rolling Stone, the Photographs. New York: Simon & Schuster, 1989.

Rose, Bleys W. "Hundreds of readers object to race photos." *News Photographer* (January 1995): 54–55.

Rosett, Jane M. "Photojournalists: Visionaries Who Have Changed Our Vision." *Media Studies Journal* 11 (1997): 39–57. Rothstein, Arthur Arthur Rothstein, Words and Pictures. New York: Amphoto, 1979.

Rothstein, Arthur. *Photojournalism*. Garden City, New York: Amphoto, 1979.

Rothstein, Arthur. *Documentary Photograph*y. 3rd ed. Boston: Focal Press, 1987.

Rotkin, Charles E. *Professional Photographer's Survival Guide*. New York: American Photographic Book Publishing, 1982.

Rowland, Jack. "Please don't call me paparazzo." *News Photographer* (November 1997): 10.

Rubin, Susan Goldman. *Margaret Bourke-White: Her Pictures Were Her Life*. New York: Abrams, 1999.

Rudd, James O'Malley. "Picture Possibilities: An Ethnographic Study of Newspaper Photojournalism." Master's thesis, University of Washington, 1994.

Russial, John. "Digital Imaging and the Photojournalist: Work and Workload Issues." Paper presented at the Annual Meeting of the Association for Education in Journalism and Mass Communication. Baltimore, Maryland, August 5–8, 1998. ERIC, ED423562.

Russial, John, and Upshaw, Jim. "See No Evil? Differing Responses to an Awful Picture." Columbia Journalism Review (January/February 1994): 9–11.

Russial, John, and Wanta, Wayne. "Digital Imaging Skills and the Hiring and Training of Photojournalists" Paper presented at the Annual Meeting of the Association for Education in Journalism and Mass Communication, Chicago, Illinois, July 30–August 2, 1997. ERIC, ED415551.

Russial, John, and Wanta, Wayne. "Digital Imaging Skills and the Hiring and Training of Photojournalists." *Journalism and Mass Communication Quarterly* 75 (Autumn 1998): 593–605.

Salgado, Sebastiao. *Other Americas*. New York: Pantheon, 1986.

Salomon, Erich. Erich Salomon, Portrait of an Age. New York: Macmillan, 1967. Schlagheck, Carol. "Handling Critics and Controversy: How Some Editors and Ombudsmen Have Dealt with Negative Reader Response." [Photojournalism mgr

Photographer (July 1993): 17–25. Schuneman, R. Smith. "The Photograph in Print: An Examination of New York Daily Newspapers, 1890–1937." Ph.D. diss., University of Minnesota, 1966.

(NPAA Management Report)] News

Schuneman, R. Smith, ed. *Photographic Communication: Principles, Problems and Challenges of Photojournalism.*New York: Hastings House, 1972.

Schwartz, Donna. "To Tell the Truth: Codes of Objectivity in Photojournalism." Communication 13 (1992): 95–109.

Sentman, Mary Alice. "Black and White: Disparity in Coverage by *Life* Magazine from 1937 to 1972." *Journalism Quarterly* 60 (1983): 501–508.

Shames, Laurence. "Profile: On the Road with Annie Leibovitz, The Queen of Celebrity Photographers Is Quite a Character Herself." American Photographer (January 1984): 38–55.

Sharkey, Jacqueline. "The Diana Aftermath." American Journalism Review (November 1997): 19–25.

Sherer, Michael D. "The Photojournalist and the Law: The Right to Gather News Through Photography." Ph.D. diss., Southern Illinois University at Carbondale, 1982.

- Sherer, Michael D. "Your Photos or Mine: An Examination of the Laws Governing Warranted Searches and Subpoenas for the Photojournalist's Work Product." Paper presented at the Annual Meeting of the Association for Education in Journalism and Mass Communication, Corvallis, Oregon, 1983, ERIC, ED236610.
- Sherer, Michael D. "Photographic Invasion of Privacy: An Old Concept with New Meaning." Paper presented at the Annual Meeting of the International Communication Association, Dallas, Texas, 1983. ERIC, ED236626.
- Sherer, Michael D. "Invasion of Poland Photos in Four American Newspapers." Journalism Quarterly 61 (1984): 422-26.
- Sherer, Michael D. "The Problem of Trespass for Photojournalists." Journalism Quarterly 62 (1985): 154-56, 222.
- Sherer, Michael D. "Photojournalism and the Infliction of Emotional Distress. Communications and the Law 8 (April 1986): 27-37
- Sherer, Michael D. "The Problem of Libel for Photojournalists." Journalism Quarterly 63 (1986): 618-23.
- Sherer, Michael D. "A Survey of Photojournalists and Their Encounters with the Law." Journalism Quarterly 64 (1987): 499-502, 575.
- Sherer, Michael D. No Pictures Please: It's the Law. Durham, NC: National Press Photographers Association, 1987
- Sherer, Michael D. "Photojournalists and the Law: A Survey of NPPA Members." News Photographer (January 1988): 16, 18.
- Sherer, Michael D. "Comparing Magazine Photos of Vietnam and Korean Wars. Journalism Quarterly 65 (1988): 752-56
- Sherer, Michael D. Photojournalism and the Law: A Practical Guide to Legal Issues in News Photography. Durham, NC: National Press Photographers Association, 1996.
- Sherer, Michael. "Fake-photo charge, filing of libel suit involve NPPA and its magazine. News Photographer (October 1997): 27.
- Sherer, Michael D. "Subpoenas Alive: Know Protection." News Photographer (January 1999) 22 29
- Shipman, Marlin. "Ethical Guidelines for Televising or Photographing Executions." Journal of Mass Media Ethics 10 (2) (1995):
- Shoemaker, Pamela J., and Fosdick, James A. "How Varying Reproduction Methods Affects Response to Photographs." *Journalism* Quarterly 59 (1982): 13-20, 65.
- Shiras, George, 3rd. "Photographing Wild Game with Flashlight and Camera." National Geographic (July 1906).
- Singletary, M. W. "Newspaper Photographs: A Content Analysis, 1936-76." Journalism Quarterly 55 (1978): 585-89
- Six Decades: The News in Pictures: A Collection of 250 News and Feature Photographs Taken from 1912 to 1975 by the Milwaukee Journal Co. Staff Photographers. MN: Milwaukee Journal Co., 1976
- Smith, C. Zoe. "An Alternative View of the Thirties: The Industrial Photographs of Lewis Wickes Hine and Margaret Bourke-White. Paper presented at the Annual Meeting of the Association for Education in Journalism. East Lansing, MI, August 8-11, 1981. ERIC, FD204770.
- Smith, C. Zoe. "Emigre Photography in America: Contributions of German Photojournalism From Black Star Picture Agency to Life Magazine, 1933-1938. Ph.D. diss., The University of Iowa, 1983.

- Smith, C. Zoe, "Great Women in Photoiournalism." Parts 1-3. News Photographer (January 1985): 20-21; (February 1985): 26, 28-29; (April 1985): 22-24.
- Smith, C. Zoe. "Black Star Picture Agency: Life's European Connection." Journalism History 13 (Spring 1986): 19-25.
- Smith, C. Zoe. "Dickey Chapelle." VCQ (Spring 1994): 4-9.
- Smith, C. Zoe, and Mendelson, Andrew. "The Health of Photojournalism and Visual Communication Education in the Nineties: Cause for Concern or a Bright Future?" Paper presented at the Annual Meeting of the Association for Education in Journalism and Mass Communication, Washington, DC, August 9-12, 1995. ERIC, ED392085.
- Smith, C. Zoe, and Mendelson, Andrew. "Visual Communication Education: Cause for Concern or Bright Future?" Journalism and Mass Communication Educator 51 (Autumn 1996): 66-73.
- Smith, C. Zoe, and Michael Winokur. "Up close and personal." News Photographer (September 1996): 42-48.
- Smith, C. Zoe, and Woodward, Anne-Marie. "Photo-Elicitation Method Gives Voice and Reactions of Subjects." Journalism and Mass Communication Educator 53(4) (1999): 31-41
- Smith, Ron F. "How Design and Color Affect Reader Judgement of Newspapers. Newspaper Research Journal 10 (Winter 1989): 75-85
- Smith, W. Eugene. "Saipan." Life (28 August 1944): 75-83.
- Smith, W. Eugene. "Country Doctor." Life (20
- September 1948): 115-126. Smith, W. Eugene. "Spanish Village." Life (9 April 1951): 120-129.
- Smith, W. Eugene. "Nurse Midwife." Life (3 December 1951): 134-145.
- Smith, W. Eugene. "A Man of Mercy." Life (15 November 1954): 161-172.
- Smith W. Eugene. "W. Eugene Smith Talks About Lighting." *Popular Photography* (November 1956): 48.
- Smith, W. Eugene. "Pittsburgh." 1959 Photography Annual (1958): 96-133
- Smith, W. Eugene. W. Eugene Smith: His Photographs and Notes. Millerton, New York: Aperture, 1969
- Smith, W. Eugene. W. Eugene Smith, Master of the Photographic Essay Millerton New York: Aperture, 1981.
- Smith, W. Eugene, and Smith, Aileen M. Minamata. New York: Holt, Rinehart and Winston, 1975.
- Sobieszek Robert A Arnold Newman. Englewood Cliffs, New Jersey: Prentice-Hall,
- Solomon, Deborah. "Newman at Work." American Photographer (February 1988):
- Souza, Pete. Unguarded Moments: Behind-the-Scenes Photographs of President Ronald Reagan. Fort Worth, Texas: Summit Group, 1992
- Souza, Pete. "White House top photo sparks pro, con on publishing." News Photographer (February 1995): 26-27.
- Souza, Pete. "Kent Kobersteen: The New Director of Photography at National Geographic." News Photographer (Summer 1998): VCQ 3-8..
- Sparks, Glenn G., and Fehlner, Christine L. Faces in the News: Gender Comparisons of Magazine Photographs." Journal of Communication (Autumn 1986): 70-79. Spence, J. "The Politics of Pictures." Red

- Pepper, no. 14 (July 1995): 37-38 Spencer, Otha Cleo. "Twenty Years of 'Life': A
- Study of Time, Inc.'s Picture Magazine and Its Contributions to Photojournalism." Ph.D. diss., University of Missouri, Columbia, 1958
- Spina, Tony. *Press Photographer*. Cranbury. New Jersey: A.S. Barnes, 1968
- Spina, Tony. On Assignment, Projects in Photojournalism. New York: Amphoto.
- Spremo, Boris. Twenty Years of Photojournalism. Toronto: McClelland and Stewart, 1983.
- Spruill, Larry Hawthorne. "Southern Exposure: Photography and the Civil Rights Movement, 1955-1968." Ph.D. diss., State University of New York at Stony Brook, 1983.
- Squiers, Carol. "Seeing History As It Happened: A Century and a Half in the Life of the World, As Recorded by Its Most Daring Witness." American Photographer (October 1988): 33-44.
- Squiers, Carol. "The House of News." American Photo 9 (September/October 1998): 20.
- Srihari, Rohini K. "Use of Captions and Other Collateral Text in Understanding Photographs." Artificial Intelligence Review 8 (Oct-Dec 1994): 409-430.
- Steele, Bob, "Protocols for Ethical Decision-Making in the Digital Age." Protocol 1991: 13-17.
- Steichen, Edward, The Family of Man. New York: Simon & Schuster, 1959
- Stein, Barney. **Spot News Photography**. New York: Verlan Books, 1960.
- Stein, M.L. "News Value vs. Gore." Editor & Publisher (12 August 1995): 12.
- Stepno, Bob. "Staged, faked, and mostl naked: Photographic innovations at the Evening Graphic (1924-1932). Paper presented at the Annual Meeting of the Association for Education in Journalism and Mass Communication. Baltimore, Maryland, August 5-8, 1998.
- Stern, Bert. Photo Illustration: Bert Stern. New York: Crowell, 1974
- Stettner, Louis. Weegee. New York: Alfred A. Knopf, 1977
- Stettner, Louis, and Zanutto, James M. "Weegee." Popular Photography (April 1961): 101-102.
- Stott, William. Documentary Expression and Thirties America. New York: Oxford Press, 1973.
- Stover, Eric, and Peress, Gilles. The Graves: Srebrenica and Vukovar. Zurich: SCALO,
- Streitmatter, R. "The Rise and Triumph of the White House Photo Opportunity. Journalism Quarterly 65 (1988): 981–85.
- Strother, Tracy. "Are We Only Wrong if Someone Gets Caught: A Study of the Credibility of Digitally Altered Photography. Master's thesis, Marquette University, 1994.
- "Suicide." (multiple article anthology). News Photographer (May 1987): 20-32, 34-43,
- Sutton, Ronald E. "Image Manipulation: Then and Now." Paper presented at the Symposium of the International Visual Literacy Association. Delphi, Greece, June 25-29 1993.
- Swanson, Charles. "What They Read in 130 Daily Newspapers." Journalism Quarterly 32 (1955): 411-21.
- Sweers, George, ed. A White Paper on Newspaper Color: A Special Report. Durham, North Carolina: National Press Photographers Association, 1985
- Szarkowski, John. The Photographer's Eye. New York: The Museum of Modern Art,

- Szarkowski, John. From the Picture Press. New York: The Museum of Modern Art.
- Szarkowski, John. Photography Until Now. New York: Museum of Modern Art, 1989.

- Tames, George. Eye on Washington: The Presidents Who've Known Me. New York: Harper & Row, 1990.
- Tannenbaum, Percy H., and Fosdick, James A. "The Effect of Lighting Angle on Judgment on Photographed Subjects." Audio Visual Communication Review 8 (1960): 253–262.
- Taylor, John. Body Horror: Photojournalism, Catastrophe and War. Manchester, New York: Manchester University Press, 1998.
- TerKeurst, Jim. "A Day in Whose Life?: Photojournalism, Culture and Imperialism." Paper presented at the Annual Meeting of the Association for Education in Journalism and Mass Communication, Anaheim, California, August, 1996.
- Terrazas, Beatriz, "Using the Camera to Peer Inside." Nieman Reports 53 (Summer 1999):
- Time: 150 Years in Photojournalism.
- New York: Time, 1989. 'To Publish? Pro and Con." News Photographer (May 1993): 12-17.
- Tsang, Kuo-Jen. "News Photos in Time and Newsweek." Journalism Quarterly 61 (1984): 578-84, 723.
- Turnley, David C., and Cowell, Alan. Why Are They Weeping? South Africans Under Apartheid. New York: Stewart, Tabori and Chang 1988
- 20 Years with AP Wirephoto. New York: Associated Press, 1955.

- Ungero, Joseph M. "How Readers and Editors Judge Newspaper Photos." APME Photo Report (15 October 1977)
- Unity '94. News Watch: A Critical Look at Coverage of People of Color. San Francisco: SFSU Center for the Integration and Improvement of Journalism, 1994.
- "U.S. Supreme Court to Review 2 'Ride-Along' Cases." News Photographer (December 1998): 32.

- Van Riper, Frank. "Perils of the Digital Camera Age." Nieman Reports 51 (Winter 1997):
- Vaughan, Keith. "Human Interest vs Sports Action in Photojournalism." PSA Journal 63 (1 August 1997): 15.
- Vernon, Mara Evonne. "The Credibility of News Photography in the Digital Age." Master's thesis, University Of Nevada, Las Vegas,
- Vitray, Laura, Mills, John Jr., and Ellard, Roscoe. *Pictorial Journalism*. New York: McGraw Hill, 1939

- Waldman, Paul, and Devitt, James. "Newspaper Photographs and the 1996 Presidential Election: The Question of Bias." Journalism and Mass Communication Quarterly 75 (Summer 1998): 302-11. Warburton, Nigel. "Ethical Photojournalism in
- the Age of the Electronic Darkroom." In Kieran, Matthew, ed., Media Ethics.

London, New York: Routledge, 1998. Warlaumont, Hazel G. "Blurring the Lines of Distinction: Photo-Documentary Advertising and Editorial Integrity." Ph.D. diss.,

University of Washington, 1993. Walter, Paulette H. "A History of Women in Print Photojournalism." MS thesis, University of Ohio, Athens, 1987.

Wanta, W. "The Effects of Dominant Photographs: An Agenda-Setting Experiment." Journalism Quarterly 65 (1988): 107-11.

Wanta, Wayne, and Leggett, Dawn. "Gender Stereotypes in Wire Service Sports Photos." Newspaper Research Journal 10 (Spring 1989): 105-14.

Watkins, Patsy G. "The Power of Editorial and Historical Context: A Photo History Interprets WW II for Americans." Paper presented at the Annual Meeting of the Association for Education in Journalism and Mass Communication. Kansas City, Kansas August 11-14, 1993. ERIC, ED362913

Webb, Alex. Hot Light/Half-Made Worlds: Photographs from the Tropics. New York: Thames and Hudson, 1986

Webb, Alex. Under a Grudging Sun: Photographs from Haiti Libere 1986-1988. New York: Thames and Hudson, 1989.

Weegee. Naked City. New York: Essential Books, 1945.

Weegee. Weegee by Weegee: An Autobiography. New York: Ziff-Davis,

Weegee. Weegee's People. 1946. Reprint. New York: Da Capo Press, 1975 Weegee. Weegee: Naked New York. Schirmer, 1997

Weill, Susan. "African Americans and the White-Owned Mississippi Press: An Analysis of Photographic Coverage from 1944 to 1984." Paper presented at the American Journalism Historians' Association Conference. Roanoke, Virginia, October 6–8, 1994. ERIC. ED379669.

Weinberg, Adam D. On the Line: The New Color Photojournalism. Minneapolis: Walker Art Center, 1986.

Welling, William. Photography in America: The Formative Years 1839-1900, A Documentary History. New York: Crowell, 1978

Wells, Annie. "Worth the trouble?" News Photographer (July 1996): 82-83. Welsch, Ulrike. The World I Love to See.

Boston: Boston Globe/Houghton Mifflin Welsch, Ulrike. Faces of New England:

Special Moments from Everyday Life. 2nd ed. Chester, Connecticut: Globe Pequot Press, 1981.

Wheeler, Chris. "Do We Best Serve the Public Interest by Covering the Ku Klux Klan?' Rangefinder (Summer 1992): 11.

Wheeler, Tom. "Public Perceptions of Photographic Credibility in the Age of Digital Manipulation." Paper presented at the Annual Meeting of the Association for Education in Journalism and Mass Communication, Washington, DC, August 9-12, 1995. ERIC, ED392085.

Wheeler, Tom, and Gleason, Tim. "Photography or Photofiction: An Ethical Protocol for the Digital Age." Visual Communication Quarterly 2 (January 1995): S8-12.

White, Frank William. "Cameras in the Courtroom: A U.S. Survey." Journalism Monographs 60 (April 1979)

Whiting, John R. *Photography Is a* Language. New York: Ziff-Davis, 1946. "Why Do They React? Readers Assail Publication of Funeral, Accident Photos." News Photographer (March 1981): 20, 22 - 23

Wilcox, Walter. "Staged News Photographs and Professional Ethics." *Journalism* Quarterly 38 (1961): 497-504.

Wilkins, Lee. "Envisioning the Blind in Film and the News: Moving from Cultural Stereotype to Reality." Paper presented at the Annual Meeting of the Association for Education in Journalism and Mass Communication. Atlanta, Georgia, August 1994

Willem, Jack M. "Reader Interest in News Pictures." In Graphic Graflex Photography, edited by Morgan and Lester. New York: Morgan & Lester, 1946.

Williams, M. Michael. "News Photographs in Stories Related to Vietnam: A Content Analysis of Photographs Relating to the Vietnam War Appearing in Life Magazine from January 1, 1966 through February 28, 1970." ERIC, ED311505.

Williams, Val. "Prints of Darkness - Can War be Represented Only by Those on the Frontline? Val Williams Reviews Powerful Photographic Images by Women Who Were There and Women Who Weren't " The Guardian (Manchester) (12 January 1995): T006+

Williamson, Lenora. "Page 1 Fire Photos Draw Reader Protests." *Editor & Publisher* (30

August 1975): 14–15. Wilson, Bradley. "Should it Run?" News

Photographer (July 1999): 8. Wimmer, Kurt. "Supreme Court Ruling in 'Ride-Along' Case May Spell Doom for Practice." News Photographer (July 1999): 12, 17,

Wischmann, Lesley. "Dying on the Front Page: Kent State and the Pulitzer Prize." Journal of Mass Media Ethics 2 (Spring/Summer 1987): 67-74.

Wolf, Henry. Visual Thinking: Methods for Making Images Memorable. New York: American Showcase, 1988.

Wolf, Rita, and Giotta, Gerald L. "Images: A Question of Readership." Newspaper Research Journal 6 (Winter 1985): 30-36.

"Women in Photojournalism." News Photographer (December 1984): 16-17; (February 1985): 25-29; (April 1985): 22,

Woo, Jisuk. "Journalism Objectivity in News Magazine Photography." Visual Communication Quarterly (Summer 1994): 9.

Wood, Deloris. "The Importance of Artificial Light in the Development of Night Photography." Paper presented at the Annual Meeting of the Association for Education in Journalism. Ottawa, Canada, August 1975. ERIC. ED130267

Woodburn, Bert W. "Reader Interest in Newspaper Pictures." Journalism Quarterly 24 (1947): 197-201.

Wooley, Al E. Camera Journalism. South Brunswick, New Jersey: A. S. Barnes, 1966.

Yang, Daqing. "Image — War's Most Innocent Victim." Media Studies Journal 13 (Winter 1999): 18-19.

Yates, Carl. "What to Do When the Law Says, 'No Pictures, Please!," News Photographer (November 1993): 19

Yu, Yong-Hoon. "Visual Silences in the American News Media: A Content Analysis of News Photos in Time and Newsweek. Master's thesis, California State University, Northridge, 1994.

Zarnowski, Myra. "Telling Lewis Hine's Story: Russell Freedman's Kids at Work." Paper presented at the 1997 Annual conference of the Natioinal Council of Teachers of English. Detroit, Michigan, 1997. ERIC, ED414574.

Policemen, one using his helmet as a "modesty shield," escort this streaker from a rugby field.

(Photo by Ian Bradshaw, Syndication International.)

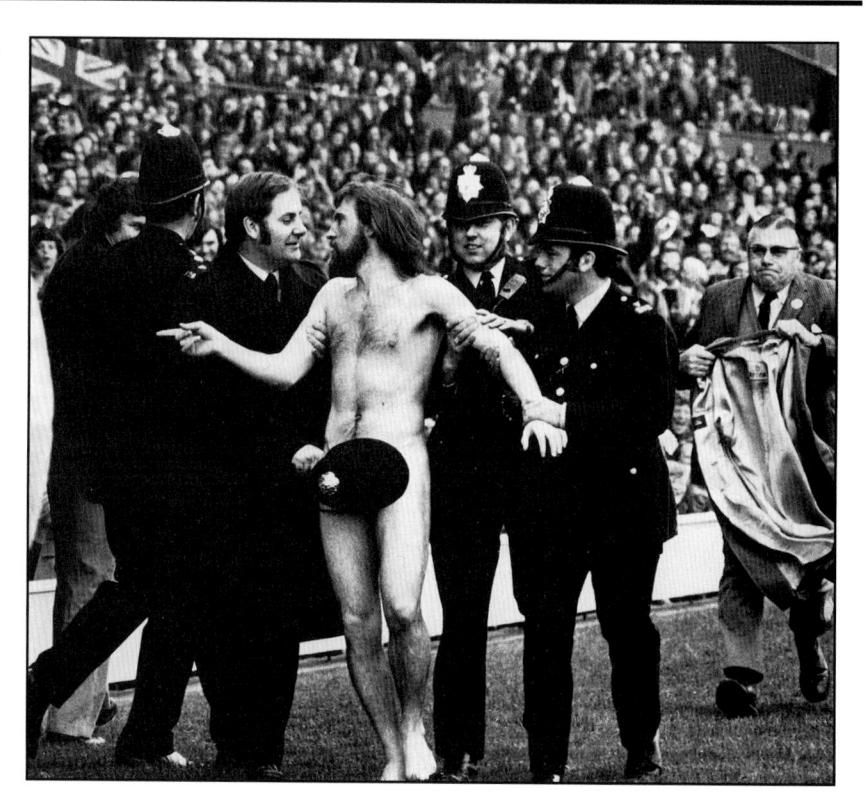

INDEX Blaylock, Ken, 324 outfitting photojournalist with, 101 Dalmatians, 181 Automatic exposure meters, overriding, Black-and-white 218-243 3200 Magic film, 224-225 color vs., 239-241 pushing color film and, 237-238 Automatic eye, 265-268 Automatic features of cameras, 220-223 film. 223-225 shooting from dawn until night and, Abrahamson, Rich, 226 Available light, combining flash with, shooting in low light with film of, 234-238 Abramson, Dean, 307 time of day critical for, 230-234 264-268 223-225 AC-powered strobes, 276-277 Canadian Illustrated News, 332 standardizing with one film of, automatic eye and, 265-268 Access vs. trespass, 289-292 determining aperture and, 265 223 Candid photography Accidental vs. revealing photos, 51 Body language, 108 anticipation and timing for, 19–20 hand-held strobe meters and, 268 Accidents, 4-5, 288-289 manual handling of, 265 Bohle, Robert, 238 big game hunter approach to, 18-19 Accidents and disasters, covering, through the lens (TTL) and, 268 Bornstein, Sam, 323 catching, 17-20 39-42 Bourke-White, Margaret, 13, 349, 349, father of, 347-348 Acme News Pictures, 359 350, 353, 356, 357 hit and run approach to, 19 Backgrounding news, 58-83 Action Boyd, Robert, 346 out-in-the open approach to, 19 arming for, 27-29 Backgrounds, 180 photographing, 92-93 Bradt, Peter, 317 external, 150 controlling with shutter speeds, 266presetting cameras for, 19 Bradshaw, Ian, 368 freezing, 120-121 267 Brecher, Ellie, 9 saving last frames and, 20 and props, 105-107 peak, 121-122 Breland, Jeff. 173, 175, 187 three approaches to, 18 Ansel, Adams, 97, 239 Bain, George Grantham, 358-359, 358 Brainstorming concepts, 177 when they know you're there and, 20 Adams, Chris, 69 Bain News Service, 335, 358-359 Brightness, handling extreme, 230 Capa, Cornell, 354 Adams, Eddie, 308, 325, 326, 314 hires Frances Benjamin Johnston, 335 Capa, Robert, 17, 17, 344, 351-352, Brill, Betsy, 172, 307, 308 Adams, Jonathan, 321 Balic, Sebastian, 317 Brink, Ben, 304, 309 352.353 Banks, Dennis, 352 AFP (Agence France-Presse), 21, 92, Britten, Jack, 305 Caption-writing styles, 217 Barnach, Oskar, 347 316 Brooks, Dudley M., 195 Captions, 211-217 Agee, James, 61 Baseball details and, 215-216 Brown, Cindy, 229, 356 Ake, David J., 316 anticipation in, 128-131 final advice for, 217 Brown, Milbert, 7 Alberico, Rocco, 256 counteracting reaction time in, 129 Browne, Malcolm, 60, 300, 301 need for, 118-119 knowing where ball will be in. Alexander, Sherry, 296 Budget meetings, 10-11 putting five Ws in, 214-217 128-129 America in Crisis, 354 Buell, Hal, 198, 203, 208, 323 quotes and, 217 American magazines adopt photography, runner vs. the ball in, 130 as stepchild of business, 211-217 Buffalo Inquirer and Courier 349-350 sliding into second in, 130 hires Jessie Tarbox Beals, 335-336 words influence picture meaning and, American Newspaper Reporter, 332 stealing bases in, 130 211-214 Bullard, Timothy, 98, 99 American Photojournalism comes unusual in, 131 Burgess, John, i, 173, 175, 180, writing clear, 214 waiting til all hell breaks loose and. of Age, 343 Carlebach, Michael, 343 266-267, 278 American Society of Media 130 Carlson, Gunnar, 321 Burke, Michael, 113 Basketball Photographers (ASMP), 308 Burrows, Alex, 55 Carlson, Nick, 191 Andrews, Nancy, 140, 143, 144-145, armpit shot in, 135 Byrd, Joan, 321 Cartier-Bresson, Henri, 16-19, 93, 113, 326 don't be faked out in sports and, 133-351-353, 351, 353 C Ang, Tom, 209 Cavallo, Robert, 287 Cable News Network, 5 Angles bring new perspectives, high/low, sideline positions in, 134-135 CBS' street stories, 291 Calvert, Mary, 69, 70 skipping cliches in, 135 14-15 The Censored War. 357 Baumann, Horst, 120, 190 Camera bag, a professional's, 223 Animals acting like people, 89-90 Censorship Baxter, William, 209, 207 Camera reporters, evolution of, 330-332 Anticipation and timing, 19-20 self, 326-327 AP. See Associated Press Beale, John, 327 war, 356-357 Beals, Jessie Tarbox, 335 digital usage of, 247-249 Aperture, determining, 265 Ceppos, Jerry, 325 keeping dry, 220 Approaches, selecting, 160 Beat reporters, 6 Chambers, Brian, 124 Beats, developing feature, 68-83 lose weight and gain versatility with, Arnett, Peter, 316 Chambers, Bruce, 210 Arnold, Edmond, 203, 209 Bengiveno, Nicole, 100, 100, 102, 104, 345-347 Chapelle, Dickey, 346 Arnold, Eve, 16, 17, 354 108 motorized, 127-128 Chapin, William C., 339 presetting, 19 ASMP. See American Society of Media Bennett, James Gordon, 333 Chapnick, Howard, 214, 310 Bentley, P.F., 44, 49, 47, 48, 51, 143, as reformers' tools, 336-338 Photographers Charities and the Commons Cameras and film, 218-243 241, 243, 254, 286 Asakawa, Glenn, 135 Lewis Hine's photos published in, 338 Berner, Alan, 76, 77, 61, 91, 137, 140, auto-exposure feature of, 220 Assignments, 2-23, 140 Chernoff, George, 293 best time for, 9 158, 159, 160 autofocus feature of, 220-222 Chicago Daily News automatic features of, 220 Berliner Illustrirte Zeitung generating one's own, 11 "daily erotica for the masses," 341 first photo essays in, 348-349 black-and-white film and, 223-225 international, 11-13 The Daily News, sister paper of, 341 influence on Life magazine, 349 color, considerations for, 230-238 making most of, 9 execution, photo of, 341 starting with imaginative, 190-194 Bernt, Joseph, 201 color film and, 225-230 use of halftones, 333 color vs. black-and-white film and, Associated Press (AP), 256, 316, 346, Bettman/Corbis, 192 Chicago Tribune, 344 Big game hunter, 18-19 239-241 359 Chicago Herald-Examiner, 344 Bingham, Ron, 151, 280 how readers react to color and. See Associated Press News Photo Children Bishof, Werner, 353, 354 238-240 Service imitating adults, 89 Associated Press News Photo Service, Black Star, 192, 214, 252, 310, 350-354 lenses and, 222-223 Chinn, Paul, 217 manual handling of, 222 Black Star Picture Agency: Life's Chwast, Seymour, 178 European Connection, 351 need for rugged equipment and, 220 Atherton, James, K.W., 53 Clark, Jason, 200

Autofocus, 125-126, 220-222

Blackwood, Roy, 201

Clark, Jim, 202, 203 who owns pictures and, 298-299 adding or subtracting elements and, Erich Salomon's use of, 347 Clarkson, Rick, 255, 259 Cortes, Ron, 18, 19 255-256 limitations of, 347 Click magazine, 350 Costa, Denise, 321 composing photos on electronic layout opens new era of photography, 346 Click, J.W., 238 Costa, Joe, 355, 358 table and, 255-258 Essays, photo Close-up Courtrooms, 295-296 how far will magazine editors go and, editorial, 158-159 photographs, 14 Coverage, ingredients for in-depth, 63 256-257 European magazines originate, scene-setter vs., 105 Covering issues, 58-83 Digital video, 254-255 348-349 CNN. See Cable News Network developing feature beats, 68-83 Disasters, 197-198 German, 348-349 Cole, Carolyn, 289 Cowles, Gardner, 350 covering accidents and, 39-42 Ethical decision making, foundations of, Coley, John, 122 Cranford, Bill, 290 Distortion, wide-angle, 16 302-304 Collins, Bill, 51, 123 Creatively, thinking, 181-183 Docudrama, 173-175 absolutist, 302 Cohen, Robert, 41, 55, 89, 90, 141, 142, Credentials, press, 297 concept photograph vs., 187 Golden Rule, 302-304 146 Credibility, losing, 257-258 confusion and, 186-187 utilitarian, 302 Collier's Weekly, 334-335, 348 Crime in progress, photographing, 31 Documentaries, observing, 159-160 Ethical standards, monitoring, 310-311 photographer Jimmy Hare and rising Crime photographers, king of, 343 Dominis, John, 146, 214 Ethics, 255-258, 300-327 circulation of, 334-335 Crimes make headlines, 26-32 Dorothea, Lang. 59 changing values and, 305 Color arming for action and, 27-29 Downs, Patrick, 114, 115 continuum of control and, 306-307 black and white vs., 239-241 getting along with cops and, 29-31 Draut, Joel, 220, 221 covering tragedy and grief and, for color's sake, 241 Cropping Duke, William, 177, 178, 179, 179, 311-315 doing the right thing, 300-327 how readers react to, 238-239 amputating at joints problem when, 180. 183 Color film, 225-230 205 Duncan, David Douglas, 220 facts conflicting with photographs and, editing ease of, 227 for cutting out fat, 202-203 Duncan, Tom, 263, 265, 265 307-308 exposure tolerance comparison, excesses of, 202-204 Durniak, John, 193 fair and balanced reporting and, 325-228-229 perfect framing and, 202 327 grain and saturation of, 227-228 preserving mood when, 203 foundations of ethical decision making, Economopoulos, Aristide, 17, 118, 119, pushing of, 237-238 price of, 203-207 302-304 140, 146, 159, 212, 213 repro quality of, 228 reduced quality when, 203-207 Golden Rule, 302-304 Eddins, J.M., Jr., 42 shooting style with, 228-230 ruthlessly, 203 keeping up with shifting standards and, Edgerton, Harold, 344-34, 345 transparency, 228 Crowe, Pat, 307 309-311 Editing Color negative film Cut and paste, electronic, 183-185 moral dilemmas of picture editor and, do-it-yourself picture, 193-194 color transparency vs., 228 317-318 ease of, 227 shooting stories with, 240 photography can make a difference D'Addario, Vincent S., 113 photo, 188-217 transparencies vs., 225-230 and, 323-325 Dailey, Larry, 253 Editorial concept illustrations, 173 Comegys, Fred, 12 professional vs. good Samaritan and, Complaints, reader, 318-323 Daily Graphic, 329-332, 359 Editorial essays, 158-159 315-316 The Daily News, 340-341, 355 Editorial illustrations, producing, Composition reader complaints and, 318-323 first tabloid, 341 adding impact, 105 175-181 readers believing their eyes and, execution, photo of, 340-341 Editors background and props, 105-107 305-309 See Illustrated Daily News. magazine, 256-257 close-up vs. scene-setter, 105 remembering readers and, 327 Daily Times Democrat, 288 moral dilemmas of picture and, conveying character, 105 responsibility and 305 Damaske, Jim, 295 Composographs, 257, 341-343 317-318 set up or just clean up and, 304-305 David, Peterson, 60 predicting readers' preferences by, Computers suicide and, 316-317 Dawn until night, shooting from, 199-201 translating pictures into numbers on, Eulitt, Dave, 127, 128 234-237 and readers, 200 251 European magazines originate photo Dead bodies, hiding, 320-321 role of picture editor, 188-217 using to create photo illustrations, essay, 348-349 DeCesare, Donna, 61, 74-75, 140, 159 Edoms, Clifton, 194 251-252 Evans, Jim, 84, 85 Decision making, foundations of ethical, Eisenstaedt, Alfred, 101, 105, 107, 350, Connelley, Sean, 247 Evans, Walker, 61, 336 302-304 357 Constanza, Sam, 4, 5, 9, 27, 28, 28, 29, Evening Graphic, 257, 341-343 The Decisive Moment, 353 Eisert, Sandra, 227 30, 43 composograph and, 341-342 Decisive moment, photojournalist of, Concept photo vs. docudrama, 187 Eisner, Bill, 318 Editor and Publisher calls shocking, 352-353 Eklund, Scott, 193, 215 Contrast, achieving with size in layouts, 342 Detrich, Allan, 96 Elbert, Joe, 194, 195 209 New York Society of the Suppression Diaz, John, 325 Electronic cut and paste, 183-185 Converse, Gordon, 87 of Vice and, 343 Diffuse light, strobe accessories to, 279 Electronic flash Cookman, Claude, 358 Exposure meters, when to override Cooke, Janet, 310 Digital cameras, using, 247-249 controversy over, 262-264 automatic, 221 Digital illustration, cooking up, 184-185 Edgerton develops, 344-345 Cooper, Martha, 307 Exposure tolerance comparison, color, Digital images, 244-259 Ellard, Roscoe, 194 Copeland, Tom, 133 228-229 computers to create photo illustrations **Emotions** Cops Eye usage and, 251-252 face and hands reveal, 51 getting along with, 29-31 automatic, 265-268 digital camera usage and, 247-249 knowing one's bounds with, 30 looking for, 194-196 keeping fresh, 90-92 digital universal, 88 police saying no pictures, 29-30 Eyes of Time, 345 ethics and, 255-258 Employers owning photos, 298–299 on the scene with, 30-31 Eyes, subjects', 107-108 Copyrights, 298-299 going too far and, 258-259 Equipment, need for rugged, 220 Internet and, delivering photos to Erickson, Pete, 33, 121 copyrighting one's own photos, 299 viewers worldwide on, 252-254 Ermanox don't infringe on, 183-185

respecting others', 299

retaining, 299

scanners usage and, 249-251

Digital images and ethics, 255-258

Faber, John. 310, 315, 344, 346 Faces, 107 and hands reveal emotions, 51 show all, 113 Falk, John, 276 Farber, Edward, 345, 356 Farley, Bob, 307 Farm Security Administration, 159, 336 Farsai, Gretchen, 198 Feature beats, developing, 68-83 getting ideas and, 68 informative features require extensive research, 72 initial stories and, 70 one story leads to another and, 70-72 organization and, 68-69 past stories on topic and, 68 start-up problems and, 70 Feature subjects, good, 88-90 animals acting like people as, 89-90 incongruity, 89 kids imitating adults as, 89 people like people as, 89 Features, 84-97 automatic, 220-223 avoiding triteness, 94 discovering, 90-97 featurizing news for, 87-88 finding, 97 good subjects for, 88-90 highlight sidelights and, 38 keeping fresh eye for, 90-92 news vs., 87-90 photographing candids for, 92-93 preferred, 198-199 research required, 72 slice of life as, 87 sports as, 119-120 timelessness of, 87 unique vantage point for, 93-94 universal emotions as, 88 Featurizing news, 87-88 Fedler, Fred, 214 Feininger, Andreas, 351 Fellenbaum, Charlie, 306 Fellig, Arthur, 342-343 Fellini, Frederico, 284 Ferro, Rich, 13 Film(s) cameras and, 218-243 3200 Magic and, 224-225 black-and-white, 223-225 color, 225-230 color negative, 228 developing, 128 overrating, 223-225 pushing color, 237-238 shooting stories with color negative, super-saturated chrome, 230 transparencies vs. color negative, 225-230 transparency color, 232

Film, color, 225-230

editing ease of slides, 227 grain and saturation of, 227-228 pushing of, 237-238 repro quality of, 228 shooting style of, 228-230 Film, color negative shooting stories with. 240 transparencies vs., 225-230 Fires, shooting, 33-39 features highlight sidelights and, 38 finding and fleeing of, 34 getting facts for, 38 looking for economic angle for, 34-38 nighttime difficulty of, 38-39 overall shots set scenes and, 34 planning for traffic and, 34 watching for human side and, 34 Fischer, Carl, 172, 173, 178 Fisher, Gail, 201 Fitzmaurice, Deanne, 249, 260, 261 Fitzsimmons, Barry, 241 Flamiano, Delores, 350 Fixed-focal-length telephotos lenses, 126 Flash, electronic available light, combining with, 264-268 automatic eye and, 265-268 bounce, caution with, 275 bouncefor softer light, 270-275 controversy over, 262-264 determining aperture and, 265 Edgerton develops, 344-345 fill-flash handles heavy shadows, 274-276 hand-held strobe meters and, 268 manual handling of, 265 through the lens (TTL) and, 268 See Strobe. Flashbulbs, 344 Flash controversy, electronic, 262-264 Flash powder, dangers of, 343-344 Flores, Silvia, 241 Fluorescent lights, shooting under, 233 Focusina autofocus and, 125-126 how to get sharper images when, 123-126 manual, 123-124 zone, 124-125 Football adjusting one's positions and, 133 avoiding standard stuff and, 133 finding, 131-133 shooting bombs and, 132-133 watching for runs and, 132 Forman, Stanley, 32, 36-37, 42, 141, 150, 151, 322, 323 Forscher, Marty, 220 Fortune magazine revolutionizes picture use, 349 Fourth Amendment, 291-292 Foy, Mary Lou, 315

Freelance considerations, 22-23

selling stock photography and, 22-23 working with picture agency and, 22 Freelancer vs. staff photographer, 20 Freezing action, 120-121 Frezzolini, James, 345 Friedmann, André, 351 FSA. See Farm Security Administration Fudge, Joe, 315 Funerals covering, 315 respecting privacy at, 315 Furstenau, Bob, 257 Galbraith, Rob. 248 Galella, Ron, 284, 285 Gaps III, John, 32, 33, 244, 245, 245, 246, 246, 248, 249 Garcia, Mario, 238 Gardner, Susan, 176, 181 Garvin, Robert, 94 Gavreau, Emile, 342 Gehrz, Jim, 313 General news, 44-57 come early-stay late, 55-56 going behind scenes for, 46-48 in-depth photo journalism and, 56-57 meetings generate news and, 51-54 photographing issues, 54 steer clear of pack and, 54-55 strategies from professionals and, 48 Gensheimer, Jim, 140, 209 Gerbich, Kim. 70 German émigrés, 350-351 German photo essay, 348-349 Get the Picture, 352 Gilka, Robert, 199, 200, 259, 346 Gilpin, John, 207 Glaser, Marilyn, 182 Glass, reflections off, 270 Glinn, Burt, 354 Goebel, Rob, 95 Goldberg, Vicki, 60 Goldsmith, Arthur, 94, 350 Good Samaritan vs. professional, 315-316 Gordon, Jim, 308, 358 Goro, Fritz, 351 Government buildings, 294-295

Grace, Arthur, 102 Graflex used until 1955, 345-346 Grain and saturation, 227-228 Gralish, Tom, 8, 141, 147 Grecco, Michael, 108, 109, 111, 271, 272, 276, 280, 280, 281 Green, Walter, 15 Greenwald, Marilyn, 201 Grief and covering tragedy, 311-315 Griesedieck, Judy, 61, 62, 63, 140 Griffiths, Philip Jones, 354 Grigsby, Bryan, 57 Grogin, Harry, 257, 341, 341, 342 Grossfeld, Stan, 61 Grosvenor, Gilbert, 338, 339 Group portraits, 113 Gruesome pictures, 317-318

Grundberg, Andy, 258 Guidan, Dale, 129 Guralnick, David, 61, *76*, 77, 129, 135, 192, 223, 247, 249, *250* Guzy, Carol, 13, 20, 60, *78*, *79*, *80*, *81*, *82*, *83*, 140, 141, 243

Н

Haas, Ernst, 16-17 Habas, Paula, 257 Haley, Peter, 170, 171 Halftone screens reproduce photos. 332-333 Halsman, Philippe, 177, 351 Halstead, Dirck, 253, 254, 255 Hand-held strobe meters, 268 Hands and face reveal emotions, 51 show of 142 Hare, Jimmy, 333-335, 334 covers first flight, 335 covers Spanish-American War, 334 Collier's Weekly and, 334-335 Harper's Weekly, 348, 359 use of drawings in, 348 Harrison, Randall, 199 Harte, John, 321 Hartley, Craig, 230, 231, 310, 315, 318 Haun, Charlie, 199 Headlines crimes make, 26-32 and pictures don't mesh, 185 poor, 185 testing themes with, 140-141 writing of, 177-178 Hearst, William Randolph, 348 Hechel, Scott, 90 Heller, Steve, 178 Herbrich, Sibylla, 70, 71, 72, 101, 102, Herzberg, Mark, 47, 313 Hetzel, Leo, 164, 165 Hicks, Wilson, 193, 210, 348, 351 High/low angles bring new perspectives, 14-15 Highlights, expose for, 230 Hine, Lewis, 59, 336-338, 337, 340 child labor laws, and 337-338 History, 328-359 American magazines adopt photography, 349-350 cameras as reformers' tools, 336-338 cameras, lose weight and gain versatility, 345-347 career of W. Eugene Smith, 354-355 competing with Life, 350 distributing pictures across the land, 358-359 Erich Salomon: father of candid photography, 347-348 evolution of camera reporters, 330-332 German photo essay, 348-349 halftone screens reproduce photos, 332-333

Maine blew up and Jimmy Hare **Images** Kodas, Michael, 13 Light blew in, 333-335 digital type of, 244-259 Koelzer, Jay, 174, 176, 179, 180 automatic eye and strobe, 265-268 opposition to photos, 333 how to get, 123-126 Komenich, Kim, 116 bounce strobe for softer, 270-275 photographers compete, 355-356 multiple, 210-111 Korff, Kurt. 349 combining flash with available, photographers organize, 357-358 translating words into, 178-179 Korn, Alfred, 359 264-268 photos fill magazines, 338-340 using someone's, 285-286 Kwok, Ken, 164 determining aperture for, 265 picture agencies supply working with, 202-207 hand-held strobe meters and, 268 magazine trade, 350-354 Imaginative assignments, starting low, 223-225 Labelle, Dave, 313 progressive visual newspaper, 356 with. 190-194 manual, 265 Labor laws, Hine's photos and child, searching for convenient light camera skills unnecessary for, 193 through the lens (TTL), 268 337-338 source, 343-345 do-it-yourself picture editing and, seeina, 103-105 LaClair, Scott, 320 tabloids, 340-343 193-194 shooting under fluorescent, 233 war censorship, 356-357 Lachman, Robert, viii research for, 192 soft, 113 Lambert, Kenneth, 324, 324 Weegee, king of crime selecting photographers for, 191-192 strobe accessories for diffusing, 279 Lamkey, Rod, 141, 143, 146, 148-149, photographers, 343 Impact understanding, 104-105 150, 151, 160 women enter field, 335-336 compositional elements add, 105 use to tell story, 103-105 Lamm, Wendy Sue, 23, 227 Holandez, Jaunito, 165, 166, 306 sizing up for, 207-210 Lighting Lange, Dorothea, 336 Home, shooting inside someone's, Incongruous photos, 89 dimly lit sports and, 128 Language, body, 108 284-286 In-depth off-camera, 270 Larsen, Rov. 350 home as castle, 289-296 coverage, 63 uneven, 270 Larson, Fredric, 11, 11 shooting outside someone's photojournalism, 56-57 whole room and, 280-281 home, 284-285 Lassiter, Don, 38 Index, photo story, 140-141 Light sources Last frames Horgan, Stephen H., 332, 333 INP. See International News Photos different films for different types of, not shooting, 43 Hospitals, 288 International assignments, 11-13 Hostage situation, case study, 24-43 saving, 20 International News Photos (INP), 355, searching for convenient, 343-345 House, shooting outside, 284-285 Law(s), 282-299 Linnett, Scott R., 116, 117 copyrights and, 298-299 Howard, Thomas, 340 Internet, delivering photos to viewers L'Illustration differing from state to state, 298 Howe, Peter, 192 worldwide, 252-254 instant transmission and, 359 Hine's photos and child labor, How the Other Half Lives, 337 Intimacy, 196 Linsenmeyer, Steve, 2, 3-4 Hu. Hyan-Joo, Lee, 209 337-338 Issue reporting, nursing homes case Liotta, Louie, 343 Hu, Paul, 164, 165, 166 study, 61-68 libel and photographer and, 297 Loche, Greg, 92 press credentials and, 297 Huang, Edgar, 258 Issues London Daily Mirror privacy and, 284-286 Hughes, Jim, 354 covering, 58-83 instant transmission and, 359 Huh, Hyan-Joo, Lee, 209 references and, 299 developing feature beats and, 68-83 Long, John, 259 subpoenas for negatives and, 297-298 Hulteng, John L., 313 photographing, 54 Look magazine, 139, 350, 354 Human interest, 197-198 private or embarrassing photos, based on survey, 350 287-289 competes with Life, 350 Jackson, Bob, 203 trespass and, 289-296 Lorant, Stefan, 348 lacono, John, 126, 127 Jarvis, Jeff, 317 Layouts, achieving contrast with size in, Low light, shooting in, 223-225 Johnson, Curt, 210 Ideas 209 Lowrey, Wilson, 257 getting, 68 Johnson, Kim, 4, 205 Lee, Matthew J., 164 Luce, Henry, 139, 349 selecting most workable, 179 Johnson, Mark, 87 Leeson, David, 101, 104, 104, 107, 277 Luebke, Barbara, 201 Illness, suicide as mental, 317 Johnston, Frances Benjamin, 335 Legal rights, miscellaneous, 282-299 Lum, Corv. 197 Illustrated American Josephson, Sheree, 189, 190, 238, 239, Leggo, William, 332 Lustig, Ray, 51, 52, 53, 53, 54 uses freelance photography, 334 253 Leibovitz, Annie, 111-113, 112, 143 Jimmy Hare and, 334 Journalistic portraits, 98-113 M Leica, 346-347 Illustrated Daily News Junco, Victor, 214 Lenses, 222-223 MacDougall, Curtis, 318, 327 first tabloid, 341 fixed-focal-length telephoto, 126 Mack, Charles, 358 See The Daily News: New York's stabilization of, 223 MacLean, Malcolm S., 197, 199, 200 Kahan, Stuart, 287 Picture Newspaper zoom, 126-127, 222-223 MacMillan, Jim, 4, 12, 27, 27, 29, 30, Kalish, Stanley, 194 Illustrated London News Leslie's Illustrated Newspaper 30, 34, 39, 43, 137, 140, 151, 252, Kao, Anne, Li-An, 197, 199, 200 first photo essays in, 348 use of drawings to illustrate in, 348 253 Kaplan, John, 198 Illustrations, 170-187 Lester, Paul, 201 Magazines Kapustin, Doug, 15, 91, 122, 190 brainstorming concepts for, 177 Levinson, Julie, 329 editors of, 256-257 Katner, Joseph, 217 computers usage to create, 251-252 Levy, Tom, 376 European, 348-349 Kelly, James, 258 creating digital, 184-185 Libel and photographer, 297 markets for pictures, 23 Kennedy, Tom, 253 docudramas, 173-175 Life photos fill and, 338-340 Kennerly, Hume, David, 48, 49, 51 editorial concept and, 173 slice of, 87 trade. 6 Kenney, Keith R., 339 producing editorial, 175-181 Life magazine, 139, 284, 343, 348, Magic film 3200, 224-225 Kerrick, Jean, 211 product, 172-173 351-355 Magnum agency, 351-354, 351, 353 Kertesz, André, 146 some work, some don't, 185-186 formula for visual variety in, 146-147 cooperative agency shares earnings, Kids imitating adults, 89 translating words into images and, integrity of photograph in, 348 Kobre, Ken, 31, 43, 72, 73, 86, 101, 106, 178-179 is born, 349-350 recruits photographers, 353-354 types of, 172-175 121, 209, 234, 235, 243, 262, 273 war photos in, 357 responds to changes, 354 Kobre, Sidney, 68, 356, 356 words of caution for, 186-187 Light, Ken, 61, 138, 141, 159 survives deaths in family, 354 Kochersberger, Robert, 316 writing headlines for, 177-178 Magnum: Fifty Years at the Front

Koci-Hernandez, Richard, 12, 87, 100.

102, 103, 105, 108, 221

Line of History, 354

Newsweek magazine, 288, 305, Philpott, Keith, 151, 264 Maharidge, Dale, 61 Motorized cameras, 127-128 Mangin, Brad, 115, 116, 118, 128, 131, Multiple images, 210-211 political coverage in, 48, 51 Photos spurs Time's first use of photography. Muncher Illustrierte Press 211, 252 development of photo story in, 348 349-350 Manos, Constantine, 92 Murphy, William T., Jr., 316 war photos in, 357 Manual focusing, 123-124 New York Herald Marshall, Joyce, 24, 24, 25, 26 refuses to use halftones, 333 Martell, George, 18, 18 Nace, Diana, 258 New York Mornina World, 355 Martin, John, 204 Nachtwey, Jim, 241 Mayer, Ernest, 318, 350 New York Newsday Naked City. 343 digitally combines images, 256 McAvoy, Thomas, 350 Narratives New York Times McClure's magazine convey plots for, 158 uses halftones in supplement, 333, use of photos in, 348 external action needed for photo McDonald, Nick, 344 narrative 150 Mid-Week Pictorial War Extra and, 339 McGill, Eddie, 344 natural, 151 Mid-Week Pictorial and, 339 McGrory, Mary, 307 Narrative stories New York Post, 356 McIntosh, Thane, 241 comparing documentaries to, 158-169 New York Sun 355 McLaughlin, Alain, 324 comparing photo essays to, 158-169 New York Mirror, 355 Meadows, Mike, 305 inherent appeal of, 158 New York World Means, Kaja, 20, 21, 22 Narrative storytelling, 147-158 reluctance to use illustrations Media events, 44-57 combination of complication and or photogrpahs, 333 and photo ops, 56-57 resolution, 150-151 Medium-powered strobes, 276 Night complication alone, 147 Medium shots, 13-14 fires at. 38-39 compressing narrative time. shooting from dawn until, 234-237 Meetings 151-158 on streets at, 27-29 for budget, 10-11 external action needed for photo Newton, Henry J., 333 for generating news, 51-54 narrative, 150 Nottingham, Emily, 92 props add meaning and, 52 inherent appeal of narrative stories, NPPA. See National Press survival tactics and, 53-54 Meinhardt, Michael, 5, 306 Photographers Association natural narratives, 151 NPPA-L, 56, 311, 358 Mental illness, suicide as, 317 resolution alone, 147-150 Nuss, Cheryl, 68 Mercanti, Michael, 56, 57 Narrative time, compressing, 151-158 Nuss, Dave, 313 Metaphors, visual, 179 Nationional Enquirer, 256 Meters National Geographic, 255, 258-59. hand-held strobe, 268 O'Brien, Frank, 116 338-339, 347 when to override automatic exposure digital manipulation of cover, 255, O'Brien, Sue, 317 of, 221 Off-camera lighting, 270 258-259 Metzger, John, 250 Outlets, determining possible, 20-22 first flash photography in, 338 Mialetti, David, 97 first use of color in, 339 Overall shots, 13 Middlebrooks, Donald, 30 Overrating film, 223-225 National Press Photographers Miller, Gary, 316 Association, 304, 310, 9, 56, 61, 78, Miller, Paul, 91 252-253, 255, 294, 298, 304, 310, Miller, Russell, 16, 113, 354 Panning, 122-123 320, 315, 308, 344, 346 Miller, Susan, 201 Pantaléon, Jennifer Cheek, v. 224 Negative film Millis, Jon. Jr., 194 Paparazzis as photojournalists, 320 shooting stories with, 240 Mid-Week Pictorial Park, Sung, 103, 100, 222 transparencies vs., 225-230 use of war pictures in, 339 Parks, Gordon, 336 Negatives, subpoenas for, 297-298 use of color in, 339 Paylos, Simeon, 201 Nelson, Roy Paul, 202 photographic firsts in, 339 Peak action, 121-122 Newcomb, John, 181 Milwaukee Journal, 329, 345, 346 Newman, Arnold, 107, 110, 111 People technical innovations in, 355-356 animals acting like, 89-90 News Minamata, 355 people like, 89 backgrounding, 58-83 Mironchuk, Greg, 56 People stories, types of, 141-143 features vs., 87-90 Models, 180 little-known but interesting, 143 featurizing, 87-88 Modern photo story, Smith introduces, little-known but representative, 143 general, 44-57 well-known, 141-143 marketing spot and, 20-22 Moment, photojournalist of decisive, Perfal, Arthur, 56 meetings generation of, 51-54 352-353 Perkins, Lucian, 218, 219 miscellaneous sources for, 5-6 Moods Perspectives sports as, 114-135 consistent visual, 146-147 consistent, 146-147 spot, 24-43 preserving, 203, 206-207 high/low angles, 14-15 where to find, 2-23 Moore, Charles, 60 Peskin, Hy, 128 Newspaper photographers Morris, Chris, 241 rivalry among, 355-356 Morris, Desmond, 108 Newspaper, progressive visual, 356 Morris, John, 353 Newspeg, finding, 141 Morris, Larry, 195 News photos, when and where Moral dilemmas of picture editor, to sell. 20-22 317-318

captions for, 211-217 concept. 187 editing, 188-217 multiple images and, 210-211 narrative for, 150 professional editors predict readers' preferences for, 199-201 research indicates reader's preferences for, 197-199 sizing up for impact of, 207-210 starting with imaginative assignments, 190-194 strategies for selecting, 194-197 what readers don't see and, 201-202 working with images in, 202-207 Photo essays comparing to narrative stories, 158-169 European magazines development of, 348-349 German and, 348-349 Photo illustrations kinds of, 172-175 using computers to create, 251-252 Photojournalism goes Hollywood, 277-281 in-depth style of, 56-57 photograph topics and, not talkers, 56 stories behind awards and, 57 Photo opportunities, 45 media events and, 56-57 Photo possibilities, from tragic to bizarre 39-42 Photo, requests, 6 Photo stories, 136-169 assignments locating, 140 bounty hunters, 160-163 comparing documentaries to narrative stories and, 158-169 comparing photo essay to narrative stories and, 158-169 finding, 139-140 Life magazine formula for visual variety in, 146-147 narrative storytelling and, 147-158 Smith introduces modern, 139 telling stories with as, 140-141 topical trends and, 140 types of people stories and, 141-143 visual consistency in, 143-147 Photo story index, 140-141 Photographers Capa as greatest war photographer. 351-354 changing with times, 308-309 competing, 355-356 king of crime and, 343 and libel, 297 making own arrangements, 9 organizing, 357-358 police inviting in, 289-292 rivalry among newspapers, 355-356 selecting, 191-192 techniques of sports, 120-123 working with reporters, 9-10

Photographer's bag of solutions, sports, 126-128 Photographer, staff vs. freelancer, 20 Photographing candids, 92-93 crime in progress, 31 issues, 54 tragic moments, 313 Photographs integrity in treatment of, 257, 348 strategies for selecting, 194-197 theories of selecting, 194 The Washington Post's hierarchy of, 194-196 when facts conflict with, 307-308 Photography American magazines adoption of, 349-350 difference making of, 323-325 father of candid, 347-348 selling stock, 22-23 Time's use of, 349-350 Photojournalists outfitting, 218-243 Photos; See also Pictures; Shots close-up, 14 composing on electronic layout table, 255-258 consistent perspective and, 146-147 consistent technique and, 146-147 consistent visual mood in, 146-147 copyrighting one's own, 299 delivery to viewers worldwide of, 252-254 halftone screens reproduction of, 332-333 high/low angles bring new perspectives to, 14-15 incongruous, 89 opposition to, 333 preconceiving, 108-111 public but embarrassing, 287-288 private or embarrassing, 287-289 revealing vs. accidental, 51 same object or place consistency in, 146 same person consistency and, 143-146 summarizing game in one, 116-118 timely, 116 visual consistency of, 143-147 weak, 185 when and where to sell news, 20-22 who owns, 298-299 Picture order varies, 160 package of, 211-213 page and, 339 pairing of, 210-211 politics and, 10-13 selection, 196 theories for selection of, 194 transmission of, 359 Picture agencies magazine trade supplying by, 350-354

working with, 22

Picture editing, do-it-yourself, 193-194 Picture editors moral dilemmas of, 317-318 role of, 188-217 Picture magazine, 139 Picture meaning, words influence, 211-214 Picture-minded, women more, 199 Picture use, Fortune magazine revolutionizes, 349 Pictures: See also Photographs: Photos: Shots background producing for, 180 come in handy at National Geographic, 338-339 computers translation into numbers of, 251 distributing across the land, 358-359 aruesome, 317-318 headlines don't mesh with, 185 history of altering, 257 models and, 180 owning, 298-299 packaging, 211 pairing, 210 police saying no to, 29-30 producing, 179-181 props for, 179-180 sequences and series for, 211 shocking, 323 telling stories with, 136-139, 140-141 time and, 180-181 The Washington Posts hierarchy. 194-196 Pierson, Terry, 90 Pix magazine, 139, 350 Plonka, Brian, 58, 59, 64-67, 137, 138, 140, 141, 146, 158, 236, 237 PM. 356 Poisson, Cloe, 206, 207 Polansky, Sharon H., 198, 203, 208 Police inviting photographers in by, 289-292 saying no pictures by, 29-30 Politicians, 44-57 Politics, 44-57 picture and, 10-13 Pool, Smiley, 100 Porter, Kent, 5, 27, 28, 30, 34, 38, 88, 237 Portraits, 98-113 building and, 111-113 compositional elements add impact to, 105 environmental details tell story in, 111 group, 113 preconceiving photos and, 108-111 providing clues to inner person in, 107-108 psychological factor in, 111-113 putting subjects at ease for, 100-103 showing all faces in group, 113 soft light and group, 113 timing is everything for, 113

PR. See Public relations Press credentials, 297 Preston, Neal, 308 Prince, Whitney, 279 Privacy at funerals, respecting, 314 Private property open to public, 292-293 Problems, start-up, 70 Professionals good Samaritans vs., 315-316 posing pictures by, 304-305 Property, private, 292-293 Props, 179-180 adding meaning using, 52 background and, 105-107 Pros, strategies from, 48 Protest, suicide as form of, 316-317 Psoras, Sam. 355 Psychological portraits, 111-113 Public places, shoot freely in, 293-294 Public relations, 6 Public's right to know, 282-299 Pulitzer, Joseph, 333, 339 0 Quarles, Rebecca, 209

Quotes, 217

Ragland, Jan, 53 Raible, John, 286 Ray, Bill, 284 Raymer, Steve, 99, 159, 160, 230, 234, 238, 238, 239, 241 Reactions, catching on and off field, 118 Reaction time, counteracting, 129 Reader complaints, 318-323 believing their eyes, 305-309 and editors, 200 reaction to color by, 238-239 remembering, 327

Readers' preferences agreement of readers and editors, 200 bus survey of, 199-200 professional editors prediction of, 199-201

what's not seen by, 201-202

research indications for, 197-199 Reaves, Shiela, 255, 256, 308 Reddy, Patrick, 52

Reed, Rita, 202 Reininger, Alon, 68

Reflections off glass, 270 Reformers' tools, cameras as, 336-338

Reporters beat of, 6

evolution of camera and, 330-332 working with, 6-10 Reporters and photographers

meeting of, 9 working in tandem with, 9-10

Reporting

fair and balanced, 325-327 issue and, 61-68

Research indicates reader's preferences. 197-199 conclusions of, 199 features preferred in, 198-199 women more picture-minded and, 199 Research, informative features require extensive, 72 Reuters, 256 Revealing vs. accidental photos, 51 Riboud, Marc, 353, 354 Rice, Steve, 220 Richards, Eugene, 16, 60 Ridealongs violate Fourth Amendment, 291-292 Riedel, Charlie, 14, 87, 87, 91, 93, 93, 94, 134 Riggins, Rick, vi. 131 Riis, Jacob, 34, 59, 336-337, 336 exposes slum conditions, 336-337 Riley, George, 116, 119, 127 Ringman, Steve, 68 Risberg, Eric, 120, 127, 130, 134, 223, 224 Rizer, Georger, ii, 34, 38, 304 Roche, James, 198 Rodger, George 351 Rodriguez, Joseph, 171 Rodriguez, Paul E., 225 Roeder, George, 357 Rogers, Matt. 248 Rook, D'Anna, Melanie, 181, 181 Room, lighting whole, 280-281 Rosenthal, Joe, 178 Rothstein, Arthur, 336 Rotogravure, 338-340 Rowland, Brownie, 356 Run, hit and, 19 Rwandan exodus, 82-83 Ryan, Patrick, 130

Saba Press Photos, 23, 192 Saba, Marcel, 23 Safranski, Kurt, 350 Sales, do-it-vourself, 23 Salomon, Erich, 347-348, 347 Salvador, Cristine, 136, 137, 139, 140, 143, 152-159 Samaritan, professional vs. good, 315-316 Sanders, Walter, 351 Sarbin, Hershel, 293 Sarno, Dick, 296 Saturation, and grain, 227-228 Saturday Evening Post magazine, 287, 354 Scanner radios, 4-5 Scanners, digital images using, 249-251 Scene-setter, close-up vs., 105 Scenes getting to, 42-43 going behind, 46-48 overall shots set and, 34 Schaben, Al, 239, 242, 243, 314 Schauer, Mindy, 141, 143, 151, 158, 167-169 Scherschel, Frank, 344, 356

use light to tell story, 103

Poush, Dan, 39

zest addition to small group, 113